WATER-COLOUR PAINTING IN BRITAIN

IN BRITAIN

III THE VICTORIAN PERIOD

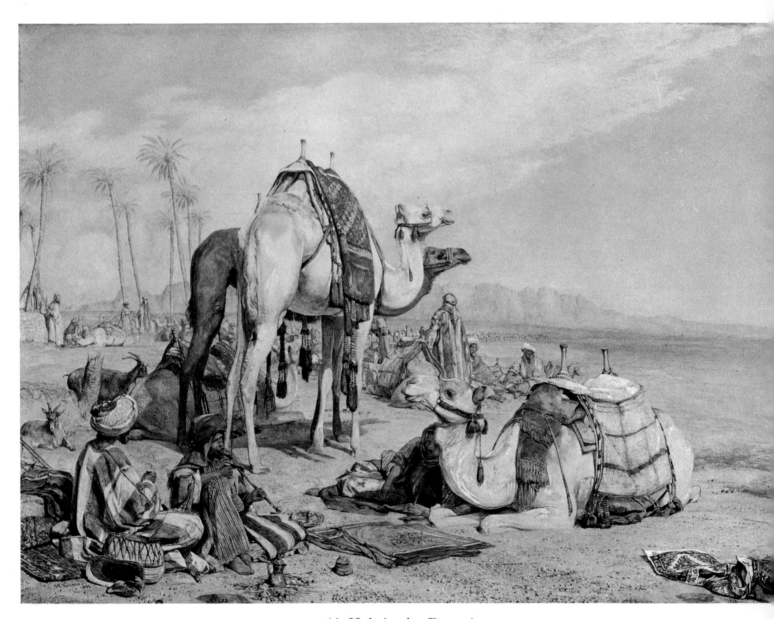

1 'A Halt in the Desert'

V.A.M. 532 $14\frac{1}{2} \times 19\frac{5}{8}$: 368×499 *Water-colour, signed and dated 1855*

John Frederick LEWIS, R.A. (1805–1876)

Water-colour Painting in Britain

III *The Victorian Period*

Martin Hardie

Edited by Dudley Snelgrove *with*
Jonathan Mayne *and* Basil Taylor

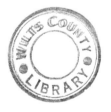
B. T. BATSFORD LTD LONDON

First Published 1968

© The Estate of the late Martin Hardie 1968

Printed and bound in Great Britain
by William Clowes and Sons, Ltd., London and Beccles,
Collotype plates by Cotswold Collotype Co. Ltd.,
Wotton-under-Edge, Gloucestershire,
for the publishers B. T. BATSFORD LTD.
4 Fitzhardinge Street, Portman Square, London W1

CONTENTS

EDITORIAL FOREWORD

To this third and final volume of Martin Hardie's work the editors have decided to add certain elements which he had not himself composed, but which we are confident he would have intended or welcomed as useful to an already ambitious design. We are indebted to the various writers for supplying this new material.

Hardie's chapters on drawing-masters, amateur artists and patrons had become out-dated by subsequent study and we asked the chief instigator of this research, Mr. Ian Fleming-Williams, to supply a new text based upon Hardie's original material to appear as appendices in this volume.

The bibliography is the work of several hands. The bulk has come from the diligent efforts of Miss Irene Whalley of the Victoria and Albert Museum in searching through the catalogues and indices of the National Art Library. We are also grateful to Mr. S. T. Lucas for allowing us to use the relevant parts of his bibliography of water-colour painting and painters, prepared as a thesis for a Fellowship of the Library Association; and this material has been further supplemented by the editors.

Finally, we are most indebted to Mr. John Dent for his invaluable assistance in supply-ing a comprehensive index to the entire work which has been added to the shorter indices of artists in the three volumes.

In the preparation of this volume, the editors are particularly indebted to the following: Miss Margot Holloway, for her considerable help in checking proofs and compiling the index to artists in each volume; Mr. Douglas Smith, who has made the majority of the photographs for the entire work; Mrs. Kenneth Sharpe, for accomplishing so accurately the heavy task of typing the last two volumes; the Keepers and Staff of the British Museum and the Victoria and Albert Museum, for their helpfulness in making material available and for providing convenient sites for photography; and to the Staff of other museums and galleries, private collectors and scholars, too numerous to mention, who have given inform-ation so readily.

The Publishers wish to thank the owners of the paintings reproduced in this book, and whose names are given beneath the illustrations. In particular they express their thanks to the Trustees of the British Museum; the President and Fellows of Corpus Christi College, Oxford; the Courtauld Institute of Art (Spooner Bequest); the Ipswich Museums Com-mittee; the National Gallery of Scotland; the Trustees of the Tate Gallery, and the Director of the Victoria and Albert Museum (Crown Copyright), for permission to repro-duce illustrations from their collections.

B.M. British Museum

Diary Joseph Farington's Diary, ed. James Greig. 8 vols. 1922–1928

L.B. Laurence Binyon: Catalogue of Drawings by British Artists in the British Museum. 4 vols. 1898–1907

Roget J. L. Roget: History of the 'Old Water-colour' Society. 2 vols. 1891

V.A.M. Victoria and Albert Museum

Whitley 1700–1799 I and II W. T. Whitley: Artists and their Friends in England 1700–1799. 2 vols. 1928

Whitley 1800–1820 W. T. Whitley: Art in England 1800–1820. 1928

Whitley 1821–1837 W. T. Whitley: Art in England 1821–1837. 1930

THE ILLUSTRATIONS

xi

CHAPTER I
Foreign Travel: Architectural Draughtsmen

Henry Edridge Samuel Prout the Pugins Thomas Hosmer Shepherd
Charles Wild the Stephanoffs Frederick Mackenzie

An earlier generation, for whom the Grand Tour was an educational duty, consisted mainly of learned or leisured aristocrats (the type of Lord Burleigh and Sir George Beaumont) who had been trained in classical ideals and were seeking the delights of classical and renaissance art. But the Grand Tour and the artificial classical sentiment came to an end with the revolutionary wars. A few English painters and travellers, Turner, Girtin and Thomas Holcroft among them, rushed over to Paris during the abortive Peace of Amiens in 1802. Not till there was a quieter France in 1816 did modern *tourism* really begin. And the tourism of the nineteenth century was inspired by different ideals and enthusiasms from that of the eighteenth. The Lake School of poets had fostered a love for simple natural beauty and Byron had enchanted his readers by a transfusion of landscape and history. Readers wanted to enjoy Swiss mountain sides and visit 'the castled crag of Drachenfels', or stand 'on the Bridge of Sighs, a palace and a prison on each hand'. And the generation of 1820 were as much interested in the life and colour of contemporary surroundings as in a reconstruction of the past. Many of them were no longer *cognoscenti, virtuosi, dilettanti*, whose culture was based upon classical study. They were not the product of Eton, Harrow and Winchester, but were successful business men, literary men, like William Hazlitt,[1] or professional men, like John Ruskin's father and Dawson Turner, travelling with their wives and daughters, not because such travel was *de rigueur*, but for change and pleasure. If they were wealthy, like the Ruskins, they chose carefully in Long Acre the perfect travelling carriage 'which was to be virtually one's home for five or six months'. If their means were moderate, they travelled like Charles Dickens and his family, who went through France and across Switzerland to Genoa in 1844, in a great lumbering carriage drawn by four horses. If their means were small, they made a shorter tour and travelled by the humbler *diligence*; perhaps, like Rowlandson, they were content with a Belgian trip. More middle-class in origin and outlook than their predecessors, who followed a systematic route through France to Italy over the Mont Cenis and returned by the Simplon, down the Rhine and through the Netherlands, they were content with briefer excursions and on

[1] His *Notes of a Journey through France and Italy* appeared in the *Morning Chronicle*, 1824–5, before being issued in book form.

their return sought in pictures something that responded closely to their personal experiences and memories. It was the rôle of Edridge, Prout, Stanfield, Harding, Roberts and others to cater for patrons who were no longer satisfied alone by picturesque views of historical architecture but whose changing taste called for Gothic cathedrals and churches, unfamiliar streets and quaint houses, with curious configuration of roof-tops, chimneys, windows, balconies and door-ways, a heritage of the past but fitting into the contemporary scene and coloured by costumes bright and gay as children's toys. It was often a stage-land or a toy-land, a little crude, gimcrack and artificial, that its painters created. It was for Prout and his companions to preserve and exaggerate the discomfort and decay of medieval dwellings; to present the picturesque in all its brilliant or sordid and forlorn aspects, so that it might hang in gilded mounts on the walls of formal Victorian drawing-rooms, and evoke memories of honeymoons and holidays which had seemed romantic adventures. Stately cathedrals, storied palaces, decrepit houses with timbered gables, high-pitched roofs and overhanging eaves, the hurly-burly of the street with its flutter of gay costumes, male and female dandies, peasants with the primitive flash of red, orange, blue or green, in their national dress, the market-place prismatic with the bright umbrellas and vividly striped awnings, the shimmering blue lakes and mountain scenery, gondolas gliding through Venetian canals, all of what the Continent means, is what Prout and his fellows supplied with consummate skill. They may have used a decorative exaggeration, their sentiment may have been laid on with too lavish a brush, but like their contemporary Charles Dickens, they appealed to 'humanity i' the large'. What they accomplished is well expressed by Ruskin, with a touch of delicate humour, in his account of the private views long ago of the Old Water-Colour Society.[1] Of Prout in particular he says:

> It became, by common and tacit consent, Mr. Prout's privilege, and it remained his privilege exclusively, to introduce foreign elements of romance and amazement into this—perhaps slightly fenny—atmosphere of English common sense. In contrast with our Midland locks and barges, his *On the Grand Canal, Venice*, was an Arabian enchantment; among the mildly elegiac country churchyards at Llangollen or Stoke Pogis, his *Sepulchral Monuments at Verona* were Shakespearian tragedy and to us who had just come into the room out of Finsbury or Mincing Lane, his *Street in Nuremburg* was a German fairy tale.

It is significant that in 1858 no fewer than twenty-two members of the Old Society exhibited continental subjects in the Pall Mall Gallery.

Edridge, fourteen years senior to Prout, visited France two years before his younger colleague. Seeing that there is much similarity in their work and that Edridge gave the lead, it is fitting to consider him first. Henry Edridge (1769–1821), born six years after Dayes, serves as a link between the earlier topographers and the later school who discovered the picturesque elements of continental architecture and scenery, and extended the methods of depicting them. Edridge was the son of a Westminster tradesman, and served his

[1] J. Ruskin, *Notes on Prout and Hunt*, 1880, p. 26.

apprenticeship with William Pether, the mezzotint engraver. It may be said here that Pether (1738–1821), who had also instructed Dayes, was painter as well as engraver. A water-colour of *Bisham Abbey*[1] signed *W.P.1769*, in the Victoria and Albert Museum, anticipates the method used by Dayes about twenty years later and suggests its origin. After his term under Pether was completed, Edridge entered the Royal Academy schools, won the notice of Reynolds, and was allowed to copy, in miniature, the President's works. Such painting in miniature was to become the main branch of his professional activity, and he specialised in portraits where the figure was drawn with slight and spirited pencil outline, and the face finished elaborately in water-colour. In the British Museum are more than a dozen of his portraits of contemporary artists, Woollett, Hearne, Farington, Stothard, Bartolozzi and others, nearly all in pencil, the head and background only being touched with colour. As examples of his more elaborate work of this nature may be mentioned the very charming *Unknown Gentleman with Two Children*[2] (Pl. 1), 1799, and a series of full-length portraits, including *Ernest, Duke of Cumberland*, 1802,[3] *Princess Mary, Daughter of King George III*, 1802,[4] and many others, in the royal collection at Windsor Castle. From the nature of his work, Edridge lived a good deal in the society of the great or the famous, and provided much gossip for his friend, Farington. In 1802 he visited Merton 'with Sir William Hamilton and Lady Hamilton and Lord Nelson who live constantly together, bearing their expenses jointly & settling up once a month'.[5] From 1802 he was frequently in demand at Windsor Castle for portraits; and as portraitist stayed at various distinguished homes, among them that of Charles James Fox. In 1806 Edridge showed Farington his 'new lists of prices for drawing portraits. He had before 15 guineas for a single whole length. He now has 20 guineas.'[6] Though Edridge had exhibited at the Royal Academy since 1786, the Academy, then as now, was not prone to elect a water-colour painter, and he did not become an Associate till 1820, the year before his death.

Edridge always had a love of landscape, perhaps owing to the early inspiration of Pether, and while his studio after 1800 was at 64, Margaret Street, Cavendish Square, he frequently occupied as a summer residence part of a picturesque cottage, which was the Deputy Ranger's lodge, on the border of the Serpentine in Hyde Park, being charmed with its rural aspect.[7] He won the friendship of Dr. Monro, whom he frequently visited at Fetcham and Bushey. He sketched the landscape in these neighbourhoods in company with Girtin, and frequently, between 1810 and 1815, with Hearne, who probably helped to foster his skill with the pencil. His charming *Portrait of Thomas Hearne*[8] is in the British Museum. Edridge's cottage and farm scenes, rural lanes and hedgerows, are drawn with intimate understanding and touched with pleasing notes of colour. This side of his work, sensitive and refined, expressive in drawing and harmonious in colour, has been too much overlooked and neglected. In 1814 he began to exhibit drawings of this nature at the

[1] V.A.M. P.9–1931.
[2] V.A.M. 504–1892.
[3] H.M. The Queen (Cat. No. 13852).
[4] H.M. The Queen (Cat. No. 13859).
[5] *Diary*, August 6, 1802.
[6] *Diary*, March 30, 1806.
[7] *Somerset House Gazette*, II, 1824, p. 386.
[8] B.M. 1867. 4.13.525.

Academy, one of the first being *A Farm House, Buckinghamshire*.[1] Many characteristic drawings of this type by him may be seen at the Victoria and Albert Museum and the British Museum. In 1817, two years before Prout's first visit to the Continent, Edridge went on a sketching excursion to France, and made studies in Normandy, as well as in Paris. In 1819 he made a second journey abroad (his sketch-book in the British Museum[2] shows that he was in France from June 11 to October 26), and began to exhibit foreign views. At the Academy from 1819 to 1821 he showed drawings of Beauvais, Rouen, Abbeville and other Normandy subjects; in 1821, his fine *Pont Neuf, Paris*[3] was on the Academy wall. At the British Museum are six outstanding examples of his Normandy drawings, dated 1817 or 1819.

More than any of his predecessors Edridge relied on the lead pencil, using the 'broken line' of which more will be said in connection with Prout. There is no direct evidence that either artist knew the other's work, though I think Prout almost certainly did see Edridge's exhibited drawings and studied his pencil technique. There is undoubtedly a remarkable similarity of style and treatment in their architectural subjects. F. G. Stephens[4] gives to Prout's pencil drawings a preference over Edridge's, but considers that 'as a painter in colour of old buildings Edridge leaves Prout, with his *vermiculated* touch and his conventionalities of drawing-mastership *in excelsis*, at an immeasurable distance in the rear'. Edridge did not possess Prout's skill in the placing and characterisation of figures, but with regard to pure drawing of architecture, Edridge surpassed Prout. The latter was brought into great prominence by Ruskin's frequent references to his work; Edridge is not mentioned once in *Modern Painters*.

Samuel Prout (1783–1852) was born at Plymouth. As a child, he suffered from a severe sunstroke, which affected his whole future life, making him subject to attacks of violent pains in the head; and until thirty years after his marriage not a week passed without one or two days of absolute confinement to his room or to his bed. Long before he attended the Plymouth Grammar School he was eagerly drawing the carts and horses which stood outside a public-house opposite his window, making sketches of landscape, and copying prints. At the Grammar School he had as a companion Benjamin Robert Haydon, famous later for his battles with the Academy, his imprisonments for debt, his triumphs, his failures, his despair, his suicide. In company with young Haydon, as Ruskin[5] records, 'Prout devoted whole days from dawn till night, to the study of the peculiar objects of his early interest, the ivy-mantled bridges, mossy water-mills, and rock-built cottages, which characterise the valley scenery of Devon.' Subjects of this nature were the stock material of Prout and many another drawing-master in the nineteenth century.

Haydon's father was a bookseller, who kept a reading-room in Plymouth, frequented by local worthies of literary and artistic tastes. Here Prout, at the age of eighteen, met John Britton the antiquary, who was in Plymouth for a few days looking for material for his

[1] V.A.M. 2937–1876. [2] B.M. 1872. 1.13.1091. [3] V.A.M. 3044–1876.
[4] F. G. Stephens, *The Portfolio*, 1880, pp. 196–200. [5] *Notes*.

Beauties of England and Wales. Britton approved of Prout's sketches and persuaded the youth to travel with him to make drawings of local architecture, but Prout was beaten by the difficulties of perspective and proportion in the old parish church of St. Germain. Discomfited by another vain attempt at the church tower of Probus, he burst into tears and returned home, 'his skill as an artist impeached'.[1] After this first failure Prout won through by sheer will-power, in spite of ill health. He planned his career from the start, and his indomitable pluck and belief in his destiny carried him through years of trial and waiting. For a year he studied perspective and architectural details with such good results that he determined to try his fortune in London. For two years he lived in Britton's house in Wilderness Row, Clerkenwell. Here he studied the work of Turner, Girtin and Cozens, and in 1803 and 1804 was sent by his patron to make drawings for the *Beauties* in the counties of Cambridge, Essex and Wiltshire. His ill health, however, so dogged and thwarted his progress that in 1805 he returned to his Devonshire home. In October 1805 he was sketching assiduously in Devon and Cornwall. He had exhibited at the Royal Academy from 1803 and had created a demand for his work among London dealers. Palser, then in the Westminster Bridge Road, who was one of the first of them to encourage David Cox, became at nearly the same time the earliest purchaser of work by Prout. At first the young artist was content with two shillings and sixpence for his small drawings, but soon Palser and Ackermann raised the price to five shillings. In 1808 Prout again had a London address, at 55, Poland Street, and in 1810 became a member of the Associated Artists in Water-Colours, with Cotman, Cox and De Wint among his fellow members. For some time after 1811 he was living at 4, Brixton Place, Stockwell, and obtained a fair connection as a teacher, one of his first pupils being J. D. Harding. There he remained till 1835, when he moved to 2, Bedford Place, Clapham Row. Until 1818 he was exhibiting drawings of west-country scenes and architecture, with a considerable proportion of coast scenes and shipping; one of his favourite subjects, repeated in several forms, was the wreck of an East Indiaman which he had seen driven ashore below the cliffs near his home in 1796. To this early period must belong his *Castle on a Rocky Shore*[2] (Pl. 6), which is closely akin to Girtin and unlike Prout's later work. Another early example, showing the influence of Varley, is *On the Devonshire Coast*,[3] and a fine drawing of this period—influenced by both Girtin and Varley—is *A Stiff Breeze*;[4] and it is worth recalling that in the Ruskin home at Herne Hill hung one of Prout's earlier drawings, *An English Cottage*, bought probably by Ruskin's grandfather. Ruskin[5] said about it that 'as early as I can remember, it had a most fateful and continual power over my childish mind'. To this drawing he attributed his love for antiquity, ruggedness in buildings and his thirst for country life.

In 1813, anticipating Cox by a year, Prout issued his *Rudiments of Landscape in Progressive Studies*, the first of his drawing-books for the use of beginners. Like Cox, he continued to

[1] J. Britton, *The Builder*, X, 1852, pp. 339, 340.
[3] Coll. Mr. Arnold Fellows; R.A. Exhibition 1934, No. 840.
[4] Coll. Mr. and Mrs. Paul Mellon.

[2] V.A.M. 2963–1876.

[5] *Notes*, p. 21.

produce many books of this nature, and his *Series of Easy Lessons in Landscape Drawing*, 1820, contains an account of processes which we find demonstrated in his own work:

> Some of the subjects are first tinted with *grey*, that is neutral tint, producing the general effect of a drawing, except what blue is in the sky, and the darkest touches. The whole is then washed over with a warm tint of red and yellow; after which a little local colour is only necessary on the different parts. It is then to be finished with a few dark touches, to make more decidedly the features of the picture. But few colours are necessary, it being the balance of warm and cold colours which produces brilliancy; some of the cold tints being carried into the warm masses, and the warm tints balanced with cold. ... Light and shade should be distributed in large masses uniting light to light, and shade to shade, to prevent confusion and distraction to the eye, which is always the effect of a number of prominent objects scattered about the picture. There should be a union in chiaro-oscuro as well as in colour; nothing discordant, every part associating with each other.

In 1819, for the benefit of his health, Prout made his first trip abroad, and so enters on the second clearly defined period of his career. From 1802, when Girtin was etching his views of Paris, to the signing of Peace in 1816, the Continent had practically closed its doors to English painters. A new generation of Britons was ready to welcome pictorial records of places of which they had heard so much and seen so little. Turner set off again to his beloved Alps, and other painters, like Edridge, Prout and Cotman, crossed the Channel for the first time. Though Prout does not deserve the title of 'Columbus of his Art', given to him by a writer[1] in 1831, he did discover and reveal, like Cotman, a wealth of picturesque architecture in old continental towns. Pure nature made little appeal to him. He liked the steadying contours of architecture much better than the loose curves of moving sky and landscape. That sense of shape appears even in his figures. And so Prout found his métier in painting pleasant aspects of continental streets, market-places and jostling crowds, and for the rest of his life made frequent journeys in search of his chosen theme. His last visit to Normandy and Brittany was in 1846. He became one of those capable practitioners who, having found that his sweetened recipe of crumbling buildings and lively figures was efficacious and soothing, prescribed it with persistent monotony.

In 1819 Prout was elected a member of the Old Water-Colour Society, and during the 33 years up to his death exhibited 511 works in its galleries. In 1822 and 1823 views in Belgium and the Rhenish provinces are added to his first Normandy subjects. His drawings are undated, and ascription to definite years is almost impossible, but through the years from 1820 onwards the change from an earlier simplicity and sombre tones to his more mannered later style and certainty of touch was gradually developing. In 1824 he paid his first visit to Italy, making a long sojourn in Venice, and thenceforward views in Rome, Venice, Verona, Padua, etc., are frequent among his exhibited works. His many sketches made in Venice provided him with a constant source of material. In Ruskin's words, he made Venice 'peculiarly his own'. The glorious sun of Turner's Venice had yet to rise.

Between 1813 and 1844 Prout issued eighteen publications. As has been said, many of

[1] *Library of the Fine Arts.*

6

them were drawing-books, containing instructions for the student and prints to be copied. The *Rudiments of Landscape*, published by Ackermann in 1813, contained sixteen fine aquatints, carefully coloured by hand. *A Series of Easy Lessons* (1820) also contains some coloured aquatints, but after that the publications are illustrated by lithographs. Lithography, for which its inventor Alois Senefelder took out an English patent in 1800, enabled the artist to work directly with chalk on a smooth surface of stone. The work was autographic; there was no intermediary interpreting engraver; no uncertain biting with acid as in the case of aquatint or soft-ground etching; the method was peculiarly adapted for reproducing the artist's exact touch with chalk or pencil. Prout exploited it successfully in publications of his foreign drawings, such as *Illustrations of the Rhine* (1824), *Facsimiles of Sketches made in Flanders and Germany* (1833) and *Sketches in France, Switzerland and Italy* (1839).

In 1845 Prout established himself at 5, De Crespigny Terrace, Denmark Hill until his death in 1852. He was Ruskin's neighbour, and used to go to dinner on Ruskin's birthday. He could rarely begin his labours before mid-day, and then, if tolerably free from pain, would continue to paint till well into the night.

Prout's drawings in his middle period were praised by Ruskin for their magnificent certainty and ease, and their firmness of line, always 'laid with positive intention'. 'Not in decrepitude', he adds, 'but in mistaken effort, for which to my sorrow I was partly myself answerable, he endeavoured in later journeys to make his sketches more accurate in detail of tracery and sculpture, and they lost in feeling what they gained in technical exactness and elaboration.'

What differentiates Prout from his contemporaries who dealt with the same kind of subject is his draughtsmanship, his crinkled and intricate line. The art critic constantly refers to an artist's 'line' as being 'nervous' and his tremulous line as being a 'broken line'. The broken line is primarily and essentially one caused by the unconscious activity of the hand as the artist records his immediate impression of his subject. A pupil once said of George Chambers: 'On any impressive effect in sea or cloudland presenting itself, his plain little face would light up, and his hand become tremulous.'[1] This tremulousness shows itself in any artist's line, much more so when he is making a rapid sketch out-of-doors than when he works at ease in his studio. Many, of course, are prone to recognise the value of this vibrant *coloratura* in line and to cultivate its use even when not stirred by feeling.

We find this slight flutter and tremor of line, in its primary and natural aspect, throughout the work of Rembrandt, Whistler and Seymour Haden, when they etched upon copper-plates in the open air. This is in no way due to method or material, for an etching-needle slides over a grounded copper-plate as easily and steadily as a skate over ice, more easily than pencil over paper. And in the case of pen or pencil used on paper a nervous line may owe something to the texture of the paper; but it may flicker and waver, break into little dots and dimples and flexures on the smoothest of paper. It may be varied in stress, broken not only in length but in width. We find the 'broken line' as a characteristic of the

[1] Roget, II, p. 237.

work of many draughtsmen of the British Water-Colour school. Turner, Rooker and Hearne use a line broken by little dots, flecks and curves; and special attention has been given in an earlier volume to the breaks, irregularities and serpentine marks in Girtin's pencil work. Cotman, who was etcher as well as draughtsman, constantly works with a broken line; and Cox's drawings are made with angular, vibratory jerks. Edridge, in his continental street scenes, worked with a crumbling line and made many pencil studies of architectural subjects which might, on a superficial inspection, be mistaken for Prout's. Their work offers a complete contrast to the fluent, sweeping curves used by Gainsborough, Farington and Rowlandson. The 'broken line' was accentuated by Prout, and has been spoken of as though it were his own invention. Actually he was following the germinal impulse apparent in the work of all the great draughtsmen throughout the centuries. What Prout did, particularly in his drawings of old towns on the Continent, was to exaggerate his crumbling line, making its wriggles almost regular 'like a runic rhyme'. It became far more than the product of natural nervousness or casual haste, and was amplified and cultivated into an overgrowth of mannerism.

It seems to me that Prout adopted much from Girtin,[1] and is in direct descent from Canaletto. Ruskin, who says that 'the mannerism of Canaletto is the most degraded that I know in the whole range of art', has nothing but praise for Prout. 'The reed pen outline and peculiar touch of Prout', he writes, 'which are frequently considered as mere manner, are in fact the only means of expressing the crumbling character of stone which the artist loves and desires. That character has never been expressed except by him, nor will it ever be expressed by his means. . . . We owe to Prout, I believe, the first perception, and certainly the only existing expression, of precisely the characters which were wanting to old art; of that feeling which results from the influence, among the noble lines of architecture, of the rent and the rust, the fissure, the lichen and the weed. . . . There is *no* stone drawing, *no* vitality of architecture like Prout's.'[2] There are elements of truth and valuable criticism in all this, but none the less it is one of the misty statements with which Ruskin so often clouded the bright mirror of his critical work. Prout's mannerism (Copley Fielding used the word 'Proutised') was excellent for its purpose, and was as emphatic as that of Canaletto. But he never drew with the true observation, the accent, the dwelling upon what was relevant or irrelevant,—upon 'the rent, the rust, the fissure, the lichen and the weed'— which make Cotman so great a draughtsman. And in all the volumes of *Modern Painters* Cotman's name does not appear. Though Prout at his best may command respect, he is, when compared with Cotman, a second-rate craftsman. Cotman has much more power in recording history 'caught and held in the split shadow staining an old grey stone'.

Prout—in his case, largely for health reasons—probably did all of his actual colour work indoors, and very possibly his pen work as well, over an outdoor pencil drawing. It

[1] See, for instance, his pencil drawing of Amiens reproduced by Ruskin in *Notes on Prout and Hunt*, pl. 4. The foreground buildings on right and left contain obvious reflections of the Girtin touch.
[2] *Modern Painters*, I, vii, § 31.

is worth noting that he frequently adds some tone to his pencil drawings by rubbing lead over the paper with a finger or perhaps by deliberately applying it with a stump. The water-colours that he sold and exhibited were based on pencil studies which always remained in his possession, ready for translation into water-colour or lithography. The four days' sale of his work at Sotheby's in 1852, after his death, consisted almost entirely of pencil drawings; that is why the total sum realised was only £1788. 'Prout is essentially a draughtsman with the lead pencil . . . his drawings prepared for the Water-Colour Society were usually no more than mechanical abstracts, made absolutely for the support of his household, from the really vivid sketches which, with the whole instinct and joy of his nature, he made all through the cities of ancient Christendom.'[1] When carrying his work further, he used brown ink for his foreground, and blue for the more distant parts, his brown plane often making a distinct contrast with the blue. It is a simple recipe, and he probably borrowed it from the makers of colour aquatints with whom he came into touch in 1813 when he issued his *Rudiments of Landscape* with its colour plates. In such magnificent publications by Ackermann as the *Royal Residences* and the *Oxford* and *Cambridge* the sky and distant trees or landscape are almost invariably printed in a blue ink, the nearer portions in brown. In Cox's *Treatise on Landscape Painting*, the ink used in the imprint for the title and artists' names varies from plate to plate, showing the particular ink, blue, green, or brown, used to convey the predominant colour in each drawing; and occasionally, when two colours have been used on a single plate, the artist's name below is printed in the one colour, and the title in the other. This method of printing, particularly with a blue and a brown ink, gave the hand-colourist, who completed the plates in simple washes of colour, an effective atmospheric base for his work. Prout, no doubt, realised that what was a help to Ackermann's trained staff of hand-colourists and finishers might help him in his own 'entirely handpainted' work. Roget, quoting from notes by J. Jenkins, says that Prout 'seems to have had a regular mechanical system in preparing his drawings, laying them in sepia, or brown and grey, the outlines gone over with a pen in which a warm brown colour was used. His system was evidently founded on the practice of the early water-colour painters, only substituting brown for the Indian ink used by the early draughtsmen in the foreground of their drawings. . . . He used a particular grey he made himself. . . . Brown and grey he kept in bottles in a liquid state.'[2] Ruskin[3] says that 'his method was entirely founded on the quite elementary qualities of white paper and black Cumberland lead; and expressly terminated within the narrow range of prismatic effects producible by a brown or blue outline, with a wash of ochre or cobalt'.

Though the foundations of a Prout drawing were well and truly laid with pencil, much of its success depended upon his work with a reed pen; and this work, which was so expert and personal, was something more than outlines gone over with a pen. It is quite clear that much of his pen work was added (as it frequently is by anyone using a reed pen for a water-colour drawing) after the colour work was complete, to give notes of form and effects

[1] *Notes*, pp. 29, 30. [2] Roget, II, p. 478. [3] *Notes*, p. 12.

of emphasis. But whether final touches were added or not, it was on a basis of pen drawing
that he laid his colour (his colours were very few) in simple washes, like those of the early
topographers or Ackermann's hand-colourists, not feeling his way tentatively and running
dry colour into wet like the painter who works direct from his subject out-of-doors. He
used much warmer colour in his shadows than the earlier topographers, and a critic in
1821 takes exception to his use of brown in shadows as 'preserving the chiaroscuro', but
'obtaining warmth where it ought not to exist'.[1] 'It has been well remarked,' Prout him-
self wrote, 'that every good artist paints in colour, but thinks in light and shadow.'[2] In
Prout's drawings it will be noted that the masses of shadow always have the binding effect
in the design which he recommended to his pupils. Ruskin condemns the conventional
colour which appears in some of Prout's work, and his excess of a sandy red, but accepts
that it is often luminous and pure, and, though he was clearly not much impressed by
Prout's colour, places him among 'our most sunny and substantial colourists'.[3] He is at
his best as a colourist in his fine drawing of the *Porch of Ratisbon Cathedral*[4] (Pl. 7) and in
a particularly impressive *Wurtzburg Market Place*.[5] Apart from his architectural subjects,
some of his drawings of fishing smacks at Hastings are superb in their descriptive line and
compositional selection.

Prout was unlike the usual topographer in that he preferred the single building to the
group and a close-up rather than the wider aspect. For the same reason, perhaps, he pre-
ferred a portion of an interior to the entire view, though in his *Interior of Milan Cathedral*[6]
he does succeed in giving a wonderful impression of size and spaciousness. His method and
manner of work give greater kinship than they actually possess to buildings at Brussels and
Venice, Chartres and Ratisbon, to northern Gothic or Baroque and the ruins of Roman
architecture. But every building, however much of adventitious decay was given to it by
Prout's prophetic eye, does stand in his drawings as the living work of man's hands, a solid
towering mass of woodwork and masonry. However engrossed he was in relics of the past,
in the intricacy of traceries and balconies and twisted columns, of cusps and cornices, he
never forgot the human note of the present. A shawl or a rug hanging over a balcony, a
striped curtain over a window, make splashes of colour and infuse what is old and dilapi-
dated with a spice of modern life. His scenes are peopled with men and women in their
habit as they lived, following their daily occupation in street, in market-place or on the
canal. You feel that you must thread your way among them and avoid the man pushing a
wheelbarrow and the woman carrying a load. In 1848 he wrote to J. C. Grundy, the Man-
chester dealer, who was both his agent and his friend: 'The two subjects of Rouen are
quite to my heart, with space for figures, which I have not spared being always at home

[1] *Magazine of the Fine Arts*, I, 121, 122. Prout's shadows are excessively brown, it is true, but in sunnier lands than
England much more light is reflected in shadows, which are far less blue and cold in tone than here.
[2] S. Prout, *Sketches at Home and Abroad*, 1844.
[3] *Modern Painters*, I, Chap. VII, § 32. [4] V.A.M. 1040–1873.
[5] Manchester University, Whitworth Art Gallery.
[6] Possibly the drawing for the lithograph illustration in *Samuel Prout*, Studio Special No. 1915, pl. L.

in a mob.'[1] The figures are drawn squarely, with a line firmer than that used for the architecture, and when coloured are treated far more for their chiaroscuro, and as animated spots of colour, than for form. In *Prout's Microcosm* (1841) he draws attention to the importance of figures, hinting that a principal group is required for the sake of unity, and showing the distinct uses of figures—to identify scenes by their character; to introduce lights, darks and colours; to lead the eye; and to give scales of proportion and distance.

From Hughes,[2] finally, I borrow this illuminating piece of criticism:

> If we examine closely the nature of this feeling for architectural forms which we find in Prout, we may arrive at some explanation of his limitations even in his own special field. His sense of design seems to run rather in perpendicular than in horizontal lines. He likes to lead you up to the sky in his pictures, and though a wealth of interest may be found in the journey there, it is, I believe, in the actual skyline, or in the parts of his composition which stand against it, that the chief attraction of his best subjects will be found. Thus we see in his foregrounds groups of figures and incidental effects few of which, though they have great value as factors of the whole, bear very close individual inspection. The architecture which appears immediately above is less carefully treated than that which appears higher, and at the top we have a generally satisfying arrangement which may have involved a considerable amount of very skilful management. If the same test be applied to Cox I think we should discover that the interest is usually to be found on a horizontal line in the middle distance. With Cotman it is surprising how frequently the focal point of the composition, whether architectural or landscape, is situated somewhere near a straight line—a line actually drawn straight—which is nearly parallel with the top and bottom of the picture.

John Hewett, a well-known dealer at Leamington, with whom Prout had continuous relations, received from him in 1842 a memorandum of prices for his drawings: '9 small £9 9/-; 4 large £12 12/-'. From 1846 to 1851 his price for drawings sold to J. C. Grundy at Manchester was from three to nine guineas. Ruskin says that Prout's fixed price for drawings of an 'understood' size, about 10 inches by 14 or 15, was six guineas for old customers like Hewett, who sold them for seven to ten guineas; and that to them the artist would never raise his price a shilling, even to the end. He adds that 'the drawings made for the Water-colour room were usually more elaborate, and, justly, a little higher in price; but my father bought the *Lisieux* off its walls, for eighteen guineas'. In 1868, less than twenty years after his death, his *Nuremberg* was sold at Christie's for £1002 15s., and in 1889 his *Wurtzburg Market Place and Cathedral* (presumably that now at Manchester City Art Gallery) for £819. Since then, familiarity with Prout's drawings and, still more, familiarity with continental scenes *in situ*, has bred a little contempt.

John Skinner Prout (1806–1876), Samuel Prout's nephew, was born at Plymouth. He was mainly self-taught, but followed his uncle in choice of subject. As a young man he went to Australia, staying at Sydney and Hobart, and some sketches which he made at this period were exhibited later at the Crystal Palace. He exhibited from 1839 to 1876 at the New Water-Colour Society (now the Royal Institute), becoming a member in 1838. Having forfeited membership by not contributing work during his stay abroad, he was

[1] F. Gordon Roe, *Some Letters of Samuel Prout*, O.W.S. Club, XXIV, 1946, p. 47.
[2] C. E. Hughes, *Samuel Prout*, O.W.S. Club, VI, 1928, p. 15.

11

re-elected as an associate in 1849 and a member in 1862. He was a friend of W. J. Müller, and in his company at Bristol made sketches of picturesque streets for his publication entitled *Antiquities of Bristol*. He was a member also of a Sketching Club formed by Müller on the lines of that to which Girtin and Cotman had belonged; and members associated with him were Samuel Jackson, William West and T. L. Rowbotham. He followed his uncle in manner of composition and in picturesque, crumbled handling of architecture in foreign towns, but had neither his power of drawing nor his eye for colour. In texture and tint he is far more woolly than Samuel Prout. The same remark applies to Prout's only son, Samuel Gillespie Prout (1822–1911), born at Brixton. In 1846 he was painting in France with support from his father, who wrote to R. H. Grundy: 'My son would be most grateful to work for the lowest price possible', and offered eleven drawings by him for five pounds.[1] He may be reckoned as an amateur, for he was more interested in social, religious and philanthropic work than in art. He was one of the first to convey food to the starving citizens of Paris after its siege during the Franco-German War. He gave service of a similar nature in 1874 during the Civil War in Spain, and ten years later in Egypt. He was a friend of Ruskin, W. Hunt, B. R. Haydon, Frances Ridley Havergal, and many other celebrities of his day.

Just as there are hints of Girtin, Hearne and Edridge in Prout's pencil work, so there is a hint of Prout in the admirable pencil work of Hugh O'Neill, to whose architectural drawings reference will shortly be made.

While Edridge, Prout and others were winning recognition by picturesque renderings of continental streets, churches and market-places, other artists who stayed at home and worked in England won high repute for their accurate delineation of buildings; and many of them commanded much higher prices for their work than Prout ever received. Living before photography, they have handed down a vast and invaluable record of ecclesiastical and domestic architecture and the general appearance of our towns and streets. In the case of buildings which survive, we are enabled to visualise them in their actual surroundings of more than a hundred years ago. Many of these artists were trained as architects, and if they were not always endowed with the pictorial sense of a Boys or a Prout, they had the merit of possessing a trained understanding of structural detail and perspective. Among the more prominent of these recorders were Augustus Pugin, Charles Wild, Frederick Nash and Frederick Mackenzie.[2] The three last, together with F. J. Sarjent, R. B. Schnebbelie and G. Scharf, were all born between 1780 and 1788. They are coeval with Cotman, Cox, Prout, De Wint and Copley Fielding.

The leader of this group was Augustus Charles Pugin (1762–1832). Born in France, he came to London about 1798, a typical Frenchman of the *ancien régime*, who might have stepped straight out of Debucourt's *Galérie du Palais Royal*. He entered the Academy Schools, and then worked for twenty years as a draughtsman in the office of Joseph Nash, the architect of Regent Street, Waterloo Place and the Brighton Pavilion. Pugin was keenly

[1] *Letters*, p. 46.
[2] For illustrations in colour aquatint from drawings by all four, Martin Hardie, *English Coloured Books*, 1906.

12

interested in Gothic architecture, and Nash found his drawings of Gothic detail of great value as a basis of design. As is said in the *Dictionary of National Biography*: 'By his careful drawings of old buildings Pugin paved the way for the systematic study of detail which followed the hopeless and unlearned period of Strawberry-Hill enthusiasm.' In the words of C. J. Mathews,[1] they 'flew to him to have their plans and alterations put into correct perspective and surrounded with the well-executed and appropriate landscapes Pugin was so skilful in producing'. He was also actively engaged in the production of volumes which were extremely influential in the development of the Gothic revival; and was one of the principal artists employed by Ackermann in the production of his most sumptuous books. It was Pugin who drew the architecture, with Rowlandson putting in the figures, for the hundred and four illustrations to the *Microcosm of London* (1808). He contributed thirty subjects to the *History of the University of Oxford* (1814), twenty-one to the companion *Cambridge* (1815), and seventeen to the *History of the Abbey Church of Westminster* (1812). The publisher was justly proud of this last volume. When it was completed, he had all the original drawings bound up with the letterpress and mounted on vellum. A special design with Gothic details was prepared by J. B. Papworth for the brass mountings and clasps of the two volumes, which cost £120. This copy Ackermann valued so highly that he used to provide a pair of white kid gloves to be worn by the happy individual who was granted the honour of inspecting it.[2] Pugin also made drawings in 1824 for a volume illustrating the Brighton Pavilion. George IV, when watching the artist at work, one day accidentally upset his colour-box, and—possibly not unmindful of a royal precedent in the past—picked it up and handed it with an apology to the painter.

Pugin had many friends among the members of the Old Water-Colour Society, notably Copley Fielding and G. F. Robson, and became an associate himself in 1807 and a member in 1812. Benjamin Ferrey[3] singles out among his exhibited works, the interiors of the *Hall of Christ Church, Oxford* (1814), *Westminster Abbey* (1810–13), *St. Paul's* (1807), 'with many views of Lincoln'[4] (1809–29). His *High Street, Oxford* (1814)[5] (Pl. 9), one of the illustrations to Ackermann's *Oxford*, is a good example of his truthful care in drawing and adept use of colour. Pugin was incidentally aiding the progress of the school of water-colour painting in that he had many pupils who came to his office to study architecture, and left him in order to practise water-colour with credit and success. He used to take them on frequent sketching excursions all over the country to places of architectural interest. Among them were Joseph Nash, W. Lake Price, J. T. D'Egville, G. B. Moore, B. Ferrey, and his own son Augustus Welby Pugin.

Augustus Welby Northmore Pugin (1812–1852) was better known as architect, ecclesiologist and writer than as draughtsman. He acquired his father's enthusiasm for medieval art, and at an early age was designing goldsmiths' work and furniture. Disgusted with the

[1] C. Dickens, *Life of C. J. Mathews*, Chap. I. Mathews was an architect before winning fame as an actor and was articled to A. C. Pugin.
[2] W. Papworth, *Life of J. B. Papworth*, 1879.
[3] B. Ferrey, *Recollections of Welby and Augustus Pugin*.
[4] Four of these are in the V.A.M. D.512 to 515–1888.
[5] V.A.M. 3015–1876.

13

neglect and decay into which our churches and cathedrals had fallen, he concluded that the only salvation of art was Roman Catholicism. Becoming a Catholic, he devoted all his energies to the promotion of the Gothic style and, in spite of an extensive practice as an ecclesiastical builder, published many works on Gothic architecture.

F. J. Sarjent (or Sarjeant), R. B. Schnebbelie and George Shepherd were all born about 1780. The first of these, under the name of Francis James Sarjeant (c. 1780–1812), was awarded the greater silver palette of the Society of Arts in 1800/01 for an original drawing of a view from the Red Lane, near Reading. When he exhibited at the Royal Academy in 1802/03 he gave his name as F. J. Sarjent, of 10, Howland Street, and became a student in the Academy schools in 1805. His Academy exhibit of 1802, *View of London from Hampstead*[1] (Pl. 11) is in the Victoria and Albert Museum. He engraved some views of the Lake District in 1811 from his own drawings, and from about 1810 to 1812 was executing aquatints from drawings by James Sillet for *The History of Lyons*, by W. Richards.

Jacob C. Schnebbelie (1760–1792), the son of a Dutchman who had settled in England, was born at Duke's Court, St. Martin's Lane, and began life by working at his father's trade of confectioner, first at Canterbury and then at Hammersmith. He abandoned this occupation when his talent for drawing obtained him posts as drawing-master at Westminster and other schools. Then, through the influence of Lord Leicester, he was appointed draughtsman to the Society of Antiquaries and made many drawings for *Vetusta Monumenta*. He was also associated with James Moore[2] and G. I. Parkyns in the production of their *Monastic Remains and Ancient Castles in England and Wales*, 1791–2. His *View of the Serpentine River, Hyde Park*, etched by himself from his water-colour, was completed in aquatint by Jukes, and published in 1786. Schnebbelie died at his residence in Bland Street in 1792, leaving a widow and three children, who were provided for by the Society of Antiquaries. Probably on their account the obituary notice in the *Gentleman's Magazine*, 1792, claims for Schnebbelie a higher position than his merit deserves. Both he and his son were painstaking but niggling in their draughtsmanship and did not often rise above a level of good hack work. The son, Robert Blemmel Schnebbelie (*fl.* 1803–1849), exhibited views of old buildings at the Royal Academy from 1803 to 1821, drew for the *Gentleman's Magazine* and other periodicals and supplied illustrations for Wilkinson's *Londina Illustrata* and similar publications.

George Shepherd (*fl.* 1800–1830) was born soon after 1780, if we take him to have been about twenty when he won the silver palette of the Society of Arts in 1803 and 1804. He enjoyed considerable repute as an architectural draughtsman in his day, and made drawings, occasionally choosing landscape subjects, in various parts of England; but from 1800 to 1830 he was chiefly concerned with the streets and architecture of London. He contributed illustrations to Wilkinson's *Londina Illustrata*, 1808, Ireland's *History of the County of Kent*, 1829–30, *Beauties of England and Wales*, and other works. Eighty of his drawings are in

[1] V.A.M. 273–1871.
[2] See C. F. Bell, *Some Water-colour Painters of the Old British School*, Walpole Soc., V, 1915–17, pp. 63–68.

14

the British Museum, and over a dozen in the Victoria and Albert Museum. A very pleas-ing water-colour by him is the *St. Albans*,[1] 1809, formerly in the Nettlefold Collection. His son, George Sidney Shepherd (*fl.* 1821–1860), practised water-colour in the same style as his father, but with greater variety of subject and treatment. He exhibited from 1830 to 1858 at the Royal Academy, Suffolk Street, and the New Water-Colour Society, of which he became a member in 1831. Among his exhibited works were many views of metropoli-tan streets and buildings, and he drew for C. Clarke's *Architectura Ecclesiastica Londini* and W. H. Ireland's *England's Topographer*.

Thomas Hosmer Shepherd (*fl.* 1817–1840)—the birth dates of the whole family remain unknown—was probably a brother of George Sidney. He drew illustrations for *Bath and Bristol*, 1829–31, but was also responsible for all the illustrations in *Metropolitan Improve-ments*, 1827, *London and its Environs in the Nineteenth Century*, 1829, etc. The family between them must have had an extensive and peculiar knowledge of London. Thomas Hosmer was largely employed by Frederick Crace (1779–1859), the famous collector of views and maps of London, in making water-colour views of old buildings in London prior to their demoli-tion. In the Crace Collection, now at the British Museum, are nearly five hundred of T. H. Shepherd's water-colour drawings. Though nearly all are London subjects, they include thirty-eight drawings of Edinburgh, made for *Modern Athens Displayed, or Edinburgh in the Nineteenth Century*, 1829.

Charles Wild (1781–1835), like Turner before him, was articled to Thomas Malton II, the teacher of perspective. From the first, Wild devoted himself to drawing architectural subjects, and his minute truthfulness of form and perspective is apparent throughout all his work in colour. In 1803 he began to exhibit at the Royal Academy, sending two views of Christ Church, Oxford. With T. Uwins, W. Payne and E. Dorrell, he was elected associ-ate of the Old Water-Colour Society in 1809, and became member in 1812. He exhibited 158 pictures in all; acted as Treasurer in 1823; and was Secretary from 1826 to 1831. His exhibited drawings were mainly of English cathedrals and churches, the originals of plates in volumes which he published, on *Canterbury* (1807), *York* (1808), *Chester* (1813), *Lichfield* (1813), *Lincoln* (1819) and *Worcester* (1823). At the same time he was making fifty-nine drawings for illustrations to Pyne's *History of the Royal Residences* and several of the originals were exhibited at Spring Gardens in 1818. With the brothers J. and F. P. Stephanoff and A. C. Pugin he was responsible for the illustrations reproduced in colour aquatint in *The Coronation of George IV*; the first part of this appeared in 1825, but the entire volume in its complete and very handsome form was not issued till 1837. Several of Wild's water-colours made for this work are in the Victoria and Albert Museum. After 1820 he began to travel on the Continent, painting the ecclesiastical architecture of France, Belgium and, in 1826, Rhenish Germany. Twelve colour aquatints from these drawings were published in 1826. He was working abroad at the same time as Prout. But whereas Prout produced his happy effects of light, shade and colour with little attention to minute accuracy of detail, Wild's

[1] F. J. Nettlefold Cat., Vol. III, p. 230.

warmth and richness of colour never concealed the underlying exactness with which his material was faithfully studied. In 1827 Wild's sight began to fail him, causing his resignation from the Society in 1833; he was blind when he died in 1835.

James Stephanoff (c. 1787–1874) and his brother have been mentioned as working in collaboration with Pugin and Wild, and are included here, not on account of their occasionally architectural drawings but because of this close association. They were the sons of a Russian painter, Fileter N. Stephanoff, who had settled in London as a painter of portraits and stage scenery. James and his younger brother, Francis Philip (c. 1788–1860), became men of learning as well as artists, and were considered 'two of the best dilettante violins of the day'. Both of them exhibited with the Associated Artists and then with the Old Water-Colour Society from 1813. James became a member of the Society in 1819, and in 1830, on the accession of King William to the throne, was appointed 'Historical Painter in Water-Colour in ordinary to His Majesty'. The work of the two brothers was largely concerned with subjects taken from the Bible, from mythology and from the poets. They joined in producing the portraits and costume subjects for the magnificent work on the Coronation of George IV, already mentioned, and a whole series of their drawings for this volume, like miniatures in their high finish and brilliant colour, will be found in the Victoria and Albert Museum. Again, with Pugin and Wild, they were among the illustrators of Pyne's *History of the Royal Residences*, 1819. Both of them contributed fanciful and sentimental trifles to the popular Annuals of the period, among them the *Literary Souvenir*, *Forget-me-Not* and *The Keepsake*.

Frederick Nash (1782–1856), born at Lambeth, was the son of a builder. He studied architectural drawing under Thomas Malton II, entered the Royal Academy Schools in the early days of Benjamin West's presidency and at the age of eighteen exhibited at the Academy a view of the *North Entrance of Westminster Abbey*. During his life of seventy-four years he constantly recurred to Westminster subjects, and must have known the stones of the Abbey even better than Ruskin knew the stones of Venice. For ten years after his first exhibit he was almost fully occupied in supplying architectural drawings to be engraved in publications of his own planning or in books issued by Britton and Ackermann. In 1807 he was honoured by an appointment as architectural draughtsman to the Society of Antiquaries. He became an exhibitor with the Associated Artists in 1808 and a member in 1809, but in the following year seceded to the Old Water-Colour Society. He left them when the constitution was changed in 1812, but was re-elected in 1824 and was still a member when he died in 1856.

Nash's *Inside of Westminster Abbey, with Funeral Procession*, 1811, won the praise of Benjamin West, who took it as his text to combat a dictum that 'such subjects demanded little more than a mere mechanical application of the executive part of painting'. 'It is true', said West, 'that an accurate view of this or any other building may be drawn on mechanical principles, but to describe the scene under the influence of this grand and pictorial sentiment is as much an affair of mind as to represent nature under the gorgeous colouring

16

of a Titian.'[1] West was a little prone to flattery, but it may be recalled that Turner pronounced Nash the finest architectural painter of his day. Though architecture remained Nash's chief subject, he was not content with merely portraying buildings. He accompanied De Wint on sketching excursions, the first of which was probably their visit to Lincoln in 1810. In 1816 he was making studies of nature among the Swiss Lakes. In Paris he made many drawings for two quarto volumes, published in 1819–23, with the title, *Picturesque Views of the City of Paris and its Environs.* In these drawings he was reaching towards a different style with a higher scheme of colour than he had employed for the grand and sombre Gothic interiors which won the praise of West and Turner. The Paris drawings are gay, pleasant impressions of open air and sparkling sunshine. Two of them were bought by Sir Thomas Lawrence for £250,[2] and one of them, *Fountains at Versailles*[3] (Pl. 20), is now in the Victoria and Albert Museum. In 1837 Nash made a tour of the Moselle, and visited the Rhine in 1843. His usual practice at that time was to make and colour on the spot three drawings of his subject, one representing a morning effect, the second that of mid-day, and the third that of evening. Concurrently with the outdoor work, which he so much enjoyed, he still continued to paint elaborate church interiors at Westminster, Durham, Windsor, and elsewhere.

Hugh O'Neill (1784–1824), born at Bloomsbury, was a son of Jeremiah O'Neill, architect, and made a special study of architectural drawing. In 1803 the Society of Arts awarded him a silver palette for his drawing of Brecknock Priory. He was among those who received help, and he is possibly the 'H. Neil' who exhibited at the Royal Academy, 1800–4. Drawings by him in the British Museum are signed *Neil, Neill, O'Neil, O'Neill.* He became a drawing-master at Oxford and afterwards at Edinburgh, Bath and Bristol. Of old buildings at Bristol alone he made over five hundred sketches. In the Victoria and Albert Museum are two or three of his water-colour drawings, including *Church and Houses at Conway*[4] and *Carisbrooke Church, Isle of Wight*:[5] he is represented at the British Museum by fifteen drawings and two of his works are in the Whitworth Art Gallery, Manchester. He died at Bristol in his fortieth year.

Frederick Mackenzie (1787–1854) was a pupil of John A. Repton, the architect son of Humphrey Repton, famous as a landscape-gardener. Mackenzie exhibited drawings at the Royal Academy in 1804 and 1809, and in 1813 was elected a member of the Old Water-Colour Society. He retired from the Society four years later, but was re-elected in 1822, and subsequently held office as Treasurer. Like so many of the other painters mentioned in this chapter who were originally trained as architects, Mackenzie was largely occupied in supplying architectural and topographical drawings to be engraved in such publications as *The Beauties of England and Wales, Architectural Antiquities of Great Britain, Cathedral Antiquities,* etc. For Ackermann's *Westminster* he made thirty-four drawings, besides others for the *History of the University of Oxford* and the *History of the Colleges.* His pictures of Gothic

[1] *Somerset House Gazette*, II, 1824, p. 128. [2] Roget, I, p. 371. [3] V.A.M. 491.
[4] V.A.M. 1695–1871 [5] V.A.M. 404–1874.

ecclesiastical buildings were highly esteemed for their accurate drawing and perspective. He was a good colourist, but his forte lay less in harmony of colour than in thoughtful design and refinement of detail. In the Victoria and Albert Museum is a large water-colour by him, which has historic importance as it portrays *The principal room of the original National Gallery, formerly the residence of John Julius Angerstein, Esq., lately pulled down*[1] (Pl. 22). The drawing was exhibited at the Old Water-Colour Society in 1834, and the *Literary Gazette* in that year described it as a 'marvellous picture in every respect—a National Gallery in itself. The perfection with which he has copied the old Masters in frames the size of dominos, and the effect of the whole, are quite extraordinary.'[2]

George Scharf (1788–1860) was born at Mainburg, Bavaria, where his father was a tradesman. Young Scharf studied at Munich in 1804, worked for some years as a miniature-painter and drawing-master, and in 1810 left his native land for a wandering, adventurous life. He was in Belgium and escaped from Antwerp during the siege of 1814, joined the English army, with an appointment as 'lieutenant of baggage' in the engineer department, spent his spare time in making miniature portraits of British officers, was present at Waterloo, and accompanied the allied armies to Paris. In the British Museum is his sketch-book containing forty-four drawings made at the British camp in the Bois de Boulogne, 1815. He came to London in 1816, and became well known as a lithographic artist. His scrupulous accuracy of drawing won him employment from scientists such as Professor Owen. He took a deep interest in the life and architecture of London streets, the shop fronts, the passing figures, the details of costume. As a foreigner he looked upon London with the same eager and enquiring eyes with which Edridge and Prout gazed upon continental cities; he absorbed every typical aspect and set it down with close fidelity. The British Museum has a large collection of his work, some 1500 drawings and sketches, most of them bequeathed in 1900 by his son, Sir George Scharf. To show with what versatile liveliness he studied the panorama of London life, it will suffice to quote the Museum catalogue description of a single sketch-book, containing: '32 sheets of studies, chiefly scenes and figures in London streets, dated 1823–1828; hawkers, labourers, ladies and gentlemen, musicians, paviours, draymen, walking advertisements, knife-grinder, waggons; also studies of dogs and of children; sketches of the artist and his family, cottages at Peckham, two views in St. James's Park; a workhouse near Kensington; Sullivan's boatyard, Vauxhall; portrait of Sullivan, the boat-builder; sketch at Tottenham; garden at Dulwich; buildings near Stamford Hill; house near Tottenham Green; Bavarian infantry 1810.' Most of his drawings in the Museum are slight sketches, but he exhibited larger water-colours at the Royal Academy, Suffolk Street, and elsewhere, and was a member of the New Water-Colour Society from 1833 to 1836. In the Victoria and Albert Museum are his *Mitcham Common Surrey*[3], 1819, and *Interior of the Gallery of the New Society of Painters in Water-colours, Old Bond Street*,[4] 1834 (Pl. 23). In 1828 he made a large water-colour draw-

[1] V.A.M. 40–1887.
[2] For identification of the pictures shown in the drawing see *Country Life*, March 29, 1921.
[3] V.A.M. 71–1903. [4] V.A.M. 2979–1876.

18

ing of the Lord Mayor's Banquet, and in 1830 painted for the Corporation of London two large subjects of the approaches to the new London Bridge, which was then in course of construction.

His son, Sir George Scharf (1820–1895), is chiefly remembered as Director of the National Portrait Gallery from its foundation in 1857 till 1895 and for his archaeological research and profound study of portraiture. But he was a draughtsman like his father, visited Asia Minor in 1840 and 1843 with Sir Charles Fellows, as artist to his expedition, and illustrated several books on art and archaeology.

Another architectural draughtsman less known, perhaps, than most of those already mentioned was Thomas Scandrett (1797–1870). Scandrett, born at Worcester, began his career as a portrait-painter, but exhibited drawings of architectural subjects at the Royal Academy. C. E. Hughes[1] points out a resemblance between his work and that of David Roberts, and says that he has seen drawings by Scandrett come under the hammer with his name erased to make room for a poor forgery of that of the more popular painter.

Again, hardly known nowadays is Joseph Murray Ince (1806–1859), born at Presteign, Radnorshire. He became a pupil of David Cox in 1823, and remained with him for three years before coming to London. He exhibited at the Royal Academy from 1826, and at the Society of British Artists. He painted pleasing landscapes on a small scale, such as *Coasting Vessels, with Harbour, 1836*,[2] and in 1832 was living at Cambridge, where he made many drawings of architectural subjects. He returned to Presteign about 1835, and resided there till his death.

Of a later generation, but in definite descent from Prout, is John Burgess (*c.* 1814–1874). The main source of information about him is a long account by Rosario Aspa, published in the *Leamington Spa Courier*, February 1877.[3] Burgess belonged to an artistic family. Here it is sufficient to say that his father was John Cart Burgess (1798–1863), a flower-painter, and that his uncle, H. W. Burgess (*fl.* 1810–1844), was landscape painter to King William IV, drawing-master at Charterhouse, and author of a set of large lithographic *Views of the General Character and Appearance of Trees, Foreign and Indigenous, as connected with Picturesque Scenery*, 1827. It was assumed that John would follow the family profession, and he sketched a great deal in the company of his uncle, learning from him the use of a 'broad lead'. While still young, he went to Normandy and Paris, making drawings of half-imperial size, and in his twentieth year went to Italy, where he worked from 1834 to 1837, enlivening his studies of landscape and architecture with figures which showed the result of his training at Paris and Rome. In 1840 he bought a teaching practice at Leamington and settled there for the rest of his life. He was thirty-seven when he won recognition by being elected as associate of the Old Water-Colour Society—Cattermole warmly supported him, saying that 'no one could draw architecture with a finer spirit'—but he never reached the higher

[1] C. E. Hughes, *Early English Water-Colour*, 1950, p. 80.
[2] V.A.M. 1206–1872.
[3] Reissued as a pamphlet in 1877; and reprinted in *Walker's Quarterly*, No. 16, 1924.

rank. With few exceptions, his exhibits represented foreign buildings and street scenes, mostly in France, from Normandy and Brittany to Burgundy in the east. Belgium (1852, etc.), Holland (1857), Westphalia (1859–1861) and Nuremberg (from constant visits) supplied further subjects. They were generally of Gothic architecture, to which a few studies of Roman remains at Trèves and Arles, and landscape sketches from the neighbourhood of Leamington, gave variety.

Burgess's drawings are admirable in their range of colour, from sunny and cheerful notes to quiet greys. But his pupils were all in favour of learning to draw with a pencil, and he 'set about showing what could be done with it'. He drew chiefly on tinted paper, with French pencils of different powers of tone, putting in highlights with opaque white. His liking was for a rough, common paper like the sugar paper used by Cox, with a substantial texture. He sharpened his pencil either flat or to a point, and used it in the manner of a brush to produce graduated tints. One of his methods was the device of indenting the paper with the uncut end of the pencil before laying on the black lead, so as to get a grey tone or a white line. Like Prout he preferred to sketch standing, not only because it enabled him to avoid the trying attention of lookers-on, but because an ordinary view of nature is observed from the eye level so obtained. He insisted upon the value of making careful drawings of architecture on the spot, and his pencil studies show his power of sketching rapidly, concisely, and suggestively. He once said: 'I make as many notes as I can on the spot of local colour and shape of shadows, but I can put in skies, shadow tints, and reflected light, as well in Leamington as in Rouen or Nuremburg.' Many have thought that the quality of his pencil work was better than that of Prout; it may not always be so sensitive and selective, but is more expressive of varying textures, and the actual line is less mannered. Those who study his *Bayeux Cathedral*,[1] or *The Lantern, Chateau de Chambord*[2] in the Victoria and Albert Museum, will realise how undeservedly Burgess has been neglected both as draughtsman and colourist.

Burgess thought that the best of himself was in his landscapes, and his ambition was to be known by them. I have never seen any, except two powerful drawings, done in chalk or pencil with a wash of Indian ink, *View at Dover Harbour*[3] and *Canal at Calais*.[4] Both of these, dated 1850, are in the British Museum. He died in 1874, and his remaining works were sold at Christie's on February 3, 1876. Burgess was highly independent. He much preferred disparagement to vapid admiration. He would sell his drawings for a trifle to anyone who showed real understanding; he would charge an exorbitant price to anyone whom he thought an ignorant Philistine. Aspa tells many tales about this side of his nature.

William Parrott (1813–1869), a lesser-known artist, belonging to the same school and generation as Burgess, exhibited regularly at the Royal Academy, the British Institution and Suffolk Street. Little appears to be known about him except that he was working at

[1] V.A.M. P.32–1925. [2] V.A.M. P.33–1925.
[3] B.M. 1875. 8.14.1165. This drawing is catalogued in the B.M. as by John Cart Burgess.
[4] B.M. 1875. 8.14.1166. This drawing is catalogued in the B.M. as by John Cart Burgess.

20

1 'Unknown gentleman with two children'

V.A.M. 504–1892 12½×9¼: 316×235 *Pencil and water-colour, signed and dated 1799*

Henry EDRIDGE, A.R.A. (1769–1821)

2 'Town in Normandy'

London, Courtauld Institute of Art, Spooner Coll. $17\frac{1}{4} \times 13\frac{1}{2}$: 428×324 *Water-colour*

Henry EDRIDGE, A.R.A. (1769–1821)

3 'River scene'

B.M. 1900.8.24.512 $12\frac{1}{4} \times 18\frac{1}{4}$: 308×465 *Water-colour*

Henry EDRIDGE, A.R.A. (1769–1821)

4 'Bisham Abbey'

V.A.M. P.9–1931 $6\frac{3}{8} \times 11\frac{3}{8}$: 162×288 *Water-colour, signed and dated 1769*

William PETHER (1738–1821)

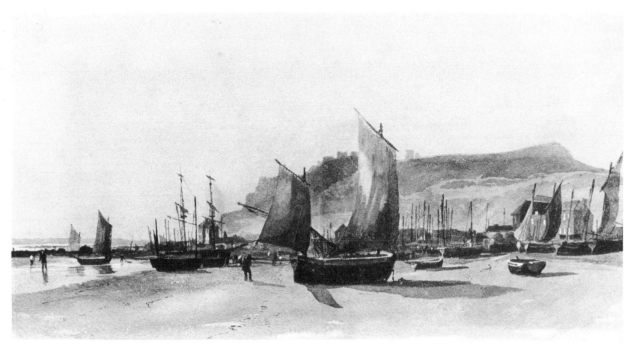

5 'Low Tide'
Coll. Mr & Mrs Paul Mellon 10 × 19 : 254 × 533 *Water-colour*
Samuel PROUT (1783–1852)

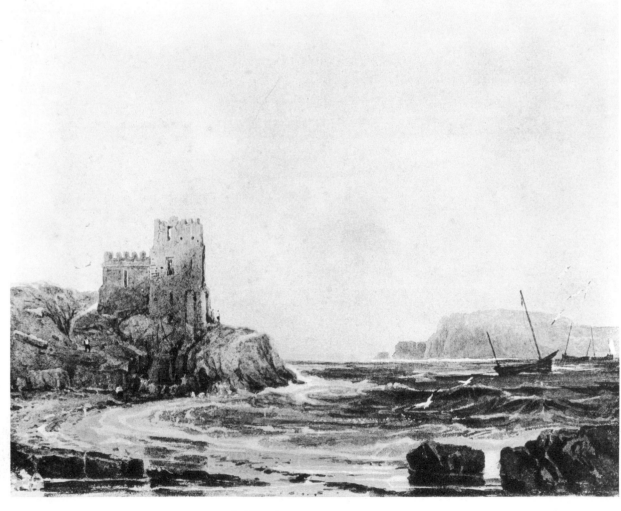

6 'Castle on a rocky shore'
V.A.M. 2963–1876 8½ × 10½ : 216 × 267 *Water-colour*
Samuel PROUT (1783—1852)

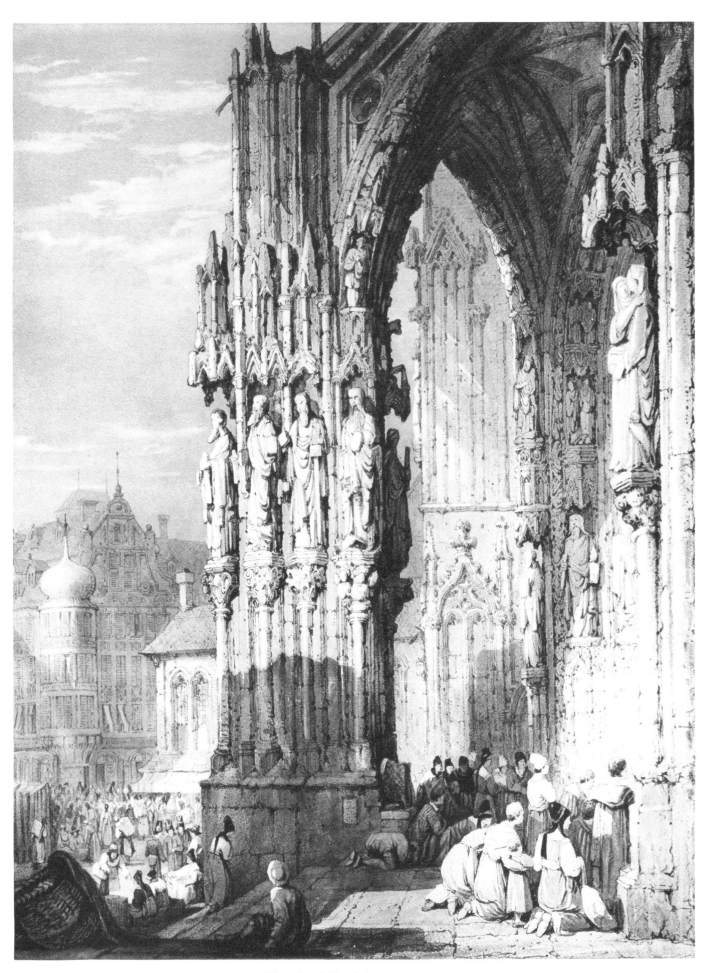

7 'Porch of Ratisbon Cathedral'
V.A.M. 1040.1873 25¾ × 18¼ : 349 × 466 *Water-colour, signed*
Samuel PROUT (1783–1852)

8 'Château de la Tremoille, Vitré'
V.A.M. 681 21¾×30: 552×761 *Water-colour, signed*
John Skinner PROUT (1806–1876)

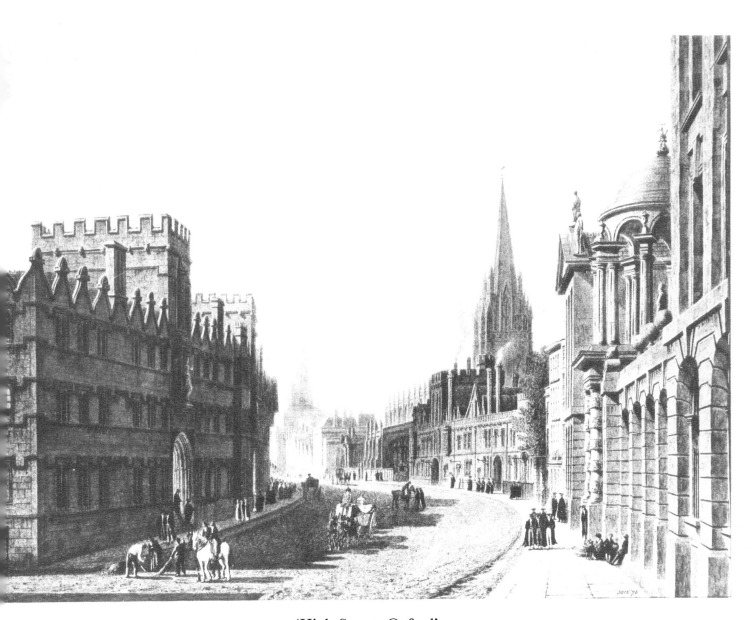

9 'High Street, Oxford'

V.A.M. 3015–1876 14⅞ × 20 : 381 × 707 *Water-colour, dated 1814 (on verso)*

Augustus Charles PUGIN (1762–1832)

10 'St. Paul's Cathedral'
V.A.M. 606–1870 18¼×22½: 462×572 *Water-colour*
Augustus Welby Northmore PUGIN (1812–1852)

11 'View of London from Hampstead'
V.A.M. 273–1871 25×34½: 634×875 *Water-colour*
Francis John SARJENT (fl. 1800–1811)

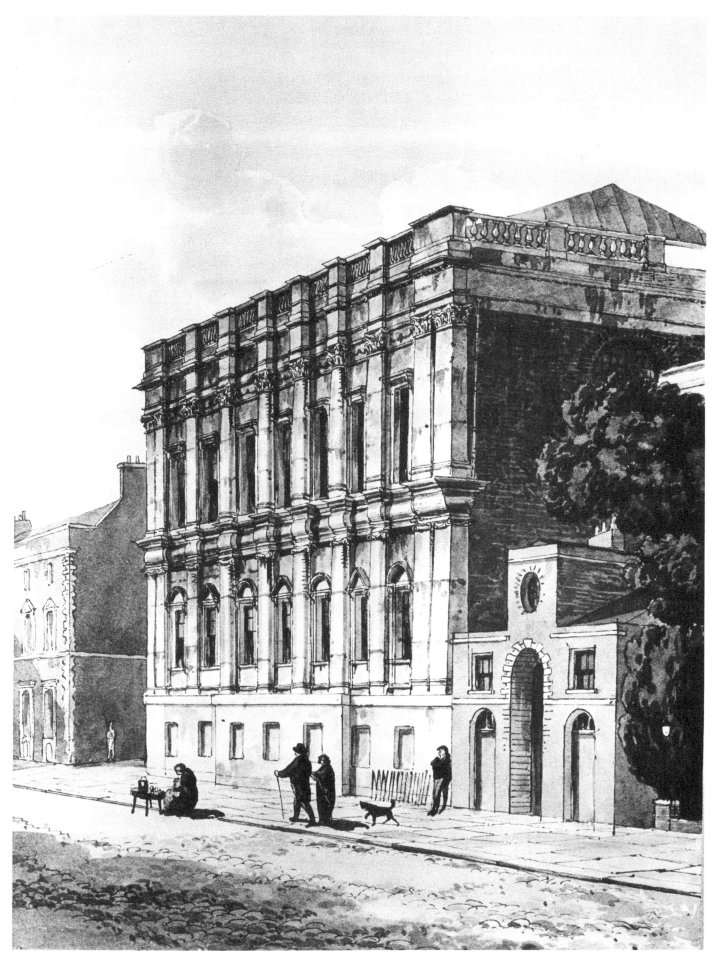

12 'The Banqueting House, Whitehall'
V.A.M. D.1096–1898 $10\frac{3}{4} \times 7\frac{7}{8}$: 273 × 200 *Water-colour*
George SHEPHERD (Exhib. 1800–1830)

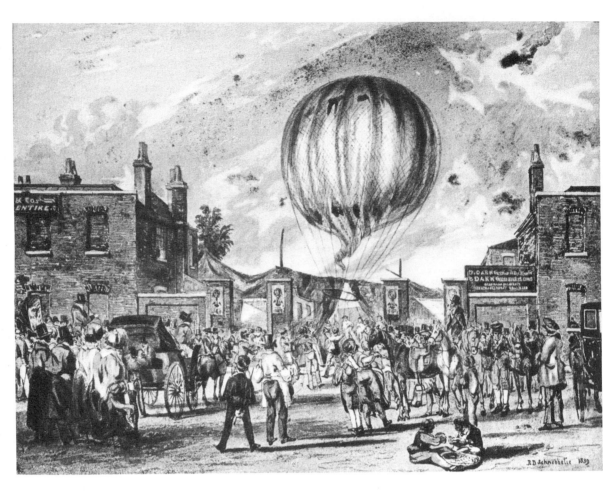

13 'Mr. Graham's Balloon at Lords Cricket Ground'

B.M. 1879.8.9.653 (LB3) $5\frac{3}{4} \times 7\frac{5}{8}$: 147×194 *Water-colour, signed and dated 1839*

Robert Blemmel SCHNEBBELIE (fl. 1803–1849)

14 'Hampstead Heath'

V.A.M. 51–1896 $11\frac{7}{8} \times 18\frac{5}{8}$: 302×471 *Water-colour, signed and dated 1833*

George Sidney SHEPHERD (fl. 1821—d. 1861)

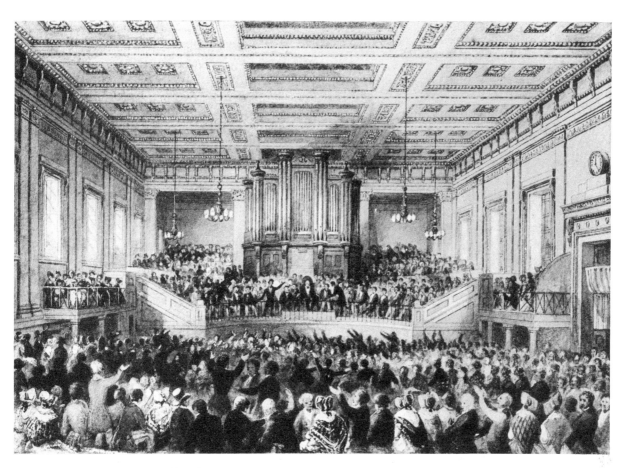

15 'The Great Anti-Slavery Meeting in Exeter Hall'
B.M. 1938.11.12.3. 5×7: 126×180 *Water-colour*
Thomas Hosmer SHEPHERD (fl. 1817–1840)

16 'St. Thomas's Hospital'
B.M. 1886.1.11.28 (LB 40) 9¾×14⅜: 248×364 *Water-colour, signed*
Thomas Hosmer SHEPHERD (fl. 1817–1840)

17 'Interior of Christ Church, Oxford'
Oxford, Ashmolean Museum $12\frac{3}{8} \times 17\frac{1}{4}$: 314×439 *Water-colour*
Charles WILD (1781–1835)

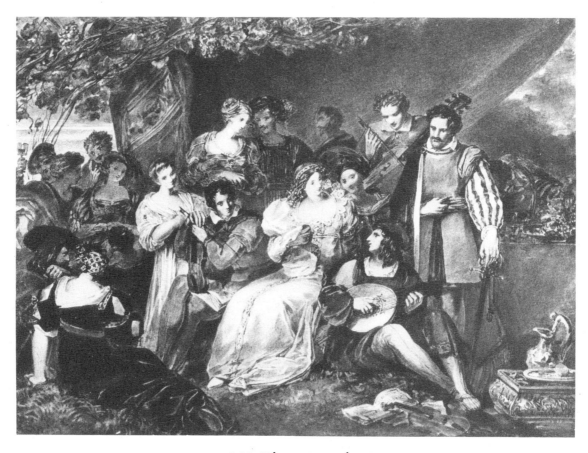

18 'A Fête Champêtre'
B.M. 1876.6.14.616 (LB 1) $6\frac{3}{8} \times 8\frac{7}{8}$: 163×225 *Water-colour*
James STEPHANOFF (c. 1787–1874)

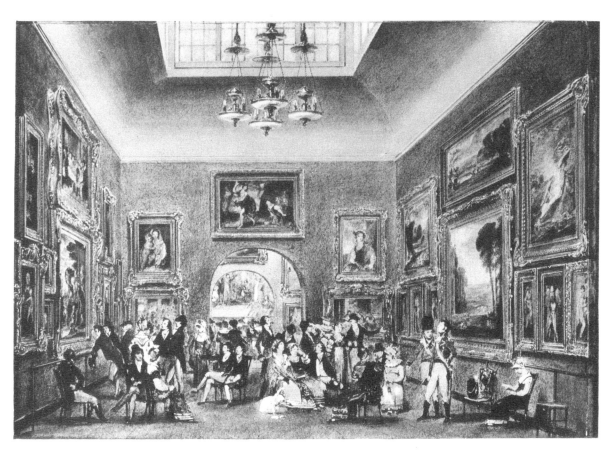

19 'Interior of the British Institution'
V.A.M. 1933–1900 7¾ × 11 : 197 × 279 *Water-colour*
Francis Philip STEPHANOFF (c. 1788–1860)

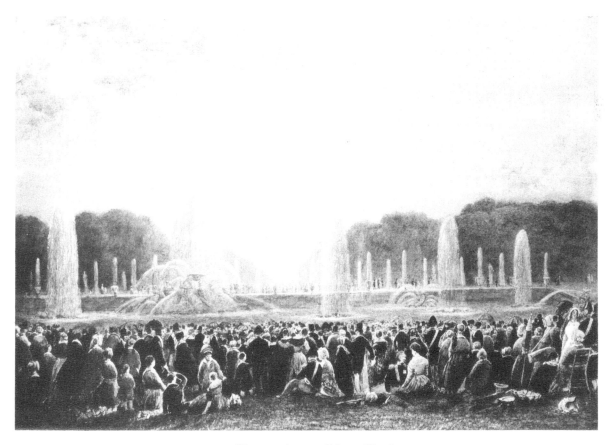

20 'Fountains at Versailles'
V.A.M. 491 21 × 30⅜ : 534 × 771 *Water-colour*
Frederick NASH (1782–1856)

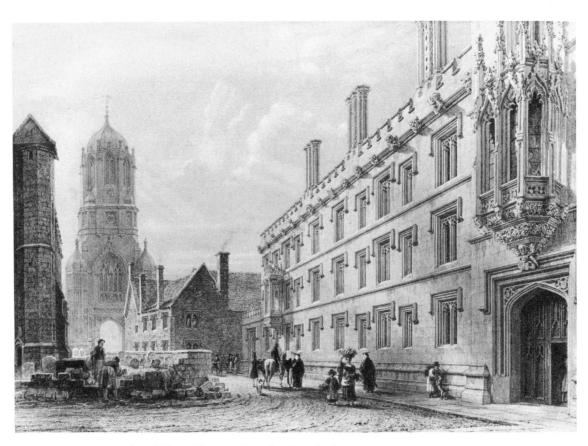

21 'New Front, Pembroke College, Oxford, 1838'
Oxford, Ashmolean Museum 8⅝ × 12⅜: 219 × 314 *Water-colour*
Frederick MACKENZIE (1787–1854)

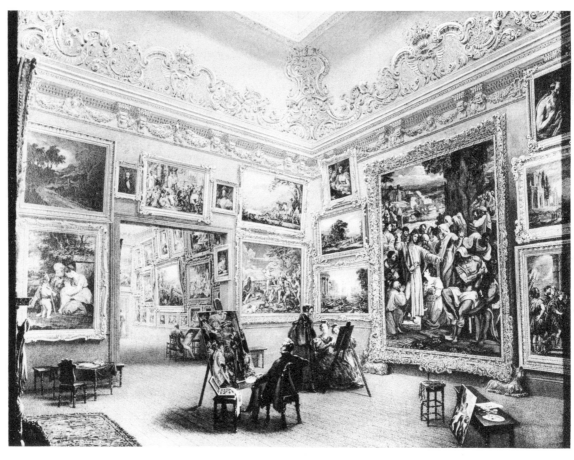

22 'The Principal room of the original National Gallery'
V.A.M. 40–1887 18¼ × 24½: 464 × 621 *Water-colour*
Frederick MACKENZIE (1787–1854)

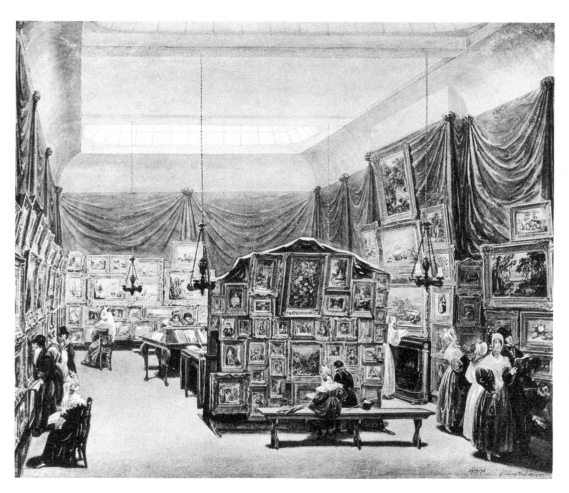

23 'Gallery of the New Society of Painters in Watercolours, Old Bond Street'
V.A.M. 2979–1876 $11\frac{5}{8} \times 14\frac{1}{2}$: 296 × 367 *Water-colour, signed and dated 1834*
George SCHARF (1788–1860)

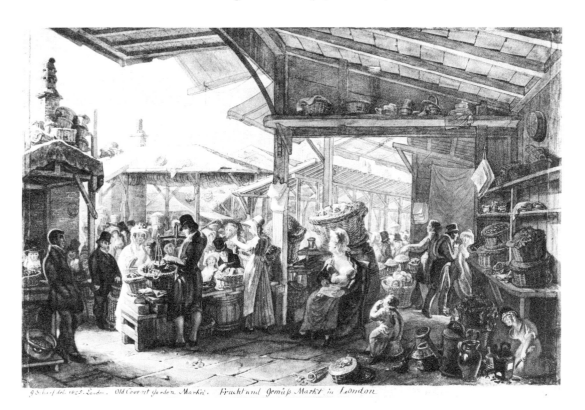

24 'Old Covent Garden Market'
B.M. 1862.6.14.31 $9\frac{1}{2} \times 15$: 241 × 380 *Water-colour, signed and dated 1825*
George SCHARF (1788–1860)

25 'Church and Old houses' ? Bristol
Coll. Mr D. F. Snelgrove 6¾ × 10⅛: 172 × 257 *Water-colour*
Hugh O'NEILL (1784–1824)

26 'St. Botolph's, Cambridge and Corpus Christi'
Coll. Mr & Mrs Paul Mellon 7½ × 10: 190 × 253 *Water-colour*
Joseph Murray INCE (1806-1859)

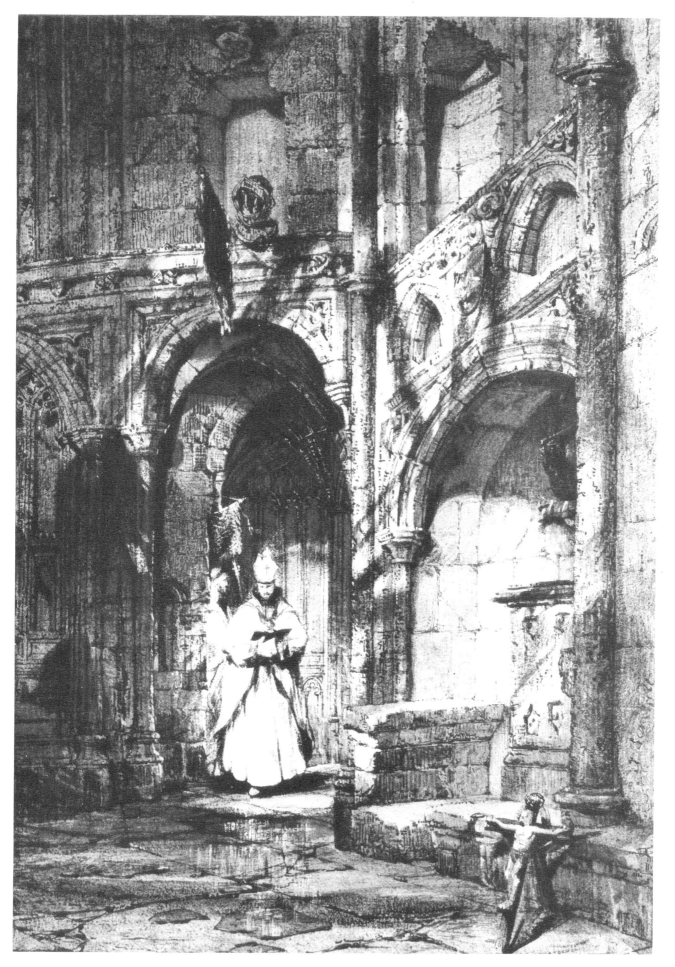

27 'Interior of a church with figures'

B.M. 1949.8.12.11 14¾ × 10¼: 376 × 260 *Water-colour*

Thomas SCANDRETT (1797–1870)

28 'Bayeux Cathedral'

V.A.M. P.32–1925 $21\frac{1}{2} \times 14\frac{7}{8}$: 546 × 378 *Water-colour, signed*

John BURGESS (1798–1863)

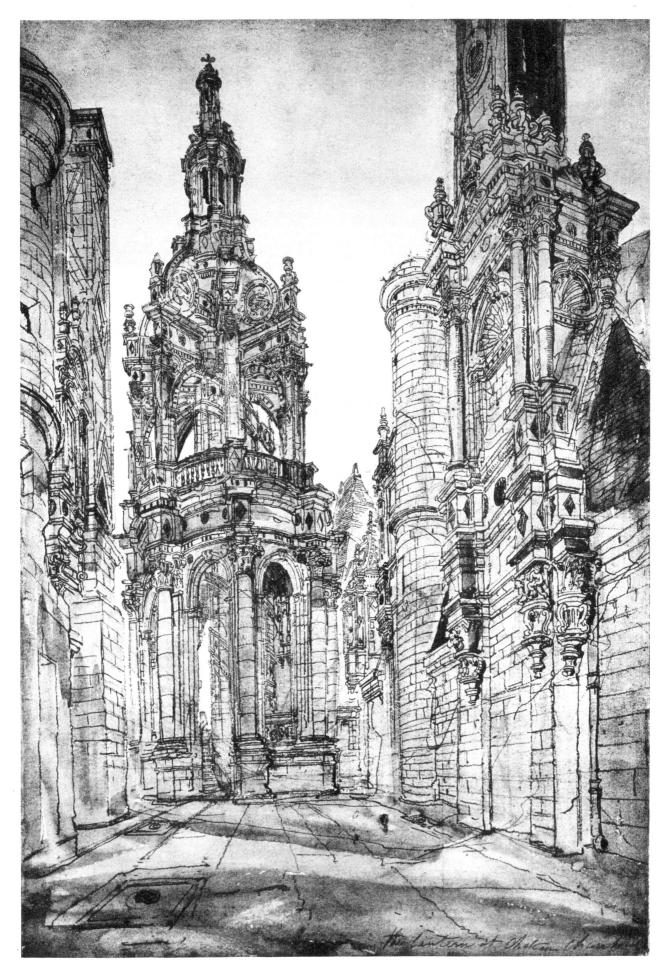

29 'The Lantern, Château de Chambord'

V.A.M. P.33–1925 $21\frac{1}{2} \times 14\frac{7}{8}$: 546×378 *Water-colour, dated 1853*

John BURGESS (1798–1863)

30 'The Old Wharf, Purfleet'
B.M. 1944.10.14.154 $6\frac{5}{8} \times 13$: 168×330 *Water-colour*
William PARROTT (1813–1869)

31 'Italian Landscape: a Sandpit'
B.M. 1890.5.12.53 (LB 2) $10\frac{1}{8} \times 15\frac{1}{4}$: 258×376 *Water-colour*
William Wood DEANE (1825–1873)

Paris in 1842 and 1843. A drawing by him of *Notre Dame*,[1] dated 1842, from the left bank of the Seine, is almost at the point where Meryon etched his famous *Abside*. A busy group of figures loosely sketched in the foreground, and making a nosegay flutter of colour against the grey buildings and quay behind, is reminiscent of Prout. The architecture, on the other hand, is most carefully and delicately drawn with a finely pointed pencil. The picturesqueness is derived from the cathedral tower and flying buttresses, so accurately portrayed, and not from any artificial or crumbling touch. I know of no other drawings by him in any public collection, except a caricature portrait of Turner in the Ruskin Museum, drawn in the same year as *Notre Dame*.

Frederick William Woledge (*fl.* 1840–1895), born at Brighton, belongs, as C. R. Grundy[2] puts it, 'to that numerous band of conscientious artists who have never found more than a measure of local celebrity'. His sole exhibit in London seems to have been *Snowdon from Capel Curig* at the Royal Academy in 1846. Three albums of Brighton views drawn by Woledge were published at Brighton in 1842–3. *St. Peter's Brighton*[3] is a capable work, showing Woledge as a successor to the eighteenth-century topographers.

Another artist of whose work I know little is William Wood Deane (1825–1873). Born in Islington, he studied and practised as an architect from 1842 till about 1859, when he devoted himself to painting. His professional work had largely consisted, like that of William Walcot later, in making finished perspective drawings in colour from architects' plans and elevations but, in conjunction with Alfred Bailey, he built Langham Chambers, where the Langham Sketch Club took up its quarters. He sketched in Normandy in 1856, and Belgium in 1857, and later made frequent tours on the Continent. With Francis William Topham (1808–1877) he travelled through Spain in 1866, and from 1868 to 1870 exhibited many Italian subjects. He was elected an associate of the New Society in 1862 and a member in 1867, but resigned in 1870 in order to join the Old Society. His death, three years later, cut short a career which showed much more than promise. In the Nettlefold Collection was a superb drawing by him of the interior of *Sta. Anastasia, Verona*[4]. Here his training as an architect has served him well, and unobtrusive rightness of drawing is coupled with an enviably simple blotting of grey and yellow tones. In space and atmosphere this drawing has all the qualities of a Bosboom. It is not signed, and it may be that similar works by him have been credited to other painters. Deane painted many landscapes, and Roget speaks of his Venetian views having an affinity to James Holland, while in a note on an *Italian Landscape*[5] (Pl. 31) Dr. Percy[6] says: 'He was a pupil of Cox. Is it not by Cox?' In the Birmingham Art Gallery is his *Portice of Octavia, Rome*, 1852.

[1] Coll. Mr. and Mrs. Paul Mellon.
[2] See *Catalogue of the F. J. Nettlefold Collection*, Vol. III, p. 178.
[3] *Ibid.*, p. 178. [4] *Ibid.*, Vol. II, p. 16. [5] B.M. 1890. 5.12.53 (L.B.2).
[6] B.M. Print Room, Dr. John Percy's annotated catalogue, 1871.

CHAPTER II

The 'Annuals' and their Influence: Later Topographers

James Duffield Harding Thomas Allom William Henry Bartlett
Alfred Gomersal Vickers James Holland William Callow

We come now to a group of painters, born between 1797 and 1812, who belonged to the same school as Bonington and were to a considerable extent under his influence. Aptly described by C. E. Hughes[1] as 'The Later Topographers', they were draughtsmen of popular landscape and picturesque architecture. If we regard such men as Harding, Holland, Callow and the rest of the group simply as craftsmen, we shall find in their best work a common element of proficiency, precision and restraint. They believed firmly in the precept which Gros impressed upon Bonington and his other pupils, 'Drawing comes first, colour second'. They took their art, and specially the art of drawing, as a serious professional matter, enjoying intensely the natural aspects of the world before their eyes. The response to their frank and open vision appeared in a deft variety of pleasant line, skill of perspective, and fine sense of composition. Their technical efficiency was always evident, and many of them were entirely satisfied by keeping within their own powers.

Among leaders of this group were Samuel Prout, David Roberts and Clarkson Stanfield. Those three figure in other chapters, but it may be said that Roberts and Stanfield both owed something to Bonington, and both of them bought pictures by him in the sale of 1829. The Bonington influence, in subject matter and technique, is clearly apparent in the work of Harding, Holland, Callow and others. These later topographers were following in his steps, winning their livelihood largely from a supply of drawings of continental places and scenery. In their case they had a new market in the various Annuals which had so great a vogue from about 1820 onwards.

In the early part of the century it was the practice of publishers to issue almanacs or pocket-books, such as the *Ladies Polite Remembrancer*, illustrated by tiny engravings at the top of the page, with a calendar or space for memoranda below. One of these was the *Royal Repository*, which contained some engravings after William Havell. From 1813 to 1817 Havell also supplied designs for the frontispieces and monthly headings of a little annual pocket-book, known as Peacock's *Polite Repository*. From 1828 Prout was also supplying drawings for the *Royal Repository*. A collection of more than 1300 proof impressions

[1] C. E. Hughes, *Early English Water-Colours*, 1950, Chaps. X and XII.

22

from these tiny plates, all engraved by John Pye, was presented by his daughter in 1882 to the British Museum.

The *Literary Souvenir and Cabinet of Poetry and Romance*, issued in 1824 at a price of twelve shillings, went a step further, in that 'all element of the pocket-book, almanac, diary, or red-book was carefully eschewed'. Then came *The Keepsake* and Fisher's *Drawing-Room Scrap-Book*, albums of appealing propriety, softly padded with poems and tales of quint-essential gentility accompanied by appropriate embellishments displaying a sentiment worthy of the text. It was a time when, as John Landseer wrote, 'It is now generally ad-mitted that the Fine Arts are copious fountains both of commercial prosperity and public happiness. They are the milk and honey of celestial promise to civilised society, blessing the land through which they flow. They not only irrigate and enrich the field of national opulence, but fertilise the still fairer fields—the paradise of national virtue.'[1] Such phrases suggest the contents of the Annuals and the atmosphere in which they were produced. Thackeray, in *Pendennis*, mocks volumes of this type with penetrating exactness:

> That eminent publisher, Mr. Bacon, used to present to the world every year a beautiful gilt volume called the 'Spring Annual', edited by the Lady Violet Lebas, and numbering among its contributors not only the most eminent but the most fashionable poets of our time. Young Lord Dodo's poems first appeared in this miscellany. The Honourable Percy Popjoy, whose chivalrous ballads have gained him such a reputation; Bedwin Sand's Eastern Ghazuls; and many more of the works of our young nobles, were first given to the world in the 'Spring Annual', which has since shared the fate of other vernal blossoms and perished out of the world. The book was daintily illustrated with pictures of reigning beauties, or other prints of a tender or voluptuous character; and as the plates were prepared long beforehand, requiring much time in engraving, it was the eminent poets who had to write to the plates, and not the artists who illustrated the poems.[2]

So it was that Pendennis—and Thackeray is probably describing his own initial effort—was given a chance of earning two guineas for some verses to accompany a picture of *The Church Porch*, for which the artist had been paid sixty pounds. So it was that scores of water-colour painters in actual life earned handsome fees.

Full opportunity was given to the topographical painter when a new class of album came into being, devoted entirely to landscape, no longer the 'gentlemen's seats' and 'beauties' of Britain, to which the earlier topographers had given their whole attention, but scenes in foreign lands, near or remote. The *Landscape Annual* led the way. Starting in 1830, it held its yearly course till 1839. *Heath's Picturesque Annual* ran from 1832 to 1843. The *Continental Annual* of 1832, in its single year of existence, was illustrated by the work of Prout. We find J. D. Harding supplying illustrations for the *Landscape Annual* from 1832–4, David Roberts from 1835–8, and James Holland for 1839. Clarkson Stanfield illustrated *Heath's Picturesque Annual* from 1832–4, George Cattermole in 1835, A. G. Vickers in 1836, Callow in 1839, and J. D. Harding in 1840.

[1] J. Landseer, *Review of Publications on Art*.
[2] The Annuals were published a month or two before Christmas. In August 1829, Turner was hastily touching up in Paris the first proof of his *Virginia Water* engraved by R. Wallis for the 1830 *Keepsake*.

In the passage quoted above, Landseer, almost with an echo of Pericles, coupled commercial prosperity with love of art and public happiness; and that brings us to a reason, not generally recognised, for the sudden outburst of Annuals. When Turner, as Hogarth had done before, started to make a business proposition of issuing engravings after his pictures, his engravers worked in etching, line-engraving or mezzotint upon copper; and from a copper-plate only a few hundred good impressions at the most can be printed. Then the possibility of engraving upon steel was discovered, and from 1821 to 1826 various improvements in the art of steel-engraving were introduced.[1] From the steel plate thousands of impressions could be printed without obvious deterioration. This accounts for the enormous editions in which Turner's later engravings, such as the *Picturesque Views in England and Wales*, were issued. And it accounts for the Annuals, which a newspaper of 1828 called 'a new and splendid ornament of our literature'. They could be sold at a price of one guinea or less and, as the writer in 1828 says, 'the circulation of some of the annuals exceeds twenty thousand in the home-market alone, to say nothing of the translations which circulate in almost every country of the old and new world. They constitute one of the most characteristic as well as beautiful illustrations of the ingenuity, intelligence and enterprise of our countrymen, and are, we think, destined to create a new era in art.' Exactly one hundred years later Clive Bell[2] wrote about the craze for illustrated books and picturesque tours as 'a malign influence obscurely but surely imposing limitations on the early nineteenth-century movement'. The truth may lie somewhere between those extreme views, but the fact remains that Ackermann's publications and the Annuals provided our water-colour painters with publicity, employment and encouragement. Their names became household words like those of Kate Greenaway, Walter Crane, Arthur Rackham and Edmund Dulac to a later generation.

Owing to his illustrations in the *Landscape Annual* and to his large output of volumes illustrated by lithography, James Duffield Harding (1797–1863) must have been one of the best-known artists of his day. Harding was born at Deptford and his father, a pupil of Paul Sandby, and himself a teacher of drawing, saw to it that his son was well trained. The boy was sent to Prout for a series of ten or fifteen lessons, and probably spent his time in copying his master's sketches of timeworn cottages and crumbling walls. Prout, when he came to London in 1811, had not yet visited the Continent or abandoned his early rustic themes. In later days Harding was wont to pay pious tribute to Prout's teaching and advice. At the time of his pupilage, however, the actual results were not apparent. When young Harding set out to sketch from nature in Greenwich Park, the future master of tree-drawing was so overcome by the difficulties of drawing foliage, and his efforts were so ineffectual, that his father abandoned the idea of making a painter of him and articled him as apprentice to John Pye, the line-engraver. The apprenticeship did not last long, and from the age of thirteen Harding was exhibiting landscapes at the Royal Academy.

[1] See *Transactions of the Society of Arts*, XXXVIII, 1821, p. 47; XL, 1823, p. 41; XLI, 1823, I. ii; XLIV, 1826, pp. 48, 53. (The possibility of steel-facing copper-plates was not known in England till 1859.)
[2] C. Bell, *Nineteenth Century Painting*, 1928.

While finding tree-drawing so desperately difficult at this early stage of his career Harding once saw an artist sketching a group of trees near the Observatory in Greenwich Park and tried to gain a hint by looking over his shoulder and even venturing a question. The artist shut up his sketch-book in the boy's face, and the lad retired in tears, vowing that if ever he became a real artist he would teach what secrets he discovered to everybody.[1] That vow was never forgotten, for Harding devoted a great part of his life to teaching and particularly to the representation of foliage; and he was a pioneer in the movement for art instruction in schools and for the training of art-masters. His own precepts were embodied in illustrated volumes on *Art, or the Use of the Lead Pencil*, 1834; *Principles and Practice of Art*, 1845; *Lessons on Trees*, 1852; in addition to many sets of lithographs for students, among them *The Lithographic Drawing Book*, in 1832 and later years; and *Harding's Drawing Book*, in 1841 and later. His publications show that in his teaching he was a whole-hearted supporter of direct observation of nature and deprecated the idea of encouraging students in smoothness of touch and facile manipulation of tricks. He did not want his own drawings just to be copied, but to be understood, and took pains to show progressive examples, leading the student from simple outlines to complex combinations. Though he expounded principles of composition, where, within certain bounds, there should be freedom rather than laws, he knew the danger of bringing up students in a rigid system and of abetting them in superficial imitation. It was not his fault that budding artists adopted his mannerisms and chose short cuts. He remains a stylist whom even now it is not inexcusable to imitate. He taught Ruskin among others, and when the first volume of *Modern Painters* appeared in 1843 many of Harding's old pupils recognised some of his lessons 'on skies', 'on water', 'on mountains', etc., in an amplified and elaborated form, and especially his theory that tree-drawing should be based upon the laws of tree-growth. Ruskin, indeed, admitted him to be, next to Turner, 'unquestionably the greatest master of foliage in Europe'.

Harding was elected an associate of the Old Water-Colour Society in 1820 and a member in 1821. He visited Italy in 1824 and went frequently to the Continent on sketching tours after that date. He was in Italy for four months in 1831, and supplied twenty-four drawings for each of the three volumes of the *Landscape Annual*, 1832–4, two dealing with Italy and one with France. He is said to have painted on the Rhine and the Moselle and at Venice in 1834, again on the Rhine in 1837, and in Normandy in 1842. He was at Verona, Venice and Mantua with Ruskin in September 1845. There was a break in his membership of the Old Society from 1846 to 1856, when he was re-elected, the interval being due to ineffectual efforts on his part at this time to obtain admission to the Royal Academy as a painter in oil. During the entire period of his membership he exhibited only one hundred and sixteen works at Pall Mall East. The reasons for this comparatively small output of exhibited work were, first, his practice as a teacher, and, second, his preoccupation with lithography. He found this a sympathetic medium, and thoroughly enjoyed drawing

[1] W. Walker, *J. D. Harding, The Portfolio*, 1880, p. 29.

upon the stone. Besides the volumes already mentioned containing an expository text, he issued portfolios containing lithographed studies of landscapes. *Sketches at Home and Abroad*, 1836, contained fifty typical subjects, and was followed in 1837 by another delightful series of twenty-four landscape drawings entitled *Harding's Portfolio* and by *The Park and the Forest*, in 1841.[1] And in the course of work done for Hullmandel and others he lithographed drawings by J. F. Lewis, Bonington, Roberts and Stanfield. One of the documents for the identification of Bonington's authentic work is his *Series of Subjects from the Works of R. P. Bonington*, 1829–30.

As is shown by his devotion to lithography, which allowed him to make full use of his irregular expressive line, Harding was a draughtsman first and foremost, a versatile sketcher in the country, on mountain or river, on the coast, or in the street. His work in pencil or chalk is swift, searching, summary, wholly delightful always. Some crayon drawings by him in the Victoria and Albert Museum and one in the collection of Mr. and Mrs. Paul Mellon show his skill of composition, his free and expressive touch, more controlled and less mannered than that of Prout, and his power to suggest subtleties and contrasts of tone even in pencil lines. His outdoor sketches show the same downright qualities. His little *Salute Venice*,[2] a study for a larger version, records the unity of a single happy impression. It is dashed in broadly with brilliant blots of colour and conveys the very spirit of sunshine, largely gained by untouched patches of white paper. Like so many other outdoor sketches, made with an immediate attempt to summarise an effect of light and colour, it is far more honest and forthright than the deliberate product of the studio. In his finished water-colours done for exhibition or for the engraver, such as *Bergamo*[3] (Pl. 34) or *Berwick on Tweed*[4] he was apt to force his colour, and to use his undoubted brilliance of execution in piling up incidents of form and tone to the sacrifice of central interest. He produces effects that are too palpable, contrasts of light and shade that are too self-evident. There is an indiscriminate cluttering of detail as though every part must have its individual accent. The man who is constantly working for line-engravers, as Harding was before he took up lithography, is apt to fall into little exaggerations and stresses in order to simplify the engraver's task, particularly when, as in Harding's case, he finds how easy it is to gain effect by flickering touches of body-colour. Even Turner, in the interests of his engravers, was led astray, and Turner in his middle period was already a master whom Harding followed. Like Cox, and like Wilson Steer in more recent days, Harding was a devoted admirer of the *Liber Studiorum*. Perhaps that is why Ruskin acclaimed Harding and rejected Bonington, Cotman and others; why also he wrote that 'the rich, lichenous, and changeful warmth, and delicate weathered greys of Harding's rock, illustrated as they are by the most fearless, firm, and unerring drawing, render his wild pieces of torrent shore the finest things, next to the work of Turner, in English foreground art'. Harding, for his part,

[1] For details of publications with which Harding was associated, see Roget, II, pp. 178–187.
[2] Coll. Mr. and Mrs. Paul Mellon. [3] V.A.M. 178–1889.
[4] Newcastle upon Tyne, Laing Art Gallery.

dissented violently from Ruskin's views upon the Pre-Raphaelites. When Henry Holiday[1] approached Harding as to the formation of a drawing-class and admitted that he was a Pre-Raphaelite, Harding's face 'became in itself a declaration of war. He at once attacked what he assumed to be my main body, viz. Mr. Ruskin, and opened fire with two charges: first, that the writings of this renegade pupil were a mass of pernicious heresies; and, second, that they were merely a re-cook of his own works on art. Indeed, he assured me that his friends asked him why he allowed Ruskin to publish his (Mr. Harding's) books under a new title *Modern Painters*.'

In one of his excursions into art criticism, Thackeray[2] said about Harding: 'If one may find a fault with Mr. Harding's works, it is that one is almost too conscious of the artist in his works—as a painter he is skilled in the use of every weapon of his art—paints alike upon canvas and paper and stone—and has never been excelled in the breadth, richness and facility with which he handles every subject he treats. He designs architecture with the brilliancy and dexterity of Bonnington [*sic*], and possesses over the trees of the forest and park a mastery of delineation of which no other artist can boast.' In making his lithographs after Bonington, Harding must have obtained a thorough knowledge of Bonington's technique, but though he may be ranked with or even above Bonington as a draughtsman, his water-colours lack the lucent delicacy, the intuitive rightness, the unexpectedness of execution, the butterfly touches, which constitute Bonington's originality.

Among other outstanding followers of Bonington were James Holland and William Callow. Along with Harding they take the lead among draughtsmen who toured the Continent in the service of the Annuals. But it may be better to insert at this point brief references to some lesser artists who belonged to the same group of illustrators and topographers. Most of them followed Bonington, and prominence was given to their work by engraved and lithographed reproductions.

Taking them in the order of their birth-dates, we come first to William Brockedon (1787–1854). Born at Totnes, he was the son of a watchmaker and for some time followed his father's trade, but came to London in 1809 and entered the Royal Academy schools. His early work consisted of portraits and historical subjects in oil, and in 1818 he was awarded a premium of a hundred guineas by the British Institution for his *Resurrection of the Widow's Son*. After travelling through France and Belgium in 1815, and Italy in 1821–2, he continued his subject-painting, but at the same time turned to water-colour for a large output of topographical work. He illustrated several volumes dealing with the Alps, Italy and the Holy Land. In the Victoria and Albert Museum are his *An Alpine Pass*[3] (Pl. 35), and his *Monte Cavallo, Rome*,[4] which was engraved in his *Road Book from London to Naples*, 1835. He was a Fellow of the Royal Society, assisted in the foundation of the Royal Geographical Society, and won distinction as a scientist and an ingenious inventor.

[1] H. Holiday, *Reminiscences*, 1914, pp. 49–50.
[2] L. Marvy, *Sketches after English Landscape Painters*, 1850.
[3] V.A.M. 318–1887. [4] V.A.M. 179–1889.

John Gendall (1790–1865) calls for mention here, not only for his own work as a topographer but because he was behind Ackermann in the production of many illustrated descriptive works dealing with architecture and landscape. Born on Exe Island, Exeter, he became servant to a Mr. White of Exeter. Recommended by White to Sir John Soane, he was introduced by Soane to Ackermann, who employed him for some years as draughtsman, lithographer and manager. Among works which Gendall himself illustrated were *Picturesque Views of the Seine* (1821) and *Views of County Seats* (1823–8). He exhibited at the Royal Academy from 1818 to 1863, and died at Exeter.

William Andrews Nesfield (1793–1881), born at Chester-le-Street, was educated at Winchester and Trinity College, Cambridge. He entered the Army in 1809, served in the Peninsular War and in Canada, and retired in 1816 on his half-pay as a lieutenant. Taking to painting in water-colour, he occupied himself with landscape, and won high esteem for his pictures of waterfalls. Ruskin[1] speaks of him as 'Nesfield of the radiant cataract' and says that 'he has shown extraordinary feeling both for the colour and the spirituality of a great waterfall; exquisitely delicate in his management of the changeful veil of spray or mist, just in his curves and contours, and rich in colour, if he would remember that in all such scenes there is much gloom as well as much splendour, and relieve the lustre of his attractive passages of colour with more definite and prevalent greys, and give a little more substance to parts of his picture unaffected by spray, his work would be nearly perfect.[2] His seas are also most instructive; a little confused in chiaroscuro, but refined in form and admirable in colour.' He was elected a member of the Old Water-Colour Society in 1823, three months after his admission as an associate. His exhibited works included subjects (chiefly waterfalls) in North and South Wales, Yorkshire and Scotland. *Bamborough Castle*[3] (Pl. 37) and *Circle of Stones at Tormore, Isle of Arran*[4] and *The River Wharfe*[5] are good examples in public collections. He differed in manner from the clean pencil-and-wash method of Holland, Callow and other contemporaries, and was more akin to Francis Oliver Finch and Copley Fielding in his aptitude for working up a picture and taking out the highlights, particularly in his foliage. In 1844 he was one of a party of painters, including David Cox, at the Devonshire Arms near Bolton Abbey. Cox rescued a drawing which Nesfield, diffident about his own merit, had crumpled up and thrown away, straightened it out and gave it to his friend Mr. Roberts of Birmingham, in whose collection it was sold after his death.[6] In 1852 Nesfield retired from the Society and took up the profession of landscape gardening: he had a hand in the laying-out of our public parks in London and at Kew. He died at 3, York Terrace, Regent's Park, in 1881. His son, William Eden Nesfield, was author of *Specimens of Medieval Architecture, from Sketches made in France and Italy*, 1860.

[1] *Modern Painters*, Vol. II, § 4.
[2] Ruskin realised all this in his own 'nearly perfect' study of a waterfall, which was on view at the Fine Art Society in 1946.
[3] V.A.M. 536.
[4] V.A.M. 987–1901.
[5] Newcastle upon Tyne, Laing Art Gallery.
[6] N. N. Solly, *Life of Cox*, 1875, p. 130.

C. F. Tomkins (1798–1844) was much more akin to the Bonington, Holland, Callow group in his use of precise drawing and simple washes, with a richer colour accent here and there. Tomkins began his career as a scene-painter and caricaturist. He exhibited from 1825 to 1844 at the British Institution and at the Society of British Artists, to which he was elected in 1837.

Thomas Allom (1804–1872), born in London, was articled to Francis Goodwin, the architect, and studied at the Royal Academy Schools. He achieved some eminence in his profession, and became one of the founders of the Royal Institute of British Architects, but is chiefly known today for his extensive production of topographical drawings. To meet demands from publishers he travelled over England and Scotland, France and Belgium, and even visited Turkey and the Far East. Among his illustrations were those for *Westmorland, Cumberland, Durham and Northumberland*, 1839. The late C. E. Hughes owned *Sty Head Tarn, Cumberland*, the impressive original of one of the engravings in this work. In the Victoria and Albert Museum are two *Designs for the Thames Embankment*[1] (probably the drawings exhibited at the Royal Academy in 1848), admirable pieces of town-planning in which he combines his good draughtsmanship with his architectural skill.

Robert Brandard (1805–1862), born at Birmingham, came to London in 1824 and studied for a time under Edward Goodall as an engraver of landscapes. He engraved after several eminent artists, and was responsible for many of the plates in Turner's *Picturesque Views in England and Wales*, 1838, and in *The Turner Gallery*, 1859. Apart from this work, with which he was occupied till his death in 1862, he painted water-colours on his own account, and exhibited occasionally from 1831 to 1858 at the Royal Academy, the New Water-Colour Society and elsewhere. He had considerable power in expressing form and tone with the blacklead pencil; in his colour work his practice as an engraver led him to introduce forced passages and harsh accents. With him may be linked Charles Marshall (1806–1890), born a year later. Like so many of his contemporaries—Cox, Roberts, Stanfield, Tomkins and others—he began life as a scene-painter. He was articled to Marinari at Drury Lane, and later executed very successful work for Macready at Drury Lane and at Covent Garden. He painted several panoramas and dioramas, and was the first to introduce limelight on the stage. Some of his drop curtains were still used in provincial theatres long after his death in 1890. His water-colours, of which *Windsor Castle*[2] is a good example, were possibly executed with a view to scenic use and were freely handled, though perhaps with undue elaboration. He was a frequent exhibitor of landscapes at the Royal Academy, the Society of British Artists, and elsewhere, from 1828 to 1884.

William Henry Bartlett (1809–1854) was born at Kentish Town. At the age of fourteen he was articled to John Britton, who sent him out on frequent journeys to make drawings for the *Cathedral Antiquities of Great Britain* and the *Picturesque Antiquities of English Cities*. About 1830 he visited the Continent, and extended his travels to Syria, Egypt, Palestine and Arabia; he went four times to America. He exhibited in 1831–3 at the Royal Academy and

[1] V.A.M. P.7 and 8–1913. [2] V.A.M. P.37–1921.

29

the New Water-Colour Society. Nearly a thousand of his drawings, effective as to topography but slight and uninspiring in workmanship, were engraved in many of his illustrated works, such as *Walks about Jerusalem*, 1845, *Pictures from Sicily*, 1852, and *The Pilgrim Fathers*, 1853. He died at sea on his way to the East.

Alfred Gomersal Vickers (1810–1837) was son and pupil of Alfred Vickers (1786–1868), who was a self-taught landscape painter, born at Newington, Surrey. The father was a popular teacher and a frequent exhibitor in London from 1828 till his death. His son, born at Lambeth, received instruction from his father, and exhibited oils and water-colours from 1827 to 1837 at the Royal Academy, the British Institution and the Society of British Artists. In 1833 he was commissioned by Charles Heath to make a number of drawings in Russia, which were engraved in *Heath's Picturesque Annual* for 1836. His water-colours of *The Kremlin, Moscow* and *The Nevski Prospect, St. Petersburg* are in the Birmingham Art Gallery, and his *Cathedral of Vassili Blagennoi, Moscow*,[1] together with some Polish subjects, in the Victoria and Albert Museum. His admirable *In the Harbour, Boulogne*[2] and some sketches in the British Museum show him as a worthy follower of Francia and Bonington. His life was brief, like that of Bonington, for his promising career was cut short by his death at the age of twenty-six.

William Frome Smallwood (1806–1834) was the son of a hotel-keeper in Covent Garden. He studied under L. N. Cottingham, an architect, and worked a great deal on the Continent, many of his drawings being reproduced in the *Penny Magazine*. One of his best works was a series of small drawings, about 8 × 6 inches, or at the most 10 × 14 inches, of churches and cathedrals, at Canterbury, Antwerp, Brussels and elsewhere. They are meticulously drawn with a fine pen, like his *Eglise du Sablon, Brussels*,[3] or with the sharp point of a hard pencil, like his *Notre Dame, St. Omer*[4] or *Coutances*[5] and washed with very slight tints. They recall etchings by Hollar or the similar work of G. H. Wedgwood, where the small scale to which a tall building is reduced makes the figures below into midgets. Smallwood's architectural training served him well and enabled him to deal comfortably with difficult problems of perspective. His work is comparatively rare because he too died young, aged 28.

Thomas Colman Dibdin (1810–1893), who worked in much the same manner as Vickers, was a son of Thomas Dibdin, the dramatist. He inherited his instinct for art from his grandfather, Charles Dibdin (1745–1814), who was not only noteworthy as a dramatist and composer of songs, especially sea-songs, but was an amateur painter of merit; two wash drawings by him of *Lyme Regis*[6] are in the British Museum. His grandson was born at Betchworth, Surrey, the same year as Vickers. At the age of seventeen he entered the service of the General Post Office (just seven years before Anthony Trollope) but quitted it eleven years later to devote himself to art. He exhibited landscapes and architectural subjects, all well and truly drawn, at the Royal Academy, the Society of British Artists,

[1] V.A.M. A.L.5742. [2] V.A.M. 52–1896. [3] V.A.M. D.165–1899.
[4] Coll. Herbert Powell (N.A.-C.F.). [5] Coll. Mr. and Mrs. Paul Mellon. [6] B.M. 1876. 7.8.2372, 2373.

and elsewhere, from 1831 until his eyesight failed him about 1883. In 1839 he made some drawings for Mrs. Hemans's works, and in 1848 published *Progressive Lessons in Water Colour Paintings*. His *Nave of St. Saviour's, Southwark*[1] is in the Victoria and Albert Museum.

An artist who painted many Venetian and other views which have been wrongly accepted as being by Bonington or Roberts was E. Pritchett[2] (*fl.* 1828–1864). Little seems to be known about him except that he exhibited—usually Venetian subjects—at the Royal Academy, the British Institution and Suffolk Street from 1828 to 1864. His *Coast Scene, Isle of Wight*[3] (Pl. 45) is a good example of his work in pure landscape, but architecture was his usual theme. He must not be confused with Robert Taylor Pritchett (1828–1907), who exhibited landscapes at the Royal Academy and elsewhere from 1851. A great many of R. T. Pritchett's drawings were engraved on wood for his own publications such as *Brush Notes in Holland*, 1871, and *Pen and Pencil Sketches of Shipping*, 1899, as well as for *Good Words* and other publications.

The volumes of *Heath's Picturesque Annual* for 1837 and 1838 contained Irish landscapes by Thomas Creswick (1811–1869), and Creswick may well come in as a tail-piece to this section. Born at Sheffield, he was a comparatively young man when he obtained this commission. After studying at Birmingham under J. Vincent Barber, son of the Joseph Barber who taught Cox, Creswick came to London in 1828. Though his work was mainly as a painter of landscapes in oil, which won him associateship of the Royal Academy in 1851, he found time for painting in water-colour. Müller's remark about him in 1842, 'I only wish he would not niggle quite so much', applies equally to his *Ponies on a Welsh Moor*[4] which, I think, must date from about 1830. It is a drawing worthy of James Ward, finely grouped, broadly handled with bold brush-work, on a Creswick paper watermarked 1818. Creswick paper was not, as I used to think, named after Thomas Creswick.

As accomplished draughtsmen, masters in the use of descriptive line, Holland and Callow may be bracketed with Harding in the first class of the later topographers. Turner, like them, was touring the Continent and bringing back drawings for *The Keepsake* and other publications, but Turner is *hors concours*.

James Holland (1799–1870) was born two years later than Harding, three years before Bonington, and came of a family long connected with the staple manufacture of Staffordshire. Burslem, his native town, is the mother town of the Potteries. James Holland's grandfather, Thomas, has been described by Roget and others as the first manufacturer of the 'shining black' ware. Colonel Grant,[5] however, discovered that he was entered in a Survey of 1786 as 'Manufacturer of Black and Red China Ware and Gilder', whereas the 'shining black' ware was the property of an earlier Jackfield Pottery of Salop. His grandmother was a painter of flowers on pottery and porcelain. Young James Holland watched her at work, so effectively that at the age of twelve he produced two original drawings of

[1] V.A.M. 798–1877.
[2] See Dubuisson and Hughes, *Bonington*, 1924, p. 107, for evidence on this point.
[3] V.A.M. 182–1889. [4] Coll. Mr. and Mrs. Paul Mellon.
[5] Col. H. M. Grant, *Chronological History of the Old English Landscape Painters*, 1961, Vol. VIII, p. 710.

a flower and a bird, and obtained a sort of apprenticeship, for seven years, as a flower-painter on pottery under James Davenport, who made at his Longport factory the coronation china ware for William IV and a noble service for Queen Victoria's first banquet.

Coming to London in 1819, Holland continued his practice as a flower-painter, and sold his first dozen drawings for a lump sum of ten shillings, thereafter receiving a raised price of five shillings a piece from Ackermann and others. Adding to his meagre income by giving drawing lessons, he extended his studies to include shipping, architecture and landscape, and made many sketches on the banks of the Thames at Greenwich and in the neighbourhood of his residence at Blackheath. By 1824 he had moved to the Fitzroy Square district, living first in Warren Street and then at 51, London Street. From 1824 to 1827 his flower-pieces were shown annually at the Royal Academy. Some of these early studies of flowers are drawn with great precision in a fine pen line, but the backgrounds tend to be heavy and opaque. To this period, or even earlier, must belong the *Flower Group* [1] which, when I saw it, was labelled with the year 1840. Later, he painted flowers with more freedom, for his own pleasure, with delicate accuracy and a sensitive love of colour, as may be seen in two examples dated 1839 and 1859 in the Victoria and Albert Museum [2] and a brilliant *Flower Study* [3] dated 1864 in the British Museum. A man of cheerful disposition, he came into friendly touch in these early years with his professional brethren. A water-colour portrait of 1828 by William Henry Hunt, [4] ten years his senior, shows Holland, dark-haired, dark-eyed, debonair, with crimson scarf and the hint of a canary waistcoat, seated negligently in front of his easel, a bit of a dandy even, in his flowered painting smock, very much the easy-going successful young artist.

In 1831 Holland went to France and made some architectural studies, among his subjects being the Cathedral of St. Denis. Bonington died in 1828, winning wide reputation during Holland's most impressionable period, and in Holland's early work between 1830 and 1840 the influence of Bonington is clearly apparent. [5] In 1835 he was elected an associate of the Old Water-Colour Society, and exhibited *A Study From Nature* (flowers), *The Hedge Side, An Old Mill at Blackheath, On the River Tay, Greenwich* and *Charing Cross.* Those titles illustrate the scope of his work at this period. It may be said here that he resigned his associateship of this Society after eight years—like Harding, and at the same time, he was trying his hand at oil-painting, with an eye to Academy honours—but gained admission again as associate in 1856, and became a member in 1857. About two hundred of his works in all were shown in the Society's gallery. From 1842 to 1848 he was a member of the Society of British Artists, probably as a painter in oil.

Holland's first visit to Venice was in 1835, and thereafter there were few years when Venetian subjects were not prominent among his exhibited works. In 1837 he was sent to Portugal by the proprietor of the *Landscape Annual,* and the resulting drawings were engraved in the volume for 1839 entitled *The Tourist in Portugal.* In 1841 he was in Paris, in

[1] Stoke-on-Trent, City Art Gallery. [2] V.A.M. P.8 and 9–1925. [3] B.M. 1900. 8.24.520.
[4] V.A.M. 451–1887. [5] See Vol. II, Chap. XI.

1844 at Verona; in 1845 he sketched in Holland, with Rotterdam as a centre; in 1850 he was in Normandy and North Wales; in 1851 at Genoa; in 1857 at Innsbruck. In the course of these tours and of journeys to and from Italy he found subjects in France and Switzerland, and thus accumulated a mass of varied material. About 1846 he moved to 8, Osnaburgh Street, Regent's Park, where he remained for the rest of his life.

Holland's work up to about 1845 is characterised by his perfect balance of selection, and his sense of proportion between the details and the larger salient forms. He does not quite possess Cotman's power of drawing so subtly and suggestively that he makes our imagination multiply and extend the detail, but his line is sure and descriptive, swift, legible and admirably constructive. His two drawings of *St. Ouen, Rouen*,[1] in pencil on grey paper, done on successive days, show how he could work in a shorthand rapidity of nervous, impulsive lines, and yet concentrate on delicacy of detail where it was required. Where the work is loose, as though done in a fine frenzy with jerky lines and expressive hooks and angles, it shows an approach to Cox and displays a faster rhythm than Prout or Harding. In twenty drawings of Portugal in 1837, now in the Victoria and Albert Museum, his searching and vigorous pencil lines are combined with a tactful and restrained use of colour washes, which give the suggestion rather than the full reality of the colour scheme before his eyes; only here and there does he place gay and enlivening notes of local colour. In his earlier work Holland was much more ready than Harding to forget the separate elements of his design and to fuse his shapes into a large unity. Those Portuguese drawings, such as the *Torre dos Clerigos*,[2] *Oporto*,[3] the *Villa do Conde*[4] or the *Porto de Moz*,[5] with their sureness of drawing and their pleasant colour, not only show Holland at his best but lift him into the highest ranks of our water-colour school. Another drawing is entitled *Moorish Palace, Cintra, from the windows of Madame de Belem's Hotel*[6]; and the hotel is the subject of *Os Pisões, a house in Cintra*.[7] Holland was taken ill while staying there, and his landlady's little daughter, who reminded him of his own child, so pleased him by her kindness and attention that he gave her this drawing as a souvenir. A *Dordrecht*,[8] with the date 1845, is very close to the Paris sketches of Cox or the early work of Callow. The artist's hand seems to have hovered over the paper, dropping a touch of colour here and there. Everything is fluttering; the wind blows; windmill, church tower, trees and masts are all enveloped in light. The Holland who painted like this, not the artist who gilded the lilies of Venice, still awaits a just appreciation. I think it was drawings such as the *Torre dos Clerigos*, *Dordrecht*, *Piazza dei Signori, Verona*,[9] or the delightful *Dover*,[10] that Holland had in mind when he wrote: 'Parting with a sketch is like parting with a tooth. Once sold it cannot be replaced.'

After the simplicity and sincerity of his earlier work Holland succumbed to the dire influences of Victorian prosperity. Like Varley and Cotman, Palmer and others, he abandoned the directness of his earlier work in favour of potent colour and undue elaboration. There

[1] London, Tate Gallery 3326 and 3333. [2] V.A.M. A.L.4360(38). [3] V.A.M. A.L.4317(40).
[4] V.A.M. 30. [5] V.A.M. A.L.4313(41). [6] V.A.M. 32.
[7] V.A.M. P.21–1909. [8] Coll. Mr. D. L. T. Oppé.
[9] Newcastle upon Tyne, Laing Art Gallery. [10] Cambridge, Fitzwilliam Museum.

must have been some common reason for this, and one regrets to think that it was probably economic; in the case of Cotman and Palmer it was admittedly so. All of these painters became too ready to bow to the public, too ready to give the prosperous buyer, who had taken the place of the discriminating amateur, what he demanded. And in the case of Holland I cannot but think that, like Bonington, he was essentially a water-colour painter on whose work oil-painting came to exercise an adverse influence. Another bad influence was Venice. Dr. Johnson declared of Ossian that 'a man might write such stuff for ever, if he would abandon his mind to it'. It may be said that Holland abandoned his mind to the dramatisation of Venice. His second visit there was in 1857, and from about 1840 to 1870 Venice was his main recurrent theme. Some of his drawings made there are restrained and convincing, some are lovely in their rich and luminous glow, but too many are crude and pretentious. Ruskin[1] realised Holland's failure when he wrote, 'I have seen, some seven years ago, works by J. Holland which were, I think, as near perfection as water-colour can be carried—for *bona fide* truth, refined and finished to the highest degree. But since that time he has produced worse pictures every year; and his fall appears irrevocable unless by a very strong effort and a total change of system.' The last sentence was omitted in later editions, rather owing to what Ruskin described to his father as 'a singularly good-humoured reproach' from the artist than because he changed his opinion.

The Venice that Holland painted was a romantic, glorified, Byronic Venice:

> *. . . Her daughters had their dowers*
> *From spoils of nations, and the exhaustless East*
> *Pour'd in her lap all gems in sparkling showers.*
> *In purple was she robed, and of her feast*
> *Monarchs partook, and deemed their dignity increased.*

His is not the grey cool Venice—a much truer Venice—of Canaletto and Guardi, or the ethereal Venice of Turner, the city that was the bride of the sea, veiled in diaphanous mist. Like Delacroix, like Félix Ziem later, Holland revelled in colourful romance. (It must have been Ziem, I always think, whom I saw painting palaces purple and gold in blazing sunshine, while his wife held a large umbrella over his head to keep off the lashing rain.) Few artists can face the full hazard of Venice. Many of Holland's Venetian subjects and his interiors in Italy and Spain are the output of a London studio, worked up fancifully and theatrically as to colour. His luscious reds and yellows and purples are too intense; his clear waters and deep skies are bluer than any blue which even Italy can produce. Body-colour, used with restraint in the *Dordrecht*, becomes a sticky porous plaster. No doubt such drawings pleased the Victorian public, who would respond heartily to the *Art Journal* critic, of 1863: 'Mr. Holland with his rapturous love of colour makes *The Rialto* (possibly the picture in the Dixon Bequest, Bethnal Green Museum) span, with its single arch of grey, the emerald green of the canal beneath, set off by the red caps of Venetian boatmen.' But Holland had come much nearer to tone perfection in earlier

[1] J. Ruskin, *Modern Painters*, first edn., 1843.

34

drawings about which Thackeray wrote in *Fraser's Magazine* in 1839, before *Vanity Fair* had made him famous: 'Mr. Holland is a welcome addition to the landscape painters. His drawings are not quite so glib and smooth as those from more practical hands, but they are, perhaps, more like Nature, and certainly less mannered than the excellent, though exaggerated, performances of the seniors in the art.' And it may well have been with a thought to the now-mannered Holland that Thackeray wrote later, in 1850: 'How long are we to go on with Venice, Verona, Lago di So-and-So, and Ponte di What d'ye-call-em? I am weary of gondolas, striped awnings, sailors with red night (or rather day) caps, cobalt distances and posts in water. I have seen too many white palaces standing before dark purple skies, black towers with gamboge atmosphere behind them.' Holland was to go on painting those gondolas, awnings and red-capped sailors. He exhibited a *Fish Market, Venice* in 1869. The climax in his case was followed—at any rate, in his exhibited works—by an anti-climax which endured for over twenty years.

In 1949 some ninety drawings by him, from the collection of the late Sir Henry Houldsworth, Bart., were exhibited in the Leger Galleries and established the fact that the quality shown in the Portuguese and Dutch drawings was not just a spring-time product. Most of the drawings on view were the smaller, intimate, first-hand sketches which Holland made for working use and above all for his own pleasure and satisfaction. Here were sketches made in Portugal in 1837 (a worthy supplement to those in the Victoria and Albert Museum), at Venice in 1835 and 1837, at Delft or Rotterdam in 1845, at Genoa in 1851, with others of a later date. They were the treasures which the artist was burying in his studio throughout the years when he pleased his Society and his patrons by exhibiting mannered and pretentious 'gallery pictures'. Of special interest were a few purely atmospheric studies of sky and weather to which, like Constable, he added notes of the time of day and the movement of the sky. Here, and in an impressionist scene of *Evening, Trafalgar Square*, was an unexpected, unfamiliar Holland. And, to myself at least, there was new revelation of the artist's mind and outlook in a whole series of gay little seaside studies, of beach, buildings, piers, bathing machines and holiday figures, made between 1849 and 1861 on the Kentish coast at Deal, Margate and Walmer. Years later, Boudin was to find the same flutter of movement and atmosphere in the sands at Dieppe. Those ninety drawings opened one's eyes to Holland's remarkable range of subject and observation, and his immense variety of mood and manner.

After Harding and Holland, and fitly associated with them, comes William Callow (1812–1908). He lived to the great age of ninety-six, so many of my generation can remember him. A tall handsome man of splendid physique, he walked five miles or more every day till the year of his death and attended an exhibition of his own work at the Leicester Gallery in 1907. He conversed with Constable and Turner, had been attached to the Court of King Louis Philippe, shared a studio in Paris with Shotter Boys, and travelled all over Great Britain and the Continent by coach, diligence and on foot, before the railway came into being.

William Callow belonged to a family, originally called De Callowe, which had settled in our eastern counties. William Callow's grandfather was John Callow, born in 1750, who was employed at the Lowestoft factory in the decoration of porcelain. He had a son Robert, who was engaged in the building trade at Greenwich and in 1813 went as manager of works for alterations and improvements in the barracks at Norman Cross, on the Great North Road near Stilton, where French prisoners were interned during the Napoleonic Wars. His son, William, born at Greenwich, was a great favourite with the prisoners, who nursed him, as France herself was to nurse him later. William was to have two sisters, and a brother, John, who was born ten years later and who became an associate of the Water-Colour Society.

As a boy, William Callow with his father's encouragement was constantly copying prints and sketching everything which attracted his artistic instinct. In 1823, at the early age of eleven, he was successful in obtaining employment under Theodore Fielding, elder brother of Copley Fielding, who required a lad to assist him by colouring prints and by giving a hand with his work as an aquatint engraver. For two years the boy worked from 8 a.m. to 6 p.m. in the studios of the Fielding family at 26, Newman Street, Oxford Street. When Theodore Fielding removed to Kentish Town in 1825, Callow was formally articled to him as a pupil for instruction in water-colour, drawing and aquatint engraving. There were two other apprentice-pupils, John Edge and Charles Bentley. The latter, whose coastal and marine subjects were later to make him a distinguished member of the Old Water-Colour Society, was some six years older than Callow and gave him his first instruction in painting. Bentley and Callow remained firm friends, and made many sketching tours together in later days. It was probably owing to Bentley's influence and example that Callow occasionally varied his architectural themes with skilful marine subjects.

In 1827 Theodore Fielding moved from Kentish Town on his appointment as Professor in the Military Academy at Addiscombe, while Bentley and Edge, having finished the time of their articles, left to start life on their own account. Callow accordingly returned to the Newman Street offices, which were then managed by another brother, Thales Fielding. Here he continued to assist in the production of aquatint engravings; and, like Turner and Girtin before him, he no doubt discovered that the colouring of prints was no bad way of getting a grasp of form and of learning how to lay the even wash of fluid colour, which is the basis of water-colour art. In spite of long hours with Thales Fielding, he rose early and retired to bed late in order to give all his spare time to the practice of water-colour; and on this side of his work he received much encouragement and kind advice from Copley Fielding. When he was able to display seven drawings which he considered to have sufficient merit he determined to offer them to a dealer at the bottom of Holborn Hill. Callow's unambitious price, one guinea for the lot, was accepted with the proviso, not a bad one for either party, that payment should be made in painting materials.

In July 1829 came a turning-point in Callow's career. A Swiss artist named Osterwald called upon Thales Fielding, stating that he required someone of sufficient training and

experience to assist him in Paris with the production of a series of engravings for a book on Switzerland. On being asked whether he would like to go abroad, Callow promptly undertook to start within a week. So on July 16, not yet seventeen years of age, he travelled to Paris. There he lived with Newton Fielding, who ran a studio-office in the Rue St. Georges near Montmartre, and had a wide commercial connection for his work as an engraver. Thales Fielding had been in this Paris office from about 1820–7 and had shared a house with Delacroix in the Place de la Sorbonne. The Fielding establishment was, no doubt, a house of call for English artists abroad. It was probably through the Fieldings that so many of them came into touch with Bonington and his work.

Callow stuck to his job of engraving, but his heart was in water-colour painting, and he made much progress by watching Newton Fielding at work. In 1830 Paris was so unsettled by the Revolution, with battles constantly flaring up in barricaded streets, that Fielding and he made for a safer home in England. After six months of once again colouring prints with Theodore Fielding at Croydon, Callow determined in 1831 to settle in Paris again.

Soon after his return there he came into close touch with Thomas Shotter Boys. They shared a studio in the Rue de Bouloy, a small street near the Palais Royal, and frequently went on sketching rambles through the ancient parts of Paris, where narrow streets without side paths were paved with cobble-stones, with gutters down the centre, and were lighted by oil lanterns suspended from ropes above the centre of the roadway. Not yet had Haussmann's wholesale reconstruction destroyed the features and character of the older parts of Paris. In company with Boys he worked at Versailles and St. Cloud, and made for him some large sketches from Paris bridges, for which the younger man, an omnivorous reader, was paid in books. It is quite possible that the *Pont Neuf, Paris*[1] signed by Boys and dated 1833 was developed from one of Callow's careful studies, or even (for it is a little immature for Boys) may be a drawing by Callow finished in colour by Boys. Even when on holiday in England in 1833 Callow was making a sketch in Pall Mall and some views of Richmond for Boys; and on his behalf he conveyed a present of a Turkish scimitar to John Constable.

It was from Boys that Callow derived not merely his love of old towns, timbered houses, picturesque street scenes with chaffering crowds in the market-place, and wharves busy with shipping, but also his directness of selective drawing, and his use of clean, transparent, colouring. This was the inheritance which Boys had received from Bonington, for although Callow in his *Autobiography* denies that Boys was a pupil of Bonington, it is safer to believe the tradition that Boys had a more intimate association with Bonington than the mere acquaintanceship which Callow suggests. Boys clearly absorbed Bonington's methods and his clarity of translucent colour, and from him the mantle descended to Callow. We may be fairly certain that among the impossible number of drawings

[1] V.A.M. P.25–1922.

37

accredited to Bonington as the product of his brief life of twenty-six years some should rightly be attributed to Boys, and a great many to Callow, particularly the English scenes. In this connection it may be remembered that for many years Callow showed both English and French views in exhibitions held throughout the provinces of France, winning medals at Cambrai in 1836 and 1839, at Boulogne in 1837, at Rouen in 1839 and 1840; and at the Paris Salon of 1840 was awarded a gold medal for his water-colour paintings. It may well be surmised that some of his earlier drawings thus exhibited and sold, or disposed of privately, have found their way back to England as the work of Bonington.

In 1834 Callow took over from Boys his atelier in the Rue de Bouloy and remained in occupation till he finally left Paris. Being in the possession of a studio to himself, he started a drawing class, and many of his pupils were members of the old French nobility, the Comte de Faucigny, the Viscomte de Rouget, the Comte de Nicolai and others. His water-colour *A View from Richmond*, from a sketch made during a visit to London in the previous year, was exhibited at the Salon in 1834 and drew considerable attention at a time when water-colour painting was practically unknown in Paris. His success at the Salon brought Callow more distinguished pupils, for soon after the exhibition opened he received a visit in his studio, on the *sixième étage*, from an equerry of King Louis Philippe, to enquire whether he would give lessons to the King's son the Duc de Nemours. Shortly after the lessons had begun, Callow was informed that the Duke's sister, the Princesse Clémentine d'Orléans, also wished for his instruction in water-colour painting. To the Princess, for nearly seven years, he gave lessons twice a week all the year round (during the summer, at Neuilly or St. Cloud), always at eight o'clock in the morning, and always carrying off a draft for twenty francs handed by a lady-in-waiting.

His drawings now commanded a ready sale among patrons and dealers, though he records forty francs as being 'a good price for me at the time'. With money in the bank and in his pocket, he set out in May 1835 on the first of his walking tours, following the Seine to Honfleur, crossing by steamer to Southampton, touring the Isle of Wight, and then making his way on foot from Portsmouth to Winchester. On this and subsequent tours he filled hundreds of sketch-books with pencil notes which were quite adequate for future development in colour on a larger scale. These excursions were always made on foot, though with an occasional lift in a passing vehicle, and the places which he visited are fully noted in his *Autobiography*. In 1836 he tramped 1700 miles through the south of France, being away for two months and a half, at an entire cost of only £20. Callow, at any rate, profited by his opportunities, and took time by the forelock (little knowing what a long stretch of time it would be) in accumulating material which was to last him for over seventy years. In 1838, knapsack on back and sketch-book in pocket, he spent ten weeks in Switzerland and Germany. In 1840 he visited Italy; in 1841, Normandy; in 1844, the Rhine and the Moselle; in 1845, Holland; in 1846, Germany, Switzerland, Venice; in 1862, Coburg, Potsdam and Berlin; in 1892, he made his final visit to Italy. In the Victoria and Albert Museum is a volume containing 196 sketches in pencil, wash or water-colour,

dated 1829 to 1850, made in Paris and its environs or during walking tours in Normandy, Touraine, the Pyrenees, the south of France, Switzerland and Germany. It contains a number of drawings made for illustrations to Charles Heath's *Picturesque Annual, Versailles* published in 1839. The Old Water-Colour Society owns similar volumes of *Sketches in England, 1848–51* and *Sketches in France and Italy, 1844–79*.[1]

In the intervals between his earlier tours Callow paid visits to England. In 1837 he witnessed, in company with Bentley, the coronation of Queen Victoria, whom he outlived by seven years, and he called upon Turner with an introduction from Charles Heath the engraver. Callow's account of his contacts with Turner has been recorded in his own words.[2]

A second meeting, not dated by Callow, must have taken place in August 1840 when Turner was in Venice for about three weeks. Less than two months before, Ruskin, then a young man fresh from Oxford, had met Turner for the first time, and on the same evening (June 22) written in his diary:

> Introduced to-day to a man who beyond all doubt is the greatest of the age; greatest in every faculty of the imagination, in every branch of scenic knowledge; at once *the* painter and poet of the day, J. M. W. Turner. Everyone had described him to me as coarse, boorish, unintellectual, vulgar. This I knew to be impossible. I found him a somewhat eccentric, keen-mannered, matter-of-fact, English-minded gentleman; good-natured evidently, bad-tempered evidently, hating humbug of all sorts, shrewd, perhaps a little selfish, highly intellectual, the powers of his mind not brought out with any delight in their manifestation, or intention of display, but flashing out occasionally in a word or a look.

That brilliant impression, which Ruskin was to look back upon half a century later with justifiable pride, pictures the painter whom Callow was to meet at Venice within eight weeks of its being written.

Callow's continental travels have been chronicled because they supplied the sources from which his paintings were obtained. Between two of his earliest excursions came what he recognised as an outstanding event in his life. In 1838, on the advice of Charles Bentley and of J. F. Lewis, a frequent visitor at Callow's studio in Paris, Callow with due trepidation entered his name as a candidate for election to the Royal Water-Colour Society. He found later that he had the support of Cattermole and of Copley Fielding, who had known him since he was a boy. His very proper pride in his election is amply shown by his own account[3]:

> On the 15th February I received the gratifying intelligence that I had been unanimously elected as Associate. For some time previously it had been my ambition to become associated with this grand Society, yet when the news of my election reached me I could scarcely believe it to be true, not having sufficient confidence in my own powers to think that I should ever succeed. A new incentive for work in the future.

[1] In 1945, the Fine Art Society acquired a volume containing over 100 sketches made by Callow from 1865 to 1892.
[2] See Vol. II, p. 25.
[3] *Autobiography*, p. 64.

The following notice appeared in the *Spectator*:

The Water-Colour Society last week filled one of two vacancies by electing a Mr. William Callow, landscape and marine painter, not known in this country, but who has studied in the French school, we have heard, and is of the dashing style of execution.

The works which Callow exhibited in 1838 were views of places in the south of France (Avignon and Marseilles supplying two subjects each), and in the next two years his contributions were mainly scenes in Germany and Switzerland. They drew the attention of Thackeray, who has never won full recognition as a sound and lively art critic, when he reviewed the Society's exhibition:[1]

There is no need to mention to you the charming landscapes of Cox, Copley Fielding, De Wint, Gastineau, and the rest.

 A new painter, somewhat in the style of Harding, is Mr. Callow, and better, I think, than his Master or original, whose colours are too gaudy to my taste, and effects too glaringly theatrical.

In 1841, encouraged by his success, but rather nervous about the idea of abandoning his profitable connection as a drawing-master in Paris, Callow sold the contents of his studio, leaving some furniture with his brother John, and started afresh in London. Part of his house at 20, Charlotte Street, Portland Place, was occupied by Bentley until in 1846 Callow married Harriet Anne Smart, a niece of Sir George Smart, the Queen's organist. In London, he soon had plenty of aristocratic pupils, among them Lady Beaujolois Bury, Lady Stratford de Radcliffe and Lord Dufferin, afterwards Viceroy of India, who 'was more interested in chemistry than drawing, so much so that his mother, one of the beautiful Sheridan sisters, told me', so Callow relates, 'that she was in constant fear lest he should blow up the house'. Callow's work as a popular drawing-master—he speaks of 'having almost more pupils than I was able to properly superintend'—continued until 1882.

In 1848 he became a full member of the Society, and his gratification is again best shown by his own words[2]:

In 1848 I was again disappointed in the sales at the Old Society, but this was fully compensated for by the good news which Bentley brought me one evening, announcing that I had been elected a full member of the Society of Painters in Water Colours. The great ambition of my life was now attained. How proud was I to think that for the future I was to be included in a body of celebrated men to whom as a boy I had looked up with an admiration approaching to awe, and to belong to the Society and home of water-colour paintings. I wonder how many of the younger generation have appreciated the honour of membership of this famous society to the same degree as I have done, and still continue to do.

His interest in the Society caused him to be chosen as a Trustee, which position he held till 1878; and he also acted as Secretary from 1865 to 1870. From his election in 1838 to his death in 1908—a period of seventy-one years—he never failed in sending his contribution to summer and winter exhibitions, and if groups of sketches in a single frame be counted separately, his grand total of exhibits was over fifteen hundred. No wonder that on his

[1] *Fraser's Magazine*, June 1839. [2] *Autobiography*, p. 100.

32 'Dunstanborough Castle'
B.M. 1958.7.12.347 12¾×8¾: 323×223 *Water-colour*
James Duffield HARDING (1797–1863)

33 Plate 20 *Harding's Elementary Art* 1846
10⅞×15: 276×380 *Lithograph*
James Duffield HARDING (1797–1863)

34 'Bergamo'

V.A.M. 178–1899 11¾×16¾: 298×426 *Water-colour*

James Duffield HARDING (1797–1863)

35 'Alpine Pass'

V.A.M. 318–1887 8⅝×13⅝: 219×346 *Water-colour*

William BROCKEDON (1787–1854)

36 'Edinburgh, from near St. Anthony's Chapel'
V.A.M. P.62–1922 $10\frac{3}{4} \times 15$: 272×380 *Water-colour*
John GENDALL (1790—1865)

37 'Bamborough Castle, Northumberland'
V.A.M. 536 $20\frac{7}{8} \times 27\frac{5}{8}$: 530×702 *Water-colour, signed*
William Andrews NESFIELD (1793–1881)

38 'Colwith Force, Westmorland'
B.M. 1913-5-28-3 7×4¾: 178×121 *Water-colour*
Thomas ALLOM (1804–1872)

39 'Yarmouth, Isle of Wight'
V.A.M. E.328–1918
4¼ × 6¼: 108 × 159
Water-colour
Robert BRANDARD (1805–1862)

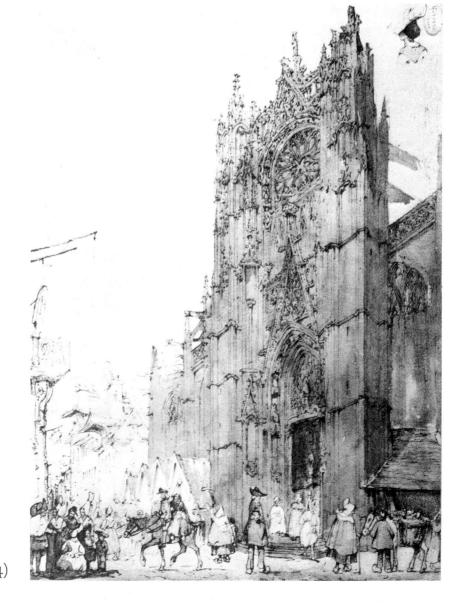

40 'Church of St. Maclou, Rouen'
V.A.M. D.169–1889
7 × 4½: 178 × 114
Water-colour, signed
William Frome SMALLWOOD (1806–1834)

41 'The Island of Philae'
V.A.M. D.12–1903 $8\frac{3}{4} \times 13\frac{7}{8}$: 222 × 351 *Water-colour*
William Henry BARTLETT (1809–1854)

42 'Cottage and figures'
B.M. 1875.814.117 $9\frac{1}{4} \times 13$: 236 × 330 *Water-colour, signed and dated ?1810*
Thomas Colman DIBDIN (1810–1893)

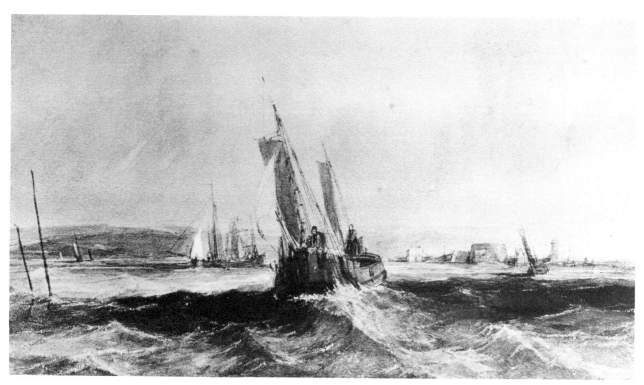

43 'Shipping off the Coast'
Coll. Mr & Mrs Paul Mellon 7¾ × 13: 187 × 330 *Water-colour*
Alfred Gomersal VICKERS (1810-1837)

44 'Sea Fisherman'
B.M. 1880.2.14.318 (LB 3) 10½ × 14⅞: 265 × 377 *Water-colour*
Alfred Gomersal VICKERS (1810–1837)

45 'Coast scene, Isle of Wight'

V.A.M. 182–1889 8⅝ × 12¼: 220 × 310 *Water-colour, signed and dated 1850 (on reverse)*

E. PRITCHETT (Exhib. 1828–1864)

46 'Landscape with Quarry'

B.M. 1912.5.13.12 9¼ × 12⅜: 235 × 404 *Water-colour*

Thomas CRESWICK, R.A. (1811–1869)

47 'Lynmouth'
B.M. 1914.4.6.9 14½ × 20¾: 367 × 526 *Water-colour, signed*
James HOLLAND (1799–1870)

48 'Venice'
B.M. 1915.3.13.32 14⅜ × 20⅜: 364 × 517 *Water-colour, signed 1857*
James HOLLAND (1799–1870)

49 'Flowers in a Jug'
B.M. 1900.8.24.520
11½ × 8⅛: 292 × 207
Water-colour, signed and dated 1863
James HOLLAND (1799–1870)

50 'Margate'
Coll. Mr & Mrs Paul Mellon
4 × 6⅛: 102 × 155
Water-colour, dated 1861
James HOLLAND (1799–1870)

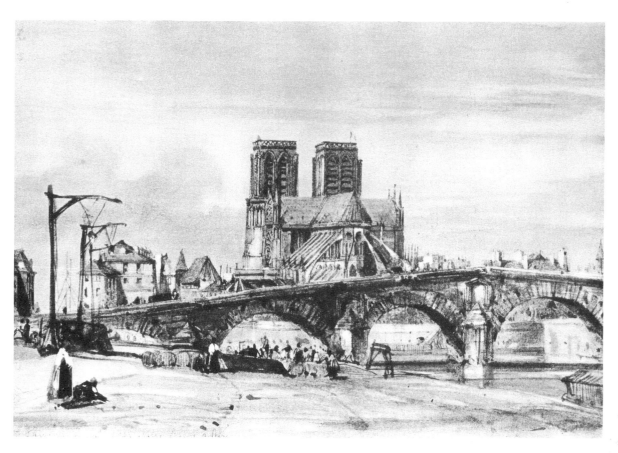

51 'Notre Dame, Paris'
Coll. Mr & Mrs Tom Girtin $6\frac{3}{4} \times 9\frac{3}{4}$: 172 × 248 *Water-colour, dated 1835*
William CALLOW (1812–1908)

52 'Palais Gallière, Bordeaux'
Coll. Captain M. L. Hardie, R.N. $4\frac{7}{8} \times 6\frac{7}{8}$: 123 × 174 *Water-colour, signed*
William CALLOW (1812–1908)

53 'The Ferry, Glenelg'
Coll. Mr & Mrs Paul Mellon $17\frac{1}{2} \times 25\frac{1}{2}$: 444×642 *Water-colour*
William CALLOW (1812–1908)

54 'View on the Serpentine, Hyde Park'
V.A.M. P.2–1909 $9\frac{7}{8} \times 14\frac{1}{8}$: 251×358 *Water-colour, signed and dated 1876 (?1846)*
William CALLOW (1812–1908)

ninetieth birthday the President and Council presented him with an illuminated address expressing their congratulations and their appreciation of his loyalty.

In 1855 Callow retired from London to a house, *The Firs*, which he built on the Chiltern Hills above Great Missenden, where he died on February 20, 1908.

Callow in his early days clung to the fine traditions in which he was trained, making a precise drawing and working over it with slight washes of colour on a non-absorbent paper. There are no alterations, no spongings and scrapings, no use of body-colour except on the rarest occasions. Typical of this honest direct work with the pencil, just tinted with pleasant colour, is his *Maison du Conseil, Malines*,[1] 1844; and if that drawing were not signed, any critic would be justified in arguing over an attribution to Cox or Holland or David Roberts. The *Palais Gallière, Bordeaux*,[2] 1836, is carried a little further; and here the inheritance from Bonington is very clear. The drawing shows clearly the technical device, employed by Bonington and his followers, of using a fine brush, charged with colour, almost as if it were a pen, for indicating outlines and emphasising details.

Callow was at his best up to about 1850. It must be frankly admitted that membership of a society where, at that time, the exhibition walls were loaded with ambitious, pretentious, highly-finished 'gallery pictures' led him astray, like Cotman and Holland, and robbed his art of the simplicity which was its charm.[3] In Callow's case the rivalry of exhibitions led him to work on a much larger scale, to strain the resources of his palette, to lose the luminosity of his skies, and to exaggerate the disposition of light and shade. His exhibited works after 1850 tended to display what Coleridge called a 'nimiety', a too-muchness, of detail and ornament and varied colour. The small sketches of his earlier days, from which he was now working, were not suited for ambitious enlargement. But, for his own pleasure, he continued to produce smaller drawings, lightly washed with colour, such as the *View on the Serpentine, 1876*[4] (Pl. 54), which still displayed what the critic of the *Spectator* had called his 'dashing style of execution'.

In a fragment of his *Table Talk* Hazlitt defines the picturesque as being determined by excess of form, the ideal by a concentration of feeling. If Callow comes just below the greatest, it is because his work is concerned with the picturesque rather than the ideal, with form rather than feeling. The visual aspect of his subject, its distinctive character and salient points, were recorded with unerring skill. He was sure of his power as a draughtsman and composer, but he lacked emotion. He liked an orderly scheme of things. When, in 1863, he asked Queen Victoria to write down a number of views which he should sketch at Rosenau, the birth-place of the Prince Consort, and then painted them one and all, he was a good courtier, or man of business, rather than a true artist. He was always cool and detached, a relentless observer, but he was unconscious that Nature, in a great piece of art,

1 Coll. Herbert Powell (N.A.-C.F.).
2 Coll. Captain M. L. Hardie R.N.
3 In later years his painting box contained such colours as pink madder, vermilion, gamboge, Naples yellow, lemon yellow, as well as flake white. M. Huish, *British Water-Colour Art*, 1904, p. 210.
4 V.A.M. P.2–1909.

must be studied *à travers d'un tempérament*. Like the sundial, he only recorded the sunny hours. No drawing by Callow reminds us that raincoat, umbrella and goloshes are necessities of our life. He never used 'rain, steam and speed', wind, atmosphere and colour, as Turner or Constable, Cox or De Wint did in excitement of their feelings and our own. None the less, the truth and placid refinement of his best work has lasting value and quiet persuasiveness.

CHAPTER III

Travellers in the Far and Near East

William Hodges Thomas and William Daniell George Chinnery
John Frederick Lewis William James Müller Edward Lear

Before the first quarter of the nineteenth century had ended most of western Europe had been explored and exploited by water-colour painters. Cozens, Pars, Warwick Smith, Turner, Prout—to name only a few—had made the scenery of France, Germany, Italy and Switzerland familiar to picture-lovers at home. There were other painters, however, who sought fortune in a much more distant field. Sir William Foster[1] records no fewer than sixty-one British painters who worked in India between 1760 and 1820. 'The magnet', he says, 'which drew so many artists to India was the same as attracted thither large numbers of their compatriots, namely, the hope that in the land of the pagoda-tree Fortune might prove kinder than in the overcrowded market at home.' In India there were wealthy communities of British residents, and, when fortunes were easily won, the East India Company's servants were munificent patrons of art. Hodges and Tilly Kettle exploited the new market, and were shortly followed by Zoffany, Smart, Humphry, Hickey and others. Most of the adventurers were portrait painters, in oil or miniature, and they had their eye on Indian princes who were beginning to follow fashion in patronising the arts of the Western world. But there were 'chiels among them taking notes'[2] in water-colour.

One of the first to promote interest in the costume, architecture and topography of India, by means of book and picture, was William Hodges (1744–1797). Born in London, he was the son of a blacksmith in Clare Market. He became successively an errand boy at Shipley's Drawing School, a fellow-pupil with Farington under Richard Wilson, and a scene-painter at Derby. He exhibited from 1766 at the Royal Academy and elsewhere, and in 1772 was appointed draughtsman to Captain Cook on his second voyage round the world. He seems to have developed in this way a liking for travel and adventure. Having obtained permission from the East India Company, he sailed to Madras in 1780. In 1781 he met with steady support and generous patronage from Warren Hastings, whom he

[1] Sir W. Foster, *British Artists in India*, Walpole Soc., XIX, 1930–1.
[2] A description of Francis Grose, antiquary, in a poem by Robert Burns:
 'A chiel's amang you takin' notes,
 And, faith, he'll prent it.

accompanied on the memorable journey to Benares. On his return to London in 1784, Hodges projected the publication of a series of engravings in aquatint by himself from sketches made in India. His *Select Views in India, drawn on the spot in 1780–83*, consisted of two volumes, each containing twenty-four coloured plates, the whole work costing £18 unbound or £20 bound. The publication was dedicated to the East India Company, who subscribed for forty sets. Though the engravings were made from water-colour drawings, Hodges was really a painter in oil and, as such, was elected A.R.A. in 1786 and R.A. in 1787. According to Farington, Hodges established a somewhat bogus bank at Dartmouth in 1795, and on its failure committed suicide at Brixham in 1797.

The publishing campaign was continued by Edward and William Orme, possibly brothers. Edward Orme, who was publisher to His Majesty and the Prince Regent, was a kinsman of Robert Orme, author of that forgotten classic *The History of the British Nation in Indostan*, of which the first volume appeared in 1763, and in that case his love of India may have been inherited. Orme's first book illustrating India was *Twelve Views of Palaces in the Kingdom of Mysore*, the twelve coloured aquatints being engraved by J. W. Edy after drawings by R. H. Colebrooke. The first edition seems to have appeared in 1794, the second in 1805. In 1803 Orme's field was still in the Far East, but embraced the Holy Land, with *Picturesque Scenery in the Holy Land and Syria*, containing nineteen colour plates from drawings executed by Daniel Orme (*c.* 1766–*c.* 1832) after sketches made by F. B. Spilsbury (*fl.* 1796–1805), surgeon in H.M.S. *Le Tigre* during the campaigns of 1799 and 1800. This Daniel Orme may have been another brother. He became a stipple engraver and miniature painter, exhibited at the Royal Academy between 1797 and 1801, and is supposed to have died about 1832. In 1805 Edward Orme also issued *Twenty-four Views in Hindostan*, with colour aquatints made by W. Orme from originals by Thomas Daniell and Colonel F. S. Ward. In the Victoria and Albert Museum it is possible to compare the prints with W. Orme's drawings, and to note with what success colour aquatint produces the effect of water-colour. *Picturesque Scenery in the Kingdom of Mysore* was Orme's next work, in 1805, with forty colour plates after James Hunter. Besides other similar volumes Orme issued in 1805 *The Costume of Hindostan*, a series of sixty plates published with descriptive text at £8 8s. A later edition, with the imprint of 1805 still on the plates, was printed on Whatman paper with the watermark date of 1823. The genesis of the book was a series of *Two hundred and fifty Drawings descriptive of the manners, customs, and dresses of the Hindoos*, by B. Solvyns, whose original drawings are in the Victoria and Albert Museum. A volume containing etchings, coloured by hand, had been published with the above title at Calcutta in 1799. Then, from Solvyns' drawings, W. Orme, as he had done with the *Twenty-four views in Hindostan*, made a set of fifty-nine water-colours (they are in the National Art Library, V.A.M.), infinitely better drawn than the originals; and it was from Orme's drawings that the plates in *The Costume of Hindostan* were executed.[1] William Orme (exhib. 1791–1819), who has thus come into view, was awarded a silver palette by the Society of Arts for a

[1] For a fuller account of E. Orme's publications, see Martin Hardie, *English Coloured Books*, 1906.

drawing of Barton Bridge in 1791–2; exhibited at the Royal Academy, 1797–1819; drew for the *Copperplate Magazine*, etc., and published a book on landscape drawing.

The largest and most serious contribution to the knowledge of India by means of drawings was made by Thomas (1749–1840) and William Daniell (1769–1837). Working in India from 1786 to 1794, they were primarily water-colour painters and were concerned with topography alone. Thomas Daniell was born at Kingston-on-Thames. His father is said to have been an inn-keeper, probably of the Swan Inn, Chertsey. Thomas Daniell told the story of his life to Farington,[1] saying that 'he came to London when 14 years of age, and was put apprentice to a coach-painter of the name of Maxwell for 7 years. After that period he was for several years employed by Catton in the same way, and did not fairly commence the practice of painting pictures till he was near 30 years of age'. In retrospect he magnified the tale of his early struggles, as the successful man who has made his own way is apt to do. In fact he showed a picture at the Royal Academy in 1772 and entered the R.A. schools in 1773, being then only twenty-four. He won some reputation by his two views in 1777 of the poet Cowley's house, and found a patron in Lord Le Despencer, who, about twenty years earlier, as Sir Francis Dashwood, had founded the notorious Hell-Fire Club or society of the monks of Medmenham Abbey. Daniell exhibited four views of his patron's West Wycombe seat in 1781. His other Academy works at this period were landscapes in Buckinghamshire, Oxfordshire, Somerset and Yorkshire. No further events of his life are recorded until his departure for India in 1785.

The directors of the East India Company had made an attempt to stem the rush of painters to the East. Thomas Daniell, however, managed to obtain permission for a passage, perhaps because he appealed as an engraver, not only for himself but for his nephew William, then only fifteen years of age. For some unknown reason uncle and nephew went first to Canton, as is evidenced by *A Picturesque Voyage to India by Way of China* (1810). They reached Calcutta early in 1786, and the first of their long tours throughout India was made in 1788–91. They were indefatigable workers, and William Daniell's diaries tell a tale of tremendous energy. The Daniells kept a close eye on subjects which Hodges had illustrated in his *Select Views*, and generally were highly disparaging about his work, often finding that he 'had made a very incorrect Aquatinta plate'. One of his views near Benares was 'so very unlike that one would imagine he had taken it under full sail'. They themselves constantly made use of the camera obscura, which at least gave an accurate foundation. After their arrival in India, Thomas Daniell certainly lost no time, for in 1786–8 he published twelve large views of Calcutta, in coloured aquatint, at the price of twelve gold mohurs to subscribers. But the main result of their travels was their *Oriental Scenery*, published in parts between 1795 and 1808. This great work, in six volumes, with one hundred and forty-four plates in colour, cost subscribers £210.[2] Thomas Daniell in this publication

[1] *Diary*, July 22, 1813.
[2] Many of the original drawings for the engravings were exhibited in 1932 at Walker's Gallery.

is given the foremost place as draughtsman, though William Daniell was now the moving force as a highly proficient engraver in aquatint.

Both Thomas and William Daniell, relying on sketches made between 1786 and 1794, continued to exhibit Indian views for many years later at the Royal Academy and elsewhere. Thomas Daniell began to work almost entirely in oil after his return, and from 1795 to 1828 showed a constant succession of Indian landscapes. He was elected A.R.A. in 1796, and R.A. in 1799. Though William's further work as a topographical painter in watercolour of English and Scottish subjects might seem strictly to belong to another chapter, it appears more convenient to continue here with particulars of his subsequent career. Though it was by his oil-paintings that he won associateship of the Royal Academy in 1807 and membership in 1822, he made the larger part of his income by his prowess as a watercolour painter and as engraver in aquatint. His *Durham Cathedral*[1] (Pl. 60), 1805, is a broad and powerful drawing, showing him as a worthy successor to Girtin in choice of subject, colour and handling. In 1804–5 he produced a magnificent set of six views of London, which show him at his best as draughtsman and engraver. These prints and a similar series of twelve views of Windsor and Eton (*c.* 1830), also in colour aquatint, finely drawn, quiet and restrained in their colouring, stand at the high-water mark of English aquatint. In two sets of these Windsor prints, one in the Royal Library at Windsor, the other in the Victoria and Albert Museum, the engravings are laid down on a back of thinnish card, with a tinted line framing them in after the fashion of water-colours; and they might well be mistaken for original water-colours, so excellently has the hand-colouring of the prints been finished. In 1862, the plates were re-issued by William Tegg, but the colour-work was greatly inferior. Sir Owen Morshead, when Librarian to the Royal Library, pointed out to me that in three of the plates Tegg made deliberate alterations and 'Victorianised' the costumes. In *Windsor Castle from the River* all seven figures on the near bank have been reclothed in Victorian costume, and are harsh in colour compared with the quiet restraint of Daniell.

William Daniell's water-colour work also served him for a memorable production, the *Voyage round Great Britain . . . by Richard Ayrton, with a series of views . . . drawn and engraved by William Daniell, A.R.A.* This work, with its remarkable series of 308 colour plates, appeared in eight volumes from 1814 to 1825. The artist and his friend Ayrton, who was responsible for the text, travelled during the summer months of each year, and completed their work during the winter. The publication belonged to days when few readers 'would venture in pursuit of amusement out of the latitude of good inns and level roads, to make paths for themselves over rocks and crags'; when even Southend—witness the plate thereof—was unknown to trippers, and Ramsgate still remained poetic and picturesque. Daniell excels in suggesting the warm haze that hangs over a summer sea, or sunlight playing on the roofs of a fishing village, or rugged cliffs where sea-gulls swoop in circling flight—note, for

[1] V.A.M. 1744–1871.

46

instance, his scenes in Cornwall, his *Tenby, Pembrokeshire*, or his *Dunbar*. His original drawing for *View of Lancaster Castle*[1] is in the Victoria and Albert Museum. Daniell should be reckoned as being one of the best of our topographical artists. He had a real eye for pictorial composition, had learned from the age of fifteen the importance of close study of architecture, with his uncle as a stern guide to correct drawing, and in colour was a skilful and pleasing technician. He was one of the first to follow Turner in the wiping out of lights in water-colour drawings.

In the wake of the Daniells, George Chinnery (1774–1852) made the voyage to India. The East was to some extent in his blood, for his father had been a Madras merchant, owning a factory at Cuddalore, before he settled about 1764 in London, where George was born ten years later. In 1791, at the age of seventeen, George Chinnery began to exhibit portraits at the Royal Academy. In 1797 he proceeded to Dublin, where he painted portraits and took an active part in the social and artistic life of the town. While in Ireland he married, in 1799, Marianne Vigne, daughter of a Dublin jeweller. Two children were born, but the union was not happy, perhaps because of Chinnery's eccentricity. Many years later he said of his wife: 'Mrs. Chinnery's appearance cannot be exaggerated. She was an ugly woman thirty years ago. What in the name of the Graces can she be now?' It was possibly to escape from his wife that in 1802 he left her and the children behind, crossed to London, and quickly sailed to Madras. For five years he was painting portraits there, besides making pen and water-colour studies of landscapes and figures. It seems to have been a source of his later troubles that he preferred out-door sketching to the painting of commissioned portraits. In 1807 he went to Calcutta to paint a portrait of Sir Henry Russell, Chief Justice of Bengal. Hickey,[2] who collected over a hundred subscribers for an engraving of this portrait, speaks of Chinnery as 'extremely odd and eccentric, so much so as at times to make me think him deranged'.

Chinnery's bye-work of this period, 1802 to 1808, in water-colour, ink and sepia, was amply displayed in 1936,[3] when some four hundred drawings from a newly discovered album were put on view. Among them was a water-colour study and two pen sketches for the Russell portrait. Other drawings showed scenery and native life in India, notably of natives carrying burdens, sitting at rest, working on the sea shore or hauling in boats. Two notable examples of his water-colour work were *Indian Water-Carriers* and *Indian Boatmen on the Sea Shore*,[4] both drawn swiftly with a fluent pen and coloured with skilful washes. Many of the other drawings were in pen-and-ink, the ink containing a touch of acid, making it bite and spread a little where lines were thickened on the paper, and so giving dark velvety touches, as of dry-point. In this and in general character his drawings are somewhat reminiscent of those by Romney and Wilkie. Though he was constantly drawing with pen and water-colour for his own satisfaction, he was making a handsome income by his

[1] V.A.M. D.259–1903.
[2] *Memoirs of William Hickey*, 1923–5, IV, pp. 384, 385.
[3] The Squire Gallery, 12, Baker Street, London.
[4] Present whereabouts of these is unknown.

47

oil-paintings and miniatures. In 1814 he made a miniature portrait of Richmond Thackeray with his wife and his son William Makepeace, then aged three.

In 1818 Chinnery was joined in India by his wife, who was not apparently his only embarrassment. Like Sir Thomas Lawrence, he was prone to accept commissions for portraits and to keep them half-finished in his studio. Chinnery had more than fifty left incomplete. Though he earned as much as 5,000 rupees a month and 'drank neither wine, beer nor spirits', his extravagance landed him in difficulties. In 1825 he got rid of his wife and £40,000 of debts by making off to China, where he lived first at Canton and then at Macao till his death in 1852.

In the British Museum are several of Chinnery's Indian studies in pencil; and both there and at the Victoria and Albert Museum will be found large numbers of his drawings made in China. His Chinese subjects, though executed after 1827, belong technically to an earlier period, for since 1802 he had been remote from the manifestations of newer methods employed by his contemporaries in Great Britain. Mr. Harold Acton,[1] who hunted in 1932 in Macao and at Hongkong for traces of Chinnery and his work, says that Chinnery had given more accurate records of this part of China than any photographer. He was a particularly good draughtsman of shipping subjects. Both his ships and his figures are put down on paper with great descriptive skill, sometimes brilliantly. His drawings, where colour enhances the bold pen-work, are vivacious and atmospheric. But for the scarcity of his work outside of public collections, his reputation might be much higher than it is.

We come now to a group of painters whose work shows no great similarity except that they were travellers and made numerous paintings and drawings in the Near East. Greece had been visited by Pars in 1766 and by Reveley in 1785, but few other British water-colour painters before J. F. Lewis and Müller had travelled east or south of Italy. John Frederick Lewis (1805–1876) spent a great part of his career in the Near East and won renown by his oriental scenes, of which *A Halt in the Desert*[2] and *Interior of School, Cairo*[3] are outstanding examples. He was the son of Frederick Christian Lewis (1779–1856), an admirable engraver who did the aquatint work for some of Girtin's *Views of Paris* and for Turner's first experimental plate in the *Liber Studiorum*. F. C. Lewis was also a painter of some merit and exhibited water-colours at the Old Water-Colour Society from 1814 to 1820. He engraved his own drawings in *Picturesque Scenery of the River Dart*, 1821; *Scenery of the Tamar and Tavy*, 1823; and *Scenery of the Exe*, 1827. His brother, George Robert Lewis (1782–1871), who had similar talent, exhibited several water-colour landscapes, and drew and engraved the illustrations of Dibdin's *Bibliographical and Picturesque Tour*. With a father and uncle both so prominent in their profession, John Frederick, a draughtsman from early childhood, was destined for an artist's career, even if at first it was intended that he should follow his father as an engraver. He was born at the house in Queen Anne Street East (now largely rebuilt and known as Foley Street) which had been the birthplace of Sir Edwin Landseer

[1] H. Acton, *Memoirs of an Aesthete*, 1948, p. 298.
[2] V.A.M. 532. [3] V.A.M. 68–1890.

two years earlier. John Landseer, Sir Edwin's father, was an engraver and a close friend of the Lewis family, so the two boys grew up in companionship and shared a common taste for drawing animals. Lewis's nephew told Randall Davies[1] that his uncle and Landseer 'were great chums as students, and used to buy carcasses of foxes and game, etc., and take them home for dissection and study, keeping them under their beds in daytime, which was never discovered'.

Young Lewis at an early age was put into training as an engraver, but was far more interested in his work from nature. His father finally made a compact that if the boy should succeed in selling a picture at a London exhibition, a painter he should be. So John Frederick was thrown into deep water, and swam. In 1820, when he was not quite fifteen, his picture of *Morning: Ploughing* at the Institution was bought by George Garrard, R.A., and he was free to follow his bent as a draughtsman of animals. There were no Zoological Gardens at that time, but he found his models in a varied and extensive menagerie which existed at Exeter 'Change in the Strand, near to the spot where Exeter Hall was later built. The drawings of animals which he made before he was twenty are masterly in their 'watchfulness of Nature', their fine use of line, their searching analysis, their grasp of muscular power and sinewy grace. Though Landseer was a great draughtsman of animals (greater as draughtsman than as painter), he was excelled by J. F. Lewis. *A Wounded Stag*[2] in body-colour on buff paper, *Sleeping Lion and Lioness*,[3] 1823, in monochrome, show Lewis's high skill in his presentation of animal life and in the rendering of form and texture.

Some of Lewis's animal studies were bought by James Northcote, R.A., and were shown by him to Sir Thomas Lawrence, who immediately employed the youthful artist to sketch in animals and backgrounds for his portraits. Lewis had to walk to Sir Thomas's house in Russell Square for breakfast at half-past seven, and 'often when he returned home in the day he was so weary and sleepy that he went to bed again'. His acceptance by leading painters led the way to commissions from owners of favourite dogs and horses, and his earliest exhibits at the Royal Academy in 1822 and 1823 were animal subjects. During 1824 and 1825 he published six mezzotints, from his own water-colour drawings of lions and tigers, under the title of *Studies of Wild Animals*. It was probably owing to these that he won the patronage of King George IV and was employed for some time to paint deer and sporting subjects at Windsor,[4] while dealing with this type of subject, in oil; he also showed water-colours at the Old Water-Colour Society in 1827 and was forthwith elected an associate. Redgrave[5] says that 'an accident turned Lewis from working in oil to the practice of water-colour painting. Being asked to do some illustrations to Shakespeare, he became fascinated with the ease and with the simplicity of the tools required for working in water-colours.' This must not be taken too literally, for many of his earlier animal

[1] R. Davies, *John Frederick Lewis, R.A.*, O.W.S. Club, III, 1925/6, p. 40.
[2] Cambridge, Fitzwilliam Museum, P.D.98–1950.
[3] Courtauld Institute—Witt Collection.
[4] E.g. *Buck Shooting at Windsor Great Park*, Tate Gallery 4822.
[5] S. and R. Redgrave, *A Century of British Painters*, 1957, pp. 412, 413.

studies and landscape sketches were tinted with water-colour. After his election, being a little wearied by his restricted range of subject and by the restraints of Court patronage, he made his first journey abroad, visiting Germany, the Tyrol and Northern Italy, and collecting material which he utilised for several years. In 1829 he became a full member of the Society, and for a long time devoted himself exclusively to painting in water-colour. In 1830 he was making peasant studies in the Scottish Highlands, among them his *Highland Hospitality*, a prominent exhibit at the Pall Mall Gallery in 1832 and once in the possession of G. A. Fuller.

All this formed a first chapter in Lewis's work, and something may be said here about the rare and little known landscape drawings of his pre-1830 period. In my own possession [1] are several of these, among them three quite early landscape studies in pure water-colour, outdoor sketches of a traditional character, done probably before he was twenty. Of much more importance are four small drawings (bought, with the other three, at the sale of the Spencer Churchill collection at Sotheby's in 1919), one of the *Via Mala*, and three in the Rhineland, *St. Goarshausen*, *On the Murg* and *Valley of Lutscheren*, all of them the fruit of the 1827 tour. They show that Lewis was beginning to mix a little Chinese White with his colours without losing clarity, and to use more solid body-colour for heightening his effects. This enabled him to combine free, sketchy, statement with an almost Pre-Raphaelite study of detail. An outstanding point of interest is that the structural drawing of rocks and trees is almost entirely done with colour on the point of a fine brush. Like Bonington and Harding, the latter possibly an immediate influence, he was using the brush-point charged with colour as though he were wielding a lead pencil. There are some other drawings of this group in the Birmingham Art Gallery which includes a *View of Ausbach*.[2] All of them are personal, like James Ward's *Chiseldon* of 1822, very decorative in design and individual in handling. The man who was producing such mature work as holiday sketches at the age of twenty-two was bound to go far. Exactly the same characteristic method, the same treatment of background landscape, the same final scumbling of dryish body-colour, are seen in a larger drawing of *Sir Edwin Landseer, angling*, which was sold in the A. N. Gilbey Collection at Christie's in 1940. There is a quotation from Izaak Walton on the panel back, and this is almost certainly the picture exhibited, without title but with an Izaak Walton quotation, at the Old Water-Colour Society in 1830. It shows Lewis combining his animal work (Landseer's dog is behind him) with the landscape studies made abroad (I think it quite likely that the river scenery is based on a study made in the Rhineland or the Tyrol in 1827), and the drawing also shows a developed interest in figure study. The pose and grouping of angler and gillie are perfectly conceived; and on an imaginary base line joining the dog's outer paw and the bottom of the landing net the two figures are enclosed in an exact equilateral triangle. I cannot imagine that this is anything but conscious design—and studio work—especially when the landscape is so co-ordinated

[1] Now Coll. Mr. and Mrs. Paul Mellon.
[2] Birmingham, City Art Gallery 269'53.

with the central theme. Lewis in his later work was always a fine composer, and similar pyramidal effects are seen in his *Halt in the Desert*[1] (frontispiece) and other works.

In 1832 a new chapter in Lewis's life opened, for in the summer of that year he set out for Spain, anticipating David Roberts by a few months. He made Madrid his temporary residence, in order to study and make water-colour copies of paintings in the Prado. Sixty-four of these copies are in the National Gallery of Scotland. From Madrid he moved to Toledo, thence to Granada, where he made many sketches of the Alhambra; from Granada to Cordova; then to Seville where he passed the winter with Richard Ford, remaining with him until April 1833. In the spring of that year he crossed from Gibraltar to Tangier, and returned to England, again after halts at Granada and Madrid, in 1834. At some time during this year he was in Paris, in the Rue de Richelieu, working indefatigably on his Spanish paintings and using William Callow as a model.[2]

At Madrid he was the guest of Richard Ford (1797–1858), author of the *Handbook for Travellers in Spain* and himself a capable water-colour painter, who did much for Lewis while they were both in Spain. Mr. Brinsley Ford,[3] Ford's grandson, draws upon a collection of old letters to give much detail about the Spanish visit. In May 1832, Richard Ford wrote a request for a passport visa stating that: 'A Mr. Lewis, a clever artist, whose father I knew well, has been recommended to me by Henry Wellesley. He is about to make a sort of picturesque tour of Spain, having orders for young ladies' albums and from divers booksellers, who are illustrating Lord Byron.' Spain, a land rich in colour and romantic association, caused a change in Lewis's outlook, as it did in the case of John Phillip, R.A. (1817–1867) (Phillip of Spain), some twenty years later. Wilkie, one of the first British artists to explore the treasures of Spain, described it as 'the wild unpoached game preserve of Europe' and perhaps inspired both Roberts and his friend Lewis (Lewis was with Wilkie at Constantinople just before Wilkie's death) and his follower, Phillip. In many of the Spanish water-colours the underlying method of the 1827 drawings is apparent, but the whole handling is looser and swifter, the colour more fluent. As was the case with Cotman at the same time, Lewis's colour was sometimes too lurid and garish, resulting from what Mr. Brinsley Ford describes as 'the exuberance of a young man intoxicated by the beauty of the Spanish scene'. For many years the sketches which Lewis made on this tour provided material for water-colours of Spanish buildings and glowing costume against a background of picturesque scenery. Up to 1841 he was still exhibiting pictures of Spain. What perfect illustrations he could have supplied for Borrow's *Gypsies in Spain* and *Bible in Spain*, but between 1836 and 1837, a few years before Borrow visited Spain, he issued *Lewis's Sketches and Drawings of the Alhambra* and *Lewis's Sketches of Spain and Spanish Characters*, each volume containing twenty-six colour lithographs. Seven of the lithographs in the first of these volumes were drawn on the stone by J. D. Harding after Lewis's original sketches.

[1] V.A.M. 532.
[2] *William Callow: An Autobiography*, 1908, p. 27.
[3] B. Ford, 'Richard Ford and Spanish Painting', *Burlington Magazine*, 1958, C, p. 263.

In 1837 he again quitted England; passed the ensuing winter in Paris, still painting Spanish subjects; and in the spring of 1838 visited Florence and Naples, and took up residence for two years in Rome. His *Easter Day at Rome*[1] was exhibited at the Old Water-Colour Society in 1841, and was an outstanding example of his advancing skill in grouping large masses of figures and of his brilliant colouring. Fourteen years later Lewis had five pictures at the Paris Salon, and Edmond About, the novelist and journalist, decried them and indeed all British water-colour painting—'Je pense qu'il est difficile de pousser plus loin le fétichisme de l'aquarelle'; and he described Lewis's execution as mediocre, his drawing as feeble, and his colour as 'criard' (discordant). Other Frenchmen were of different opinion, for a few months later, in January 1856, the Minister of Public Instruction in France applied to the Society of Painters in Water-Colours for full information as to its procedure and rules and 'tout ce qui peut le mieux faire apprécier son utilité incontestée'.[2] It was not, however, till 1879 that a Société des Aquarellistes was formed in France.

In 1840 Lewis set out to the East, passed through Albania, nearly died of fever in the Gulf of Corinth, and made his way to Athens and to Constantinople, where he drew the principal mosques and the life of the city. In November he sailed for Egypt and for ten years had his headquarters at Cairo. He made endless studies of native types, and in 1843 went on excursions to Mt. Sinai and up the Nile into Nubia. During these ten years he worked on Eastern subjects with the most painstaking and sometimes microscopic detail of form and texture and with glittering opulence of colour; his material claimed that the colour should be 'criard'. From 1841 to 1850 he had no exhibits at his Society's gallery, and under its rules his resignation was demanded, but his promised compliance averted the threat. When, in 1850, he sent *The Hhareem*,[3] with its finely grouped figures and sunlight flickering through latticed shutters, quivering in the air, and clinging in bright patches to walls and resplendent dresses, it startled the art world of London by its amazing manipulation, and its author appeared almost as an unknown man, a new star on the horizon. Ruskin found *The Hhareem* 'faultlessly marvellous'.

In 1844 Thackeray visited Egypt and in his account of *A Journey from Cornhill to Grand Cairo* gives a vivid description of Lewis and his surroundings:

I was engaged to dine with our old friend J., who has established himself here in the most complete Oriental fashion. You remember J., and what a dandy he was, the faultlessness of his boots and cravats, the brilliancy of his waistcoats and kid gloves; we have seen his splendour in Regent Street, in the Tuileries, or on the Toledo. . . . Could this be the exquisite of the Europa and the Trois Frères? A man in a long yellow gown ,with a long beard, somewhat tinged with grey, with his head shaved, and wearing on it first a white wadded cotton night-cap, second a red tarboosh—made his appearance and welcomed me cordially. . . . When he goes abroad he rides a grey horse with red housings, and has two servants to walk beside him. He wears a very handsome grave costume of dark blue, consisting of an embroidered jacket and gaiters, and a pair of trowsers which would make a set of dresses for an English family. His beard curls nobly over his chest, his Damascus scimitar on his thigh.

[1] Sunderland, Museum and Art Gallery. [2] Roget, II, p. 91. [3] V.A.M. P.1-1949.

52

... Here he lives like a languid Lotus-eater—a dreamy, hazy, lazy, tobaccofied life. He was away from evening parties, he said; he needn't wear white kid gloves, or starched neckcloths, or read a newspaper. And even this life at Cairo was too civilized for him; Englishmen passed through; old acquaintances would call: the great pleasure of pleasures was life in the desert—under the tents, with still *more* nothing to do than in Cairo; now smoking, now cantering on Arabs, and no crowd to jostle you; solemn contemplations of the stars at night, as the camels were picketed, and the pipes were lighted.

Thackeray was quite unfair in suggesting that it was 'an indulgence of laziness' which kept Lewis away from 'home, London, a razor, your sister to make tea, a pair of moderate Christian breeches in lieu of those enormous Turkish shulwars'. Lewis was far from being an idler. Apart from many pictures of the East sold by him during his lifetime, some four hundred drawings, many of them highly finished, made in Turkey, Egypt and Nubia, were sold by his executors after his death.

In 1851 Lewis returned to London bringing this vast treasure of material from which he produced his exhibits till the end of his life. He was elected President of the Old Water-Colour Society in 1855 on the death of Copley Fielding. In 1858 he left the Old Society to devote himself to oil-painting; became an associate of the Royal Academy in 1859, and a full member in 1865. He told the Secretary of the Water-Colour Society in 1858: 'I work from before 9 in the morning till dusk, from half-past 6 to 11 at night always, I think that speaks for itself, and yet I swear I am £250 a year poorer for the last seven years. . . . When I wrote my first letter to you I was so ill as to be frightened. I felt that work was destroying me. And for what? To get by water-colour art £500 a year, and this, too, when I know that as an oil painter I could with less labour get my thousand.'

This account by Holman Hunt gives Lewis's opinion on Pre-Raphaelite painting:

When in town Millais casually encountered John Lewis, the painter of Egyptian social scenes, near Portland Place. He was of particular interest to us because he had recently declared to Leslie in Millais' presence that on his return to England after seven years in Egypt he had found English art in the woefullest condition, its only hope being in the reform which we were conducting, and he had told Millais to speak to me of his appreciation of my work. Millais answered all Lewis's questions about our present occupations, and assured our new champion that when he brought his work to town he hoped that he would come and see the new background he was now painting in the country. Unexpectedly at this point Lewis exclaimed, 'I shall frankly tell you what I don't like in it.' Millais said he should expect him to do so, and then Lewis, who betrayed to his companions the querulous temper he was reputed to have at times, added, 'You should know that although I think your painting much better than that of most of the artists exhibiting, I am sure that oil painting could be made more delicate than either of you make it; not sufficient pains are taken to make the surface absolutely level. Why should it ever be more piled up than in water-colour? But stop, I must have a cigar; come in here.' Being furnished with his usual sedative, he walked on, resuming his diatribe, 'I intend to take to oil colours myself, and damme, I'll show you how it ought to be done. The illusion of all modern painting is destroyed by its inequality of surface. Hang if this cigar won't draw,' and he stopped to give it attention with his penknife. 'Holbein's and Janet's paintings are as smooth as plate glass. Why should not yours be equally even?' And then denouncing his cigar as atrocious, he went on, 'Parts of your painting are level enough, I admit, but in your deep tints there is a great deal of unseemly loading.' Stopping still, he then broke out into an unmodified oath, and

threw the roll of tobacco into the road, adding 'Everything goes wrong today. Goodbye, goodbye.'[1]

It was probably the hope of an increased income which led Lewis to abandon watercolour rather than Ruskin's note to him in 1856: '*Are* you sure of your material? If one of those bits of white hairstroke fade—where are you? *Why* don't you paint in oil only, now?'

The bits of white hairstroke seem to remain as fresh as ever, and even if they did darken owing to sulphur in the atmosphere, could nowadays be restored. It is certainly astounding to find how brilliant the white in Lewis's water-colours remains. His later works, especially, were painted in a solid impasto of Chinese White. By no other method could he —or Hunt, or Birket Foster—obtain such a high degree of manipulative finish, such amazing virtuosity. All of them were harking back to the method of painting 'in little' followed by Holbein and Hilliard. I suspect that Lewis followed Hunt in covering his paper with a sort of gesso of white before he used brush and colour, and that upon this he drew mainly with the brush as he had done in his early landscapes.[2] A study in the Victoria and Albert Museum (for his *Halt in the Desert*[3] or a similar painting) is on a wooden panel, and this suggests that to paper as well as to wood he applied a white ground. Certainly, in building up his painting, he worked always with Chinese White and into white. His Spanish drawings such as *The Alhambra, Granada,*[4] 1832, and *Street Scene, Seville,*[5] 1838, are in bodycolours on a toned paper, but they are not so highly finished, so solidly painted with white, as his last exhibits from 1850 to 1857; there were only nine in those eight years. His final achievement can be perfectly studied in his *Arab Scribe, Cairo,*[6] 1852, and *Halt in the Desert,*[7] 1854. When a similar subject, *A Frank Encampment in the Desert of Sinai,* was exhibited in 1856, Ruskin published a pamphlet on the Society's exhibition, and seven of his eleven pages were devoted to a lyrical rhapsody over this picture:

> I have no hesitation in ranking it among the most *wonderful* pictures in the world; nor do I believe that, since the death of Paul Veronese,[8] anything has been painted comparable to it in its own way. . . . Labour thus concentrated in large purpose—detail thus united into effective mass —has not been seen until now. All minute work has been, more or less, broken work; and the most precious pictures were divisible by segments. But here gradations which are wrought out through a thousand threads or meshes are as broad and calm in unity as if struck with a single sweep of the hand. . . . If the reader will take a magnifying glass to it, and examine it by touch, he will find that literally, any four square inches of it contain as much as an ordinary water-colour drawing: nay, he will perhaps, become aware of refinements in the handling which escape the native eye altogether. Let him examine, for instance, with a good lens, the eyes of the camel, and he will find there is as much painting beneath their drooping fringes as would, with most painters, be thought enough for the whole head.

That passage makes it clear why Ruskin, the champion of the Pre-Raphaelites, considered that Lewis was the painter of the greatest power, next to Turner, in the English

[1] Holman Hunt, *Pre-Raphaelitism*, 1905, I, p. 270. The editors are grateful to Brigadier J. M. H. Lewis for bringing this extract, and other up-to-date details about J. F. Lewis, to their attention.
[2] For a description of Hunt's method, see Chap. VI. [3] V.A.M. P.41–1925.
[4] B.M. 1885. 5.9.1644. [5] B.M. 1885. 5.9.1645.
[6] Present whereabouts unknown. [7] V.A.M. 532.
[8] Ruskin cannot have known that in 1840 W. Collins, R.A., wrote to Sir David Wilkie from Pera: 'called on Lewis; saw his sketches; advised him to begin a Paul Veronese subject.'

school. It contains statements which nowadays we cannot accept without reservations and qualifications. Though not one of the Pre-Raphaelites, Lewis worked faithfully on Pre-Raphaelite lines, building up his subjects with endless exact notation of expressive details. Ruskin[1] claimed Lewis as a Pre-Raphaelite, but qualified that statement later by saying: 'I never meant that he had been influenced in his practice by any of the other members of that school; but that he was associated with it. . . . He worked with the sternest precision twenty years ago, when Pre-Raphaelitism had never been heard of.' Lewis was a consummate craftsman, alike in his use of a high key of jewelled colour and in his observation of effects of light, whether the glaring light of the desert or the reflected light of an interior. In the use of body-colour he is supreme; and body-colour, so often used with unconvincing mannerism, is only justified when it results in the enamelled perfection which Lewis attained. Perhaps he fails because, like so many painters of our school, he is the ideal illustrator, giving the outward appearance rather than the soul of the East. Perhaps Ruskin was nearer the truth when he wrote, on an earlier occasion, about Lewis's drawings in Spain, that he painted 'habits of people more than their hearts' and that from Italy he 'sent nothing but complexions and costumes', or that 'the result does not, at first, so much convey an impression of inherent power as of prolonged exertion. Water-colour drawing can be carried no further; nothing has been left unfinished or untold.' And Laurence Binyon, while recognising that Lewis was capable of exquisite things, adds that 'he disappoints because he fails too often to transmute fact into idea'.

Another painter, peculiarly associated with the East, is William James Müller (1812–1845). Into his crowded life he packed a vast amount of brilliant work, but like Bonington he died at an early age, in his case at thirty-three. He was born at Hill's Bridge Parade, Bristol. His father, John Samuel Müller, was a Prussian by birth, and came to Bristol as a refugee from his native town of Danzig during the Napoleonic Wars. He was a student of geology, botany and conchology; was appointed Curator of the Bristol Museum and married a Bristol woman. William, who was their second son, never went to school, but was educated entirely by his mother. The boy took naturally to the pencil and at a very early age was encouraged by his father to make careful drawings of shells, and diagrams of skeletons, fossils, etc., for use by various lecturers at the Bristol Institute. When he was twelve, he made a creditable copy in oil of a picture by Terburg, and began sketching from nature. More than twenty years later, he was to write: 'I am looking forward to sketching green fields, trees, etc., the works of a living God—these things make my heart glad. It is in nature, and not in streets, that I find my *own self*.'

The system of apprenticeship was then in vogue and, when barely fifteen, Müller was apprenticed to James Baker Pyne (1800–1870), a local artist, who did not move to London until 1835. It was felt that Müller was gaining little from his master, and after about two years the indentures were cancelled. Pyne, however, must have given him sound instruction in the rudiments of both oil and water-colour, and at least set his pupil a good example

[1] *Academy Notes*, 1858.

by his own supple skill with the brush. Long afterwards in 1843, Müller wrote: 'In early life, placed under the tuition of my friend, J. B. Pyne—nay, serving a regular apprenticeship to the arts with him, to whom I owe so much—I commenced painting in earnest.' Let it be said here of the man who taught Müller that he was born at Bristol, and was articled to an attorney but abandoned the law for painting, being self-taught as an artist. In 1835 he moved to London, where he joined the Society of British Artists in 1841, and subsequently became its Vice-President. He travelled in Italy and elsewhere on the Continent, painting landscapes both in oil and water-colour, chiefly river and lake subjects. He died in 1870, outliving his pupil by twenty-five years. One of Pyne's water-colours, *A view of Old Exeter*, lives in a poem by Siegfried Sassoon. The poet bought at a cheap price as he relates, this picture by Pyne, 'a small honest painter, well content to limn our English Landscapes':

> *For J. B. Pyne Old Exeter was good;*
> *Cows in his foreground grazed and strolled and stood;*
> *For J. B. Pyne Victorian clumps of trees*
> *Were golden in a bland October breeze;*
> *Large clouds, like safe investments, loitered by;*
> *And distant Dartmoor loomed in sombre blue.*

There are many other prim paintings of the nineteenth century of which also it might be said that: 'Time has changed this "View" into a Vision.'

Before he was twenty Müller had received £30 from the Dean of Bristol for a large oil-painting of the Church of St. Mary Redcliffe, which had been one of Girtin's subjects some thirty years earlier. He soon had a profitable connection among Bristol dealers, who purchased small paintings made in the district at prices from one to five pounds each. In 1830 he came into touch with James Bulwer, the collector of Cotman's work, who was then residing at Clifton. Müller was given the run of his collection and was allowed to borrow several Cotman drawings for copying. Here may be the origin of the broad simple washes which are a feature of his own subsequent work. His appreciation of Cotman led him in 1831 to spend two months in Norfolk and Suffolk and to study their low-lying landscape and river scenery. 'All the sketches made at this time', says Solly,[1] 'were on tinted papers of various low-toned colours—green and grey and greyish blue predominating, and for the highlights body-colour was introduced; the handling is rather careful and less free than in later years.' At this period, too, he was sketching the picturesque old streets, the ancient buildings and the docks and wharves of Bristol, in company with Skinner Prout, Samuel Prout's nephew, who was preparing the volume published in 1834 with the title, *Prout's Antiquities of Bristol*. Then, as in after-life, his work was done rapidly. He appears to have stuck to the excellent rule of never touching a sketch after he left the spot; to alter or tamper with it in the studio, he said, was 'ruin'. Though his constant study from nature of

[1] N. N. Solly, *A Memoir of the Life of W. J. Müller*, 1875.

56

a great variety of subjects, coupled with a natural genius for colour, was enabling him to form a style of his own, he was always ready to absorb new ideas and was strongly influenced, in his oil-painting, by Gaspar Poussin, Ruysdael, Claude and Ostade. He even painted a small upright oil in the manner of Poussin which, it is said, might well have been accepted as a genuine work of that master, and—he was always given to practical jokes—he signed it *G. Poussin, junior*.

About the year 1832 Müller took a share in the formation of a Sketching Club similar to that of which Girtin and Cotman had been members. Among the artists concerned were Skinner Prout, Samuel Jackson, T. L. Rowbotham, William West, H. B. Willis and William Evans, known in London as 'Welsh' Evans, to distinguish him from William Evans of Eton. There was a weekly meeting at each member's house in turn. The programme began with tea and talk at six, and at seven all set to work, drawing-boards with paper ready strained being provided at each house. Sepia, or various shades of grey, were generally used, though oil-colours were occasionally introduced. At nine a simple supper of cold meat, cheese and beer was served. A subject, usually consisting of a single word, was set; and Müller frequently made two drawings in the three hours of working time. As has been the case with so many other sketching clubs of similar nature, the hosts began to vie with each other in more and more luxurious fare, and the membership declined.[1]

By 1833 Müller was beginning to find purchasers for his work outside the limits of Bristol. Among his patrons was a Birmingham collector, who brought the young artist to the notice of David Cox. Later on, Cox was to seek Müller's advice as to oil-painting, and himself became a collector of Müller's oils. But in spite of many small commissions Müller found time in May for an excursion to South Wales, and then in June took part in a walking tour with his friends, Skinner Prout and Samuel Jackson, through Cardiganshire, Merioneth and Carnarvonshire. His twenty-first birthday was spent in sketching the little lake of Llyn-y-Cae at the base of Cader Idris. Dolgelly, Harlech, Beddgellert, Nantmill, Carnarvon, Llanberis, Bettwys-y-Coed and Conway were among the halting-places where they sketched. Landscapes of every kind and Welsh interiors with figures were Müller's subjects on this trip, mostly in pencil, but several in water-colour.

In 1834, in company with George Fripp, one year his junior, Müller made his first foreign tour. Sailing from London Bridge to Antwerp, they travelled along the Rhine, passing through Cologne, Koblenz, where they spent a week, then to Heidelberg, the Black Forest, Strassburg and Schaffhausen, all of them possibly familiar to Müller, as to us, from Turner's drawings and engravings. Halting for two days at Zurich, they went on to the Splugen Pass—and like Turner, Müller made drawings from the Via Mala—skirted Lake Como and made their way to Baveno on Lago Maggiore. Fascinated by the scenery here, Müller spent ten days in making drawings of Isola Bella and other parts of the Lake. They reached Milan in September, visited Verona, and finally arrived at Venice. For two

[1] For similar sketching clubs, see W. D. Mackay, *Scottish School of Painting*, 1906, p. 333; and M. Hardie, 'A Sketching Club, 1855–1880', *The Artist*, January 1902.

months they worked every day from a gondola, on the Rialto and up and down all the mysterious alley-ways of the small canals. The luscious beauty of Venice, its time-worn coloured buildings reflected in narrow waters, its bridges, its boats with picturesque awnings, its gaily clad figures, enthralled Müller and filled his sketchbook with a stock of material which lasted him for several years. Perhaps it was a sight of Müller's drawings on his return in 1835 which sent James Holland off to Italy in that year and made him almost a victim to Venice, which for many painters has been a potent drug. Müller and Fripp left Venice in November 1834, travelled to Florence and Rome, made many sketches at Tivoli, and were back at Bristol in February 1835, after an eight months' tour. He must have brought home a prodigious quantity of work, for he never spared himself. Fripp stated that his companion generally completed a half-imperial sketch in two hours and that he never knew him take more than three hours for any water-colour during the whole of their journey; two or three sketches being frequently made in one day.

After his return Müller settled down at Bristol, resuming his sketching excursions with Prout and Jackson. For water-colours he varied between the use of Harding's paper and a tinted paper. John Harrison, a Bristol surgeon, was a frequent sketching companion from 1837, and left a record that: 'A folio (half imperial) with tin rim, Harding's paper, colour box of dry-colour cakes, common camel-hair brushes, lead pencil, and a small bottle of chalk, prepared by himself (presumably body-colour of a Chinese White nature) were the materials he carried.' Oil-paintings were being rapidly produced from his continental sketches, and though his paintings were now in high demand he projected another, more extensive, foreign tour. The thought of Greece and Egypt, rich in material for landscape and figure subjects, stimulated his imagination. In 1838 he set out for the East, arrived at Athens on September 30, and for six weeks spent most of his time on the Acropolis. Though he gathered much material at Athens and elsewhere (fifty Grecian sketches were included in the sale after his death), his subsequent visit to Egypt inspired him still more, and on his return he seems to have neglected the Grecian subjects. He was only twenty-six when he landed at Alexandria from a French steamboat in November 1838. Cairo, its mosques and bazaars, the Moorish archways with the throng of natives and camels passing beneath, the coffee houses, and particularly the slave-market, made a strong appeal. He travelled up the Nile, made drawings of temples at Karnak and Denderah, saw the Pyramids, and visited Luxor by moonlight. After spending another week or two at Cairo he returned by Alexandria, Malta and Naples, and arrived in London in March 1839.

On his return to Bristol he began a long series of oil-paintings, mostly small in size, from his Egyptian subjects. The prices were low, averaging about £10 apiece, but his success induced him to move to London, largely with a view to conquering the Royal Academy; he was bitterly disappointed when he gained no more than a footing. In the autumn of 1839 he settled in Rupert Street, but in 1840 moved to more commodious quarters at 22, Charlotte Street, Bloomsbury. There he worked unceasingly from nine to five each day, went out to dine, and then joined a coterie of artists who worked from the model in a studio at

29, Clipstone Street, Fitzroy Square. Roget[1] tells us that the Artist's Society, according to the heading of its printed notice form of 'List for providing Models', was established in 1830 'for the Study of Historie, Poetrie and Rustic Figures'. Thackeray must have known it, for 'Clive Newcome' used to take refuge of an evening in the Clipstone Street Studio, to escape from 'the Campaigner'. Beggars, ballad-singers, gipsies, street-musicians, the rag tag and bobtail of the street, were brought in, and enjoyed being well paid for 'sitting still and doing nothing' for a couple of hours on three evenings of the week. That the Clipstone Street society was still flourishing in 1851 is shown by various entries in the diary of G. P. Boyce.[2] He records, on October 2, 1851: 'Received notice of my election to the Clipstone Street Artists Society from Mr. Lee, Secretary. Entrance £1 1s., one quarter's subscription, £1 9s. 6d.' Boyce was a constant visitor there, meeting such painters as J. F. Lewis, Edward Duncan, Frederick Goodall and Carl Haag, and on November 6 he notes that, 'at supper tasted some sardines for the first time. Very delicious.' With the termination of the Clipstone Street lease, the members moved to rooms built for them in Langham Chambers. This must be the beginning of the long and prosperous existence which the Langham Sketch Club is still enjoying.

In 1840 Messrs. Hodgson and Graves, of Pall Mall, entered into an agreement with Müller by which he was to tour the northern and central departments of France and make a series of forty drawings of the principal monuments of the Renaissance period of Francis I and other French kings. A selection of twenty-six drawings was reproduced by lithography in a volume published in 1841 with the title *The Age of Francis I of France*. I am inclined to think that the venture was Müller's own idea, for at the age of about twenty he had revelled in the autobiography of Benvenuto Cellini, and was constantly drawing oak-panelled parlours, ornamental ceilings, high mantelpieces and latticed windows, and in depicting cavaliers or pages at play with greyhounds or mastiffs. Possibly also he had been impressed by Bonington's treatment of similar themes; he is certainly in the main line of descent from Bonington as a colourist and in parade of dexterity. The drawings show the great accuracy with which Müller rendered architectural details and the vivacity with which he introduced figures. One of them, *The Gallery of Francis I at Fontainebleau*,[3] shows a number of figures grouped in the long gallery adorned with sculpture; among them is a man, presumably Benvenuto Cellini, who kneels before Francis and offers him a book (changed, in the lithograph, to a vase on a salver).

Between 1841 and 1843, and again in the spring of 1845, he constantly joined J. C. Gooden (*fl.* 1835–1875) in sketching expeditions down the Thames in a half-decked boat which Gooden hired. In his companion's words: 'Müller always did a good deal of hard work—not less than two sketches a day, very often on tinted paper, so as to obtain breadth of effect more rapidly.' At the end of 1841 he paid a visit with his brother to North Wales, staying at Tal-y-Bent, and at a hamlet called Roe-ty-Gwyn near Conway with Charles

[1] Roget, II, p. 320 n.
[2] A. E. Street, *George Price Boyce*, O.W.S. Club, XIX, 1941. [3] V.A.M. P.72–1930.

Bentley and other friends in the autumn of 1842. But he was again drawn to the East, and in September 1843 he left England to join the Lycian Expedition, conducted by Sir Charles Fellows, to remove the remains of the previously discovered antique sculpture known as the Xanthian Marbles. He had not been able to resist when Fellows expatiated on the romantic scenery and the beauty of the rock tombs of Lycia. Taking with him his pupil, Harry Johnson[1] (afterwards a member of the Royal Institute and a fellow-worker with Cox in Wales), he found splendid material in the ancient and almost deserted cities of Xanthus, Pinara, Tlos and Telmessus, and in the wild scenery which surrounded them. He wrote home: 'Lycia is a landscape and figure country; my best subjects, Turks; my home, a tent'; and to Gooden: 'Oh, Clipstone Street! Oh, ye little water-colour imps of great Water-colour drawings! Oh, ye admirers of rags as costume! How your eyes would have opened to see the wonders of that scene' (a wrestling-match by torchlight between Yurooks and Turkomans). Solly records that as the time drew near for their departure from Lycia, all of their cobalt and several other colours were used up, so that Müller was reduced, when making his last sketches there, and later in Rhodes, to a very simple scale of colour, mainly ochre, light red and indigo. The Lycian sketches were made entirely without body-colour, since Müller found that the white which he had taken out in bottles or tubes invariably turned brown or black. To this may be appended Müller's own description of his method, given in a letter of 1841 to W. Roberts:[2]

> As regards water-colours, as I in general require my sketches to paint from in oil, and find it *impossible* to sketch in the latter in many situations, so have I attempted to introduce a few of the qualities of oil into water. First, then, the grand distinction between the two methods may be considered as follows: transparent and opaque. In water all transparent; in consequence, I use *body-colour*. In the second instance, a dark-toned paper, as I get depth sooner: general tint often assists for local colour. I enclose a bit of my toned paper that I think best calculated: white paper I do not like, unless I wish to finish on it.

But Müller was not consistent about the use of body-colour. Perhaps his Lycian sketches, where he perforce had to abandon its use, showed him the value of purity and transparency. At any rate, in the last year of his life, he urged his friend, Harrison, to 'keep to dry colours, shun the bottle white, and leave your lights to the paper'. Müller never overdid his use of white. His white was kept in bottles, and this implies that he used it as a medium (like the creamy whitened water which Turner sometimes employed) rather than as a solid opaque substance.

Müller returned from Lycia, reaching his Charlotte Street studio in May 1844, and in July went sketching in North Devon, and then to Bristol. At the close of the summer he was back in Charlotte Street to paint large pictures for the Royal Academy from his Lycian subjects. In May 1845, he returned to Bristol, and Dr. J. Harrison, his medical adviser, and often his fellow-sketcher, found his heart weak and enlarged, and decided that his

[1] See Vol. II, p. 209.
[2] This and other quotations are from Solly, *Life*.

60

overwrought nervous system had given way from too great absorption in his work following on the hardships of his Lycian life. An added factor was the treatment of his contributions to the Academy; it caused him the deepest dejection that all of them were, in his own words, 'conspicuously obscure!!'. Harrison[1] himself described his ending:

> The rest is soon told. He continued gradually to fail: two attacks of haemorrhage induced alarming prostration. Still he painted.
> A few days before he died I was with him. He had received some flowers from a friend that morning—red and white carnations, fuchsias, yellow St. John's wort, and purple and blue flowers made up the bouquet. He separated them with his long fingers and said to me, 'Let us arrange a chord of colour?' He placed them in his sketching water-bottle, and we moved each flower so as to arrange an harmonious whole. 'We must have some carmine,' he exclaimed. It was sent for from a neighbouring shop. All this time, though really tremblingly weak, he was as usual full of spirits. He said, 'When the carmine comes, we will have a stunning effect.' The colour came, and we arranged the little picture exactly as he wished; he made a rapid outline, and began to paint, much as he did out of doors, with a common camel-hair pencil, putting in at once each separate leaf and flower, and when dry enough sharpening out in the old way. I stayed till it was done, perhaps an hour.

That was his last water-colour. The next day or two he painted a flower picture in oil, and then, while his palette was being set for him, fell back and died.

On April 1–3, 1846, Christie's held a sale of Müller's remaining works, including about two hundred Lycian drawings, about two hundred made in Greece and Egypt, and some unfinished oils. The 453 lots realised £4420, at that date a high price for sketches and unfinished works.

The City Art Gallery of Bristol, Müller's native town, contains a large collection of his oil-paintings and water-colours. The Birmingham Art Gallery also has a rich supply, and his work is well represented in the British Museum, where there is a long series of his sketches made in Lycia and in Egypt, as well as English scenes, mainly from the Henderson collection. His *Apothecaries' Garden, Chelsea*[2] (depicting the same trees which Samuel Palmer drew so carefully) is a typical product of his fluent brush and flashing colour. There are some fine examples in the Tate Gallery, notably a little sketch of a white building and a tree reflected in water, a drawing so brilliant in its precision and selection that one feels its maker must have known and admired Girtin's *White House at Chelsea*. Also at the Tate is *Lycia; The Valley of the Glaucus*,[3] and I cannot do better than quote what D. S. MacColl once wrote about it: 'In that piece, the rare miracle of water-colour has taken place; the quality; the dampness of paper exactly favourable; tone and colour, drawing and handling exquisitely right.' At the Victoria and Albert Museum are several fine examples of Müller's art, and I have a special affection for his *An Eastern Burial Ground*,[4] with its mellow colour and noble design—a fine drawing which may stand beside De Wint for its resonance of colour and glowing harmony. Though we may prefer Müller's smaller and more intense works of the type of the *Eastern Burial Ground*, he maintained his masterly

[1] Solly, *op. cit.*, p. 254.
[2] B.M. 1878. 12.28.135.
[3] Tate Gallery 2377.
[4] V.A.M. 91–1894.

freedom of technique on a larger scale; *Cottage in a Wood*,[1] and *The Fir Wood, Lycia*,[2] bigger in size, are brilliant examples of his swift and summary execution. The extent of his travels and the fine draughtsmanship, which underlay his more finished work, will be seen in an album in the Victoria and Albert Museum, containing 235 sketches of figure, landscape and architectural subjects in England, Wales, France, Germany, Switzerland, Italy, Greece and Egypt, executed between 1830 and 1840, and given by him to the lady to whom he was about to be married.

A good deal has already been said about Müller's technique; it need only be added that he worked swiftly in a groundwork of broad flat washes, like De Wint, and was very adept in the defining touches (what Harrison called his 'sharpening out'), which he added to give form and substance. And enough has been said to show that Müller's merit lay in his power of rapid sketching and of finding a design based on the impromptu groupings of nature. He was one of those who look all round them, and not just in front, when making an outdoor sketch. He did not sit down face-forward to make a faithful record; he adapted, accumulated, generalised, composed, from all that surrounded him. Always he impressed upon his pupils the value of a happy fragment. In the Bristol Art Gallery is his oil-painting *Eel Bucks at Goring* with his inscription on the back: 'Left as a sketch for some fool to finish and ruin. W. M. 1843.' The man who wrote, 'I *want* to *paint*, Gooden; it's oozing out of my fingers', was not the man to pause, revise and elaborate. Cosmo Monkhouse[3] writes of Müller as an impressionist: 'The impressions he painted were the impressions of the eye and the moment, and he painted them at once in a sketch and strove to preserve its freshness unimpaired, either by elaboration or added sentiment. . . . Müller may be said to have been in a measure an innovator, an introducer of a new spirit among painters, or at least among water-colourists'; Monkhouse forgets that Constable, Cox and Holland, to give three names only, were making brilliant impressionist sketches while Müller was still a schoolboy. The true estimate, I think, is that while Cox and others produced finished and laboured work as well as the sketch, Müller produced nothing but the sketch. In oil-painting and his water-colours alike he always worked swiftly, accurately, confidently, to an end. What was done, was done. He was not an innovator, but Monkhouse is perhaps right to the extent that his influence upon art was that he quickened its tempo, just as the railway, introduced during his life-time, quickened the tempo for the traveller. Müller does not often rise to the heights of creative intuition, but for sheer vitality and lucid expression he has rarely been surpassed. His work is not memorable for such poetry as that of Cozens or Girtin, but his prose is of high quality and invests visual images with a cloak of fine pattern and sumptuous colour—that 'chord of colour' which he found in a bunch of flowers just before his death.

It is of interest that Müller painted as a rule with his left hand, though occasionally he

[1] Once belonging to Mrs. C. P. Allen.
[2] Manchester University, Whitworth Art Gallery.
[3] C. Monkhouse, *Earlier Water-Colour Painters*, 1890, p. 139.

62

used either hand; he wrote always with his right hand. He had small hands, with long and slender fingers, like the hand of an Arab. (Joseph Pennell was similarly ambidextrous: I used to watch him working on his large lithographs of the Panama Canal with a piece of chalk in either hand.) Müller was short-sighted. One eye was brown, and one grey, and he used to say jokingly that with one eye he saw colour and with the other he saw form. He worked with his face close to his paper or canvas, occasionally using an eye-glass to view remote objects, but he invariably removed the glass from his eye when he used the brush. His eyesight may account for the broad way in which he generalised his subject and saw it in the mass.

We come now to Edward Lear (1812–1888), and it should be no surprise to anyone to find that he was a painter, or to discover that his work as a draughtsman has the swiftness, the impulse and, to some extent, the wit of his verse.

Lear's water-colours are not, as a lover of his nonsense might expect, set in a land of inconsequent folly and joyous absurdity, nor drawn with a sort of rational lunacy. His drawings were to Lear what mathematics were to Lewis Carroll, who once insisted that mathematics were the true wonderland where nothing is impossible and the incredible must always be credited. When Dodgson became Lewis Carroll and hunted the Snark, he forgot about mathematics, and when Lear drew landscapes he forgot nonsense. But the happy intermingling of the spirit of sense and nonsense was present in them both.

Lear is far greater as draughtsman and painter than has hitherto been admitted. This is partly because his work has remained largely in the homes of those who, in a past generation, were his personal friends. The dispersal of some of those collections during recent years has brought wider knowledge of his power.

Edward Lear, the youngest of twenty-one children, belonged to a Danish family, naturalised in England a generation or two before his birth at Highgate.[1] At the age of fifteen he was poring over books of natural history, making small pictures of birds, and colouring prints and screens. In his own words, 'I began to draw, for bread and cheese, about 1827, but only did uncommon queer shop-sketches, selling them for prices varying from ninepence to four shillings'. At nineteen he found employment at the Zoological Gardens as a draughtsman, and in the following year, 1832, published his *Family of the Psittacidae*, one of the earliest collections of coloured ornithological drawings on a large scale made in England. Illustrations to another book on *Indian Pheasants* were followed by his association with Lord Derby, who was contemplating the volume, privately printed in 1856 and entitled the *Knowsley Menagerie*. Lear did the bird portion of the illustrations for this book, and worked at Knowsley for four years. In his life of the artist Angus Davidson[2] suggested that at Knowsley Lear studied the early English tradition in water-colour and so developed the method which he retained throughout his life. While at Knowsley he made

[1] Vivien Noakes, *Edward Lear: the Life of a Wanderer*, 1968, says Lear was the twentieth of twenty-one children and his father a stock-broker who lived in Holloway. Her information, too, would seem to remove any legend of Lear's Danish ancestry.
[2] A. Davidson, *Edward Lear*, 1938.

many friends among 'half the fine people of the day' (the phrase is his) and in 1846 gave drawing lessons to Queen Victoria, and found, as others had done, that his usual habit of migration to the hearth-rug in the royal drawing-room was almost *lèse-majesté*. Apart from this lapse in etiquette, Lear always possessed the arts of the drawing-room, had many aristocratic friends, and complained in 1848, possibly with an intentional mixed metaphor, that 'a vortex of Society hath eaten my time'.

In 1835 and 1836, being in Ireland and the Lakes, he leaned more and more to landscape, and from 1837 to 1841 wintered in Rome, where he added to his income by giving drawing lessons. He worked throughout Italy,[1] and later travelled to Malta, Greece, Constantinople, the Ionian Isles (1848), Mt. Sinai and Greece (1849), and later went to Egypt, Switzerland, Jerusalem, Corfu, Syria, etc. He published the *Journals of a Landscape Painter in Greece and Albania* (1851) and *Southern Calabria* (1852) and the first edition of the *Book of Nonsense* in 1846. From 1864 to 1870 Lear spent his winters in Nice, Malta, Egypt and Cannes, till finally he settled at San Remo, where he died in 1888.

Lear's output of work was enormous. In April 1865 he wrote to Chichester Fortescue (Lord Carlingford): 'You ought some day to see the whole of my outdoor work of twelve months—200 sketches in Crete, 145 in the Corniche, and 125 at Nice, Antibes, and Cannes.' Though he made money by his books and lessons he complains in 1870 that he was unfortunate about selling pictures and 'only got £30 from the rich Cannes public this last winter'. With his oil-paintings, for which he sometimes obtained quite large sums, we are not here concerned.

'It is on the Himalaya of nonsense that Edward Lear sits enthroned',[2] but though he takes this high and undisputed place in what is a specifically English contribution to the world's literature, he takes a secure place, one higher than has been recognised, in water-colour, again a specifically national heritage in the world's art. When the painter of birds' feathers came to work at landscape, he brought to the task his explosive energy and a subtle insight, analysis and delicacy of art. He was among those who paint for pure enjoyment—lack of sales might discourage him, but had no effect on his output—and we shall not form a true estimate unless we consider him in that category, and not as one of the commercial showmen of water-colour.

Like Girtin and De Wint and Cameron, Lear had the panoramic sense. He was quite at his ease with a wide sheet of paper across which he drew the long lines of receding landscape. His *South End of the Dead Sea*[3] (1858) is a good example of his love of wide spaciousness, and of his power to lend it interest. He liked to be lord of the horizon, to see before him wide spaces leading to the misty blue moutains far away. His landscape is very often a bare one with a bistre monotony of sand-dunes and of rocks and desiccated scrub herbage

[1] In 1941 Francis Edwards, of 83, Marylebone High Street, offered for sale a collection of about two hundred watercolour drawings, made in Italy between 1843 and 1847. The drawings were reproduced in Lear's *Illustrated Excursions in Italy*, and *Journals of a Landscape Painter in Southern Calabria*, the texts of which were mounted with the drawings in seven large folio morocco-bound volumes. The whole collection was originally arranged by Lear's friend, Thomas George, Earl of Northbrook.

[2] *Times Literary Supplement*, December 26, 1929. [3] Coll. Mr. and Mrs. Paul Mellon.

55 'View on the Island of Otaheite'
B.M. 1890.5.12.107 (LB 2) 14¼ × 21¼: 362 × 537 *Water-colour*
William HODGES, R.A. (1744–1797)

56 'A Valkeel's Castle at Anchshur, Bengal'
V.A.M. 6784-12 11¾ × 16¾: 300 × 426 *Water-colour*
William ORME (fl. 1791—1819)

57 'Sketch of a Common, with houses'
V.A.M. 145–1890 $11\frac{7}{8} \times 21$: 301 × 534 *Water-colour*
Thomas DANIELL, R.A. (1749–1840)

58 'Brimham Crags'
Coll. Mr Leonard G. Duke $14 \times 19\frac{1}{2}$: 356 × 495 *Water-colour*
Thomas DANIELL, R.A. (1749–1840)

59 'Palace at Madura'

V.A.M. D.606–1887 $16\frac{1}{4} \times 23\frac{1}{4}$: 412 × 591 *Water-colour*

Thomas DANIELL, R.A. (1749–1840)

60 'Durham Cathedral'

V.A.M. 1744–1871 $15\frac{3}{4} \times 25\frac{5}{8}$: 400 × 650 *Water-colour*

William DANIELL, R.A. (1769–1837)

61 'Hurdwar, 1789'

London, Courtauld Institute of Art, Spooner Bequest 13 × 18¾: 330 × 476 *Water-colour*

William DANIELL, R.A. (1769–1837)

62 'Lulworth Cove'

Coll. Mr & Mrs Paul Mellon 6½ × 9⅜: 165 × 239 *Brown wash heightened with white*

William DANIELL, R.A. (1769–1837)

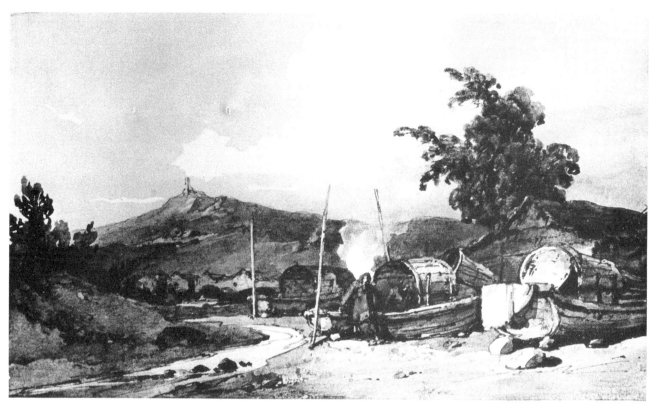

63 'Boat Dwellings, Macao'
V.A.M. P.42–1928 5½×9¼: 140×235 *Water-colour*
George CHINNERY (1774–1865)

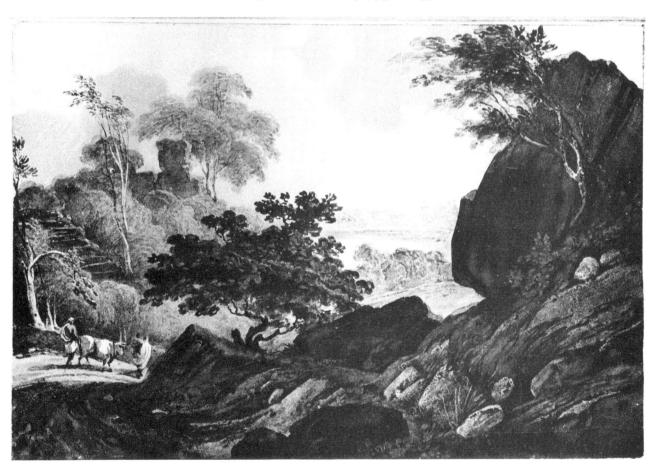

64 'Near Midnapur, Bengal'
V.A.M. P.51–1928 8¼×12⅜: 210×314 *Water-colour*
George CHINNERY (1774–1865)

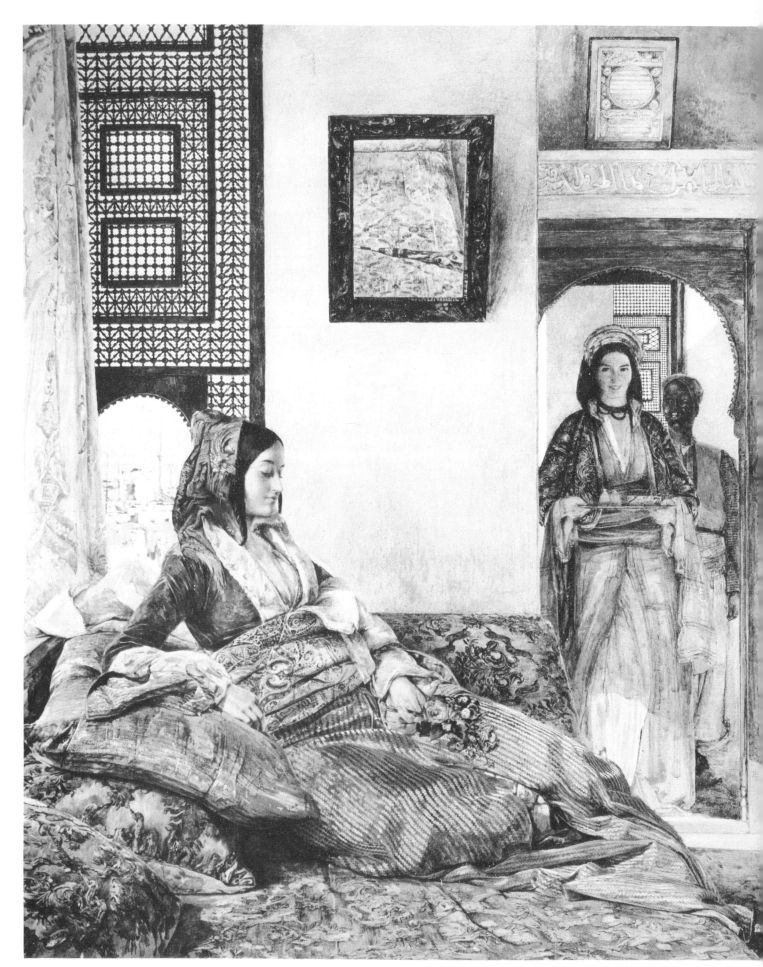

65 'Life in The Harem, Cairo'

V.A.M. 679–1893 $23\frac{7}{8} \times 18\frac{3}{4}$: 607 × 476 *Water-colour*

John Frederick LEWIS, R.A. (1805–1876)

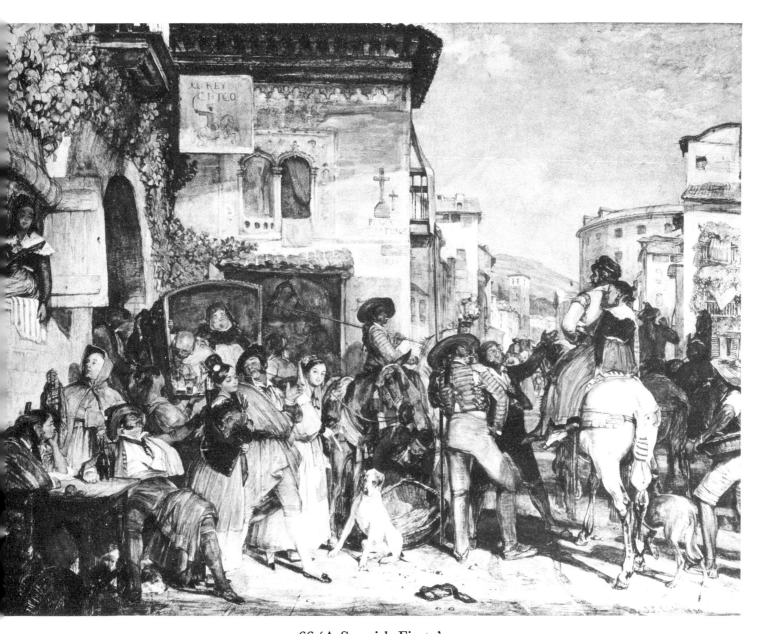

66 'A Spanish Fiesta'

Manchester University, Whitworth Art Gallery $25\frac{5}{8} \times 33\frac{3}{4} : 651 \times 857$ *Water-colour*

John Frederick Lewis, R.A. (1805–1876)

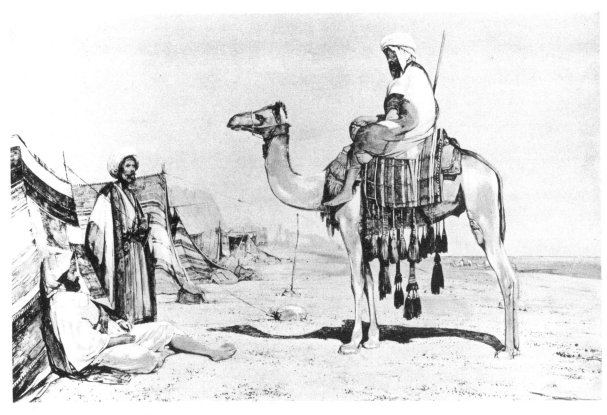

67 'Bedouin Arabs'
Coll. Mr & Mrs Paul Mellon 14×20½: 355×521 *Water-colour*
John Frederick LEWIS, R.A. (1805–1876)

68 'The Escorial'
Coll. Mr D. L. T. Oppé 10¼×14¼: 260×362 *Water-colour*
John Frederick LEWIS, R.A. (1805–1876)

69 'Study of a Lioness'
Coll. Mr & Mrs Tom Girtin $14\frac{1}{2} \times 16\frac{1}{2}$: 367 × 419 *Water-colour*
John Frederick Lewis, R.A. (1805–1876)

70 'The Old Water-colour Society Gallery'
London R.W.S. *Pencil drawing*
John Frederick LEWIS, R.A. (1805–1876)

71 'The Old Bridge'
Coll. Mr & Mrs Paul Mellon 13 × 20: 330 × 508 *Water-colour*
William James MÜLLER (1812–1845)

72 'Rock Tombs and Precipices, Tlos'

B.M. 1878.12.28.113 (LB 63) $22\frac{1}{8} \times 14\frac{7}{8}$: 562×378 *Water-colour, signed and dated 1844*

William James MÜLLER (1812–1845)

73 'Venice'

V.A.M. 32–1900 $8\frac{5}{8} \times 15\frac{3}{4}$: 219 × 400 *Water-colour*

William James MÜLLER (1812–1845)

74 'The Great Harbour, Rhodes'

B.M. 1878.12.28.159 (LB 74) $14\frac{1}{4} \times 22$: 361 × 527 *Water-colour, signed and dated 1844*

William James MÜLLER (1812–1845)

75 'A view in Italy at Evening'
B.M. 1958.7.12.365 $10\frac{7}{8} \times 17\frac{1}{8}$: 277×434 *Water-colour*
James Baker PYNE (1800–1870)

76 'All Souls, Oxford'
Coll. Mr & Mrs Paul Mellon $8\frac{3}{4} \times 11\frac{1}{2}$: 222×286 *Water-colour, signed*
James Baker PYNE (1800–1870)

77 'Battle Abbey, Sussex'
B.M. 1948.4.10.10 6×8¼: 152×210 *Water-colour*
James Chisholm GOODEN (fl. 1835–1875)

78 'Villefranche'
Coll. Sir John and Lady Witt 14⅛×21½: 358×546 *Water-colour*
Edward LEAR (1812–1888)

TROGON GIGAS
Giant Trogon

Drawing by Edw Lear

79 'Trogan Gigas'
Coll. Mr Leonard G. Duke 21¼ × 14½: 539 × 367 *Water-colour*
Edward LEAR (1812–1888)

80 'Turin'

Coll. Mr & Mrs Paul Mellon 10 × 20½ : 254 × 520 *Pen and sepia wash*

Edward LEAR (1812–1888)

81 'Gozo'

Coll. Mr & Mrs Paul Mellon 6¼ × 9½ : 159 × 242 *Water-colour, dated 1866*

Edward LEAR (1812–1888)

in the East that he loved, but long lines are there to be found and lost and found again, and the mountains are nebulous and blue.

In the Victorian period he carried on, almost alone, the tradition of the water-colour drawing as opposed to the water-colour painting; he is of the school of Francis Towne rather than that of Lewis and Müller. He seems to have worked always with a pen, using a fine nib and blue or blue-black ink for his distance, a wider pen (possibly a reed pen) or occasionally a brush, and brown ink, for his foreground. His *Constantinople, Eyoub,*[1] dated September 4, 1848, is a brilliant drawing where this method is exemplified, ranging from minute detail of delicate drawing in the distant town, to a very broad rendering in brown ink of the foreground trees, with slight indications of almost neutral colour on the foliage. In this drawing there is a distinct inheritance from Francis Towne through Baverstock Knight. At times, as in his *Tripoliza*[2] (1849), at the Victoria and Albert Museum, he anticipates Sir D. Y. Cameron. The line is less resilient and sympathetic, it is true, but the treatment of the distant range of hills, and the colour scheme of faint blues and purples and ochre are curiously akin to the work of the Scottish artist. Notable drawings are his *Andora,*[3] 1861, and *Villefranche*[4] (Pl. 78), 1865, both exhibited at the Redfern Gallery in 1942. A drawing of *Malta*[5] made in 1866 is again a forerunner of Cameron in its construction, in its warmth of yellow-brown colour, and in its summary treatment of the foreground. Cameron has carried further the method of Lear's water-colours, just as others have extended and improved the form and method of his limericks.

Lear does not seem to have worked for exhibition. His drawings are nearly all scribbled over with notes in pencil and ink, and he follows the commendable habit of annotating them with title and date. Obviously, they were made on the spot, and colour applied afterwards—a way of success for water-colours made with simple washes, without attempt at elaboration, over a careful drawing. He speaks, in 1857, of 'getting up, by my usual dilatory but sure process of penning out and colour, all my drawings', and it is clear from other letters that the colouring was studio work. In the Preface to *Later Letters of Edward Lear,* Mr. Hubert Congreve confirms what might have been guessed from an examination of the drawings: 'He would put on paper the view before us, mountain range, villages and foreground, with a rapidity and accuracy that inspired me with awestruck admiration. Whatever may be the final verdict on his "Topographies" (as he called his works in oil or water-colour) no one can deny the great cleverness and power of his sketches. They were always done in pencil on the ground, and then inked in in sepia and brush washed with colour in the winter evenings. He was an indefatigable worker, and at his death left over 10,000 large card-board sheets of sketches.'

On his sketches he set down notes about localities and colours, and so far did he carry

[1] Present whereabouts unknown.
[2] V.A.M. P.2–1930.
[3] Present whereabouts unknown.
[4] Coll. Sir John and Lady Witt. [5] Coll. Mr. and Mrs. Paul Mellon.

his 'penning out' that he cheerfully inked over his pencil notes, though they often come in obtrusive places that would seem to spoil the commercial value of his drawings. On the *South End of the Dead Sea*,[1] he has written *Gebel Usdon and Ghor Sunrise—April 16 Sunset April 15, 1858 . . . 1 Moab = evening, velvet pink, morning gray 2 purple gray plain 3. immense tufted marsh purple pink and green*. (The numbers refer to numbers written on the drawing: (1) the mountains, (2) the light streak of plain in the distance, (3) the marsh.) Two water-colour drawings by Lear in the British Museum, one of *Parnassus*,[2] 1849, and the other of *Mount Ida*,[3] 1864, have similar notes, which are also seen in the drawing of *Tripoliza*,[4] where it will be observed that he writes *1 to 9—a series of green earth and gray rox—all receding*. He loved to 'play' in spelling as in all else, and constantly writes 'brix' for 'bricks' and uses such spelling as 'beens' (for the vegetable), intermingled with words in Greek. His palette was simple, and he constantly notes his intention of using ultramarine ash for his sky, etc. A great deal of his work was done on a cartridge paper of cream tint.

Lear as a water-colour painter is not in the highest class with Cozens and Girtin, Cox and De Wint, but this big man, adventurer and Bohemian, friend of aristocrats, at home in drawing-room and desert, now holding Private Views in his flat at Stratford Place, now camping out with his Greek servant in wild places of the Near East, was an interesting and outstanding personality. De Wint could never have written his usual morning prayer or made a dozen happy drawings after being bitten all night by fleas, or worse, in some disgusting hostelry of Albania. Turner alone had the same zest for life, the same infinite capacity for work, but Turner, though he did try his hand at poetry, could not write nonsense verse. 'Topographies' these drawings are, but they possess something more. Lear set down observantly, rightly, rhythmically, the facts of life and nature, without any high flight of poetry or imagination.

It is of interest to know that at Athens, in the Gennadeion, there is a considerable collection of Lear's original water-colours, perhaps larger and more complete than most such collections. There are 188 of these drawings, all of them dated, even to the day and hour, with the artist's whimsical notes on each picture as to light, shade, detail, etc. They cover in all six trips made in Greece and Dalmatia, as follows: March 9 to April 16, 1849, Gulf of Corinth, the Peloponnesus, Attica, and Bœotia; April 10, 1856, to April 16, 1857, Cavalla, Salonika, Troy, Thessaly, and Epirus; February 24 to May 27, 1863, the Ionian Islands; April 15 to May 10, 1862, Corfu; May 5 to May 28, 1864, Crete; April 18 to May 8, 1866, Dalmatia. The series made in 1849 and in 1864 are the most complete, and it is possible from them to reconstruct his trip. Many of them show details of medieval architecture now lost. In many of them he has caught in a marvellous way the colour effects so typical of Greece at sunrise and sunset.[5]

[1] Coll. Mr. and Mrs. Paul Mellon.
[2] B.M. 1929. 6.11.67. [3] B.M. 1929. 6.11.65. [4] V.A.M. P.2–1930.
[5] Information given in a letter to the *Times*, June 28, 1938, by Prof. S. H. Weber, Director of the Gennadius Library, Athens.

Another painter of Eastern subjects was Carl Haag (1820–1915). Born at Erlangen, Bavaria, he studied art at Nuremberg and Munich. After practising for a time as a miniature painter at Brussels he came to England in 1847, entered the Royal Academy schools in 1848, and thereafter concentrated upon landscape and figures in water-colour. He rejected entirely the gouache method, which was still dominant abroad, seeking for purity and permanence of colour, and was elected associate of the Old Water-Colour Society in 1850 and member in 1853. He was still a painter of small-sized portraits, but in 1853 painted landscapes in the Tyrol and then worked at Balmoral, for the Queen and the Prince Consort, on two large pictures of stag-shooting. In 1854, he saw a new opening for his energy, and visited Dalmatia and Montenegro. In 1858 he went to Cairo with Frederick Goodall and for over two years travelled in Egypt, Palestine and Syria, living with the desert tribes. His painting of eastern scenery, of lone and level sands, of Bedouins and camels, mosques and encampments, won for him a great prosperity and a celebrity which is of little account today. In any history of water-colour he ranks as a Cattermole rather than a Bonington, a follower rather than an originator. Several of his eastern subjects painted between 1855 and 1866 are in the Victoria and Albert Museum.

A notable painter who was working in the Near East, in Egypt and Syria, at the same time as Lewis and Lear, was David Roberts. This side of his work will be discussed in a later chapter, where he takes his place as a member of the Scottish school.

CHAPTER IV

Later Marine Artists

Samuel Owen Clarkson Stanfield James Wilson Carmichael G. Chambers
Edward Duncan Charles Bentley Edward William Cooke

The tradition of marine painting in England which had begun with the Van de Veldes continued throughout the nineteenth century. And in this later period water-colour had an increasingly important place in the development of this specialised field of art. Certainly the achievement of Turner, the greatest English painter of the sea, must have had its influence in this respect as did his vision of the subject upon so many artists.

Samuel Owen (*c.* 1768–1857) living to the age of eighty-nine, thus spanned the lives of the most eminent artists of the British School of water colourists up to six years after the death of Turner. From 1794 to 1807 he exhibited marine and naval pieces at the Royal Academy, and at other exhibitions till 1810. In 1808 he became a member of the short-lived society of Associated Artists in Water-Colours, of which David Cox was President in 1810. Like his contemporaries at the end of the eighteenth century, he clung to the tradition of the Van de Veldes, but his colour work, fresh and transparent, belongs to his own period.

John Christian Schetky (1778–1874), though a notable marine painter, is claimed categorically for the Drawing Masters (Appendix I), where his activities at the military and naval colleges, and elsewhere, are recorded.

Another minor painter was Joseph Cartwright (*c.* 1789–1829), thought to have been born in Dawlish. He served in the Navy, apparently as a pay-master, and for some years was Paymaster-General to the forces at Corfu. On his return to England he devoted himself to art, and exhibited from 1823 at the British Institution and at the Society of British Artists, of which he became a member in 1825. He was concerned principally with marine subjects and naval engagements, and published a volume of *Views in the Ionian Islands*. In 1828, the year before his death, he was appointed painter to the Duke of Clarence.

We come now to a major group of marine painters, Clarkson Stanfield, S. Austin, G. Chambers, E. Duncan, C. Bentley and others, born from 1793 onwards, who applied the extended technique of their time to the painting of sea and shipping. Their popularity was encouraged by the new migration of whole families every summer to seaside resorts. Though Turner and Constable, Cox and De Wint, Prout and others, painted coastal

68

scenery and Channel shipping as an interlude in their work, this group of artists concentrated upon the sea as their theme. The sea-piece took its place among drawings of continental scenery and old towns hung in rooms, which Jane Austen describes so faithfully and so well, 'in a solid roomy, mansion-like looking house, such as one might suppose a respectable old country family had lived in from generation to generation, through two centuries at least, and were now spending from two to three thousand a year in'. The Mr. Bennetts and Sir Thomas Bertrams of 1830 were no doubt coaxed by their wives and daughters into the purchase of a Clarkson Stanfield, a Chambers or a Bentley for the embellishment of their drawing-rooms.

Clarkson Stanfield (1793–1867), sometimes having the name William prefixed in error, was born at Sunderland. His Irish father, James Field Stanfield, had gone to sea in his young days in a vessel engaged in the slave trade. Revolted by the horrors of this traffic, he joined a theatrical company, and later won some reputation as a writer, particularly by his work on behalf of the abolitionists. His son, Clarkson, whose name was obviously a tribute to the greatest of anti-slavery agitators, was apprenticed at the age of twelve to an heraldic painter in Edinburgh, but his love of the sea, inherited perhaps from his father, made him enter the merchant service in 1808. After several voyages he was pressed into the Navy and served as a clerk. In 1814, when in H.M.S. *Namur*, he painted scenery for theatricals held on board, with Douglas William Jerrold, then a midshipman, as 'managing director'. He is said also to have attracted the attention of Captain Marryat,[1] who recommended him to take up art as a profession. Temporarily disabled by a fall in 1816, he obtained his discharge from the Navy in 1818, and started on his career as a scene-painter at the old Royalty Theatre in Wellclose Square, Wapping, a favourite haunt of shore-going seamen. Three years later he obtained a similar post at the Pantheon Theatre, Edinburgh, and here became a firm friend of his colleague, David Roberts. He returned shortly to London, where Roberts followed him, and both were employed at the Coburg Theatre, and afterwards at Drury Lane, where their work received high commendation.[2] In 1827 Stanfield exhibited at the Royal Academy, and as he began to achieve reputation by his easel pictures, gave up scene-painting in 1834, though he occasionally painted scenery for friendship's sake or for a purely nominal fee. He was on terms of close friendship with Charles Dickens (for whom, as for David Roberts, he was 'Stanny') and constantly supplied scenery for the theatrical performances, half amateur, half professional, held by Dickens at Tavistock House. We read of Stanfield, before the production of *The Frozen Deep*[3] by Wilkie Collins in 1856, among carpenters, gasmen, mechanicians and the smell of boiling size, 'perpetually elevated on planks and splashing himself from head to foot'. Dickens himself appeared as Richard Wardour in this play, and Stanfield was always immediately excited by the prospect of working as his collaborator. In these theatricals Dickens found a form of escape from

[1] Captain Marryat, famous as the author of *Peter Simple*, *Midshipman Easy* and other novels of sea-life, was also a skilful draughtsman and caricaturist. [2] For Drury Lane scenery painted by Roberts and Stanfield, see pp. 180–1.
[3] *The Frozen Deep* was produced at the Royalty Theatre (demolished in 1828). *Little Dorrit* was dedicated to Stanfield by Dickens (kindly communicated by Mr. Colin Sorensen).

69

literary toil and domestic troubles, 'a satisfaction of a most singular kind, which has no exact parallel in my life'. Perhaps it meant escapism too for Stanfield, a recovery of his careless youth, a release from the cramping commissions which awaited him in his studio. In a memorial notice in *All the Year Round*, 1867, Dickens calls him 'the soul of frankness, generosity and simplicity, the most loving and most lovable of men'.

Stanfield counts mainly as an oil-painter of marine subjects; as such, he was elected an associate of the Royal Academy in 1832, and a full member in 1835. But, particularly on his tours on the Continent in 1829 and, 1839 in France, Holland, Belgium and Italy, he made many water-colour drawings. In these he showed himself a fine draughtsman, of the school of Bonington, J. D. Harding, James Holland and A. G. Vickers. His drawing of *Waterloo Bridge and the Shot Tower*[1] shows his close relationship to this group in outlook and in method. Like them, he was thorough and unpretentious, honest in his direct statement about things he had seen. He did effective work in recording landscape, but where he dealt with marine subjects, his principal theme, he was able to turn to good account the minute and accurate knowledge of shipping which he had accumulated in his younger days as a seaman. His retentive memory gave him confidence in dealing, not only with ships, but with effects of atmosphere and what Ruskin[2] calls the 'surge of Stanfield's true, salt, serviceable, unsentimental sea'. With no great subtlety of feeling or treatment, he worked accurately and honestly: Ruskin described him as 'the leader of the English Realists'. There is little of such affectation or mechanical contrivance in his art, as there is in that of Copley Fielding. Though he could not be described as a great or inspired painter, he was an honest craftsman whose popularity is not unmerited. Some of his best work as a draughtsman was made for reproduction in *Heath's Picturesque Annual* for 1832, 1833 and 1834; in his volume entitled *Coast Scenery*, 1847, with views in the English Channel, of Falmouth, Portsmouth, Plymouth, Rye, Hastings, Dover, etc.; and in his frontispieces and vignettes for an edition of Crabbe's Poems published in eight volumes in 1834. *The Dogana, Venice*[3] (Pl. 86), engraved for the *Picturesque Annual*, 1832, shows delicate colour, a crisp touch—and a pleasing sense of design. And in the British Museum also is a small water-colour of an empty upland with a distant small town on the horizon dark under a rapid storm-cloud that advances to fill the sky.[4] 'For such a drawing', says Laurence Binyon,[5] 'one would give most of his finished work.' In the Victoria and Albert Museum, among many drawings by Stanfield, is one of special interest showing the *Logan Rock, Cornwall*,[6] with figures of Charles Dickens, D. Maclise, J. Forster (Dickens' biographer) and the painter. It was made as a souvenir of a tour in Cornwall in 1842, and was given by Stanfield to Dickens. A good example of his more finished work is *St. Michael's Mount*, in the Art Gallery at Bury, Lancs.

Samuel Austin (1796–1834) is mentioned elsewhere in this work[7] as having had three

[1] V.A.M. 2983–1876.
[2] J. Ruskin, *Modern Painters*, I, § 36.
[3] B.M. 1900. 8.24.537.
[4] B.M. 1913.5.28.67.
[5] L. Binyon, *English Water-Colours*, 1933, p. 172.
[6] V.A.M. F.93.
[7] Volume II, pp. 218, 219.

precious lessons from De Wint. His work includes landscapes vaguely suggestive of Cox, and by means of purloined patches of colour he sometimes makes a near approach to De Wint. To that extent he was a good landscape painter, but his reputation rests mainly upon his more individual work as a painter of coast scenery; which is why he is included here. Austin was born at Liverpool in 1796, of humble parentage; was educated at the Bluecoat School of his native town; and became a clerk in the office of a Liverpool merchant. Before and after his office hours he was always sketching; and perhaps the same charitable person who paid for his lessons with De Wint gave him further financial help. At any rate, he became a professional artist in London; exhibited at the Royal Academy in 1820; was a foundation member of the Society of British Artists in 1824; and in 1827 was elected as associate of the Old Water-Colour Society. The Society's catalogues show that between 1827 and 1834 he exhibited sixty-one drawings. His best work deals with coast, harbour and river scenes with boats—the kind of subject in which he had acquired facility by patient study on his busy native river, the Mersey. Many of his subjects were sought in Liverpool and its surroundings, but from 1829 he began to find new themes of a similar class in Holland, Belgium and on the Rhine. In the *Gallery of British Artists*, 1834, two of his drawings are reproduced, *View of the River at Dort* and *Church of Notre Dame, Bruges*, the former engraved by J. C. Bentley, to whom reference is made later in this chapter. Many of his landscapes were painted in North Wales, and it was at Llanfyllin that he died from an attack of pneumonia contracted while sketching. On his deathbed he was elected a full member of the Water-Colour Society (Copley Fielding was then President) so that his widow (who had been a dancer and helped out the family exchequer by giving dancing lessons) might benefit by a grant from the Society's funds.

Like many others, Austin gained part of his livelihood by giving lessons to lady amateurs: his last pupil was Miss Anna Swanwick, translator of Goethe, Schiller and Aeschylus. In this connection it is interesting to record that: 'Samuel Austin had a beautiful face, as a miniature by Thomas Hargreaves proves. He gave lessons in water-colour at a girls' school in Liverpool; but the head-mistress had to get rid of him. "The fact is," she said, "you are altogether *too* good-looking. On the days when you are here, the girls can think of nothing else."'[1]

Comparatively few works by Austin are in public galleries, but there are some in the Walker Art Gallery, Liverpool, Manchester Whitworth Institute, British Museum and Victoria and Albert Museum, where in 1929 an interesting group of Austin's drawings belonging to his descendant, Mr. George Hornblower, was exhibited.[2] Three were Normandy subjects, including *Place de l'Eau de Robec, Rouen*, which bears a striking resemblance to a Lincoln theme by De Wint. *Dover* is a bold sketch with a loose foreground exactly in the De Wint manner. One cannot help wondering how many water-colours of Austin's have been fathered upon De Wint, especially as De Wint rarely signed his drawings. Mr.

[1] W. Shaw Sparrow, *Memories of Life and Art*, 1925, p. 79.
[2] B. S. Long, 'Samuel Austin', *The Connoisseur*, LXXXIV, 1929, p. 239.

71

Hornblower's *Dieppe*, with a crowd of shipping on the foreshore, is Austin's more personal and elaborate work, with a touch of Bonington influence in subject and composition.

James Wilson Carmichael (1800–1868), born at Newcastle-upon-Tyne, is of no great account, though his marine pictures were highly esteemed in the north of England during his lifetime. Like some of his predecessors, he painted with real knowledge of his subject, having gone to sea at an early age, and later having served his apprenticeship to a shipbuilder. He exhibited at the Royal Academy from 1835 to 1859. About 1845 he came to London, and during the Crimean War visited the Baltic in a warship, making sketches which were reproduced in the *Illustrated London News*. In 1859 he published a book on marine painting in water-colour. C. E. Hughes[1] speaks of his compositions as very unequal in merit, but many of them are full of dignity and a fine understanding of the motion of water and the animation of shipping, while others are dull and uninteresting. 'On the whole', says Hughes, 'he is less successful when he is at the water's edge than when he is out at sea and only a vague distance of land is visible.'

To a minor position also belong the brothers William Joy (1803–1867) and John Cantiloe Joy (1806–1866), born at Yarmouth, I. O. W. The drawings attributed to them were usually the joint production of 'The Brothers Joy'. About 1832 they removed to Portsmouth and were employed by the Government to draw the various craft used by fishermen. Later they resided in Chichester and in London, being represented occasionally at Suffolk Street and elsewhere.

George Chambers (1803–1840) was born at Whitby, the second son of a fisherman, who occupied a humble tenement in a court leading to the old Methodist Chapel. It lay in a district of squalor and dirt, where the houses, crowded and jumbled, stretched up the East Cliff under the Abbey ruins. George and his brother took turn and turn about at school, though the fees were only one penny a week. That was all the education George received, and at the age of eight he was launched on the world. His first service was on board coal sloops in the harbour, where he held sacks open for filling, for a wage of two shillings a week. Two years later he was sent to sea in the *Experiment*, a Humber-keel, owned by his uncle, whose only crew was himself, a hand and the boy. At twelve he was apprenticed for seven years to Captain Storr, of the transport brig *Equity*. He was of unusually small build, and it was difficult to find clothing that did not completely envelop him; in his first ketch, where there was no spare berth, he is said jokingly to have slept in one of the skipper's sea-boots. In the *Equity* he suffered from neglect, cruel jokes and harsh treatment, which permanently weakened his constitution. In foreign ports he visited churches, studied the many pictures which hung on their walls, and began to display a love of drawing. Encouraged now by the crew with gifts of paper and pencils, he sketched passing vessels and headlands, and decorated the ship's buckets. This ornamentation caught the eye of Captain Braithwaite, of the Whitby vessel *Sovereign*, when lying alongside the *Equity* at St. Petersburg, and the cabin-boy was borrowed as a decorator. His work gave such

[1] C. E. Hughes, *Early English Water-colours*, 1950 (rev. and ed. J. Mayne), p. 131.

72

satisfaction that Braithwaite, over a bottle at the London Docks, induced Storr to swear that he would set the young artist free. Storr, who in his cups constantly bullied the boy, was now kind; and finally the shipowners were induced to cancel the lad's indentures, with two years of the seven still unexpired.

At the age of seventeen, therefore, he was thrown on the world, with his living to seek. Working his way in a trader to his native Whitby, he engaged himself for three years as a house and ship painter, at from five shillings to six shillings and sixpence a week. He brought new custom to the widow who owned the business, by his skill at graining mantel-pieces and his clever lettering and marking of Greenland whale boats. His spare time was occupied in making copies on millboard of sketches brought home by sea captains in the whale fishery, and in designing valentines. His best efforts were small oil-paintings of vessels at sea, not painted, as his biographer[1] says, to look 'fine', but actually sailing, and their crews engaged upon some nautical manœuvre of reefing or tacking. When his term of service expired, he was again thrown upon his own resources (his sailor father was still of the opinion that painting only spoiled good canvas), and so worked his passage in the *Valleyfield*, with a Captain Gray, arriving in London with two pounds earned in his pocket. When this sum was dwindling and prospects were looking black, he was fortunate in meeting a friend and benefactor who recognised his talent. This was Christopher Craw-ford, landlord of the *Waterman's Arms* in Wapping, where young George had been brought with his bundle of clothing, bought in Ratcliff Highway eight years before. The publican, who had been on the stage as a comedian at Whitby, and had served as doctor in a Green-land ship, 'was an honest, hearty, blunt and bluff John Bull, ever to be found seated in his great arm-chair in the bar, smoking cigars, surrounded by parrots and other exotic things, presented to him by sailors, from some far foreign land'. There was a room up-stairs kept for the use of ship-owners and known as the House of Lords, another below for captains, and the bar downstairs for common seamen. The Lords, some of whom hailed from Whitby, wanted to have their room adorned with a picture of 'the good old town'. They approached William Huggins (1781–1845), the well-known marine painter, but he had never seen Whitby, and wanted a sum of money in advance for travelling expenses, at which the Lords demurred. All of this came to the ears of the Commons in the bar, who put forward little Chambers as a champion painter. The Goliath of marine painting (afterwards Marine Painter to King William IV) was ousted by the tiny David, who knew Whitby, as it were, by heart, needed no travelling expenses, and so got the commission. He carried it out with such success that the ship-owner, who had kindly cancelled his inden-tures years ago, commissioned another picture of his own ship, the *Phoenix*, returning home with full cargo. Other commissions for ship portraits followed, and some of these were seen by a Mr. Horner, proprietor of the Colosseum in Regent's Park (on the site of what is now Cambridge Gate), who engaged Chambers to assist with a panorama of London, which

[1] J. Watkins, *Life and Career of George Chambers*, 1841.

was subsequently exhibited there. This work, which occupied him for some years, led to further employment as a scene-painter at the Pavilion Theatre, just about the time when Clarkson Stanfield and David Roberts were similarly employed at Drury Lane. He soon learned about distemper and theatrical perspective, and his success with a scene depicting a view of the Liffey was rewarded by an engagement at two guineas a week, which amount soon doubled. His scenes were so admired by his successor, W. L. Leitch, that he preserved them intact, instead of painting them over, long after they had been discarded from use.

Meanwhile his evening painting of cabinet pictures in oil, and two of these works, shown in a Greek Street framer's window, caught the eye of Admiral Capel by their nautical exactness. Admirals Munday and Lord Mark Kerr were induced to take an interest in the young man's work, and he left the theatre to set up as a marine painter at 37, Alfred Street, Bedford Square, with certainty of employment from the leading naval commanders of the day. In 1830, when he was only twenty-seven, he was taken aback when his noble friend in the Navy informed him that the King had commanded his presence at Windsor, with examples of his work. So terrified and abashed was he at this royal interview that, when Queen Adelaide offered him accommodation in Windsor Castle, he blurted out that he thought he should be 'more comfortable at the *Red Cow*'; and, when Her Majesty stood too close in examining his work, did not scruple to tell her to 'coom backarder'. Four of his oil-paintings commissioned on this occasion remain in the Royal Collection at Windsor and at Buckingham Palace.

In 1834, four years later, Chambers writes: 'I was last week elected an associate of the Old Water-Colour Society, which is almost as being a Royal Academician. I was unanimously elected, although I do not know a single member.' He became a full member in the following year. The forty-one drawings which he exhibited at Pall Mall East belong to the last seven years of his life. They comprise shipping or boats and studies of waves and water, with scenery of the coast of the Thames below the bridges. About half a dozen, in 1837, 1839 and 1840, are Dutch in subject, the result of two trips to Holland in company with pupils. ('Knock the colours about more', he would say to a pupil who was working in piecemeal fashion.) One of these Dutch drawings, *A Windy Day*[1] (Pl. 89), is in the Victoria and Albert Museum; a lively, spirited drawing, full of movement and showing how the inland waters of Holland, even on a day of sunshine, can be lashed into fury by a sudden gale. In colour that drawing is as luminous as a Bonington. That same clarity of colour in clear transparent washes marks his *Shipping off the Mumbles, Swansea* of 1838.[2]

Within the next year or two Chambers' health was failing rapidly. When he was unable to work and threatened by poverty, his old benefactor Christopher Crawford sent him off on a cruise on the *Dart* packet to the Mediterranean and Madeira. He was able to make some studies on deck, but returned home to die of heart disease at Brighton, aged only thirty-seven. Sidney Cooper and Turner were among brother artists who contributed to a fund

[1] V.A.M. 510.　　　　　　　　　　　　　　[2] Huntington Art Gallery, San Marino.

in aid of his destitute widow; and Clarkson Stanfield put the last touches to a painting which had been left unfinished. Although there was genuine kindness in that action by Stanfield which was tearfully acknowledged by the widow, perhaps there was a little condescension as well. Stanfield was *the* marine painter of the day, a friend of the great, an intimate of Charles Dickens, a leading member of the Royal Academy; and the Academy had rejected or ignored Chambers.

Sidney Cooper,[1] in his autobiography, wrote about Chambers: 'His early death was a very great loss to art, for, had he lived, I feel convinced that he would have become one of the greatest marine painters of his time, or indeed of any time. . . . His painting of rough water was truly excellent, and to all water he gave a liquid transparency that I have never seen equalled . . . his ships were all in motion.' It may be added that his waves show true perspective, and his ships not only rode the water, but sat comfortably in it. How thoroughly he pursued his job is shown by the fact that in 1837 he obtained permission from Trinity House to spend several days on the light-vessel at the Nore, in order to make studies of shipping at the entrance of the Thames and the Medway. His biographer well says that a seaman looking at a ship by Chambers could almost fancy himself on board. In Byron's words: 'She walks the waters like a thing of life.' And the truth of all this will be found in good examples of water-colour drawings by Chambers not only in London but in the galleries at Birmingham, Manchester, Leeds and Newcastle.

Edward Duncan (1803–1882) was born in the same year as Chambers, the year after Girtin's death. He cannot be considered as anything but a painstaking, skilful painter of a class below Stanfield, Chambers and Bentley. Duncan began his career as an apprentice to Robert Havell, the well-known engraver in aquatint. He copied, and probably helped to engrave, many water-colours by William Havell, and that was a solid foundation for his own original work. Setting up as an engraver on his own account, he was employed on the reproduction of stage-coach incidents and sporting scenes for Fores of Piccadilly and of shipping subjects by William Huggins, mentioned before in connection with Chambers. There was nothing of the sailor about Duncan; his home was never on the rolling deep. Though he once made a little voyage to the Zuyder Zee in a Dutch *schuit* from Billingsgate Wharf, his was a longshoreman's knowledge of the sea. But, in the language of his day, he led Huggins' daughter to the hymeneal altar; and he justified his existence and his marriage by becoming a marine painter himself. He also drew, for illustration purposes, fat cattle and sheep at agricultural shows, and later painted a good deal of quiet inland scenery, where sheep and oxen are prominent. *On the River Yare, Norfolk*[2] is a good example of his faithful, if uninspired, rendering of such subjects. The farmyard and its denizens figure frequently in his drawings, and a study of exhibition catalogues shows that a considerable portion of his work comes under the heading of Landscape. His marine pictures, however, were more numerous and always in the forefront. In 1833 he became a member of

[1] T. S. Cooper, *My Life*, 1891, p. 141.
[2] Bethnal Green Museum 1220–1886.

the New Society of Painters in Water-Colours, but retired in 1847, and in 1848 joined the parent Society, of which he became a full member in the following year. For thirty-four years he never missed an exhibition. At the New Society, from 1832 to 1847, he showed 163 exhibits; at the Old Society, from 1848 to 1882, about 250 works, not including groups of sketches shown in the same frame.

As a marine painter, Duncan was not concerned with men-of-war and nautical engagements, but dealt mainly with trading craft and such vessels as luggers which can be drawn up on the shore. It is true that he delights in wild weather, wrecks, life-boat manœuvres, and rescue with the rocket line, but his was the landsman's aspect; and what he liked was a foreground of beach or harbour peopled by figures engaged in the landing of fish or cattle, and crab-catchers or shrimpers among the flotsam and jetsam of the sea upon a rocky shore. When he paints *Isle of Wight: the Channel Fleet coming out of Portsmouth*[1] (Pl. 91), the ships are a far-off incident; it is the shrimpers, the lobster-pots, the stones on the foreground beach, which make his picture. His *Spithead*[2] (Pl. 92), 1855, well composed and massed with an admirable sky and his *Whitby*[3] show him at his best. He remained an illustrator; his careful work with its exact finish could be faithfully engraved on wood; and books published in the 'fifties and 'sixties teem with subjects drawn by Duncan, and often engraved by William Linton.

As a painter Duncan was thorough in his study of the English scene, equally at home in characterising the rural surroundings of the farmstead and coast scenery with shipping and craft, but his work lacks distinction and individuality. It is deficient in the airiness and freedom, the swing and sensuous movement of a Turner, or even of Stanfield, Chambers and Bentley. He was tame, a Victorian in period and in mental outlook. The reason was partly perhaps because he did not get into his stride as a painter till the 'forties and 'fifties of last century, when the old impulses in painting had become exhausted or had died out. The demand of the Victorian moneyed classes was for painstaking exactitude, honesty and sentimental prettiness, the qualities which marked their own week-day work and their Sunday religion. They liked an artist to be thorough; and to paint what they thought they saw. Duncan, like Charles Dickens, was typically Victorian in his overflowing sentiment and his realism of multitudinous detail; within his limitations he was an able painter, and deserved the reputation which he won from his contemporaries. As in the case of many painters whose finished work won favour by meticulous care and florid colour, we find more pleasure and interest in the studies which reveal more of the man himself and his methods. Duncan's son, Walter, born in 1848, was elected an associate of the Old Water-Colour Society in 1874; but disappeared under a cloud from their list of members, in 1906.

Charles Bentley (1805/6–1854) was a year or two younger than Chambers and Duncan. He was born in Tottenham Court Road, where his father was a master carpenter and

[1] V.A.M. 3061–1876.
[2] Birmingham, City Art Gallery, 59'99.
[3] V.A.M. P.11–1948.

76

builder. The son was apprenticed as an engraver to Theodore Fielding and worked under him and his two engraver brothers. His mother wrote that 'while he was 'prenticed he went to Paris to do a work Mr. F. had there'. This was a folio volume entitled *Excursion sur les Côtes et dans les Ports de Normandie*, Paris, 1823–5. Bentley was only an assistant and his name is not coupled on the plates with those of Newton and Thales Fielding. What is important is that most of the plates were after water-colours by Bonington, and there is no doubt that this close study of Bonington's work, the engraver's careful copying of form and colour, influenced Bentley's own style when he became a water-colour painter. About this time he formed a life-long friendship with William Callow, who in 1823 was articled to Theodore Fielding at 26, Newman Street, for eight years, 'for instruction in water-colour drawing and in aquatint engraving'. We are told that Bentley, somewhat older than Callow, who was born in 1812, assisted him to master the technical side of his calling and gave him his first painting lesson.[1] Thus the Bonington influence was spread. Bentley's articles expired in 1827, and soon he combined his work as an engraver with the production of drawings for illustrated publications, not perhaps so many as those listed by Roget,[2] for I think Roget has confused some of his work with that of Joseph Clayton Bentley (1809–1851). This Bentley was born at Bradford, was a pupil of Robert Brandard, the engraver, practised line engraving and landscape painting, and exhibited his paintings from 1833 till his death in 1851, at the British Institution, Royal Academy (from 1846), and Suffolk Street. His work, though weaker than that of his better-known namesake, undoubtedly bears a resemblance to that of Charles Bentley, and the similarity of name, as well as of the mixed profession of painter and engraver, tended to further confusion.

Charles Bentley was elected an Associate of the Old Water-Colour Society on the same day, February 10, 1834, as George Chambers, and became a full member, nine years later, in 1843. His exhibits with the Society from 1834 to 1854 amounted to 209. He died, from an attack of cholera, at 11, Mornington Place, Hampstead Road, in 1854. Redgrave tells us that he was 'in the hands of picture dealers, uncertain in his transactions, and always poor'. He was one more able artist who made but a pittance from his profession. His effects after his death were sworn as not exceeding £300 in value, and he left a widow and a very aged mother, then living at Boston in Lincolnshire, who was more or less dependent on his support.

Bentley's subjects are generally coast and river scenes, with varying effects of sunset and evening, storm and calm. His sketching areas covered the seas within sight of almost the entire round of the British and Irish coasts, as well as Normandy and the Channel Islands. With Callow he visited Rouen and Havre in 1836, making sketches by the way, and other trips with Callow to Paris took place in 1840 and 1841, the pair also visiting St. Malo, Avranches, Caen, Dieppe and Abbeville on the latter occasion.[3] Some drawings of Venice, Holland, Dusseldorf and the Near East, which were among his exhibits, were probably

[1] H. M. Cundall ed., *W. Callow, R.W.S., An Autobiography*, 1908, pp. 3–5.
[2] Roget, Vol. II, pp. 238, 239. [3] Callow, *op. cit.*, pp. 74, 86.

worked up from sketches by amateurs. He seems to have specialised in this bread-winning work, for instance in *Twelve Views of the Interior of Guiana*, published by Ackermann in 1821. The sketches for this book were made by John Morison, who went out as draughtsman on a tour organised by the Royal Geographical Society with the Government's support, but 'the artist's finish, the effect of colouring, light and shade, were communicated . . . by Mr. Charles Bentley, whose drawings in water-colours have been long esteemed'. F. Gordon Roe[1] quotes an earlier and probably the first serious appreciation of Bentley's work, at the very start of his career, from Nagler's *Künstlerlexicon*, of 1835. It describes him as 'a leading London water-colour artist, now alive, who serves a special purpose among those Englishmen who practise this form of art. He paints splendid views, which leave nothing to be desired in the tone and strength of the colours. His water-colours are thus greatly sought after by lovers of art, and are only to be found in first-class cabinets.' There is not much to say in addition to that estimate. Though Bentley had little actual experience of marine life, he depicted his coastal scenes with keen enthusiasm and fine colour sense. His colour, that of a disciple of Bonington, was luminous and deftly applied. His dash and vigour sometimes have to atone, particularly in his landscape dealing with lake or river scenery, for a certain weakness in drawing and perspective. Roget says that he 'used body-colour without stint', a statement which is misleading, for though body-colour appears in many of his drawings, its use is not excessive, and much of his best work shows no trace of its employment.

George Balmer (*c.* 1806–1846) was born in the same year as Bentley, and his work as a marine painter is not dissimilar. Balmer was the son of a house-painter at North Shields, and began work as a decorator at Edinburgh. Beginning at the same time to paint in water-colour, he exhibited at Newcastle and for a time was in residence there. After an extensive tour on the Continent and a period of study at the Louvre he settled in London, and though his best work had marine interest he exhibited rural and architectural subjects as well from 1830 to 1841, at the British Institution and the Society of British Artists. In 1836 he started the issue of a publication entitled *The Ports, Harbours, Watering-Places and Coast Scenery of Great Britain*, which contained engravings of some of his best drawings; but the work was never completed. His *Tynemouth Castle, Northumberland*[2] (Pl. 95) was engraved by E. Finden for this work, of which the first volume appeared in 1842. In that year, having inherited some property, he abandoned art as a profession. He continued, however, to paint for his own pleasure, at Ravensworth, Durham, where he had retired; and he died there in 1846. His work is comparatively rare, and I think his has been a convenient name for attachment to drawings which cannot be safely attributed to Bentley or another painter.

Belonging to the same tradition, as a popular exhibitor of marine subjects and landscapes, was Thomas Sewell Robins (1814–1880). His work appeared from 1829 to 1879

[1] F. Gordon Roe, 'Charles Bentley', *Walker's Quarterly*, April 1921, with a catalogue of C.B.'s exhibited works.
[2] V.A.M. 2970–1876.

at the Royal Academy, the British Institution, Suffolk Street, and the New Water-Colour Society. He became a member of the last (now the Royal Institute) in 1839, but resigned in 1866. Examples of his work, belonging to the 'fifties and 'sixties of last century, may be seen at the Victoria and Albert Museum and the Bethnal Green Museum. At his best, Robins was a highly accomplished painter of marine subjects, and conveyed a vivid sense of atmospheric effect.

With Edward William Cooke, R.A. (1811–1880), born at Pentonville, we come to an artist of greater distinction. He had the benefit of instruction from his father, George Cooke, the engraver, and before he was nine drew illustrations of plants for Loudon's *Encyclopædia*, and subsequently made drawings and etchings for the *Botanical Cabinet*. His hand, thus trained to minute exactitude, did not lose its cunning when he turned his attention later to shipping. So far as his work in water-colour was concerned, Cooke was no great colourist, but his tinted drawings, made largely as studies for his oil-paintings, have their definite charm and value. A series of water-colours in the Victoria and Albert Museum, of windmills at Blackheath, shows fine draughtsmanship and delicate colour. As C. E. Hughes[1] points out, Cooke was one of the few painters who carried his pencil work beyond the limits of a sketch: 'indeed, his drawings in black-lead are full of interest for those who can appreciate directness and delicacy of touch, combined with a feeling for light and shade, which in many instances almost gives the illusion of colour.' He was conversant with the appearance and function of every smallest spar, rope, sail, or piece of rigging from the Thames skiff to a three-decker battleship or East Indiaman, and not only of British vessels but of foreign types as well. His sketch-books were made up of Penny's patent metallic paper, with a smooth and shiny surface. When a book was full his sister Harriet used to break it up and sort the contents, putting them into classified boxes when mounted. If he wanted Dutch or Venetian craft, he could at once find details of the required sails and rigging. His volume of etchings entitled *Shipping and Craft* includes many charmingly composed little coast views in addition to shore details such as windlasses and stranded spars. Though for the most part small in scale, these etchings are packed with detail of meticulous accuracy, and apart from their subject-matter are a model of precision and skill in biting. No wonder that in 1825, when only fourteen, he was employed to make sketches of ships' gear for Clarkson Stanfield. About that date, no doubt influenced by Stanfield, he began to study oil-painting, and from 1830 made tours in France, Scandinavia, Holland, Egypt and elsewhere, in the pursuit of his art. His exhibits at the Royal Academy, chiefly river and sea subjects in oil, range from 1835 to 1879, the year before his death at Groombridge, near Tunbridge Wells. He was elected an associate of the Royal Academy in 1851 and a full member in 1863.

John Absolon (1815–1895) painted not only marine subjects but landscapes and figure subjects in both oil and water-colour, and made numerous drawings for book illustrations. He is included in this chapter because in at least one coast scene he showed himself as a

[1] *Op. cit.*, p. 134.

painter of salient importance in comparison with most of the marine artists whose work has been described. He was born at Lambeth, and after earning his living for a time by painting portraits, was employed by the Grieve family for about four years on theatrical scenery at His Majesty's Theatre, Drury Lane and Covent Garden, being responsible mainly for the figures. His first exhibited work appeared at the Suffolk Street Gallery in 1832, when he was only seventeen. In 1835 he went to Paris, and on his return in 1838 became a member of the New Water-Colour Society, the same year as John Skinner Prout, Samuel Prout's nephew. He was to be followed in the succeeding year by Henry Bright, of Norwich, and by William Telbin, who is best remembered as a theatrical scene-painter. For many years Absolon acted as Treasurer of the Society and was a frequent contributor to its exhibitions. He was certainly versatile, because in 1838 he went off with his wife to Paris, and practised there for nearly a year as a miniature painter; and in 1850 he helped T. Grieve and Telbin to produce the first diorama, *The Route of the Overland Mail to India*. His outdoor landscapes in water-colour, executed in a fresh and breezy manner, with figures happily introduced, have high merit, and at least one of his works, *Coast Scene*[1] (Pl. 101), deserves to be called a masterpiece. Painted about 1860, to judge by the costume, it is reminiscent of Manet and Boudin, in its sparkling atmosphere, its broad massing of the figures, and its daring use of black. There is no afterthought in this drawing; its effect of sunshine and cool shadow is gained by swift and direct touches; everything seems just to be dropped on the paper with inevitable rightness. The result is a common scene touched to splendour and a work which can be set beside the best of Constable or Wilson Steer. I cannot imagine that it was just a happy accident.

Compared with this, the work of his immediate successors, going by order of birth-dates, G. H. Andrews and O. W. Brierly, seems like mere illustrations to a ship's log. George Henry Andrews (1816–1898) born at Lambeth, was an engineer by profession, but devoted most of his time to painting. He became an associate of the Old Water-Colour Society in 1856, and a member in 1878. He painted chiefly marine subjects in water-colour and contributed drawings for reproduction to the *Illustrated London News* and *The Graphic*.

Sir Oswald Walter Brierly (1817–1894) was born at Chester. After a grounding in art at the academy of Henry Sass in Bloomsbury he went to Plymouth to study naval architecture. He took part in many voyages on Admiralty and other surveys round the coasts of Australia, New Zealand and South America, producing many drawings of scientific and historical value. He was with the Hon. Henry Keppel during operations in the Baltic in 1854, and in the Black Sea and Sea of Azov, 1855, and published many drawings of incidents in war. With the Duke of Edinburgh he made a tour round the world in 1867-8, and accompanied the Prince and Princess of Wales on their tour to the Nile and the Crimea in 1868. He exhibited marine subjects at the Royal Academy in 1859–61, and again in 1870–1, but ceased to contribute on his election as an associate of the Royal Water-Colour Society in 1872. He became a full member in 1880. He exhibited about two hundred works in all,

[1] V.A.M. D.154–1895.

founded in large part on his early travels. On the death of J. C. Schetky he was appointed marine painter to Queen Victoria, and was knighted in 1885.

John Mogford (1821–1885) was born in London, of a Devonshire family. He studied at the Government School of Design at Somerset House, married the daughter of Francis Danby, A.R.A., and specialised in painting seascapes and rocky coast scenery. He became an associate of the Royal Institute in 1866, and a member in 1867, exhibiting nearly three hundred works in the Institute's Gallery. To the same period belongs James Chisholm Gooden (*fl.* 1835–1875), who exhibited at the Royal Academy, British Institution, and Society of British Artists from 1835 to 1865. He painted landscapes but was chiefly interested in marine subjects, and compiled the *Thames and Medway Admiralty Surveys*, 1864. Gooden drew boats with much skill, and his sketches made among the tidal waters of estuaries have considerable charm. George Chambers went yachting with him on the Thames, and the last sentence William Müller spoke contained the name of his friend Gooden, whom he first met in 1840 and with whom he made many sketching expeditions, down the Thames and elsewhere.

With Henry Moore (1831–1895), born at York, we come to a sea-painter of much higher merit and importance. He began his career under the tuition of his father, William Moore, a portrait-painter, and had some training also in the York School of Design and, for a short time, in the Royal Academy Schools. In earlier years he painted landscapes and rural scenes with cattle and horses; and, like his brother, Albert Moore, was influenced by the Pre-Raphaelite movement. About 1857, however, he turned his attention almost entirely to marine subjects, adjusting his earlier analytic habit and love of minuteness to a wider and more persuasive conception of atmospheric conditions. In his case the sea was no longer a background or setting for the dramatic movement of ships. Like his contemporary, Whistler, but in a different way, he was one of the first to paint the open sea for its own sake. He watched its ever-changing lights and colours, the subtle play of sunshine and shadow in partnership, interweaving and moving to and fro, like dancers in a quadrille, over its surface. He was particularly impressed by its vastness; 'There is one thing respecting the sea I never saw truly given in a painting—viz. its size and extent'; and again, 'I thought I had never seen the wet, polished surface of water truthfully given by *anybody*'. His numerous pencil studies of waves and of boats in movement show his correctness of vision and his keen observation. In his colour work, both in water-colour and oil, he advances from scrupulously accurate wave-drawing and an academic tightness to a larger treatment, an eliminative power, and more suave appreciation of form and colour. Cold, steely colour became more rich and glowing; the deep blues and greens of a sparkling, sunlit sea won his favour. French critics spoke of 'la note bleue de Moore'. He studied nature with unquestioning fidelity and rendered with marvellous accuracy the variations produced by sunshine and catspaw breezes upon a restless expanse of open sea. Moore was elected an associate of the Royal Water-Colour Society in 1876 and a member in 1880; he became A.R.A. in 1885 and R.A. in 1893, two years before his death.

Sir Francis Powell (1833–1914), born at Pendleton, Manchester, two years after Moore, studied at the Manchester School of Art. He exhibited at the Old Water-Colour Society from 1856, becoming an associate in 1867 and a member in 1876. His drawings were mostly marine and lake views. In 1878 he was one of the founders, and the first President, of the Scottish Society of Painters in Water-Colours, and was knighted five years after the society was created Royal in 1888. His own example, as an admirable painter of sea subjects, coupled with his enthusiasm, tact and personal charm, did much to advance the development of water-colour in Scotland, which is dealt with in a later chapter.

Charles Edward Holloway (1838–1897) was born five years later than Powell, at Christchurch, Hampshire. He was a fellow-pupil of Fred Walker, Charles Green and Sir J. D. Linton at Leigh's Studio in Newman Street, London, and was subsequently associated with William Morris till 1866 in the production of stained glass. Then, devoting himself entirely to painting, he exhibited at the Royal Academy and elsewhere, showing many drawings of the Fen district and the Thames, besides frequent marine subjects. He was elected an associate of the Royal Institute in 1875, and a member in 1879. He visited Venice in 1875 and 1895. His water-colours show his acceptance of the Impressionist outlook and also a kinship with Whistler in their suave and subtle colouring. The grey-green of shallow seas that take some of their colour from sand-banks off our Suffolk and Essex coasts has never been more faithfully rendered; it is entirely different from the sparkling iridescence of purple, blue-green and violet in northern or Cornish waters. Such drawings as *A Breezy Day*[1] and *On the East Coast*[2] (Pl. 106) are testimony to his keen observation, direct handling and fine colour sense.

Holloway, though he was a finer artist, never won such popular success as Thomas Bush Hardy (1842–1897), who was born at Sheffield. In early life Hardy travelled in Holland and Italy; first exhibited at the Royal Society of British Artists in 1871; and was elected a member in 1884. His innumerable sketches, fresh and vivid in colour, of tossing vessels in Channel waters commanded a ready sale. Though he produced drawings of genuine merit, particularly in the 'seventies and 'eighties, much of his work was hasty and commonplace, with little that was solid behind its façade. In latter days particularly, his facility tended to overrun conscience, and his forces were apt to skirmish over a wide front without any solid centre of attack. For some reason I seem to associate him in my mind with Wilfrid Ball (1853–1917), only incidentally a marine painter, but possessing the same kind of slick accomplishment and popular appeal. Their contemporary William Ayerst Ingram (1855–1913), who was elected a member of the Royal Society of British Artists a year before Hardy, was the son of the Rev. G. S. Ingram of Glasgow. He was a considerable traveller, and exhibited from 1880 at the Royal Academy and elsewhere; he became a member of the Royal Institute in 1907. Much of his work was in oil, but his water-colour drawings of subjects found on the coast and the open sea have a quiet, though not impressive, accomplishment, but are lacking in bite and personality.

[1] V.A.M. D.3–1900. [2] V.A.M. P.78–1922.

Owners of drawings signed *Albert* may not know that the artist's name was Albert Ernest Markes (1865–1901); he was the son of a marine artist named Richmond Markes, who worked at Newquay, Cornwall. Albert was a shop-assistant at Newquay, when a youth. Subsequently he came to London and was exploited by various dealers, who traded on the fact that though he painted in water-colour he required a quantity of liquid more stimulating as a fillip to his work. He was colour-blind and could use only one eye. After painting at Leigh-on-Sea and Southend, he was sent by a dealer to Belgium and Holland, on whose coasts and waterways he found new material for his stock-in-trade. There were four sea-pieces, all signed 'Albert' *tout court*, in the Nettlefold Collection.[1]

Colin Hunter (1841–1904), born at Glasgow, was best known for his seascapes in oil which won for him election as A.R.A. in 1884. But, though practising chiefly in oils, he was also an accomplished painter in water-colours. He was a keen and original observer of all the colour and movement of the sea, and particularly of the storm-swept waters of the Western Highlands where he spent his youth. His *Lobster-Catchers*, 1886, formerly in the Nettlefold Collection,[2] is a good example of his skill in suggesting with rapid touch the subtle changes of colour and varying reflections in moving water.

William Frederick Mayor (1866–1916), known generally as Fred Mayor, was born at Winksley, Yorks., the only son of the Rev. William Mayor. Educated at St. Edmund's Canterbury, he studied painting in what is now the Royal College of Art, and for six months at Julian's in Paris. In his early days he shared a studio with Frank Brangwyn. His best water-colours, those that linger in the memory, were beach scenes, painted swiftly and impulsively like Absolon's *Coast Scene*. Mayor discarded formulas, and was intent only on the quick utterance of the impression made upon him by some combination of colour and atmospheric effect. He was one of several water-colour painters at the turn of the century (Cecil Hunt, Lamorna Birch, Dame Laura Knight among them) who did not hesitate to use body-colour freely, if it served their purpose. In many of Mayor's drawings large clots of white stand out in the sky like thick touches of oil paint. Owing to the sulphur in the atmosphere of London, his masses of white have frequently become oxidised, turning to a silvery black. More than one owner of his drawings has been deeply distressed by what seemed irremediable decay, not knowing that treatment with hydroxyl will permanently restore the white to its original brilliance. Good examples of Mayor's bold and effective work will be found in the Victoria and Abert Museum.

Nelson Dawson (1859–1941), a Lincolnshire man, began his career in the office of a provincial architect. But a love of painting, and a passion for the sea and the ways of ships and sailormen, led him into marine-painting. He settled down at Chelsea in a circle which included Whistler, Brangwyn, Short and Llewellyn. He married Miss Edith Brearey Robinson, a flower painter, of Scarborough. They had little money in their joint purse, and

[1] F. J. Nettlefold Cat., Vol. III, pp. 64, 66, 68, 70.
[2] F. J. Nettlefold Cat., Vol. II, p. 226.

together turned to craftwork in metal as a means of livelihood, soon employing a number of workmen to assist in producing all kinds of architectural fittings, gates, railings, lamps, memorial tablets, jewellery and enamelled ornaments. Though this was the main centre of Nelson Dawson's activity, he continued to paint in water-colour, and became an associate of the Royal Water-Colour Society in 1921. Like Holloway, he studied the colour and spirit of the sea on our eastern coasts. At Whitby, Yarmouth and off the Suffolk coast, he made many breezy, intimate studies of vessels and seas in motion. His drawings were simple, direct, animated and full of atmosphere. They owed much to his close knowledge of ships and to his sound draughtsmanship. As a member of the Royal Society of Painter-Etchers, he was one of the few recent artists to revive the soft-ground method, so admirably used by Cotman, and he employed it with great success in studies of sea and shipping.

Though he was not entirely a painter of the sea and the sea-coast, E. Leslie Badham (1873–1944) may be included here. He was a well-known painter of landscape in oil, and became a member of the Royal Society of British Artists and the Royal Institute of Painters in Oil. For a great part of his life he lived in Hastings and taught in the local School of Art. In water-colour he painted landscape and architecture, but is entered here because what I remember best of his work are his studies, rich in colour and firm in design, of rivers and boats, and of fishing smacks on the beach at Hastings. Many of them were exhibited at the Royal Academy. From about 1920 every part of Hastings, and not least the fishing quarter with its net-sheds and varied craft, became part of his daily life; he was painting what he knew and loved. He worked frequently with Hawksworth at Winchelsea, Rye and other places, and to some extent was influenced by him in such a subject as *Shipping at Rye*,[1] 1929. In other cases, notably in his dramatic *Old Town, Hastings*,[2] 1935, there is no obvious resemblance in their work, beyond the use of pen and ink and a similarity of subject. In 1928, when he drew his *Beach at Hastings*,[3] he was beginning to reach the height of his power. In 1944 he and his daughter were killed at Hastings by a bomb dropped from a German raider. In 1945 the Hastings Corporation acquired a collection of his drawings, including many aspects of Sussex landscape and architecture, and particularly a series of records showing the older streets and houses of Hastings, many of them now obliterated.

[1] Once owned by the author. [2] Once owned by the author. [3] Once owned by the author.

82 'Shipping in a Roadstead'
B.M. 1868.3.28.304 (LB 2) 11¾×9: 301×226 *Water-colour*
Samuel OWEN (c. 1768–1857)

83 'New Harbour at Alderney'
Coll. Mr W. A. Brandt 8 × 11⅜: 203 × 289 *Water-colour, dated 1858*
John Christian SCHETKY (1778–1874)

84 'In the English Channel'
V.A.M. P.102–1920 7¾ × 11⅞: 197 × 302 *Water-colour, signed and dated 1821*
Joseph CARTWRIGHT (c. 1789–1829)

85 'A Storm'

B.M. 1913.5.28.67 $6\frac{1}{2} \times 9\frac{3}{4}$: 165 × 247 *Water-colour*

Clarkson STANFIELD, R.A. (1793–1867)

86 'The Dogana & Church of the Salute, Venice'

B.M. 1900.8.24.537 (LB 5) $8\frac{3}{4} \times 12\frac{1}{2}$: 221 × 317 *Water-colour*

Clarkson STANFIELD, R.A. (1793–1867)

87 'Alnmouth'

V.A.M. P.49–1948 $7\frac{7}{8} \times 12\frac{5}{8}$: 200 × 320 *Water-colour, signed and dated 1823*

James Wilson CARMICHAEL (1800–1868)

88 'Shipping in a Roadstead'

B.M. 1877.5.12.523 (LB 1) $7\frac{1}{4} \times 10\frac{3}{4}$: 184 × 273 *Water-colour*

John Cantiloe JOY (1806–1866)

89 'A Windy Day: Boats in a Gale'
V.A.M. 510 $9\frac{3}{8} \times 14\frac{1}{8}$: 238 × 358 *Water-colour, signed*
George CHAMBERS (1803–1840)

90 'View near Gillingham'
B.M. 1957.7.31.6 $11 \times 17\frac{1}{2}$: 280 × 444 *Water-colour*
George CHAMBERS (1803–1840)

91 'The Fleet leaving Portsmouth'
V.A.M. 3061-1876 14 × 20⅞: 355 × 530 *Water-colour, signed and dated 1859*
Edward Duncan (1803–1882)

92 'Spithead'
Birmingham Museum and Art Gallery 59'99 13¾ × 20¾: 350 × 526 *Water-colour, signed and dated 1855*
Edward Duncan (1803–1882)

'Landscape with Elm trees'
B.M. 1885.10.10.32 (LB 2)
$16\frac{5}{8} \times 13\frac{1}{2}$: 422×332
Water-colour, signed and dated 1839
arles BENTLEY (c. 1805–1854)

94 'Fishing Boats'
V.A.M. 3024–1876
18×26: 457×660
Water-colour
arles BENTLEY (c. 1805–1854)

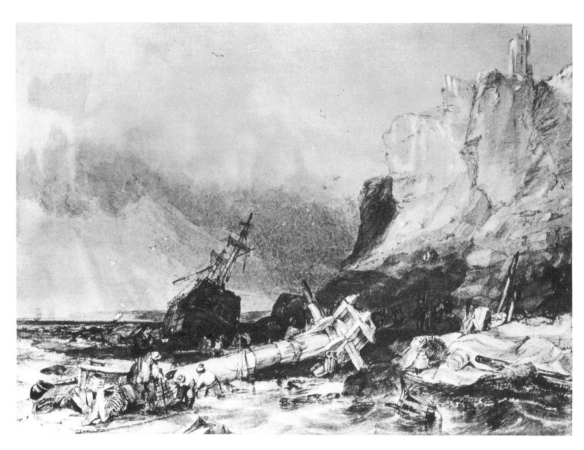

95 'Tynemouth Castle'
V.A.M. 2970–1876 $9\frac{3}{4} \times 13\frac{3}{4}$: 248 × 349 *Water-colour*
George BALMER (c. 1806–1846)

96 'Mutton Cove, Plymouth'
Coll. Mr & Mrs Paul Mellon $8\frac{1}{4} \times 11$: 204 × 280 *Water-colour, signed*
Thomas Sewell ROBINS (1814–1880)

97 'Dover Harbour, 1850'

B.M. 1900.8.24.503 12½ × 18½: 318 × 470 *Pencil and water-colour*

Edward William Cooke, R.A. (1811–1880)

98 'Dutch Fishing Boats'

Coll. General Sir John and Lady Anderson $9\frac{3}{4} \times 13\frac{1}{4}$: 247×337 *Water-colour, signed and dated 1833*

Edward William COOKE, R.A. (1811–1880)

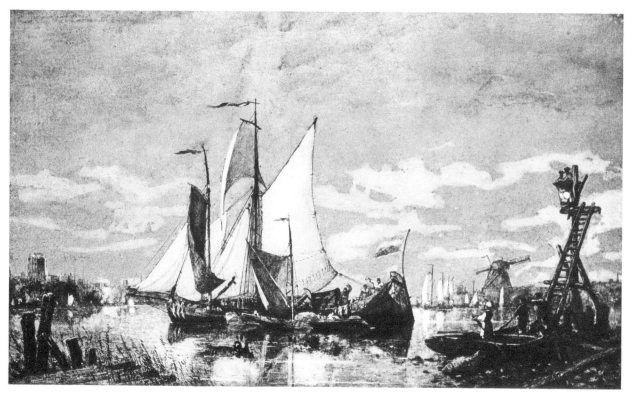

99 'Barges on a Dutch canal'

London R.W.S. (diploma drawing) $11 \times 18\frac{1}{2}$: 279×470 *Water-colour, signed and dated 1893*

George Henry ANDREWS (1816–1898)

100 'Millfield Lane, Highgate'
B.M. 1947-6-19-11 17 × 13¼: 432 × 337 *Water-colour*
John ABSOLON (1815–1895)

101 'Coast Scene'
V.A.M. D.154–1895 $9\frac{1}{4} \times 15$: 235 × 381 *Water-colour*
John ABSOLON (1815–1895)

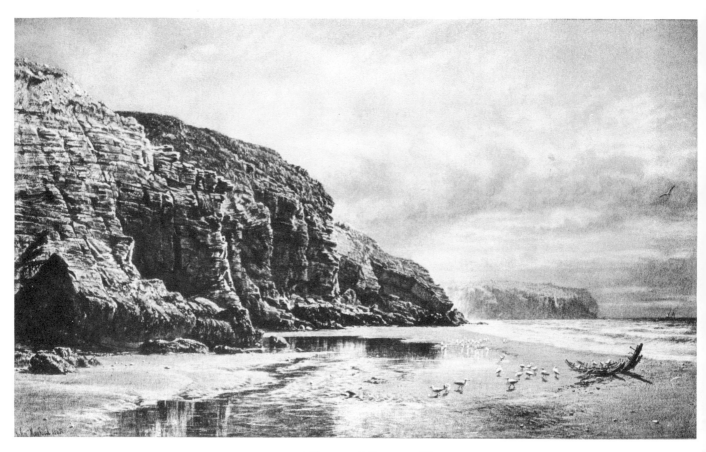

102 'Coast of Cornwall'
V.A.M. 417–1891 $12\frac{1}{8} \times 20\frac{3}{8}$: 307 × 517 *Water-colour, signed and dated*
John MOGFORD (1821–1885)

103 'Sgurr Dhu, Loch Coruisk'
London R.W.S. (diploma drawing) $25\frac{1}{2} \times 37\frac{1}{2}$: 646 × 948 *Water-colour, signed*
Sir Francis POWELL (1833–1914)

104 'A Squally Day'
V.A.M. D.1-1906 $11\frac{1}{8} \times 15\frac{1}{4}$: 283 × 387 *Water-colour, signed and dated 1879*
Henry MOORE, R.A. (1831–1895)

105 'Falmouth Harbour'
V.A.M. P.65–1917 $14\frac{3}{4} \times 29\frac{7}{8}$: 375 × 757 *Water-colour*
William Ayerst INGRAM (1855–1913)

106 'On the East Coast'
V.A.M. P.78–1922 $10\frac{5}{8} \times 15$: 270 × 381 *Water-colour*
Charles Edward HOLLOWAY (1838–1897)

107 'Hay barge'

B.M. 1880.2.14.332 (LB 1) 13 × 9¾ : 330 × 246 *Water-colour, signed and dated 1878*

Thomas Bush HARDY (1842–1897)

108 'The Bathing Tent'

Newcastle Upon Tyne, Laing Art Gallery 10¼ × 14: 260 × 356 *Water-colour, signed*

William Frederick MAYOR (1866–1916)

109 'Shipping Scene'

B.M. 1915.11.8.8 7 × 12: 178 × 304 *Water-colour, signed*

Albert Ernest MARKES (1865–1901)

CHAPTER V

The Earlier Illustrators and Portrait Painters

*John Augustus Atkinson John Masey Wright George Cattermole
Frederick Tayler Louis Haghe Joseph Nash George Richmond*

An earlier chapter[1] contained reference to painters of figure subjects, many of whom, such as Corbould, Stothard and Burney, were occupied largely with the illustration of books. They satisfied a demand for anecdote, history, poetry and sentiment at the same time that the travelling draughtsmen were recording country seats and the natural features of landscape. The Annuals which flooded the book market from 1825 onwards helped to foster a similar demand both for landscapes and for figure subjects. The landscapes, as we have seen, were largely realistic renderings of foreign towns and scenery. The figure painter relied upon imagination, brought to bear upon subjects dealing with sentiment or romance such as Gipsies, Reveries, Ringlets, Bouquets and Billets-doux, Love Offerings, Evening Prayer, Partings and Meetings, Falstaff or Sancho Panza, Rowena or Juliet, *et hoc genus omne*.

Among earlier men in this group, H. J. Richter, J. A. Atkinson and J. Masey Wright have still to be mentioned. They were followed by the new group of painter-illustrators, a very compact group when we consider that four of the leaders, C. Cattermole, F. Tayler, L. Haghe and Joseph Nash, were born between the years 1800 and 1808. As with Bonington and Delacroix, the works of Sir Walter Scott opened up, for earlier and later men alike, a new and hitherto unknown kingdom of romance, and stirred them to depict moving incidents in history and to search for archaeological accuracy in their treatment of anachronistic themes. They delved into Shakespeare, Scott's novels, Cervantes' *Don Quixote*, Cellini's autobiography and similar works, in order to fire their own imagination with what was vivid in character, incident and setting. Whereas the Rev. William Gilpin and 'Dr. Syntax' voyaged in search of the picturesque in landscape, these painter-illustrators sought for it in history and literature. For their scenic background they had the stately homes of England, Tudor or Elizabethan mansions, fronted by terraces and wide balustered steps, and cornered by turrets containing spiral stairs. For interiors they had baronial halls with richness and mystery in their fretted ceilings and panelled and

[1] Vol. I, Chap. VIII.

tapestried walls, their vast sculptured chimney-pieces, feudal bric-à-brac, ornate buffets and moulded furniture. Against this background they set their imaginary figures, in costume and armour which were tolerably correct. It all savoured too much of the stage, and undoubtedly led the way to Charles Kean's lavish profusion and realistic scenery and costume in his Drury Lane productions.

To consider the three earlier men first; Henry J. Richter (1772–1857), almost forgotten now, but in his time a successful painter of subject pieces, was born in London. He exhibited two landscapes at the Royal Academy when only sixteen, but turned later to figure work, and was forty-one when he was elected to the Old Water-Colour Society. Pyne, writing in 1824,[1] mentions Richter's *Falstaff and Dame Quickly* as advancing a considerable step beyond Heaphy's *Fish Market* 'in brilliancy, luxuriancy and harmony of colouring'. He was not a prolific painter, and his most ambitious subjects were taken from Shakespeare, among them a *Taming of the Shrew* in 1827 and *The Parting of Romeo and Juliet* in 1845. He was a frequent contributor to the Annuals. Between 1828 and 1833 his work appeared in *Forget-me-Not*, *The Keepsake* and *Fisher's Drawing-Room Scrap-Book*. Due possibly to his German descent, he was a speculative student of transcendental philosophy, which has no place in this book, though it made Richter an intimate friend of William Blake.

John Augustus Atkinson (1775–fl. 1833) was born in London, in the birth-year of Turner, Girtin, Heaphy and Reinagle. At the age of nine he was taken to Russia, enjoyed imperial patronage, and came home in 1801 with sketch-books full of costume studies and memoranda of social habits and military scenes which supplied him with much of the material for work produced later in his own country. In 1803 and 1804 he provided one hundred illustrations (soft-ground etchings, coloured by hand) for *A Picturesque Representation of the Manners, Amusements and Customs of the Russians*, and in 1807 began *A Picturesque Representation of the Naval, Military and Miscellaneous Costumes of Great Britain*. The project was for three volumes of which one only, containing thirty-three plates, was issued. The plates in these books show him as a vigorous, and at times a brilliant, draughtsman with great power of selecting what was most relevant in form, accent and colour. His flowing pen line with its easy curves appears to owe something to Rowlandson's example. There is nothing stiff or stereotyped, nothing of the fashion-plate, about Atkinson's treatment of scenes and figures.

I think that we may accept as Atkinson's the fifty illustrations in *Picturesque Representations of the Dress and Manners of the English*, 1814. In this volume the strange juxtaposition of characters reminds one of the old rhyme of 'tinker, tailor, soldier, sailor', etc. The titles of some of the illustrations may be quoted in the amusing order in which they stand without respect to persons—Yeoman of the Guard, Shrimper, Peer in his Robes, Dustman, . . . Dairy Maid, Drayman, Speaker of the House of Commons, Butcher's Boy, Admiral, and so on. In 1814 he also etched sixty-one plates for *Selections of the Ancient Costume of Great*

[1] *Somerset House Gazette*, I, 1824, p. 114.

Britain and Ireland, with figures wearing costumes of the seventh to the sixteenth century and placed in appropriate surroundings.

Atkinson was elected to the Old Water-Colour Society in 1808 and during the next ten years exhibited studies of military or rustic figures and groups as well as scenes from Shakespeare, Scott and *Don Quixote.* In the Victoria and Albert Museum are some admirable studies of coast scenery, two subjects from *Ivanhoe,* and one from *Don Quixote.* Seven more illustrations to *Don Quixote* were exhibited at the Fine Art Society in 1946, very simply executed, with pen line and flat washes. They display the artist's almost boyish delight and abandon in sparkling and unconventional approach to such themes as Don Quixote attacking the windmill, destroying the puppet show, or stabbing the winebag. 'His light touch', said Seguier,[1] 'appears to put everything in motion.'

A newspaper of 1815[2] says: 'We perceive by the Advertisements that those distinguished Artists, Atkinson and Denis (J. Dennis?), are gone to the continent for the purpose of procuring every information relative to the grand decisive Battle of Waterloo.' One result of that journey was his *Belgian Waggon conveying wounded from the Field after the Battle of Waterloo*[3] and a large *Battle of Waterloo.*[4] The latter is the finished study for an oil-painting by Atkinson, exhibited in 1819 and engraved by J. Burnet.

John Masey Wright (1777–1866) was born at Pentonville in one of two cottages owned by his father, who was an organ builder. The boy could not settle down to his father's trade—he got into trouble through a habit of making sketches on the organ pipes and effacing them with a plane—and was allowed to follow his natural bent as a draughtsman. At the age of sixteen he was encouraged by Stothard and had the advantage of frequently watching him at work in his studio. At the age of thirty-three he married a Miss Meadows and went to live in Bishop's Walk, Lambeth, at that time a theatrical quarter. In the same house as the Wrights resided John Wilson, later to become a member of the Royal Scottish Academy as a marine painter, but at that time better known as 'Jock Wilson', scene-painter at Astley's. In the old wooden public house in Bishop's Walk, frequented by actors and scene-painters, Wright and Wilson used to foregather with Clarkson Stanfield and David Roberts, George Chambers and Thomas Barker, eldest son of Robert Barker, the founder of panoramic exhibitions. Wright obtained employment from Thomas Barker and his brother Henry, painting figures for their panoramas (that of Waterloo, exhibited in Leicester Square, made Barker's fortune) and also worked as a scene-painter in His Majesty's Theatre. In 1824 Wright was elected to the Old Water-Colour Society, and from then until 1848 Shakespeare's plays were his main source of inspiration, but other themes were provided by *The Vicar of Wakefield* and *Don Quixote.* His work was in demand for the Annuals. He figures in the *Literary Souvenir* for 1825 and 1826 and *The Amulet* for 1826 and 1827. Though Wright won contemporary favour by the aptness and felicity of his

[1] F. P. Seguier, *Dictionary of the Works of Painters,* 1870, p. 7.
[2] V.A.M., Newspaper Cuttings, IV, 948.
[3] V.A.M. P.36–1919. [4] B.M. 1872. 2.10.2.

illustrative work, his talent was of the fragile and modest kind which does not lead to any lasting fame.

It may be well to mention here John William Wright (1802–1848) because he is so often confused with J. M. Wright. They both belonged to the same group of figure-designers and illustrators, and were both members of the Old Water-Colour Society, but were not relations. J. W. Wright belongs really to a later generation. The son of John Wright, a miniature painter of repute, he began his studies with a view to portraiture in oil, and then devoted himself to water-colour. Elected an associate of the Old Water-Colour Society in 1831 and a full member in 1841, he exhibited eighty drawings in all, mostly illustrative subjects of a conventional kind, frequently studies of fair ladies with such titles as *Meditation, The Blue Domino, Yes or No*, or *There's nothing half so sweet as love's young dream*, often accompanied by descriptive verses of a sentimental kind. It goes almost without saying that from 1832 to 1851 his lovely, full-breasted, ringleted ladies adorned the pages of such Annuals as *The Keepsake, The Literary Souvenir, Heath's Book of Beauty*, and *Fisher's Drawing-Room Scrap-Book*. His work, like that of his namesake, is delicate and pleasing, to be treasured only for its contemporary flavour and association, as we may treasure other products of that day, a Baxter print, a Paisley shawl, a papier mâché tray, a sampler, or a piece of Tonbridge ware.

We come now to the group of three or four men who concentrated upon historical and romantic *genre*, turning history not into a cold catalogue of men and dates and events but a passionate reconstruction of what Macaulay described as 'fragments of truth', the warm intimate background, the clothes and weapons, the colour and infinite variety of the past. The historical setting, by novelist and painter alike, is rendered with sufficient, though not always scholarly, correctness.

George Cattermole (1800–1868) was born at Dickleburgh near Diss, Norfolk. At the age of fourteen he was sent to London for the purpose of studying architecture under John Britton, and was soon engaged in providing drawings for the *Cathedral Antiquities of Great Britain* and other works. His elder brother, Richard (c. 1795–1858), who was similarly employed at the time under Britton, exhibited at the Oil and Water-Colour Gallery in Spring Gardens and drew nine of the illustrations to Pyne's *Royal Residences*. Removed from Britton's employment, he was sent by his parents to Christ's College, Cambridge, and became a historian and divine of considerable note. George, a year or two younger, exhibited studies of Peterborough Cathedral at the Royal Academy in 1819 and 1821. In 1826 he gave the first hint of the work which was to make him so popular, by exhibiting at the Academy, in addition to two architectural subjects, a historical picture of *Henry II discovering the Relics of King Arthur in Glastonbury Abbey*, and in 1827 an equally ambitious *Trial of Queen Catherine*. From that point of departure he never looked back. In 1822 he had been elected an associate of the Old Water-Colour Society and showed a *View of the West Front of Wells Cathedral*, but owing to pressure of work for Britton dropped out and was re-elected in 1829, becoming a full member in 1833. His exhibits at this period show that his

range of subject, concerned with the drawing and grouping of figures in historical settings, was now fixed, and his architectural themes were no longer severe cathedral fronts but interiors such as that of *Haddon Hall*. One cannot help surmising that the vogue for Bonington's work which followed his death in 1828 helped to launch Cattermole on his career.

Roget,[1] on whom everyone must depend for a full account of Cattermole, emphasises that his position and importance in the Water-Colour Society were due to the fact that his works were, at the time, of a unique character. The predominating landscapes of so many other members were enlivened by contrast with the moving incidents of Cattermole's creation, distributed at chosen intervals upon the walls. He is well summed up by Thackeray[2]:

> A few glittering dashes of the brush, and wonderful cups and salvers, and shining suits of armour, are represented by this marvellously facile pencil. Monks, cavaliers, battles, banditti, knightly halls, and awful enchanted forests in which knights and distressed damsels wander, the pomp and circumstance of feudal war, are the subjects in which Mr. Cattermole chiefly delights.

And Dickens may have been poking a little fun at his friend Cattermole when he made Mrs. Skewton[3] say: 'The Castle is charming—association of the Middle Ages and all that —which is so truly exquisite. Don't you dote upon the Middle Ages, Mr. Carker? Those darling bygone times, Mr. Carker, with their delicious fortresses and their dear old dungeons and their delightful places of torture and their romantic vengeances and their picturesque assaults and sieges and everything that makes life truly charming. How dreadfully we have degenerated.'

Cattermole was a man of wide reading and of social proclivities. Before his marriage in 1839 he was a member of the Garrick Club and the Athenaeum, and occupied chambers in Albany which had once been Byron's and afterwards Bulwer-Lytton's. In the early part of 1839 he declined a knighthood offered him at the command of Queen Victoria for his large *Diet of Spires, 1529*,[4] which Her Majesty had suggested as a subject. He was wont to speak of it as one of his most laboured and therefore worst productions, because he was hampered by the necessity of depending upon prints and portraits and of following authorities for facts. He declined also the honour of acting as instructor to the French princesses then resident at Claremont on the plea that 'his line of art could not be taught'. He was one of the distinguished circle that surrounded Lady Blessington[5] and Count D'Orsay at Gore House, a close friend of Dickens (whose *The Old Curiosity Shop* and *Barnaby Rudge* he illustrated), and an associate of Lytton and Disraeli, of Thackeray and Jerrold, of Macready, Macaulay, Robert Browning and Landseer. He was a good whip, a rider, an amateur actor and a humorist; in the last two capacities giving imitations which were a delight to Dickens. There was nothing of the Bohemian about him, he was a bit of a dandy

[1] Roget, I, pp. 495–498. In addition to full biographical information Roget gives a long list of publications in which Cattermole's works were reproduced. Many of them were engraved in the various Annuals from 1832 to 1850.
[2] L. Marvy, *Sketches of the English Landscape Painters*, 1850.
[3] *Dombey and Son*. [4] V.A.M. 1016–1873.
[5] A number of pencil and chalk studies by Cattermole in the British Museum include a portrait of Lady Blessington.

in dress, a precisian in speech, a Tory in politics. He was not enough of an economist to provide for his old age, and when he died in 1868 his widow became dependent upon a Civil List Pension. His many friends also came to the rescue. I have seen a letter of W. P. Frith, R.A., which says: 'By the enclosed, written by C. Dickens, an old friend of Cattermole, you will see that that great artist has left his family destitute and in debt. Will you help us for the love you have for all that is beautiful.'

In 1852 Cattermole, yielding unwisely to the persuasion of friends, J. F. Lewis among them, resigned his membership of the Old Water-Colour Society in order to devote himself to oil-painting. Like others he coveted Academy honours, and the refusal of the Royal Academy to elect any water-colour painter, as such, was constantly responsible for much misplaced ambition. Accustomed to the free use of water-colour, Cattermole's hand felt hampered and weighted by the more viscid medium. As Cox[1] said: 'His water-colours are more under his command.' Returning to his earlier love, though not to his Society, he resumed his practice of water-colour, and a drawing by him shown at the Paris Exhibition of 1855 shared with Sir Edwin Landseer the honour of being awarded a *grande médaille d'honneur* of the first class.

Ruskin[2] and other critics have spoken in praise of the fine qualities of Cattermole's painting in its pictorial and decorative aspect, the power and facility of his drawing, the grouping of his figures. But Ruskin qualifies his reference to Cattermole's 'very peculiar gifts and perhaps also powerful genius', and his 'very grand perceptions of general form' by adding: 'I do not recollect in any, even of the most important of Cattermole's works, so much as a fold of drapery studied out from nature. Violent conventionalism of light and shade, sketchy forms continually less and less developed, the walls and faces drawn with the same stucco colour, alike opaque, and all the shades on flesh, dress, or stone, laid on with the same arbitrary brown, for ever tell the same tale of a mind wasting its strength and substance in the production of emptiness, and seeking, by more and more blindly hazardous handling, to conceal the weakness which the attempt at finish would betray.' Redgrave amplifies what Ruskin says about drapery by telling us that Cattermole worked from memory without the intervention of a model; and from Roget[3] we learn that 'he abhorred the practice, considered by more matter-of-fact painters as essential to good art, of copying perpetually from models'. Two years after Cattermole's death Tom Taylor[4] wrote in the *Art Journal* that: 'Whatever hampered the free play of his imagination seemed to impair both his inventive and executive power to a degree hardly conceivable by robuster natures.'

Cattermole's facility of execution was what gave freshness and vigour to his compositions, but he was inclined to freewheel, and I feel that he was not at his best when he was content to rely upon his facility. He was compelled to serve up his heavily garnished fancy

[1] N. N. Solly, *Life of David Cox*, 1875, pp. 133, 134.
[2] *Modern Painters*, I, § 33.
[3] Roget, II, p. 68.
[4] *Art Journal*, 1857, pp. 209–211.

90

dishes, such as his *Diet of Spires*, for the Victorian patron (there are examples in the Dixon Bequest, Bethnal Green Museum), but we realise nowadays that more pleasure may be given by his unpretentious work, where his power of improvisation and his inventive drawing were given free play. In his slighter work, in many rapid and dashing sketches made with manifest enjoyment, he is not the careful competent professional but the amateur. Some landscape sketches of this type, *Rochester Castle, Attack on a Moorland Hut, Castle among Trees and Rocks*, show a very marked resemblance to the free work of Cox and Harding, as well as intrinsic skill.[1] In the same way his rapid handling of interiors and figures, as shown in *Interior of a Baronial Hall*[2] (Pl. 113), is far more vivid and inspiring than the more laboured finish of his exhibition pieces. Opportunity for a study of Cattermole's work is given by some thirty examples in the Victoria and Albert Museum.

At an early stage of his career Cattermole adopted the use of Chinese White, and his pictures are solid or semi-solid throughout. In his landscape work he was obviously a student and admirer of Cox, and, like Cox, he found an advantage, especially when sketching with opaque colour, in the kind of paper used at the time by wholesale grocers, and had some specially made by Winsor and Newton of a superior quality. It is a thick absorbent paper, rather warm and brownish in colour. He was highly skilled in using both the tone and the grain of the paper. His use of brown in his shadows, to which Ruskin refers, perhaps rose partly from the nature of the paper, and gives an appearance of fading to many of his drawings. He was very far from possessing either Bonington's verve or his gift of rich and luminous colour.

If we are to understand the work of this period and the atmosphere in which it was produced, as exemplified not only in the Annuals but in the drawings of Cattermole, Fred Walker, Birket Foster and others, it is necessary to realise the differences between Victorian sentiments and emotions and the changed values given to them in our own times. Cattermole, for instance, won tremendous approval for his illustrations to *The Old Curiosity Shop*, ending up with his drawing of the death of Little Nell. It is hard for us nowadays to believe that crowds on the New York quays, waiting for the last instalment of Dickens' book, hailed an incoming vessel with shouts of, 'Is Little Nell dead?' Dickens himself suffered terribly in writing Nell's death scene. Men like Daniel O'Connell, Lord Jeffrey, Carlyle, were among thousands who openly burst into tears when they read what to us seems melancholy bathos.[3]

Frederick Tayler (1802–1889) was born two years after Cattermole. The son of a country gentleman living at Boreham Wood near Elstree, Herts., he received a classical education both at Eton and Harrow; in this surely he was unique. He was destined for the Church —his grandfather and his uncle were prominent divines—but against the family wishes he adopted art as his profession. He studied at Sass's Academy, the Royal Academy and under Horace Vernet in Paris, and his close association with Bonington about 1826 has

[1] These drawings are reproduced in O.W.S. Club, IX, 1932.
[3] See Una Pope-Hennessy, *Charles Dickens*, 1945, pp. 148–150.

[2] V.A.M. 1454–1869.

already been recorded.[1] He soon became known as a water-colour painter of sporting and pastoral scenes, was elected to the Old Water-Colour Society in 1831, became a full member three years later and was President of the Society from 1858 to 1871.

Between 1834 and 1836 Tayler painted a dozen pictures in collaboration with George Barret. He was a frequent guest at country houses in Scotland and in his early days was much engaged in teaching aristocratic pupils. Queen Victoria and the Prince Consort purchased several of his pictures, which are now in the royal collection. There are several examples of his work in the Victoria and Albert Museum and in the Dixon Bequest, Bethnal Green Museum. Six of his drawings were bequeathed in 1900 to the British Museum by Henry Vaughan.

Roget classifies Tayler's works as: (1) Sporting scenes both of past and present times. The former include stag-hunts of the early eighteenth century, and hawking parties of prior date, when gay costumes of ladies were among the picturesque accompaniments of horn and hound. The latter are for the most part incidents on the moors, and of deer-stalking in the Scottish Highlands. (2) Pastoral scenes, with rustic figures of gleaners and the like, also mostly from Scotland. (3) Other illustrations of past times, involving the picturesque grouping of figures and animals, some being suggested by scenes in the Waverley Novels.

Tayler handled water-colour with free fluid strokes which he seems to have derived from a study of Cox. Ruskin[2] couples them, saying that 'the purity and felicity of some of the careless, melting, water-colour skies of Cox and Tayler may well make us fastidious of all effects of this kind'. But as usual, he is making a comparison with Turner, and so continues: 'In Tayler and Cox the forms are always partially accidental and unconsidered, often essentially bad, and always incomplete; in Turner the dash of the brush is as completely under the rule of thought and feeling as its slowest line.' Earlier, in the first chapter of *Modern Painters*, he had written that 'there are few drawings of the present day that involve greater sensations of power than those of Frederick Tayler. Every dash tells, and the quantity of effect obtained is enormous in proportion to the apparent means. But the effect obtained is not complete. Brilliant, beautiful, and right, as a sketch, the work is still far from perfection, as a drawing.'

Tayler, Cattermole and other water-colour painters of this period were, like Bonington, increasingly using body-colour, partly through a desire to push their painting to the force of oil, partly to save labour. Thackeray was outspoken in giving his opinion about the demerit of body-colour with reference to a painting by Tayler:

> We are led bitterly in this picture to deplore the use of that fatal white-lead pot that is clogging and blackening the pictures of so many of the water-colour painters nowadays. His large picture contains a great deal of this white mud, and has lost in consequence much of that liquid mellow tone for which his works are remarkable.

[1] Vol. II, p. 177.
[2] J. Ruskin, *Modern Painters*, I, § 24.

Louis Haghe (1806–1885) was another painter whose romantic leaning caused him to divide his interest between figures and an environment of medieval architecture. Born at Tournai, Belgium, he was the son of an architect. His right hand being deformed from his birth, his work was executed entirely with his left hand. He studied lithography at Tournai, working with the Chevalier de la Barrière and J. P. de Jonghe, and, coming to London at an early age, entered into partnership with William Day, a publisher in Gate Street, Lincoln's Inn Fields. Their success was largely due to Haghe's own artistic powers, and also to the fact that Day and Haghe had the knack, like Ackermann, of gathering round them a brilliant and resourceful staff. It was Haghe who executed the lithographs for David Roberts's *Holy Land*. From 1840 to 1850 he issued his own *Sketches in Belgium and Germany*; the first volume with twenty-six plates in 1840, the second with twenty-six plates in 1845, and the third with twenty-seven plates in 1850. In 1852 he published his last work in lithography, a set of views at Santa Sophia, Constantinople, and resigned from the firm, which continued as Day and Sons, and later as Vincent Brooks, Day and Son.

From 1835 Haghe exhibited at the New Water-Colour Society (now the Royal Institute), and served as its President from 1873 to 1884, the year before his death. Though he was resident in London, his favourite subjects were scenes in the old towns of Belgium, Germany and Northern France. In 1853 Dickens found Haghe and David Roberts painting together in St. Peter's at Rome. Particularly in the old town-halls of Flanders, Haghe found the sculptured fireplaces, the walls hung with tapestries or Cordova leather, the massive carved furniture, which, as in the case of Cattermole, served him as background for conclaves of burghers or military leaders clothed in doublet and hose, armour and rich furs. His work is much less lively than that of Cattermole, but he was far more conscientious as a draughtsman, taking infinite pains to indicate details, and using his pencil skilfully both to generalise his masses and to define the particulars. Ruskin puts him on a lower level than Prout, saying that, 'Haghe's work may be depended on for fidelity. But it appears very strange that a workman capable of producing the clever drawings he has, from time to time, sent to the New Society of Painters in Water-Colours, should publish lithographs so conventional, forced and lifeless.'

Joseph Nash (1808–1878), son of a clergyman who presided over a private school at Croydon, was born at Great Marlow. In 1829 he became a pupil of Augustus Pugin, and accompanied him to Paris to help in making drawings for *Paris and its Environs*. Though, like Haghe, he was chiefly concerned with lithography in the early part of his career, he was training himself to become a very skilful draughtsman and a painter of *genre*. In 1834, along with George Chambers and Charles Bentley, he was elected an associate of the Old Water-Colour Society, and became a full member in 1842. His exhibits were architectural subjects, interspersed with designs from Shakespeare, Scott and Cervantes. Examples of this work were plates for *The Keepsake* and other Annuals between 1834 and 1848. His great success and celebrity were achieved by his careful studies of civil architecture, in which he showed a liking for the late flamboyant period of the Gothic style and

93

its mixture with that of the Renaissance. Knole, Hampton Court and Speke Hall, among others, were buildings which made a constant appeal. He was quite openly competing with Cattermole—and both of them agreed in the lavish use of body-colour—but Nash made no pretension to the other's dramatic power and luxuriant fancy. He liked to dispose and group his figures in gay costume set off by a pleasant play of light and colour, but his nobles, cavaliers and stately dames were not the main source of attraction as in Cattermole's work. They were accessories to the architectural scene, which was nearly always the grand interior of a Tudor baronial mansion or an Elizabethan hall.

In 1838 Nash published a set of twenty-five lithographs with the title *Architecture of the Middle Ages*, for the most part foreign ecclesiastical buildings; and from 1839 to 1849 issued four sets of twenty-six lithographs entitled *The Mansions of England in the Old Time*, described as 'depicting the most characteristic features of the domestic architecture of the Tudor Age, and also illustrating the costumes, habits, and recreations of our ancestors'. The plates are admirably coloured and *Nash's Mansions* has taken its place as an historical work of lasting value. Three of the original water-colours lithographed for this series are in the British Museum,[1] and it is interesting to compare them with the prints and to note the shifts and changes made by the artist in the figures and their grouping: there is always, however, the feeling that he was a producer moving about a crowd of rather conventional crowd players. In the Victoria and Albert Museum are numerous examples of his work, including *The Black Knight and Wamba the Jester fall into an Ambuscade*,[2] which show his skill in handling a forest scene, as a complete change from his architectural work.

The direct successor to Cattermole and Nash, as a maker of the sentimental romance and picturesque *genre* so dear to respectable Victorians, was Sir John Gilbert (1817–1897), born in Blackheath, nine years later than Nash. With a view to following his father's profession he spent two years with a firm of estate agents in the City. Seated at an office window overlooking the Mansion House, he spent his time in making graphic notes of costumes and liveries of City Companies and the florid trappings of man and horse that enhance the dignity of the Corporation of London. He filled his portfolios with sketches on Woolwich Common of the Royal Horse Artillery and other troops upon manœuvre till he knew the uniforms of the British Army to the last buckle and button. Uniforms and military equipment, troops and war-horses, were to figure among his later subjects, and he had consummate skill in suggesting their sweep and movement over rolling ground or in wild forest landscape. His *Crusaders on the March*[3] (Pl. 116), dated 1862, is typically effective. While he was gathering the material which led to this kind of work it became quite obvious that Gilbert would never make a good land and estate agent. In 1836 he abandoned his office stool and began to exhibit at the Royal Society of British Artists and the British Institution, but his chief employment was in drawing upon wood for book-illustrations.

[1] B.M. 1900. 8.24.524–526. [2] V.A.M. 1038–1873. [3] V.A.M. 217–1890.

His masterpiece was the *Shakespeare* in three volumes, for which he designed four illustrations a week during the four years over which its publication was spread. For a long time he was the leading artist for *The Illustrated London News*, to whose first number in 1842 he contributed, little thinking that his illustrations in this paper alone would amount to some thirty thousand in all.[1] He did constant work for *The Leisure Hour* and *The London Journal*. The library catalogue of the British Museum contains about 150 separate entries of books illustrated wholly or in part by Gilbert. His work of this nature appeared at the time 'eminently daring, suggestive, picturesque and playful'. 'Sir John Gilbert', says one of his contemporaries, 'has the faculty of thinking out his subject at the end of his pencil. He extemporises on paper as a musician does on the piano; a theme given, he can reduce it to form; a narrative read, he at once knows how best a picture can be made. His fertility of pictorial invention is inexhaustible.'[2]

From about 1851 Gilbert transferred his chief energies to water-colours. Together with Samuel Palmer, he was elected an associate of the Old Water-Colour Society in 1852 (two portraits painted by him in this year are in the Laing Art Gallery, Newcastle). He became a full member in 1854, and on the retirement of F. Tayler became President in 1871. He was knighted in 1872, and as an oil-painter (though he used the medium neither much nor proficiently), became A.R.A. in that year and R.A. in 1876. He followed the earliest members of his group in choosing subjects from Shakespeare, *Gil Blas* and *Don Quixote*. His work in water-colour was lively and amusing, but never very profound in thought or characterisation. Mr. Ralph Edwards, indeed, describes his *Don Quixote and Sancho Panza*[3] as representing 'two gentlemen in fancy dress careering through Devonshire on a summer afternoon'. His jumble and hotch-potch of book-illustrations had made him far more nimble and mercurial than Cattermole. His prolific work on the block had given him extraordinary freedom of manipulative execution. He used the point of his vagrant and shifting brush as if it were an easily running pen or pencil, and he was successful in giving a sense of movement and atmosphere. He was a powerful colourist, fond of rich and full contrasts, from scarlet in a soldier's coat or cardinal's robe to harmonies of black and grey. He was never consistent and symmetrical like Cattermole or Nash. In an atmosphere where they were pedantic erudite dons, Gilbert was the lively erratic undergraduate. While they were cloistered among the historical and antiquarian bric-à-brac of baronial halls Gilbert went roving and crusading in search of romance. He had greater sympathy than either of them with the actual quality of his medium and its fluid transparency. To the Corporation of London for their Guildhall Gallery Gilbert presented in 1893 thirteen water-colours and thirty other drawings slightly tinted, or in black and white. The water-colours show Gilbert's experiments in working upon the very large scale which is so often tiring and disastrous for the medium. Three of them have a height or width of

[1] H. Hubbard, *Some Victorian Draughtsmen*, 1944, p. 22.
[2] J. B. Atkinson, *English Artists of the Present Day*.
[3] V.A.M. 1762–1900.

sixty inches or over. *The Witch*, of more normal size (24 × 36 inches), shows his feeling for drama and his skill in depicting the movement of horses. To the Royal Academy he bequeathed a number of scrap-books, filled with his sketches and usefully annotated. At the beginning of one of these volumes is the inscription 'John Gilbert, Vanburgh Park, bought this book 25th August 1868, 10s. "The true artist talks but little about art: he leaves that to those who know nothing about it."'[1]

Coming to the fore somewhat later, but belonging to the same school, was Sir James Dromgole Linton (1840–1916). Born in London, he studied at Leigh's Art School in Newman Street, and exhibited from 1863 onwards at the Dudley Gallery and elsewhere. In his early years he made many drawings for *The Graphic*, became an associate of the Institute of Painters in Water Colour in 1867, a member in 1870 and was elected President in 1884, soon after the Institute won the prefix of 'Royal'. He held office from 1884 to 1898 and from 1909 to 1916, and was knighted in 1885. In his work he was a little laboured and heavy-handed, following Cattermole in a dull and encyclopædic fashion but without any of Cattermole's *curiosa felicitas*. He painted figure subjects and liked colour in costume and rich stuffs, but the costume was fancy dress. It cannot be said of him that he had a creative or imaginative mind, but as an accomplished speaker and man of the world he made an ideal President.

Under the rule of Haghe, Linton and E. J. Gregory, the Royal Institute took a benevolent interest in the art of figure painting and particularly in the work of book-illustrators. Charles Green, E. H. Fahey and William Small were all prominent in the latter field, as was Sir Hubert von Herkomer in the early days of his drawings for *The Graphic*. Then the ranks included war correspondents, such as William Simpson and R. Caton Woodville. G. H. Boughton, Alfred Parsons and Edwin Abbey were members and masters of illustration before their subsequent achievements overshadowed their work for the printed page. Randolph Caldecott, Kate Greenaway and Walter Crane, that great trio famed for their children's books, were on the roll of members; and then came Sir John Tenniel, Bernard Partridge, Hugh Thomson, Phil May, Claude Shepperson, Tom Browne and Charles Brock. The tradition is still continued by living members and differentiates the Institute from the Water-Colour Society, where Cattermole, Nash and Gilbert have had few descendants, though Arthur Rackham, one of the great book-illustrators, was an esteemed member.

As a postscript to this chapter we may pick up the threads of portraiture, with reference here not to miniatures but to portrait drawings over miniature size executed with a free use of water-colour on paper. Such portraiture did not die out with Downman and Edridge, for the Annuals rekindled the flame and kept it alive. Their readers revelled in the sight of Araminta smelling a rose or Arabella reading a love-letter. Moreover, in pre-photography days there was a family demand for likenesses which, being larger than

[1] R. Davies, *Sir John Gilbert*, O.W.S. Club, X, 1932–3.

miniatures, might adorn the drawing-room wall and were less costly than a miniature or an oil-painting. The water-colour portrait had a distinct vogue until it was ousted by the photograph, but one feels that even now it might be possible to revive a liking for the pleasant drawing which conveys, as no photograph can, the colour and character of the sitter as seen and interpreted by an artist. With painters like J. F. Lewis, William Hunt and others, whose portraits we have already met, portraiture lay in a side street; but with others it was the main frontage of their professional work. Though portrait-drawings were immensely popular, particularly from about 1840 to 1860, they have tended to remain in family ownership, and remarkably few have passed through the sale room (their market value has never been sufficiently high to encourage sellers) or have found a place in public collections. Some exception may be made in the case of George Richmond, to whom we shall come later, and A. E. Chalon, whose prolific work as a portrait draughtsman has already been mentioned.[1]

Among early practitioners in the nineteenth century was Horace Beever Love (1780–1838), born in Norwich, who exhibited portrait drawings at the Royal Academy from 1833 to 1836. He made a portrait in water-colour of Cotman[2] (Pl. 117) in 1830, which once belonged to James Reeve; and in the Victoria and Albert Museum is a full-length figure of a little girl in a blue dress,[3] painted two years earlier. Thomas Wright (1792–1849), born at Birmingham, was a pupil of Henry Meyer and worked as a stipple engraver and portrait draughtsman in London. During two periods of his life (1822–6 and 1830–45) he worked in St. Petersburg. In the British Museum are two portraits by him,[4] in pencil with touches of colour in the Edridge manner.

Stephen Poyntz Denning (1795–1864) was the author of a charming portrait group of the *The Children of Elhanan Bicknell*[5] (Pl. 119), painted in 1841 and exhibited at the Royal Academy in 1842. Denning began life as a beggar boy, but at the age of twenty-six was appointed curator of the Dulwich Picture Gallery. He died at Dulwich College forty-three years later, in 1864. Rather less is known about him than about Elhanan Bicknell, father of the children he painted. Bicknell was a merchant who derived a large fortune from whale fishery. He was one of the great nineteenth-century art patrons, a collector of paintings by Turner and between 1838 and 1851 filled his country house at Herne Hill with pictures and sculpture. His collection was described by Waagen,[6] who says about the drawing-room that 'the chief ornament of the room consists of a collection of admirable drawings in water-colour, which cover the walls', and writes of the children's portrait that 'the cheerful sunny transparent character of this picture corresponds admirably with the happy ages of the little party, among which a girl in a white frock, in the centre, is particularly remarkable'.

Another portrait painter of the same school was Octavius Oakley (1800–1867). He

[1] Vol. II, pp. 149–151. [2] B.M. 1902. 5.14.442. [3] V.A.M. E.661–1923.
[4] B.M. 1883. 5.12.165 and 166. [5] V.A.M. P.18–1934.
[6] G. F. Waagen, *Treasures of Art in Great Britain*, 1854–7, Vol. II, p. 349.

was sent at an early age to work with a cloth manufacturer near Leeds, with a view to following his father's trade as a wool merchant. Soon, however, he was making pencil portraits of his acquaintances, and when sitters became numerous he set up as a professional artist. His talent became known and gained him the support of aristocratic and influential patrons. He worked at Leamington, and when he took up residence in Derby, about 1825, was invited to stay at Chatsworth, where he painted the Duke of Devonshire and many of his distinguished guests. From Derby he used to drive round the country, executing groups and single figures in water-colour. It must have been about this time that he made the water-colour portrait of Sir George Sitwell of Renishaw, great-grandfather of Sir Osbert Sitwell, who reproduced it in *Left Hand, Right Hand*, 1945. It is a charming piece of work, finely drawn and composed, with all the accents rightly distributed; and it shows Oakley as a worthy successor to Henry Edridge. He had seventeen portraits in the Royal Academy between 1826 and 1832, but abandoned this, the best aspect of his art, for the landscapes and gipsy subjects which he painted during several years. About 1841, he came to London and in 1842 was elected an associate of the Old Water-Colour Society; full membership followed two years later. While still sending so many drawings of rustic subjects to the Society's exhibitions that he was known as 'Gipsy Oakley', he resumed his portrait subjects, of which he sent thirteen to the Royal Academy between 1842 and 1860. He died at 7, Chepstow Villas, Bayswater.

Best known of all this little group is George Richmond (1809–1896), son of Thomas Richmond (1771–1837), a miniature painter. He was born at Brompton, then a country village. At the age of fifteen he entered the Royal Academy schools and was much impressed and influenced by Fuseli, the professor of painting. Among his fellow-students were Edward Calvert and Thomas Sidney Cooper, and at the same time he formed a lifelong friendship with Samuel Palmer. With Palmer and Calvert he was among the little band of Blake's followers known as *The Ancients*. Palmer and he made frequent drawings of the magnificent oaks in Lullingstone Park, which lies within an easy walk from Shoreham, where Palmer resided in his earlier days. At the age of sixteen Richmond met Blake in Linnell's house at Highgate, accompanied the painter-poet on his homeward journey, and felt 'as though he had been walking on air, and as if I had been talking to the prophet Isaiah'. In 1827 he was present at Blake's deathbed, and followed him to his grave in Bunhill Fields. Richmond's early work followed Blake's manner earnestly and felicitously, but this influence faded away after the master's death.[1]

In 1828 he had earned enough money by painting miniatures to enable him to study art and anatomy in the schools and hospitals of Paris. At Calais, on his outward journey, he exchanged pinches of snuff with the exiled Beau Brummel and wrote to Palmer that 'from enquiry, two might go to Rome and stay six months, for ninety pounds between them'.

[1] See reproductions in *Followers of William Blake*, by L. Binyon, 1925.

To the Academy, from 1825, Richmond sent poetical subjects which showed the strong influence of Fuseli, and still more of Blake; so much so that, even in 1839, Linnell in a letter to Palmer speaks of Richmond as 'entirely devoted to spiritual art . . . leaving the Vanity Fair and entering the wicket gate to go to the New Jerusalem'. That was not the entire truth, for in 1831 Richmond eloped to Gretna Green with a daughter of Tatham, the architect, and adopted portraiture as the readiest means of securing an adequate income. In 1829 he made the water-colour portrait of Lord Sidmouth now in the National Portrait Gallery, and in 1831 a similar portrait of William Wilberforce, which was engraved by Samuel Cousins and gave the painter an assured position. Then came a long series of successful portraits in water-colour of Lord Teignmouth, members of the Fry and Gurney families, and many distinguished patrons. In 1868 he earned £3469 14s. 6d. He became the G. F. Watts of his day, man of mark, and painter of the great. In 1834 Palmer sent him a letter, explaining that he had got out a sheet of his best writing-paper, 'as you are now become a great man'; and we shall find later that when Palmer was stranded without money at Tintern it was to Richmond he wrote for a small loan.[1] It is not without significance that whereas Palmer always addressed Calvert as 'My very dear Friend', his letters to Richmond, even after years of friendship, always begin, 'My dear sir'.

In 1827 the Rome journey at last took place. Richmond and his wife started out in company with Samuel Palmer and his bride who were on their honeymoon journey; and the Richmonds stayed in Italy for about two years. After their return and until about 1846 Richmond worked almost entirely in crayon and water-colour, his ideal of portraiture being 'the truth lovingly told'. Then, as a painter in oil, elected A.R.A. in 1857, and R.A. in 1866, he passes beyond our province, though throughout his life he made numerous slight sketches of landscape and figures in pencil and water-colour. A large exhibition of portraits by him was held at the Castle Museum, Norwich, in 1937. It showed that among his early patrons were five East Anglian families, the Hoares, Gurneys, Buxtons, Barclays and Upchers, who derived their wealth from banking and were keen workers for the anti-slave movement and for social reform generally.

At this point a sidelong glance must be cast at Thomas Frank Heaphy (1813–1873), son of the Thomas Heaphy who was one of the early members of the Old Water-Colour Society. T. F. Heaphy began life as a portrait-painter in water-colour and for many years enjoyed an extensive patronage, but branched off into the painting of subject pictures in oil. He exhibited at the Royal Academy from 1831. Thereafter he spent many years in an investigation of the traditional likeness of Christ, and his researches provided the subject-matter of a volume, *The Likeness of Christ*,[2] edited by Wyke Bayliss in 1880, seven years after Heaphy's death. Of Heaphy as portrait-painter I have little personal knowledge (and

[1] In 1831 Palmer had lent Richmond £40 to enable him to get married and had given Mr. and Mrs. Richmond a temporary home at Shoreham. See the grateful letter from Richmond in 1847, when his daughters were being taught by Palmer. (V.A.M. Palmer Exhn. Catalogue, 1926.)
[2] An album of drawings and oil sketches for this work is in the British Museum, 1881. 6.11.358–401 (201.c.3).

know of no portrait by him in any museum or public gallery), but I once saw a skilful and charming portrait by him, belonging to Col. G. Loring. It would undoubtedly have been ascribed to George Richmond, but for an inscription on the back: *No. 5. T. F. Heaphy, 8 Great Marylebone Street, Cavendish Square.*

Among those who carried on the old tradition of figure-painting into the second half of the century were F. W. Topham and Hugh Carter. Francis William Topham (1808–1877), born at Leeds, was apprenticed to his uncle, as a writing engraver, and about 1830 came to London to work as an engraver of heraldic designs. Then he took to line-engraving in general (Roget gives a long list of his engraved works) and passed on to painting in water-colours. He was a member of a society of artists, founded about 1823, which met in a rough room down a stable-yard in Gray's Inn Lane for the study of a model brought in from the streets.[1] In 1842 he was elected an associate, and in 1843 a member of the New Water-Colour Society. He retired in 1847, and became first associate, and then member, of the Old Society in the following year. Scottish and Irish peasants, under such titles as *Galway Peasants*[2], 1857, (Pl. 121), and *Highland Smugglers leaving the Hills with their Whisky*, 1851, are frequent in his drawings. In 1852–3 he travelled in Spain, and exhibited subjects such as *A Gipsy Festival near Granada*, 1854, and *Spanish Gossip*, 1859. After paying his second visit to Ireland (the first was in 1844) he returned to Spain at the end of 1876, and died at Cordova. Topham was of his period in the use of body-colour. Joseph J. Jenkins,[3] who often worked beside him, related that Topham 'put on colour and took off colour, rubbed and scrubbed, sponged out, repainted, washed, plastered and sputtered his drawings about in a sort of frenzied way in the effort to produce something lurking in his mind, but which he could not readily realize'.

Hugh Carter (1837–1903), born at Birmingham, was the son of the solicitor to the London and North Western Railway. He studied at Heatherley's Art School, and afterwards with F. W. Topham, J. W. Bottomley, Alexander Johnston and John Phillip, R.A. He began to exhibit at the Royal Academy in 1859, and during the 'sixties went to study at Düsseldorf under E. von Gebhart. As a water-colour painter he became an associate of the Institute of Painters in Water-Colours in 1871, and full member in 1875. A visit to Holland after this date brought a good deal of the Hague school, particularly of Josef Israels, into his subjects and his treatment, as is shown in *The Young Mother*.[4]

To close this chapter brief reference may be made to a little-known painter of figure subjects, Margaret Gillies (1803–1887), the niece of Lord Gillies, an Edinburgh judge. Brought up in his house after her mother's death, she lived in an artistic and literary society, coming into contact with Sir Walter Scott, Jeffrey and Lord Eldon. She resolved to try her fortune in London as an artist, and received instruction from Frederick Cruickshank in miniature painting. From 1832 to 1861 she was a steady annual exhibitor of

[1] Afterwards the Langham Sketching Club, see p. 59.
[2] V.A.M. 545.
[3] Roget, II, p. 325.
[4] F. J. Nettlefold Cat., Vol. I, p. 52.

110 'Fair scene in London'
London, Courtauld Institute of Art, Spooner Bequest 8½ × 12½: 216 × 317 *Water-colour*
John Augustus ATKINSON (1775–after 1833)

111 'Battle scene'
Coll. Mr & Mrs Paul Mellon 7½ × 15: 190 × 381 *Water-colour*
John Augustus ATKINSON (1775–after 1833)

112 'Huntsman'

London R.W.S. (diploma drawing) 18×24½: 456×621 *Water-colour*

J. Frederick TAYLER (1802–1889)

113 'Interior of a Baronial Hall'

V.A.M. 1454–1869 13⅛×17½: 333×444 *Pencil and water-colour*

George CATTERMOLE (1800–1868)

114 'The Shrine of the Three Kings, Cologne Cathedral'
B.M. 1900.8.24.490 15¾ × 11 : 400 × 279 *Water-colour*
Louis HAGHE (1806–1885)

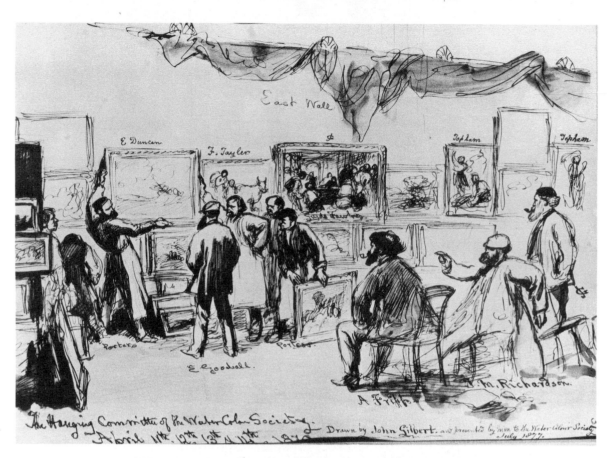

115 'The Hanging Committee of the Water-colour Society'
London R.W.S. 12¾×9¼: 321×236 *Pen and wash, signed and dated 1877*
Sir John GILBERT, R.A. (1817–1897)

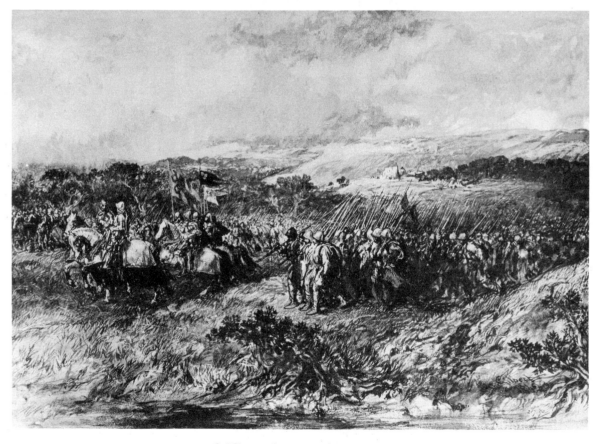

116 'Crusaders on the march'
V.A.M. 217–1890 11⅞×17¾: 302×451 *Water-colour, signed and dated 1862*
Sir John GILBERT, R.A. (1817–1897)

117 'John Sell Cotman'
B.M. 1902.5.14.442
$10\frac{3}{4} \times 9\frac{1}{2}$: 273 × 246
Pencil and water-colour
ce Beevor LOVE (1780–1838)

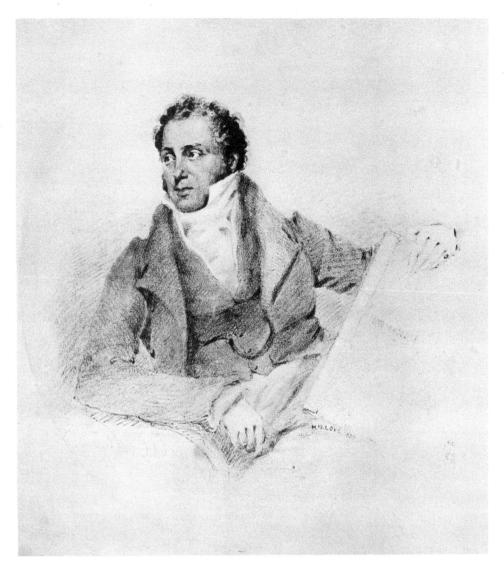

118 'Long Gallery,
Haddon Hall, Derbyshire'
Coll. Mr & Mrs Paul Mellon
$21\frac{1}{4} \times 30$: 540 × 762
Water-colour, signed and dated 1839
Joseph NASH (1808–1878)

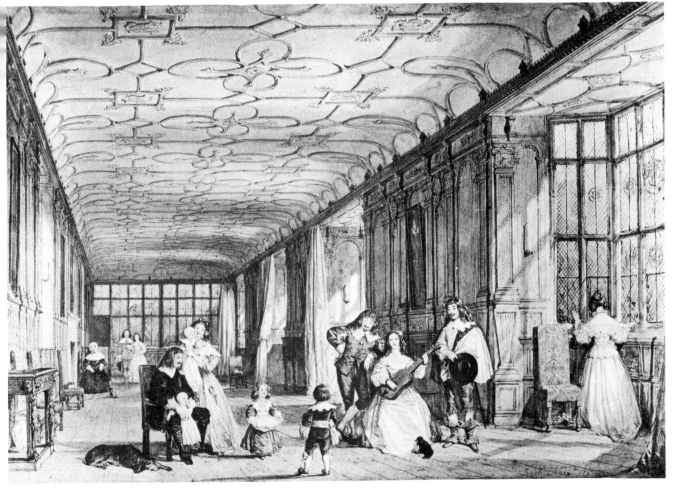

119 'The children of Elhanan Bicknell'

V.A.M. P.18–1934 20 × 30⅛: 506 × 763 *Water-colour, signed and dated 1841*

Stephen Poyntz DENNING (1795–1864)

120 'Landscape near Boulogne'

V.A.M. P.34–1952 5 × 7: 127 × 178 *Water-colour, dated 1859*

George RICHMOND, R.A. (1809–1896)

121 'Galway Peasants'
V.A.M. 545
$15\frac{3}{8} \times 12\frac{1}{4}$: 390 × 310
Water-colour, signed and dated 1857
Francis William Topham (1808–1877)

122 'Capuchin Convent, Albano'
V.A.M. D.2–1905
$10\frac{3}{8} \times 14\frac{3}{8}$: 264 × 365
Water-colour, signed
Hugh Carter (1837–1903)

123 'Buy my spring flowers'
V.A.M. 1466–1869
24 × 16⅝: 608 × 472
Water-colour
Octavius OAKLEY (1800–1867)

124 'June in the Country'
Coll. Mr Leonard G. Duke
5 × 12: 127 × 304
Water-colour
Margaret GILLIES (1803–1887)

portraits at the Royal Academy. In 1851 she went to Paris and studied under Ary Scheffer, and in 1852 won election to the Old Water-Colour Society, where she exhibited figure subjects and fancy compositions. The Fine Art Society in 1945 exhibited a very attractive costume piece, *London in June*, signed M. G. and dated 1850; Mr. Leonard Duke owned a companion piece *June in the Country*[1] (Pl. 124), similarly signed. I can think of no other M. G. in 1850 except Margaret Gillies who could have produced drawings of such accomplishment and charm.

[1] Coll. Mr. Leonard G. Duke.

CHAPTER VI

The Victorian Picturesque

William Hunt Myles Birket Foster Helen Allingham
Henry Benjamin Roberts William Hough George Samuel Elgood

There could be no more perfect representatives of what is generally understood as Victorian Art than William Hunt and Birket Foster. 'It has been estimated', says G. M. Young,[1] 'that between 1815 and 1830 the purchasing capacity of the classes above the wage-earning level was all but doubled.' After 1830 those classes increased and incomes became still higher. A period of profit-making and a sense of steadily improving security caused the building of larger and more comfortable houses both in country and in town. The occupants of what Felicia Hemans first called the 'stately homes' of England, standing among ancestral trees, were no longer the only patrons of art. The rising merchant and the successful manufacturer who represented the new aristocracy of wealth were filling their cellars with sound port and claret, their libraries with books such as 'no gentleman's library should be without', and their rooms with pictures. Water-colours, with their gold mounts and frames, became part of the paraphernalia attached to a prosperous, well-ordered way of life. Very often they hung three deep on the drawing-room wall. Those whom Disraeli described as 'the lords of suburban villas, the owners of vineries and pineries', bluff, hearty, unimaginative men sought the kind of art which, like themselves, had an air of sleekness and prosperity. Artists prospered in England as never before. Their patrons, calling the tune, knew the value of competition, and were quite prepared to outbid one another for what seemed the height of artistic perfection. 'In those days,' said Sickert, 'at least if they patronised, the brutes bought.' In exhibitions and in sale-rooms prices began to soar. And pictures, so far as they were innocent, were part of the spiritual uplift encouraged by the moral revival and evangelistic religious experience shared by high and low, rich and poor. The new rich lived in a world where respectability was one of the highest virtues. What could be more innocent and respectable than water-colours?

To a large extent the water-colours of the Victorian era reflect the dullness, vulgarity, pretentiousness and self-righteousness of the period. The water-colours of the time, compared with those of J. R. Cozens, Sandby or Girtin, are like the contemporary architecture

[1] G. M. Young, *Victorian England*, 1936, p. 6.

102

of the Gothic revival with its plethora of ornamentation, following upon the dignified grace and proportion of the Adam brothers or the simplicity and comeliness of spacious Georgian dwellings. The earlier water-colours were made as though to harmonise with furnishings of Chippendale and Sheraton. The mentality of the Victorian era demanded pictures to suit surroundings that were more ostentatious and ornate. The love for debased and superfluous ornament in every kind of architecture, furniture and fittings was accompanied by a similar degradation in all the arts. There was a lavish display of 'useless, excessive, meretricious adornments', which is the dictionary definition of 'frills'. The chesterfield was bedizened with plush or velvet stamped out with a floral design. Older men, like Prout, Cox and De Wint, in their later lives, were compelled by popular taste to seek the *réclame* given by large gold-mounted and gold-framed pictures showing high finish, topographical exactitude, and a touch of sentiment. The opulent buyer liked the grandiose and pretentious picture, which made him feel that he was getting full value for his money, and Whistler's dictum that 'the large etching is an offence' is equally applicable, as a general statement, to the large water-colour. Fortunately for us, Cox, De Wint and others had times when they sat in a hayfield under a breezy sky and painted on a small scale to please themselves. That is how the good water-colour is made, and not in a studio, on a large sheet of the finest Whatman paper, for a clamorous client.[1] Cox and De Wint combined freedom and the prison-house. Birket Foster, on the other hand, born in 1825, grew to maturity with the Victorian age, and his art is a microscosm of the taste, temper and sentiment of his time. William Hunt is more interesting because, having known the earlier freedom, he was completely engulfed in what many would consider as the Victorian maelstrom. His work developed from an early simplicity of drawing and wash to a painstaking elaboration and minuteness which to the Victorians of the mid-century was their ideal of art.

It is easy for the critic to adopt a superior pose and form hostile generalisations about the art of the Victorian era. Much of it is beneath contempt, but it does not follow that everything produced in the Victorian period falls under the sweeping and comprehensive damnation which the title 'Victorian' is often considered to imply. If the critic or historian is to maintain his integrity and avoid the danger of being a mere propagandist, he must not ask whether Hunt and Birket Foster are acceptable to a modern generation, but rather ask of what school or kind is his art? Is it successful in its school or kind? Does it reflect the spirit of its time? There is no sense in trying to match a woodcut by Bewick against a fresco by Giotto, a bird's nest by Hunt against a Tintoretto, a pastoral of Birket Foster against a Claude, or any of them against a picture by Cezanne, Picasso or Matisse. As Hunt himself said, in giving advice to a young student, 'The artist must have a greater love for his art than for anything else, and try to screw himself up to doing whatsoever he does better than anyone else who has done the same sort of thing.' If Foster struggled for

[1] In 1852 Ruskin's father wrote to his son: 'I got a piece of advice from Hunt, never to commission a picture. He could not have done my pigeon so well had he felt that he was doing it for anybody.' W. G. Collingwood, *Life of Ruskin*, 1893, p. 137.

perfection in the painting of boscage and pinafores, or Hunt in the painting of peaches and pine-apples, and if they excelled in that particular kind of work, let us try to see them against the background of their time, and to appreciate their aims and their merits.

I have studied scores of drawings by Hunt and hundreds by Birket Foster, and am convinced that in their particular kind of painting (call it still-life or merely representational, if you will) they reached a summit of conscientious completion. It is true that their art conveys none of the meditative meaning which lies in things left half unsaid. But there can be acceptance of their plain and simple statement of homely truths and of their intense love of the smiling surface of Nature. And in this connection I may well quote Ruskin's principle, which he re-affirmed in his *Notes on Prout and Hunt*, that 'interest in the story of a picture does not in the least signify a relative interest in the art of painting', and that the first thing needful in these matters is 'to understand what painting is as mere painting'. When Ruskin wrote about a mug in a drawing by Hunt that, 'The whole art of painting is in that mug. . . . If you can feel how beautiful it is, how ethereal, how heathery and heavenly, as well as to the uttermost muggy . . . ', he was an evangelist, anticipating in that last emphasised word the essence of Roger Fry's gospel of Post-Impressionism.

William Henry Hunt (1790–1864), commonly known as 'William Hunt', was a Londoner, born at 8, Old Belton Street, now Endell Street. His uncle, a village butcher near Strathfield Saye, who owned some drawings by him, once told a passing visitor that they were by his 'nevvy, little Billy Hunt. He was always a poor cripple, and as he was fit for nothing, they made an artist of him.' That was partly true, in that Hunt from childhood had deformed legs, with knees and toes turned in, and could only shuffle along. This difficulty in walking, especially as he grew older, was the main reason for his abandoning outdoor landscape work and concentrating upon figures and still life. His father, a tinman, followed the good advice of those who saw promise in the boy's drawings, and placed him under John Varley about 1804. The father insisted upon having his son apprenticed for the regular term of seven years, being convinced that a knowledge of the arts was not to be learned in less time than what was legally required to make a good tinman. Young Hunt could not have had a more kindly and inspiring teacher than Varley. With Linnell, one of his fellow-pupils, he used to sketch at Kensington Gravel Pits, then open country. Unable to move about with any ease owing to his bodily infirmity, he would sit down and make careful studies of a cottage paling, an old post, or a mossy wall. Then he began to draw interiors, and frequently worked from windows overlooking the Thames and London streets or from a house in the fishermen's quarter at Hastings, a constant sketching ground throughout his life.

In 1807 Hunt made his first appearance at the Royal Academy with three oil-paintings, and in 1808, on Mulready's advice, entered the Academy schools. He was one of a group of promising students selected to help in the decorations of Drury Lane Theatre, then being rebuilt after the fire of 1809, and tried his 'prentice hand not only upon wall decoration but upon a drop scene. Soon after this he was commissioned by the Duke of Devonshire

104

to make drawings of the state rooms at Chatsworth, and by the Earl of Essex to carry out similar work at Cassiobury Park.[1] At Cassiobury he made the acquaintance of Dr. Monro, that large-hearted patron whose house at Bushey was in the neighbourhood. Roget[2] relates that Hunt 'often stayed with the Doctor for a month at a time, and was paid by him 7s. 6d. a day for the drawings he produced'. Some of his most charming outdoor drawings were made round about Bushey, where he was 'trundled on a sort of barrow with a hood over it, which was drawn by a man or a donkey, while he made sketches'.

About 1815 Hunt had an address of his own at 5, Charles Street, Soho Square, and continued to paint architectural subjects in London, or rural scenery, mainly with farms or cottages in the foreground. These early subjects were the product of Varley's teaching. In them Hunt was working with loose lines of pencil or pen, and then with colour laid in fluid and transparent washes. In his early work the tree drawing does not suffer from the 'over-fidelity' to which Ruskin refers as a characteristic of Hunt's trees.[3] On the contrary, it is reasoned out and well suggested. This work of his younger days has unquestioning sincerity: it is done without regard of convention; in line and colour it conveys a sense of homespun poetry. In 1824 he was elected an associate of the Old Water-Colour Society, and a member two years later. By this time he had abandoned entirely his practice in oil, and made his début in Pall Mall East as a painter of rustic figures, gamekeepers, poachers, gardeners and fishermen. Let it be said here that his figures, racy of the soil, their wholesome, ruddy, pippin-like faces, their smocks and hobnailed shoes, their greedy appetites, their hoyden clumsiness, whether of lad or lass, have little of the idealised sentimentalism which was to mark the work of Fred Walker. His *Farmer in Barn*[4] in pure water-colour is a good example of this class.

Then, in 1827, Hunt began to show studies of fruit and vegetables, and won his first conspicuous success with a drawing of a vegetable stall lighted by a candle in a paper lanthorn. 'In the luminous quality', says Roget,[5] 'with which he had endowed this simple subject, his marvellous command of colour and gradations of tone were immediately recognised.' Other candlelight effects were to follow; and a series of picturesque figure compositions (he made admirable drawings of a woolly-headed negro as well as of farm-hands in smock frocks), contained an element of humour and won popular favour. In great demand, too, were the still-life pieces in which he painted 'primroses fresh from the bank and hawthorns white from the hedge', the bloom on peach or grape, the frosted gold of a pine-apple, the bird's nest full of speckled eggs on a bed of mossy green. Then, as now, there were conflicting opinions. Pictures such as *The Lump of Pudding*, raised on a fork by a small boy, or *Hot Bread and Milk*, being puffed at by a child in the presence of an

[1] The Earl of Essex had been a patron of Turner and Girtin. Turner's *Cassiobury Park*, 1807, is in the Whitworth Art Gallery, Manchester. Two drawings made by Edridge, in Cassiobury Park, are in the Sir Edmund Bacon collection.
[2] Roget, I, pp. 392, 393.
[3] *Modern Painters*, Vol. I, § 33.
[4] Birmingham, City Art Gallery.
[5] Roget, I, p. 468.

intelligent and greedy old dog, were not to everyone's liking. A newspaper critic[1] wrote about the O.W.S. Exhibition in 1831:

> Hunt's *Smuggler of Hastings* and *Gipsey Girl* are the only two of the great quantity of *single* figures he has sent this year that we would put in our portfolio. The choice of subject is for the most part of a disgusting nature, otherwise he is remarkably unfortunate in invariably getting the most ugly and common-place creatures, that are to be found within the bills of mortality, who lose not a jot of their ungainly appearance in his hands. We marvel how noblemen and gentlemen can collect pictures of *grinning urchins*, studies of *pugs, salt jars*, and such *Tom-foolery*. This certainly is the lowest ebb and prostitution of art.

On the other hand, in his second lecture on the Fine Arts in 1839, Thackeray[2] wrote:

> If you want to see *real* nature, now, real expression, real startling home poetry, look at every one of Hunt's heads. Hogarth never painted anything better than these figures, taken singly. . . . Come hither, Mr. Maclise, and see what genuine comedy is; you who can paint better than all the Hunts and Leslies, and yet not near so well.

Ruskin's appreciation was even higher, for in his *Notes on Prout and Hunt* he writes, about a drawing entitled *The Butterfly*, that the 'little brown-red butterfly (which Mr. Gurney is so fortunate in possessing) is a piece of real painting; and it is as good as Titian or anybody else ever did'. And he helps us by dividing Hunt's work into six classes:

CLASS I

Drawings illustrative of rural life in its vivacity and purity, without the slightest endeavour at idealisation, and still less with any wish either to caricature or deplore its imperfections. All the drawings belonging to this class are virtually faultless, and most of them very beautiful.

CLASS II

Country life, with endeavour to add interest to it by passing sentiment. The drawings belonging to this class are almost always over-finished, and liable to many faults.

CLASS III

Country life, with some expression of its degradation, either by gluttony, cowardice, or rudeness. The drawings of this class are usually very clever, and apt to be popular; but they are on the whole, dishonourable to the artist.[3]

CLASS IV

Flower pieces. Fruit is often included in these; but they form a quite separate class, being necessarily less finished drawings—the flowers sooner changing their form.

CLASS V

Fruit pieces, on which a great part of the artist's reputation very securely rests.

[1] V.A.M., *Cuttings from English Newspapers*, VI, No. 1599.
[2] *Fraser's Magazine*, 1839.
[3] Elsewhere Ruskin says: 'There is no place for humour in true painting.'

CLASS VI

Dead animals. Alas! if he could but have painted living ones, instead of those perpetual bunches of grapes. But it could not be. To a weakly sensitive nervous temperament, the perpetual changes of position, and perpetual suggestion of a new beauty in an animal, are entirely ruinous: in ten minutes they put one in a fever. Only the very greatest portrait-painters—Sir Joshua and Velasquez—can draw animals rightly.

I imagine that in Class I ('virtually faultless') Ruskin intended to include the earlier drawings of farm, field and fold; but he omits mention of some equally admirable drawings made in London at the same period. And, perhaps because Hunt once failed with a commissioned portrait of Mrs. Ruskin, he makes no reference (there should be a Class VII) to the light, easy and spontaneous portraits which Hunt painted for his own pleasure: one, for instance, of Samuel Prout; his self-portrait in the British Museum[1]; and the brilliant study of James Holland[2] to which reference has been made in a previous chapter.

Hunt's two periods—the dividing line came about the time of his election to the Old Water-Colour Society—are marked by a complete change of technique. He would almost seem to embody two different personalities, and today there is an understandable reaction in favour of his earlier style with its honesty and unemphatic directness. In his first period, as has been said, he made drawings which followed the old traditions and were dependent upon skilful notation with the reed pen and upon the simple management of luminous colour, with a preference for cool browns and greys. Then he began to discard the even wash and to work in detached and sharply defined touches and patches, breaking up his washes into varieties of colour, often using body-colour in parts of his work. His portraits and figures are painted in this manner, and it is a method which helped to lend atmosphere to his interiors. Ruskin points out that in Hunt's fruit and flower pieces the most desirable colours cannot be obtained by any direct wash of pigment (there is no blue that by itself will literally render the colour of a violet or a plum) but only by broken colour and by superimposed or interlaced touches of pure tint. When Hunt came not merely to employ body-colour here and there but to work upon a white priming in a high key, this juxtaposition of touch and touch, this use of hatching with colour, was not only necessitated but was simplified by his medium. He could glaze with his colours over the ground of Chinese White without disturbing it much or letting the ground mix to any extent into the clear transparence of his overlaid tints. It was a method which allowed for great swiftness of execution (hence the large output of Hunt and Birket Foster) and for extreme accuracy in form and gradation. As Ruskin says: 'All disputes about the use of body-colour begin and end in the "to be or not to be" of accurate form.' Not by any other means could Hunt have painted the bloom upon a peach, or Lewis a camel's eye.

Hunt's technique is admirably explained in the biography of James Orrock,[3] who

[1] B.M. 1889. 8.8.1. [2] V.A.M. 451–1887.
[3] B. Webber, *James Orrock, R.I.*, 1903, I, p. 149.

knew Hunt, probably watched him at work, and owned a large collection of his drawings:

> In early life Hunt painted without the use of any body-colour and it was not until the middle period that he used it. It is quite certain, however, that as no luminous sky can be produced with body-colour, so no still-life of the highest excellence can be produced without it. Hunt found this out, and left off an excessive use of transparent colour when he painted his wondrous still-life pictures. He never, however, at any time used body-colour in his figure painting. Body-colour painting in the ordinary sense means mixing pigment with body-colour. Hunt never did this; he painted on body-colour which was laid on the objects thick, and then left to dry to hardness. He would, for instance, roughly pencil out a group of flowers or grapes, and thickly coat each one with Chinese-white, which he would leave to harden. On this brilliant china-like ground he would put his colours, not in washes, but solid and sure, so as not to disturb the ground which he had prepared. By this process the utmost value for obtaining strength and brilliancy was secured, for the colours were made to 'bear out' and almost rival Nature herself.

Largely for the purpose of writing about technique in this chapter, I bought a *Plums and Mulberries* by Hunt. On the plums one can see not only the bloom, but also where it has been removed by human touch.

It is possible that the method of working on a prepared white ground was adapted from the practice of the wood-engravers. John Jackson[1] says that 'some artists, previous to beginning to draw on the block, are in the habit of washing over the surface with a mixture of flake white and gum-water'. Though Jackson did not entirely approve of this practice it was in quite general use by the middle of the century. His reference to gum-water gives a clue, I think, to Hunt's method. My own experiments in trying to elucidate the manner in which Hunt painted his fruit or birds' nests showed that, when the paper was coated with pure Chinese White, the white, being somewhat powdery in texture, became disturbed by the application of colour and tended to blur the edges and made the colour mat. One could understand the effect produced by this means in a water-colour by Arthur Melville but not in the stippled method used by Hunt with its pure colour and compact detail. But on laying a ground made of Chinese White mixed with plentiful gum, I found that the surface of the paper became, in Orrock's words, much 'more brilliant and china-like', with an almost enamel quality. The white was less liable to be 'lifted', and pure colour could be applied much more readily in stipple or in wash. I would suggest that Hunt and others, when laying their surface ground, used a free admixture of gum.

Hunt, fifteen years older than J. F. Lewis, and three years his senior as a member of the Water-Colour Society, influenced his younger colleague considerably: to some extent in subject-matter and to a large extent in the actual use of the body-colour method. I have quoted and written so fully about Hunt's method of working upon a hard priming of Chinese White, because I believe that this particular method (the mixing of colour with Chinese White before applying it to paper was an old process), can be credited to Hunt as his own invention. And I have described it fully in this chapter because it was the method

[1] J. Jackson and W. A. Chatto, *A Treatise on Wood-engraving*, 1839.

108

adopted by his successors; by Lewis, Birket Foster, Fred Walker, the whole Pre-Raphaelite group, and many others who were striving for exactness of meticulous detail.

Hunt was always experimenting. In the same drawing we may find pure colour and body-colour, delicate stippling and broad hatching of tint over tint without any process being concealed or obtrusively employed. Nor did he hesitate to use a knife to chop or slice or scratch the surface of his paper, cleaning up points and lines or patches of light, to be left untouched or modified with colour. (See *Boy and Goat*[1] (Pl. 130) and *A Brown Study*.[2]) Asked by Ruskin why he put on such and such a colour, Hunt answered: 'I don't know; I am just *aiming* at it.' On another occasion, questioned about the work of a fellow-artist, he replied: 'Well, he has fudged it out. We must all fudge it out. There is no other way than fudging it out.' He had the art of concealing his art. No drawing has less appearance of being fudged out than a fruit piece by Hunt.

Hunt's manner of painting fruit and flowers was sometimes followed very closely by W. Hough, W. Hull, T. F. Collier, J. Sherrin, J. J. Hardwick and others. During the later years of his life Hunt's ordinary price for pictures sold from his studio was 25 to 35 guineas, but in his life-time he had the pleasure of seeing *Too Hot*, a boy cooling his porridge, sold at Christie's for 300 guineas. From 1870 on—perhaps because Ruskin was still at the zenith of his influence—prices of 500 guineas and more were frequent, and *Too Hot*, or another version of it, realised 750 guineas at the Quilter Sale in 1875. Samuel Palmer[3] wrote in 1872, eight years after Hunt's death: 'The only quite certain way of making money by water-colours is, I fancy, to do such figures, fruit and flowers as William Hunt did, and to do them as well. This again wants a whole life.'

For the great mass of people who seek in pictures just what they like to imagine they see for themselves in nature, that and no more, Birket Foster will always be a great painter. Myles Birket Foster (1825–1899) was born at North Shields. He was brought to London at the age of five and was educated at Quaker Schools at Tottenham and Hitchin. He received little instruction in drawing but showed such aptitude that his father decided to apprentice him to Peter Landells, one of the leading wood-engravers of his day. Landells had been a pupil of Bewick at Newcastle, and it is more than likely that Bewick himself knew the Foster family. I cannot help thinking that young Birket Foster studied the lovely vignettes in the *Birds* and *Quadrupeds* as Foster was particularly fond of vignettes, and I have seen a sketch-book of his inscribed *For Vignettes*. In Landells' office Foster worked at cutting blocks for *Punch*, the *Illustrated London News* and other magazines, and then was employed for producing drawings of topical scenes and current events. He and his fellow-apprentice Edmund Evans were often sent into the country for this purpose, and thus he obtained his love of working from nature. In 1846 he set up on his own account, illustrating many books and for some years working upon a series of landscape and rustic subjects for the *Illustrated London News*. By 1859 he was finding patrons for his work

[1] V.A.M. 341. [2] V.A.M. 526.
[3] A. H. Palmer, *Life and Letters of Samuel Palmer*, 1892, p. 336.

in water-colour and abandoned his practice as a wood-engraver. He was elected associate of the Old Water-Colour Society in 1860 and a full member in 1862. Between 1860 and his death in 1899 he exhibited close upon four hundred drawings (but these were only a fraction of his output) in the galleries at Pall Mall East.

In 1852, 1853 and 1861 Birket Foster travelled about the Continent, chiefly up the Rhine, making innumerable colour sketches and pencil notes; and very charming his pencil studies are. At his death more than a hundred sketch-books, full of British and Continental drawings, were in his studio, and some sixty odd were sold at Christie's. His first wife died in 1859, and in 1864 he married Frances Watson, sister of J. D. Watson, a fellow-member of his Society. In 1866 he was again abroad and in 1868 visited Venice in company with W. Q. Orchardson and Fred Walker. He made many later visits to Italy, largely to execute a commission from Charles Seeley to make fifty Venice drawings for the round sum of five thousand pounds. His *Sta. Maria della Salute*[1] and *San Giorgio Maggiore*[2] (Pl. 131), in the Victoria and Albert Museum, probably come from this source. In 1863 he built a house at Witley, near Godalming, and the Surrey scene is portrayed in many of his drawings. At Witley he had Fred Walker as a constant guest and companion. The *Dictionary of National Biography* says that Walker's influence is clear in Foster's figure painting. It is only fair to suggest that this should be reversed. Walker was fifteen years younger than Foster, and was a black-and-white artist until after he came into touch with his senior member of the Water-Colour Society.

What Joseph Conrad said about the writing of books applies to every art, 'The formulas of art are dependent on things variable, unstable, and untrustworthy; on human sympathies, on likes and dislikes, on beliefs and theories that, indestructible in themselves, always changing their form—often in the lifetime of one fleeting generation.' Over the years that have passed since Birket Foster was born, opinions about his merits, his methods and his subject-matter may fluctuate but, as has been indicated, he manages always to hold sympathy and win fresh admirers. As was the case with Hunt, much of his work responded to the sentiment and taste of his time; vast numbers of his pictures are overloaded with pretty conceits; and to use a popular word of his age, he was far too philo-progenitive in pictorial offspring. But, like the topographers who were discussed in a previous chapter, he went through the mill as a draughtsman; his pencil sketches are accurate, happy, observant and lively; his figures and his animals are searchingly and honestly drawn. Where the figure predominates it has too often the obviousness of a posed model, but where children scamper over the grass, or swing on a gate, or a young mother holds up her child, or a dog chases sheep, action and movements are free, natural and well observed. As a painter, he worked with meticulous finish and with astounding technical skill. At his best he showed a fine sense of composition and command of colour. Under all the rather sugary surface of sentiment and prettiness lies a hard core of sound and honest craftsmanship. We may deplore the sentiment, but we shall be narrow-minded if we fail to respect

[1] V.A.M. 523–1882. [2] V.A.M. 524–1882.

110

the artistry. We may be bored to the extreme by his more finished pictures in quantity, but we must not overlook his quality, and especially the quality shown in the numerous outdoor studies of figures and landscapes which filled the pages of one sketch-book after another.

There are scores of drawings in Birket Foster's sketch-books, and larger drawings such as *Landscape with Mill* or *The Old Curiosity Shop*,[1] which are free of all fussy elaboration and are almost audacious in their vigour and sketchy freedom. *The Old Curiosity Shop* has a lovely quality of rich and subdued colour, applied in loose and fluid touches; and no artist ever lived who would not have been proud if he had painted the white cat which rubs its head against the antiquary's stool. Studied closely, *The Fruit Shop* (sold at Sotheby's on November 15, 1944; probably *A Fruiterer's Shop*, exhibited in 1873) must command respect for Foster both as draughtsman and colourist. The tones, details and texture of the different baskets and of all the varied fruits and vegetables are superbly realised. The girl standing in the doorway is painted, like the figures in a picture by Orchardson, with rare refinement of thin delicate tones, like flavours subtly blended. The whole colour scheme, the grey-blue woodwork as a setting for the brilliant flashes of luscious fruit and homely vegetables, has real quality; and it is quality that matters most.

If we look at such different drawings as his *Near Dalmally*,[2] and *The Sheep Fold*[3] or *The Milkmaid*[4] (Pl. 133), we may decide that all of them are statistical, without any leaven of imagination or romance, but that they render with consummate skill thousands of facts in Nature. *The Sheep Fold* is finely composed, with beautiful clarity and precision of detail in figures, wild-rose hedge, sheepfold, and distant wooded slopes in a haze of blue. *Near Dalmally* (29 × 42 inches) appeared at Christie's in 1943 beside forty-four drawings by T. M. Richardson, of the same sort of subject on the same scale, and one felt that Foster said more, and said it better.

Foster's drawings are usually small; it would be safe to say that the majority are less than half-imperial in size. His *Children Running Down Hill*[5] is larger than usual, being 13 × 28 inches, but there are some larger still. *The Meet*[6] measures 59 × 27, and *Ben Nevis*[7] (Pl. 132) $46\frac{1}{2}$ × 31 inches. Water-colours on this large scale fail, as a rule, through elaboration and lack of unity; and the method is too fluent and accidental for sustained and searching analysis of varying forms and planes, though the use of body-colour may supply far greater possibilities. It is surprising to find how Foster in *The Weald of Surrey* held the whole thing together and brought the charming group of lively figures and the melting distance into complete and satisfying unity. I know no other water-colour which to the same extent can satisfy the ambition, so common in the first half of last century, to 'approach the

[1] See, respectively, reproduction in O.W.S. Club, XI, and colour reproduction in 'English Water-Colour', *The Studio*, 1902.
[2,3] Present whereabouts unknown. [4] V.A.M. 520–1882.
[5] Bethnal Green Museum, Dixon Bequest, 1221–1886.
[6] Reproduced O.W.S. Club, XI, 1934, pl. XVII (then Coll. Sir John Jarvis).
[7] Newcastle upon Tyne, Laing Art Gallery.

111

strength of oil-painting'. Add to this that the picture, which was exhibited first at the Old Water-Colour Society in 1870, and the International Exhibition in 1871, has preserved all of its pristine freshness.

Birket Foster did his outdoor work, at home or abroad, on blocks which he could slip into his pocket, or in sketch-books containing papers of different tints. His colour-box, now belonging to the Royal Water-Colour Society, was small and of comparatively limited palette. Beginning life as a wood-engraver, he was used to drawing with pencil or pen, sometimes with a slight wash, on a box-wood block which always had a coating of white over its highly-polished surface. His familiarity with this method during twenty years, in addition to the example set by Hunt, may have encouraged him to work in colour over the smooth and brilliant surface given by Chinese White laid upon paper. Unfinished work by him shows that he made a careful pencil drawing, often covered parts of it with transparent colour, and then applied patches of Chinese White, over which he worked with stipple or hatched strokes of pure colour. His method was much the same as that of Hunt and Lewis. All of them could finish their work piece by piece, making and mending as they carried it to completion. His body-colour mixture of white made the blue of his skies sufficiently tacky for the hair strokes of his brush to show quite clearly. Sickert,[1] with his reverence for all that was best in craftsmanship, found Hunt's drawings 'exquisite'. He saw Hunt as anticipating the Impressionist technique in its multitude of small touches building up a sensitive whole. He saw how both Hunt and Pissarro 'mirror the life of their country with intense local and national character and tenderness of general observation'. He deprecated the 'taint of smiling toleration', which clings to the appreciation of Hunt's work. And for a moment I thought there was a touch of malice when Sickert wrote: 'Oh for one hour of Birket Foster! Birket Foster, with his darling little girls playing at cat's cradle, or figuring on their little slates!' But he was sincere in his admiration, and wrote later that Birket Foster's children, like Stothard's, 'bear the imprint of truth in every lovely gesture'.

William Foster (1853–1924), the second son of Birket Foster, followed his father's methods in the painting of interiors and landscapes, but never with quite the same proficiency. He studied at Heatherley's, and exhibited at the Royal Academy from 1872 onwards. Several of his water-colours, which are signed *W. Foster*, appeared at Christie's in March 1946 in a collection containing a large number of Birket Foster drawings, sold after the death of Mrs. William Foster. He was a fellow of the Zoological Society and supplied colour illustrations to several books on birds, besides doing much illustrative work in black and white.

Birket Foster's method was closely followed by Mrs. Allingham (1848–1926), whose maiden name was Helen Paterson. Daughter of a physician, she was born near Burton-on-Trent. After being educated at the Birmingham School of Design, she came to London as a

[1] W. R. Sickert, 'Fathers and Sons', *The Art News*, April 7, 1910.

125 'Dr. Monro's Carpenter at work'
Coll. Mr & Mrs Tom Girtin $11\frac{3}{4} \times 9$: 299 × 228 *Water-colour*
William Henry HUNT (1790–1864)

126 'Bird's Nest'

Coll. Mr & Mrs Cyril Fry 7½×8⅜: 192×212 *Water-colour*

William Henry Hunt (1790–1864)

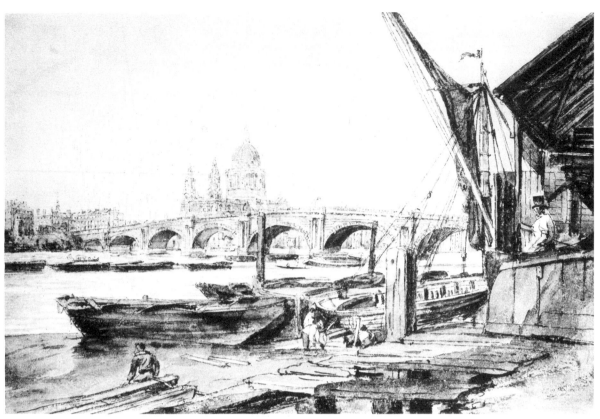

127 'Blackfriars Bridge and St. Paul's'
Coll. Mr & Mrs Paul Mellon 9 × 13⅜ : 228 × 339 *Water-colour*
William Henry HUNT (1790–1864)

128 'Blacksmith's Forge'
Coll. Mr J. A. Crabtree 12 × 16½ : 304 × 418 *Water-colour*
William Henry HUNT (1790–1864)

129 'The Morning Ride'
Coll. Mr & Mrs Paul Mellon 2⅛ × 5¾ : 54 × 147 *Water-colour*
Myles Birket FOSTER (1825–1899)

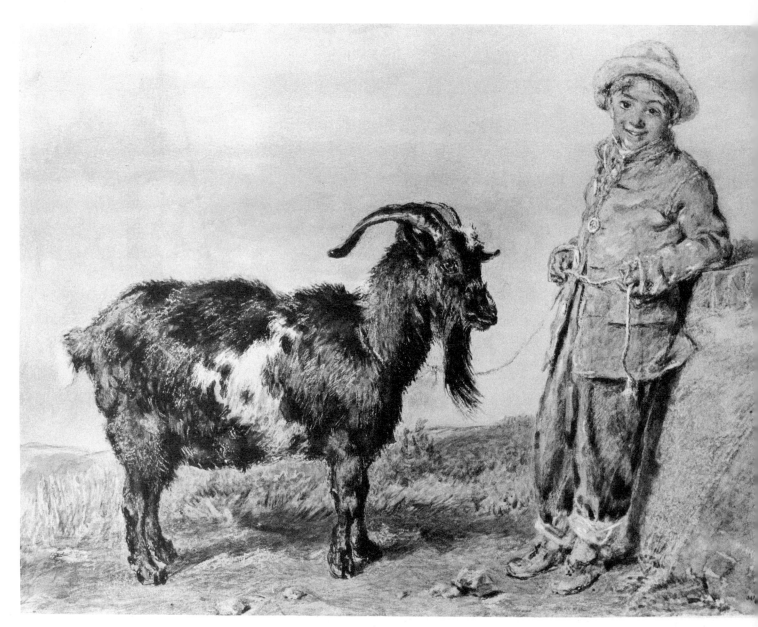

130 'Boy and Goat'
V.A.M. 341 12¼ × 16 : 310 × 406 *Water-colour, signed and dated 1836*
William Henry HUNT (1790–1864)

131 'San Giorgio Maggiore, Venice'
V.A.M. 524–1882 7¼ × 10¼ : 185 × 260 *Water-colour, signed*
Myles Birket FOSTER (1825–1899)

132 'Ben Nevis'
Newcastle upon Tyne, Laing Art Gall. 46½ × 31 : 1181 × 787 *Water-colour*
Myles Birket FOSTER (1825–1899)

133 'The Milkmaid'

V.A.M. 520–1882　　11¾ × 17½: 299 × 444　*Water-colour, signed and dated 1860*

Myles Birket FOSTER (1825–1899)

134 'Feeding the fowls, Pinner'
London R.W.S. (diploma drawing) 13¼×20: 336×508 *Water-colour*
Helen ALLINGHAM (1848–1926)

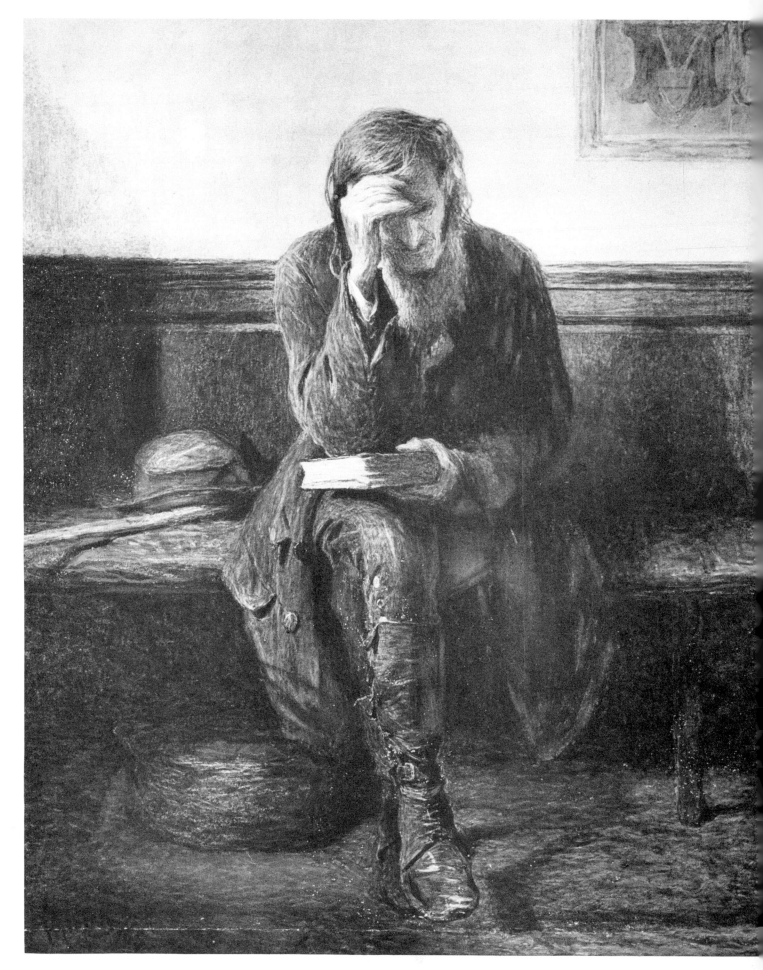

135 'The Sermon'

V.A.M. 425–1891 $10\frac{3}{4} \times 8\frac{1}{2}$: 273 × 216 *Water-colour, signed and dated 1868*

Henry Benjamin ROBERTS (1832–1915)

student in the Royal Academy Schools and was strongly influenced by Foster and by Fred Walker. In 1874 she married William Allingham, the Irish poet, and took her place in a literary circle which included Carlyle, Ruskin, Rossetti, Browning and Tennyson. Her drawing of Carlyle in his garden in Cheyne Walk, with his pipe and cat, is well known by reproductions. When Ruskin met the artist at the Old Water-Colour Society's Gallery in 1877, where the drawing was hung, he asked her why she painted Carlyle like a lamb when he ought to be painted like the lion that he was. She was elected as associate of the Royal Water-Colour Society in 1875 and, when women for the first time were admitted to membership in 1890, was at once raised to full rank. Her pictures of cottages and gay gardens, green lanes, sunny hillsides and woodlands were a little idealised but had their integrity and were immensely popular. Looking at her work it is difficult to realise that she used nine colours only, five of them being yellows: her palette, as given to Huish,[1] consisted of cobalt, rose madder, aureolin, yellow ochre, raw sienna, sepia, permanent yellow, light red and orange cadmium. In *The Art of England*, 1884, Ruskin placed her name with that of Kate Greenaway at the head of his lecture on *Fairy Land* and specified as her true gift the representation of 'the gesture, character, and humour of charming children in country landscapes'. W. Graham Robertson[2] has paid a fine tribute to her as woman and as artist:

> What would have happened to William Allingham had he not married Helen Paterson it is impossible to imagine. She understood him thoroughly, cared for him deeply and made life smooth and happy for him; and to do all this for a poet would have provided most women with a fairly arduous career. But she also had her work as an artist and she painted day in and day out; in fact she hardly ever seemed otherwise occupied.
>
> Her lovely little transcripts of the Surrey Lanes and woodlands, of the school of Birket Foster—but, to me, fresher, more fragrant and close to Nature than the work of the elder painter—are delights to the eye and lasting memorials of the fast-vanishing beauty of our countryside. In a few more years they will seem visions of a lost Fairyland, a dream world fabulous and remote as Lyonesse or Atlantis, but they are no false mirages but beautiful truth; few painters have ever penetrated so close to the soul of the English country.

A very able and not unworthy follower of Hunt and Foster was Miss Adelaide Maguire (*fl.* 1868–1876), who was unknown to me until a group of her drawings was exhibited at Walker's Galleries in 1941. Her highly finished landscapes and figures show that she followed closely in the steps of Hunt, Foster and the Pre-Raphaelites. *Cottage Interior: Learning to Sew*, originally exhibited at the Royal Academy in 1876, is a charming study of a room, brightly lit, with good grouping of figures, all of it lovingly wrought.

A close follower of Hunt's *genre*, both in subject and manner, was Henry Benjamin Roberts (1832–1915), born at Liverpool and trained in his father's trade as a house decorator. He became a member of the Liverpool Academy in 1859, began to exhibit at the

[1] M. B. Huish, *British Water-colour Art*, 1904.
[2] W. Graham Robertson, *Time Was*, 1931, p. 292.

113

Royal Academy in that year, and was a member of the Institute of Painters in Water-colours from 1867 to 1884. Typical works by him, showing fidelity in part to nature and even more to William Hunt, are *The Sermon*[1] (Pl. 135), 1868, and *The Fishmonger's Call*.[2] Yet another close follower of Hunt in his rendering of flowers and fruit was William Hough (Exhib. 1857–1894).

George Samuel Elgood (1851–1943), a contemporary of Mrs. Allingham, lived to the age of ninety-two and specialised in the painting of English and Italian gardens. He lived in Italy for several months each year, and was an authority on gardens of the Renaissance. A typical water-colour by him would show rich herbaceous borders, clipped yews, a stretch of green lawn, with a flight of stone steps or a portion of a building. Though he liked a wealth of detail, he managed to maintain considerable breadth in his design as a whole.

Elijah Walton (1833–1880) was born near Birmingham, studied at the R.A. Antique School and exhibited generally in London. He travelled extensively and countries ranged from Norway, Switzerland and Italy to Egypt and the Holy Land. Among books illustrated and published by him is *Clouds: their forms and combinations*, and studies for this work, often romantically composed and vividly coloured, are frequently seen in collections.

[1] V.A.M. 425–1891.
[2] F. J. Nettlefold Cat., Vol. III, p. 205.

CHAPTER VII

The Pre-Raphaelites and Some Contemporaries

Dante Gabriel Rossetti Sir Edward Burne-Jones
Sir John Everett Millais William Holman Hunt George Price Boyce
Richard Dadd Thomas Matthew Rooke

To remember that the Pre-Raphaelite Brotherhood was contemporary with the Great Exhibition of 1851, which housed such a vast collection of pompous mediocrity and tawdry design, is to realise how revolutionary the movement was. And when Ruskin emerged as champion of the Pre-Raphaelites, many people who thought they had learned from *The Seven Lamps* and *Stones of Venice* and the first two volumes of *Modern Painters* what truth and beauty meant in art must have felt a sense of shock. Ruskin's intervention was described at the time as 'coming like thunder out of a clear sky'.

The Pre-Raphaelites had a convention of their own, but it swept away a large amount of dust and decay. They were like picture restorers, removing old *pentimenti* and coats of darkened varnish. In their oil-paintings they worked upon a wet white ground, bringing light and high colour into their pictures instead of heavy chiaroscuro and gloomy brown. Their brave and youthful efforts brought into disrepute, only temporarily, the trivial sentiments and generalisations of their contemporaries. The movement was not the natural outcome of any national tradition; and this is perhaps the only justification for its absurd title. It sprang up unexpectedly and unaccountably, lived a brief and hectic life of fierce activity, and then dissolved. Rossetti, like Blake and Turner before him, proved that genius owes little to environment or the *Zeitgeist*.

Ever since the movement was launched it has had its ardent friends, its fierce opponents, its insidious detractors. When yesterday, for instance, it was in disrepute it was either because the Pre-Raphaelites were literary, or because they were regardless of true aesthetic values. What we have to consider in Pre-Raphaelite art is not its dramatic structure, but the relationship between the literary interest and those qualities of design and colour which by themselves may make a great work of art, or which, combined with subject-matter, may make a work of art more potent in its wide appeal.

In 1848 Millais was eighteen, Holman Hunt was nineteen and Rossetti twenty. Millais and Hunt were close friends and fellow students in the Royal Academy Schools. Hunt

relates how they agreed in thinking that Raphael's *Transfiguration* was to be condemned for its grandiose disregard of the simplicity of truth, the pompous posturing of the Apostles and the unspiritual attitudinising of the Saviour. They looked upon this picture as 'a signal step in the decadence of Italian art'. Other students in mockery said: 'Then you are Pre-Raphaelite.' Hunt continues: 'Referring to this as we worked side by side, Millais and I laughingly agreed that the designation must be accepted.' Soon after this, Hunt and Millais met Rossetti, adopted him as a leader, and persuaded him that 'Early Christian' (the term adopted by an earlier group of German painters with similar ideas working under Overbeck in Rome) was the wrong term for the art which they themselves sought to practise. Probably it was Rossetti, of Italian origin, who suggested that they should form a secret society, an art Camorra, the 'Pre-Raphaelite Brotherhood'.

The first meeting of this brotherhood of three took place in 1848, and soon they were joined by William Rossetti (Gabriel's art critic brother), J. Collinson, F. G. Stephens and T. Woolner. Ford Madox Brown was a prop and an inspiration, but not one of the brethren. Their first principle was to eschew all that was conventional in contemporary art and to appeal to unsophisticated Nature. They revolted against the generalised form of Reynolds and his followers. Sir Joshua Reynolds—to the Pre-Raphaelites he was 'Sir Sloshua'—had said in his *Discourses* that: 'A painter must have the power of contracting as well as dilating his sight; because he that does not at all express particulars expresses nothing; yet it is certain that a nice discrimination of minute circumstances and a punctilious delineation of them, whatever excellence it may have (and I do not mean to detract from it), never did confer on the artist the character of Genius.' The Pre-Raphaelites were to show that contraction of sight, equally with dilation of sight, was not incompatible with genius. They demanded absolute truth and accuracy of detail, without regard for atmosphere or for any large balance of design. Like Blake, they felt that 'to particularise is the only distinction of merit', but at the same time they wanted to renew imaginative life in pictorial art and to fuse poetic idealism with scientific objectivity. As Thomas Carlyle cannily remarked: 'These Pre-Raphaelites they talk of are said to copy the thing as it is, or invent it as they believe it must have been! Now there's some sense and hearty sincerity in this. It's the only way of doing anything fit to be seen.'

Their choice of designation was unfortunate and misleading, for there was no actual resemblance in spirit or in method between the work of the artists who preceded Raphael and these young aspirants of the nineteenth century. The only link was simplicity of principle and earnestness of purpose in going direct to nature and searching for truth. If they seemed revolutionary, it was mainly because of their choice of poetic subject, their intellectual aim, their impassioned fervour, and the intensity of their realism. Much more than their contemporaries, they took a sensuous enjoyment in the decorative elements of shape and colour. They startled a public used to what Ruskin summarised as 'cattle-pieces, sea-pieces, fruit-pieces or family-pieces, the eternal brown cows in ditches, and white sails in squalls, and sliced lemons in saucers, and foolish faces in simpers'.

116

For the Pre-Raphaelites at their start the subject-matter of their paintings had to be poetry, their own poetry, or that of Chaucer, Dante, Keats, Browning, Tennyson, or such romance as they found in medieval legend or the *Morte d'Arthur*. And always Rossetti was saying, 'If any man has any poetry in him he should paint it, for it has all been said and written, and men have hardly begun to paint it. Every man who has that gift should paint. That's how we began.' In those words Burne-Jones described to Lady Horner his early life in Rossetti's company.[1] The Pre-Raphaelites saw life in terms of romance; they aimed at transposing fact into fantasy, veiling harsh reality with the entrancement of a dream. Anyone who saw Burne-Jones's *Merlin and Nimue*,[2] without being aware of its title and without knowing the *Morte d'Arthur*, could none the less feel that the scene was actual in a world outside of actuality.

In their uncompromising truth to nature the Pre-Raphaelites differed in no wise from Hunt and Foster and Lewis. In that respect they were not revolutionary. They were revolutionary, however, in the licence which they assumed with regard to water-colour technique. They came to their task fully equipped with genius and imagination but, like Blake, not knowing how to express their passion in terms of actual pigment. The central tradition of water-colour meant nothing to Rossetti. He started out to hack his way to expression. Yet he, and Burne-Jones in his earlier work, did manage somehow to achieve an unusual depth, glow and translucency of colour, obtaining the quality gained by the early makers of cathedral windows who laid pieces of glass one over another in varying thicknesses till they gleamed like a jewel. A *Girl in Red*,[3] by Burne-Jones, painted with a rich impasto as of oil, has a warning on the back, in the artist's hand, that the picture is a water-colour and the surface must not be varnished. An amusing anecdote illustrating this impurity of style is told by Sir William Rothenstein.[4] 'One evening, at the rue du Bac, a man from Goupil's came, very worried, to ask Whistler's advice. Goupil's had been asked to clean Burne-Jones's *Love Among the Ruins*; they had foolishly treated it as an oil painting, and thereby ruined it. What was to be done? Whistler had never forgiven Burne-Jones for giving evidence against him at the Ruskin trial. He shouted with derision at the disaster. "Didn't I always say the man knew nothing about painting, what? They take his oils for water-colours, and his water-colours for oils."' It is indeed sometimes a puzzle to decide what medium Rossetti and Burne-Jones are using. The puzzle is not so much what the medium was, but what they did with it. They certainly made free use of moist colours, rubbing and scrubbing them on the paper and into the paper, with the most meagre intervention of water, as if they were oils. What people thought was some mysterious tempera—even Laurence Binyon was not sure whether Burne-Jones's *Sidonia von Bork*[5] was actually in

[1] Francis Horner, *Time Remembered*, 1934, p. 15.
[2] V.A.M. 257–1896.
[3] Coll. Mr. Gordon Bottomley.
[4] Sir W. Rothenstein, *Men and Memories*, I, 1935, p. 114.
[5] London, Tate Gallery, 5877.

117

water-colour—was merely a tempera of gum and water, with a lavish use of body-colour. Burne-Jones sometimes worked over a chalk drawing, which added to the mystery. He and Rossetti liked their work to look like fresco or egg tempera. The only parallel is to be found in the work of Blake and the early work of Palmer. That the link is a strong one is shown by the reverence paid alike to Blake and the Pre-Raphaelites by so notable a collector and so wise a critic as Graham Robertson.

During the years 1850 to 1853, the Brotherhood was breaking up, though its influence lingered on. The members of the movement had won an established place by 1853; their methods were being accepted by other painters; their pictures were being bought by patrons. Each now felt free to follow his own course. Hunt set off for Palestine; and on November 8, 1853, Rossetti wrote to his sister: 'Millais, I just hear, was last night elected an Associate, so now the whole Round Table is dissolved.' Rossetti alone for many years was to continue with his water-colours of medieval legend, fairy-tale and poetry, embodying always the original Pre-Raphaelite ideals. There was no open split; they were all good friends. G. P. Boyce pictures the group in his diary, under the date January 6, 1853: 'To Rossetti's, Blackfriars Bridge. Met there W. Holman Hunt, J. E. Millais, J. P. Seddon, Clayton, Munro, whose charming group of Francesa and her lover was in Rossetti's studio, Stephens, Blanchard, C. Lucy, a Scotchman and a foreigner. Millais somewhat egotistical and little real, his attention being easily distracted. He jerked out some good remarks. Spoke highly of Ruskin as a friend of Art; said that Mrs. R. was sitting for one of his pictures. Hunt struck me as a thoroughly genuine, humorous, good-hearted straightforward English-like fellow. Said he was bound for Syria before long.'

So far as water-colour is concerned, Rossetti stands out as the central figure of the movement, certainly as the chief intellectual force. More than any of the others he made his appeal by mental images and symbols pregnant with eternal verity rather than by rigid representation of facts. He was one of the few painter-poets—Blake was another—who brought poetry into his paintings and pictorial powers into his poetry. W. M. Rossetti, in his preface to Dante Gabriel's poems, wrote: 'I have not infrequently heard my brother say that he regarded himself as more essentially a poet than a painter.' William Allingham, a fellow-poet associated closely with the Pre-Raphaelite group, records in his Diary, with reference to Rossetti, that 'the simple, the natural, the naive, are merely insipid in his mouth; he must have strong savours, in art, in literature, and in life. Colours, forms, sensations, are required to be pungent, mordant. In poetry he desires spasmodic passion, and emphatic, partly archaic, diction.'

Gabriel Charles Dante Rossetti, generally known as Dante Gabriel Rossetti (1828–1882), was born in London, the son of Gabriel Rossetti, an Italian refugee who became Professor of Italian at King's College. Young Rossetti was educated at King's College, where he studied drawing under Cotman, from 1837 until 1842, and in 1845 he entered the Royal Academy Schools. While there, he was composing his poems rather than submitting to the drudgery of drawing. As a painter, he was strongly attracted by the art of Ford

118

Madox Brown, whose powerful influence permeates the early work of the Pre-Raphaelites. In his Diary of March 25, 1848, Brown records: 'Elliott, Thomas and Rossetti called; the latter my first pupil. Curious enough—he wrote to ask me to give him lessons, from his opinion of *my high talents*; knew every work I had exhibited and all about them. Will see what we can make of him.' During four months Rossetti underwent a bitter apprenticeship, for Madox Brown tried to break in his exuberant pupil by setting him to make studies of pickle jars and jam pots. Impatient with this continuance of academic training, Rossetti left Brown in order to share a studio with Holman Hunt, and so became one of the founders of the Pre-Raphaelite Brotherhood. In 1849 he and Hunt toured France and Holland. In 1857 and 1858 he was assisted by Burne-Jones and others in painting a series of frescoes in the Library of the Oxford Union. In *The Blessed Damozel* and other poems he showed the same mystic intensity as in his paintings. From 1862 he lived at 16, Cheyne Walk, Chelsea, with his brother, W. M. Rossetti, Swinburne and Meredith. Boyce[1] records he 'has got a most quaint barn owl in his studio and two fierce foreign owls in the garden, besides peacocks, pigeons, hens, ravens, etc.'

About 1850 Rossetti first made the acquaintance of Elizabeth Siddall, without reference to whom no account of his life, however brief, would be complete. Their first meeting was probably in the studio of Walter Deverell, who had seen Elizabeth in a milliner's shop near Leicester Square and had induced her to pose for him. She sat also for Millais and Holman Hunt and became to the Pre-Raphaelites a symbol as well as a model, a kind of Virgin Princess whose residence with Rossetti during their long engagement till she became his wife in 1860 never gave rise to any breath of scandal. She inspired a considerable portion of Rossetti's own work. She was his Beatrice in the three paintings of Dante, his Virgin in *The Annunciation*, his *Francesca da Rimini*, his *Ophelia*. Her sensuous face, her brooding heavy eyelids, her drooping lips and columnar neck, her weight of red-gold hair, appeared in *The Blue Closet*, in the *Wedding of St. George*, in the ghostly *How they met Themselves*, in *The Rose Garden*, in *Regina Cordium*, and after her death, in her apotheosis, *Beata Beatrix*. Her end was tragic, and the manner of it is still disputed. On February 10, 1862, some two years after her marriage, Rossetti and she returned home after dining with Swinburne. Rossetti then went out again and on his return towards midnight found that his wife had emptied a phial of laudanum which stood beside her bed. She never recovered consciousness, and the coroner's jury returned a verdict of accidental death. In her coffin Rossetti laid his manuscript poems which many years later he was induced to exhume.

Rossetti was not a natural craftsman. Neither oil nor water-colour were pliant and malleable materials in his hands. He was wrestling with refractory substances, and perhaps for that very reason his work has the intensity and inner glow so often lacking in the painter who attains a surface of superficial ease. Rossetti impregnates our imagination not only with his subject but with his fight to achieve an impassioned result. In a letter of April 28, 1864, written to E. Gambart, the picture dealer, he claims to have originated a new style

[1] G. P. Boyce, *Diary*, pub. O.W.S. Club, XIX, 1941.

of water-colour painting and gives his reasons for not joining the Old Water-Colour Society:

> I know all that is to be said as to the advantage to me of joining the Old Water-Colour Society; but I declined doing so some years ago, when Ruskin offered me his influence, on the ground, which I still adhere to, that I would not on any account become ticketed as a water-colour painter wholly, or even chiefly.
>
> Certainly it may now become additionally advisable in some respects for me to do so, when painters whose works resemble mine are joining the Society one by one. But I must trust to the fact which I and some others know, that I painted in the style which I originated, for years, when no works at all resembled mine except my own, to retain still perhaps some claims which may counter-balance their greater publicity.[1]

In connection with that letter it is interesting to hark back to what Ruskin had written in 1856:

> Dear Rossetti—I enclose a letter from John Lewis, and we must now have your *final* answer. I object, myself, to the whole system of candidateship, but, as it is established, neither you nor I can at present overthrow it. I don't believe there is the least risk of your rejection, because Lewis is wholly for you, and the others know that you are a friend of mine and that I am going to write a 'notice' in 1857 as well as in 1856. I don't say that if they rejected you, I might feel disposed to go into further analysis of some of their own works than might be altogether pleasant. But don't you think *they* will suppose so, and that your election is therefore rather safe?
>
> But suppose the reverse. All that could be said was that they rejected—not Rossetti but *Pre-Raphaelitism*. Which people know pretty well before. But it would give me a hold on them if they did, which would be useful in after attacks on this modern system, so that, whether they took you or not, you would be helping forward the good cause. But all the chances are that you get in, and if you do, consider what good you may effect by the influence of your work, and votes in that society, allied with Lewis and Hunt.
>
> So *pray* do this. Write to Lewis instantly, saying you accept. I will write to Oxford for your Dante drawing. Morris will, I am sure, lend his; and I will lend my *Beatrice*, and there we are, all right.
>
> Yours affectionately, J.R.

Rossetti's colours were chosen methodically, as a woman chooses the silks that lend bright pattern to her embroidery, or as a craftsman selects the portions of glass which make his window glow. Indeed, the tapestry, the window richly dight, were part of the archaic instinct which gave to his art its glamour and its gleam. One feels that he not only brooded over the poetry and chivalry of past ages, but studied the work of medieval illuminators. I think that medieval missals and the work of Memlinc and Van Eyck, which he probably saw on his visit to the Low Countries, were far more potent factors in his art (as they were in that of Burne-Jones) than frescoes by any forerunner of Raphael. The illuminators and the Flemings may well have led him to use flat and vivid touches of green and scarlet and purple. Boyce has the significant entry in his *Diary* for April 8, 1854, that Rossetti 'said he thought the most beautiful combination of colour in a picture to be green, blue, and carmine, all inclining to purplish, but the general tone of picture colour to incline to yellow. An opal I showed him elicited this.'

[1] Messrs. Maggs, *Catalogue of Autograph Letters*, 1931.

120

Rossetti's liking for bright viridian green is shown in *Dante's Vision of Rachel and Leah*[1] 1855, in his *Meeting of Dante and Beatrice in Paradise*,[2] 1852, and in *Fra Pace*,[3] 1855, the last a drawing in which the wall of the monk's cell and the tiled floor are all in vivid green. The *Golden Water*,[4] 1858, is in the 'yellow tone' for which he expressed a preference, and we may find perhaps in it the origins of the 'greenery-yallery' aestheticism of the later eighties. The *Golden Water* is a drawing of simple beauty and quiet dignity, but one cannot help feeling that it was responsible for much that was cheap and undignified in Albert Moore and other later men. In the *Mary Magdalen*[5] there is strangeness of colour, the bright green moss on wall and stair contrasting with dull reds and purples.

One of the most interesting and most lively of all Rossetti's water-colours is *The Laboratory*,[6] 1849, illustrating Browning's: 'In this devil's smithy, Which is the poison to poison her? prithee.' This was Rossetti's first completed work in water-colour. There is a naïveté and directness in it which is lacking sometimes in the more sophisticated later work, and which gives so much charm to some of his earlier drawings in black-and-white such as *Tennyson reading 'Maud'*[7] (Pl. 138), 1855, and the lovely illustrations to the Moxon Tennyson, published in 1857. *The Laboratory*, for all its charm, is immature. Craftsmanship, power of design, lyric quality, are much more advanced in *Dante drawing an Angel on the Anniversary of Beatrice's death*,[8] 1853. Most admirers of Rossetti, I think, would agree with me in concentrating upon the work done before 1860. What marks the later drawings, such as *The Borgia Family*,[9] 1863, and *How They met Themselves*, 1864 (now in America: a pen-and-ink study of it in the Fitzwilliam Museum), is a more sensuous, sinuous flow and curve of line. Thereafter Rossetti was increasingly painting in oil. A long letter, written on March 22, 1867, by W. Bell Scott to Herbert Horne on the subject of Rossetti's poetry, ends: 'You are right about his small water-colour works, after his earliest two thinly-painted oil pictures, being his best works as a painter. I know E.B.J. and W.M. [Burne-Jones and William Morris] agree in thinking so.'

Sir Edward Burne-Jones (1833–1898) must take next place because, though not one of the original Pre-Raphaelite brethren, he was the disciple and faithful follower of Rossetti. Baptised Edward Coley Burne Jones (the name was not hyphenated then) he attended King Edward's Grammar School at Birmingham and went up to Exeter College, Oxford, in 1852, with the intention of entering the Church. At Oxford he was a fellow-student of William Morris, and both were influenced by the atmosphere of medievalism and symbolism left as an aftermath of the Oxford Movement. It was but natural that he should become a fervent admirer of Rossetti, and this led to the determination on his own part to follow an art career. He went to London in 1855 and for a time worked with William Morris at 17, Red Lion Square, keeping in close touch with Rossetti. In 1857 he returned to

[1] Tate Gallery 5228.
[2] Once coll. Sir Sydney Cockerell.
[3] Once coll. Lady Jekyll.
[4] Cambridge, Fitzwilliam Museum.
[5] Tate Gallery 2859.
[6] Birmingham City Art Gallery 481'04.
[7] Birmingham City Art Gallery 495'04.
[8] Oxford, Ashmolean Museum.
[9] V.A.M. 72–1902.

121

Oxford, joining Rossetti, Morris and others, who were working on the fresco decorations in the Union. He visited Italy in 1859, and again in 1862. He was elected associate of the Old Water-Colour Society in 1864 and member in 1868; he retired in 1870 for reasons which will be given later, but rejoined in 1886. In 1885 he was elected A.R.A. but resigned in 1893. By that time he had gained high reputation as a decorative painter in oil and had won distinction by his book-illustrations (notably his superb designs for the Kelmscott Press publications), his designs for stained glass, and his tapestries. He was created a baronet in 1894. It is with his work in water-colour only that we are here concerned.

In a letter written by Rossetti in January 1862 to Professor Norton in America, enclosing a prospectus of the Morris firm,[1] comes this passage: 'A name perhaps new to you on our list, but destined to be unsurpassed, perhaps unequalled in fame by any of this generation, is EDWARD BURNE-JONES. He is a painter still younger than most of us by a good deal, and who has not yet exhibited, except at some private places: but I cannot convey to you in words any idea of the exquisite beauty of all he does. To me no art I know is so utterly delightful, except that of the best Venetians.' That is a generous, perhaps an extravagant, tribute and it may seem wild exaggeration to those who regard Burne-Jones simply as an anaemic aesthete. But at the time it was written Burne-Jones had painted, in water-colour, the supremely powerful and striking *Clara von Bork*[2] and *Sidonia von Bork*[3] (Pl. 141), 1860, the *Merlin and Nimue*,[4] 1861, and three pictures, *Backgammon Players*,[5] 1862 (originally known as *Chess Players*), *The Annunciation*[6] (Pl. 142), 1861, and *An Idyll*[7] (Pl. 143), 1862. Painted under the immediate inspiration of Rossetti, these pictures were noteworthy for their bold pattern, their mellow depth of warm colour, and their powerful poetic intensity.

Those early pictures illustrate, far more than his later work, his saying that: 'I mean by a picture, a beautiful romantic dream of something that never was, never will be—in a better light than any light that ever shone—in a land no one can define or remember, only desire—and the forms divinely beautiful.' Later, he was to fall victim to a sentimental melancholy, picturing a world of indolence, of *triste plaisir*, or vague nostalgic regrets for 'old, unhappy, far-off things'. And while he was living in a world of romantic dreams his nephew proclaimed that: 'Romance brought up the nine-fifteen.' But Burne-Jones's earlier drawings were robust. There was a richness and fervour which disappeared later, as he shook off the mannerisms acquired from Rossetti. At that time, like Rossetti, he was scrubbing and shifting his colour, stippling and scumbling blue over blue, red over red. When he gained an easy proficiency in handling his medium on a much larger scale,

[1] Rossetti, Burne-Jones, Madox Brown and Philip Webb were all partners in the manufacturing and decorating firm of Morris, Marshall, Faulkner and Co., dissolved in 1874.
[2] Tate Gallery 5878.　　　　　　　　[3] Tate Gallery 5877.　　　　　　　　[4] V.A.M. 257–1896.
[5] Birmingham, City Art Gallery, 146'23.
[6] Birmingham, City Art Gallery, 441'27.
[7] Birmingham, City Art Gallery, 91'24.

his work lost a forceful vigour which was not counterbalanced by any gain in purely decorative quality.

In 1864, along with G. P. Boyce and Fred Walker, Burne-Jones was elected an associate of the Old Water-Colour Society. 'His pictures', says Roget,[1] 'seemed a foreign element there and struck a discordant note. One can indeed imagine no more diverse ways of entering into the spirit of the past than that of the new-comer and what the elder members had been accustomed to in the works of George Cattermole. Nor had Mr. Jones's medieval renderings of classical legends much in common with the sentimental treatment of them by the fathers of the Society, such as Shelley and Rigaud, or even the sculpturesque classicism of Cristall.' None the less, such exhibits as *Fair Rosamund* (purchased by Ruskin's father), *Cupid and Psyche*, *Le Chant d'Amour*, *The Annunciation* and *The Merciful Knight* led to his election as a full member in 1868. In 1870 certain visitors to the gallery took objection to his *Phyllis and Demophoon*[2] on the absurd ground that the male figure was inadequately draped. He declined to cover a suggestion of pubic hair with removable chalk, and was asked by the President to withdraw the picture. Instead, he withdrew himself from the Society, and in a most courteous letter of resignation, expressing his regrets, claimed rightly that, 'I cannot allow any feeling except the necessity for absolute freedom in my work to move me.' Sir Frederick Burton, who had become an associate in 1854 and a member in 1855 (later he was to be Director of the National Gallery from 1874 to 1894), resigned in sympathetic protest. In 1886 Burne-Jones allowed his name to be replaced on the list of members, and Sir Frederick Burton was made an Honorary Member. From 1886, except in 1890, Burne-Jones exhibited annually till his death in 1898. In 1887 he received a commission from the Corporation of Birmingham to paint a large water-colour, *The Star of Bethlehem*[3] (Pl. 140), measuring 101 × 152 inches. It was completed in 1890, and two years later came *The Tree of Life*, 71 × 95 inches, painted in body-colour and gold for the American Episcopal Church of St. Paul at Rome. Other very large water-colours, the six panels of *The Days of Creation*, exhibited at the Grosvenor Gallery in 1877, and *In the Depths of the Sea*, exhibited at the Royal Academy in 1887, are in the Fogg Museum of Art, Harvard University. His later work may be seen to advantage in the *Flower Book*[4] in the Print Room of the British Museum. Here, within a circular form, he has devised compositions of real or imaginary flowers with great originality of design and in colours that are strange and rich. A large water-colour for *Phyllis and Demophoon* is in the National Museum of Wales. Appropriately, in view of the artist's Welsh ancestry, the Museum contains other cartoons by him, as well as his water-colours, *Nymphs of the Moon* and *Nymphs of the Stars*, and his water-colour designs for the obverse and reverse of the seal of the University of Wales.

About Sir John Millais and Holman Hunt there is less to be said. Their output in water-colour was slight in comparison with the overwhelming quantity of their work in oil. For

[1] Roget, II, p. 116.
[3] Birmingham, City Art Gallery, 75'91.
[2] Birmingham, City Art Gallery, 37'16.
[4] B.M. 1909. 5.12.1–42.

most of us the water-colour side of their art can only be known from a few examples in public galleries. John Everett Millais (1829–1896) was born at Southampton. Showing remarkable talent for drawing, he was sent to Sass's school and, at the age of eleven, entered the Royal Academy schools. When sixteen, he exhibited his first oil-painting at the Academy, *Pizarro seizing the Inca of Peru*,[1] now in the Victoria and Albert Museum. His connection with Hunt and Rossetti in the foundation of the Pre-Raphaelite Brotherhood has already been related. His work in water-colour belongs almost entirely to those early days when Pre-Raphaelitism was still burning with a hard and gem-like flame. He produced numerous drawings in black-and-white for the wood-engravers, notably his little masterpieces for the Moxon Tennyson, 1857, and for the *Parables of our Lord*, which was published in 1863 after the artist had completed twenty out of the thirty illustrations for which he had been commissioned in 1857. Many of these designs were finished in water-colour, or were duplicated in water-colour versions; there are some of them in the Whitworth Art Gallery, Manchester. Another intimate little water-colour of the same period is *Love*,[2] an illustration to a poem by Coleridge in *Poets of the Nineteenth Century*, 1857. In the Birmingham City Art Gallery are an early drawing, *The Gipsy*,[3] 1846; *Framley Parsonage*,[4] 1861; *The Anglers of the Dove*,[5] 1862, and three other works, all of small size. Other water-colours, such as *My Second Sermon*[6] (Pl. 144), 1862, and *The Eve of St. Agnes*,[7] 1862, were studies for larger pictures in oil. *My Second Sermon*, a charming rendering of his five-year old daughter, seated in a pew in the church of St. Thomas, Winchelsea, most faithfully portrayed, is akin to William Hunt in thought and manner, and has little of the inner Pre-Raphaelite spirit. Millais was much more conscious than Rossetti of the water-colour tradition, and shows no great originality in his use of the medium. In *The Eve of St. Agnes*, though by 1862 he was passing beyond the Pre-Raphaelite stage of his career, he does hark back to the kind of romantic subject and punctilious treatment which was in keeping with the early tenets of the brotherhood. Inspired by Keats's poem, he found a suitable background in an old room at Knole, whose tapestries and furnishings remained as they were when King James I had slept in the vast bed. Here, for three bitter December nights in succession, from midnight onwards, Lady Millais poses, shivering and slightly clad, 'her rich attire rustling to her knees', till the moment came when 'the wintry moon threw warm gleams on Madeline's fair breast'. All that was in the true Pre-Raphaelite spirit. Millais had apparently forgotten how, ten years before, he had kept Miss Siddall, his model for *Ophelia*, lying for hours wrapped in sodden drapery in a bath, beneath which the lamps intended to keep the water tepid had long gone out. A severe illness was the result, and Millais had to pay the doctor's bill. For *The Eve of St. Agnes* similar demands were somewhat cruelly made upon a faithful model, and with fine result. The subtle rendering of

[1] V.A.M. 121–1897.
[2] V.A.M. 178–1894.
[3] Birmingham, City Art Gallery, 660'06.
[4] Birmingham, City Art Gallery.
[5] Birmingham, City Art Gallery.
[6] V.A.M. 399–1901.
[7] V.A.M. D.141–1906.

124

moonlight, the pattern of the window panes thrown across the figure and chequering the floor, seem to be the artist's farewell tribute to Pre-Raphaelitism. Like Madeline in the poem, he 'dare not look behind, or all the charm is fled'. The future, to be filled with supremely dexterous and versatile oil-painting, beckoned him on to wealth, prosperity and the presidency of the Royal Academy.

William Holman Hunt (1827–1910), solitary, Puritan—what a contrast with Rossetti—was a faithful steward, always 'redeeming the time'. Son of a warehouse manager, he was born in London. For a year or two he was clerk to an estate agent, but in 1844 entered the Royal Academy Schools, and thus began his friendship with Millais and his share in the formation of the Pre-Raphaelite Brotherhood. In 1869 he was elected to the Old Water-Colour Society without having to wait for a vacancy or having to undergo the formality of submitting work. Even then he was generally regarded as an oil-painter, whose occasional water-colours deserved honour, and so he remained. From 1869 to 1903 he had only thirty-nine exhibits in the Society's gallery, and it may be assumed that they comprise the greater part of his water-colour work. In his case again a large portion of his work is in public galleries, but some private owners (Mr. Hilary Holman-Hunt, Mrs. Michael Joseph, Mrs. Sydney Morse and Mr. J. T. Middlemore) allowed water-colours in their possession to be reproduced by the Old Water-Colour Society's Club[1] and the illustrations are accompanied by interesting extracts from contemporary criticism published in the years 1869 to 1893. For Holman Hunt the essence of the Pre-Raphaelite movement was to paint 'the glory of the earth in actual sunlight', and for that reason, when he turned to water-colour, he differed from his fellows in that he eschewed body-colour and worked in transparent colours, often used very dry, on brilliant white paper. It was this brilliance and purity of tint which startled the public who saw his *Moonlight at Salerno* in 1869; to some of the critics it seemed extravagant and eccentric.

Holman Hunt's *Ponte Vecchio*[2] in the Victoria and Albert Museum was painted in 1867, two years before his election to the Old Society. It is a study of a night effect on dark water and dark bridge, of lights in windows and lights reflected in the deep Arno. Lower in tone than the *Salerno*, it shows his close study of nature in rendering colour which in moonlight is not chilly and metallic, as so many of his predecessors had thought, but mellow and warm. The painter, like Burne-Jones in his *Merlin and Nimue*, is still having to coax and wheedle his paper and his colours and, as his old namesake William Hunt said, 'fudge it out'. To an earlier date still, 1860, belongs the *Helston Cornwall*,[3] a delightful drawing, worked out with meticulous exactness in its rendering of sunlight upon meadows, hill slope and summer-green trees. It still displays the Pre-Raphaelite impulse and intensity which reduced later to some extent as the painter began to hold an easy command over his material. His later quality of radiant and brilliant illumination by vivid sunlight, a tincture of crystalline facets and flashes of colour, is evident in *Apple Gatherers, Ragaz*[4] (Pl. 147).

[1] Vol. XIII, 1935–6.
[2] V.A.M. 196–1894.
[3] Manchester University, Whitworth Art Gallery.
[4] Birmingham, City Art Gallery.

125

Ford Madox Brown (1821–1893) was born at Calais and was firmly established as a painter before he came into contact with the Pre-Raphaelite movement. By 1845, when he visited the studios of the German Pre-Raphaelites in Rome, he was an accomplished artist, with a full understanding of his medium. On his return to England, he concentrated more upon a direct transcript from Nature. As Ford Madox Hueffer puts it[1]: 'He seems to have been the first man in modern days to see or put in practice the theory that aesthetic salvation was to be found not in changing the painter's subject, but in changing his method of looking at and rendering the visible world. He began trying to paint what he saw.' In every way he was a fore-runner to the Pre-Raphaelites. He gave his blessing to the movement, and his own perfect sympathy with their ideas and aims is fully shown in his oil-paintings, *Work*[2] and *The Last of England*.[3] His water-colours are rare and are mostly to be found in public galleries. The *Elijah restoring the Widow's Son*,[4] 1868, is nobly conceived; *Chaucer at the Court of Edward III*[5] (Pl. 149), the water-colour version of his oil-painting, is fine both in design and subtle characterisation. Others to mention are his *Romeo and Juliet*,[6] 1869, and *Byron's Dream*,[7] 1889. The latter, with figures finely composed and distant landscape most attractively rendered, shows that even in his latest years the early vision had not faded. It has kinship in symbolism and in the actual treatment of the two figures with his early and brilliant illustration to Rossetti's poem *Down-Stream*, a drawing about which Rossetti said, 'You certainly have not minced the demonstrative matter.' Ruskin once asked, 'Why do you always choose such ugly subjects, Mr. Brown?' Madox Brown's reply was, 'I set truth above originality, and wish chiefly to be true, no matter whence the truth comes.'

Not within the inner circle of the Pre-Raphaelite Brotherhood, but touching it closely, are Simeon Solomon and G. P. Boyce. Simeon Solomon (1840–1905) was born of wealthy Jewish parents and at an early age showed unusual artistic promise and literary attainment. At the Royal Academy in 1860 his oil-painting, *Moses*, won high commendation. Much sought after in social circles, he was a close friend, in his young days, of Rossetti, Burne-Jones, Holman Hunt, Swinburne, Tennyson and Walter Pater. His *Painter's Pleasaunce*,[8] 1861, shows how completely, when barely of age, he had absorbed the spirit and method of Pre-Raphaelitism. Well versed in Italian poetry, he chose his later subjects from Dante, but found his favourite themes in Scriptural subjects and particularly, though belonging to the people of Israel, in the life of Christ. Well might Swinburne write: 'Thou has conquered, O pale Galilean.' In the Victoria and Albert Museum are *Isaac and Rebekah*[9] (Pl. 151), 1863, and *In the Temple of Venus*,[10] 1865.

[1] F. M. Hueffer, *Ford Madox Brown*, 1896.
[2] Manchester, City Art Gallery.
[3] Birmingham, City Art Gallery, 24'91.
[4] V.A.M. 268–1895.
[5] Birmingham, City Art Gallery, 356'27.
[6] Manchester University, Whitworth Art Gallery.
[7] Manchester University, Whitworth Art Gallery.
[8] Manchester University, Whitworth Art Gallery.
[9] V.A.M. P.46–1925.
[10] V.A.M. D.142–1906.

126

Though he promised a real originality, Solomon's period of work possessing intrinsic merit was very short. In Robert Buchanan's[1] famous outburst against the Fleshly School of Poetry, he says that: 'English society goes into ecstasy over Mr. Solomon's pictures—pretty pieces of morality such as Love dying by the Breath of Lust.' Mr. Solomon, he adds, was one of those who 'lend actual genius to worthless subjects and thereby produce monsters'. In the charge against Solomon there was justification. He began to go downhill in 1871, and slid into misery and squalor. In 1873 he was in gaol for moral offences and thenceforth became a pariah. By 1887 he had entirely ceased to produce work of any value, but poured out a quantity of pastels, their subjects mainly derived from the Bible and from Catholic, Jewish or Greek Orthodox ritual, for sale at a guinea a piece. Right on into the late nineties they were almost as popular as portraits of Edna May and May Yohe for the decoration of undergraduates' rooms. Solomon died in St. Giles's workhouse from chronic alcoholism, and a newspaper obituary says that he had 'stepped back into the riotous pages of Petronius'. Robert Ross gives the verdict: 'In respectable London he was quite impossible. In the temple of Art, which is less Calvinistic than artists would have us suppose, he will always have his niche.'

George Price Boyce (1826–1897), very different in character from Solomon, was closely linked with the Pre-Raphaelites. Born in Bloomsbury (rather senior to Millais and Hunt) of parents who seem to have had ample means which he inherited, Boyce was articled to an architect and travelled on the Continent for purposes of study. After a memorable meeting with David Cox at Bettws-y-Coed in 1849, he abandoned his intended career and devoted himself to painting. The effect of his early training is seen in his predilection for architectural subjects, and the scrupulous care with which he executed them owes much to Pre-Raphaelite influence. As he saw his subject, the *Catterlen Hall, Cumberland*[2] (Pl. 191), for instance, so he painted it, without 'composing' for the sake of heightened effect. His exact perspective and precise attention to every brick or stone and their texture make his drawings look almost photographic when reproduced in black and white, but his colour is mellow and pleasing in his simple landscapes, methodically recorded with an atmosphere of quiet and repose. His *Sacca della Misericordia*,[3] painted when he was twenty-eight, is handled with more breadth than his later work. Boyce exhibited at the Royal Academy from 1853 to 1861. In 1864, along with Burne-Jones and Fred Walker, he was elected an associate of the Old Water-Colour Society, and became a full member in 1877.

From May 1, 1851, to Aug. 31, 1875, Boyce kept a diary[4] which contains frequent references to his own work, but is the more valuable because it speaks in asides about the whole Pre-Raphaelite group. Boyce lived in constant, often daily, touch with Rossetti for over twenty years: he gives vivid and intimate pictures not only of Rossetti but of Ruskin, Millais, Holman Hunt, Swinburne, William Morris, Whistler and others. In 1851 Ruskin

[1] R. W. Buchanan, *The Fleshly School of Poetry*, 1872, p. 38.
[2] V.A.M. P.6–1911. [3] V.A.M. P.8–1933.
[4] See footnote on p. 119.

127

told Boyce not to go and botch his drawings in the studio and 'hoped I was a confirmed Pre-Raphaelite'. In 1858, 'went to 13, Foster Terrace and saw Madox Brown and his *Work* picture. Some fine stuff in it, but it will scarcely be appreciated but by few. Martineau as a swell on our omnibus introduced; Maurice and Carlyle in the corner.' In 1866, 'Swinburne in a very excited state, using fearful language', and later, 'Saw Swinburne who was rather drunk safely into a cab at Pimlico station.' In 1874, 'Thos. Carlyle called. The old gentleman was very pleasant and chatty and made himself at home. Spoke of Burns as the greatest of the British poets, of Keats as a weak, unbraced writer, but a poet.' These random extracts show the quality and interest of a diary which, except in print, no longer exists. All of the volumes, sad to say, were destroyed in an air-raid on Bath at the house of Boyce's niece, Mrs. Arthur Street.

Alfred Stevens (1817–1875), born at Blandford, Dorset, the son of a house painter, lived in Italy from 1833 to 1842. While there he copied frescoes at Florence and the works of Andrea del Sarto at Naples, studying also at Venice and under Thorwaldsen in Rome. He made a great number of figure studies in red chalk in the manner of Raphael, but his rare water-colours with their faithful search for truth and their imaginative quality show him to have been in many ways at one with the Pre-Raphaelite movement. From 1845 to 1847 he was a professor in the Government School of Design at Somerset House. In 1850 he became designer to Hoole and Robson, a firm of metal-workers at Sheffield. Memorable for his oil portraits and as the author of the Wellington Monument in St. Paul's Cathedral, he will go down to posterity as one of the greatest (if not the greatest), of English craftsmen and designers. There are large collections, showing every side of his genius, at the British Museum, the Victoria and Albert Museum and, particularly, in the Tate Gallery. He clearly enjoyed finishing his designs in colour; and, being essentially a craftsman, he understood his medium and used it to felicitous purpose. In a crowded career his water-colours were merely an interlude, but the high quality of his landscape work is shown in *Sketch in Italy: a Valley with Boulders*.[1]

Within the orbit of the Pre-Raphaelite group comes Frederic James Shields (1833–1911). Born of poor parents, he worked from the age of fourteen with a firm of commercial lithographers. He embarked upon book-illustration (notably his drawings for *The Pilgrim's Progress*) and made many water-colours in Devonshire. In 1865 he was elected as associate of the Old Water-Colour Society, and from that date was closely in touch with the Pre-Raphaelites. His life work consisted largely in the execution of mural decorations in churches throughout the country, in the chapel at Eaton Hall, and the little Chapel of the Ascension, which was utterly destroyed by a German bomb. The chapel was a retreat in the Bayswater Road, erected by Mrs. Russell Gurney, from designs by Herbert P. Horne. In preparation for his spirited fresco decorations in the Chapel of the Ascension, Shields travelled to Italy in 1889 in search of inspiration. He went in company with Horne, whose

[1] V.A.M. E.2473–1911.

128

Porta Maggiore, Orvieto[1] bears the date, '4th October, 1889'. Shields' high proficiency as draughtsman and water-colourist is shown in *Playing Checkstones*[2] and *Holly-Gatherers*.[3]

Moving parallel with the Pre-Raphaelite movement, but totally outside its orbit or influence, comes Richard Dadd (1817–1887). He was born at Chatham, where his father was a chemist. On moving to London, the son entered the Royal Academy Schools, and from 1837 to 1842 exhibited portraits, figure subjects and landscapes in oil and water colour, at the Society of British Artists and at the Royal Academy. His most important work was a series of over a hundred paintings, commissioned by Lord Foley, to illustrate Byron's *Manfred* and Tasso's *Jerusalem Delivered*. In 1842–3 he journeyed in the Levant, and on his return, though his brain showed signs of weakness, he executed admirable water-colours of Egyptian scenes. In 1843 Dadd's mind gave way. He took his father—the first on a list of people who, he thought, would be better dead—for a walk in Cobham Park, near Gravesend. Next day the father's body was found in an unfrequented part of the park dreadfully mutilated. The son fled to France, but was arrested soon after in the act of trying to cut a fellow-traveller's throat at Fontainebleau. Perhaps the forest surroundings reminded him of Cobham Park and renewed his frenzy. He was brought back to England, and from 1844 till his death in 1887 was kept under prison restraint, first at Bethlehem Hospital, and then from about 1861 at Broadmoor. Imprisoned in body, and imprisoned behind the bars of his tormented mind, he was without knowledge of any contemporary work produced outside of what Osbert Sitwell calls 'his besieged world of delusion'. In Bethlehem and at Broadmoor during four decades he was constantly painting groups of figures, either romantic or satirical. The logic and the faithful realism, so absent from his mind, were present in work which showed Pre-Raphaelite intensity and imagination. His work is sometimes based on history or legend; sometimes, as in the *View of Port Stragglin*[4] (Pl. 154), it depicts a scene of pure fantasy. The whole range of his output with, as Binyon says, a 'strange and exquisite technique of its own, marvellously delicate in colour', is shown at the Victoria and Albert Museum. The collection there includes many examples of his Egyptian landscapes, his *Christ rescuing St. Peter from the Waves*,[5] 1852, *A Fallen Warrior*,[6] 1855, three studies to illustrate *The Passions*[7] (*Idleness*, Pl. 153), 1853–56, and other works. In the Library of the Museum is a manuscript poem illustrated with pen-and-ink drawings by Dadd.

Closely associated in his younger days with Ruskin, Burne-Jones and William Morris, T. M. Rooke grew up under the immediate influence of the Pre-Raphaelites. Thomas Matthew Rooke (1842–1942) was born in Marylebone. He began his working life in an Army Agents' Office, where he came to know several of Wellington's old Peninsular Officers. He attended classes at the National School of Design (now the Royal College of Art) and then passed on to the Royal Academy Schools. At the age of twenty-nine he applied for a

[1] Birmingham, City Art Gallery.
[2] Manchester, City Art Gallery.
[3] Manchester University, Whitworth Art Gallery.
[4] B.M. 1919. 4.12.2.
[5] V.A.M. 33–1878.
[6] V.A.M. A.L.8391.
[7] V.A.M. F.59; D.1 and 2.1908.

vacancy as designer in William Morris's firm, and on his appointment was assigned as assistant to Burne-Jones, with whom he worked for many years. In 1878 Ruskin was searching for suitable artists to make drawings of cathedrals and other ancient buildings on the Continent threatened both by neglect and decay and by restoration, and Burne-Jones recommended Rooke, saying in his letter ' . . . also there is a very high place in Heaven waiting for him, and HE DOESN'T KNOW IT'. As a result Rooke spent at least half of his time working for Ruskin abroad. The drawings thus made were given by Ruskin to the Ruskin Museum at Sheffield. The employment under Ruskin ended in 1893, and thereafter, for some fifteen years, at the suggestion of Sir Sydney Cockerell, and with the aid of Burne-Jones, Lord Carlisle, J. R. Holliday and others, Rooke was engaged on similar work, 'Rooke to make a drawing of some building agreed between us, *as well as ever he could*, in return for an unspecified sum'. In this instance the whole collection of thirty-four drawings was handed over to the Birmingham Art Gallery.

In 1891 Rooke was elected an associate of the Royal Water-Colour Society, and a full member in 1903. His work, like that of Boyce, was without largeness of style, but it was faithful and accurate, and always pleasing both in colour and sentiment. He both knew and loved the buildings which he portrayed, and he never varied from the painstaking exactness which had very properly won Ruskin's approval. At his death, at the age of ninety-nine, he had long been the doyen of the Old Society, a man loved by all for his gentle kindness and endearing charm. His son, Mr. Noel Rooke, tells how his father continued to paint till he was nearly ninety-eight, and adds that, 'though painting had the first place in his affections he continued to play the violin, or sometimes the tenor fiddle or the 'cello, almost every day up to the age of ninety-six, whether at home or travelling; a day without music was a day lost'.

One of the last survivors of the later Pre-Raphaelites—later, because they had no contact with the original Brotherhood—was Eleanor Fortescue-Brickdale (1871–1945). Like Byam Shaw and Robert Anning Bell, she inherited the Pre-Raphaelite love of moral and symbolic meaning, of allegory and decoration, of glowing colour. As far back as 1901, before she was thirty, Percy Bate[1] said that Miss Fortescue-Brickdale 'should do much in the future to exemplify the still living force of Pre-Raphaelitism as a school'. She studied at the Crystal Palace School of Art and at the Royal Academy Schools, making her first appearance at a summer Academy exhibition in 1897. Concentrating upon water-colour work of a highly wrought character, she was necessarily limited in her output. She was elected associate of the Royal Society of Painters in Water-Colours in 1902 and full member in 1919. Essentially an illustrator, she put precise drawing into a jewelled setting of brilliant colour in such works as *The Forerunner*, which depicted Leonardo da Vinci showing his model of a flying machine to the Duke of Milan, and *The First Visit of Simonetta*. As might be expected, she was a successful designer of stained glass windows; there are examples of this side of her art in Bristol Cathedral and at Brixham, and she painted the

[1] P. Bate, *The English Pre-Raphaelite Painters*, 1901, p. 14.

reredos for the Chapel of Remembrance in the British Empire Exhibition, 1924. She is represented in the art galleries at Liverpool, Birmingham and Leeds.

Here too may be mentioned Joseph Southall (1861–1945), not consciously a Pre-Raphaelite but a follower of the movement in his meticulous precision of statement and his peculiar glow of colour. Maxwell Armfield,[1] than whom no one could be better qualified, has written fully and sympathetically about the scope and nature of Southall's work. Born at Nottingham, Southall was articled in 1878 to a firm of architects, but broke away from that profession and worked as an assistant to Sir W. Blake Richmond, R.A. In 1895 he exhibited at the Royal Academy, and from 1897 at the New Gallery. He concentrated on tempera painting and, as Armfield says, 'in a way, it is true to say that Joseph Southall invented Tempera as a modern language'. About 1900 he helped found the Society of Painters in Tempera, with Holman Hunt, Watts, Walter Crane, Mary Sargent-Florence, Maxwell Armfield, J. D. Batten and others. In 1925 he was elected to membership of the Royal Water-Colour Society, where the intense blue and gold of such pictures as *San Giorgio, Venice* and *The Old Seaport* sang out upon the walls. His pictures—they cannot be described as water-colour drawings—of ships, bridges and landscape, however static they are, seem more intense, more personal, more satisfying, than his large figure compositions of a mythological nature, where a stilted realism of face and costume make more obvious a lack of movement and atmosphere. Movement and atmosphere did not interest him. His preoccupations were largely with his materials, the empirical value and their proper use. Armfield tells us how he rejoiced in pigments, collecting ochres, for instance, wherever he went, and having in his studio innumerable bottles labelled, 'Banbury Ochre', 'Dunster Earth', etc. Needless to say, he used real ultramarine. He reached the final translucent effect on his meticulously prepared panel by the laborious building up, in many stages, of preliminary contrasting colours. 'He was rightly contemptuous of "stuff in tubes", with which he saw his medium travestied and spoiled in later days.' His work was highly objective, so much so that people, however delighted with his presentation of ships, almost all from material found at Fowey and Southwold, were very apt to say that they were like models. Armfield's reply to that is that, like medieval and oriental renderings, they are actual presentments of objects and, quite deliberately, not representations of them as subject to surrounding influences of wind, light and shadow.

Joseph Southall wrote to me in 1931, with reference to his methods: 'I do not think there is any other member or associate of the R.W.S. who works as I do, because my *handling* of water-colour is largely influenced by my handling of tempera, though I never use any tempera medium in my water colours, whether on paper or silk. There are great differences in the working of the two media, especially in the initial stages. In water colour one can use washes up to a certain point, after which I finish with broad or fine stippling, to achieve a depth and richness of tone not otherwise attainable. In water colour I aim at greater

[1] M. Armfield, *Joseph Southall*, O.W.S. Club, XXIV, 1946.

depth than is usual in that medium. I try to lay one colour *over* another without disturbing what is underneath, because this gives greater purity and richness of colour than can be obtained by mixing wet colours together. I usually give my paper a yellowish tone before I begin to draw on it—this saves time and helps to achieve a golden or sunny effect.'

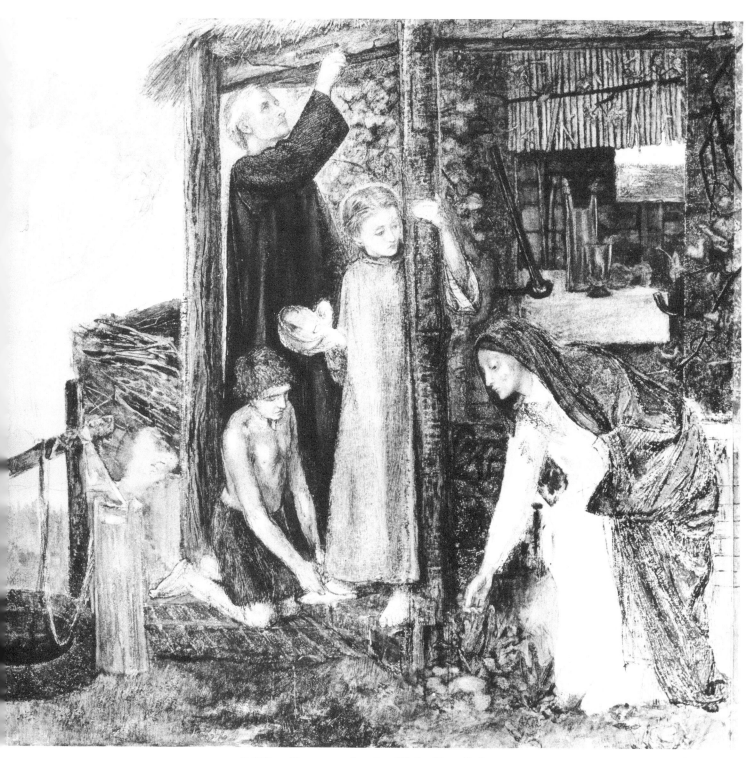

136 'The Passover in the Holy Family'
Tate Gallery, 3156 16 × 17: 406 × 432 *Water-colour*
Dante Gabriel ROSSETTI (1828–1882)

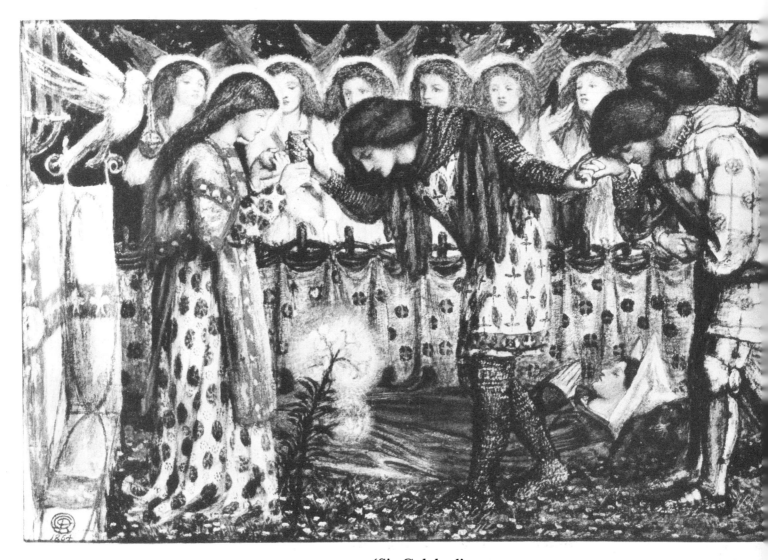

137 'Sir Galahad'
Tate Gallery, 5234 $11\frac{1}{2} \times 16\frac{1}{2}$: 292 × 418 *Water-colour, signed and dated 1864*
Dante Gabriel ROSSETTI (1828–1882)

138 'Tennyson reading 'Maud' '
ngham, Museum and Art Gallery 495'04 8¼×6: 210×153
Pen and ink and grey wash, dated 1855
Dante Gabriel ROSSETTI (1828–1882)

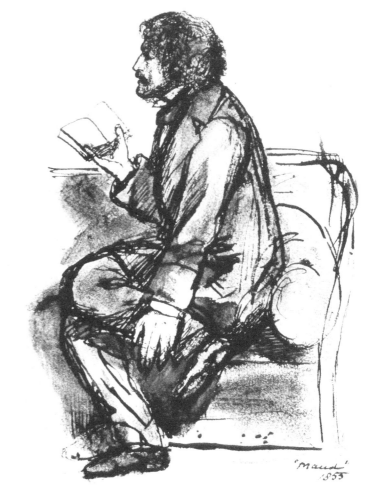

139 'Writing on the Sand'
B.M. 1886.6.7.14 (LB 2) 10⅜×9½: 263×241
Water-colour, signed
Dante Gabriel ROSSETTI (1828–1882)

140 'The Star of Bethlehem'

Birmingham, Museum and Art Gallery, 75'91 101 × 152: 2,559 × 3,851 *Water-colour and body colour, signed and dated 1890*

Sir Edward Burne-Jones Bt. (1833–1898)

141 'Sidonia von Bork, 1560'

Tate Gallery, 5877 13×6¾: 329×172 *Water-colour, signed and dated 1860*

Sir Edward BURNE-JONES Bt. (1833–1898)

142 'The Annunciation'
Birmingham, Museum and Art Gallery, 441'27
$20\frac{1}{2} \times 14\frac{5}{8}$: 520 × 371
Water-colour, signed and dated 1861
Sir Edward BURNE-JONES Bt. (1833–1898)

143 'An Idyll'
Birmingham, Museum and Art Gallery, 91'24
$11\frac{7}{8} \times 11$: 302 × 279
Water-colour and body-colour, signed and dated 1862
Sir Edward BURNE-JONES Bt. (1833–1898)

144 'My Second Sermon: Millais' daughter Effie'
V.A.M. 399–1901 9½×6½: 241×164 *Water-colour*
Sir John Everett MILLAIS, P.R.A. (1829–1896)

145 'Girl by a Window' (Engraved in 'Once a Week'
Nov. 16, 1859)
B.M. 1937.4.10.3 4⅛×3⅜: 104×86 *Water-colour*
Sir John Everett MILLAIS, P.R.A. (1829–1896)

146 'Study for 'Christ in the House of His Parents' '
Tate Gallery, 4792 7½×11⅜: 190×290 *Pen and ink and wash*
Sir John Everett MILLAIS, P.R.A. (1829–1896)

147 'Apple Gatherers in the Rhine Valley, Ragaz'
Birmingham, Museum and Art Gallery, 145'35 $15\frac{3}{4} \times 17\frac{5}{8}$: 400 × 417 *Water-colour, signed*
William Holman HUNT, O.M. (1827–1910)

148 'Head of a Lammergeier or Bearded Vulture'
Coll. Mr Leonard G. Duke 7 × 10⅛ : 178 × 257 *Water-colour*
William Holman HUNT, O.M. (1827–1910)

149 'Chaucer at the Court of Edward III'

Birmingham, Museum and Art Gallery, 356'27 14¼ × 15: 360 × 380 *Water-colour and body colour*

Ford Madox BROWN (1821–1893)

150 'The Coat of Many Colours'
Tate Gallery, 4584 12 × 12 : 304 × 304 *Water-colour, signed and dated 1867*
Ford Madox BROWN (1821–1893)

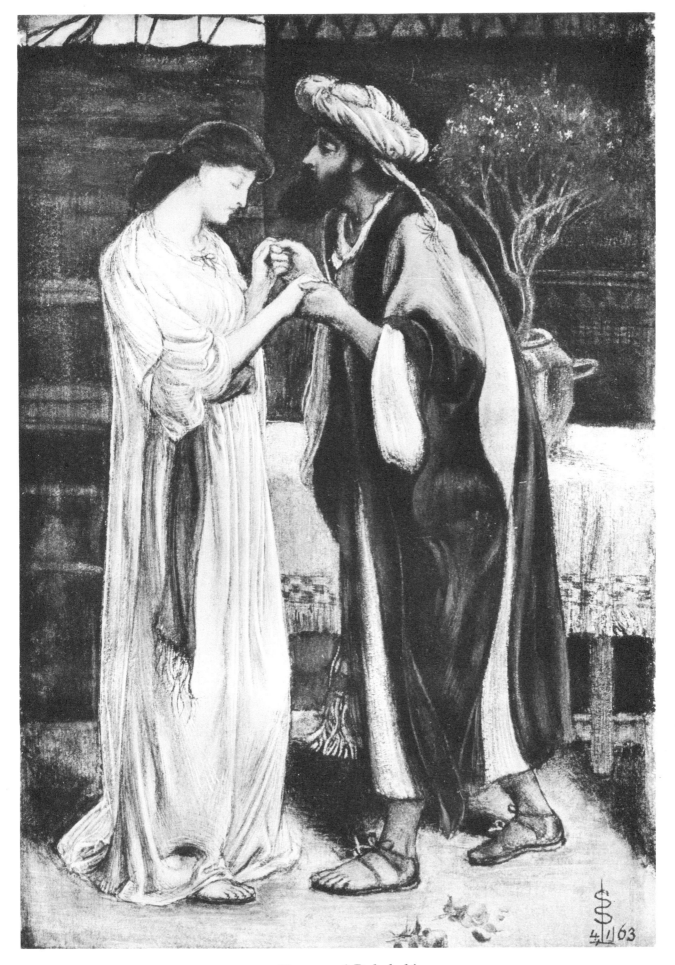

151 'Isaac and Rebekah'

V.A.M. P.46–1925 11½×8: 292×203 *Water-colour*

Simeon SOLOMON (1840–1905)

152 'South porch, Chartres Cathedral'

B.M. 1931.5.29.1 $14\frac{3}{8} \times 7\frac{5}{8}$: 264 × 194 *Water-colour, signed and dated 1885*

Thomas Matthew ROOKE (1842–1942)

Sketch to illustrate the Passions
Idleness — Idleness is the Mother of Vice.
by Richard Dadd · Bethlem Hospital London Dec.ʳ 20ᵗʰ 1853

JOLLY BEGGARS

153 'The Passions: Idleness'
V.A.M. D.1–1908 14⅜ × 10⅛ : 365 × 258 *Water-colour*
Richard DADD (1817–1887)

154 'Port Stragglin'
B.M. 1919.4.12.2
$7\frac{1}{2} \times 5\frac{1}{2}$: 190 × 140
Water-colour
Richard DADD
(1817–1887)

155 'Façade of the Ca'd'Oro, Venice
B.M. 1890.10.13.51 (LB 18)
$9\frac{1}{2} \times 12$: 241 × 305
Water-colour
Alfred STEVENS (1818–1875)

CHAPTER VIII

Narrative and Pastoral Painters and the Later Illustrators

*Frederick Walker George John Pinwell Charles Green
Walter Crane Kate Greenaway Randolph Caldecott Charles Keene*

The 'sixties of the last century witnessed the rise of a new group of water-colour painters whose work, narrative and pastoral, supplied the kind of sentiment which was openly popular in their day. These artists followed, with only a sidelong glance at the Pre-Raphaelites, a tradition with eighteenth-century roots. Fred Walker, G. J. Pinwell and J. W. North never equalled, nor indeed strove to equal, the Pre-Raphaelites in their intensity of feeling and in their gift for attaching an imaginative and poetic fancy to simple truth. They followed the Pre-Raphaelites' realism, but made it more homely and more typically English. Walker's *Philip in Church*[1] was painted in 1863, a year after Millais' *My Second Sermon*,[2] and the two pictures are natural companions as a lingering tribute to Pre-Raphaelitism. Thereafter Walker's pastoral subjects and his decorative classicism have nothing in common with the Pre-Raphaelites except the sincerity of the approach to Nature and, to some extent, the deliberate use of a body-colour method.

Walker, Pinwell and North all began their careers as book-illustrators in a golden age of English book-illustration. The Moxon Tennyson had given to Rossetti and Millais their early opportunity. In the 'sixties (Gleeson White and others have written about the magnificent output of this period) *Once a Week*, *Good Words* and other publications, backed by Swain and the Brothers Dalziel as wood-engravers, were similarly encouraging young artists to produce vital and original drawings. Walker, Pinwell and North, after years of memorable work for the engraver, most of it interpretative, abandoned drawing upon the block for the freedom of their own original water-colours. Other contemporaries such as Randolph Caldecott, Kate Greenaway and Walter Crane were occupied mainly with book-illustration to the end of their lives, bringing to it an inventiveness and originality which set their work in its kind upon a high level. Walker, Pinwell and North were born in

[1] London, Tate Gallery 3515.
[2] London, Guildhall Art Gallery.

133

the years 1840 to 1842; Caldecott, Kate Greenaway and Crane in the years 1845 and 1846.

Frederick Walker (1840–1875)—the Little Billee of Du Maurier's *Trilby*—was born in Marylebone. His father, a jeweller with a taste for painting, gave every encouragement to his son in the pursuit of an art career. After a general education at the North London Collegiate School, Camden Town, where his incessant sketching showed his natural bent, Fred Walker (as he became generally known) was placed for eighteen months with an architect and surveyor named Baker. On leaving, he devoted himself to the study of the antique at the British Museum (nurturing a passion which he never entirely got out of his system). He attended evening classes at Leigh's Life School in Newman Street and in 1858 was admitted as a student at the Royal Academy Schools. Constant in his appearance at the Langham Sketch Club, he produced spontaneous drawings which were often the envy of his fellow-workers. To gain a livelihood he found employment for three years under T. W. Whymper, the wood-engraver, drawing three days a week on the block and learning the full technique of engraving upon wood. By the end of 1860 he had contributed drawings for twenty-four illustrations in *Once a Week*, and in the following spring came under the notice of Thackeray, who was then editing the *Cornhill Magazine*. Invited to the editorial office, young Walker was called upon to make a test sketch of the back view of the great man (he was dressing for dinner, and shaving in front of the mirror over his mantelpiece), and was convincingly successful. He was commissioned to help with the illustrations for *Philip*, which appeared monthly in 1861 and 1862; at first he was humbly working up Thackeray's own sketches and then, after a firm protest, making and signing his own designs. He was soon producing illustrations for *Good Words*, *A Round of Days* and other publications. While designing for the engravers, and designing all the better because he knew exactly what powers of alteration and correction the engraver possessed, he began to practise in oil and water-colour.

He exhibited an oil-painting at the Royal Academy in 1863, and won a triumph with his four subjects shown at the Old Water-Colour Society on his election as associate in 1864. His work, with its apparently simple but very artificial account of humble life, and rustic surroundings and its pathos, endeared him to the public and had a strong influence upon his contemporaries. However differently, his pictures, like those of Samuel Palmer's, told of a happy pastoral life evoking Milton's lines:

> *While the Ploughman near at hand,*
> *Whistles ore the Furrow'd Land,*
> *And the Milkmaid singeth blithe,*
> *And the Mower whets his sithe.*

One of his 1864 exhibits was *Spring*[1] (Pl. 156), a boy and girl gathering primroses in a copse. It is a perfect example of the artist's skill in realising the movement of a figure and

[1] V.A.M. P.2–1911.

134

of his conscientious rendering of leaves and buds, saplings and young shoots, tender flowers and all growing things, coming to life in the moist, delicate atmosphere of an English April. The picture was bought by Sir William Agnew, head of the Bond Street art-dealing firm, passed to Mr. William Leech and bought by Sir William again in 1887 for £2000, as 'the finest drawing that Walker ever made'. With its companion, *Autumn*,[1] it was handed over after Sir William's death to the Victoria and Albert Museum in fulfilment of his wish. *Spring* is the more satisfying of the two, but the figure is somewhat awkwardly posed and the drapery is unrestful. Walker worked at intervals on this picture for over a year and a half and, in his own words, 'never spent so much time and trouble over anything before'. He was 'sick of the very name', and glad when Agnew carried the 'beastly thing' away.

In company with *Spring* may be mentioned *The Violet Field* (1867) for its dewy tenderness and unaffected charm. In the following year, 1868, Walker painted his little study of *Mushrooms and Fungi*, lovely in colour and showing a kind of divination as well as imitative skill. Ruskin, indeed, went so far as to say: 'It entirely beats my dear old William Hunt in the simplicity of execution, and rivals him in the subtlest truth.' Here, too, may be mentioned another aspect of Walker's art, shown in *Rainy Day at Bisham*[2] (Pl. 157), so happy in spite of the rain; *The Ferry*[3] (at Bisham just above Great Marlow); and *The Street, Cookham*;[4] all show scenes which the artist knew by heart and indeed painted from his heart. Compared with them *The Gondola*,[5] so poor in composition, is dull and uninspired, a holiday exercise and no more.

Several of Walker's oil-paintings, such as *Wayfarers*, *The Harbour of Refuge* (Tate Gallery), and *The Old Gate* (Birmingham, City Art Gallery) were repeated by him in watercolour. In his oils, on the larger scale, he adopted a deliberate classicism, derived from his early devotion to Greek sculpture. This became a little overpowering in his water-colours and was unsuitable to the slighter medium. The figures, it may be allowed, are nobly seen and unerringly right in pose and arrested movement, but they belong to Athens and the fifth century B.C., not to the nineteenth century and Cookham-on-Thames. The mower in *The Harbour of Refuge* and the labourer on his homeward return in *The Old Gate* are Hermes and Apollo as seen by Pheidias; and of the cottage girl supporting her aged grandmother in *The Harbour of Refuge* it might fairly be said: *vera incessu patuit dea*. Ruskin complained rightly of this artificiality, the 'galvanised-Elgin' attitude of some of Walker's figures.

Several writers about Walker's art have followed Sir Hubert von Herkomer in stressing, quite wrongly, the influence upon him of J. W. North. In 1868, when Walker was working beside that artist in Somerset, he was two years older than North, and was already the mature painter quite fixed in his own methods and purposes. He had been elected to the Old Society in 1864, and North did not win election till 1871. It would be fairer to say that

[1] V.A.M. P.3–1911.　　　　　　　　　　　　　　[2] V.A.M. 37–1892.
[3, 4] C. Black, *Frederick Walker*, 1902, illus. on pp. 143 and 113.
[5] Birmingham, City Art Gallery, 35'94.

Walker was much more indebted to William Hunt and, particularly, to Birket Foster. In January 1864 he showed *Philip in Church*,[1] one of his two first serious efforts in water-colour, to Hunt, who 'seemed greatly pleased with it and gratified me very much'. And, just before his death in the following month, Hunt recorded his vote for Walker's election to the Old Society. When Walker, in 1859, not yet twenty, painted his *Blackberrying*[2] he was quite obviously an admirer and disciple of Birket Foster. Walker stayed in Birket Foster's home in 1863 and later, in that year, he was still the novice as a painter in water-colour, timorously working on his *Strange Faces*.[3] While North in 1868, when they worked side by side, was perfecting a technique which eliminated the use of body-colour, Walker, as early as 1863, had adopted the body-colour method of Hunt and Foster. Is it not likely that Foster, having himself started life as a wood-engraver, should have taken a fatherly interest in the young and promising illustrator, many years his junior, and revealed to him such secrets as there were in his own experience of the water-colourist's craft? Walker's mentality was naturally different, but one cannot fail to find throughout his work a re-semblance to Birket Foster in sentiment, subject-matter and technique. It seems to me significant that in 1873 Birket Foster should have exhibited a picture of the full front of a *Fruiterer's Shop*,[4] and Walker, at the end of 1872, the full front of a *Fishmonger's Shop*.[5] It is impossible to say which was actually painted first, but they are identical in theme and composition, and precisely identical in method. Walker said, about his picture, 'I have put into it all I know'. But—wet, shiny and real though his fishes are—I think the Birket Foster is to be preferred.

Walker was not a very successful colourist. Ruskin,[6] with some truth, denounced his skies as of 'the colour of buff plaster', admitting at the same time that in their chosen key, his 'harmonies of amber colour and purple' were 'full of exquisite beauty'. His water-colour method was described by Ruskin as 'semi-miniature fresco, quarter wash manner of his own—exquisitely clever, and reaching under such clever management, delightfullest results here and there, but which betrays his genius into perpetual experiment instead of achievement, and his life into woeful vacillation between the good, old, quiet room of the Water-Colour Society and your labyrinthine magnificence at Burlington House'. I think that what Ruskin meant by his 'quarter wash' was Walker's habit of working portions of his drawings in washes of transparent colour, and then finishing the rest with the aid of Chinese White. He seems to have followed Hunt and Birket Foster in covering parts of his drawing with a china-like surface of white body-colour, before apply-ing his stippled tints. In some of his pictures, certain passages are in transparent, or almost transparent, colour, and in other parts quite an apparent halo, perhaps round a figure, showing where he has added a thick coat of white and then worked into it with colour. His

1 Tate Gallery 3515.
2 F. J. Nettlefold Cat., Vol. IV, p. 86.
3 C. Black, *op. cit.*, p. 59.
4 See Chapter VI.
5 Port Sunlight, Lady Lever Art Gallery.
6 J. Ruskin, Letter to H. Stacy Marks, A.R.A., in *The Times*, January 20, 1876.

fellow-worker, J. W. North, always pedantic on the subject of paper, said that 'the uncertain character of the paper led Walker into excessive use of chinese-white in his earlier water-colours. This use of white he gradually diminished until in some of his later work in water-colour there is scarcely a trace, and that existing only because of some defect in the paper.' Walker was quite conscious of his heterodoxy, as is shown by a caricature of himself, made about 1865. He pictures himself painfully embracing a double tube of flake-white almost as large as himself and compelling it to exude vast serpentine coils upon his palette. Beneath is the legend: 'What *would* the Society say if it could only see me?' A minor point is that he was ambidextrous, often painting with right and left hands freely and alternately.

Fred Walker had unfortunately inherited a consumptive tendency, with its concomitant symptoms of depression and despair mingled with feverish outbursts of creative work, as in the case of other painters and poets with this tendency. As his trouble developed, he visited Algiers in the winter of 1872 in search of a warmer climate, and frequently made journeys to Scotland for the sake of its bracing air and the angling which he loved. He died, while on a fishing excursion to St. Fillan's, Perthshire, in 1875. He was buried at his favourite sketching resort, Cookham-on-Thames, where a portrait medallion by H. H. Armstead, R.A., was later placed in the church. At the age of thirty-five (his life was not much longer than those of Girtin and Bonington) a career of brilliant promise was cut short. Hampered by ill health, as well as by his fastidious search for perfection, he had not reached the fullness of his powers. His remaining works were sold at Christie's on July 17, 1875, and in 1876 a representative collection (with a full and excellent catalogue, prefaced by Tom Taylor) was shown at Deschamps' Gallery, 168, New Bond Street.

John William North (1842–1924) has already been mentioned. Born at Walham Green he studied at the Marlborough House School of Art, and then became a wood-engraver, working under Whymper. Of Josiah Wood Whymper (1813–1903) it may be inserted here that, coming to London in 1829 (he was born in Ipswich), he learned the craft of wood-engraving and built up a successful connection. He took lessons in water-colour from Collingwood Smith, and became a member of the New Water-Colour Society in 1854. It was in 1860 that North was apprenticed to Whymper and worked side by side with Walker, Pinwell and Charles Green. From 1862 to 1866 North found employment with the firm of the Dalziel Brothers, and his charming interpretation of landscape (his pencil drawings of manor house and farm in their rural surroundings are delicate and truthful) may be seen in the pages of *Wayside Posies* (1867) and other publications of this period. In 1868 he lived at Halsway Farm, Somerset; and through his long life of eighty-two years, at Withycombe and elsewhere, Somerset was his actual and spiritual home. Walker stayed with him in 1868 at Halsway Farm, and found nearby the subject for his *Old Gate*;[1] and it was in North's congenial company that he travelled to Algiers. In 1871 North was elected an associate of the Old Society; and, largely through Herkomer's advocacy, he became an associate of the Royal Academy in 1893.

[1] Birmingham, City Art Gallery.

137

North was always a student of landscape rather than of the figure. Recognising his weakness, he was inclined to avoid figures, and sometimes induced Walker to put one in for him. It may be, however, that he agreed with Wordsworth, who said to Farington[1] that 'where the Landscape was intended to impress the mind, figures, other than such as are general, such as may a thousand times appear, and seem accidental, and not particularly to draw the attention, are injurious to the effect which the Landscape should produce as a scene founded on an observation of nature'. North is far more interesting as a technician than as a colourist or composer. His landscapes reveal an almost scientific search for detail in the tangled luxuriance of orchard and copse. He was inclined, in Corot's phrase, to 'look at landscape through a telescope and turn painting into astronomy'. He was much more interested than Walker in atmosphere, and his wish to make his drawings tingle and shimmer with light led him to paint multitudinous details melting together, with spots and particles of pure colour. His method can be compared with *pointillisme*; certainly, he was groping for methods of expression which the French Impressionists developed more fully. As a technician, he was obsessed with the idea of producing a pure linen paper and, as has been already recounted,[2] spent years of his life in a very unremunerative commercial venture for the production of his 'O.W.' paper. In fact, this paper was so pure, being nearly 100 per cent linen, that it was hard and resistant, making the even laying of a flat wash very difficult to manage. Herbert Alexander[3] observed that 'North found his greatest trouble in the treatment of a large sky. On the other hand, the almost indestructible surface was ideal for his elaborate technique, by which his work was very much wrought with a sharp knife and submitted to all kinds of processes, such as re-sizing and burnishing, and even the fine linen in its metamorphosis often suffered again the ordeal of the box-iron!' It is the perfect paper for that kind of work (I have some of it, forty years old, given to me by Sir Frank Short, who was North's firm supporter), but, though it improves with age and with the perishing of the size, it is not the ideal paper for a rapid outdoor sketch.

There are no better examples of North's curious craftsmanship and conscientious purpose than his *Gipsy Encampment*[4] (Pl. 158) in the Victoria and Albert Museum (I suspect that the central stooping figure was by Walker) and the very faithful, elaborate study of a *Pear Tree* in the Southampton Art Gallery.

George John Pinwell (1842–1875) born at High Wycombe, was younger than Walker by rather more than two years and his survivor by three months only. He studied at St. Martin's Lane School and at Heatherley's. He and Walker were alike in beginning their career as draughtsmen on wood, and sometimes supplied illustrations for the same book. From 1864 Pinwell was working for the brothers Dalziel, and his illustrations will be found in *A Round of Days* (1866), *Wayside Posies* (1867), as well as in *Once a Week*, *Good Words* and

[1] *Diary*, April 28, 1807.
[2] Vol. I, p. 27 n.
[3] H. Alexander, *John William North, A.R.A.*, O.W.S. Club, V, 1927–8, p. 46.
[4] V.A.M. 68–1895.

138

other periodicals. When the Dudley Gallery was founded, it supplied in 1865 an opening for him to exhibit water-colours, and he began, like Walker, by developing into water-colours the drawings which he had made for the press in black-and-white. He was elected an associate of the Old Society in 1869, and made his mark by two drawings of the *Pied Piper of Hamelin* and a version in colour of his effective illustration, *A Seat in St. James's Park*. They were so well received that he won election to full membership in the following year. His drawings on the wood block (examples at the B.M. and V.A.M.) are the work of a natural composer and show great sensitiveness of line, coupled with both interpretative and inventive power. His work, both in colour and in pencil, appeals by its refinement and poetry, sometimes by its dramatic pathos. He invests his crinolined figures with extraordinary grace and charm. Through his search for textures in clothing, in foliage or weeds, in brick or stone, and his happy appreciation of the play of light and shadow over a farm house, a dovecote, a crannied wall or in the gloomy interior of a barn, he gives dignity and constant charm to rustic subjects. One may set him beside Charles Keene as one of the greatest of British draughtsmen. When he works in water-colour the landscape backgrounds tend to smack of the studio rather than the open air. His water-colours in the Victoria and Albert Museum, the rather sentimental *Lovers*[1] and, more lively and personal, *The Gossips*[2] (Pl. 159) (based on an illustration in *Wayside Posies*) are charming indeed, but are indications of what he might have accomplished as a colourist if he had not been so restricted by commissions for work in black and white, and if long and severe illness had not hampered his art and brought his life to an untimely close.

In his method of work Pinwell followed Birket Foster and Walker, and it may be repeated that to all these men who were designers on the box-wood block the constant practice of using white to alter or to heighten their drawing made its use quite instinctive. When a would-be purchaser of a water-colour asked Pinwell whether he used Chinese White, he replied: 'Chinese-white! God forbid. I only use body-colour.'[3] Like Walker, he hoped that he would escape notice in his use of methods which most members of his Society eyed askance.

Arthur Boyd Houghton (1836–1875), who belonged to the same school of draughtsman-illustrators, was born four years before Walker, and studied at Leigh's Art School. Like Walker and Pinwell his career was prematurely terminated by death. Boyd Houghton became known by his inventive and dramatic illustrations to Dalziel's *Arabian Nights* (1865) and *A Round of Days* (1866), and supplied many drawings to *The Graphic* when it began its career at the end of 1869. A series of drawings made in America won particular success. He was elected an associate of the Old Society in 1871, and one of his first exhibits, *Hiawatha and Minnehaha*, is now in the Victoria and Albert Museum under the title, *The Return of Hiawatha*.[4] His inspiration came a good deal from the Orient, as in *The*

[1] V.A.M. 92–1896. [2] V.A.M. 69–1900.
[3] M. Huish, *British Water-Colour Art*, 1904, p. 202.
[4] V.A.M. P.124–1920.

139

Transformation of King Beder[1] (Pl. 162), and this helped to make him more susceptible than Walker and Pinwell to the glamour of rich colour. He was blind in one eye from youth, and suffered increasingly in the other as he grew older. It is a curious coincidence that two of his immediate contemporaries, George du Maurier and Sir John Tenniel, illustrators like himself, should both have lost an eye, causing perhaps a difficulty of spatial measurement but an increased power of observation in the remaining eye.

Briefly, as belonging to the same school, may be mentioned James Mahoney (*c.* 1810–1879). Born at Cork, he came to London after his resignation from the Royal Hibernian Academy in 1859, became an associate of the New Water-Colour Society in 1867, and gained repute by his illustrations for *The Illustrated London News* and other periodicals. A very capable craftsman, with a sure command of his medium, he was a skilful painter of domestic *genre* after the manner of William Hunt. *Now then, Lazy*[2] (Pl. 161), a boy leading a horse, shows his ability as an executant.

Charles Green (1840–1898), of much the same calibre as Mahoney, was born the same year as Walker, his career following along the same lines. Starting under Whymper, he worked for *Once a Week* and other periodicals, and became one of the most successful of the black-and-white draughtsmen of his time. His illustrations to Dickens showed his power of dramatic expression and freshness of imagination. Many of them, such as two of *Little Nell*[3] (Pl. 163) in the Victoria and Albert Museum, were turned into water-colours. As a water-colour painter he became an associate of the Royal Institute in 1864 and a member in 1867. In his water-colours he chose subjects which were likely to appeal in manner and matter to the large section of the public which enjoys some part of a story or history cleverly interpreted. In his costume pieces narrative took the first place in his mind; he was a little obvious in his motives, too little concerned with subtleties and harmonies of colour. His elder brother, H. Towneley Green (1836–1899) began his career in a bank, but subsequently followed the lead given by Charles and turned his attention to water-colour and black-and-white drawing. He became an associate of the Royal Institute in 1875 and a member in 1879.

Because he is linked with the school of Walker and North in thought, sentiment, and to some extent in method, Lionel Smythe calls for mention in this chapter. His friend North had a strong admiration for his work. Lionel Percy Smythe (1839–1918) was educated at King's College School, studied at Heatherley's Art School, and began to exhibit in 1860. From 1880 to 1890 he was a member of the Royal Institute, and then transferred his allegiance to the Old Society, of which he became associate in 1892, and member in 1894. He was elected A.R.A. in 1898 and R.A. in 1911. His landscapes and episodes of rural life, painted with great purity of delicate colour, are poetic and refined. The outdoor figures are surrounded by shimmering light and air. A good example is *Under the Greenwood Tree*[4] (Pl. 164), 1902. For many years he lived at the Château de Honvault, near Wimereux, and

[1] V.A.M. 66–1900.
[2] V.A.M. 657.
[3] V.A.M. D.387 and 388–1907.
[4] V.A.M. P.5–1919.

died there in 1918. French peasant girls and the breezy uplands round Wimereux and Ambleteuse figure in much of his work.

Herbert Alexander (1874–1946), born at Cranbrook, became a student in Herkomer's school at Bushey and for a short time at the Slade. He had great admiration for the work of Birket Foster and North. Like them he had a peculiarly English way of looking at nature, concentrating upon picturesque detail rather than seeking a broader design and atmospheric aspects. He was a sensitive colourist, and his drawings with their searching observation and conscientious craftsmanship have the charm of simple truth. He became an associate of the Royal Society of Painters in Water-Colours in 1905, and a full member in 1927. Much of his work was done in Kent.

We pass now to some great illustrators who worked in water-colour, but used colour almost entirely with a view to its reproduction by the wood-engraver. Printing in colour from wood-blocks, an ancient process, as the *Book of St. Albans* shows, had fallen into complete disuse. It was revived in the nineteenth century by Whittingham, Leighton and others, and was brought to full success by the energy, enterprise and artistic skill of Edmund Evans. He was the impresario and producer who discovered Walter Crane, Kate Greenaway and Randolph Caldecott, and gave them their pre-eminence. Edmund Evans served a seven years' apprenticeship in wood-engraving under Ebenezer Landells. Birket Foster, one year his senior, was articled to Landells at the same time, and the two pupils would often join in sketching excursions on a free afternoon. In 1847 Evans launched out on his own account, and received many orders from the firm of Ingram, Cooke and Co. On their behalf he produced an illustrated cover, then quite a novelty, for Mayhew's *Letters left at the Pastry-cook's*. The white paper on which his colours were printed was easily soiled, and this led him to substitute a yellow paper with an enamel surface. It had an immediate popularity, and was greatly in request for railway novels—whence the term 'yellow-back'. His first colour-printing of real importance was for *The Poems of Oliver Goldsmith*, 1858, with illustrations by his friend, Birket Foster. From then onwards he settled down to improving his colour reproductions, made for various publishing firms, and year after year provided plates which were printed on a hand-press using from six to twelve colour blocks. By 1877 he was making ventures of his own, and in the printing of children's books by Crane, Caldecott and Kate Greenaway he built his most enduring monument.[1] Crane was a notable illustrator, a decorator, a revivalist of high principles in design, but he was not essentially English in his art, unlike Kate Greenaway and Caldecott. And I have no doubt that future generations will count Caldecott as the finest artist of the three.

Those three have been grouped under the title of 'Academicians of the Nursery', and their names have long been household words. As contemporary illustrators of children's books they must always be linked, although all have gifts peculiarly their own, with a style

[1] For details of the work of Edmund Evans, and of books illustrated by this group of artists, see M. Hardie, *English Coloured Books*, 1906, pp. 266–282.

most distinct and individual. A glance at a drawing by any one of them reveals the artist; together they produced work that made our children's books the best in the world at their time. Such books as *Under the Window*, *The Baby's Opera*, *The Three Jovial Huntsmen* and *The Great Panjandrum Himself* were delectable beyond all books that children of my generation had ever seen or imagined.

All three artists made the ideal book for children, and the ideal water-colours for the purpose. They were not books ostensibly intended for the young, while addressing themselves to grown-ups under a false disguise, but books richly endowed for the child mind, and at the same time instilled with fascination for any Olympian who had kept the eyes of youth. They seemed to be working intensely for their own satisfaction no less than for the delight of youthful spectators. In technique, all of them took into consideration the possibilities of the method by which their drawings were to be reproduced. Edmund Evans wrote to me in 1905: 'I must say I do think the three-colour process will utterly drive out this now old method of colour-printing. I do think that Walter Crane toy books or the Caldecott drawings could *not* have been better reproduced by any process. Birket Foster *could*.' Crane and Caldecott took into full consideration the method by which their drawings were to be reproduced. In their individual way they displayed consummate skill in working with pure colours and flat tones, with a simple and direct treatment adapted to the scope of the engraver and the colour-printer of wood-blocks. In the case of Kate Greenaway I think much more is owing to Edmund Evans. He invented, one might almost say, a reproduction method for her work. He strengthened her colour, solidified and broadened the daintiness of her drawing, massed her delicate touches; where she was flabby, he provided sinew and bone.

Walter Crane (1845–1915), the eldest of the trio, born in Liverpool, published his first toy books fifteen years before Kate Greenaway and Caldecott entered the field. When he was fourteen he made a set of coloured designs to Tennyson's *Lady of Shalott*. They were shown to Ruskin and to W. J. Linton, the leading wood-engraver in 1859. The former praised them, and the latter took Crane for three years as his apprentice. Crane's first published illustrations appeared in a series of sixpenny toy-books, published between 1864 and 1869—*The Railroad Alphabet*, *The Farmyard A.B.C.*, *Dame Trot and her Comical Cat*, with many others, among them the best of all in decorative aim and quaint humour, the *Song of Sixpence*. At an early stage in producing these books he was amused by a request sent by the publishers through Edmund Evans that some children designed for his next book 'should not be unnecessarily covered with hair', this being considered a dangerous innovation of Pre-Raphaelite tendency. The cap may have fitted, for Crane was strongly influenced by the Pre-Raphaelites. In these sixpenny books he was limited to the use of red, blue and black. The range of colour was enlarged for *The Fairy Ship* in 1869, with 'raisins in the cabin; almonds in the hold', all under the command of the captain who 'said Quack!' In the famous *Baby's Opera* of 1877 the colours were still more extended and more carefully blended. The price was five shillings, and Routledge, who was publishing

142

the volume for Evans, scoffed at the notion of ten thousand copies being printed, especially with no gold on the cover! The public thought differently, and a second edition was soon in demand.

Crane continued producing his nursery books till the *Floral Fantasy* of 1899, with Evans always making his colour-printing a labour of love. In all his water-colours and in all these books the important element is decoration. Graphic skill, originality, purity of line, charm of colour are always part and parcel of a decorative design. His creed, expressed in his *Decorative Illustration of Books*, was that each picture must be an organic element, forming an integral and constructive part of the book as a unified whole. Even end-papers must be 'delicately suggestive of the character and contents of the book . . . a kind of quadrangle, forecourt, or even grass plot before the door'. Even before 1899, he was busily occupied with painting portraits and figure subjects, designing tapestries and wall-papers, and writing books on decorative art. He was a member of the Royal Institute from 1882 to 1886; then became associate of the Old Water-Colour Society in 1888 and member in 1899. He was Principal of the Royal College of Art in 1898–9. Many of his water-colour designs for book-illustrations are in the Victoria and Albert Museum, which also possesses his large water-colour cartoon for *The Goose Girl*,[1] from which a piece of tapestry was woven in 1881 by Messrs. Morris and Co. at Merton Abbey, and several of his landscape studies, such as *Llyn Elsie, near Bettws-y-coed*[2] (Pl. 168), 1871, and *Trees near Sorrento*,[3] 1872.

To pass from the work of Crane to that of Kate Greenaway (1846–1901) is like passing from the poetry or landscape of one country to that of another. The principal elements in the work of Walter Crane are decoration and symbolism. Kate Greenaway, too, had an instinctive sense of decoration, but in her case ornament, spacing and proportion were secondary objects. Her work is more purely pictorial, with a grace and beauty entirely individual. Perhaps it is the directness of the pictorial motives, coupled with her obvious goodness and sincerity and love of children, which stirred Ruskin to one of his strongest expressions of enthusiasm and make the Greenaway pictures so memorable. She ruled in a small realm of her own, like the island-valley of Avilion, 'deep-meadowed, happy, fair with orchard lawns', a land of flowers and gardens, of red brick houses with dormer windows, peopled by toddling boys and little girls clad in long, high-waisted gowns, muffs, pelisses and mob-caps. In all her work there is an atmosphere of an earlier peace and simple piety that recalls Izaak Walton and 'fresh sheets that smell of lavender'. The curtains and frocks of dimity and chintz, the houses with the reddest and pinkest of bright bricks, the 'marigolds all in a row' in gardens green as can be (what savoury and luscious green she and Evans found for trees, hedges and grass!), the lads and lasses with rosy cheeks and flaxen curls, all make for what is best in the best of all possible worlds. Kate Greenaway not only brought happiness to two Continents with a world of peace and contentment but she 'dressed the children of two Continents'.

[1] V.A.M. 155–1898. [2] V.A.M. P.81–1920. [3] V.A.M. 283–1898.

Born a year later than Crane, it was not till 1879 that Kate Greenaway won any real success. She was the daughter of a wood-engraver, and studied at the Islington School of Art, at Heatherley's and the Slade School. She did unsigned work for some children's books, and drew for *Little Folks* and other periodicals. Then, in 1878, her father's friend, Edmund Evans, induced her to make the fifty fresh and charming drawings of child life which appeared with the title, *Under the Window*. It was both written and illustrated by Kate Greenaway, pictorial and literary inspiration working harmoniously together as they did in the case of Blake. The book was a triumph for artist and printer, being printed and reprinted till 100,000 copies were issued, without taking into account the French and German editions. The original drawings were exhibited at the Fine Art Society in 1879, on which occasion Ruskin saw them, and exhausted the resources of his overflowing vocabulary in praise of their unaffected beauty, their sweetness and naïveté, their delicacy of sentiment, their subtlety of humour and their exquisitely simple technique. In writing some early words of encouragement to Kate Greenaway Ruskin said: 'Holbein lives for all times with his grim and ugly "Dance of Death"; a not dissimilar and more beautiful immortality may be in store for you if you worthily apply yourself to produce a Dance of Life.'

That dance of life runs gaily on from *Under the Window* to *Mother Goose* (1881), *The Language of Flowers* (1882), *Marigold Garden* (1885), and many other books; and the charming little *Almanacks* published yearly from 1883 to 1897 must not be forgotten, for every volume is full of the charm which characterises all of Kate Greenaway's colour work. In the Victoria and Albert Museum are numerous original drawings in water-colour made for her illustrative work.

Randolph Caldecott (1846–1886) was born in the same year as Kate Greenaway, but it was his misfortune to be born into a less artistic family. His father was an accountant, and though Randolph as a schoolboy won two drawing prizes from the Department of Science and Art, he was set to work as a bank clerk, and remained until 1872 at a desk in Manchester, making merry sketches of clients and of comic episodes on his blotting paper or the backs of envelopes. Encouraged by the appearance of work in local periodicals (1866–9) and by its acceptance for *London Society* in 1871, he came to London in 1872. The clink of sovereigns and rustle of notes in a Manchester bank became things of the past. Even in Manchester, however, he was draughtsman first and bank clerk second, and was developing a style peculiarly his own, obtaining wonderful effects by sheer power of line. In his own words, he studied the 'art of leaving out as a science', believing that 'the fewer the lines, the less error committed'. There is little in Phil May's art of drawing in terse dramatic outline, which is never strictly outline at all, that is not found already developed by Caldecott. In both cases the economy of means and apparent simplicity suggested by the final drawing were only achieved by endless studies.

Caldecott made his name by his illustrations to Washington Irving's *Old Christmas* (1875) and *Bracebridge Hall* (1876). It was here that he found his true milieu. He is a caricaturist, but his caricatures are always poetical and romantic. His world, or a large

144

part of it, lay in the past, among the manners and customs of eighteenth-century England, not the eighteenth century of Pope and Sheridan, but rather that of Gray and Goldsmith amid simple country life with its 'homely joys, and destiny obscure'. He excelled in picturing fresh, vigorous scenes of the English squirearchy in manor-house and hunting-field. He was equally happy in seeing the humorous aspect of his contemporaries, whether at home or abroad, upon pleasure bent. His work is characterised by eloquent design, vivid movement, an abundance of kindly humour, an inexhaustible store of fancy. All of that he began to express in attractive colour, and from 1876 to 1886, in summer and winter numbers, *The Graphic* issued sets of coloured reproductions, *Christmas Visitors*, *The Rivals*, *The Strange Adventures of a Dog-Cart* and the rest, which made the public aware of Caldecott's delicate colouring and freshness of invention.

It is again to the credit of Edmund Evans that he first suggested to Caldecott the making of coloured illustrations to children's books. The 'small, small royalty' which Caldecott at first viewed with misgiving was amply balanced by the immediate success of the first two picture books, *The House that Jack Built* and *John Gilpin*, issued in 1878. It was the year of Kate Greenaway's *Under the Window*, and two such discoveries as Greenaway and Caldecott in one year might well have made Evans a less modest man than he always remained. *John Gilpin* seemed inimitable, but it was followed in 1879 by the fascinating *Elegy on the Death of a Mad Dog*, and in later years by *Three Jovial Huntsmen*, *The Farmer's Boy*, *Baby Bunting* and other equally endearing productions; sixteen books in all, ending with *The Great Panjandrum Himself*, published in 1885, the year before Caldecott's death. It was a truly remarkable output of consistently fine work for a man who died when just under forty.

Ostensibly picture-books for children, these books, appearing two a year towards Christmas time with unfailing regularity, were in reality works of art imbued with subtle charm and rare originality. Every variety of Caldecott's genius found its full display in his ingenious adaptation of nursery rhymes, old ballads and the comic poems of the eighteenth century, all treated with a delectable sense of humour. In his colouring he employed flat tints of great variety, usually making his drawings with a pen, and colouring a proof of the wood-engraving sent by Evans. Sometimes he made a finished water-colour drawing first, and his acceptance as a water-colour painter is shown by the fact that he exhibited at the Royal Academy from 1872 to 1885, and was elected a member of the Royal Institute in 1882. The British Museum and Victoria and Albert Museum own very representative collections of his water-colours, his pen drawings, and his coloured proofs. His fresh and invigorating method of uniting line and colour is shown in two delightful drawings of *Diana Wood's Wedding*[1] (Pl. 170) and *Fox-Hunting: Going in to Cover*.[2]

The success won by the illustrations of Crane, Caldecott and Kate Greenaway depended not merely upon the power and originality of the artist but upon the skill and sympathetic co-operation of the wood-engraver. Before the end of the nineteenth century, however,

[1] V.A.M. 295 and 295a–1886. [2] V.A.M. 293–1886.

145

mechanical methods of photographic reproduction brought about a revolution. The three-colour process in particular ousted all the previous methods of colour reproduction. Theoretically it rests upon the general principle that any colour can be resolved into the three primary colours of red, yellow and blue-violet, which form its component parts. Theoretically, any painter can produce a complete picture by the use of those three colours only. That theory had long been known and accepted, and one likes the pious thought of an essayist in the early part of the nineteenth century:[1] 'Dull of consciousness will be the mind that in contemplating a system so simple, various and harmonious as that of colours, should not discover therein a type of that Triune Essence who could not construct all things after the pattern of His own perfection.' Religion and Science met together. In the last decade of the nineteenth century it was finally established that a picture, however varied and graduated in tint and tone, could, as it were, be automatically dissected upon three photographic negatives produced by means of light filters (each admitting any two of the primary colours and absorbing the third), and could be printed by means of the half-tone process. It was obvious that the human element supplied by an interpretative engraver was no longer required. When water-colour drawings could be reproduced, almost in facsimile, very rapidly, and at comparatively small commercial cost, a new era began for the illustrator and the illustrated book. In the opening years of this century the new process restored to many water-colour artists the prosperous conditions under which Turner and the topographers had flourished a century before. The modern painter, like his predecessors, but without the intervention of the aquatint engraver, could produce water-colours, mainly of topographical views, which could be sold as pictures and could be used for the plates of a published volume. The three-colour process produced the paradoxical result that the plates made the book, while the text merely illustrated. Messrs. A. and C. Black were among the first publishers to appreciate the scope and possibilities of colour books produced by the new process; and such artists as Mrs. Allingham, John Fulleylove, R. Talbot Kelly, Mortimer Menpes and Walter Tyndale found a new and profitable market for their wares.

For book-illustration proper, which implies some authority of interpretation, one of the first to cultivate the rich field opened up by the new methods of reproduction was Arthur Rackham. The new process was fortunate in having so worthy a pioneer, since his fine intellectual power and his individual technique set a remarkably high standard, to be followed very soon by Edmund Dulac (1882–1953) (more oriental in his ideas, more sensuous, more concerned with the invention of strange original colour harmonies), Russell Flint (even in his early days an illustrator, showing his love of rich colour), and others who, like them, survived into modern times. Where Caldecott and Kate Greenaway had to submit to a rigorous discipline of line and colour, these later illustrators, like the writer of a book, could employ a style which was rambling or precious, prolix or terse, at their will and as the occasion seemed to require.

[1] G. Field, *An Essay on the Analogy and Harmony of Colours.*

146

Arthur Rackham (1867–1939) received his art education at the Lambeth School of Art and the Slade School. No doubt Charles Ricketts and Charles Shannon, who were his fellow-students at Lambeth, helped to interest him in the printing and decoration of books, but the first influence of permanent value in his development was Boyd Houghton's *Arabian Nights*. After some years of free-lance work in black-and-white illustration, Rackham was commissioned to make colour illustrations for *Rip Van Winkle* (1905), *Peter Pan* (1906), and *Ingoldsby Legends* (1907), but he first blossomed into fame with his illustrations to *A Midsummer Night's Dream* (1908) and *Grimm's Fairy Tales* (1909). In these volumes he showed the full measure of his exquisite fancy and fertility of imagination, coupled with unusual technique and a rare quality of line and tone. His poetic fancy found full scope in the realisation of a fairyland peopled by elves and sprites, dwarfs and gnomes, whom children welcomed with affection. With a rich generosity of invention, Rackham gave life to his landscape and, above all, to his gnarled and twisted trees whose threatening branches harbour snakes, spiders, blindworms, snails, mice and birds, interwoven with the knots and curling lines of the bark, and perhaps some radiant fairy or hamadryad peering out from the intricate design. His work tended always to the sublime, never to the macabre. He illustrated over thirty other volumes between 1905 and his death.

Rackham had an ingenious personal technique, which rose in the first place from a desire to turn black-and-white drawings in line into pictures which might win interest in an exhibition. In the beginning, as is related by A. S. Hartrick,[1] a friend from his early days, his habit was to wash a fairly strong tint of raw umber over his pen drawing, except for a few spaces where he might need some accents of pure colour in the end. This warm tone he lifted with a wet brush as he went along, working in some local colour where he wanted, while carefully watching the main gradations—warm to cold, and vice versa. The result was highly pleasing in tone, possessing the off-white, gold-tinting quality yielded by old vellum or ivory—a suggestion of patina. His drawings could be reproduced in the closest facsimile by four printings, one for black, the others for the three primary colours.

While Rackham will always be regarded as illustrator first and foremost, throughout his life he exhibited many water-colour drawings, decorative and fanciful, which were not conceived as book-illustrations; drawings such as *The Incoming Tide, Erda* and *Old Isaak*.[2] The last shows his brilliant accomplishment as a painter of landscape, with a delicate sense of colour and of the flicker of light upon trees and water. Splendid opportunity for the exercise of this little-known side of his art was offered by a commission to illustrate Kenneth Grahame's *Wind in the Willows*, Rackham's last work, issued after his death to members of the Limited Editions Club in New York. As a painter of water-colours, his success began with an exhibition of the original water-colours for *Rip van Winkle*, at the Leicester Galleries in 1905, to be followed by others later. He told A. S. Hartrick that before the opening of that first exhibition he was offered £1000 for it as it stood; he firmly refused, and wisely, for the show was sold out at a far higher total. He was elected an associate of the Royal

[1] A. S. Hartrick, *Arthur Rackham*, O.W.S. XVIII, 1940. [2] *Ibid.*, pls. X, XII and XIII.

Water-Colour Society in 1902, when his published illustrations were still in pen line only, and he became a full member in 1908.

Beatrix Potter (1866–1946) was brought up, a lonely child, in a very prim and proper Victorian household in Bolton Gardens, South Kensington. Perhaps Caldecott's *A Frog he would a-wooing go*, published when she was a child, provided her with inspiration for Samuel Whiskers and Jeremy Fisher. She had no companions of her own age, no schooling or school friends, but in London and on visits to the country she had wide open eyes and an absorbent mind. 'I do not remember a time', she said later, 'when I did not try to invent pictures and make for myself a fairyland amongst the wild flowers, the animals, the fungi, mosses, woods and streams, all the thousand objects of the countryside.' She filled many volumes with careful studies, particularly of fungi, but not till she was in her middle thirties did she venture upon her first modest little book for children, *The Tale of Peter Rabbit*. Encouraged by its success, she dared to assert her independence and to break loose, not without difficulty, from the Victorian rule and possessiveness imposed by her parents. She bought Hill Top Farm at Sawrey above Windermere, and during a productive period of eight years completed all her best work. Ever since then children and lovers of children in many lands have found delight in the slim little volumes which tell in words and pictures about Peter Rabbit, Jemima Puddleduck, Mrs. Tiggy-Winkle and other animal friends. 'I can't invent,' she said, 'I only copy'; and she was indeed a realist and a close observer of form and colour. Her dainty water-colours, as might be expected from one who spent years patiently drawing fungi, have a close fidelity to nature and to animal character. She rendered with accuracy the lineaments of bird and beast, but only after spending years in acquiring knowledge, from the closest contact, of their structure, habits and movements. In 1913 Beatrix Potter married William Heelis, an Appleby solicitor, but she clung to her farm life, avoided everything of the nature of publicity and notoriety, managed to fend off even her American admirers, and for thirty years was no longer an artist, but a dominant, crusty, good-humoured and salty character of the Lake countryside, one of the shrewdest farmers in North Lancashire, and eventually president-elect of the Herdwick Sheep-Breeders' Association. After her death Captain K. W. G. Duke, R.N., her Executor, presented to the Tate Gallery twenty-two of the original water-colour drawings (one of them not used) for *The Tailor of Gloucester* published in 1902. There are many who consider these illustrations more satisfying and remarkable than those for the very popular *Peter Rabbit*. The drawings, slightly larger than the reproductions, show a perfection of detail and finish which the colour plates, charming though they are, could not completely attain.

In a chapter dealing with nineteenth-century draughtsmen and illustrators it may seem strange that mention of Charles Keene (1823–1891) has been left to the close. 'If we allow ourselves to ask', says Walter Sickert, 'who was the greatest English artist of the nineteenth century, it would be difficult to find a candidate to set against Charles Keene.' If we write draughtsman instead of artist, the word difficult can be changed to impossible. Supreme though Keene was, his name has not been given a prominent place in these pages because

148

156 'Spring'

V.A.M. P.2–1911 24½ × 19¾: 621 × 501 *Water-colour, signed and dated*

Frederick WALKER, A.R.A. (1840–1875)

157 'Rainy Day at Bisham, Berks.'
V.A.M. 37–1892 4⅝×10: 117×254 *Water-colour, signed*
Frederick WALKER, A.R.A. (1840–1875)

158 'Gypsy Encampment'

V.A.M. 68–1895 25¼ × 36½ : 642 × 924 *Water-colours, signed and dated 1873*

John William NORTH, A.R.A. (1842–1924)

159 'The Gossips'
V.A.M. 69–1900 $5\frac{3}{4} \times 6\frac{3}{4}$: 146 × 172 *Water-colour*
George John PINWELL (1842–1875)

160 'King Pippin'
B.M. 1939.7.11.6 $5\frac{1}{8} \times 6\frac{1}{2}$: 131 × 165 *Water-colour*
George John PINWELL (1842–1875)

161 'Now then, Lazy'
V.A.M. 657 5×6: 127×153 *Water-colour*
James MAHONEY (1810–1879)

162 'The Transformation of King Beder'
V.A.M. 66–1900 19½×23½: 495×597 *Water-colour*
Arthur Boyd HOUGHTON (1836–1875)

163 'Little Nell, aroused by the Bargeman'
V.A.M. 388–1907 $4\frac{7}{8} \times 6\frac{1}{2}$: 124 × 165 *Water-colour, signed and dated 1876*
Charles GREEN (1840–1898)

164 'Under the Greenwood Tree'
V.A.M. P.5–1919 $17\frac{1}{2} \times 22\frac{1}{8}$: 444 × 561 *Water-colour*
Lionel Percy SMYTHE (1839–1918)

165 'P. Peeped in It' (illus. to 'A. Apple Pie Alphabet')
V.A.M. 32-1902 $8\frac{1}{2} \times 11$: 216 × 279 *Water-colour*
Kate GREENAWAY (1846–1901)

166 'Landscape with castle'
London, R.W.S. (diploma drawing) $14\frac{1}{2} \times 21$: 369 × 533 *Water-colour*
Herbert ALEXANDER (1874–1946)

167 'Pan Pipes'

B.M. 1933.4.11.195 $7\frac{3}{8} \times 10\frac{1}{2}$: 187×267 *Water-colour, signed and dated 1884*

Walter CRANE (1845–1915)

168 'Llyn Elsie, near Bettws-y-coed'

V.A.M. P.81–1920 $15\frac{1}{2} \times 24\frac{1}{2}$: 392×621 *Water-colour, signed and dated 1871*

Walter CRANE (1845–1915)

169 'The Tale of the Flopsy Bunnies'
B.M. 1946.11.21.6 4⅜ × 3¾ : 111 × 96 *Water-colour*
Beatrix POTTER (1866–1943)

170 'Diana Wood's Wedding: Returning from Church'
V.A.M. 295–1886 5½ × 9½ : 140 × 241 *Water-colour*
Randolph CALDECOTT (1846–1886)

171 'Midsummer Night's Dream'

V.A.M. P.34–1917 13×8¼: 330×209 *Water-colour, signed and dated 1908*

Arthur RACKHAM (1867–1939)

172 'Evening on the Arun'

V.A.M. P.22-1921 $10\frac{1}{4} \times 14\frac{1}{4}$: 260 × 362 *Water-colour, signed*

William Charles ESTALL (1857-1897)

173 'Book illustration'
B.M. 1944.10.13.23 $4\frac{3}{4} \times 6\frac{7}{8}$: 121 × 175 *Pen and ink*
Charles Samuel KEENE (1823–1891)

174 Drawing for 'Punch'
Tate Gallery 2467 $5\frac{7}{8} \times 6\frac{1}{2}$: 150 × 165 *Pen and ink*
Charles Samuel KEENE (1823–1891)

he was not a systematic painter in water-colour. He might, without doubt, have won an enlarged fame either by work in water-colour or in oil—witness his brilliant self-portrait in oil in the Tate Gallery—but his use of both methods was infrequent and almost accidental. Hundreds of engravings made from his masterly pen-drawings in *Punch* are very well known but few of us can recall the sight of a water-colour by Keene. He did, very occasionally, use water-colour charmingly and competently, but it was a sort of fancy dress for a drawing on some festive occasion, never for ordinary wear. Mr. Derek Hudson[1] indicates how rare the colour work is, and can summarise it all in a paragraph. Four water-colours, he tells us, were reproduced (though not in colour) in G. S. Layard's biography (1892). They are *The News*, a study of two old soldiers reading a newspaper, and three slighter sketches. Interesting figure studies in water-colour are to be seen at the Tate Gallery, and at the Fitzwilliam Museum, Cambridge. There is also at the Fitzwilliam an historical water-colour, *Soldiers preparing for the Fight*. At the Tate Gallery is the *Man Polishing Armour*—not Keene at his best, but one of his most finished water-colours—and a small sketch, *The Duel*.

[1] D. Hudson, *Charles Keene*, 1947, p. 20.

CHAPTER IX

Victorian Landscape Artists

Thomas Collier James Orrock Henry Gastineau Samuel and Samuel Phillips Jackson Albert Goodwin the Goodalls

Preceding chapters have dealt with the work of artists—the Pre-Raphaelites, J. F. Lewis, W. Hunt, Birket Foster and others—who had a passion for detail and high finish. They were a sort of rear-guard desperately holding off the advance of the photographic camera or trying wrongly to fight it on its own ground and with its own weapons. Their use of body-colour in large or small quantity enabled them to load their colour to a full impasto, as in oil, and to specify every dot and speck, as in miniature painting, by means of indefatigable stippling. In bringing their work to a jewelled finish they abandoned the subtler qualities of water-colour, the luminosity and lovely bloom to which the whiteness of paper shining through translucent colour gives its full effect.

Victorian patrons of art were not the cultured aristocracy who had fostered the arts in the eighteenth century. They were mostly men of industry whose own fortunes depended upon impeccable craftsmanship and machine-made exactness. They understood what they would have called honest-to-God workmanship. They were prepared to make a lavish expenditure upon art so long as the pictures they bought displayed the high polish and precision which in their eyes were a sign of the best quality. But by 1870 a section of the public and a section of the artists hankered for a return to the simple and direct methods and the fluid washes of Cox and De Wint. Therein, after all, lay a large part of the great tradition of the British School, and that tradition was worthily revived in the art of Thomas Collier. He brought back the open air into the art of water-colour.

As one of the supreme water-colour painters of England, Collier has been strangely ignored. Forty years ago, when the 'problem picture' was in vogue at the Royal Academy, scores of people knew about the Hon. John Collier for one who had heard of Thomas. Standard books pass him over, and as a measure of this lack of appreciation it may be noted that the name of Thomas Collier (except as a seventeenth-century divine) has no place in the *Dictionary of National Biography*, where many painters who have done much less for British art than Collier have their full recognition. Full justice was not done to him till 1944, when Mr. Adrian Bury published his *Life and Art of Thomas Collier, R.I.* Collier did not die till 1891, but a few years will cover the tracks of a man who has lived a quiet

150

and secluded life, and Mr. Bury found the utmost difficulty in reconstructing Collier's personality and environment and in tracing the actual facts of his career. It is astounding to think that we know more about the boyhood, education, life and talk of David Cox than we shall ever know about Collier. Much of the information in the following pages is due to Mr. Bury's careful research.

Thomas Collier (1840–1891), the son of a successful tradesman, was born at Glossop, Derbyshire. Nothing is recorded about his childhood and schooling, and the first established fact in his career is that he attended the Manchester School of Art; when, and for how long, is not known. As a water-colour painter, he was probably self-taught, and his first exhibited picture *On the Llugwy, North Wales*, was sent to the Society of British Artists when he was twenty-three. He was so impressed by the neighbourhood of the Llugwy that, from 1864 to 1869, he lived at Llugwy Cottage, opposite the falls, at Bettws-y-Coed. This attachment to Bettws-y-Coed, the favourite sketching-ground of David Cox, may connote an admiration for Cox and may account for the fact that many of Collier's early works, such as *The Siabod Flats, Caernarvonshire*,[1] 1867, and the *Pen Craig Moors*,[2] c.1864, show the influence of Cox in subject, in treatment of the sky, and in the disparate brush-strokes of the foreground.

In 1865 Collier married a Miss Hermione Holdstock, who had been a student in the Manchester School of Art, and a year or two later determined to settle in London with the hope of being elected to the Water-Colour Society. Mr. Bury relates that Collier applied twice for membership, but 'though supported by many of the members was rejected on the grounds that his work was too much like that of James Whittaker'. A similar comparison, though a more favourable one, had been previously made by James Orrock, the well-known painter and collector. In his *Autobiography* he refers to his first sight, about 1868, of water-colours by Collier at an exhibition of the Birmingham Society of Artists. Orrock displayed such interest in the unknown painter's work that Mr. Flavell, a musician and art-collector resident in Birmingham, took him off to his house and showed him several portfolios of Collier's drawings. After looking through them Orrock said: 'Well, this is a master in our English School, just below the greatest, but above Whittaker.'

This double reference to Whittaker may puzzle many, as it did myself on originally reading the Orrock book. Part of the answer to that query is that in the Victoria and Albert Museum there are two drawings by James William Whittaker (1828–1876) of subjects in North Wales. We know that he was born in Manchester, was apprenticed as an engraver to a firm of calico-printers, and saved enough money to settle at Llanrwst in North Wales and to practise there as a landscape painter in water-colours. F. W. Topham saw and admired his work while on a visit to Wales and advised him to stand for election to the Old Water-Colour Society. He became an associate in 1862, and a member in 1864. He was accidentally drowned near Bettws-y-Coed in 1876, by slipping from the rocky side of a steep gorge above the River Llugwy.

[1] V.A.M. 1775–1900. [2] Coll. Miss F. M. Millard.

Orrock was right in his summary judgment that Collier was a master in our English School, and the Water-Colour Society made a grave error in rejecting Collier's claim. They may have felt that the younger man was trespassing when he painted the same themes as Whittaker at Bettws-y-Coed, but they should have recognised that there was much more originality and individuality in his art. The Water-Colour Society's loss meant a gain to the Royal Institute, which elected Collier an associate in 1870 and a full member in 1872. This gave him great encouragement, and we find him writing in the late summer of 1870 from the Tan-y-Bwlch Hotel, Capel Curig, to his friend C. S. Millard: 'At the end of June they elected me an Associate of the Institute of Water-Colours and I have to get my sketches ready for the Winter Exhibition so that I'm in a fluster at present and shall be till the middle of next month.' He was not a prolific exhibitor. During this and the following nineteen years he showed only eighty drawings at the Institute and only one hundred in all at London exhibitions. In 1869 he sent his *Coming Tide* to the Royal Academy, and in 1870 three pictures, *Birker Moor*, *Summer Time on the Cumberland Fells* and *Evening after Rain, Harter Fell*. Thereafter the Institute claimed his allegiance, but it should be added that in 1878 he sent to the Paris International Exhibition his large water-colour of *Arundel Castle from the Park*, painted three years earlier. Like Constable's *Hay Wain* of fifty-four years previously, it made a great impression, and Collier was awarded the rare distinction, for an English artist, of being appointed a Chevalier of the Legion of Honour.

When he was elected to the Institute Collier was living at 10, Maitland Park Road, Haverstock Hill, Hampstead. In 1879 he built a large house in Hampstead Hill Gardens, naming it *Etherow* after a stream, familiar to him in childhood, near Glossop. Shy, sensitive and retiring, he was ill at ease among strangers, but at *Etherow* he welcomed such friends as Charles and H. Towneley Green, James Orrock, John Fulleylove, Edmund M. Wimperis, R. Thorn-Waite, R. G. Hine and Alexander T. Hollingsworth, who was an enthusiastic admirer and purchaser of his drawings. In these later years his delicate health confined him more and more to his studio, and, in Mr. Bury's words, 'though Collier reached the age of fifty, it was a very precarious fifty'. He worked with the feverish energy of those who seem conscious of mortality. Some years after Collier died, Sir Frederick Wedmore recalled that 'the artist was struggling for years, as I remember, with death as well as art'.

Though so little is known about Collier's life, he has left an enduring monument in his work. Mr. Bury's catalogue shows that there are twenty of his drawings in the British Museum, fourteen in the Victoria and Albert Museum, nine in the Lady Lever Gallery, Port Sunlight, eight at Birmingham, seven at Leeds, seven at Nottingham, and seven at Cardiff, besides others scattered through various art galleries and there are several private owners who are happy in the possession of large groups of Collier's work.

Collier was a firm believer in outdoor work for the subjective recording of aspects of nature modified and altered by the changes and variations of light and weather. Like De Wint, Cox and Müller, he was a master of the sketch. He achieved what someone has

described in another connection as 'the perfect happening, at the perfect moment, in the perfect way'. From his earliest days he cultivated the habit of working in the open air, and his health, never robust, was probably impaired by his determination, whatever the weather, like the worker on a farm, to follow his chosen pursuit. Collier would sit and sketch in the snow until his palette was covered with ice and the brushes frozen quite stiff.

During his later years he was compelled by reasons of health to complete much more of his work indoors, but from the large studio window at *Etherow* he could always watch and study the changing of those ample skies which are a feature of his work. In speaking of Collier's style and methods, Orrock asserts:

> It is not too much to say that Tom Collier was the finest of sky painters, especially of rain and cumulus clouds, while possessing more mastery of direct modelling and pearl-grey shadows than any of our brotherhood. His painting of cloud-life was little short of magical. He was slow and deliberate, and when he had finished, the intention was complete. In moorland with brilliant skies full of 'accident' he has never had a rival. . . . One Sunday morning, between the hours of eleven and two, he painted in my presence a moorland and 'crockery' sky drawing which is as perfect as art can make it. He and Müller were the most impressive sketchers from Nature I know.

It is obvious that many of his larger works were painted indoors from smaller sketches. In his *Annals of Hampstead*. T. J. Barratt, who knew Collier personally, wrote that 'the artist became consumptive during the latter part of his life, and a great part of his drawings was made in the studio from *memoranda*, his retentive memory and powers of observation being such as to make it impossible to discriminate between those so done and those made in the open air'. Whether one agrees with the latter part of that statement or not, the fact emerges that Collier, like so many others, was tempted to work indoors on a larger scale. Out of some three hundred and fifty water-colours carefully recorded by Mr. Bury, eighteen only are over half-imperial size—the largest convenient size for outdoor work— and it is significant that they were painted after 1880. The greater part of his work consists of outdoor drawings under 10 × 14 inches in size. If we look at his larger drawings such as the *Arundel Castle*[1] or the *Wide Pastures*[2] they are just a little prosy and scholarly, a little tired, compared with the vivid, confident outdoor studies. Mr. Bury rightly points out the contrast between the *Arundel Castle* and the brilliant small version of the same theme, *Arundel Park with Deer*.[3] The *Wide Pastures*, 28 × 42 inches, was the largest drawing Collier ever painted, and it was a special commission to fill a particular place in a patron's drawing-room.[4] One might indicate a similar contrast between this drawing, which must have involved days of studio work, and the smaller drawings in the Victoria and Albert Museum, all of them infinitely more moving and exciting because the artist himself was moved and excited when he blotted them out upon paper in a feverish hour when the wind was on the heath. There could be no better example of Collier's swiftness and assurance

[1] Coll. Charles Burton (Bury, pl. 8). [2] V.A.M. P.5–1923.
[3] Once Coll. F. J. Nettlefold (Bury, pl. 48).
[4] See *Yorkshire Post*, February 28, 1923.

than *Path over the Fields*,[1] 1881, where tossing clouds are driven in feckless hurry over a landscape flecked with the rapture of green and gold, the sombreness of grey, the shining of a silvery shower over viridian moss and russet bracken. And the whole essence and worth of Collier is in his small and breezy *Walberswick Common*, which I have come to know so intimately since it passed into my own hands from the collection of F. Dayman, four years after his death.

Though Collier might cast a sidelong glance at the opinion of the world at large, his private means enabled him to stand aside from the market-place. He could work from morning to night without care. He could travel at his pleasure, collecting hundreds of notes and impressions. He was never idle. Mountains and moors in Wales, Cumberland and Yorkshire, the pastoral landscape of Surrey, the sweep of the Sussex Downs, the charms of Arundel and its park, the beach at Eastbourne, all supplied material which he treated with bold simplification. Grey, green or purple hills, moorland carpeted with heather, a patch of dark trees, a flash of water echoing dark and light, clouds, and the blue rifts of an overarching sky—that was Collier's subject. One subject, perhaps, but limitless in its variety. And nowhere did he find themes more after his own heart than on the coastland of Suffolk. He loved the groups of stunted wind-blown trees, the lonely windmills, and the stretches of sea-salted heath which go zig-zagging, just inland from the sea, from Southwold past Walberswick, Blythburgh, Dunwich and Sizewell Gap as far as Aldeburgh. Wherever the painter works in those parts there is always beyond his horizon to the east a hint rather than a presence of the North Sea. And the heaths themselves are tossed like a sea, with tree or church tower rising like some solitary ship, and over it all the vast varying sky, now shining blue, now a battle-ground where battalions of clouds march towards the east. Collier loved the space and wind and freedom of that Suffolk coast. He was not painting for sale or exhibition or to please the public. You feel that he was pleasing only himself when he painted the glowing landscape with cloud shadows flung over its pattern of green and purple and grey. He did not concern himself with the details, and loving the great spaces of land and sky he showed little interest in architecture or human life. If church, mill, cottage, or figure, appear in his work they are there as incidents, never prominent, never an inherent part of his design. His only change of subject—and not a very real change, because sky and space were still his theme—was when, with the utmost bravura of execution, he painted such subjects as *A Grey Day, Eastbourne*,[2] the windswept sky and storm-tossed sea in *Eastbourne*,[3] a swift and luminous record of fishing-boats on the beach in *Worthing*,[4] or *Bardsey Beach*,[5] all of them illustrated in Mr. Bury's volume. This group of seaside subjects forms a rare and little-known side of Collier's art, but one which

[1] Once Coll. F. J. Nettlefold (Bury, pl. 3).
[2] Once Coll. C. B. Gabriel (Bury, pl. 32).
[3] Bradford, City Art Gallery (Bury, pl. 39).
[4] Once Coll. W. Turner (Bury, pl. 45).
[5] Once Coll. Dr. H. Thompson (Bury, pl. 47).

154

shows at its highest his broad vision and his power of recording vividly an immediate impression.

If Collier must rank a little below De Wint and Cox, it is not because of any inferiority of observation or manipulative skill, but because his range is more limited. He never had their wide interests, their enterprise or their ambition. Perhaps because his physical strength was restricted, he reserved it for the type of subject which he painted with unerring brilliance of touch. In a curious way he combines in his work some qualities inherited both from De Wint and from Cox. Like De Wint he worked with undisturbed blots of rich, juicy, earthy, mossy colour. Like Cox, the Cox of his last great period of unity and power when wide vision had ousted his passion for detail, he loved the open heath and moving skies. He too was at his best when he worked in the open and not under a studio roof.

Cox and De Wint climbed to greater heights, but sometimes they palpably failed. Collier's work, on the other hand, was of a constant and supremely high standard. As Mr. Bury says: 'I have not yet seen anything by him that can be said to be a complete failure technically.' I would add a personal opinion. If I were invited to select, blindfold, for my own possession, six drawings from a pile of one hundred by Cox, or six from a pile of one hundred by Collier, I should unhesitatingly choose Collier. Chance might land me with six bad drawings by Cox, but could not possibly deal out six bad drawings by Collier. The supreme Cox, such as *The Challenge*,[1] may transcend anything which Collier accomplished, but in resolute constancy to the virtues of water-colour Collier surpasses Cox. He is to be reckoned among the masters.

For Collier's technique, his palette and method of work, we are fortunate in having his own description in a letter addressed from the Norfolk Arms, Arundel, Sussex, September 14, 1883, to Mr. Peters, a member of the staff of Messrs. Rowney,[2]

Dear Mr. Peters,

You have asked me to tell you something of my water-colour methods. I find it difficult to put them into words. I always paint a subject as simply and as direct from nature as possible, using the fewest colours I can. What I mean by that is that I have twelve colours in my box, but I only use 4 or 5 for any one picture, but I do not use the same set for all subjects. My list is as follows:

1. Gamboge (only used slightly and then mostly mixed with black for strong touches in the foreground). 2. Yellow ochre for greens with cobalt. 3. Raw Sienna, for rich green with Prussian Blue or Ultramarine. 4. Burnt Sienna, for shadows, with ultra, or greens with Prussian Blue. 5. Light Red, splendidly useful for every kind of subject. 6. Indian Red used very slightly, but sometimes needed (be careful not to make your picture look purple with it). 7. Crimson Lake, for dark mixture with Black and Gamboge, mostly for foregrounds. 8. Lamp Black. I use this colour quite a lot for taking down other colours, and for rich darks. 9. Indigo, not much used, but good to take other blues down with. 10. Ultramarine, either the so-called French or (when I can afford it, and for a special treat) the genuine. 11. Prussian Blue. Be careful with this as it makes rather strong greens, but is useful for pale washes in the sky, etc. 12. Cobalt, very

[1] V.A.M. 1427–1869.
[2] This letter, printed on pp. 44, 45, of Mr. Bury's *Thomas Collier*, is quoted here with his kind permission. He tells me that Mr. Peters was killed in a bombing raid, and that the letter, which was in his possession, has disappeared.

useful for greens, and for soft distances with Light Red and Yellow Ochre, also for skies, some-times with Indigo. My water-colours are Rowney's hexagonal colours. I find them best and most like the paints used by the Old Masters of water-colour. I do not like tube colours. And do not use Chinese White. I leave my lights as much as possible clean white paper, sometimes hav-ing to scrape small ones out. If a small light looks too white, slightly scrabble over it with pencil. Use good paper, and stretch it on a board with gum or paste, by turning up an inch all round and damping the wrong side of the paper, turning it over and sticking it to the board with the edges which you have left dry during the damping and have since pasted. Use a tight wedged wooden board, and carry two or three ready for use.

I hope these few hints will be useful.

Yours truly,

(Signed) TOM COLLIER

Two or three points in this letter call for comment. Though Collier gives his normal palette, there were other colours which he used. These are given in a manuscript note written by Edmund M. Wimperis, one of Collier's greatest friends, and later owned by his son, Edmund Wimperis, F.R.I.B.A., himself an ardent and skilful painter in water-colour. They are as follows:

Rose Madder	Purple Madder
Ultramarine Ash	Sepia
Raw Umber	Brown-Pink
Brown Madder	Vandyke Brown

I had always suspected that Collier, like Cox, used brown-pink extensively, and was sur-prised not to find it mentioned by him. His mixture of crimson lake, black and gamboge may stagger some water-colour painters, but it is quite practicable and gives the warm tones with which Collier strengthened his cloud shadows and foregrounds. And not many realise, like Collier, that a film of transparent black will not only reduce, but warm, other colours. As to stretching paper on a board, Collier did not practise what he preached; and I feel that when he advised the preparatory straining of paper (and omitted any reference to brown-pink) it was because he was giving advice to a beginner. Edmund Wimperis, a close friend and disciple of Collier, nearly always used loose paper unstrained, in a folio with a metal-hinged frame to hold down the paper. It is emphatically stated that both he and Claude Hayes followed the practice of Collier in never stretching the paper.

Many water-colour painters have gleaned in the fields of De Wint, Cox and Collier, but none can match these three artists. Nevertheless, Edmund Wimperis and Claude Hayes did follow Collier in bringing back to landscape some of the breadth and grandeur which had been scattered into disunity by some of their predecessors. They were avowed disciples of Collier and they achieved something more than mere imitation. Edmund Morison Wim-peris (1835–1900) was born in Chester, where his father was cashier in the lead-works of Messrs. Walker Parker. Showing some talent for pencil drawing, he was apprenticed at the age of sixteen to Mason Jackson, a well-known London wood-engraver, and had some training as an illustrator under Birket Foster. He gave up the graver to become a draughts-man on the wood-block, and supplied drawings for the *Illustrated London News*, S. C. Hall's

11 'Wide Pastures, Sussex'

V.A.M. P.5. 1923 28 × 42⅛: 711 × 1070 *Water-colour, signed and dated 1879*

Thomas COLLIER (1840–1891)

Book of the Thames, and other publications. He drifted gradually into landscape painting, chiefly in water-colour, and exhibited from 1859 at Suffolk Street and elsewhere. He became an associate of the Royal Institute in 1873, a member in 1875, and Vice-President in 1895.

In his first phase, up to about 1870, Wimperis was working in the painstaking way of a man used to stippling, under a magnifying-glass, on a boxwood block. Birket Foster was still his model, but in his later period, after he came into touch with Collier, his work began to show greater breadth and atmospheric quality. In the late 'seventies and early 'eighties he worked by Collier's side in Suffolk, at Capel Curig and Criccieth, in the Valley of the Arun, at Amberley, Bury and Burpham. Though still a little more inclined than Collier to the realisation of minor details, he painted expansive landscapes with breadth and decision; he dealt tenderly with the form and movement of spacious skies, and boldly with fleeting shadows cast over broken ground. *On the East Coast*[1] shows the full compass of his power. He did better work out-of-doors, when treating his subject with directness and sturdy significance of touch, than when he carried drawings to a high degree of finish in his studio. His son tells us that he disliked working upon paper which had been strained, holding that the wetting and stretching of paper robbed it of some of its quality and sympathy of surface. 'Whatman Not', unbleached 'Arnold', and 'Binfield', were his favourites, and he laid down paper, as another man might lay down port, with the feeling that it mellows and matures; as indeed it does. He realised that the final quality of a drawing is determined by the manner in which the first washes are received by the virgin surface of the paper. He used square-headed sable brushes, moist colours from tubes, and set his palette each day before starting work. It was his sound maxim: 'Never paint with a starved palette.' His colours, as given by his son, were: Indigo, Cobalt, Yellow Ochre, Light Red, Burnt Sienna, Gamboge, Raw Umber, Golden Ochre, Vandyke Brown, Sepia, Roman Ochre, Brown Madder, Rose Madder, and occasionally Payne's Grey, Prussian Blue, Brown-Pink, Vermilion and Charcoal Grey.

Like Wimperis, Claude Hayes (1852–1922) followed the great principles and aims of Cox and Collier. Maintaining worthily and without imitation their breezy, open-air style, he had the power of following broken ground into receding distance with able indication of form and colour values. His transparent use of fresh and untroubled colour allowed the sparkle of white paper to play its part in the general scheme. As a rule, his work is overshadowed by that of his more distinguished predecessors, but he produced many outdoor sketches of singular charm and freshness. I recall *A Pastoral, Spring*, exhibited in 1912, which had a personal and poetic note and showed kinship with the Impressionists in its vibrating light. Hayes was born in Dublin and at an early age he showed signs of talent, inherited from his father, Edwin Hayes, who had specialised successfully in marine painting and was a member of the Royal Hibernian Academy and of the Royal Institute in London. But the father was determined that his son should follow a business career.

[1] V.A.M. P.18-1918.

157

There was a clash of wills, and the boy ran away to sea, serving in *The Golden Fleece*, one of the transports used in the Abyssinian Expedition of 1867–8. Then he spent a *Wanderjahr* in the United States, working for his living, and earning dollars here and there by making drawings. On his return to London the truant found his father more amenable, entered the Royal Academy School, and later continued his studies at Antwerp. Starting with oil portraits, he gradually became a landscape painter, first in oil and then with water-colour as his favourite medium. He became a member of the Royal Institute of 1886. He worked in Hampshire, meeting James Aumonier, who helped him greatly, and in Surrey with William Charles Estall (1857–1897), who painted evening mists and moonlight in a delicate manner, and whose sister he married. Like Wimperis, Hayes met Collier, who influenced profoundly the evolution of his technique, though he always realised that before Collier there came Cox.

E. P. Reynolds,[1] who had frequently watched Hayes at work, describes his process in full detail, emphasising his rapidity of work, his facility in painting his washes at a subtly correct wetness for the blending and modifying of his tones, his decisive building up of accents put in strongly and then left alone. He was a good water-colour painter in that he always had full control of his brakes. Reynolds gives his palette:

Lemon Yellow	Raw Sienna	Cyanine Bleu
Yellow Ochre	Light Red	Vermilion
Roman Ochre	Rose Madder	Indigo
Aureolin	Purple Madder	Sepia
Orange Madder	Cobalt Blue	Transparent Oxide of Chromium
Burnt Sienna	French Ultramarine	Emerald Green
		Blue-Black

For smaller sketches up to 10 × 7 inches he used smooth and medium surface papers, such as 90 lb. Whatman, 'O.W.' and Michallet. (He must have been one of the first to employ Michallet, so much favoured later by Wilson Steer, for colour work). For larger drawings he chose rough or medium Arnold or a stoutish Whatman. He never stretched paper on a board or frame before commencing his work.

An exhibition of selected works by Claude Hayes was held in 1911 at 14, Brook Street; and among drawings that I starred then were *River Arun in Flood*; *Low Tide, Christchurch*; *The Old Mill, Norfolk*; *A Scene in Surrey*; *A Sussex Common*; and *Goathland, Yorks*. They must be widely scattered now, but the titles suggest how, up and down the land, he sought subjects which embodied light and life from the sky. He was a successful painter in his day. One who knew him well assured me that whenever Hayes was a guest anywhere at lunch or tea he liked to bring the conversation to a point where he was able to announce: 'For many years I have never made less than £700 a year by my painting.' In his later years ill health and loss of money through unfortunate speculation led Hayes to turn out a good deal of hasty and indifferent work, but at its best, when he dealt with 'the uncertain glory of an April day' or with 'a southerly wind and a cloudy sky', he produced drawings which

[1] E. P. Reynolds, 'Claude Hayes, R.I., R.O.I.', *Walker's Quarterly*, No. 7, 1922.

were wholly admirable in their freshness of colour and fluidity of atmosphere. He has never quite received the recognition which he deserves.

Claude Hayes must not be confused with Edwin Hayes, his father, or F. W. Hayes, the latter entirely unrelated to them. Edwin Hayes (1820–1904), born at Bristol, began to exhibit in London in 1854, and made a name by his marine subjects. He became an associate of the New Water Colour Society in 1860 and a member in 1863. His *St. Malo*,[1] 1862, is a typical work. Frederick William Hayes (1848–1918), born at New Ferry, Cheshire, after working for a time with a firm of architects in Ipswich, went to Liverpool to study painting and became in 1870 a pupil of Henry Dawson in London. Returning to Liverpool, he became one of the founders of the Liverpool Water-Colour Society. He made many experiments in painting landscapes direct from nature with transparent oil colours copiously mixed with turpentine. His versatile talent is shown by the fact that he was an able musician, a song writer, the author of several historical novels and a book, *State Industrialism* (1894). His *Landscape, Snowdon*[2] (Pl. 179), shows his power as a painter in water-colour.

In his landscape work John Jessop Hardwick (1831–1917), born in Beverley, Yorkshire, belongs to the same school as Collier and Wimperis. When fifteen, he was apprenticed to Henry Vizetelly, well-known as wood-engraver and publisher. Vizetelly started the *Illustrated London News* in 1855, and in 1858 induced Hardwick to become a member of his staff. Hardwick clung privately to work in colour, with the encouragement and advice of Redgrave, Ruskin and Rossetti. In 1861 he contributed a *Study of Fruit* to the Royal Academy, and was represented every year until 1915, two years before his death, by flower subjects. He was elected an associate of the Royal Society of Painters in Water-Colours in 1882. His landscape drawings, of commons and breezy skies, show his close study of nature and a pleasant colour sense. A good example is *Stormy Day on a Surrey Common*.[3]

James Orrock (1829–1913) has been mentioned in this chapter as a champion of Collier, and something may be said here about his own work as a painter. Orrock was born in Edinburgh, where his father was a dentist. Besides studying medicine and surgery, he qualified as a dentist, and practised for some years at Nottingham. Keenly interested always in art, he worked at the Nottingham School of Design, and later studied under James Ferguson, John Burgess, Stewart Smith and W. L. Leitch. He settled in London in 1866, became an associate of the Institute of Painters in Water-Colours in 1871, and achieved full membership in 1875. He was well known as writer and lecturer upon art subjects, as an enthusiastic collector of pictures and of china, and as a donor of works to public galleries. He was an ardent admirer of Cox, De Wint and Constable, and this predilection is echoed in his own work, which displays the merits of breadth and freshness resulting from the direct study of nature by an artist with a purposeful control of his medium. Several of his water-colours are in the Victoria and Albert Museum, among them

[1] Bethnal Green Museum 1208–1886. [2] V.A.M. P.64–1919.
[3] Once Coll. F. J. Nettlefold.

159

Bradgate Park, near Leicester[1] (Pl. 181), which he described rightly or wrongly as his 'best and most important water colour drawing'.

This section is intended primarily to include many worthy painters of landscape, working roughly between 1850–90, who have not hitherto found a place.

Henry Gastineau (*c.* 1791–1876), for instance, has not found previous mention; although his work was always technically accomplished, it was not particularly original and rarely impressive. At one time in his long career he was obviously influenced by Turner, but he belonged to no very definite school. Of French origin, he exhibited at the Royal Academy from 1812 to 1830. He was elected an associate of the Old Society in 1821 and member in 1823. For fifty-eight consecutive years he was an exhibitor at the Pall Mall Gallery, contributing an average of twenty-three drawings each season. His landscapes are chiefly stock picturesque subjects in England, Scotland and Wales. After 1838 he painted a number of subjects in Ireland, notably the rock-bound coast of Antrim, *Near Trim, County Meath*,[2] and two Italian views which are in the Dixon Bequest, Bethnal Green Museum. He was much engaged in teaching, sometimes giving in one day a lesson at Highgate and another at Sydenham, without our present facilities of locomotion. 'He used to prescribe', says Roget,[3] 'a course of practice which led the learner gradually on through the use of one, two, and then three colours, to the full palette.' Gastineau, from 1833 onwards, produced a great many drawings for topographical publications, and with him the old school of picturesque topography may be said to have expired.

George Haydock Dodgson (1811–1880), born of a middle-class Liverpool family, was brought up as a civil engineer in the office of George Stephenson, but abandoned this profession in 1835 owing to a breakdown of health and turned to art for his living. After doing a good deal of illustrative work on wood and stone, he was elected an associate of the New Water-Colour Society in 1842 and a member in 1847, but resigned in order to join the Old Society. With E. Duncan and F. W. Topham he was elected associate in 1848, and gained full membership in 1852. His subjects were chiefly English landscapes, garden scenes and *fêtes champêtres*, diversified with romantic figures. He worked much in Yorkshire and Cumberland, and in later years gave his attention to coast scenery, mainly at Whitby, and was highly successful in suggesting the effects of storm-driven spray. From a technical aspect Dodgson is of special interest because he was one of the first water-colour painters to make full use (but not always or consistently) of a wet method, dropping spots of pure colour, including vermilion and emerald green, on very damp paper, blending broken tints together and wiping out touches, in an attempt to obtain a suggestive effect and atmospheric values. He used strong colour in landscape almost with the depth of De Wint, his *Cockermouth Castle*[4] being very near to that artist. He had a way of dragging

[1] V.A.M. D.1073–1904.
[2] V.A.M. 1214–1886.
[3] Roget, I, p. 508.
[4] Newcastle upon Tyne, Laing Art Gallery.

160

a large brush over Whatman or Creswick paper so as to leave a sparkle of light in the minute interstices of his paper. Matthew Hale relates that Dodgson, like Arthur Melville later, used sometimes to coat his paper with a film of Chinese White. It is probable that his manipulation rose to some extent from a nervous tremor which had always affected his hand. *Dorothea*[1] is a good example of his management of colour upon wet paper. His work is well represented in the Dixon Bequest at Bethnal Green Museum.

Samuel Jackson (1794–1869), son of a Bristol merchant, was born in Wine Street, Bristol. Being more interested in art than business, he took lessons in water-colour from Francis Danby. He was an associate of the Old Water-Colour Society for twenty-six years from the date of his election in 1823, and in the early years of his membership exhibited many subjects found in or near his native city. He painted chiefly in England and Wales, but visited the West Indies in 1827, and made two tours in Switzerland, one probably in 1854, the other with his son S. P. Jackson in 1858. At Bristol he became the senior member of a coterie of painters who resided in the neighbourhood or were members of the sketching club founded by Müller.[2]

His son, Samuel Phillips Jackson (1830–1904), was taught by his father. He was elected associate of the Old Water-Colour Society in 1853 and a full member in 1876. His subjects were found chiefly in the coast scenery of England, particularly in Cornwall and Devon. In later years these were intermixed with inland scenes in Wales and around Streatley-on-Thames and Henley, in both of which places he had a home in the years following 1870. His work displays clean handling and a pleasant feeling for moist and hazy atmosphere.

Alfred William Hunt (1830–1896), born in Liverpool, was the son of a landscape painter, and exhibited at the age of twelve. But, having a scholastic mind, and his parents wishing him to enter the Church, he went up from Liverpool Collegiate School to Corpus Christi College, Oxford, in 1848. He won the Newdigate Prize for English Verse in 1851, and in 1853 obtained a Fellowship, which he had to resign on his marriage in 1861. He then decided to devote himself to art, and became an associate of the Liverpool Academy in 1854 and a member in 1856. From 1854 to 1857 he exhibited works in the Pre-Raphaelite manner at the Royal Academy, which were highly praised by Ruskin. He came to London in 1862 and was elected associate of the Old Society; in 1864 he became a member. To a certain extent he was influenced by Turner's works of his middle period and followed very closely his methods of sponging and stippling, with a Pre-Raphaelite minuteness of detail as his aim. His favourite sketching ground was North Wales, but he also visited Scotland, the Lakes, the Thames Valley and Southern England, and had a special love of Whitby and its neighbourhood. Like Girtin, he painted from the rocky bed of the Greta, viewing the bridge from a dry, flat boulder in mid-stream. He worked also at Mont St. Michel in France and Oberwesel in Switzerland. In his water-colours he clung conscientiously to the rule that a sketch should be halted before lighting conditions

[1] Once Coll. F. J. Nettlefold. [2] See p. 57.

changed, and would frequently make a morning, afternoon and evening study at the same place on the same day. His summer and autumn studies provided subjects which he wrought out, with much hard usage of delicate surfaces, during the winter months in his studio high up at Tor Villas (now 10, Tor Gardens) on Campden Hill; and many golden and purple skies, seen through London smoke, gave a finish to some Welsh or Yorkshire evening sketch.

In the Ashmolean Museum are some water-colours by A. W. Hunt, which show that, in true Pre-Raphaelite style, he worked on his picture piece by piece, often finishing out a portion of foreground completely before even washing in the rest. Other drawings in the same collection show how he rubbed and scrubbed, possibly with a hog's hair brush after holding his drawing under running water, so as to reduce his finish, eliminate detail, and secure atmospheric effect. Some of the monochrome drawings at the Ashmolean have a strongly poetic feeling; they will bear comparison with Turner's drawings for the *Liber Studiorum*. There is one particularly memorable example of a Yorkshire cliff running down to a beach on which are boats with sails drying, like butterflies in a mist.

Hunt's wife, who was Margaret Raine, achieved great popularity as a novelist in the days of the three-decker novel. Their daughter Violet Hunt won fame as the authoress of *The Flurried Years*, *The Wife of Rossetti*, and other books.[1] In the second annual volume of the Old Water-Colour Society's Club (1925) Violet Hunt wrote—so affectionately and so delicately—a fascinating account of her father and his work. As a child she looked upon her father's art as a natural, inevitable trade, as simple as shoemaking, but she grew up to watch his long nervous bird-like fingers propel or arrest his brush within the merest fraction of an inch in any given direction and place a dab of colour here or there with the force of a hammer or the lightness of the swish of a bird's wing. She watched him sponging Whatman's Imperial into submission and scraping it into rawness and a fresh state of smarting receptivity. At home, and in all weathers away from home, he toiled incessantly by daylight and by artificial light, 'literally never without a brush in his hand'.

Albert Goodwin (1845–1932), may be bracketed with A. W. Hunt. Both of them were ardent admirers of Turner. Both painted the same kind of subject, using very similar methods of washing, sponging and stippling; both fell under the fascination of Whitby. As a boy of fifteen, Goodwin exhibited at the Royal Academy. In 1871 he was elected associate of the Old Water-Colour Society, and in 1881 a full member. His work, at first in oil, was now almost entirely confined to water-colour. His delicate compositions, mingled the real and the unreal, appearing and disappearing as in the waywardness of a dream. He liked the effects of misty dawn and evening, the flicker of light, the glowing orgy of a sunset sky. Neither he nor Hunt, who also began as a painter in oil, ever found the water-colour medium tractable or submissive; they were always building, unbuilding, and re-building. But if Goodwin's work was at times unduly laboured, he did sometimes succeed

[1] For the Hunt family and their social circle at South Lodge, Campden Hill Road, and for Violet Hunt's relationship with Ford Madox, see D. Goldring, *South Lodge*, 1943.

in rendering the magic of a cathedral tower shimmering white against the melting blueness of the sky or of fishermen's cottages and boats melting into evening mists. He can be counted as one of those who have dealt successfully with twilight and sunset. The effect of one of his drawings can hardly be better described than by some lines of his contemporary Henley:

> *And from the sky-line far away*
> *About the quiet heaven are spread*
> *Mysterious hints of dying day,*
> *Thin, delicate dreams of green and red.*

One phase of his technique should be specially mentioned. He was one of the first of modern artists to use a pen-line in combination with water-colour wash. In his later work the light pen-line is used effectively and unobtrusively.

A painter strongly influenced by the Barbizon School was Sir Alfred East (1849–1913). Born at Kettering, he entered a business firm at Glasgow, and attended evening classes in the Glasgow School of Art. Starting as an oil-painter, he studied at Paris under Tony Fleury and Bouguereau. Soon after 1883, when he first exhibited at the Royal Academy, he settled in London and became one of the earliest members of the Royal Society of Painter-Etchers. In 1889 he toured Japan, bringing home many admirable water-colours, and at later dates pursued the water-colour side of his art in France, Spain, Italy and Morocco. He was elected A.R.A. in 1899 and R.A. in 1913; in 1906 he became President of the Royal Society of British Artists, and was knighted in 1910. East was one of the few artists of his day to give serious consideration to decorative design, and his romanticised landscapes were always well composed. He was a successor to J. D. Harding in his love of trees and in his penetrating treatment of their form and character. His subject and his methods can be well studied in his volume entitled *Brush and Pencil Notes in Landscape*, published in 1914.

I am sorry not to have better acquaintance with the work of Edward Hargitt (1835–1895), because his *Leixlip on the Liffey, near Dublin*,[1] painted in 1852, has always seemed to me extremely good. Like a Harpignies, it has breadth and subtle refinement in its low-toned scheme of grey and green. Hargitt was born in Edinburgh and became a pupil of Horatio MacCulloch. He was elected an associate of the Royal Institute in 1867 and a member in 1871.

A water-colour exhibition of 1890 would not have been complete without some example of landscape work by H. Clarence Whaite (1828–1912), C. E. Johnson (1832–1913), W. Matthew Hale (1837–1929), Herbert Marshall (1841–1913), W. Eyre Walker (1847–1930), Alfred Parsons (1847–1920) and an animal study by Joseph Wolf (1820–1899). There would be something also by three members of the Goodall family. E. A. Goodall, Frederick Goodall and Walter Goodall were sons of Walter Goodall, the engraver, whose

[1] V.A.M. 66–1896.

burin was employed for reproducing many of Turner's finest compositions. Edward Angelo Goodall (1819–1908), whose talent for water-colour painting won him a silver medal from the Society of Arts in 1837, four years later accompanied the Schomburgh Guiana Boundary Expedition as draughtsman. He exhibited from 1841, at the Royal Academy and the Society of British Artists. In 1854 he journeyed to the Crimea for a couple of years as artist to the *Illustrated London News*. He explored Morocco, Spain, Portugal and Italy, making no fewer than fifteen visits to Venice. He was elected associate of the Old Water-Colour Society in 1858, and member in 1864. Frederick Goodall (1822–1904) won a silver medal at the Society of Arts in the same year as his brother. In 1843 he made three tours in the west of Ireland, accompanied by F. W. Topham. At first a follower of Wilkie in painting peasant and village life, he later travelled much in Egypt (he was there for the winter of 1858 in company with Carl Haag) and painted landscapes of the Nile and the Pyramids. Devoting himself almost entirely to oil, he was elected A.R.A. in 1852 and R.A. in 1863. Two of his sons, Frederick Trevelyan and Herbert H. Goodall, became professional painters, but are of minor importance.

Walter Goodall (1830–1889), the youngest of the three brothers in this artist family, worked at the Clipstone Street Studio, and studied at the School of Design at Somerset House and at the Royal Academy. With S. P. Jackson he was elected associate of the Old Water-Colour Society in 1853, and attained full membership in 1861. He spent the winter of 1868 in Rome, and he painted many Venetian subjects. His work in water-colour (he never practised in oil), like that of his brothers, showed taste and refinement, though never any great vigour or personality. Much of it deals with figures, pleasantly set in Dutch or French surroundings or on the coast of Devon.

Frederick John Hiles (1872–1927), known professionally as Bartram Hiles, was born at Bristol and had the misfortune when a boy to lose both arms in a street accident. He learned to write and draw with a pencil held between his teeth. Later he used brush and colour in the same way, and from the Bristol School of Art won a national art scholarship for two years training at South Kensington. He made his way with indomitable patience, exhibiting at the Royal Society of British Artists in 1893 and for several years at the Royal Institute. Queen Victoria and Queen Alexandra were among his early patrons. He painted seascapes, the shipping of Bristol, and many landscapes. In 1908, 1909 and 1912 he was represented at the Royal Academy by large landscapes; in 1908 his *Where Nature's Heart beats strong amid the Hills* was sold for £100 a fortnight after the opening of the exhibition. At times he had a hard struggle, and when I first met him in 1899 he was colouring photographs and doing copying work at the Victoria and Albert Museum. I well remember the loose black Inverness cape which he wore, from a pocket of which one was invited to take out a roll of drawings. When he was hard up, as was too often the case, some members of the Museum staff used to arrange a raffle for one of his drawings.

Bartram Hiles was not alone as an armless artist. Sarah Biffin (1784–1850) who was born at East Quantoxhead, Somerset, and died at Liverpool, had neither hands nor feet, and

175 'Moorland Stream'
B.M. 1904.5.30.19 $14\frac{3}{8} \times 21\frac{1}{4}$: 364 × 539 *Water-colour*
Thomas COLLIER (1840–1891)

176 'Leeds Castle, Kent'
Coll. Mr & Mrs Paul Mellon $9 \times 13\frac{3}{8}$: 228 × 343 *Water-colour*
Thomas COLLIER (1840–1891)

177 'On the East Coast'
V.A.M. P.18–1918 12½ × 19½: 317 × 495 *Water-colour*
Edmund Morison WIMPERIS (1835–1900)

178 'Sheep on the Moor'
V.A.M. P.63–1923 14½ × 21⅛: 368 × 537 *Water-colour, signed*
Claude HAYES (1852–1922)

179 'Landscape: Snowdon'
V.A.M. P.64–1919 14×20: 356×508 *Water-colour*
Frederick William HAYES (1848–1918)

180 'Azaleas'
London R.W.S. (diploma drawing) $6\frac{7}{8}\times9\frac{7}{8}$: 174×251 *Water-colour*
John Jessop HARDWICK (1831–1917)

181 'Bradgate Park, Leicester'
V.A.M. D.1073–1904 $29\frac{3}{8} \times 45$: 745 × 1143 *Water-colour*
James ORROCK (1829–1913)

182 'A view of Rochester'
Coll. Mr & Mrs Paul Mellon $21 \times 28\frac{1}{4}$: 535 × 715 *Water-colour*
Henry GASTINEAU (c. 1791–1876)

183 'Scene from 'As You Like It' '
London R.W.S. (diploma drawing) 9¼ × 13: 235 × 330 *Water-colour*
George Haydock DODGSON (1811–1880)

184 'Tintern Abbey'
Bristol, City Museum and Art Gallery $6\frac{7}{8} \times 9\frac{5}{8}$: 175 × 245 *Water-colour*
Samuel JACKSON (1794–1869)

185 'Hulk in an Estuary'
B.M. 1922.7.14.13 $9\frac{1}{2} \times 14\frac{5}{8}$: 241 × 372 *Water-colour, signed*
Samuel Phillips JACKSON (1830–1904)

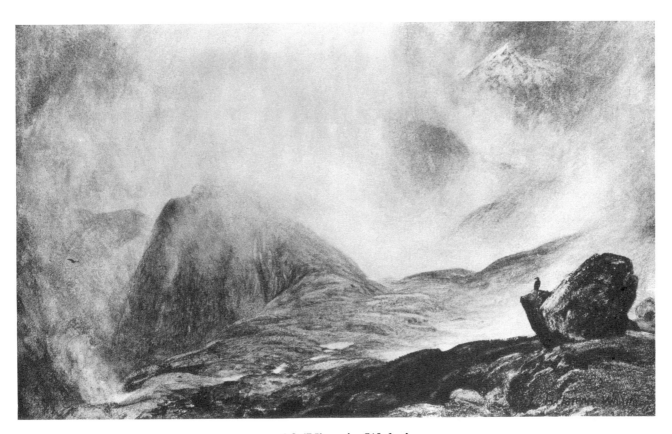

186 'View in Wales'
London R.W.S. (diploma drawing) 12 × 19½: 304 × 495 *Water-colour, signed*
Henry Clarence WHAITE (1828–1912)

187 'Sonning on Thames'
B.M. 1934.2.2.1 9⅝ × 14½: 244 × 368 *Water-colour*
Alfred William HUNT (1830–1896)

188 'Engelburg'

B.M. 1913.1.11.1 10×12¼: 254×310 *Water-colour and body colour, signed and dated 1911*

Albert Goodwin (1845–1932)

189 'Lago Maggiore from Stresa'

V.A.M. P.6–1918 $10\frac{7}{8} \times 15\frac{1}{8}$: 276×384 *Water-colour, signed*

Sir Alfred East, R.A. (1849–1913)

190 'near Leasowe, Cheshire'
V.A.M. 72–1896 9¼ × 13⅞: 235 × 352 *Water-colour*
Edward HARGITT (1835–1895)

191 'Catterlen Hall, Cumberland'
V.A.M. P.6–1911 12½ × 16¼: 217 × 413 *Water-colour, signed and dated 1885*
George Price BOYCE (1826–1897)

192 'Ptarmigan: Summer'

V.A.M. 429–1891 11 × 19¾: 279 × 501 *Water-colour, signed and dated 1875*

Joseph WOLF (1820–1899)

193 'Whitby, Yorkshire'

London R.W.S. (diploma drawing) 9½ × 13½: 241 × 343 *Water-colour, signed*

Herbert Menzies MARSHALL (1841–1913)

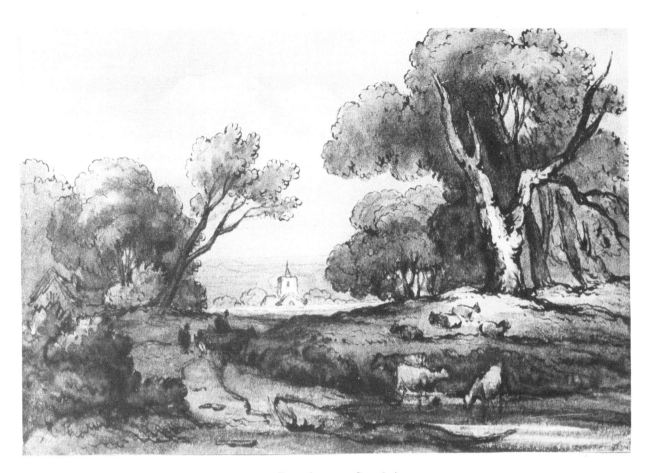

194 'Landscape Study'

B.M. 1943.11.13.113 $6\frac{3}{8} \times 9\frac{7}{8}$: 162 × 243 *Pen and water-colour*

J. ROBERTSON (Exhib. 1815–1836)

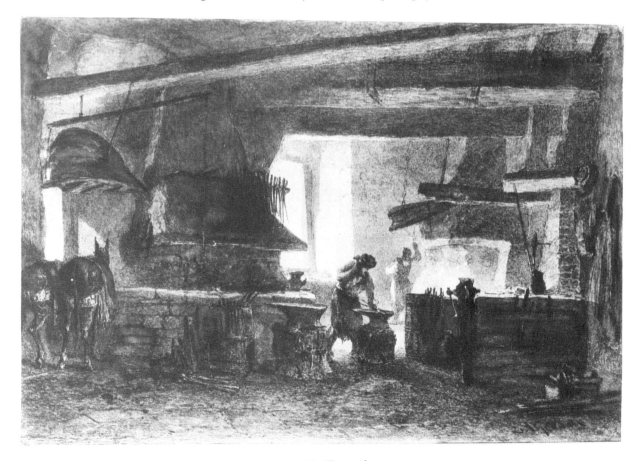

195 'A Forge'

London R.W.S. (diploma drawing) $14\frac{1}{2} \times 9\frac{3}{4}$: 368 × 248 *Water-colour and signed*

Edward Angelo GOODALL (1819—1908)

painted miniatures with brushes held in her mouth. She was a pupil of W. M. Craig, and practised at Brighton and Liverpool.

A group of drawings in the Victoria and Albert Museum assigned to J. Robertson (exhib. 1815–1836), unsigned and measuring 7 × 9 inches approximately, were at one time thought to be by Ramsay Richard Reinagle.[1] Following an article by me[2] to this effect, A. P. Oppé informed me that he had seen a volume of drawings by this hand attributed to J. Robertson containing a note that he had been employed in a china works in Derby. (That three of the V.A.M. drawings had been bought as the work of 'C. Robertson' helps to confirm the attribution.)

Dr. Percy[3] describes him as ' . . . a drunken fellow, frequently the inmate of a workhouse. He worked rapidly and sold his drawings for a trifle. Palser . . . bought largely of him.' His drawings deal with landscape, rural cottages and groups of trees; with windmills and boats, bridges and quiet waters; with, occasionally, something more romantic in the way of a ruined castle set high in scenery of mountain and of lake. There is often a pencil outline, but usually the drawing is done with a reed pen and a light brown ink. The pen has been used on the flat and on the edge with the greatest looseness and freedom. Sometimes the drawings are washed with sepia for the foreground and a pale blue for the middle distance and beyond. More often, they are tinted with washes of simple colour, always pleasantly subdued. The artist is one of those who look for the masses and character first; the colour takes a secondary place. A distinctive note is given to almost every drawing by two or three quite separate passages of highlight, nearly always produced by leaving the white paper. All of them have an air of swagger, but they are the work of a man who, with limitations in imaginative power, had sure command of pen and brush, a sound knowledge of Nature and a firm grasp of the essential qualities of design.

Ramsay Richard Reinagle (1775–1862), son of Philip Reinagle, R.A. (1749–1833), was born the same year as Turner, and began to exhibit at the Royal Academy in 1788, when he was thirteen. In 1805 he became an associate and, in the following year, a full member of the Old Society. He became President, but, in consequence of the Royal Academy's rules, resigned in order to become A.R.A. in 1814, and R.A. in 1823. His reputation suffered in 1848, when he was forced to retire in consequence of his having exhibited, and sold as his own, a picture painted by a young artist called Yarnold, which he had bought at a broker's shop.

[1] Iolo Williams possessed a drawing by this hand with a contemporary inscription *Original Sketch by Reinagle*.
[2] M. Hardie, *The Collector*, June 1930.
[3] B.M. Print Room, Dr. John Percy's annotated catalogue, 1871.

CHAPTER X

Artists from Overseas

James Abbott McNeill Whistler John Singer Sargent Charles Conder

My excuse for including in this book artists who were not British-born is that they had British blood in their veins and that the greater part of their work was done in this country.

James Abbott McNeill Whistler (1834–1903), born in Lowell, Massachusetts, was the son of a distinguished civil engineer, Major George Washington Whistler, and his second wife, Anna Matilda NcNeill, of Scottish descent. In 1842 Major Whistler went to St. Petersburg at the invitation of the Emperor Nicholas to construct the railroad between St. Petersburg and Moscow. Here the family resided for six years. About 1847 Whistler, being a delicate boy, was sent to England to be under the care of his step-sister, who had married Sir Francis Seymour Haden, founder and first President of the Royal Society of Painter-Etchers. It was under Haden's auspices that Whistler acquired his early knowledge of etching.

In April 1849 Major Whistler died and his widow returned to America with her two sons. In 1851 Whistler entered the military Academy at West Point. He was not fitted physically or by inclination for a military career, so left West Point, although he was easily first in the drawing section. For a short time he worked on etched plates in the Coast Survey Office. He finally left America in 1855, settled in Paris as an art student, and was in close touch with Courbet, Fantin-Latour and the artists of the French School. His early etchings, known as the *French Set*, were published in 1858; coming to London in 1859, he commenced work on his *Thames Set*. He stands beside Rembrandt as one of the greatest of etchers. His pastels and water-colours show the same power of delicate handling which is found in his etchings, with a complete evocation of form and atmosphere produced by the utmost economy of means; the same feeling for elegance, the same sophistication wedded to the artistic integrity which characterises all his work. Of Whistler the painter in oil, of his curious personality, his stinging wit, his 'butterfly' humour, his friendships and quarrels, this is not the place to write. His biography by the Pennells and many later books give a full picture of his genius and his individual character. In all the books, however, there is very little about his work in water-colour.

In 1934, to celebrate the centenary of Whistler's birth, Miss Birnie Philip, his sister-in-law and executrix, lent a collection of his water-colours, pastels, etchings and lithographs for exhibition at the Victoria and Albert Museum. It was the first opportunity, since his

166

death in 1903, for a later generation to study his work as a little master in water-colour. Opinions may still differ to some extent about his larger oil-paintings, but few can fail to respond to the exquisiteness of his diminutive work in the lighter medium, so much rarer and so much less known. It is easy to forget that Whistler, at the time when he was accused by Ruskin of 'flinging a pot of paint in the public's face', was an adventurous innovator. His water-colours were not mere transcripts of Nature: they were decorative schemes, in 'silver and gold', 'green and grey', and so forth. His contemporaries suspected such descriptive titles as being either affected or subversive, and must have thought it eccentric for any artist to paint small beach scenes, such as *Blue and Silver: Bell Isle*, or *Violet and Silver: low tide, Bell Isle* as uprights, instead of in 'landscape' form. They must have been startled by anyone who was so daring as to consider beach and sea and sky as three subtle pieces of tone, beautifully related; with no accent, no stress on rocks or stones or sea-lavender in the foreground, with nothing to suggest recession, but just sand melting into sea, and sea melting into sky, in a delicate harmony of colours which owed something to Nature, and much also to the artist's refinement of colour-sense. Whether he painted sea and sky, or the Maas at Dordrecht, or little shops at Chelsea, we find throughout his work the same sustained emotional rhythm. His colour is always quiet, floated on to paper that is sometimes wet, sometimes dry. The *Sunny Shower, Dordrecht* is a superb example of simplification by this method: the actual rain-drops in the sky which have fallen upon the paper from the sky and not the brush, testify that it was made from observation. Or take *Grey and Green: a Shop in Brittany*, and note the flower-pots and geraniums above the doorway, their suggestion more than a statement, the mastery with which they are expressed, the perfection not only of tonality but of form achieved by single liquid touches of a wet brush. *The Convalescent*[1] is a perfect example of Whistler's manner and of his sensibility; the bed and bedroom all in subtle modulations of white and cream; the pallid flesh of the invalid's face and the pale blue of a book which he holds, almost the only touches of colour. The drawing gives the very essence of the invalid state. Here, and in all of Whistler's water-colours, every touch is alive, becomes an element of space, yet plays its part in a considered artistry. And over each drawing a hand hovered till it dropped the butterfly signature at the one precise spot where it gave the final touch to the decorative scheme, echoing in rose or grey or green the dominant note.

Whistler liked the purity of water-colour and only occasionally used gouache. But when he did work with body colour, as in *Noir et Or: Millie Finch*, the opacity of the material enabled him, on a small scale, to reinforce the subtlety of tone which is the prevalent note in his oils. As to the new and unusual shape of some of his water-colours, it is likely that he deliberately chose it in memory, or emulation, of the Japanese *kakemono*. In their prints and in their water-colour *kakemonos* the Japanese realised the value of a narrow upright design. The colour-print was often designed either to stand by itself or to take its place as part of a

[1] Coll. Mr. Ronald Tree, New York.

167

triptych, and the *kakemono* was often composed in a similar way with a vertical flow of lines and yet with a perception of horizontals that would relate it to a neighbour. No student of Japanese art was more devout than Whistler—with Rossetti he was a pioneer in appreciation of it—and although this devotion is also reflected in his oil-paintings, its influence is even more apparent in his water-colours.

All the water-colours which have been mentioned, with the exception of *The Convalescent*, were placed in 1935, by Miss Birnie Philip, under the permanent charge of Glasgow University, and are in the Hunterian Museum of the University. The collection includes a fine oil-portrait of Whistler when a boy, about 1848, by Sir William Boxall, R.A., a large number of lithographs and etchings, with stones and copper plates, pastel drawings, water-colours, personal relics of the artist, and his Oriental China.

Whistler's use of water-colour was only occasional dalliance; in the case of Sargent, oil and water-colour were both constant companions throughout his life. John Singer Sargent (1856–1925) was born of American parents, in Florence. By the time that he was thirteen he was specifically pledged, with his parents' approval, to the profession of an artist. His first essays in water-colour were made in Switzerland in 1869 and 1870. In 1874 Whistler met his young compatriot at Venice, and was enthusiastic in praise of his drawings. In the autumn of the same year Sargent became a pupil in the studio of Carolus Duran, then the foremost portrait-painter in Paris. Into Sargent's career as a painter in oil we need not enter. From 1880 onwards he had a triumphant success, which led to his election as an Associate of the Royal Academy in 1894, and a full member in 1897. Evan Charteris, his official biographer, omitted to state that he was elected an associate of the Royal Water-Colour Society in 1904 and member in 1908. For a time he was perhaps unduly devoted to material success, but when he wearied of the constant task of producing commissioned portraits of rank, fashion and celebrity in England and the United States, he turned with joy to the freedom of water-colour. He bolted and barred the door of 31, Tite Street, against the queue of prospective sitters whom Max Beerbohm so wittily depicted, and found in water-colour endless scope for his driving energy and his need for emancipated personal expression.

It is as a realist that Sargent must be considered, both with regard to his water-colours and his oils. Like Constable, who loved the blaze of noon, he was a 10 a.m. to 4 p.m. painter and, as was the case with Constable, his water-colours seemed at times to his contemporaries too startling and forceful in their assertive satisfaction with life, almost brutal in their dominating strength. Strong, vital, burly—in art as in life—he preferred to face the harshness and glare, the midday glitter and contrasts, from which many painters shrink. He was not concerned with the beauty of the world and the fullness of it, or like Whistler, with the exquisite half-tones of dawn and twilight. Tenderness, gentleness, poetry—much of what seems inseparably bound up with the water-colour medium—are almost alien to his art. He looked for facts, for relations of form and texture, for dramatic changes and oppositions of light and colour, not for sentiment and poetry. It may be said

that Turner painted, and Whistler etched, the spirit of Venice, the romance and magical fascination of this bride of the sea: whereas Sargent drew and painted just the facts, the accidental things that caught his eye, the queer irregular shapes of dark gondolas on the canals, the big masses of larger ships with their sails and spars on the Giudecca, the gay mooring-posts, the flash of light on the façades of palaces, and the reflections on the glittering water. Yet, in these fragmentary, fortuitous, impromptu studies the spirit of the place, the sense of the past, is there as if by chance.

With regard to Sargent's technique I must differ from Evan Charteris,[1] who states of him that 'it was not his habit to use the opaque method: he trusted for his highlights to the white of the paper'. It would be more true to say that Sargent nearly always used an opaque method. In some of the slightest and swiftest of his outdoor sketches, pure colour was used throughout, and in all his work he knew the value of highlights obtained by leaving the white of the paper; but in most of his water-colours opaque colour was certainly used. In those in the Tate Gallery, and in the Imperial War Museum, lights are expressed here and there by leaving the paper untouched, but opaque colour has been used somewhere in every drawing, and in many instances, as in *Miss Eliza Wedgwood with Miss Sargent Sketching*, the highlights are obtained with a loaded impasto of Chinese White. It was by this means only that, as Charteris rightly states, 'water-colour in his hands seemed to lose something of its limitation and become a more powerful medium, giving the substances represented a solidity and volume more associated with oil-colour'.

It may be taken that as a general rule Sargent worked on a damp paper. At his first wash of pure colour on the wet paper, the colour naturally spread at the edges, as will be frequently seen in his background architecture. He was a very rapid worker, and for that reason he seems to me to have added, as his work progressed, a little Chinese White into his colour. This gave some slight opacity, but the addition of body-colour makes it easier to work quickly and with comparative solidity on a damp paper. It also gave Sargent a material that he could more readily move and handle, as in his oil method; and his final touches were nearly always made with pure white or with colour to which much white was added. And he knew exactly how his free blots and dashes of colour—seemingly indefinite, but none of them irrelevant—would fuse and coalesce into form and meaning when seen from a few feet away.

His rapid drawing of three sleeping figures in *The Siesta* shows Sargent's outlook, his avoidance of any pose other than the natural and accidental; and it illustrates the buoyancy with which he made his sudden attack. Nor can one believe that he deliberately set out with campstool and umbrella to paint the *Miss Eliza Wedgwood with Miss Sargent Sketching* or *The Siesta*. They just happened to be like that; and his drawing just happened, too. With Sargent it was always the unexpected, the unsought, that stirred his interest and made his theme. Sargent was a severe critic of his own water-colours. It was with the

[1] E. Charteris, *John Sargent*, 1927, p. 224.

169

utmost reluctance that he could be induced, for the purpose of sale, to take some out of the rack in which they were stored, and he never knew 'what to ask for a mere snapshot, especially if it does not happen to be a miraculously happy one'. And those were the drawings which realised prices running to a height of £4,830 at Christie's sale in July, 1925, with an average price of £65 for seventy-five drawings.

There is a vast gap between the virile open-air work of Sargent and the boudoir intimacies of Charles Conder (1868–1909). Almost forgotten since his death, Conder in his time won a reputation which should not be allowed to fade away. Charles Ricketts called him 'one of the most exquisite personalities in modern art', and Laurence Housman described him as a 'man of almost incalculable genius'. Born in London, Conder spent his childhood in India, where his father was working as an engineer. Australia has claimed him, since at the age of fifteen he was sent to work under an uncle who was an official in the Lands Department of New South Wales. He studied art in Sydney and Melbourne and before he was twenty was making drawings for the *Illustrated Sydney News*. In 1890, with the help of his uncle, he went to study in Paris. From 1897 he lived principally in England, but for a long time was equally at home in the lovely house overlooking the Seine at Chantemerle (a tablet on the wall commemorates his name) which was afterwards occupied by Romilly Fedden. In London he exhibited at the Leicester Galleries, the Grafton Gallery and the New English Art Club, and was one of the founders of the Society of Twelve.

Conder painted landscapes and portraits in oil, but was best known for his compositions, in water-colour upon silk, as panels for wall decoration or as fans. Both fans and panels were wrought with the utmost delicacy of colour and daintiness of design. Light festoons and garlands of flowers, linked with fluttering ribbons and shepherds' crooks, serve to unite medallions wherein are scenes from classical myth, or Marguerite tempted by Faust, or the pseudo-pastorals of eighteenth-century France, with lovers whispering among the roses. The fans ('loves in a mist of light, roses and vaporous blue, Hark to the dainty frou-frou') might have been carried by some butterfly beauty in the reign of Louis Quinze. His tender and elusive tints, with the opalescent use of twilight or dawn, agree perfectly with the frail texture of his material and his idyllic subjects. His kinship with Beardsley, his contemporary in the 'nineties, is often apparent in details and dottings of ornament, but it is a kinship also in their common outlook upon life, their love of an artificial world of pleasure. Their expression of joy is on the surface only; underlying it is a touch of morbid decadence. Such morbidity is less evident, perhaps, in Conder's case, but it is there. His fragile and enchanting caprices, with the sense of romance which they evoke, and the sense of luxury which they express, are things of melancholy if fragrant beauty. They are the dead and scented roses, the pot-pourri of art.

It seems more than doubtful whether Conder's fan designs were ever made up and used as actual fans. Any that I have seen have always been mounted with a special preciosity and framed as water-colours. And one is led to think of other artists who have seen beauty in the fan shape: Charles Shannon made his designs conform to the required space with

170

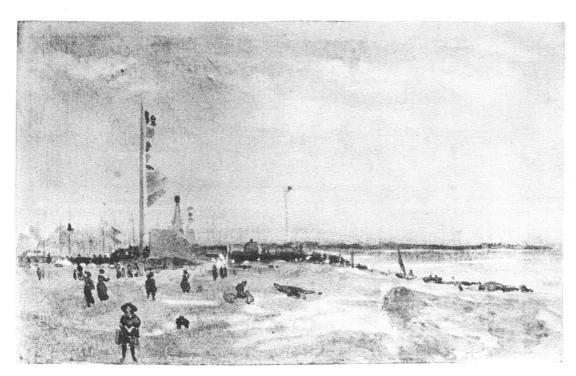

196 'Pourville sur mer'
Coll. Mr & Mrs Paul Mellon $3\frac{1}{2} \times 5\frac{3}{4}: 89 \times 147$ *Water-colour*
James Abbott McNeill WHISTLER (1834–1903)

197 'Mother and Child'
V.A.M. P.7-1943 $7\frac{1}{8} \times 10\frac{1}{2}: 181 \times 267$ *Water-colour*
James Abbott McNeill WHISTLER (1834–1903)

198 'River bed'

London R.W.S. (diploma drawing) $19\frac{1}{2} \times 13\frac{1}{2}$: 495 × 342 *Water-colour, signed*

John Singer SARGENT (1856–1925)

199 'A Moorish Patio'

B.M. 1959.1.2.8 8 × 8¾ : 203 × 222 *Water-colour*

John Singer SARGENT (1856–1925)

200 'Imperia La Belle'

V.A.M. E.188–1948 $9\frac{5}{8} \times 13\frac{3}{4}: 245 \times 350$ *Water-colour, signed and dated 1906*

Charles CONDER (1868–1909)

all his skill of composition and draughtsmanship, but he did not possess the subtle sympathy with the fan for its own sake shown by Conder and later by George Sheringham, as the symbol of love and laughter and coquetry. With motives and ideas woven together with rare power of imagination, Sheringham showed that the fan resembles a butterfly, beautiful at rest, but more beautiful when it moves with open wings, revealing subtle, iridescent colour. Over a wide range of subjects Sheringham's inventiveness never failed, and every spot of colour, now delicate and now brilliant, seemed to float upon the silk with inevitable rightness.

CHAPTER XI
The Scottish School

Sir David Wilkie David Roberts Sam Bough
William Leighton Leitch Cecil Gordon Lawson William McTaggart
Arthur Melville Joseph Crawhall Edwin Alexander David Muirhead
Sir David Young Cameron

The essence of Scottish literature and Scottish art is the mingling of sound and inventive technique with romance, colour and poetry. Sir James Caw takes a step further when he writes that the most characteristic trait of Scottish character is the faculty of combining idealism and practical achievement. It may be argued that there is no such thing as national art, but nevertheless racial character and environment do play a definite part in the spirit and the substance of Scottish art. Intense patriotism, pride of race, love of the land, trust in religion, relish for home life, for 'plain living and high thinking', shrewd interest in character, humour and sentiment, produced in the nineteenth century a native achievement in painting only comparable to that of Holland in the seventeenth century.

In Scotland the distracted condition of the country during the sixteenth and seventeenth centuries was little conducive to the cultivation of the arts. Up to the '45 there were few years when nobles were not resisting the authority of the King or engaged in strife with one another. It was only after the middle of the eighteenth century, when Union had been achieved, and the last rebellion had been suppressed, that there came a period of settled well-being and prosperity which initiated a golden age of Scottish literature and Scottish art. Burns struck a new note in national, and indeed international, literature by his vernacular poetry, touching the whole gamut of Scottish life, and expressing with insight, rich humour, and natural pathos, all the aspects, grave or gross, of the national character, the gladness or sadness of the common people. Again, in literature, Scott by his dealing with the historical glamour of Scotland's past founded a new school of romance, which fired the imagination of the wide world. In painting, Allan Ramsay's refined art rivalled that of France in graceful charm; but the poets and painters and novelists of France retaliated by taking Scott to their hearts. Raeburn and Wilkie, and the whole school of their successors, followed Burns and Scott in giving expression to a realistic and emo-

tional treatment of life and nature and history, coloured at every turn by a national outlook and philosophy.

One of the fore-runners of the Scottish School, indeed of the British School of water-colour, was Robert Adam (1728–1792), born at Kirkcaldy and educated at Edinburgh University. He followed his father as an architect, but was a landscape painter as well. In 1754–8 he travelled in France, Italy, Dalmatia and Germany, and in 1764 he and his brother James, who commenced the construction of the Adelphi in 1768, edited a work on the ruins of Diocletian's palace at Spalatro. Some of his travels were made in the company of Clérisseau, and he was the friend of Piranesi. As an architect he helped to rid England of the heaviness and pedantry of classical convention; he combined perfect proportion with a nice adjustment of ornament to plain surface; he brought elegance into the details of furniture and fittings, even locks and keys.

The interest of his landscape work became completely overshadowed by his prowess as an architect. In Sir James Caw's large volume[1] the only reference to him relates to his work as an architect, chiefly as one of the creators of the New Town in Edinburgh. In the long article about him in the *Dictionary of National Biography* there are only seven words to say that he 'obtained some reputation as a landscape painter'. More than a hundred years earlier, however, Cave of the *Gentleman's Magazine* pointed out, in his obituary notice of 1792, that: 'His talents extended beyond the line of his profession: he displayed in his numerous drawings in landscape a luxuriance of composition, and an effect of light and shade, which have scarcely ever been equalled.'

Adam's passage down the Rhine on his return from Italy in 1758 impelled him to sketch scenes of a romantic character, and the persistent element of romance in his nature was, without doubt, warmed and fostered by his association with Clérisseau, Piranesi and others of their school. There is strong kinship between his drawings and those of Alexander Cozens, as well as those of the Rev. W. Gilpin, whose work Adam knew and admired. The type of subject which he found on the Rhine, his early recollection of the ruined castle, the beetled crag, the 'horrid' rock, the winding river, supplied the inspiration for his later themes. They were always purely imaginative. Like Browning he had an unnatural craving for 'a castle precipice-encurled, in a gash of the wind-grieved Appenine'. He was composer and draughtsman rather than painter. Most of his drawings are in black-and-white, bistre or Indian ink, but now and then, as in some drawings now in the Soane Museum and the Victoria and Albert Museum, he added low tones of slight colour.

As A. P. Oppé has pointed out,[2] his drawings make an occasional appearance in the sale-room, generally in batches, probably just as they appeared in the Adam Sales of 1818 and 1821, which included several lots of 'Picturesque Scenery', 'Coloured Drawings', 'Views in Scotland', 'Romantic Landscapes', and the like. They are enough to show that

[1] Sir J. Caw, *Scottish Painting past and present*, 1908.
[2] A. P. Oppé, 'Robert Adam's Picturesque Compositions', *Burlington Magazine*, March 1942.

173

he devoted a large part of his leisure to such work, possibly with an architectural eye to its development as decoration of an overdoor, staircase or ceiling. The drawings are usually on a card with a surround of brightly coloured lines, between which they are sometimes signed with dates, as so far noted by Oppé, from 1778 to 1787.

Sir John Soane came to London in 1768, the year of the start of the Adelphi, and from the age of fifteen was deeply impressed by the architectural work of the Adam brothers. When in 1818, and again in 1821, William, the last surviving brother, was obliged, by increasing poverty and old age, to sell the family collections, Soane bought for £250, a bold price in those days, a set of forty drawings (now in the Soane Museum) made in 1782 by Robert Adam. To quote Arthur Bolton,[1] late Curator of that Museum; 'One series deals with "Antiquity", in the form of compositions reminiscent of the ruins of Rome, as they were when Robert Adam studied them on the spot. The other group, sometimes called "Picturesque Scenery", traces back to memories of his early days in the Highlands of Scotland. It will be remembered that his father was concerned with the roads and forts built after the rising of 1745. The two Sandbys were engaged in making views, and it is always supposed that Robert Adam must have been known to them at this time. . . . Both groups of compositions have this in common, that they are essentially designs, an outlet for the overflowing power and invention which Robert Adam possessed. None of these drawings can be taken as anything that ever existed outside the realm of his own mind . . . They also show what was in his mind when building Culzean Castle on the rocky coast of Ayrshire.' Conversely, it seems possible that his *Rocky Landscape with Castle*[2] is an imaginative rendering of Stirling Castle; other landscapes seem definitely to be natural records of Highland scenery; and the parcel of drawings described as 'Views in Scotland' in his sale strengthens this assumption.

It was not till the nineteenth century was well under way that we find work in water-colour which breaks away from classical traditions, becomes more naturalistic and individualistic in spirit and outlook, and reveals greater imaginative freedom together with larger resource of technique. As the century progressed painting naturally became more catholic under wider influences from England and the Continent, but it may be claimed that through it all there run the definite national traits. Sir Walter Armstrong once said that Scotland, in spite of many disadvantages, had one of the few original schools.

Water-colour, in the hands of Wilkie and others, had been practised as an auxiliary to oil-painting, for making quick notes and projects for pictures, rather than for its own sake. By the middle of the century water-colour was being taken more seriously as a medium possessing quite definite qualities of its own. Bough and Roberts and Wintour were among the pioneers, but before 1870 they had been joined by Fettes Douglas, Lockhart, McTaggart and Manson. In 1878 a Scottish Society of Painters in Water Colours (to be created Royal in 1888) was founded, with Sir Francis Powell, an Englishman by birth and an able

[1] A. J. Bolton, 'The Classical and Romantic Compositions of Robert Adam, 1782', *The Architectural Review*, LVII, 1925.
[2] V.A.M. 130–1890.

174

painter of seascapes, as its first President, and the virile Sam Bough as Vice-President. Most of the Scottish painters in water-colour at this time had a true understanding of the specific tendencies of the medium, and like the oil-painters of their day had a real appreciation of the musical quality of colour in its richer harmonies. Their work was bold and expressive, but it is to be regretted that, as Sir James Caw says, 'admiration for the fine pictures of Israels, Maris and their *confrères* led in some cases to a halting and unsatisfying compromise between tone and colour'. The corrective came towards the end of the century, with the work of McTaggart, whose art is a triumph for the Scottish School in that his vivid impressionisms of colour, sunlight and movement was an individual achievement in anticipation of Claude Monet and his followers in France. Finally, the Glasgow School, an outcome of the Impressionist movement, brought into Scottish art a new sense of decorative quality both in colour and design, and influenced a new group of painters in water-colour among whom Crawhall and Melville stand supreme.

To return from that rapid review to our starting-point, it may be said that though Alexander Runciman, Robert Adam and other forerunners in the eighteenth century may have used a touch of colour on their drawings, the Scottish School of water-colour does not apparently begin until Sir David Wilkie made free use of the method. Even by him it was used as a means to an end and not entirely for its own sake as an expressive medium. David Wilkie (1785–1841), a son of the manse, was born at Cults, Fifeshire, and at the age of fourteen became a student at the Trustees' Academy, Edinburgh. Before he was twenty he exhibited his *Pitlessie Fair*, an oil-painting in which some statistician has counted 140 figures. In 1805 he moved to London, and became a student in the Royal Academy Schools. His paintings of domestic life, of *genre* and historical subjects, won for him an early fame. Having made a great hit with *Village Politicians* in 1806, and with *The Blind Fiddler* in 1807, he was elected A.R.A. in 1809, and R.A. in 1811 at the age of twenty-six. On the failure of his health in 1825, Wilkie travelled extensively abroad. In 1840 he set out for the Holy Land and Egypt but died at sea in 1841 on the return voyage, near Gibraltar. His ending is commemorated in Turner's tribute to his friend, *Peace—Burial at Sea*, in the Tate Gallery.

Wilkie's water-colours are nearly all in the nature of studies for his oil-paintings. When he was embarking upon a new picture, he jotted down in pen-and-ink on any scrap of paper which came to hand, even the backs of envelopes and tradesmen's bills, his ideas of the general composition, of separate figures and of groups; altering and revising his notions for the design; posing, composing and recomposing the elements of his picture. With Scottish care and thrift he seems to have conserved every one of these notes; and in public galleries and private collections throughout Scotland and England there are innumerable examples. In January 1939 many of these sketches appeared in the exhibition of Scottish Art at the Royal Academy. Wilkie's draughtsmanship, based originally upon close study of Rembrandt and the other great Dutch painters of the seventeenth century, is vigorous and precise, and at the same time fluent and sympathetic. With a vivacious and pleasantly varied line, akin to that of Rembrandt, he gives pawky expression to the character which

175

he is rendering. His fine sense of line and form appears in the brilliant composition of his pictures, with the repetition of a pyramidal shape as the dominating motif (see, specially, his *Blind Man's Buff*), and with all the consenting parts happily building a logical and coherent whole. He excels in arranging figures, whether individually or in groups, to give full force to his humorous or dramatic narrative. On the occasion of Wilkie's centenary in 1885, Sir John Millais wrote to the Secretary of the Scottish Academy: 'In the history of Art there has been no superior to him for knowledge of composition, beautiful and subtle drawing, portrayal of character and originality. You may well be proud of your greatest painter.' Delacroix, who paid visits to Wilkie's studio, did not always like his paintings, but said: 'Ses ébauches et ses esquisses sont au-dessus de tous les éloges.' Most of these sketches are in black and white, but frequently Wilkie made water-colour studies, using colour over pen, chalk or pencil. The tints were employed to enhance his drawing, to suggest in a limited way what his larger purpose was in oil, perhaps even just to 'fix' the pencil. He put on colour with a delightfully fluid touch; with hesitant hints rather than considered statement; with the charm that belongs to slightness and delicacy. His colour is never full-blooded and robust, but in its use there is a never-failing dexterity.

In Scotland one of the principal pioneers of landscape painting in water-colour was Hugh William Williams (1773–1829), born on board his father's ship on the high seas and therefore legally a native of Wapping. He was brought up by an Italian step-grandfather in Edinburgh; he worked in Greece but, cosmopolitan though he was, his close association with Scotland entitles him to a place in this chapter. While in Edinburgh, his work must have won attention in London, for in 1808 he was elected a member of the short-lived Associated Artists in Water-Colour. From 1810 to 1816 he was a contributor to the exhibitions in Edinburgh of the Society of Associated Artists. Scott's *Lady of the Lake*, published in 1810, made Highland scenery the vogue, and Williams won quick success by his Highland views. Four of these, bearing dates between 1802 and 1806, are in the Victoria and Albert Museum, and in the British Museum *A Highland Landscape*[1] is dated 1802. His work, of which there are many characteristic examples in the Scottish National Gallery, was executed as a rule, and particularly in his earlier days, with tinted washes confined to brown, grey and blue, over a carefully pencilled outline. His *Glencoe*, however, exhibited in 1812, is surprisingly modern in its treatment. The hill forms are boldly painted in warm local colour, but though this and others of his drawings have a hint of the force and fullness of Cox, Bough and De Wint, he clung mainly to the more timid classical convention. This is particularly the case with the drawings of more arid landscape and less humid skies which he made in Italy and Greece, when gathering material for an exhibition held at Edinburgh in 1822. His illustrated volume of *Travels in Italy, Greece and the Ionian Islands* was published in 1820, and his *Select Views in Greece*, issued in 1827–9, earned him the title of 'Grecian Williams' by which he became generally known. Lockhart, Scott's biographer,

[1] B.M. 1875.8.14.958*.

176

described him as 'one of the most original, one of the most impressive, and one of the most delightful of painters', and in a contemporary criticism of his 1822 exhibition the writer says, 'There is room for more unqualified praise than in the works of any single artist in landscape painting to which this country has yet given birth'. That he won such high praise was perhaps due to pioneering water-colours 'coloured on the spot' rather than the customary practice of adding colour to outline later.

His work is accomplished and distinctly personal, sensitive in drawing and effective in light and shade. His conception of drawings made for purposes of engraving led him to use colour in an almost monotonic scheme or with an attenuated thinness inadequate to the scale on which he painted several of his pictures. His *Temple of Minerva Sunias* is of unusually large size, 50 × 30 inches. If he had continued to describe the features of his native land with more force and realistic quality in his colour, he might have taken a far higher place in any history of the earlier water-colour school. A sale at Edinburgh in January 1858 included a long series of drawings by H. W. Williams from the collection of Aeneas Mac-Bean. Among them were about forty of the originals for his engraved views of Greece. His *Plain of Marathon* fetched £84, *The Temples of Erectheus and Minerva Pollias*, £74, and *Mount Olympus*, £63.

Andrew Wilson (1780–1848), born seven years later than Williams, was a pupil of Alexander Nasmyth. At the age of seventeen he came to London, and after working for a short time at the Royal Academy Schools went to Italy and studied at Rome and Naples. After a short visit to England in 1803 he settled at Genoa. In 1806 he returned to England, joined the Associated Artists in 1808, and about this time became drawing-master at Sandhurst Military College. In 1818 he returned to Edinburgh on being appointed master of the Trustees' Academy. In 1826 he went to Italy with his wife and family, and stayed there till 1847, the year before his death. His house in Rome was a rendezvous for British painters, and he figures largely in Wilkie's letters and journals. He took an active part in the formation of various British collections, and during his Italian sojourn kept in close touch with other artists and connoisseurs at home. He acquired paintings in Italy for well-known private collectors such as Sir Robert Peel and the Earls of Pembroke and Hopetoun and many paintings now in the National Galleries of Scotland were acquired ultimately through his efforts. His career almost precluded the attainment of any great distinction as an executant, but his work is not negligible. It is told that Napoleon once stopped to admire a painting by him in an exhibition at Genoa, and on being informed that it was the work of an Englishman, made the retort: 'Le talent n'a pas de pays.' Wilson is seen at his best in the water-colours which he painted from his sketches of Italian scenery and architecture. He is well represented in the Victoria and Albert Museum.

A pioneer in the Scottish School, and a much greater artist than Williams or Andrew Wilson, was the Rev. John Thomson (1778–1840), known as 'Thomson of Duddingston'. Born at Dailly, in Ayrshire, he was a son of the manse and succeeded his father as minister there in the Presbyterian church. In 1805 he was transferred, through Sir Walter Scott's

influence, to Duddingston, near Edinburgh. His early efforts in art, while he was still a student of divinity, were encouraged and assisted by Alexander Nasmyth. After 1805 he lived in close touch with the intellectual and artistic life of Edinburgh which circled round Scott, William Clark of Elgin, Wilkie, Raeburn and George Watson. Turner visited him in the Duddingston manse in 1822. It is a mistake to regard Thomson as, in Redgrave's words, an 'amateur landscape painter'. He was no more an amateur painter than Dean Swift was an amateur author. Though he never failed in his clerical duties, Thomson's brush was constantly active, and he won high fame as a painter. On account of his cloth, he declined to take professional rank in the Scottish Academy, but was elected an honorary member in 1830, ten years before his death. Mackay[1] says that he awakened Scottish painters to the pictorial possibilities of their country and adds that 'for vigour of conception and imaginative power none of his Scottish followers have excelled him'. Caw[2] sums him up as 'the greatest Scottish landscape-painter of his time and the first to seize and express fitly the true character of Scottish landscape'. Though his work was mostly in oils and based upon the classical tradition of Gaspar Poussin, Claude and Richard Wilson, he worked in water-colour occasionally. He used the lighter medium with quite free expression, in his own personal and naturalistic way, with a full appreciation of its loose and fluid qualities. His *Duddingston Loch and Neighbourhood*,[3] painted more than one hundred years ago, but with a breath of new life in it, has close affinity with the work of Tonks and Steer, and would have fallen into its place in any exhibition of the New English Art Club in its heyday during the early years of this century.

Born at Edinburgh, Patrick Nasmyth (1787–1831) (he was christened Peter, but styled himself Patrick) came to London at the age of twenty. He took delight in the woodland scenery, the green lanes, the hedgerow trees and slow-running streams of the south. Following Dutch models very closely he won the title of the 'English Hobbema'. He exhibited from 1811 to 1830 at the British Institution, the Royal Academy and the Society of British Artists, becoming a member of the last-named in 1823. His pictures are nearly all in oil, with neat and conventional treatment of foliage, and somewhat static skies, following the Dutch convention. In his rare water-colours, such as *St. Paul's Cathedral from Lambeth Marsh*,[4] 1807, and *Netley Abbey*,[5] he is more free from foreign influence and shows greater breadth and freedom of handling. At the British Museum are his *Between Bridgenorth and Much Wenlock*,[6] 1828, and *Turnpike House, near Cowes, Isle of Wight*.[7] James Nasmyth, inventor of the Nasmyth hammer, was Patrick's brother. Their father, Alexander Nasmyth (1758–1840), though mainly engaged on family groups and portraits in oil, took up landscape in his later life; he outlived his son Patrick by nine years. He painted occasional water-colours such as his *View in North Wales*[8] (Pl. 207).

[1] W. D. McKay, *The Scottish School of Painting*, 1906, p. 187.
[2] *Op. cit.*, p. 143.　　　　　　　　　　　　　[3] V.A.M. 1453–1882.
[4] V.A.M. P.24–1922.　　　　　　　　　　　　[5] Coll. Mr. and Mrs. Paul Mellon.
[6] B.M. 1861. 12.14.235 (L.B.1).　　　　　　　[7] B.M. 1878. 7.13.1273 (L.B.2).
[8] B.M. 1882. 8.12.551 (L.B.3).

Water-colour may have played only a small part in the life of Wilkie or Thomson or the Nasmyths, but with David Roberts it was a serious affair, because water-colours, accumulated during his travels abroad, were the foundation of nearly all his profitable oil-paintings. David Roberts (1796–1864) belongs to the same generation and the same school as Copley Fielding, born in 1787, Clarkson Stanfield in 1793, and J. D. Harding in 1767. He was the son of a poor cobbler at Stockbridge, near Edinburgh, and was apprenticed at an early age to a house-painter and decorator named Gavin Beugo. He worked hard, and much of his spare time was occupied in sketching the architectural monuments of his native city. There is a tale that, as a boy, he was caught by the great Sir Henry Raeburn perched on his garden wall, but the laird of Deanhaugh, Stockbridge, treated him gently on finding that the young intruder's purpose was to sketch a Gothic window of his summer-house. Free at the age of twenty-one, after serving his full time of seven years, Roberts worked at his normal trade, but soon accepted an offer to act as scene-painter to J. Bannister, who intended to add a stage to the ring performances of his travelling Circus. With him Roberts went to Carlisle, Newcastle, Hull and York. It was York Minster which, according to his *Journal*, taught him to appreciate Gothic architecture.

> Here, I may say, I first became a painter. . . . I have sat for hours in the *snow*, sketching York Minster. . . . Here, and here alone, was my spelling-book of Gothic architecture. Day after day I made the most careful drawings of every buttress, canopy, bar and crocket, with all a lover's first love and devotion. Is there a part of that old minster I do not know? How often have I studied that Screen? . . . Even now I have drawings of Micklegate Bar, etc., with the Old Castle and Roman Keep. I recollect Old Ouse Bridge before it was removed to make way for the modern one. Is there an old abbey or village church within a dozen miles that I have not visited? And all the time I was for twenty-five shillings a week—painting scenes in the hay-loft of 'The White Swan in The Pavement'. Sometimes I enacted in the evening the part of a robber in the pantomime of Silver Mask, or of the Blood-Red Knight, but this, I must admit, was more for my own amusement than by the manager's wish, for, in playing the bandit one night, I was so far in earnest (as Scotsmen generally are), I fired the pistol in his face, to the great terror of the actor himself. Fortunately it was not loaded.

Thus young Roberts was educating himself as a painter as well as a scene-painter. Owing to the experience gained during this tour in the latter capacity he was engaged to paint scenery, first for the Edinburgh Pantheon, next for the Theatre Royal, Glasgow, and then for the Theatre Royal, Edinburgh. Shoemaker's son, scene-painter at Carlisle, Glasgow, Edinburgh, Sam Bough was to follow exactly in his footsteps, some twenty-five years later.

In 1822, the year of Bough's birth, Roberts obtained, through William Barrymore, a post as scene-painter at Drury Lane Theatre, and settled in London. Drawings by Roberts, belonging to the period before he left Edinburgh, such as *Edinburgh Castle from Greyfriars Churchyard*,[1] 1822, are of some rarity. In London he renewed a friendship which he had

1 Coll. Mr. Leonard G. Duke.

179

formed in Edinburgh with Clarkson Stanfield, who was then acting as scene-painter for Barrymore at the Edinburgh Pantheon. Their joint work at Drury Lane played an important part in the attractions which the Theatre provided and won reputation for both as well as a steady income. The association was the beginning of a lifelong friendship, as the familiar 'Stanny' of Roberts' letters sufficiently testifies. When, nearly forty years later, in the zenith of their reputation, they were entertained at a banquet given in their honour by the Royal Scottish Academy, thoughts of the days when in the cavernous emptiness of Drury Lane they covered vast spaces with large brushes dipped into buckets of colour, must have been vividly in their minds. The two serious veterans probably recalled the plays for which, under Marinari the principal scene-painter, they provided the scenery[1]:

Gog and Magog, or Harlequin Antiquary, December 26, 1822.
Chinese Sorcerer, or The Emperor and his Three Sons, March 31, 1823.
Cataract of the Ganges, or The Rajah's Daughter, October 27, 1823.
Harlequin and the Flying Chest, or Malek and the Princess Schirine,
 December 26, 1823.
Zoroaster, or The Spirit of the Sea, Apr. 19, 1824.

Neither of them, after those hard struggles, suffered any of the disappointments which often chequer the careers of greater artists. Both won professional honours and rewards, as well as large incomes. On the formation of the Society of British Artists in 1823, Roberts became its Vice-President (he became President in 1830) and gradually abandoned the theatre in order to find free scope for the peculiar bent of his talent in the treatment of architectural subjects. In 1827, however, he was entirely responsible—this time without Stanfield's aid—for the seventeen scenes, backcloths, wings, borders, for the first London production of the *Seraglio* ('arranged and adapted from Mozart's celebrated Opera') at Covent Garden. His last work for the theatre was in 1830, a drop-scene for the Edinburgh Theatre Royal and three scenes for the Christmas pantomime at Covent Garden. In 1829 he was elected an honorary member of the Royal Scottish Academy. He became an associate of the Royal Academy in 1838, full membership following in 1841. Owing to his high position in the world of art he was made one of the Commissioners for the Great Exhibition of 1851. Roberts also holds the unique position among Scottish artists of having received the highest compliment which the capital of his country can give and ranks among distinguished statesmen, soldiers and scientists on the Burgess roll of Edinburgh. Looking down a by-way in his life, it is interesting to note that in 1847 he was summoned by a Committee of the Privy Council to assess the actual value of one of George Baxter's shilling colour-prints.[2] His evidence was that he considered it 'worth half a guinea' and that there was 'nothing known that equalled the Patentee's invention in Colour Printing'.

[1] I am indebted to Mrs. Enthoven, who has kindly supplied this information from the original play-bills in her Collection at the Victoria and Albert Museum.
[2] See Baxter's preface to his *Pictorial Key to the Great Exhibition*, 1851.

180

It was a generous statement when we consider that the colour-lithographs of Roberts' *Holy Land* were in course of publication at the time.

Like so many Scots, Roberts had a roving disposition. Several short trips to the Continent, where he visited Dieppe, Le Havre, and Rouen (he was at Dieppe in 1831) whetted his appetite for foreign travel, and in 1832–3, acting on the advice of Wilkie, he spent a considerable time in Spain and at Tangier. He set out, as he says, 'owing no man in England a shilling', with sufficient means to sustain him for a year. He put in plenty of hard work, and wrote from Gibraltar: 'I have already made 206 finished drawings, many of them coloured, in addition to many others in my small sketch book.' In 1838 he visited Egypt and the Holy Land, where in less than twelve months he amassed sketches sufficient to keep him working for ten years. In 1851, and again two years later, he toured Italy, again storing his lockers with ammunition for several years. He became one of the best known of the later topographers, and the results of his many journeys exist not only in oil-paintings and water-colours but in the form of coloured reproductions which were highly popular and brought him a considerable fortune.

Picturesque Sketches in Spain during the years 1832 and 1833 is a somewhat rare volume, with coloured plates, and his Spanish tour also provided material for a series of engravings in the *Landscape Annual* for the years 1835–8. Jennings, the publisher, bought the first of the drawings for these engravings at £20 each and sold them at £40. Later, Roberts raised his price to £25. It was not till the completion of this undertaking that he set out in 1838, by way of Lyons, Marseilles and Malta, to Egypt and the Holy Land. The prints from his drawings of the Holy Land were probably the first publication which ever gave a vivid presentment of sites, scenes and buildings famous in sacred history and Eastern legend. His diaries and letters, quoted in James Ballantine's *Life* (1866), give a full descriptive account of his journeys and his subjects. The drawings, exhibited on his return, caused a great sensation. The fidelity of his accurate pencil, his skilful adherence to truth in costume and surroundings, his attention to characteristic effect in architecture and landscape, won immediate recognition and praise. Commissions from royal and other patrons of art crowded upon him for pictures of his Eastern subjects, and a publisher, F. G. Moon, was soon found to undertake their reproduction for wider circulation. The result was a book published in parts from 1842 to 1849, *Views in the Holy Land, Syria, Idumea, Arabia, Egypt and Nubia*, containing in all about two hundred and fifty plates, with descriptive text by the Rev. Dr. Croly and W. Brockendon. The plates are all in chromo-lithography. The drawing upon the stone was done, from Roberts' original sketches, by J. D. Harding and Louis Haghe, the latter of whom devoted about eight years to the series. For the coloured edition the plates were all executed in two tints by Haghe, and were then finished in colour by hand in faithful imitation of the originals. The work cost £50,000 in the production, and the original cost to subscribers, for six volumes in the edition with the plates in colour, was close on £150. The artist received no less a sum than £3000 for the right to reproduce his drawings. He subsequently sold to Lord Francis Egerton twenty-five relating to the Holy

Land for £500, and fifty Syrian subjects for £900. During his later years Roberts stirred less from home, and had commenced a series of pictures of London as seen from the Thames, when he died suddenly in 1864.

Throughout his life Roberts kept a journal in which he made careful notes of the localities which he visited, entering the prices he obtained for his pictures together with a pen-and-ink sketch of the subject, by which means his more important works can generally be authenticated. Roberts' early training as a scene-painter led him to choose his standpoint happily and to grasp compositional effects of light and shade, though sometimes with too much of the spot-light here and there; at the same time it developed his power of free and rapid execution. His work done in Palestine and Egypt is accurate but conventional, neither expressing any personal mood nor showing particular study of atmospheric effect. He supplies the facts, not the glamour and mystery of the East. He had real interest in architecture, which he rendered with intelligent fidelity and with special facility in organising masses and in co-ordinating groups of figures in consonance with his architectural background. He did not possess Prout's interest in pathetic mutilation, in the softening and mellowing effects of time upon venerable buildings and storied cities; he tended rather to become accurate and mechanical, and made a free use of ruler and set-square in his larger subjects, as will be seen particularly in his oil-paintings. In his drawings he worked very carefully with a hard lead pencil, relying upon this, rather than upon fine touches with a brush, for form in landscape and for his architectural detail. Over the pencil work he applied quite thin washes of colour, and frequently worked on a tinted paper, obtaining his highlights with Chinese White.

A typical architectural subject of the best type *Saint Lo*[1] (Pl. 212) (*c.* 1825) is drawn with a hard pencil, used freely but with crisp and precise touches where detail is required; then washed with delicate colour, the buildings all in parchment tones of ivory and cream. In subtle contrast with the definition of the old gabled houses is the sketchy looseness of the figures in the street. They are by Roberts the scene-painter; he seems to have been thinking of some ballet or opera, so dancing are they. Theirs is the light and fluttering movement of ladies and gallants painted by Conder or Sheringham on a silken fan; indeed the whole drawing resembles their work in its refinement of muted colour. Most of Roberts' drawings done in the East are a little monotonous in their uniform scheme of grey, dull red, brown and yellow, the last described by Ruskin as 'a singularly false and cold though convenient colour'. Ruskin[2] praises his endurance, his exquisite drawings and his statements of facts, but says that among his sketches he saw 'no single instance of a downright study; of a study in which the real hues and shades of sky and earth had been honestly realised or attempted —nor were there, on the other hand, any of these invaluable blotted five-minutes works which record the unity of some simple and magnificent impressions'. Many of his drawings

[1] Coll. Mr. and Mrs. Paul Mellon.
[2] J. Ruskin, *Modern Painters*, Pt. II, § I, Chap. vii.

and oil-paintings, however accurate in technical mastery of detail, are uninteresting just because they are so empty and monochromatic. And yet, of his hundreds of sketches (his finished water-colours are more rare) there are few that do not display honesty of purpose and excellency of craftsmanship; just now and again, like the *Saint Lo*, they possess something more. After his death his daughter, Mrs. Henry Bicknell, selected some of his drawings and sketches. The remainder, consisting of nearly 1100 lots, were offered in a six days' sale at Christie's in May 1865 and realised between £16,000 and £17,000.

Samuel Bough (1822–1878), as we have seen, followed closely in Roberts' footsteps at the beginning of his career. Sam Bough, as he was always known, is not strictly a Scot, for he was born at Carlisle, of Border ancestry; but his later associations were Scottish, and it was as a member of the Royal Scottish Academy that he won success and fame. He died in 1878, but in Edinburgh the legend of Bough as a character, humorous, rollicking, irresponsible, still lingered on in my younger days. Bough's upbringing belies the usual tale about the parental thwarting of young artists. His father, a Carlisle shoemaker, actually encouraged his son, when quite a young boy, to become an artist, and had him trained at a humble academy run by a local cobbler, John Dobson, who was an amateur painter. Later, his father sent him, as a lad of fifteen, to learn the art of landscape-engraving from Thomas Allom in London: a short-lived experiment in view of Sam Bough's restless and roving disposition. We find him back at Carlisle, at the age of eighteen, contributing nine drawings to an illustrated edition of the *History of Leath Ward in the County of Cumberland*, published in 1840 by Samuel Jefferson, a local bookseller. For the next year or two he seems to have been known as a somewhat shiftless, feckless youth, prone to all sorts of scrapes, tall and big-boned, wandering about on casual sketching tours, and selling a picture here and there for half-a-crown. Struggles and buffetings soured his temper not a little, but in 1845 he obtained a settled job, best described in his own words:

> I shall leave Carlisle in the course of a fortnight or three weeks for a situation I have taken in the Theatre Royal, Manchester, as a scene-painter. It may possibly end by making me a rich man. The School is a good one. Stanfield and Roberts did not paint there for nothing, and I don't see anything to prevent me from doing likewise. A good salary of one pound, fifteen shillings, English money, per week, is not to be despised.

The first scene which he painted was a back-cloth, about forty feet in width, of woodland scenery with a large oak, which so pleased the manager that Bough's salary was raised five shillings forthwith. Though Bough's time was well occupied with scene-painting, he worked hard for the exhibition of the Royal Manchester Institution in 1847, to which he contributed five water-colours, and also sent works for exhibition at Liverpool and Worcester. At Manchester, he won a silver medal for the best water-colour drawing.

Finding that he was making no progress in Manchester, Bough settled in Glasgow towards the end of 1848, having obtained a post as scene-painter in the newly erected Princess Theatre. His pay was not large, and he continued the happy-go-lucky, thriftless

[1] S. Gilpin, *Sam Bough*, 1905, p. 34.

existence which he had led in Carlisle, adding to the strain on his resources, and irritating the theatre manager, by taking to himself a wife. In May 1849 he was busily painting scenery at the Adelphi Theatre, Edinburgh, but again there was a quarrel with the manager, and Bough was thrown upon his own resources as a painter of landscape. It is to this period that his *Barncluith*[1] belongs.

Drifting quite apart from his theatre connection, Bough resolved to settle in the town of Hamilton, in order to have full facility for studying landscape effects in Cadzow forest; and here he worked with much greater earnestness of purpose. In 1851 he painted his *Cadzow Forest*, in oil, and it may have been this picture which was awarded the gold medal and £10 offered by the West of Scotland Fine Art Association for the best painting of Scottish landscape scenery, though his water-colour *On the Clyde* belongs to the same year. Looking upon Edinburgh as the principal art centre for Scotland, Bough was anxious to establish his standing there as an artist among artists, and so we find him in 1855 first at 2, Upper Dean Terrace, and then at 5, Malta Terrace, Stockbridge. In this year he sent six works to the Royal Scottish Academy, and was elected an associate in 1856. It was due to his own cantankerous nature that he was not elected a full member till nearly twenty years later, in 1875.

As an associate of the Scottish Academy, Bough found many of his subjects at Canty Bay, where the Bass Rock stands at the entrance to the Firth of Forth. He was equally inspired by the Fifeshire coast, with its fishing villages and sheltered harbours. There were few parts of Great Britain which he did not visit, but year after year, and for three months in 1876, he sought the coast of Fife. St. Monance, Dysart, Cellardyke, St. Andrews, are all recorded in his work.

By the time Bough was fifty his work was rising rapidly in value. R. L. Stevenson said of Bough's painting that it was 'an act of dashing conduct, like the capture of a fort in war'. Like George Borrow at Oulton Broad, he was celebrated for his promiscuous hospitality, and like Girtin, he welcomed visitors while he was at work. All sorts and conditions of visitors he had; actors such as Charles Matthews, Toole, Wyndham and Joseph Jefferson, the American impersonator of Rip Van Winkle; literary men such as Dr. John Brown, author of *Rab and his Friends*; Jem Mace, the prize-fighter; soldiers, sailors, even a bishop, who remarked—'A very clever man, and, at times, a very *irreverent* one, too.' His biographer sums him up: 'Of chaff and nonsense, and all sorts of whims, Bough had abundance and to spare; and these were often indulged in to an extent altogether beyond the bounds of reason and decorum. Keeping little or no restraint upon his sayings or doings, he was apt to drift into too much pawky forwardness to be at all times an agreeable companion. He broke down and set at nought all sorts of class barriers; paid no respect to the manners and customs of the day; could be very open and plain with his Saxon speech; and was an adept at rapping out a good mouth-filling oath.' Add to all this that he was well-

[1] Glasgow Corporation Art Gallery.

184

read in a wide range of subjects, sang a good song, could perform on various instruments, and even in later days, when he had grown fat, could dance a measure with the lightness and grace of a 'young Lochinvar'. No wonder that a man so alert and agile, physically and mentally, left a lasting legend quite apart from his work as a painter. It is typical of him that in the 'seventies he signed some of his pictures, 'Sam Bough, 1857', with the explanation: 'You know, that's said to be my best period!' For the same reason most forgeries of David Cox will be found to bear the date 1845.

To Miss Mary Tait, a student at the Scottish National Gallery, Bough supplied a list of the colours which he used:

Yellow Ochre	Raw Umber	Crimson Lake
Raw Sienna	Vandyke Brown	Vermilion
Burnt Sienna	Light Red	Prussian Blue
Cobalt	Ivory Black	

'There's eleven colours', said Bough. 'Put in Gamboge, if you like, to make up the dozen—but take my advice and never use it.' He was violently opposed to emerald green; and added, 'Never use body-colour', in singular contradiction to his own mode of working. At the same time it should be said that as a rule he used body-colour with discretion, though sometimes with an unsparing hand, and probably realised that his best work was in pure colour, like that of David Cox. He recommended Miss Tait, and indeed all students, to copy a small water-colour sketch, *Crossing the Moor* by Cox, in the National Gallery, Edinburgh.

Bough's own water-colours, the best of them, are swiftly and thinly painted in transparent colour. As time went on, he sought fuller colour, and bolder treatment of light and shadow, working on paper of a rougher texture. Of his procedure as a water-colour painter Stevenson writes: 'It was a sight to see him attack a sketch, peering boldly through his spectacles, and, with somewhat tremulous fingers, flooding the page with colours; for a moment it was an indescribable hurly-burly, and then chaos would become ordered, and you would see a speaking transcript.' In his loose touches of broken colour, and in his feeling for atmosphere, he has a close affinity with David Cox. He does not always attain to Cox's purity of transparent colour, but both men, in their nature and in their work, showed the same breezy, open-air, homespun feeling. Bough comes nearer than anyone to Cox in his swift sureness of touch, his command of the ever-shifting movement of tossing clouds over a wind-blown landscape.

Bough's reputation rests much more securely upon his water-colours than upon his oils. In the Scottish Exhibition at the Royal Academy in 1939 the balance weighed down on the wrong side. His oil-painting of *Dunkirk* was more telling and impressive than his water-colours of *Barncluith* and *View from Richmond Hill*.[1] They were accomplished, but the 'dashing conduct' was not displayed, as in some wave-worn harbour of Fife, like the

[1] R.A. Exhibition of Scottish Art, 1939, No. 626.

Pittenweem, Fifeshire,[1] where his quality of colour, his subtlety of atmosphere, his sense of hurly-burly movement, his dramatic instinct, were more vividly expressed.

William Leighton Leitch (1804–1883), born in Glasgow, was a successful painter but lacked the imaginative intelligence of Roberts and Bough. He served a boyhood apprentice-ship with a decorator and sign-painter, and about 1824 he became scene-painter at the Glasgow Theatre Royal. Soon afterward he came to London, where he succeeded George Chambers as scene-painter at the Pavilion Theatre and afterwards was associated in similar work with Clarkson Stanfield and David Roberts. He then went to Italy, and after studying there for five years returned to London and contributed to the exhibitions of the Royal Academy (1833–61) and other Societies. He became a member of the New Water-Colour Society (now the Royal Institute) in 1862 and was for many years its Vice-President. He was teacher of water-colour painting to Queen Victoria and other members of the royal family, and has been described as 'certainly the last of the great English teachers of landscape-painting'. An anecdote, typical of Whistler's biting wit, if a little unfair to Leitch, tells how Whistler, catching his name in conversation said: 'Leitch? Leitch? Oh, yes, didn't he teach the Queen to paint? Or did she teach him?' Sir James Caw, referring to Leitch's start as a scene-painter, points out how the early associations lingered in 'landscape which usually looks as if it had been painted as a setting for romantic opera'. Though he was a skilful draughtsman, with intimate knowledge of what pencil and brush could accomplish in capable hands, his outlook was neither original or emotional; he was insensitive to atmosphere; and was apt to clutter his work with a profusion of details and incidents rendered with painstaking accuracy. Everything is carried to extreme finish, everything is emphasised alike, the range of colour is wide; but the coloured transcript of a thousand things is not the same as a good picture. Leitch was a typical Victorian; he belongs, like Birket Foster and T. M. Richardson, to that school of painters who are con-cerned with the surface rather than form. In spite of all that, Leitch's drawings take the place that must be given to work which, though lacking in the higher inspiration, is charac-terised by thorough observation, nicety of touch and supreme competence. His *Moel-y-Gest, North Wales*,[2] is a good example of his power as a composer and of his artificial dexterity. His work is fully represented in the Victoria and Albert Museum, and numerous examples in the Glasgow Gallery exemplify his treatment of Scottish landscape and Italian scenes. His brother, Richard Principal Leitch (*fl.* 1840–1875), exhibited at the Royal Academy and at Suffolk Street between 1840 and 1862, and had a considerable practice as a drawing-master. The basis of his teaching and of his own practice was the laying in of all shadows with a neutral grey composed of lake, indigo and vandyke brown or sepia. Examples of his somewhat mechanical work will be found in the Victoria and Albert Museum.

Not quite of the same calibre as David Roberts, but a facile and prolific draughtsman,

[1] V.A.M. 42–1896. [2] Bethnal Green Museum 1189–1886.

working much in the Roberts manner, was William Simpson (1823–1899). He was born in Glasgow and in 1839 was apprenticed to a Glasgow firm of lithographers, and came to London in 1851 for similar employment with Messrs. Day and Son. At the outbreak of the Crimean War he was commissioned by Messrs. Colnaghi to make sketches at the seat of hostilities,[1] and thus became the first war artist, indeed one of the first 'special artists', who have now yielded place to the camera-man. After the fall of Sebastopol he was attached to the Duke of Newcastle's expedition in Circassia, and from 1859 to 1862 travelled in India, Kashmir and Tibet, making architectural and archaeological sketches. In 1866 he joined the staff of the *Illustrated London News* and for twenty years in its service he travelled the globe. He attended the marriage of the Czarevitch (Alexander III) at St. Petersburg, followed Napier in his Abyssinian campaign, was with the German army in the war of 1870 and in Paris during the Commune. He depicted the pomp and pageantry of the Prince of Wales's tour through India in 1875–6, and accompanied the Afghan expedition of 1878–9, when he had a very narrow escape in the Khyber Pass. His last long journey was in 1884, when he was with the Afghan Boundary Commission at Penjdeh, and the latter years of his life were devoted to completing the series of water-colour drawings of *Glasgow in the Forties* (from sketches made in his youth), acquired by the Glasgow Gallery in 1898. His work in water-colour is very fully represented in the Victoria and Albert Museum. In 1874 he became an associate, and in 1879 a member, of the Royal Institute. His *Autobiography* was published posthumously in 1903.

Simpson's work, like that of Roberts, was spirited and dexterous. It may be placed beside that of Edward Lear, as the work of a cultured traveller, possessing open eyes, keen interest and a skilful hand. Much of what he produced in colour (his output in pencil and wash was prodigious) was in the nature of a tinted sketch, but his more thoughtful work, when he was student rather than shorthand reporter, as in some of the water-colours made in India and Egypt, has considerable merit. On the whole, as Sir James Caw[2] puts it: 'it is the romance of his career, from lithographer's bench to the suites of princes and the staffs of famous generals, rather than the quality of his art, that makes appeal.'

Of the many Macs in Scottish painting Horatio McCulloch (1805–1867) takes the earliest place. McCulloch was a dominating figure in Scottish landscape art during the middle part of last century, and was one of the first to revel in mountain, moor and loch, one of the first to popularise the beauty of the Highlands. Horatio McCulloch was born at Glasgow on the night when the city was illuminated for the victory of Trafalgar, and hence his Christian name. I do not know to what extent McCulloch practised in water-colour, but I once owned a water-colour drawing by him, which was finely composed and broadly executed. It was a brilliant study for his picture of *Kilchurn Castle* in the Glasgow Art Gallery, a solid, sombre castle on the shores of Loch Awe with mountains behind.

[1] *The Seat of War in the East*, with 81 lithographs, from his drawings, and Brackenbury's *Campaign in the Crimea*, with 40 plates, were published in 1855. Later, and better in execution, were the 50 plates of his *India Ancient and Modern*.
[2] *Op. cit.*, p. 292.

I had bought this drawing, at the sale of his effects in 1912, as a personal memory of Alexander Strahan, who founded *Good Words* about 1860 and was an early patron of my uncle, John Pettie.

With McCulloch as a romantic painter may be linked John Crawford Wintour (1825–1882). As painters in oil both of them had a touch of the theatrical scene-painter in their treatment of landscape. Wintour was born at Edinburgh and studied at the Trustees' Academy.[1] About 1850, after producing portraits and *genre* subjects, he found his real vocation in landscape, painting broadly and with poetic and romantic suggestion. He was elected A.R.S.A. in 1859, but his personal conduct and not any decline in his art prevented his reaching full academic honours. His drawing at times is slightly flimsy, and in water-colour he is at his best in pure sketches made as memoranda of composition, effect or colour. As Sir James Caw[2] says: 'In some of these the pencilling is not obliterated or lost in the simply laid tints which are frequently modified by preliminary pencil shading; yet, abstract as they are, they suggest in abbreviated form the essential charm which arrested the artist.'

An artist who would undoubtedly have occupied a very prominent place in the history of British art if he had lived longer was Cecil Gordon Lawson (1851–1882) who, though born at Wellington, Shropshire, was the son of Scottish parents. His father, William Lawson, was a portrait-painter, and brought his son with him to London in 1861. Apart from what he absorbed in his father's studio, Cecil Lawson was self-taught, and as a boy made many elaborate studies of fruit and plants in the manner of William Hunt. His later work proves how he benefited by this profound study of detail, but in his maturity he was concerned with broader effects. He was a more profound painter than Fred Walker, who died just when Lawson was rising to fame. *The Minister's Garden*, a large oil-painting now in the Manchester Art Gallery, was exhibited at the opening of the Grosvenor Gallery and secured a triumph for the young painter, who was then twenty-seven, with but four years to live. Two water-colour drawings of *Hollyhocks*[3] in the Victoria and Albert Museum are studies for the foreground of the Manchester picture. His large oil-paintings left him little time for water-colour, and his drawings are so rare that he suffers from undeserved oblivion as a water-colour painter. Such drawings as exist show him as a painter singularly sensitive to the grandeur and bold rhythm of Nature, and skilled in recording his impressions with confident sweep of line and colour. In his vigour and breadth, in his rich harmonies of colour, and in his emotional outlook, he displays his Scottish origin. In Scotland, where he won acceptance from the first, he exercised great influence as a stylist. In the evolution of younger men, Sir James Caw gives his considered opinion that Lawson 'remains one of the greatest landscape-painters of his century'. Sir George Clausen, in his

[1] For the origin and nature of the Trustees' Academy, Edinburgh, see Caw, *op. cit.*, pp. 35, 67–8, etc.
[2] *Op. cit.*, p. 187.
[3] V.A.M. P.53 and 54–1934.

188

charming address on Landscape Painting,[1] pointed out that Lawson was very like Rousseau in his austerity, and fine sentiment, and his large view of Nature.

In one of his water-colours, *Hop Gardens of Kent*,[2] he has condensed and compressed the whole of a county into a space of 10 by 20 inches. It is a drawing which combines a triumphant grasp of detail with magnificent sweep of design; that flight of birds, so thoughtfully and perfectly placed, is an integral part of his ordered pattern. Indeed, in all his work, the broad and poetic effect is enhanced by the aptness of his impressionistic method. *In the Wharfedale, Yorkshire*[3] (Pl. 221) is nobly composed as regards light and shade, landscape and sky, and is a rich, sonorous work, which I always see as a potential mezzotint worthy of the tools of a Davis Lucas. This and *A Woody Landscape*[4] are not large drawings, but like the last conceptions of Cotman they are large and spacious in their treatment of Nature's pageantry. Cotman in his last years and Lawson, young and ardent, both admitted a certain romanticism. Like Fred Walker and other artists who were portrayed by Du Maurier in *Trilby*, Lawson comes into another kind of romance. George Bernard Shaw, as a very shy young man, newly arrived from Ireland, used to visit the Lawson family in their home at 15, Cheyne Walk,[5] and it is not generally known that Cecil Lawson posed unconsciously as a model for the character of an artist in Shaw's first novel *Immaturity* (written in 1879, but not published till half a century later).

Sir William Fettes Douglas (1822–1891), born in Edinburgh, worked in the Commercial Bank of that city for ten years, not coming into the open as an artist till he was twenty-five. His pictures soon attracted notice, and in 1851 he became an associate of the Scottish Academy, full membership following three years later. He became its President in 1882, after being Director of the National Gallery of Scotland for six years. He is best known as an oil-painter of historic and romantic incident, largely based upon his profound knowledge as an antiquary and collector. In such pictures as *The Spell* he combines his study of the occult with the most loving study of accessories. His painting of still life, of the nicely discriminated textures of parchment and ivory and brocade, the frayed leather of old books, the gleam of porcelain, enamels and chased metal, is as satisfying as any to be found in the Flemish or Dutch masters of the seventeenth century. About 1875 he began to exhibit oil landscapes (e.g. *Stonehaven* and *A Fishing Village*) which are original in design as well as accomplished in execution. For a time after 1879 the effects of a serious illness laid him aside, and when he resumed his art it was to work at landscape in water-colour only. Mostly small in size, his water-colours, to which his scholarly temperament gave intellectual coherence, are sympathetic renderings of such places as the shores of Angus and the Mearus in quiet moods. Low in tone, worked in subdued greys and sombre

[1] Sir G. Clausen, *Six Lectures on Painting*, 1904.
[2] Birmingham, City Art Gallery 27'08.
[3] V.A.M. D.167–1907.
[4] Once in author's collection.
[5] Rossetti was a neighbour. In his later years he lived at 16, Cheyne Walk with his brother, W. M. Rossetti, Swinburne and Meredith.

189

greens and umbers, they combine restraint with a largeness of style which has yet to win the appreciation which it deserves. Such drawings as *Landscape with Rocky Stream*[1] (1886) (it was once a treasured possession of John Pettie, R.A.) and *The Estuary*[2] (1887), are typical of the sobriety, the reticence, the subtle charm, which penetrate all his landscape painting.

A worthy successor of Sam Bough was William Ewart Lockhart (1844–1900). In 1867, stimulated by the influence of John Phillip, he made the first of his journeys to Spain, and produced many oil-paintings of Spanish subjects with rich colour effects. He became a full member of the Royal Scottish Academy in 1878, and was commissioned by Queen Victoria to record on a large canvas the Jubilee Ceremony at Westminster Abbey in 1887. Though he won success by his oil-painting, Lockhart's work in water-colour was more subtle and distinguished, more in consonance with his douce, delicate nature. His work in this medium shows genuine feeling for open-air effects, a good pictorial sense, expressive drawing both in landscape and figures, and an informal, breezy directness which connects him with Bough. I have specially in mind a drawing of Edinburgh and Prince's Street Gardens, as well as a small study of a group of figures, *The Wine Cart, Spain*,[3] as typical examples of his fresh and sympathetic handling.

George Manson (1850–1876), born in Edinburgh, started his art career as an apprentice wood-engraver to Messrs. W. & R. Chambers, and at twenty-one left their employment to become a painter in water-colour. Not only in shortness of life, but in outlook and in the lyric quality of his work, he is akin to G. H. Mason and Fred Walker. Most of his water-colours deal with scenes of child life, depicted with delicate and fragrant sentiment. A good example is his *Children at a Well*, belonging to the National Gallery of Scotland. At one time, his talent was held in great esteem, heightened perhaps by the pathos of his untimely end at Lympstones, Devonshire, owing to consumption, at the early age of twenty-six.

There is much more actual debt to Mason and Walker in the art of Robert W. Macbeth (1848–1910), who was born in Glasgow and went to London about 1870 as an illustrator on the staff of the *Graphic*. A few years later he became a member of the Old Water-Colour Society; was elected A.R.A. in 1883, and R.A. in 1903. There is always charm in his pastoral subjects, particularly in the Fen country which he loved, in his understanding of rural life and seasonal changes, and particularly in his seizure of character in figures set always with dignity of gesture and movement in relation to their open-air work. Macbeth is perhaps best known for a long series of accomplished etchings, in which he interpreted the work of Mason and Walker, as well as masterpieces by Velasquez and other painters in the Prado.

The Scottish Water-Colour Society was founded in 1878, and its formation was not only evidence of quickened interest in water-colour art but an assurance that this interest would

[1] V.A.M. P.51–1921.
[2] R.A. Scottish Exhibition, 1939, No. 603.
[3] Once in the author's collection.

be fostered in the future. For the first time we get painters such as T. Scott and R. B. Nisbet who devoted themselves entirely to this medium instead of using it as a subsidiary to painting in oil. Thomas Scott (1854–1927) was born at Selkirk, and after being an assistant to his father in the tailoring trade, entered the R.S.A. Schools in Edinburgh in 1877. His drawings won him associateship of the R.S.A. in 1888 and full membership in 1902, a singular honour for a painter who worked exclusively in water-colour. His work may be said to be competent and complete rather than marked by any depth of emotion, but he had a genuine feeling for Nature, and his Border landscapes, such as *Hartwoodburn, Selkirk, An Autumn Afternoon in Yarrow*, and *Moss-Troopers returning from a Raid*, convey a spirited and sympathetic rendering of his native county.

Robert Buchan Nisbet (1857–1942), born in Edinburgh three years later than Scott, also devoted himself entirely to water-colour. His art was always popular, and much appreciated abroad. He became A.R.S.A. in 1893, R.S.A. in 1902; was a member of the Scottish Water-Colour Society, the Royal Institute and the Royal Society of British Artists; and an Hon. Member of the Royal Belgian Water-Colour Society. He was entirely a landscape-painter, and in my younger days I was greatly impressed by the richness and fine quality of his work. He had clearly made a close study of the earlier English masters, notably of Girtin, Cox and De Wint, but while he maintained a kinship with De Wint in broad contrasts of light and shade and in depth of low-toned masses, his method was much less direct and spontaneous. Some of his small sketches are fresh and fluent, but in larger work he was tempted into rubbing and scrubbing his colour. He gained by this a controlled effect and a certain quality which has its own appeal (it is very apparent in the work of his contemporary Dutch water-colour painters), but the painter who uses this method does so at the cost of losing the beautiful transparency which has given charm, and perhaps more actual permanence, to the work of the older English masters, such as Cox and De Wint. Though it is unfair to judge a man by a single piece of his work, a small *Landscape*[1] (Pl. 225) by him, in the Victoria and Albert Museum, may be considered as a summary of his high merit and undoubted skill of execution. In its own kind Nisbet's work is both impressive and effective.

Alexander Kellock Brown (1849–1922), born in Edinburgh, started life as a textile designer and studied in the Haldane Academy, Glasgow. He was an active supporter of the Royal Scottish Society of Painters in Water-Colours, of which he became a member in 1878; he was elected A.R.S.A. in 1892 and R.S.A. in 1908. A drawing such as his *Criffel*[2] shows his delicate perception and his intimate understanding of a subtle atmospheric effect and his special feeling for skies. To the same period and group belongs Thomas Marjoribanks Hay (1862–1921). *The Cove, Berwickshire*,[3] belonging to the National Gallery of Scotland, is a good example of his pleasant colour and feeling for atmospheric effect.

In the same company may be mentioned James Kay (1858–1942), born at Lamlash in

[1] V.A.M. P.50–1921.
[2] R.A. Scottish Exhibition 1939, No. 625.
[3] Edinburgh, National Gallery of Scotland.

the Isle of Arran, a well-known member of the Scottish Water-Colour Society and elected A.R.S.A. in 1893. His subjects were found on Dutch rivers and in coast towns of France, but his distinctive place was as a painter of the river Clyde, its liners, its ocean-tugs, its tramp steamers, the life of the quays, and usually the griminess and murkiness of it all rather than sunny aspects. His painting is a little monotonous, and sometimes overworked like that of Nisbet, but honest, purpose-like and showing a genuine concern for his subject. Of the same school is Emily Murray Paterson (1855–1934), born at Kidderminster, of Ayrshire parents. After studying in Edinburgh and Paris she, like Kay, sought ships and shipping on canals and broad water-ways, painting at Dordrecht and in Venice happy effects of colour and atmosphere, which were recorded with considerable technical power. She was a member of the Royal Scottish Water-Colour Society, and followed the tenets of the Glasgow School in casting over her work a veil of nebulous tones, blurring her edges rather than making positive statements of form. Light and atmosphere were her main concern; and, like other members of the School, she did not just float transparent colour over a careful drawing, but loaded her paper with colour, often with body-colour, and then washed it down, wiped it out, scraped it with a knife, and polished it with cuttlefish bone. Her flower-pieces, usually with dark backgrounds, are pleasantly atmospheric and attractive in colour. The clearer air of Switzerland called for more vivid colour and greater emphasis of form, to which she was quick to respond.

To this generation also belongs James Garden Laing (1852–1915), who was born in Aberdeen. Laing was trained as an architect in Aberdeen, and was in practice for some time before turning to water-colour. He painted landscape with some feeling, but his expert knowledge of architecture led him to take special interest in church interiors and city views. He frequently painted in Holland, and was greatly influenced by Bosboom and other Dutch artists with whom he came into personal contact. His *Haarlem Church*, 1904, *The Hour of Prayer in St. Jacques, Antwerp*, 1905, and *Interior of St. Maclou, Rouen*,[1] painted at about the same date as the other two, are good examples of his capable craftsmanship.

John Robertson Reid (1851–1926) was born in Edinburgh and, after studying in the R.S.A. Schools under Chalmers and McTaggart, went in 1881 to Cornwall, where he worked for twenty years before settling in London. Much of his work was in oil, but he produced many water-colours and was a member of the Royal Institute. His subjects were often found in Cornish harbours, with figures effectively placed in their native environment. He worked rather solidly, with great brilliance of lighting and force of colour. His landscape work was powerful and dramatic (three good examples are in the Victoria and Albert Museum), but in order to secure fullness of tone he was apt to overload his colour and to lose luminosity in his shadows, which are often unduly black. When his work is not too forced and clamorous he gives a noble rendering of sea and harbour or of trees and sky.

[1] Glasgow Corporation Art Gallery.

192

Henry Wright Kerr (1857–1936), born in Edinburgh, worked in a commercial firm at Leith, and then entered the R.S.A. Schools. He first attracted notice by little heads in water-colour, delicately handled, not unlike George Manson's in method but broader in touch. Like many artists of the Scottish School, he was strongly influenced by the work of Dutch water-colour painters, particularly by Israels, Maris and Mauve, and the influence, as in other cases, was strengthened by sketching trips to Holland. Many of his drawings, such as *The Kirk Collection*,[1] deal with Church life and the Scottish Sabbath, but technically he is at his best in his virile yet subtle studies of heads or single figures made for his larger drawings or his water-colour portraiture.

Another painter, even more obviously influenced by Israels, both as to manner and subject, was Robert Gemmell Hutchison (1855–1936), born in Edinburgh. His oil, *Bairnies, Cuddle doon*, which won him a gold medal at the Paris Salon, is a typical rendering of Scottish life, and in water-colour he touched similar subjects with good pictorial effect. He became a member of the R.S.W. in 1895, A.R.S.A. in 1901, and R.S.A. in 1911.

Sir David Murray (1849–1934), born in Glasgow, worked in a mercantile firm, studied at the Glasgow School of Art, and migrated to London in 1883. He was a man full of honours; he was elected associate of the Royal Scottish Academy in 1881 and an honorary member in 1919. He became an associate of the Royal Water-Colour Society in 1886, and at a time of stress during the Great War was induced by the Royal Institute to become its President in 1917. He was elected A.R.A. in 1891 and R.A. in 1905; and was knighted in 1918. Murray's best, certainly his most ambitious, efforts were in oil, but his water-colours were imbued with the same fine sense of colour and showed his intense appreciation of the sparkling aspects of Nature. He composed well, and with a sound knowledge of the growth and form of trees; his colour was opulent and richly varied; his immense admiration for Constable is, to some extent, reflected in his own work. His observation was so keen, and his memory so rich, that at times he was inclined to overstress colour and detail. In later years he worked mainly in body-colour and in tempera, often on a much larger scale than his subject demanded.

Murray was always eager to give help and encouragement to the young painter; he will still be remembered by some as a leader, a man with great social instinct, of strong character and powerful personality.

Robert Weir Allan (1851–1942) was born in Glasgow, but migrated from his native city to London, when about thirty. He became an associate of the Royal Water-Colour Society in 1887 and a member in 1896, remaining active almost till his death. What one best recalls of his work are subjects found in fishing-harbours along the Scottish coast, grey-green water, tanned sails, gulls flying. Sometimes the skies are lowering, and wild waves break over the harbour walls, casting spray across the sheltering smacks. But he painted much also in Holland, Belgium, France and Italy, recording quaint buildings,

[1] R.A. Scottish Exhibition, 1939, No. 647.

market-places and their crowds, with verve and brilliancy. His work is fresh and direct, but not without mannerism of technique. Visits to Japan and India gave full scope to his gay colour and record of character. He was perhaps unduly prone to tilt his paper and allow colour to run into little spots and blots like rain-drops hanging from the bough of a tree. In other hands the method has been overdone, though it certainly does emphasise the water side of water-colour.

His contemporary, Robert Little (1854–1944), was the son of a Greenock shipowner, educated at Glasgow University. He became a student at the R.S.A. Schools, from 1876 to 1881, worked at the British Academy in Rome, and under Dagan-Bouveret in Paris. In 1886 he was elected a member of the Scottish Water-Colour Society. In 1892 he became associate of the Royal Water-Colour Society in London, and full member in 1899; he held the office of Vice-President in 1913, and became an honorary retired member in 1933. Many of his subjects were found among the hill towns of Italy, and show great charm in his treatment of material which he knew and understood. Other themes were domestic, with such titles as *Renunciation* and *Yours faithfully*. His work is never very robust, but displays a pleasing romanticism of sentiment. Though he was a good designer, he resembled James Paterson in his liking for the softened contour and tenderness of tone. His work did not often stand out in an exhibition, but it always had a quiet distinction of its own.

Robert McGown Coventry (1855–1914), born in Glasgow, studied at the Glasgow School of Art and in Paris. He found his subjects among the western lochs and East Coast harbours of Scotland, in the market-places of old-world cities on the Continent, and specially along the water-ways of Holland and in Belgium. He was elected A.R.S.A. in 1906. Though he worked much in oil, water-colour was a sympathetic medium in his hands. His colour, at times a little patchy and spotty, was applied in a high key, and suggested atmospheric freshness and vibration. A typical work of his is *The Busy Corner, Anstruther*, belonging to the Glasgow Art Gallery.

Born in Aberdeen, James Cadenhead (1858–1927) worked in the school of the Royal Scottish Academy and then for two years under Carolus Duran in Paris. He became a member of the Scottish Water-Colour Society in 1893, A.R.S.A. in 1902, and R.S.A. in 1921. He was linked with members of the Glasgow School; his work was less traditional and conventional than that of the artists with whom we have been dealing and it is significant that he joined the New English Art Club when it was founded in 1886. Like many of the Glasgow artists he was strongly influenced by Japanese prints, and, as Sir James Caw[1] puts it, 'his work is largely founded upon combinations of decoratively coloured spaces, in favour of which light and shade, full modelling, and even true atmospheric effect are frequently suppressed or overlooked.' Into his later work, however, such as his *Lochnagar*,[2] he introduced a greater degree of realism.

[1] *Op. cit.*, p. 387.
[2] R.A. Scottish Art Exhibition, 1939, No. 669.

William Gibb (1839–1929), born in Laurieston, was the elder brother of Robert Gibb, R.S.A., who won fame by his painting of *The Thin Red Line* and other military themes. William was trained as a lithographer, and won a great reputation by his water-colour drawings in which he recorded, with meticulous skill and ingenuity, all kinds of precious relics, goldsmiths' work and objects of art generally. His water-colours are, in fact, the counterpart of Jacquemart's etchings in France; both of them had the same interests and the same cunning of execution. Even though Gibb's drawings possess prismatic clarity and hairbreadth precision, they cannot be called inspiring. The photograph and the coloured reproduction have killed this kind of art. Gibb had been working in London for some years when he died there.

I feel I should include here a reference to my uncle, Charles Martin Hardie (1858–1917), partly in order that the similarity of name should not cause confusion between his work and mine. Born in East Linton, he received his training in the Scottish Academy Life School. He was elected associate of the Royal Scottish Academy in 1886 and became Academician nine years later. His work was almost entirely in oil, and he won success and popularity by such pictures as *Burns in Edinburgh*, 1887, *The Meeting of Burns and Scott*, 1894 (I posed as model for the figure and colouring of young Walter Scott), and *The Unrecorded Coronation*, 1889; but in the earlier part of his career, while occupied with these pictures, he made many pleasant water-colour studies of Scottish landscape.

The very name of William McTaggart (1835–1910) reveals his Highland origin. He came of a race of small farmers and crofters in the southern part of Kintyre, and was born in Aros, where the Atlantic breaks upon the sands of Machrihanish. Those seas and sands made him a painter, as surely as the mills and trees and placid waters of the valley of the Stour, by his own statement, made Constable a painter.

After attending a school in Campbeltown, McTaggart became an apprentice apothecary in the dispensary of Dr. Buchanan. Encouraged by his master he read widely, and did some carving and modelling, besides making surreptitious portraits of waiting patients and local characters. Before he was seventeen, he was producing portraits in crayon, water-colour or oil at a price varying from 10s. 6d. to £3, and was determined that art should be his profession. With much bravery in his heart, and very little money in his pocket, undeterred by the doubts and fears of his family and the contempt of the Free Kirk Minister, who dismissed art as vanity and wickedness, 'a dravelin' trade', he enrolled himself as a student in the Trustees' Academy in Edinburgh in 1852.

For seven years McTaggart studied at the Trustees' Academy, then at its most notable epoch under the directorship of Robert Scott Lauder. Among his fellow students were W. Q. Orchardson, Hugh Cameron, Peter Graham, J. MacWhirter, George Paul Chalmers, Tom Graham and John Pettie—a brilliant group. In Edinburgh and in Dublin, where he was taken during a holiday by Captain Watt, the skipper of a steamer plying between Glasgow and Ireland, he obtained, every year, a steady flow of small commissions, and this 'pot-boiling portraiture', as he called it, enabled him to pay his school fees and even to

195

save a little money. He exhibited at the Royal Scottish Academy from 1853 onwards, and was elected an associate in 1859. His friendship with Sam Bough during the following years may have inspired McTaggart to make an increasing use of water-colour. McTaggart became a full member of the Academy in 1870.

McTaggart's biography has been well and fully written by his son-in-law, Sir James Caw,[1] late Director of the National Gallery of Scotland, and this book contains a full record of his life, much brilliant critical analysis, and a detailed list of his works, both in oil and water-colour. His work, in which he was far in advance of his period, was too little known outside of his native Scotland until the exhibition held at the Tate Gallery in the summer of 1935, to celebrate the centenary of his birth. In 1939 a full representation of his paintings in the Scottish Exhibition at the Royal Academy gave still better opportunity for the study of his work.

Once McTaggart's early struggles as a student were over, his career became one of growing achievement. His early work shows that he could render form, modelling, texture in close and imitative detail, but soon after 1870 he was giving a general impression of form and colour, swayed, altered, modified, unified, under the influence of light and weather. In his high pitch of brilliant colour, in his rendering of movement and the variations of light under the play of atmosphere, he was working in a way comparable with the French Impressionists. Although he knew nothing of the work of Monet, Pissarro, Renoir (it was not till the 'nineties that he saw his first Monet), in the decade in which the Impressionists were startling Paris McTaggart was attaining effects of the same kind in actual rendering of light, colour and movement under the direct inspiration of Nature. It interests me to recall that when, familiar with Scottish art, I first saw in later years the figures of Renoir, with their sensuous curves, their tossing movement, in lambent atmosphere, they recalled at once the figures of McTaggart. As was the case with the Impressionists of France, McTaggart's paintings are not 'emotion recollected in tranquillity' but an immediate record of emotion felt upon the spot. In his search for the high key and brilliance of open-air colour, for movement, for the dancing and shifting of light, he has been rivalled by no one in the British School except Turner. Even Turner has not excelled him in his knowledge of the swift movement, the scudding foam and spray, the changing light and colour of the sea, or in rendering simple aspects of nature, of cloud and wind, the glitter of sunlight, the sense of meadowland and water acting as a mirror to the sky. In his work man and nature are part of a cosmic whole.

Some critics have misgivings about his figures, which seem to them flimsy and fragile; they find children with apparently an unaccountable number of arms and legs. But if we look at McTaggart's early oil-paintings, such as *Dora* or *Spring* (both in the National Gallery of Scotland), we find that he could paint figures with Pre-Raphaelite exactness. *Dora*, painted in 1869, is of special interest because the foreground figures and flowers are

[1] Sir J. L. Caw, *William McTaggart, R.S.A., V.P.R.S.W.*, 1917.

196

like an early Millais in their close-wrought precision, whereas the background shows all the loose, airy impressionism, the study of light and atmosphere, which was to become his aim. It is a picture which bears out the truth of Samuel Palmer's dictum: 'The best artist, in some two points of his work, will give the extremes of the definite and the indefinite if he can, and the lesser intensities of both elsewhere.' And when he said that to Millais, he got the reply, 'The indefinite half is the more difficult of the two.' McTaggart's figures, then, in his later work are not just haphazard and careless; they are moving objects in the field of vision, part of the actual landscape. They are not painted with a central focus, as in his earlier *Spring* or as in the work of most other painters. They are alive and fluttering; swaying and tossing like the whin bushes or the corn or the waves against which they are set. McTaggart is in league with the air and the sunshine when he makes those children flicker in our sight. They are treated as part of nature's movement and nature's growth. Air and water, as well as children, can dance and glitter and play, and those are the qualities which will be found in *Whins in Bloom*,[1] 1881, and *Where the Burnie runs into the Sea*,[2] 1883.

Soon after 1870 McTaggart's matured practice in water-colour began to influence his oil-painting. In water-colour, rather than in oil paint, to quote Caw, 'he began to liberate his hand to express the sparkle and flicker of light, the purity and brilliance of colour, and the dancing and rhythmical motion', which marks all the work of his full maturity. *The Sunny Summer Shower*[3] is an example of this foreshadowing type, a brilliant presage of what was to follow.

In 1889 Alexander Dowell, the Edinburgh auctioneer, held a sale of what was described as *The McTaggart Portfolio*. It consisted of about 120 water-colours, comprehending the greater part of the water-colour drawings produced by the artist from 1857 to 1888. Those drawings, in part used as studies for oil-paintings, had been made entirely for his own use and pleasure; no artist had ever thought less of pleasing the public. The exhibition of these drawings before their sale gave an opportunity of studying the artist's progress and achievement during the first thirty years of his career, and the fact that the drawings realised over £4000, at the time an unprecedented amount for a sale of this kind, shows that as a water-colour painter, at any rate in his own native land, his position was accepted and assured. Sir James Caw catalogues less than thirty water-colours produced after the date of the Dowell Sale. From 1889 onwards the artist's main output was in oils, but he retained his interest in the Scottish Water-Colour Society, of which he was Vice-President from its foundation in 1878.

It need hardly be said that McTaggart's water-colours were outdoor sketches, done in a *premier coup* method. The figure incident was usually with charcoal, and the space of untouched paper left for later treatment in his studio. He worked, as a rule, on thick,

[1] Edinburgh, National Gallery of Scotland D.(NG)1650.
[2] Edinburgh, National Gallery of Scotland D.(NG)1736.
[3] Once Coll. Sir James Caw.

197

rough-surface Whatman paper, imperial or half-imperial in size. The paper was held down merely by the thin metal frame attached to his sketching folio, and using a light easel, he stood to his work. His method allowed of no second thoughts, no joining up of separate passages, except for the completion of figures. He was wise in using paper of a size which allowed the brush to sweep from one edge to the other. When he wanted a bigger scale, fuller and deeper tones, he turned to oils. The smaller scale for water-colour allowed all that lightness and fluidity of touch, all that brilliance and bloom and sparkling transparency from which his water-colour art, indeed all great water-colour art, derives its distinctive power and fascination.

McTaggart usually worked with fresh washes laid swimmingly with a big brush and modulated in colour and tone while the paper was still wet. As a rule he used water-colour as transparent pigment; his highlights are usually given by the untouched paper; but occasionally, and more often in his earlier work, he introduced body-colour, partly because it gave him a smoother surface and a different quality of white from that of the paper. In *The Moor beside the Sea*,[1] which he gave as a wedding present to my mother in 1875, Chinese White has been used freely in the sky, and sparingly in the foreground. Very much later, *Where St. Columba Landed*,[2] painted in 1904, shows free use of Chinese White. Frequently McTaggart made splendid use of his rough paper by passing the brush so deftly and flexibly across the surface that the sparkle of white shone through from all the hollows of the texture. Caw tells us that: 'His favourite brush was an eagle sable mounted in a quill. Indeed, he never used more than one, and most of his water-colours were painted with a single brush which he had for twenty-five years, and which was "better than ever", he said when he lost it.' Few painters have been less dependent upon a variety of colours. When he was painting at Machrihanish in 1907, his oil palette was set with only cobalt, lemon yellow, rose madder, vermilion, yellow ochre, raw sienna, besides flake white and ivory black. This limited range, and the fact that his work was usually finished on one day, may account for the fact that his oil-paintings have preserved their first freshness and brilliance, whereas the work of Manet, Monet and Renoir has darkened, becoming brownish in the violet shadows, what J. E. Blanche in his *David à Degas* describes as *plombé*. I am sure that McTaggart's water-colour palette was just as restricted.

Throughout Caw's biography of McTaggart there are constant references to John Pettie, R.A. (1839–1893), his fellow-student, lifelong friend and sincere admirer. In the list of Pettie's works there will be found but few water-colour drawings. Only on rare occasions did he make use of water-colours. Sometimes he used water-colour for a rapid sketch when the idea came to him for a picture, such as those for *The Tiff* and *Two Strings to her Bow*. The oil-painting of the latter belongs to the Corporation Art Gallery, Glasgow, and his light and free use of water-colour in the small sketch (once in the possession of Mr. Charles

[1] Once in the author's collection.
[2] Once Coll. Sir James Caw.

198

Winn) shows a power which he never himself realised. 'Life's too short, and my fist's too clumsy', he once remarked, when urged to use water-colour more.

Both Pettie and McWhirter are included in this chapter not for the character of their work but because of their warm friendship and close personal association with McTaggart. John McWhirter (1839–1911) was born at Slateford, near Edinburgh, the same year as Pettie. His father, a paper manufacturer at Colinton, died when his son was eleven, and the boy was apprenticed at the age of thirteen to Oliver and Boyd, booksellers in Edinburgh. He left this employment after five months and entered the Trustees' Academy, where he worked in close friendship with Pettie, Orchardson and McTaggart. He was elected an associate of the Royal Scottish Academy in 1867. In 1869 he settled in London, won great favour by his oil-paintings of scenes in his native Highlands and in Switzerland, became an associate of the Royal Academy in 1879 and a full member in 1893. The Scottish Academy made him an honorary member in 1882. In 1901 he published *Landscape Painting in Water Colours*.

Though best known as a painter in oil, McWhirter did much work in water-colour, especially upon foreign tours in France, Switzerland and Italy. He also visited Sicily, Austria, Turkey, Norway and the United States. Some of his early work is strong and direct. This applies, for instance, to drawings which he made as a member of a Sketching Club of Scottish artists in London, who from about 1870 to 1885 used to hold evening meetings in one or the other's studio.[1] The subject was usually indicated in a single word— 'Joy', 'Sorrow', 'Destruction', 'Frolic', 'Childhood' and the time allowed was an hour to an hour and a half. A water-colour made by McWhirter under these conditions, *Destruction*,[2] depicts a burning castle—the dark mass of ruins, the withered trees, and the red glare in the sky making a fine piece of composition and harmonious colouring. In later years he was apt to be somewhat meretricious and mannered. He dealt always with beautiful material—too much search for the beauty-spot all over the world was perhaps his failing— but he painted his subject with the sympathy and clarity which appeal to many who find more imaginative and interpretative art a stumbling-block. To say that is not to gainsay the deftness and charm of much of his water-colour work, done in happy and holiday mood. He himself told me how, in his younger days, Ruskin encouraged him to make precise, almost miniature water-colours of flowers; and that teaching, no doubt, was the root of *June in the Austrian Tyrol*[3] and similar pictures.

I have spoken of McTaggart as an Impressionist. Arthur Melville also is an Impressionist, but what he conveys—by quite different means—is the heat and glamour of the East, the movement of motley crowds in white-walled courts and mysterious bazaars, instead of the chill winds and tossing waves of the Scottish coast. His staccato effects are quite different from McTaggart's quiet and subtle symphonies. Arthur Melville (1855–1904) was born

[1] M. Hardie, 'A Sketching Club', *The Artist*, XXXIII, January 1902.
[2] Present whereabouts unknown.
[3] Tate Gallery 1571.

of humble parentage at Loanhead-of-Guthrie, Forfarshire. He was still a small boy when his family moved to East Linton, where he obtained some schooling and was apprenticed to the local grocer. The lad was haunted from early life by 'the vision and the dream'. Fascinated, engrossed and spellbound by the idea of Art, at the age of twenty, Melville entered the Schools of the Royal Scottish Academy. His first exhibit in the Scottish Academy was in 1875, and was followed by others, all oil-paintings, somewhat dull and over-elaborated. But he won enough support to enable him, in 1878, to study in Paris; and in France he began to find that water-colour was an appropriate instrument for the production of full tones. His *Interior of a Turkish Bath*,[1] painted in Paris in 1881, shows that his method of water-colour, however much it ripened with experience, was already developed, already a highly individual form of expression. It was in 1881 that he made for Egypt in search of romantic colour, and found his way by Suez and Aden to Karachi—then on up the Persian Gulf to Baghdad. From here, a nomad in the company of travelling caravans, he rode across Asia to the Black Sea, where he took steamer to Constantinople. The journey occupied two years, during which Melville finished many water-colours and made numerous studies which were to produce fruit in later years. Belonging to this period are such noteworthy works as *The Sortie*[2]; *The Call to Prayer, Bagdad*[3]; *The Snake Charmer*[4]; and many others.

In 1884 he was back in Scotland, in the midst of the movement started by the 'Glasgow School'. He has been claimed as the pioneer, or originator of the movement, but, on the other hand, certain Glaswegians have disclaimed or minimised, not his talent or genius, but his influence with the original group and its development.[5] Both views were right and wrong: the movement was well on its way when Melville appeared upon the scene. He came, however, as a mature artist, a man of exceptionally strong personality and driving force. His impact upon the movement helped to accentuate and to some extent mould it. The force, distinction and superb colour of his work must have influenced his Glasgow contemporaries, as it was to influence many others later. He became an associate of the Royal Scottish Academy in 1886, and of the Royal Water-Colour Society in 1889, about which time he settled in London. A Memorial Exhibition of his work was held in 1906 at the Galleries of the Royal Institute, 99, Piccadilly.

From 1881 Melville was painting the East, its pageantry and romance, sunlight, heat, dust and crowds, mystery; but he found similar effects upon the Mediterranean littoral, in Spain, Morocco and Italy, in the bull-ring, the crowded market-place, on the canal, wherever he found scenes of vivid life, and of colour in motion. After Baghdad, it was Spain and Morocco that gave him the best of what he enjoyed. In his *Ronda Fair*[6] how well he renders the sultry heat of Spain, the dust that envelopes the long street disappearing into the distant haze. His *Bravo, Toro*[7] (Pl. 233) at first appears a mere mass of blots, blobs and

[1–4] Present whereabouts of these drawings is unknown, but see 'A. Melville's Exhibits', O.W.S. Club 1923, pp. 46–59. [5] Caw, *op. cit.*, p. 394. [6] Liverpool, Walker Art Gallery. [7] V.A.M. D.143–1906.

dashes of pure colour, a patchwork brilliant in its intensity. From a distance it gradually takes form, and resolves itself into a marvellous presentment of a Spanish bull-ring, of crowds of brightly-clad spectators, of mantillas and fluttering fans, of daring toreadors and a maddened bull, of movement and excitement in the dust and dazzling sunshine. Melville is painting not banderilleros and picador and bull, but their movement; not individual spectators, but an animated, sweltering crowd; not merely the bull-ring at Madrid, but the heart of Spain. Typical again in its rendering not merely of local colour but of heat and clamour and movement is his *Moorish Procession*,[1] painted in 1893 at Tangier. *The Captured Spy*[2] again shows the heat and glitter of the East, with all the richness of motley-coloured costume, set against the arid brightness of sandy soil and white-walled buildings. There is a similar effect in *Waiting for the Sultan*,[3] and it is extraordinary how with just a blot of colour dropped from a wet brush Melville could express a swarthy face, the fold of a robe or the branch of a tree.

In Melville's case, as with Rossetti and with Brabazon, we find colour used not so much in conjunction with form as for its own quality as a stimulus or attraction to the senses. Colour indeed sometimes appears as colour itself, not as a coloured form or object.

And all of that brings us to his means of achievement, that strange technique which was so entirely his own invention. It was described to me, many years ago, by Theodore Roussel, himself a fine painter and etcher, who married Melville's widow. Melville's method was pure water-colour, but water-colour applied on a specially prepared paper. This paper was soaked in diluted Chinese White, till it was literally saturated and impregnated with white. He worked often into a wet surface, sponging out superfluous detail, running in those warm browns and rich blues and reds which he knew so well how to blend and simplify. His colour was often dropped on the paper in rich, full spots or blobs rather than applied with any definite brush-marks. The colour floats into little pools, with the white of the ground softening each touch. He was the most exact of craftsmen; his work is not haphazard and accidental, as might be rashly thought. Those blots in his drawings, which seem meaningless, disorderly and chaotic, are actually organised with the utmost care to lead the way to the foreseen result. Often he would put a glass over his picture and try the effect of spots of different colour on the glass before applying them to the surface of his paper. Melville knew his job as a water-colour painter and had an intuitive skill for using vital and scintillating spots of colour to express the dominating accents of scene or incident. As Sir James Caw[4] has said: 'He made out objects more by what surrounds them than by rendering constructive form.' And Romilly Fedden,[5] who was largely akin to Melville in his own methods, writes: 'When we look at a Melville water-colour, we are at once impressed by what in painting we understand as *quality*—beautiful paint, beautifully

[1] Edinburgh, National Gallery of Scotland D.(NG)947.
[2] Glasgow Art Gallery.
[3] Edinburgh, National Gallery of Scotland D.(NG)1485.
[4] *Op. cit.*, p. 397.
[5] R. Fedden, *Arthur Melville, R.W.S.*, O.W.S. Club, I, 1923–4, p. 41.

handled, the perfect juxtaposition of the lost and found edge, that *mat* texture which is exclusively the property of water-colour and which at the same time can be transparent and sparkling.'

Melville's outstanding personality and brilliant technical powers have exercised a profound influence upon other water-colour painters who, like Romilly Fedden and Brabazon, at some stage of their work, have fallen under his spell. But one contact with him was dramatic, almost volcanic, in its results. In 1892, Frank Brangwyn made a tour through Spain in the company of Melville, twelve years older than himself. Hitherto Brangwyn had painted grey, low-toned, sea-pictures such as *The Burial at Sea* in the Glasgow Gallery. He came back to paint *The Buccaneers*, first of a series where glowing brilliance of colour is used as a pattern of separate notes and masses. The mosaic of blots of rich colour, the deliberate decorative planning, which we find in Melville's water-colours, became on a larger scale an integral part of Brangwyn's work in oil.

On his contemporaries and on later painters in Scotland his influence is again obvious. Perhaps his closest follower was James Waterson Herald (1859–1914) working in the manner of Melville but in a lower key, and with less vivacity of colour. His drawings are remarkable for their truth of tone and their fluent washes, treated with a sense of decoration which is sometimes Japanese in its correctness. He made a cunning use of blots like Melville, and had the rare knack of so applying his colour as to make it seem wet and luminous even when dry. Like many other members of the Scottish School, he was not specially concerned with significance of form, and if he gave detail it was only to corroborate the effect of his impression. He was at his best in water-colours of harbour scenes at Arbroath such as *Brown Sails in a Scottish Harbour*.[1] In these pictures of the interplay of light and shadow harmoniously enveloping brown-sailed smacks, cottages and dancing waters he conveyed not so much the actuality of the scene as the romantic recollection of it. Herald spent ten years in London; then from 1901 lived and died at Arbroath, something of a recluse, in poor circumstances. His work is limited in amount and little-known.

Linked up in many ways with Melville, by their adherence to the Glasgow School and by their common idea that the primal quality in painting as in Nature is fullness and richness of tone, are W. Y. Macgregor and James Paterson. William York Macgregor (1855–1923), who has been described as 'father of the Glasgow School', was born in the same year as Melville, at Finnart, Loch Goil, and studied for a time under Legros at the Slade School in London. Perhaps it was from this source that he imbibed the stylistic tendencies, with inspiration from Claude and Poussin in the background, which were to influence his whole art in later years. In water-colour, as in oil, he aimed at a large balance of design, expressed with bold vigour and firmness of drawing and brushwork. His *Ludlow*[2] is a typical example. In water-colour he liked the solidity given by a firm basis of charcoal drawing.

[1] Once in author's coll.
[2] R.A. Scottish Art Exhibition, 1939, No. 628.

202

At times he was too consciously stylistic, but where his personal sentiment for landscape was concerned, he attained in a high degree both pleasing pattern and pastoral charm.

Like his friend Macgregor, James Paterson (1854–1932), born a year before him in Glasgow, was a painter of effects rather than facts. Both were akin to Melville in preferring the blurred edge to the clean-cut line; they liked to look upon things a little out of focus. Both of them were more interested in the poetic effect of colours, rather than the facts of structure. After studying in Paris under J. P. Laurens, Paterson returned to Glasgow in 1882 and became a member of the Glasgow School, being in close contact with Guthrie, Crawhall and Henry, as well as with Macgregor. On his marriage in 1884 he settled near the Dumfries village of Moniaive, where he found landscape of moor, sloping hills, woodland and river, peculiarly suited to his taste. A noteworthy example is his *Craigdarroch Water, Moniaive*. [1] In this neighbourhood he continued to work with the broad and powerful method adopted by the Glasgow School, and at the same time was cultivating the sense of decorative design which was characteristic of the movement. He was elected an associate of the Scottish Water-Colour Society in 1884; became a member of the New English Art Club, then recently founded in London, in 1885; was elected associate of the Royal Water-Colour Society in 1898, and full member in 1908. In 1922 he succeeded E. A. Walton as President of the Royal Scottish Society of Painters in Water-Colour.

Though Paterson remained faithful to Moniaive, from 1898 Edinburgh, its castle, its old grey city, its surrounding hills, became the most immediate source of his pictorial inspiration. A typical example is his *Edinburgh from Calton Hill*. But he found subjects in the Western Isles, in Iona and Skye (e.g. *The Corrie, Isle of Skye*), besides making visits to the south and east of England, France, Italy and Corsica (e.g. *Evisa, Corsica*, and many drawings made at Corte and Ajaccio). In his later work he was using more and more a wet method, of running colour, softened edges and accenting blots, generalising form, more broadly, but with a tendency to romance in colour and design, which became sometimes a little overpowering and dangerously dramatic. He was unduly prone, in his later years especially, to lose the surface bloom of direct washes and to rub down, sponge out and retouch his work in his endeavour to secure the fullness of decorative effect which was his ultimate aim. His purpose can perhaps be best described in the reported words of a lecture, *A Talk about Landscape*, given by him at Glasgow. 'Absolute truth to nature was impossible. A selection from and suggestion of the tones and tints and forms which we saw in the landscape was the only course open to the painter. What might be called decoration was an essential quality of every real work of art. The forms, tones and colours must be agreeable to the educated human eye, and only so far as nature suggested these to him could he follow her. It thus arose that in nearly all the greatest examples of landscape art there was a distinct departure from the actual facts of nature, a departure wilful and necessary, and not accidental and culpable.'

[1] Caw, *op. cit.*, pl. 63.

Closely associated with the Glasgow School was Joseph Crawhall (1861–1913), born at Morpeth. From 1877 to 1879 he was at King's College School, London, where the drawing-master at the time was P. H. Delamotte, F.S.A., possibly a son of William Delamotte.[1] Though Crawhall was a Northumbrian by birth he had a Scottish mother, and his early associations were all Scottish. On that account he may be fairly ranked among Scottish painters, as Whistler and Sargent may be reckoned as members of the British School. He was given a prominent place in the Exhibition of Scottish Art held at the Royal Academy in 1939; he chose Scotland for his early life, and Scotland has adopted him. Before he was twenty, Crawhall was working at Brig o'Turk with James Guthrie, E. A. Walton and George Henry, founders of the Glasgow School; and in 1882 he spent a summer with Guthrie at Crowland in Lincolnshire. His only contribution to the Royal Academy was *A Lincolnshire Pasture*, 1883. Though there are naturally distinct differences in the work of members of this group, they had a common aim in the pursuit of true tonal relationships and of values in colour; they sought technical qualities rather than appeal of subject; and they gave a high place to decorative elements in design. The main note in Crawhall's work is his distinction of pattern, his harmony of pictorial result, his refinement of tone. He developed a method of swift brush drawings more in the style of Chinese and Japanese artists than in a manner usual in the West. His wash drawings of *Donkeys*[2] has close affinity, in its directness and simplicity of flat pattern, with the old calligraphic art of China.

Almost all that need be said about Crawhall is written in a brilliant essay entitled *Creeps* (so Crawhall was known by his friends) by R. B. Cunningham Graham.[3] He tells of Crawhall's adventures, or misadventures, at Tangier, where he spent much of his later life, and pictures him in his riding-breeches and dog-skin gloves looking, like Phil May, the second whip to a pack of hounds rather than a great artist and man of genius. Cunningham Graham links him with the great draughtsmen of the caves of Altamira, and describes his uncanny observation, his power of memorising animals and their movement, his supreme skill in limning their line and shape. 'Creeps', he says, 'suffered no pangs of parturition, and I remember once when someone said all art was difficult he answered simply, without a trace of boastfulness, "No, not at all." He never strove after originality, but painted as a bird sings, without a thought of the effect it makes. That was the reason, probably, that all he did was original.'

Sir John Lavery, who considered that Crawhall was the artist to whom the Glasgow School owed its greatest distinction, was an intimate friend and draws a similar picture.[4] 'In appearance—except for his eyes, which were a very deep brown and unusually intelligent—he might have been taken for a whipper-in. He had a long sallow face like

[1] S. T. Shovelton, Registrar of King's College, has supplied information that drawing-masters at King's College School were John Sell Cotman, from 1834 to 1842; Miles E. Cotman, 1842 to 1851; Henry Worsley, 1851 to 1855; P. H. Delamotte (in the King's College records spelt De La Motte), 1855 to 1879.
[2] V.A.M. P.22–1926.
[3] R. B. Cunningham Graham, *Writ in Sand*, 1932.
[4] J. Lavery, *The Life of a Painter*, 1940, Chap. VII.

204

that of a North American Indian, and rarely spoke unless he had something to say. Graham nicknamed him "The Great Silence", but he had acute observation and a ready wit on occasion. Usually, however, his pencil was to him what the tongue is to the other men.' That his tongue could be mordant is shown in Lavery's tale that he once drew Crawhall's attention to a drawing by Conder; and all that Crawhall said was: 'Umph. Whisky and Watteau!' Of his work Lavery says: 'In a few lines he could sketch an animal making it more recognisable than the most candid camera could do—and from memory. If he did a pack of hounds, the huntsman would be able to recognise every single one, even when it was only indicated in half a dozen marks on the linen or paper he happened to be working on.'

No one ever produced a rabbit out of a paint-box with such convincing legerdemain as Crawhall. Crawhall made and tore up scores of drawings throughout his life, even many of those done to amuse Lavery's young daughter.[1] Rigorous in his self-censorship, he allowed the world to see only what he felt had achieved some quality of permanent value.

Crawhall's father, Joseph Crawhall senior, a Yorkshire squire, was the chief purveyor of the subjects and legends for Charles Keene's *Punch* drawings. Keene's Yorkshire friend was apparently a painter of admirable landscapes and had learned lithography from its inventor, Senefelder. He had album after album of jokes written or collected by himself, so that Keene and Crawhall became almost a firm working for *Punch* and the delight of the public. For a long time Keene exchanged his sketches for Crawhall's legends or north-country landscapes. Young Joseph Crawhall (he signed himself *Jos. Crawhall, Jnr.* so long as his father was alive) was brought up in an atmosphere of art, and, surrounded by Keene's sketches, must have been profoundly influenced by the art of one of the greatest of British draughtsmen. A pen-and-wash drawing by Keene of Lord Suffield on horseback[2] contains the essence of Crawhall's art; it might almost be mistaken for his work. And the young artist, up in the north country, a frequenter of the race-course, the hunting field, the horse-fair, saw Keene subjects on every side. Horses, dogs, animals, birds, were to remain as his source of inspiration.

Keene's outlook and superb draughtsmanship in line and wash were to remain the basis of Crawhall's work; but superimposed upon that were the tenets of the Glasgow School and, above all, the sense of decorative design derived largely from the art of Japan. One sweeping touch of his brush, with endless thought and infinite practice behind it, can produce the most subtle suggestion of form and volume. Crawhall's only real teaching came from his father, who insisted upon his drawing from memory exclusively and would never allow any correction or erasure to be made. He did go to Paris for a time to study under Aimé Morot, but it was teaching entirely at variance with his early training. Crawhall's methods were in far more sympathetic alliance with those of Lecoq de Boisdaubran, the advocate and apostle of memory-drawing.

[1] Examples of these are in the Print Room of the B.M. 1964.2.8.8–11 (pl. 238).
[2] F. L. Emanuel, *Charles Keene*, Print Collectors' Club, 1938, XIV, pl. XI.

Crawhall held a one-man show of his work in 1894 at Alexander Reid's Galleries in Glasgow, but the first notable exhibition of his work took place in 1912 at W. B. Paterson's Gallery, 5, Old Bond Street. It comprised fifty drawings, on loan from shrewd collectors, for Crawhall's work was always sought privately rather than allowed to go for sale in public exhibitions. His pictures were usually bought by such Scottish collectors as Sir William Burrell and Mr. W. A. Coats. He belonged to the International Society for a time, and in 1909 joined the New English Art Club. His irregular habits of work and the persistence with which he destroyed his drawings made his output very limited. Several of the drawings exhibited at Paterson's Gallery appeared again in the Scottish Art Exhibition at Burlington House in 1939, where he was represented by fourteen chosen works. His superbly summarised method of drawing animals, with brilliant memorisation, was shown in *Casting Hounds*[1] and *Four-in-Hand*[2], whose original more lively title was *The Flea-Bitten Grey*. In *The Aviary, Clifton*,[3] an earlier water-colour made in 1888, he displays the sense of rich colour which is inherent in Scottish painting, as in the Scottish language. He was still young, still close to the Glasgow School, when he painted thus brilliantly, but in his later work the colour is far more subtle, with finer feeling for quality of tone, as is seen in his *Performing Dogs*[4] of 1894, when he had arrived at his full power of forceful draughtsmanship and intense vitality. So it was with his *Bull Fight*[5] (Bury, Pl. 42)—the essence, as it were, being extracted from this scene of a picador inciting the bull, and realised with summary strokes of the brush. Each drawing by him seems to be so swift and sure—a fence and a ditch taken at an easy stride on a galloping horse. And then there are his inimitable drawings of birds and animals, *The Spangled Cock*[6] (1903) (Bury, Pl. 52), *The White Drake*,[7] *The Black Cock*[8] (Bury, Pl. 28), *The Jackdaw*[9] (Bury, Pl. 33), *The Black Rabbit*,[10] all of them painted on silk or linen[11] and set down with emphatic vigour of patterning and yet with a liquid sense of surrounding atmosphere. Each has the finality of purpose and execution which mark a great work of art.

In his later years Crawhall bought a house at Brandsby, fourteen miles due north of York, and lived there with his mother and sister. Sir Walter Russell, who was a frequent visitor at Brandsby, described Crawhall as of an essentially easy-going and inactive disposition. He would spend carefree workless weeks, and then in a frenzy of creation would shut himself up in the room at the top of the house which served as his unpretentious studio. Meals and sleep were disregarded; the outer world meant nothing to him; friends were forgotten; he was totally absorbed in his art. Russell recalled him as being a very rapid

[1] Coll. Mr. L. Harper-Gow. [2] Glasgow Museum.
[3] The Burrell Coll., Glasgow Museum.
[4] The Burrell Coll., Glasgow Museum.
[5] Coll. Mr. J. E. C. Wood; A. Bury, *Joseph Crawhall*, 1958.
[6] Coll. Sir John Craik Henderson. [7] Coll. Mr. T. H. Coats.
[8] The Burrell Coll., Glasgow Museum.
[9] Melbourne, National Gallery of Victoria.
[10] Present whereabouts unknown.
[11] It is possible that Crawhall sized the linen or silk on which so much of his work was done. For difficulties and problems connected with painting upon fabric, see F. G. Morris, 'Bird Painting in Water-Colours', *The Artist*, 1941.

206

worker and never saw him using a model when he painted man, bird or beast. Everything he drew or painted took form as the result of intense observation and amazing memory. He saw his subject, not factually, but with the eye of his mind. He had, in a way, to forget before he could record. He was not imitating lines and colours and patterns from an object before his eyes; he was depicting (in much the same way as Max Beerbohm depicts in his caricatures) an image which had been conceived in the recesses of his own brain and re-moulded with his own very personal sense of pattern and colour. That was the impression which he gave to Sir Walter Russell, who in 1910 or 1911 painted the portrait of Crawhall, which was acquired later by the Scottish Modern Arts Association.

With reference to the Brandsby days, Lavery tells us that though Crawhall mixed very little with the neighbouring families, they appreciated his work highly and used to circulate among themselves such pictures as they possessed, each keeping one for a few months at a time. It may be added that not every drawing purporting to be by Crawhall and to come from a Yorkshire house is an indisputable work of his own hand. Some drawings may be by his father; some are fraudulent imitations.

Crawhall died in a London hospital from emphysema, cut off at the height of his power; and was buried at Rothbury.

Edwin Alexander (1870–1926), son of Robert Alexander, R.S.A., was born at Edinburgh. From his boyhood he took special interest in flowers and acquired a real knowledge of botany, which, with his knowledge of the habits and plumage of birds served him as the foundation of his later art. At the age of seventeen he went for a long holiday to Tangier in the company of his father and Joseph Crawhall, then aged twenty-six. His boyhood interest in botany and birds, combined with the influence and example of Crawhall, undoubtedly determined his whole career as an artist. In the years that followed, he made many bird studies in water-colour, and in 1891 was a student under Fremiet in Paris. From 1892 to 1896 he spent much of his time in or near Cairo, under canvas in the desert or in a houseboat on the Nile. Desert studies, in which camels constantly figure, form an important side of his work. It was always with the desert that he was concerned and not, like Melville, with the spectacular aspect of the East and the motley coloured crowds of market or mosque, or like others with the lurid, passionate purple and gold of an Egyptian sunset. His draughtsmanship applied to camels and Arabs is superb; his colour is sparingly used with a quiet harmony of greys and buffs, which expresses the very spirit of these drab and dusty regions. *The Ship of the Desert*, belonging to the Scottish Modern Arts Association, is a perfect example of this side of his art.

In 1904 Alexander married, and took his bride to their first home at Shepherd's House, Inveresk, where she found herself endowed not only with a *ménage*, but a menagerie. The tumble-down outhouses and stables contained not merely ordinary fowls and farmyard animals, goats, kids and turkey-cocks, but peacocks, twenty varieties of sea-gulls and at one time a nine-foot python. Here, Alexander made innumerable studies of birds, animals, flowers and gentle landscapes. He became an associate of the Royal Scottish Academy in

1902 and a full member in 1913; a member of the Royal Scottish Water-Colour Society in 1911; in 1899 he had been elected associate of the Royal Society of Painters in Water-Colours in London, attaining full membership in 1910. He died at Musselburgh.

Alexander's work, influenced by the decorative aims of the Glasgow School, was founded on a sense of pattern, linear rather than tonal in essence, and expressed with exceptional power of draughtsmanship. His delicate and constructive drawing of feathers would have charmed Dürer or Ruskin, but while true to details he never missed the significance of their relation to their surroundings. Japanese art is an obvious influence of the spirit rather than the letter. He had a true craftsman's care for perfection of technique, an infinite capacity for taking pains, but less natural genius than Crawhall. Many of his finest water-colours were painted on a fabric, silk or linen, or on various textured papers, particularly grey packing-paper. His *Magpie*[1] of 1897 is on silk. The use of a fabric or of grey paper compelled the free employment of body-colour, but it is body-colour utilised in unobtrusive washes and with the greatest discretion. His colour, used for subtle nuances of form, contour and texture in birds and flowers, is delicate and refined. Very charming, and wrought with a rare refinement of vision, are his little drawings of wayside flowers and seeded grasses, painted with great delicacy of touch.

In the exhibition of Scottish Art at Burlington House in 1939 Alexander was represented by nine chosen examples of his work. *The Belgian Hare*,[2] painted on linen when the artist was twenty-seven, is an example of superb observation and meticulous feeling for detail—the eye and the modelling of the head are masterly. His *Dead Peacock*,[3] again on linen, is over six feet in width. No water-colour paper is made to that size, and if we except Chinese and Japanese scrolls this is, apart from cartoons by Burne-Jones, probably the largest single work in water-colour ever produced. It is an astounding tour-de-force, both in the rendering of the tangled, sweeping mass of plumage and in its colour where greys and browns mingle with touches of iridescent green and blue. Work of the same quality, on a smaller scale, is shown in the *Dead Heron*,[4] his diploma work for the Royal Society of Painters in Water-Colours.

Alexander is known generally as a painter of birds and animals, but his much rarer work in pure landscape has a refinement and charm which, I believe, will be rediscovered. On exhibition walls his landscapes, wrought in muted tones of rare distinction, entirely failed to hold their own in mixed company among works of full tone and rich colour. In his outdoor studies, of camels in the Egyptian desert, of river and mountain in his native land —in Iona, at Kirkcudbright, on Holy Isle, and nearer his home at Gullane and Longniddry—there was the same unerring selection of the significant in form and in essential structure as in his studies of birds and flowers. 'In his landscape', as James Paterson[5] wrote

[1] Kirkcaldy, Museum and Art Gallery.
[2] R.A. Scottish Art Exhibition, No. 624.
[3] R.A. Scottish Art Exhibition, No. 620.
[4] Repro. in colour O.W.S. Club, IV, p. 53
[5] J. Paterson, *Edwin Alexander*, O.W.S. Club, IV, 1926–7, p. 60.

201 'Castle in mountainous landscape'
B.M. 1872-10-12-3335 (LB 3) $9\frac{3}{8} \times 11\frac{7}{8}$: 238 × 302 *Water-colour*
Robert ADAM (1728–1792)

202 'The Earring'
B.M. 1910.2.12.291 $8\frac{1}{8} \times 6\frac{1}{4}$: 206 × 161
Pen, ink and water-colour, signed and dated 1832
Sir David WILKIE, R.A. (1785–1841)

203 'Fifeshire'
Coll. Mr & Mrs Paul Mellon 5 × 7: 126 × 178
Water-colour
Sir David WILKIE, R.A. (1785–1841)

204 'Nude Study'
B.M. 1885.7.11.302 (LB 11) 13×9: 330×228
Water-colour
Sir David WILKIE, R.A. (1785-1841)

205 'Storm over a gorge'
Coll. Mr & Mrs Paul Mellon $15\frac{1}{8} \times 20$: 384×508 *Water-colour*
Hugh William WILLIAMS (1773–1829)

206 'Battersea Fields, painted for Charles Matthews'
Coll. Mr & Mrs Paul Mellon 5½ × 9¼: 140 × 235 *Water-colour*
Patrick NASMYTH (1787—1831)

207 'View in North Wales'
B.M. 1882.8.12.551 (LB 3) 5⅜ × 8½: 136 × 216 *Water-colour*
Alexander NASMYTH (1758–1840)

208 'Bruges Cathedral'

B.M. 1900.8.24.533 (LB 4) $15\frac{1}{2} \times 10\frac{1}{4}$: 392 × 261 *Water-colour*

David ROBERTS (1796–1864)

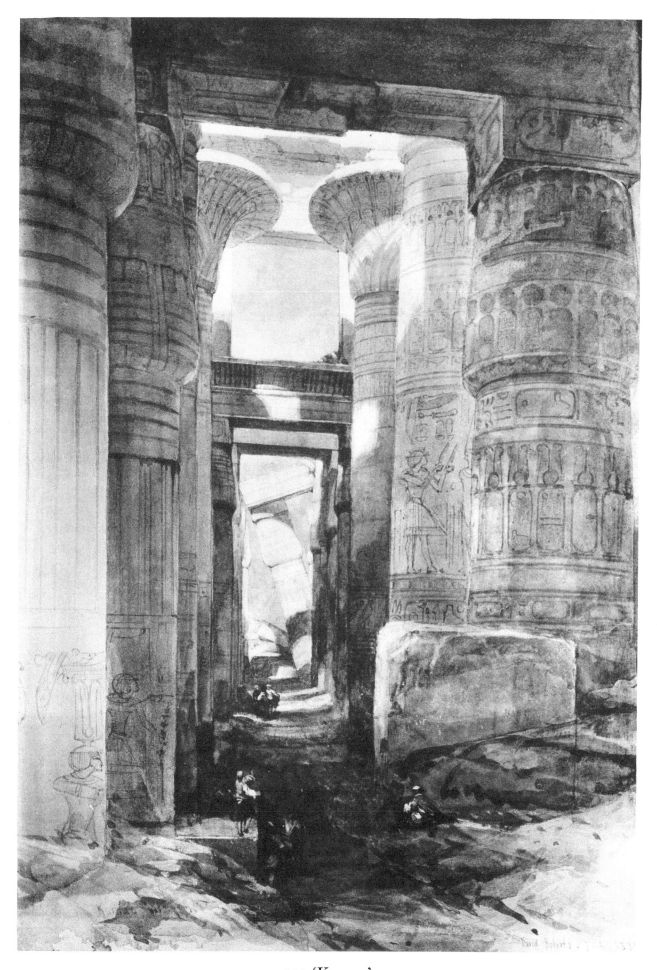

209 'Karnac'

Coll. Mr & Mrs Paul Mellon 19¼ × 13: 490 × 330 *Water-colour, signed and dated 1838*

David ROBERTS (1796–1864)

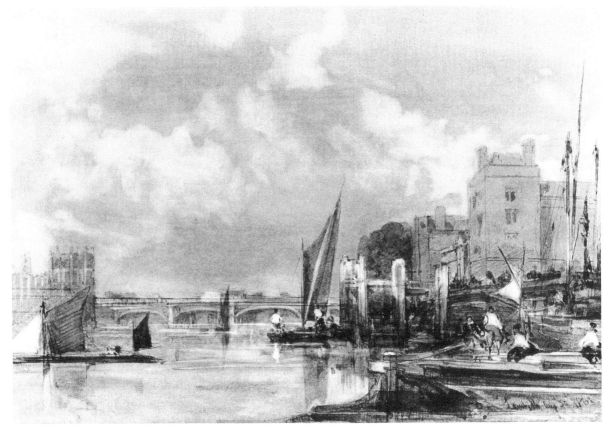

210 'Lambeth'

Coll. Mr & Mrs Paul Mellon 9 × 13⅜: 229 × 345 *Water-colour, signed and dated 1861*

David ROBERTS (1796–1864)

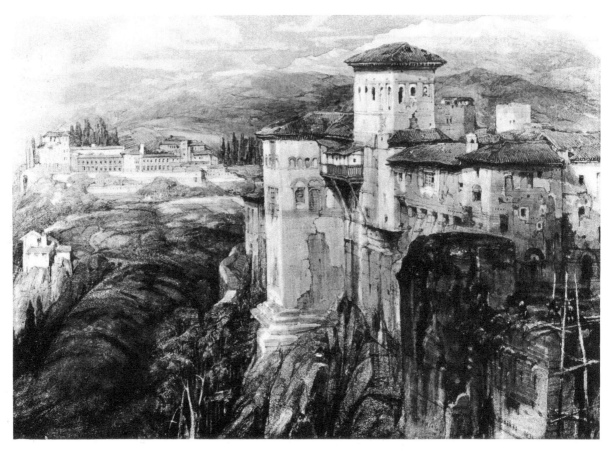

211 'The Alhambra 1834'

Once in coll. Mrs Bateson, West Chiltington 9 × 12⅞: 229 × 327 *Water-colour*

David ROBERTS (1796–1864)

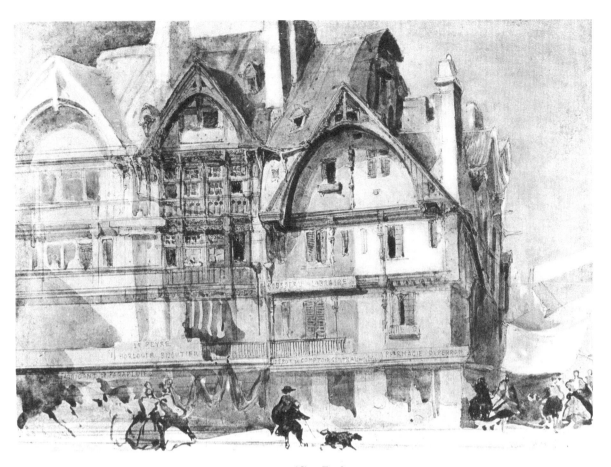

212 'St. Lo'

Coll. Mr & Mrs Paul Mellon $9\frac{7}{8} \times 13\frac{5}{8}$: 251×345 *Water-colour and gouache on brown paper*

David ROBERTS (1796–1864)

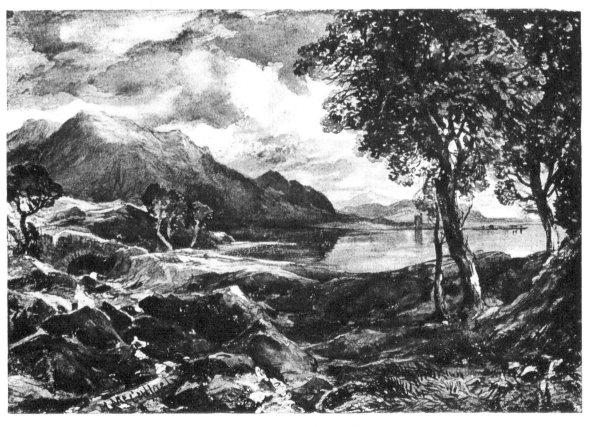

213 'Near Glencoe'

Edinburgh, National Galleries of Scotland, D. 4914 $15\frac{1}{2} \times 23\frac{3}{4}$: 395×603

Water-colour, signed and dated 1864

Horatio McCULLOCH (1805–1867)

214 'View of a manufacturing town'
B.M. 1886.6.7.9 (LB 1) 7¼×12⅝: 184×320 *Water-colour*
Samuel BOUGH (1822–1878)

215 'Snowballing outside Edinburgh University'
Edinburgh, National Galleries of Scotland, D (NG) 1684 7¼×8⅞: 184×225
Water-colour, signed and dated 1853
Samuel BOUGH (1822–1878)

216 'Eilean Donan Castle, Loch Duich, Wester Ross'

Coll. Mr & Mrs Paul Mellon 26 × 40: 660 × 1014 *Water-colour, signed and dated 1865*

William Leighton LEITCH (1804–1883)

217 'Castellamare'

V.A.M. P.63–1922 9 × 11½: 228 × 292 *Water-colour, dated 1836*

William Leighton LEITCH (1804–1883)

218 'Crocodiles on the Ganges'

B.M. 1900.4.11.36 9¾ × 17¾: 248 × 448 *Water-colour, signed and dated 1875*

William SIMPSON (1823–1899)

219 'Avnungabad'

B.M. 1900.4.11.35 10¾ × 17: 273 × 431 *Water-colour, signed and dated 1875*

William SIMPSON (1823–1899)

220 'The Weir Hill Pool on the Tweed'

Edinburgh, National Galleries of Scotland, D. 4520 5 × 7⅛: 127 × 180 *Water-colour, signed*

John Crawford WINTOUR, A.R.S.A. (1825–1882)

221 'In the Wharfedale, Yorkshire'

V.A.M. D.167–1907 10½ × 15: 267 × 381 *Water-colour*

Cecil Gordon LAWSON (1851–1882)

222 'Lunan Bay'
Edinburgh, National Galleries of Scotland, D (NG) 973
6 × 10⅞: 151 × 276 *Water-colour, signed and dated 1890*
Sir William Fettes DOUGLAS (1822–1891)

223 'Sunset over Selkirk'
Edinburgh, National Galleries of Scotland, D (NG) 1737
10½ × 14⅛: 266 × 358 *Water-colour, signed and dated 1913*
Thomas SCOTT, R.S.A. (1854–1927)

224 'Cove, Berwickshire'
Edinburgh, National Galleries of Scotland, D (NG) 1682
$9\frac{1}{4} \times 13\frac{5}{8}$: 235×345 *Water-colour, signed*
Thomas Marjoribanks HAY (1862–1921)

225 'Landscape'
V.A.M. P.50–1921 $6\frac{1}{4} \times 8\frac{1}{2}$: 158×216 *Water-colour, signed*
Robert Buchan NISBET (1857–1942)

226 'Teneriffe'

London R.W.S. (diploma drawing) $14\frac{1}{4} \times 20\frac{1}{4}: 362 \times 523$ *Water-colour, signed*

James PATERSON (1854–1932)

227 'Hay makers'

V.A.M. P.17–1933 $11\frac{1}{4} \times 15\frac{3}{8}$: 286 × 390 *Water-colour, signed*

John Robertson REID (1851–1926)

228 'A Peasant with spade and basket'
Edinburgh, National Galleries of Scotland, D. 4818 $15\frac{1}{4} \times 11\frac{7}{8}$: 387 × 303 *Water-colour*
Henry W. KERR, R.S.A. (1857–1936)

229 'Yarmouth'
London R.W.S. (diploma drawing) $14\frac{1}{2} \times 21 : 369 \times 533$ *Water-colour*
Robert Weir ALLAN (1851–1942)

230 'Children Paddling'
Edinburgh, National Galleries of Scotland, D. (NG) 2122 $13\frac{1}{2} \times 20\frac{1}{2} : 343 \times 520$ *Water-colour*
William MCTAGGART (1835–1910)

231 'Henley Regatta'
B.M. 1908.2.14.8 10¼ × 14: 261 × 355 *Water-colour*
Arthur MELVILLE (1855–1904)

232 'Dawn, Berwick on Tweed'
Edinburgh, National Galleries of Scotland, D.4536 10 × 14: 253 × 355
Water-colour, signed
John MACWHIRTER, R.A. (1839–1911)

233 'The Little Bullfight, "Bravo Toro"'
V.A.M. D.143–1906 22×30½: 548×774 *Water-colour*
Arthur MELVILLE (1855-1904)

234 'South of England Landscape'
Edinburgh, National Galleries of Scotland, D. (NG) 1694
$15\frac{1}{2} \times 23\frac{3}{4}$: 395×603 *Water-colour, signed and dated 1905*
William York MACGREGOR (1855–1923)

235 'On the Sands, Arbroath'
B.M. 1910.7.7.2 $7\frac{3}{4} \times 9\frac{1}{8}$: 197×232 *Water-colour, signed*
James Watterson HERALD (1859–1914)

236 'The Jungfrau'

V.A.M. P.27–1935 $10\frac{7}{8} \times 15\frac{1}{4}$: 277 × 386 *Water-colour*

Emily Murray PATERSON (1855–1934)

237 'Matador and Bull'

Coll. Mr Leonard G. Duke $5\frac{5}{8} \times 10\frac{3}{4}$: 143 × 273 *Black wash, signed*

Joseph CRAWHALL (1861–1913)

238 'A Buffalo'
B.M. 1964.2.8.1 5×8: 127×203 *Grey wash*
Joseph CRAWHALL (1861–1913)

239 'Barnet Fair: Putting him through his paces'
Coll. Mr & Mrs Paul Mellon 10×10⅝: 254×270 *Water-colour, signed and dated 1896*
Joseph CRAWHALL (1861–1913)

240 'Study of a Peacock'
Edinburgh, National Galleries of Scotland, D. 4073 $19\frac{1}{4} \times 9\frac{3}{4}$: 487×247
Water-colour, signed
Edwin ALEXANDER (1870–1926)

241 'Sleeping Wolves'

V.A.M. E.379–1924 $16\frac{5}{8} \times 22\frac{1}{2}: 422 \times 571$ *Water-colour, signed and dated 1912*

William WALLS (1860–1942)

242 'East Side of Monte Roza'

B.M. 1958.7.12.450 $9\frac{3}{4} \times 13\frac{3}{4}: 248 \times 350$ *Water-colour*

Elijah WALTON (1833–1880)

243 'The White House'
London R.W.S. (diploma drawing) $14\frac{3}{4} \times 10\frac{1}{4}$: 375 × 260 *Water-colour*
John Henry LORIMER (1856–1937)

244 'Landscape and Windmill'
V.A.M. P.222–1935 9½ × 12: 241 × 304 *Water-colour, signed and dated 1909*
David MUIRHEAD, A.R.A. (1867–1930)

245 'The Hills of Morvern'
B.M. 1920.6.22.1 10½ × 16½: 267 × 418 *Water-colour, signed*
Sir David Young CAMERON (1865–1945)

'there is never a hint of storm, never the glow of sunset; a spell of peace and dream pervades all nature as he saw and loved it.' Into his work of this nature he put 'the breath and finer spirit of all knowledge' with quiet and unobtrusive mastery. Steer alone, and mostly at a somewhat later date than Alexander, obtained the same subtle quality given by sparing colour and lovely greys.

William Walls (1860–1942), born at Dunfermline, may well be linked with Alexander as an animal painter. He does not possess Alexander's virtuosity and impeccable method, but there is greater virility, more elbow and wrist work, as it were, in his free draughtsmanship. He studied in the R.S.A. Schools, and then worked at Antwerp, particularly in its Zoological Gardens. Here, and in the London Zoo, he made numerous very able studies of wild animals, lions, tigers, jaguars and parrots. Later, when he settled in Edinburgh, dogs, horses and donkeys became his frequent models. His work shows sympathetic observation and highly skilled craftsmanship. His colour is deliberately reticent, his aim being always to register the special qualities of form and tone. Many of his drawings are handled with delightful ease upon tinted paper; and few artists have shown greater appreciation of animal life or of its relationship with its landscape environment. He was elected A.R.S.A. in 1901, R.S.W. in 1906, and R.S.A. in 1914.

Associated with the Glasgow School, but on the whole more effective in oils than in water-colour, were Lorimer and Walton. John Henry Lorimer (1856–1937), born in Edinburgh, had a university education before entering the R.S.A. Schools. In 1882 he was elected an associate of the Scottish Academy, and two years later went to study in Paris under Carolus Duran. This meant that he was concentrating upon portraits and also upon the formulated theory of values and the study of tone. Later he won distinction as a subject-painter, particularly of the intimacy of home life in Scotland. *The Ordination of the Elders in a Scottish Kirk*, an oil-painting of 1891, belonging to the National Gallery of Scotland, is described by Sir James Caw as one of the most national pictures ever painted. He was elected R.S.A. in 1900. In London he became associate of the Royal Water-Colour Society in 1908 and member in 1932. His work in water-colour is always luminous and transparent, showing a sensitive perception of light and atmosphere, particularly in interiors. He excelled in the subtle use of white and grey, flushed with warmer tones.

Edward Arthur Walton (1860–1922), born in Renfrewshire, studied at the Glasgow School of Art and at Dusseldorf. He was closely associated later with members of the Glasgow School such as Macgregor, Guthrie and Crawhall, and was much influenced in his early days by the work of Cecil Lawson. After living in London from 1894 to 1904, he settled in Edinburgh. He was elected A.R.S.A. in 1889 and R.S.A. in 1905; became an associate of the Royal Scottish Society of Painters in Water-Colour in 1885, and was its President from 1915 till his death in Edinburgh in 1922. Like other members of his School he aimed at the decorative quality obtained by considered and balanced beauty of design and of tone. His work, is, as it were, a half-way stage towards the pure distillation of the advanced modernists today. At an early stage of his career he attained great executive skill

209

in water-colours, which enabled him to express the essentials of his subject with deftness and subtlety of handling. He experimented with various materials as a ground for water-colour. 'Sometimes he chooses a tinted paper, sometimes a material like cork-carpet, of which both colour and texture can be taken advantage of, as in the delightful *Gate of the Fens*, 1901; and this device, in which body-colour is largely used, he has also employed with exquisite results in a number of semi-decorative studies of girlish beauty set amid subtle suggestions of romantic landscape.'[1] Among his more memorable water-colours are a beautiful little *Pastoral*, 1883, *The Upland Track*, 1917, and *The Lone Tree*, belonging to the Paisley Art Institute.

David Muirhead (1867–1930), born in Edinburgh, started life as an architect, and later studied painting in the R.S.A. Schools and at Westminster School of Art under Professor Fred Brown. In 1894 he settled in London, becoming a member of the New English Art Club a few years later. He was elected associate of the Royal Water-Colour Society in 1924, and became an associate of the Royal Academy in 1928. He remained Scottish in speech and manner, but in spite of this his painting followed a definitely English tradition. In oil-painting, like McEvoy, and particularly in his figure-subjects and interiors, he resembled Gainsborough in his poetic sensibility, his feathery touch and veiled colour. In water-colour he links with other members of the New English Art Club—such as Ambrose McEvoy, Sir Walter Russell and Wilson Steer as the dominant figures of the group—in his impressionist treatment of landscape, with an atmospheric quality and tenderness of vision derived from Gainsborough and, more particularly on this side of his art, from Constable. In water-colour, like Steer and Russell, he produced his best work in his rendering of low-lying landscape and open skies, of river scenes, creeks and estuaries, on the Thames, the Wye, the Medway and in Essex. He was content to sacrifice local colour to some extent in favour of light and atmosphere, using washes of quiet and persuasive colour. His work was done directly and fluently from Nature, but like McEvoy he sometimes obtained his effect later by washing down his more positive colour in order to harmonise his drawing and to flood it with quiet sentiment rather than hard fact. His work is always liquid and transparent, showing a fine instinct for broad relationship of tone. Typical examples of his art are *The Boatbuilding Yard, Brightlingsea*,[2] dated 1923, and his *Afternoon on the Severn*,[3] 1922. An Exhibition of a large number of his water-colours was held at the Rembrandt Gallery, Vigo Street, in 1933. The exhibition showed that here and there, when he chose to use stronger colour, his work had close affinity in outlook and method with that of Alfred Rich. In the exhibition of *British Painting since Whistler*, to which the National Gallery gave war-time hospitality in 1940, such drawings as his *Richmond Castle*[4] and *Open Landscape*[5] were worthy compeers of Wilson Steer.

Robert Purves Flint (1883–1947), younger brother of Sir W. Russell Flint, was born in

[1] Caw, *op. cit.*, p. 371.
[2] Edinburgh, National Gallery of Scotland.
[3] V.A.M. P.36–1925.
[4] Then in Coll. Mr. A. S. Watt.
[5] Then in Coll. Mr. Harry Collison.

210

Edinburgh. He first won recognition with a successful show of his drawings at the Leicester Galleries in 1926. His water-colours, swiftly and surely recorded, delicate and quiet in colour, but resting on a sound basis of drawing and of keen observation, won him election as an associate of the Old Water-Colour Society in 1932 and full membership in 1937.

Sir David Young Cameron (1865–1945), a son of the manse, was born in Glasgow. In the 'nineties he became known for his etchings, the *Clyde Set* (1890), *North Holland* (1892) and *North Italy* (1896). These were followed in 1900 and later by similar sets dealing with London, Paris and Belgium, and then by individual prints, notably *The Five Sisters*, *York Minster* and *Ben Ledi*, which won him international fame as an etcher. During all this time, however, he was working in water-colour and in oil. He was elected associate of the Royal Society of Painters in Water-Colours in 1904 and a full member in 1915; A.R.A. in 1911 and R.A. in 1920. He was also a member of the Royal Scottish Academy and the Royal Scottish Society of Painters in Water-Colour. He was knighted in 1924.

For his water-colour work Cameron began with a drawing, usually in chalk, but often in pencil or pen, sometimes on Whatman paper but more frequently on old hand-made paper (of which he was a notable collector, for the purpose of his etchings) or on Japanese paper. From the start he approached his work as an etcher would do, with a basis of line at once sympathetic, constructive and expressive. He did not use a sweeping boundary line, but seemed to hold brush or pencil almost upright, as an etching needle is held, and to think about almost every separate part and accent of his line, as though it were something precious. Little touches, lines, and then accents of colour, were a kind of shorthand, symbols which conveyed the fullest meaning in the briefest code. He considered carefully, as in his etchings, the placing of light and dark passages. The eye is carried over the foreground (and the foreground is often a bugbear to the water-colour painter) into the arabesque of his central design. My own affection is for his earlier work where nervous searching line is barely concealed by light and delicate tints, such as *The Valley*,[1] *Kinfauns*[2] or *Pluscarden Priory*.[3] Cameron wrote to me in 1931: 'I am never done wondering why collectors wish my simple things, just impressions of beautiful days and places, often in preparation for, or a change from, heavier oil work or the exacting copper plate and its unpleasant technicalities.' It seems to me that his earlier work, both in oil and water-colour, had a reserve, an austerity which he sacrificed in his later ambitions to express in strong tone and brilliant colour the glamour and romance which he found in the Highland scenery which surrounded his home at Kippen.

[1] V.A.M. P.15–1914. [2] V.A.M. P.173–1929. [3] Present whereabouts unknown.

211

The appendices, based upon Martin Hardie's original conception of these chapters, have been substantially revised and enlarged by Mr. Ian Fleming-Williams.

APPENDIX I

Drawing-Masters

The earliest known adoption of the term 'drawing-master' is to be found in the records of a school, Christ's Hospital, where, in an entry in the Governor's Committee Book for June 21, 1693, there is a reference to 'Mr Ffaithorne the Drawing Master'. But, although there is documentary evidence of amateurs having received instruction in drawing as far back as the reign of Edward VI, outside the classroom, where it was necessary that he should be distinguished from the writing-master or the mathematical-master, and later from the fencing- and dancing-masters, it was some time yet before the drawing-masters, named as such, found recognition in society, as it was some time before there was a wide-spread demand for their services amongst the professional and leisured classes. By the middle of the eighteenth century, however, he had become an established though humble figure in the artistic scene and well before the turn of the century there was hardly a city or fair-sized market-town in the land that lacked its resident teacher of drawing, or even its rival families of drawing-masters.

Before 1700, most of those who are known to have taught drawing were employed at Court or in aristocratic households. There were men such as the Frenchman Nicolas Denisot, who taught the Protector Somerset's daughters (before he was discovered sketching coastal fortifications); such as David Beck and Wenceslaus Hollar, whom Charles I appointed to instruct his children; Edward Norgate, whom the Earl of Arundel employed for a similar purpose; and Richard Gibson, the dwarf, who tutored Queen Anne as a girl and then went to Holland to teach the Princess of Orange (later Queen Mary II), but these are known only because they were attached to such prominent households. We also know of a few of those who taught elsewhere: Alexander Browne, for example, picture-dealer, limner, etcher, translator and author of the popular treatises on drawing *Ars Pictoria* (1669) and *A Compendious Drawing Book* (1677), who instructed Princess Ann, Duchess of Monmouth, and the daughters of William Penn, and whose lessons with Mrs. Pepys caused the lady's husband such unease. But there must have been a host of others also engaged in part-time teaching who have not been so spotlighted. Confirmation of this is to be found in the publication of the numerous instructional manuals written specifically for amateurs that appeared between 1573—when the first was printed— and the end of the seventeenth century, as well as in the concurrently popular Courtesy books, which set out precepts for the behaviour of a gentleman and the attainments required of such a being, and which devoted an increasing amount of space to the arts of drawing and limning, the taking of likenesses 'in little'.

Whilst royalty experienced no difficulty in persuading artists to forsake the studio for the school-room, and while a few of the more enlightened nobles and commoners could readily procure drawing tutors for their families, it is doubtful if any artists in the seventeenth century found full employment on these levels of society as teachers of drawing. Initially this was offered on much humbler strata

212

by the schools which trained the children of the artisan classes and by those requiring an elementary knowledge of draughtsmanship for the successful practice of their trade.

One of the first who can be presumed to have scraped a living by teaching was the Sussex-born draughtsman and self-styled 'School-master and Teacher of the Art of Drawing', John Dunstall, who died in 1693, and whom Vertue later recorded as a small professor who had lived in the Strand. Apart from his etchings of natural history subjects and his plates for drawing copy-books, our knowledge of Dunstall as a draughtsman rests on only two drawings, one of which is the naive yet charmingly coloured *A Pollard Oak near West Hampnett Place, Chichester*,[1] (Pl. 246) in the British Museum. From the introduction to his undated autograph treatise on the *Art of Delineation*,[2] we can, however, learn something of Dunstall as a teacher; and, from his eagerness to combine a display of learning with both moral and practical arguments in favour of his art, sense the effort required at that time to convince a still largely puritanical society of its necessity and acceptability. He pleads for his Art of Drawing on two counts: firstly, in that it has a spiritual purpose, and secondly in that it provides for lawful delight and usefulness. As the Chief Author of this Art he claims that God, in his Infinite wisdom:

Has given to Persons several Senses, so he hath provided objects suitable to those Senses, as

1. Melodious and Harmonious Musick to delight the Ear or Sense of Hearing.
2. Odoferous and Fragrant Smells, to please the Nose or Sense of Smelling.
3. Delicious, Sweet and Pleasant Food, to Please the Appetite, or Palat or Sense of Tasting.
4. Things smooth and Soft such as Silks and Sattens: and Temperate weather to please the Sense of Feeling. And so Likewise Beautiful Objects and things Pleasing to the Eyes, to delight the Sense of Seeing.

It is, Dunstall suggests, by the exercise of God-given wisdom and understanding in delineating such beauty that man can fulfil his spiritual purpose. The author is on firmer ground when he turns to more practical matters. After recommending drawing to persons of quality as an innocent employment for their vacant hours, and to young gentlewomen as an aid in making patterns for their stitch-work, he ends his final exhortation by listing those who would find it most useful:

It is of much Use for Jewellers, Gold-smiths, Silver-smiths, Chasers and Embossers, and Watch-makers and Clock-makers. It is useful for Stone-cutters and Carvers. Drawing is of great use for Cosmographers, Geographers and Surveyors; in Describing the Globe of the Earth in General, and in Particular the Quarters of the World, Kingdoms, Counties and Shires and the Mapps of any Persons land. It is useful for Architectors, Brick layers, Carpenters and Joyners to make Draughts for Fabricks or Buildings And Cabinet makers to designe their work etc.

Oddly enough Dunstall's list is both echoed and amplified in a letter Pepys wrote to the Governors of Christ's Hospital in 1692 when they had asked for his opinion as to whether they should appoint a drawing-master to teach the boys in the Mathematical School. In his characteristically long letter Pepys adds craftsmen such as lock-smiths, silk-weavers, gun-smiths, coach-makers, glass-painters and shipwrights to those mentioned by Dunstall, and continues:

I do not remember any one instance of a Manuall Trade that I have had to do with, where I have not found a plaine Difference in the Degree of satisfaction given me by a workman that could lay either his or my owne conceptions before me in Draught, and he that could do it only in Talks, which at best can never be but imperfect and uncertain.

And by the way it comes into my head to give you one further note, namely, that I do not know any one thing that conduces more to the recommending fforeigne Artisans, and especially the ffrench, to the

[1] B.M. 1943. 4.10.1. [2] B.M. Add. MS.5244.

213

acceptance they commonly meet with, among people of Quality, before our owne Countryman, than that you hardly find one of them of any note, but what will give you a Designe of the thing you bespoke, to your entire satisfaction, before he goes to worke upon it, thereby preventing the disappointment and often the final loss of a customer.[1]

The inability of the craftsman to express himself graphically seems to have been a matter of general and patriotic concern at this time, for Sir Christopher Wren had also been asked for his opinion on the matter and he too stressed the importance of a draughtsman's training for artificers. 'Our Natives want not Genius', he wrote, 'but education in that which is the ffoundation of all Mechanick Arts, a practise in designing or drawing to which everybody in Italy, ffrance and the Low Countreys pretends to more or less.'[2] The receipt of these letters was noted in November 1692. The following February William Faithorne the Younger (1656–?1701) was appointed to teach drawing for three afternoons a week at a salary of £20 per annum. Unfortunately, the experiment was a lamentable failure owing to Faithorne's dilatory habits, and in March 1696 he was discharged. Bernard Lens, the second, succeeded him, but only after an interval of nine years and after a trial of skill with the pencil in which Lens was taken up on to the roof of the Mathematical School by some of the Governors and matched against George Holmes, his rival for the post. Lens was judged to have won the day as he 'drew the quickest and the best'.

Care has to be exercised when referring to any member of the Lens family. This Bernard Lens (1659–1725) was the second of four in successive generations to be so named. His father, the first, was also a painter; his eldest son, the third, best known as a miniaturist, was also a drawing-master; his second son Edward succeeded him as drawing-master at Christ's Hospital. John, an otherwise unknown member of the family, failed to obtain the post on Edward's death in 1749. At least two other members of the family, Andrew Benjamin and Peter Paul, the second and third sons of Bernard Lens III, were also miniaturists. At least four members of the family were etchers and engravers—Bernards II and III, Edward and Andrew Benjamin—and, though so far their hands have not been satisfactorily distinguished, it is evident that both Bernard II and Bernard III (and possibly other members of the family) were also topographical draughtsman.

Bernard Lens II had had some experience of teaching, before his Christ's Hospital appointment of 1705, at a drawing-school in St. Paul's churchyard which he and the engraver John Sturt were running between the years 1697 and 1700—possibly the earliest establishment of its kind in the country. Here, a broadsheet of 1697 proclaims, was taught 'the Art of Drawing; On Tuesdays, Thursdays and Saturdays in the morning from eight to eleven; for Five Shillings Entrance and Five Shillings a Month. Also on Mondays, Wednesdays and Fridays in the Evening from Six to Nine. At the same Place on the same terms.' Those that pleased, it was also announced, could be taught at their respective habitations.

After only six months in his new post Lens put in for a rise, and as the Governors of the Hospital were of the opinion that he was a deserving man and ought to have further encouragement his salary was raised from £30 to £50 for the three afternoons' work, with the proviso that the numbers he taught be raised from forty to fifty. He is not mentioned again in the Hospital records until after his death in 1725 when his son Edward was elected to succeed him.

The most talented member of the Lens family was his son Bernard III, who, besides holding a

[1] Christ's Hospital, *Court Books and Committee Books*, November 18, 1692.
[2] Christ's Hospital, *Court Books and Committee Books*, November 18, 1692.

Royal appointment as Limner, was drawing-master to Horace Walpole and also, it is stated, to the Duke of Cumberland and the Princesses Mary and Louisa. It is he who might fairly be described the first of the fashionable drawing-masters.

Outside the Christ's Hospital records, Edward Lens has left only the very slightest traces, his initials on two engravings in a drawing-book from which the boys at the Hospital made copies during their lessons, and a mention of his name on a printed circular that an aspirant for his post sent round after his death to those who would shortly be electing his successor. It appears thus:

> Sir
> Your vote and interest are humbly
> desird for
> Alexander Cozens
> To be DRAWING-MASTER of
> Christ's Hospital London in the room of Mr. Edward Lens deceased.[1]

The voting for the five candidates in the ensuing election—Robert Brown, 43; Alexander Cozens, 59; John Lens, 5; Jacob Smith, 11; John Warman, 2—indicates the importance the appointment had assumed in the eyes of the Governors, while also showing that Cozens had not gone to unnecessary lengths in thus circularising the Governors. The number of applicants is also significant. Practising artists of one sort or another were by this time evidently realising the benefits to be derived from steady employment as teachers of drawing. Cozens assumed his new rôle in January 1749.

Combined with a technical knowledge of drawing ships, headlands and coastlines, accurate draughtsmanship above all else was required by Trinity House of the boys from the Mathematical School who were sent on to them for examination prior to their acceptance as apprentices at sea. The new drawing-master's inability or disinclination to teach these skills can be imagined. Not unexpectedly, it was from Trinity House that the first complaints arrived about the boys' standard of drawing. In July 1753 the Governors took note of the contents of a letter from the Corporation, in which it was observed that the drawings produced by the five boys under examination 'were worse than heretofore', and in which the Governors were desired 'to give such Directions to the Drawing Master as they should think necessary'. Cozens was called in. He said in excuse, and how one sympathises with him, 'that three of the said children were very dull and the other two but indifferent', and promised to take particular care that there should 'be no cause of Complaint of the Future'. When, in the following May (1754), warning of fresh complaints reached him, rather than appear before the Governors for a further dressing down and humiliation, Cozens anticipated events by sending in a letter of resignation.

This time there were only two applicants for the vacated post, probably because one of them, a Frenchman, Jacob Bonneau, had included with his petition a testimonial signed by thirty-five of London's painters, sculptors and engravers expressing their confidence in his moral and professional character. Among the signatories were Highmore, Hogarth, Samuel Scott, Lambert, Wootton, Joshua Reynolds, Cotes, Rysbrack and Roubiliac—an astonishing galaxy.[1] Too brilliant by half, apparently; for the city gentlemen who governed the Hospital chose the other man—a nondescript called Thomas Bisse. Possibly they had had enough of artists for the time being.

We have followed the Christ's Hospital minutes this far as they provide an unrivalled record of the early drawing-masters in schools. But by the middle of the eighteenth century artists were beginning

[1] Coll. Mr. D. L. T. Oppé. [2] Whitley, 1700–1799, II, 317.

215

to find employment in other types of educational establishment, and it is to these that we must now turn.

It is not surprising to find that in the army it was the engineers and gunners who initially engaged professional artists to teach their young cadets drawing, for, besides being the first branches of the service to set up a properly regulated training establishment—the Royal Military Academy at Woolwich—draughtsmanship had always played an important part in their work, their officers having long been familiar with plans and designs of one sort or another. The first man appointed to instruct at the new Academy was a certain John Fayram, who, in 1743, was engaged at the princely salary of three shillings a day. With some degree of certainty, Fayram can be identified with an artist of the same name who was a subscriber to Kneller's Academy in 1713, who painted a number of portraits of the Hervey family, and who in 1739 published eight engraved views of the London area which he dedicated to the Hon. Thomas Hervey.

Within a year of engaging Fayram, the Academy Board found themselves having to pay his funeral expenses. They were more fortunate in his successor, Gamaliel Massiot, who remained on their books until 1780. Apart from his association with the Academy at Woolwich and his will in Somerset House,[1] nothing is known of Massiot. To begin with his salary was the same as Fayram's, but, as the Academy prospered and greater claims were made on his time, from an increase to £54 in 1759, in 1767 it was advanced to £100 p.a. 'on account of the loss of his private teaching by his constant attendance at Woolwich'.[2]

Encouraged by the success of the drawing classes, in 1768 the Academy authorities decided to appoint a better-qualified drawing-master additional to Massiot who could advance the cadets' work still further. By offering a handsome salary—£100 p.a. for one day's teaching a week—they were able to obtain the ideal man for the post, Paul Sandby, who by now was at the height of his powers with a host of distinguished pupils, but who in his youth had worked at the Drawing Office at the Tower of London, had served as a draughtsman in the Board of Ordnance survey of the Highlands after the '45 Rebellion and was well acquainted with military requirements.

Sandby's influence was considerable during his twenty-eight years at Woolwich, and in later life amongst his closest friends he could count a number of high-ranking officers who, as cadets, had been his pupils at the Academy. His style was imitable and the results of his teaching are to be detected in many quarters: in the charmingly coloured drawings provided by serving officers to illustrate their operational reports; in the widely popular prints of military engagements that were engraved from drawings made by officers who had fought in or witnessed the actions depicted; in artillery manuals; and, to complete the full circle, even in paintings by professional artists. For example, in Reynolds' portrait of Lord Heathfield, the cannon with the depression carriage in the smoky background was undoubtedly taken from an etching made by Lt. Koehler, a Sandby pupil, of the weapon which he had himself invented. Sandby finally retired in 1796, on what he considered to be a 'pitiful pension' of £50. He was succeeded, in January 1797, by his son Thomas (who had already instructed the cadets once before when his father was ill) at a salary lower than that of his father by £50. There must then have followed a little wire-pulling and a little rustling of petticoats, for in the following October, the Governor of the Academy was informed that 'in consideration of the long service of the late Mr. Thomas Sandby near the King's Person, it is their wish that Mr. Sandby's nephew, who is

[1] His will was proved in March, 1782.
[2] *Records of the Military Academy, 1741–1892*, 2nd ed., 1892, p. 16.

216

also *his son-in-law* (author's italics), should have his income as Drawing Master at the Royal Military Academy made equal to what his father Mr. Paul Sandby received in that station'. The Governor was also informed that this was not to be considered a precedent by a successor.

Thomas had succeeded his father as Chief Drawing-Master. As assistant drawing-master, Massiot, earlier on, had been followed by Robert Davey, a somewhat unsuccessful portrait and miniature-painter who previously had had some experience of teaching at a young ladies' school in Queen's Square. Davey died in 1793 from the injuries he received when he was set upon and robbed by footpads off Tottenham Road, and in turn was succeeded by Joseph Barney (1751–1827), a regular exhibitor at the Royal Academy, known chiefly for his figure and flower paintings. Additional instructors for sketching what was known as 'ground'—i.e. terrain—were added to the drawing staff, so that eventually, during the period 1806–1811 when the national war effort was at its height, there were five drawing-masters on the Woolwich establishment: one for landscape, two for figure (one of these was a certain Robert Shipster who had been loaned, of all places, from the Royal Carriage Department), and two for ground.

Though the great days of military topography had passed, a number of the later water-colour painters were able to supplement an otherwise uncertain income by teaching at Woolwich, and such comparatively well-known names as those of Thales Fielding (Copley Fielding's brother), Aaron Penley and John Callow are also to be found in subsequent lists of the Staff at the Royal Military Academy. Before completing this brief survey of the military drawing-masters, there is perhaps something to be gained from a narration in greater detail of the events surrounding the appointment of just one of them—William Alexander's engagement as First Drawing-Master of the Junior Department of the Royal Military College at Marlow.

As we have learnt, until the later stages of the Napoleonic wars, infantry and cavalry training had consisted almost entirely of arms drill and endless exercises in deployment and manœuvre. Until then, the regiments had been officered by gentlemen, and that had been considered sufficient; for a regimental officer had only to lead his men and fight courageously, and by birth every gentleman was both courageous and capable of leadership. It was only when the new professionalism began to penetrate the army at the turn of the century that training on more sophisticated levels was deemed necessary for the defeat of the enemy. The new attitude was represented by men like Le Marchant (who started both the Staff College and the Royal Military College), and it was their passionate belief in the necessity for such training and the attention they paid to detail which created the new, and finally victorious army. With this in mind it comes as no surprise to find that it was Le Marchant, also a talented amateur artist,[1] who personally set about the business of finding capable landscape draughtsmen to teach at his new Military College at Marlow. It was his enthusiasm which also nearly embroiled John Constable in the country-wide military training programme.

Although Le Marchant had been put in command of his brain-child, the new Military College with its Senior and Junior departments at High Wycombe and Marlow, in fact General Harcourt, as Governor, was the titular head. By his seniors Le Marchant was still regarded as something of a firebrand, and Harcourt had been given the post over him to see that the younger man's enthusiasm did not get the better of him. Now, Mrs. Harcourt, the General's lady, was also a keen amateur artist. She had been a pupil of Alexander Cozens and one of his most ardent admirers; she had exhibited at

[1] See Appendix II, pp. 251–2.

217

the Royal Academy; her drawings had been praised by Horace Walpole; she was, in truth, a bit of a blue-stocking and, what is more, she disliked Le Marchant. When the question arose of appointing a drawing-master at Marlow, what could therefore be more natural than that the General, prompted no doubt by his wife, should take it upon himself to find a young artist for the post; and, as he was living at Windsor at the time, to whom should he turn more naturally than to his friend Dr. John Fisher, Canon of Windsor, himself a talented amateur and an intimate friend of the King's as well as of Benjamin West, the President of the Royal Academy? Fisher evidently thought he knew the man who would suit, and on May 16, 1802, John Constable (whom Fisher had first met when on one of his visits to Essex as Rector of Langham) was summoned to Windsor to meet the General and his wife.[1] As soon as he could after his arrival at Windsor, Constable hastily made three water-colour drawings of the Castle as evidence of his proficiency, and one can presume that when, as the Canon's nominee, he produced these at the interview, the General and his wife were satisfied that they need look no further for a drawing-master. If they were satisfied, Constable, however, was not. Though the post was his for the taking, the prospect alarmed him and so he took advice on the matter, first from Farington and then from the President himself. Both urged him to refuse the offer—showing, one feels, some percipience in so doing—and thus the question was decided. To help him out of the awkward position in which a refusal would place him, West undertook to break the news tactfully to Dr. Fisher. On May 29, Constable[2] wrote to his friend Dunthorne:

> I hope I have done with the business that brought me to Town with Dr. Fisher. It is needless now to detail any particulars as we will make them the subject of some future conversation—but it is sufficient to say that had I accepted the situation offered it would have been a death blow to all my prospects of perfection in the Art I love.

The General having failed, Le Marchant now decided to see what he could do. He in turn went to see Farington, with whom he had already had some dealings, and asked for his assistance, giving him the fullest possible details: salary (£200 p.a., with a possible future increase); vacations; hours of attendance; anticipated number of pupils (25 to 30); and plans for assistant drawing-masters. This sort of business was meat and drink for Farington. He discussed it first with Smirke and then with Thomas Hearne, who was only asked to agree that a suitable man to approach would be William Alexander. The next day, over a cup of tea, Farington offered Alexander the post, thinking that, as Le Marchant's envoy, it was his to dispose of, quite unaware of the fact that the Harcourts still had a finger in the pie and had authorised his colleague Benjamin West to act for them in a precisely similar capacity. This all came out when Alexander, anxious for the job, was advised to delay his acceptance by yet another party, the portraitist Henry Edridge, who seems to have had some influence with Mrs. Harcourt and who thought he could thus obtain for Alexander an increase in the salary offered. It was through Mrs. Harcourt, via Edridge, that Alexander (and Farington, too) eventually learned the true state of affairs: that not only did the final choice of a drawing-master for Marlow rest with the Harcourt's agent West, but that he, the President, had been given a different set of conditions from those Farington had received from Le Marchant. Finally, however, everything sorted itself out, and after an unofficial interview with the Harcourts at Portman Square, when he showed his drawings, and an official one before a Board at Marlow, on August 29, 1802, the bewildered but delighted Alexander found himself First Drawing-Master at the Junior Department of the Royal Military College.

[1] R. B. Beckett, *John Constable and the Fishers*, 1952, p. 9.
[2] R. B. Beckett, *John Constable's Correspondence*, II, 1964, p. 31.

218

This comparatively well-documented story might be continued to include further and later appointments—that of William Delamotte as second drawing-master in 1803, and Sawrey Gilpin as third drawing-master in 1806 (when there were six other candidates: Mather Brown, history painter; Reynolds [probably the engraver Samuel William]; Havell; the Oxford drawing-master O'Neill; Sherlock; and one of the Chalons)—but, instead, we shall round off with a revealing, if melancholy, little coda.

In 1793, young Thomas Sandby had called on Edward Edwards to ask him whether he would be interested in the place of second drawing-master at the Woolwich Academy. Edwards, who, by then, was probably at work on his *Anecdotes of Painters* (see Vol. I, p. 95), declined the offer, but later evidently regretted having done so, for in December 1802 he came grumbling to Farington about the Marlow appointment which West had told him was vacant and which he, Edwards, had wanted for himself. Farington, understandably, justified his recommendation of Alexander by referring to Edwards' earlier refusal of Woolwich. Four years after this, in his sixty-ninth year, Edwards heard of the vacancy for third drawing-master at the College and called on Alexander to sound him out on the chances of obtaining the place. It was doubtful, he was summarily told, if the College Board would appoint an elderly man to the situation. Unwanted, Edwards died before the year was out.

A little more should perhaps be said about William Alexander (1767–1816). The son of a coach-maker, he was born at Maidstone, where he received a grammar school education. Moving to London, he studied for two years under William Pars and Ibbetson before entering the Royal Academy Schools in 1784. In 1792 he was appointed as one of the draughtsmen to accompany Lord Macartney on the mission to China which set sail in September of that year with the object of establishing a British minister in the Far East. When the expedition put into Rio de Janeiro, Alexander made a panoramic drawing of the city, for the use of which Robert Barker, the painter of panoramas, later engaged to pay him a fee of 70 guineas. After an adventurous two years, the Embassy returned, its mission uncompleted, but for Alexander, with his sketch-books filled, the voyage had been a valuable experience. For the next few years he was busy illustrating the official published account of the Embassy, furnishing drawings for his own and other books on the Orient, besides providing sketches for various works on British topography. Between 1795 and 1804 he exhibited sixteen Chinese landscapes at the Royal Academy. In 1805, three years after his appointment at Marlow, he published a volume of engravings from the Egyptian Antiquities in the British Museum which had been wrested from the French Army of the Nile. In 1808 this led to his resignation as drawing-master to the College at Marlow in favour of a new appointment at the Museum as Keeper of its prints and drawings with the rank of Assistant Keeper of the Antiquities Department, a position which he held until his death.

An undeservedly neglected draughtsman, Alexander is best known for his oriental landscapes and figure studies which, with their clear, pale washes of colour over graceful and neatly pointed pencil work, seem to accord more closely with the fabulous land of Cathay than with the China he actually visited. But he had a sharp eye for incident, nevertheless, and many a courtier, beggar, boatman or criminal, in splendour, misery or final agony, are to be seen recorded for all time in the sketches he made on the spot and the water-colours he painted in retrospect. Although there is a tendency towards sterile dryness in his later drawings, the topographical landscapes he made in this country before devoting himself to the study of antiquities quite readily find acceptance as pleasant examples of their kind.

Though most of the teachers of drawing at the Junior Department of the Military College were practising artists and are listed in the Book of Appointments at Sandhurst as 'drawing-masters', or

even as 'landscape drawing-masters', those who taught at the Senior Department, the Staff College, are always referred to as 'military draughtsmen', and between 1799 and 1820, only one of these, David Cox, had been trained as an artist.

According to his biographers, Cox spent a year as a uniformed Captain teaching at the Staff College, which had moved to Farnham from High Wycombe in 1813. We are told that Sir William Napier—who later wrote with such effect on the Peninsular War—was one of his pupils. He left Farnham for Hereford, it is also said, as he found the work uncongenial. This information is based on Hall's[1] accounts of the conversations he had with the painter many years later, when the old man was reminiscing about his early life. The truth, it seems, was a little less colourful. He succeeded one George Jones who had remained on the College books for less than a fortnight. His appointment was dated from March 14, 1815; it was terminated after five weeks, on April 18. As a civilian instructor he would neither have held military rank nor worn uniform. Napier was at the Staff College at about this time so the artist was probably just within his rights when claiming the distinguished historian as a pupil, and he was also probably speaking the truth when he described the work as uncongenial, but as he had had no experience whatsoever of military draughtsmanship it seems likely that it was his employers' dissatisfaction with his teaching capacity rather than his own disinclination for the work that precipitated his abrupt departure.

Owing to a general lack of interest shown by the Navy in shore-training, and a consequent and proportional dearth of documentation, the naval drawing-masters are less rewarding for study than their more prosperous brethren at Woolwich, Marlow, Sandhurst, Addiscombe and elsewhere. Drawing was established as part of the curriculum at the Portsmouth Naval Academy from its inception in 1733,[2] but the earliest instructors in the subject (who also taught French, at a salary of £100 p.a.) are known and the first three named as drawing-masters, Richard Clarke (1769–74), J. Jeffrey (1774–94), and T. Witchell (1795–96?), have so far evaded identification, although the last-named might be linked up with the somewhat confusing Whichelo family. With Richard Livesay (1749 or 50–1826), however, who succeeded Witchell and was still teaching at the Academy in 1810, we are on firmer ground. First a pupil and then an assistant of Benjamin West, he was an exhibitor at the Royal Academy from 1776 onwards, and between 1777 and 1785 lodged with Hogarth's widow, during which time he engraved facsimiles of some of her husband's drawings. In the 1790s he lived at Windsor, where he found employment as a portrait painter and as drawing-master to the royal children. Seemingly quick to make the best of his opportunities, after his appointment to the Naval Academy (which, after 1808, was known as the Royal Naval College) Livesay turned his hand to marine painting. In 1800 he published a set of four plates, engraved by Wells, of the reviews of the Isle of Wight militia. At this time he described himself as 'Portrait, Landscape and Marine Painter, Drawing-Master to the Royal Academy, Portsmouth', and gave his address as 61, Hanover Street, Portsea. His death at Portsmouth at the age of seventy-six is recorded in the *Bath Chronicle* of December 6, 1826, which refers to him as 'late of Bath'—the only reference so far noted of his sometime residence in that city.

Livesay's successor was a marine artist noted for his longevity, John Christian Schetky (1778–1874), who, when retiring from teaching in 1855, could look back on more than sixty years as a drawing-master.[3] Born in Edinburgh, he was the fourth son of an Hungarian composer and 'cellist

[1] W. Hall, *David Cox*, 1881. [2] *Naval Review*, XIV, 1926, p. 792.
[3] *Ninety years of work and play, sketches . . . of John Christian Schetky, by his daughter*, 1877.

Johann Schetky, who had settled in the Scottish capital and married Maria Reinagle, an artist in her own right and the sister of a pupil, Joseph Reinagle. As a boy John Schetky's first love was for the sea and for ships. Thwarted by loving parents in his desire for a sea-faring career, he turned to drawing and painting and, for a time, took lessons with Alexander Nasmyth—though he afterwards claimed a Van de Velde to be his true master. His career as a teacher began at about the age of fifteen when he helped his mother with a drawing class for ladies which she had formed. After her death in 1795, to help support his younger brothers and sisters, he took to theatrical scene-painting. In 1801, with little else but a spare shirt in his pocket, in the company of two friends, he set off on foot for Rome. One evening some weeks later he entered the city having walked forty-three miles that day. Ignoring the famous adage, during his two months in the city he played Scottish tunes on a shepherd's pipe in the Coliseum, and dressed sufficiently unlike a native to be recognised as a Scot by the exile Cardinal York, last of the Royal Stuarts, who stopped his carriage to enquire after the welfare of 'his' fleet and armies. In Toulon, on his homeward journey, Schetky narrowly escaped arrest as a spy when, somewhat unwisely one would have thought, he began sketching two captured English men-of-war in the dockyard.

While at Oxford, shortly after his return, he was visited by two proctors who asked him to stay and teach the undergraduates drawing, which, he was told, would be of much use to them 'instead of nothing but boating, billiards and cricket, perpetually'. He agreed to stay, and passed six of the most agreeable years of his life there. In 1808 he applied for and obtained the post of third drawing-master at the Marlow Military College, and in the same year exhibited at the first show held by the newly formed Associated Artists in Water-Colour. During the Christmas vacation of 1810/11 he spent some time in Portugal with his brother, John Alexander Schetky, then serving as assistant surgeon with the Dragoon Guards. Though by profession a surgeon, John Alexander was also a keen water-colour painter, and between 1811 and 1821 he showed at both the Associated Artists' and the Water-colour Society's exhibitions. On more than one occasion the two brothers collaborated on the same work.

On returning from his jaunt to the Peninsula, Schetky resigned from the Military College and shortly afterwards became Drawing-Master at the Portsmouth Naval Academy, a post for which, as a marine artist, he was best fitted. This brought him into contact with many eminent people, and eventually led to his appointment first as Painter in Water-colour to the Duke of Clarence and then as Marine Painter in Ordinary by George IV—an office to which he was re-appointed by Queen Victoria in 1844.

In 1836 the Portsmouth Academy was closed and he lost his job. However, his influential friends lost no time in finding him another, this time at Addiscombe (the East India Company's military cadet school) in the place of Thales Fielding, who had just been promoted from assistant to Master of Civil Drawing in succession to W. F. Wells, recently deceased. Fielding was known to the cadets as 'Johnny Bleu' from his Frenchified pronunciation. There was a tradition that in order to be marked high in his class it was advisable to take lessons from his brother Newton Fielding during the holidays. In 1850 Fielding retired, Schetky was promoted to Master, and John Callow came in as his assistant. Known as 'Sepia Jack', Schetky was warmly liked by the cadets and, unlike Wells, had little trouble in maintaining discipline. A cadet wrote of him: 'he was a genial old salt who would sometimes come into his study when the cadets were loitering about, larking, etc., and open the proceedings quite in the old style with "Now then, damn your eyes! Clear the decks for action." Mr. Schetky was as good

an old fellow as ever lived.'[1] Another wrote that he distanced all other professors by his great height as well as by his marked individuality; a fine breezy old fellow with gaunt spare frame, stray white hairs, and clothes 'thrown on him from at least a mile'.

Though there is now only a very limited public for his work, in his day it was greatly admired; to those who in their youth had swarmed up the rigging he so skilfully delineated, his meticulous attention to detail must have given much pleasure. Ignorant as we are of such technical matters, for us it is a little dull and mechanical, lacking in personal comment and expressiveness.

As is apparent even from the few lives already sketched in, artists taught both at varying stages in their careers and for a variety of reasons. It may also have been noted, moreover, that more than one class of artist thus found employment. Among those who taught in schools we have so far met the drawing-master who forsook teaching for a more congenial post (Alexander), the failing artist who finally resorted to teaching (Livesay), and the outmoded elderly painter who failed even to find a place as a subordinate drawing-master (Edwards). We have had examples of the full-time drawing-master (Edward Lens and Massiot), the pedagogue (Dunstall), the engraver (Bernard Lens II), the struggling portrait painter (Fayram), the successful water-colourist (Paul Sandby), the water-colourist who could not entirely subsist on the sale of his work (Alexander Cozens, David Cox, Thales Fielding, John Callow), and the salaried teacher who found a market for his drawings (Schetky). But after 1750 schools employed only a small percentage of the total engaged in teaching, and to complete the picture we must extend the scope of our survey further to include the whole- or part-time domestic drawing-masters and professors of small drawing academies, as well as some of those who, to a lesser or greater extent, professionally or otherwise, and at one time or another, were engaged in teaching: the print-sellers, artists' colourmen, shop-keepers, amateurs, tutors, unqualified ushers, the aspiring and despairing artists.

While the most successful of the drawing-masters, such as Alexander Cozens, Sandby, Varley, Nicholson and Payne, seem to have experienced no difficulty in obtaining pupils, a great number, including poor Cotman, found it necessary to draw attention to themselves by putting notices in the advertisement pages of their local newspapers or by circulating printed business cards. Basil Long[2] quotes the following two interesting examples, which well illustrate the variety of tastes and interests for which the ingenious and enterprising, but perhaps hard-pressed drawing-master was prepared to cater:

> Mr. Beauvais, well known at TUNBRIDGE WELLS to several of the Nobility and Gentry for taking a striking Likeness, whether in Water Colours or India Ink. Miniatures Pictures copied by him from large Pictures, to any Size, and Pictures repaired if damaged. He also teaches by a peculiar Method Persons of the least Capacity to take a likeness in India Ink, or with a black Lead Pencil, in a short Time. To be spoke with at Mr. Bryan's, the Blue Ball, St. Martins's Street, Leicester Fields, from Eleven to One O'clock.
> A Curious Collection of Prints and Drawings to be sold at the Lowest Prices.

That appeared in the *Public Advertiser* in 1774. Little else is known of Beauvais as a drawing-master. Is this perhaps explained by the fact that as described by J. T. Smith, 'through sheer idleness (he) became so filthily dirty in his person that few of the company would sit by him'?[3]

[1] Col. H. M. Vibart, *Addiscombe, its Heroes and Men of Note*, 1864.
[2] B. Long, *British Miniaturists, 1520–1860*, 1929, p. 24.
[3] J. T. Smith, *A Book for a Rainy Day*, 1861 (3rd edn.), p. 102.

It is not certain which of the many Jones was the next resourceful self-advertiser. The notice is from a newspaper dated September, 1782.

STRIKING LIKENESSES

In miniature profile, taken in one minute, by Mr. Jones, Artist and Drawing-Master, from Bath.— That no person may be deprived of their own or friend's likeness, they will be done at so small a sum as half a crown. Nothing is required unless the most striking likeness is obtained.—Any lady or gentleman having shadows by them of their living or deceased friends, may have them reduced to any size, and the likeness most critically preserved in the miniature.—Miniatures highly finished, and neatly set for the neck or arm, at two guineas and a half each, equally to many done at Five guineas.—Likewise teaches the art of painting on silk, in imitation of needlework, tambour, etc., in the space of four hours, though the person never made use of pencil before. Also teaches the art of painting on glass.— That no lady may lose the opportunity of learning these arts, they will be instructed at one guinea each. Nothing required till the pupil be fully instructed. Specimens may be seen each day, from twelve till seven, at No. 137 facing Catherine St., in the Strand.—Also his new invented Camp Paper, for writing and drawing, without pen, ink or pencil.

In a further advertisement, By His Majesty's special appointment, Mr. Jones cries other of his wares to the curious:

The various, beautiful, and almost incredible effects of his new invented Optical Instruments, for copying drawings, paintings, natural flowers, insects, etc., it giving the true likeness, of paper to any size, either as large as life, or as small as miniature, in one minute, with all their proper colours, either by day or candle-light. . . . Likewise the reflecting Mirror, at one guinea, for taking perfect likenesses, landscapes, etc.

The notices Bonington's father and mother put into the Nottingham papers between 1797, the year in which the former vacated the post of Governor of the County Gaol, and 1817, when he took his family to Calais and set up as a lace manufacturer, tell us as plainly of a provincial drawing-master's hard struggle to make both ends meet as they do of his decline and final defeat.[1] In June 1797 the *Nottingham Journal* carried the following:

R. Bonington

Drawing-master (at Mr. Needham's, the Portrait Painter) in Hounds Gate, Nottingham, respectfully informs the ladies and gentlemen of Nottingham and its vicinity that he has opened a Public Drawing School at his lodgings. Private attendance upon any Lady and Gentleman if required. R. Bonington will occasionally employ his leisure in drawings for sale, which he hopes will not be found undeserving of Public Attention.

In July 1798 the school re-opens at Captain Grundy's, Goose Gate; in 1799 it is to be found at Mr. Hutton's, Butt Dyke. By August of that year he had moved to a Mr. Rother's, Confectioner, Bridlesmithgate. By the following January he had moved yet again to a Mr. Tomlinson's, in Weekday Cross. After their marriage in 1801 an advertisement appears for an academy for young ladies at Arnold to be run by Mrs. Bonington, at the end of which notice Mr. Bonington 'Presents his respectful acknowledgements to his friends and the public in general, informing them that he shall attend the Academy in Nottingham, the several schools in the county, and give private lessons to families as usual'. In 1802 Mrs. Bonington announces a move into Nottingham 'where she purposes continuing

[1] C. E. Hughes, *Notes on Bonington's Parents*, Walpole Soc., III, 1914, p. 99.

her school for 12 young ladies', and once again her husband hopefully adds: 'R. Bonington, Portrait Painter and Drawing-Master, takes this opportunity of informing the Public, that having returned to Nottingham, he purposes re-opening his Drawing School, for the reception of pupils at his house, St. James's Street.' In 1806 he chances his arm at retailing and opens a shop 'where he will keep a complete assortment of the most valuable prints and drawings, with every other requisite for the gratification and instruction of all who admire the various imitations of nature and art. To the ladies in particular he can recommend a very choice display of fancy articles at the opening of his Repository.' Later he advertises 'an assortment of the most modern music from Clementi and Co., also a large stock of superfine writing papers, a choice collection of optical glasses, camera obscuras, etc., and a fresh supply of prints and drawings'. The Repository fails to attract custom and within a few months he has to sell off his stock. He publishes an occasional view of the town. For a time his wife's school flourishes and they move to better quarters in Park Row, where, not to be outdone, he opens an Exhibition Room for portraits in oil. But despite happy notions such as 'a fashionable and expeditious style of writing taught in one Quarter' and a declaration that Mrs. Bonington 'purposes teaching flower-painting to young ladies', a joint statement issued in January 1817, 'Mr and Mrs Bonington respectfully inform their friends and the public that their Drawing School will reopen on Monday the 27th inst. They will also continue to attend schools and private families in Notting-ham and its vicinity as usual', but this time from a house in Park Street, indicates that they are near the end of their tether. In the final announcement, having relinquished his profession of drawing-master, Mr. Bonington solicits the attention of the nobility, gentry and public to his collection of paintings and drawings, which, with the family furniture and household effects, will be offered for sale on August 26, 27 and 28, 1817. They were on their way to Calais.

It was not only the obscure and lowly who had to call thus plaintively from the roof-tops. In 1774 the newly elected Academician James Barry had also been driven by straitened circumstances (which, by his arrogance and bellicosity, he had brought entirely upon himself) to adopt the same obsequious tones and submit to the public humiliation of self-advertisement:

> James Barry, Painter, Member of the Royal Academy, and the Clementini Academy of Bologna, informs such of the young Nobility and Gentry as may be desirous of forming a taste for the Arts and a Knowledge and Practice of Drawing that he will wait upon such as honour him with their commands, and give lessons twice a week at three guineas a month. He continues his business as usual at Suffolk Street, No. 29, Haymarket, where he is to be met with, Mondays and Tuesdays excepted.[1]

Nor would it be correct to assume that such public solicitations necessarily signalled pecuniary distress. New arrivals would wish to give notice of their intention of setting up a temporary practice, as Cotman did in his native Norwich on his return from Wales in 1802, when he informed his friends that during his stay of three or four weeks, he proposed giving lessons in drawing to those ladies and gentlemen who might think his sketching from nature or style of colouring (rather than Crome's?) beneficial to their improvement. And where there was competition, especially in places such as Bath where the population was constantly changing, occasional public reminders were essential for the running of a successful practice. By some, other means were adopted to bring themselves before the public. It was J. C. Nattes' habit to stick a prettily engraved label on the back of his drawings, or even on those of his pupil's inscribed thus:

[1] Whitley, 1700–1799, I, p. 294.

Monsieur Nattes No. 41, Charles Street, Westminster, Pupil of Mr. Dean, respectfully acquaints the Nobility and Gentry that he teaches Drawing in the manner of that celebrated Master, on moderate terms—he also teaches Perspective so very essential in taking Local Views—
 Monsieur Nattes likewise continues to decorate Drawings and Prints in the most elegant manner, has a very superior method of fixing or binding drawings, in Chalks or Lead, to prevent them from being Effaced.[1]

Many had business cards printed. A typical example is that of Richard Noyes, drawing-master at Wolverhampton school from 1822 to 1831.[2]

Mr. R. Noyes, artist, Darlington Street, Wolverhampton. Pupils are carefully instructed in Drawing the Figure, Landscape, Flowers, Architecture, and Isometrical Perspective (the latter particularly useful to mechanics)

TERMS

Scholars per Quarter.................. £1 1 0
Private lessons of two hours 5 0
Private lessons in the country according to distance.

Although serious-minded artists ranked drawing-masters as amongst the lowest of their kind, in fact most of the water-colour painters taught at some stage of their careers. For the truth of the matter was that teaching had a number of attractions. It often enabled a young and aspiring painter to make contact with those upon whom his livelihood would ultimately depend.[3] As a supplementary source of income it enabled many in their maturity to maintain a degree of integrity in their work which otherwise might not have been possible. It provided the ageing artist in his decline with adequate means of support. If all else failed, it might serve as a living. Besides those already quoted, innumerable other examples of the part it played are to be found in the lives of the water-colour painters. Many, like Glover, began as country drawing-masters and then practised as such in London while endeavouring to establish themselves as legitimate members of their profession. Many were content to remain in their own part of the country, and some of these, like Francis Towne and Henry Bright, earned substantial sums through their practices. Some, like Alexander Cozens, Crome, Cotman and a number of lesser men, for a time became attached to one particular patron and worked exclusively for his household.[4] Many, of course, trained those whom later generations knew as patrons, and there is also a significant number who in early life taught those who subsequently became their own admiring patrons.

As the number of amateurs and their attendant teachers steadily built up in the latter half of the eighteenth century it created new markets and new demands, and to meet these small industries came into being. In the past artists had bought raw materials and prepared their own colours, and for a time amateurs had followed suit, as is evidenced by the pages of receipts to be found in the early treatises. But one of the characteristics of the amateur is that he is impatient and another is that he likes to spend money on elaborate equipment. This the suppliers of artists' materials gradually came to

[1] I. A. Williams, *Early English Water-colours*, 1952, p. 223.
[2] G. Mander, *A History of Wolverhampton School*, 1913.
[3] 'Thus Girtin, young as he was, became established as an artist of note, and, what was more to his professional advantage, as a favourite teacher of drawing.' Roget, I, p. 90.
[4] There is the case of the young Swiss, Peter Denys, who became drawing-master at Easton Neston and who, 'though very plain in person', after the death of the Earl, married one of the daughters with her £4000 a year and the consent of her mother.

appreciate, and by 1800 Ackermann's, for instance, were advertising every kind of aid and device for the convenience of their customers including a choice of seventy colours—seven had been enough for John Cozens. Makers of optical instruments, paper manufacturers and publishers, all found that they were operating on a rising market. The furnishing of examplars became another little industry in itself. Publishers did their best by issuing portfolios of soft-ground etchings in imitation of the drawings that would be made during a course of lessons and by offering drawing-books with the same engravings interleaved with blank pages on which the copies could be drawn. But originals were naturally preferred and the supply of these kept many a young artist busily employed. John Burnet in his *Progress of a Painter*, a romanticised account in the form of a novel of his brother William's life, describes just how these were produced.

> The print-sellers and dealers in drawings not only supplied the amateurs, but furnished the libraries with examples to be sent out to schools and pupils. These our artist Scaife used to manufacture at two-and-sixpence each, and supply the shops, not by dozens, but by hundreds. . . . Detail could not be expected in works manufactured at so cheap a rate. But the drawings of Scaife always possessed breadth of effect and chasteness of colour, engendered by the works of Girtin, which at that time were at their zenith. How drawings of this excellence could be produced at so cheap a rate, may be a mystery to many. But the way that Scaife took to produce this result was, by dividing a large sheet of Whatman's grand elephant into twelve compartments with pencil; and having out-lined in each a subject of rock, hill or dale, according his sketches, or his imagination, he then saturated the paper as thoroughly as a wet blanket, and laid it down on a table, and commenced with grey colour or neutral tint, until every subject was charged with its light and shade. The next process was to apply colour, to suit the various designs and then allow the whole to dry; the consequence was, that it not only facilitated the advancement of the drawings, but gave a firmness and solidity to the manipulation. The detail was afterwards supplied by the hair pencil; and where lights were required, such as foliage, or small stones in the foreground, he touched them with water and then rubbed the drawing (while the touches were wet) either with bread, or gave it a blow with the sleeve of his coat. The consequence was an appearance of finish, which effect he heightened by touching in shadow and portions of colour. I have been thus particular, as many of Turner's finest early drawings are conducted on the same principle.

This is fiction, it is true, but entirely founded on fact. As has already been noted in a previous volume,[1] the brothers William and James Munn kept a stationery and print-shop in Bond Street which sold just such drawings as copies which their brother Paul Sandby Munn made by the hundred, with the help for two years, of his young friend Cotman.

In the sections devoted to artists such as Alexander Cozens, John Varley and John Sell Cotman there have already been many references to the methods adopted by the drawing-masters in instructing their pupils. Here it is only necessary to attempt a summary of these methods. While quite a lot is known about the instructional technique employed by two of the outstanding teachers—Alexander Cozens and John Malchair of Oxford, whose practices differed radically from those adopted by the general run of drawing-masters—we still have little idea of how others such as Paul Sandby, Girtin and Crome conducted their lessons. Until contrary evidence proves otherwise it can only be assumed that, unlike the two just mentioned, they also adopted one of the current systems.

Without exception, all instruction was based upon precept and example, the systems differing only in choice of media, in the degree of emphasis on draughtsmanship, and in the ultimate aims that the training was designed to achieve. Pencil, chalk, pen and wash, introduced in that order, were considered most suitable for the beginner until well into the second half of the eighteenth century, when

[1] Vol. II, p. 76.

teachers began to encourage their more advanced pupils to complete their work with a little tinting. It was not until towards the end of the century that brushwork and the manipulation of colour washes was introduced at an early stage, and not until well into the nineteenth century that linear draughts-manship was finally abandoned for true painting in water-colour. In general, both master and pupil, right from the start, were in complete agreement as to what the latter was setting out to achieve: a manner, modelled touch by touch on that of the master, which would enable him to reproduce the examples set before him, or executed for him while he watched. In other words, to draw and paint exactly in the style of the master, no less and no more. At each stage the pupil was shown by example, by actual demonstration, precisely the way he was to proceed. How much the pupil did during the lessons depended upon how much he was paying for them and the amount of time the master could afford to give him. Some teachers would show how to wash in a sky, for instance, and guide and direct while the pupil attempted to do likewise. Others would demonstrate that stage and then leave the pupil to practise and advance his copy up to that point between lessons. A lesson with a busy and fashionable drawing-master such as Francis Nicholson would consist of no more than watching while the artist (who could not spare the time to instruct) worked on one of his own water-colours. Until the second or third decade of the nineteenth century few of the drawing-masters made it their prac-tice, or in any way felt themselves obliged to take their pupils out of doors and to give lessons from nature, unless they were staying in a country house with a patron, in which case it might be reckoned as part of their duties to occupy the young with sketch-book and pencil in the grounds or surrounding countryside. The system encouraged a high standard of manipulative skill just as the old writing-masters ensured a high degree of general proficiency. It served to teach thousands to open their eyes to aspects of nature which they would otherwise have overlooked. It taught them to understand and appreciate thoughtful craftsmanship and the basic elements of design. It gave them new values and standards when they visited picture galleries and exhibitions. It also bred confusion for the Museum officials and collectors of the future, for many of the pupils became brilliant copyists and, as in the case of Cotman, it is now by no means always easy to tell the original from a copy.

Salaries and the scale of charges for tuition varied enormously: the drawing-master in the town got less than his counterpart in the country who had to ride through the lanes to reach his pupil; the fashionable teacher in London or Bath received more than those who eked out a living in some remote provincial town; the fortunate who taught in the heyday of the 1820s and 1830s obtained three times the earnings of half a century before. John Glover's advance in scale of fees may be taken as typical of the hard-working and successful teacher's charges. In 1794, when he was dividing his time between London and Lichfield, he asked 7s. an hour, and 2 guineas if he spent a day at a house. After his move to London in 1805, he was getting 5 guineas a day by his teaching. In 1808 he was charging 2 guineas for a lesson of three hours (i.e. 6 guineas or more for a day's work), the drawings he made dur-ing the lessons, for which he afterwards obtained good prices, remaining his own property. 7s. seems to have been a standard charge in the country at about that time, as the following extract from a letter indicates: 'Mr. Cox stays one hour for seven shillings if he take away the drawing he makes during the lesson or for 10/6 if he leave it.—With 2 scholars he remains double the time for double the price.'[1] (Three and six, that means, for a David Cox!) The 22-year-old Turner, on the other hand, told Farington that he was determined not to give any more lessons in drawing as he had had only five shillings an hour. Salaried teachers in schools of one sort or another did not do so badly, and even an

[1] Noted and kindly provided by Mr. A. G. Thomas.

227

obscure artist like John Milbourne (in 1816) could make a respectable £500 or £600 a year as a full-time teacher. But until 1800, or thereabouts, it was only in London and at places such as Bath that a domestic drawing-master could find full employment. Unless he was taken up by some wealthy household (where, even so, he might have to make himself useful to the family as a general handyman), he would almost certainly have had to find some supplementary source of income to maintain a living elsewhere. For the talented or lucky few, who were able to market their work, this only required incessant labour at the drawing-table, but for the remaining majority the life was precarious as well as hard, and many, various, and ingenious (and also ignominious) were the methods adopted to keep the wolf from the door. Some ran businesses; some became picture-framers and restorers; some turned to authorship; some relied on their wives' or daughters' earnings as seamstresses; and some, like Mr. Bonington, became a headmistress's husband.

One of the most striking instances of such vocational duality was to be found at Oxford where, from 1760 until almost the end of the century, the sole drawing-master was a violinist who supplemented his salary as leader of the Music Room orchestra by teaching drawing to the undergraduates and younger residents. This was the German-born John Malchair (1729–1812) who, during his long residence in the university city, founded what, with some justification, may be termed an Oxford School of landscape.

The son of a watch-maker, Malchair was born in Cologne, where in 1744 he was accepted as an alto for the cathedral choir, of which he remained a member for six years. Between 1751 and 1754, when he arrived in London, it is only known that he spent some time in Nancy, where he afterwards recollected having made his first drawing from nature. Though trained as a singer, it was as an orchestral violinist that he first gained employment in London, where he also taught music and drawing. Through meeting an English officer who had known his family in Cologne, he next found work as a music teacher at Lewes. After two years in Sussex he was brought to the notice of Robert Price, who invited him to Foxley in Herefordshire, and then saw him settled in Bristol. In the autumn of 1759 the post of leader of the Music Room 'band' (as it was called) in Oxford fell vacant, and through Shute Barrington, Robert Price's brother-in-law, Malchair successfully obtained the appointment— a position that he held until his retirement.

Within a year of his arrival at Oxford he had married a local girl, Elizabeth Jenner, and, to augment the regular but slender salary he received from the Music Room Stewards, he set up as a teacher of drawing and of the violin. Both the time and the place favoured his practices—especially as a drawing-master. The young experienced a novel pleasure in learning to appreciate landscape, if only as a preparation for the Italian tour, and Oxford itself had never before possessed a resident teacher of drawing. Soon Malchair had gathered about him a company of lively and amusing young friends who, after an initial training in draughtsmanship, he was able to lead out into the surrounding countryside, on foot or by water, for day-long sketching parties. His 'school'[1] nicknamed its master *Giovanni Battista, Il Colonnese* (an honorary christening which, in the anglicised form, he afterwards adopted quite often), and referred to the sketching excursions as 'Eggs and Bacon' or 'Pork Griskin' expeditions. For a while, contentedly married, with a busy musical life and a seemingly

[1] Which at that time included John Skippe, Robert Price (the son of his old patron), Peter Rashleigh, Thomas Frankland (of Thirkelby, Yorkshire), Luttrell Wynne, Heneage Finch (then Viscount Guernsey, but later the 4th Earl of Aylesford) and his brother Daniel, George Legge (afterwards the Earl of Dartmouth), the young baronet George Beaumont, and Oldfield Bowles of North Aston. William Amherst (later the Earl of Amherst), W. H. Barnard, Edward Nares, James Austen (Jane Austen's eldest brother), and William Crotch were among the later pupils.

228

inexhaustible supply of youthful pupils, Malchair flourished in this Oxford Elysium. But it did not last.

In 1773, after a very short illness, his wife died. In 1776 he attempted to gain a footing as a topographical draughtsman and failed. He began to write a book on the art of landscape painting for beginners, and gave up. There was a temporary improvement in his fortunes when the second Lord Clive took an interest in him and when he privately published three very successful views of Oxford as it had appeared before its re-modelling by John Gwynn in the '70s. But, tethered as he was by his Music Room duties, he was never able to take full advantage of such professional openings. The nadir was reached in 1789 when, after a run of unsuccessful seasons, the regular Music Room subscription concerts ceased, and he became almost entirely dependent on his teaching for a living. His musical career ended tragically in 1792 when, during a tumult at one of the new season's concerts, a gang of rowdies started throwing fruit at the orchestra and an orange broke the better of his two violins, 'a fine Cremona'. He never played in public again.

Meanwhile a few friends who cared for his welfare had decided to launch an appeal on his behalf, and the response—mainly, one supposes, from his old pupils—was remarkable. With the £1000 subscribed and part of his own savings, an annuity of £150 was bought for him which enabled him to spend his remaining years in retirement at his house in Broad Street. He had visited Wales twice before, in 1789 and 1791, and in 1795, before blindness overtook him (his final drawing, a mere scribble, is dated 1799 in another hand), he made one last tour of its northern counties—in more senses than one his *ultima Thule*. From this journey of four weeks he returned with fifty-one drawings, most of them on a scale larger than any he had done before.

Always of a gentle and pious disposition, music, religion, and the devotion of a new young friend—Oxford's precocious young Professor of Music, William Crotch—provided him with all the solace he needed when his sight left him.

Though many of the leading instrumentalists who played at the Oxford concerts were also friends and he was a familiar figure at various annual music festivals such as the Three Choirs (in which he took part for nearly twenty years), Malchair was most widely known as a drawing-master. As he only exhibited once—at the Royal Academy, in 1773—and apparently made little or no attempt to sell his work, only a privileged few had any idea of his true powers as an artist, and those, mostly amateurs, regarded him in this respect as a lover of the art like themselves, as one apart from professionalism and its associated standards of performance. Fortunately, for an estimation of his capabilities as a teacher we do not have to rely entirely upon contemporary comment, his extant pedagogic drawings, and the work of his pupils. In his last sighted years he returned again to the task of writing a book on how the young should be taught the art of landscape, and this work has survived in the form of an autograph manuscript. Entitled *Observations On Landskipp Drawing with many and various Examples Intended for the use of beginners*, and subtitled *Rules and Examples for the drawing of Landskipp according to the practise at Oxford*,[1] it is a revealing document, for many of the techniques he recommends and describes for the young were those he himself practised, and the thoughts he put down for them reflect a faith in which he as an artist implicitly believed.

Briefly, he taught thus. The first lessons were devoted to the management of a broad and soft 'lead' pencil, to a study of the kind of marks which it could produce under rhythmical handling and

[1] Coll. Mr. Ian Fleming-Williams.

varying degrees of pressure, and to the establishment of a simple ABC of semi-representational notation and textures. At all the early stages he taught by example and this alphabet he demonstrated to the pupil as though he too were a beginner. Although teaching in this manner by example was current practice, unlike the majority of his contemporaries (and even those in succeeding generations) Malchair made it his principle always to minimise his own skill and invariably to draw down to the pupil's level of attainment, or, if need be, just a little above, so as to lead him on. In the *Observations*, after detailing the materials most suitable for the beginner, he digresses to describe what he considered to be a proper relationship between teacher and pupil.

> It is necessary to pause a while in consideration of those who very early in life show a disposition of exercising themselves in this art. Hardly anywhere can a teacher display more judgement than in the contriving proper means for assisting them in this pursuit. It is often more easy for an able artist to produce a skilful drawing, than a proper lesson for a child, because the master in this case must refrain his powers and carry back his recollection to the time when he himself was but feeble in his art.

After rating 'false critics and pretending judges', who seek to overawe the pupil and use the language of the artist to cover their own ignorance, he continues:

> One who would teach a child, must draw like a child to conceal his skill as much as possible. His style must gradually improve as the pupil advances; he must even seem to learn the art rather than to teach it. He must also be very patient and careful not to tire the young one, but leave off before a surfeit comes on. He must at times confess that the task is rather difficult, for nothing is so humiliating to a learner as the master's telling him that the very thing which he cannot do is extremely easy.
>
> If the instructor shows a more finished performance in order to give the learner a foresight of what is yet to be done, he must declare that he spared no labour in producing it. He must by no means say that he did do that in half an hour which the scholar despairs of ever being able to do at all.

'To draw like a child while teaching a child', and 'to seem to learn the art rather than to teach it': it is difficult to reconcile such principles with one's notion of education in the eighteenth century, but these are not the only passages in the *Observations* that one would expect to find in writing of a much later date.

Having familiarised the pupil with the required repertoire of touches—lines, flicks, scribbles, dots, squiggles and smudges—these were then combined straight away into simple little compositions containing some feature such as a cottage or tower. Right from the start the finger and stump were brought into use for rubbing and smudging. Also right from the beginning, the pupil was encouraged to work with the utmost freedom, to enjoy the flowing movements of the hand, for 'nothing impedes the beginner so much as the intricacy of finished works'. Once he had learnt to associate this multiplicity of different kinds of marks with experience, to appreciate that a blob could be a window, a bush, or a rock, and that a wriggle of a pencil could produce a tiled roof, a rut, or a twig, the pupil was given more elaborate exercises to copy. With these, in which Malchair exhibited greater skill, his pupil was made to realise that 'hitherto their work had been done but coarsely' (a touching use of the possessive adjective), and that now it was 'necessary to endeavour strongly to mend their hand'. Having known the delight of free movement, the scholar appreciated the need for control and the acquisition of manual skill.

Malchair had strong views on the use of line, as 'natural objects have, strictly speaking, no outline and may be imitated without the help of lines in painting',

> In drawing [he continues], the artist is often rather obliged to use them [lines] in order to make out the form and dimensions of the several objects, before he discriminates the mass by shadow and

complexion. Outline is not a sufficiently precise word to express the painter's way of beginning his work. The italians more properly use the word contorno—circumference, bound or extremity. The painter, as has been observed already, may express an object without the assistance of lines, by beginning at once with the shadows and complexions. But if he chooses to mark out the extremities first, he undulates his chalk or lead about in a particular way, at times so tenderly as to be scarce visible, which is generally the case when he marks that part of the object which is towards the light, then again he swells out broad, which he can do tenderly or strong in the proportion he thinks fit and best adapted to express Nature. Often he leaves, as it were, the continuity of his line to supposition, then breaks out all at once in dots of all manner of size and complexion, or in a variety of jaggedness. In short, the formation of his extremities is itself painting in some degree already.

Almost from the start, the pupil was taught to work tonally, in masses. Throughout these early stages Malchair's aim was to teach 'the alphabet of a language', so that when a pupil drew from nature he would 'readily account for every touch he had learned'. This is the key to the Oxford training: that a scholar should bring to his first experience of direct vision only this alphabet of touches, not—to continue the analogy—a ready-made vocabulary. There is a fundamental difference between this attitude and those which obtained in most other centres where, even if it was the intention to study nature, and this was by no means always the case, the training aimed at providing just such a vocabulary, which would, of course, condition the student's choice of subject as well as his eventual response to it.

The amount of time the pupil spent on the preliminary stages indoors must of course have depended on his rate of progress and his inclinations, as well as upon the season of the year. With extemporised compositions, ideal in character, of an ever-increasing complexity and variety of mood, and with other models—such as engravings after the Carracci and Claude—the pupils were nurtured until they were ready to leave the nest, as it were, for the first flight into the open. The *Observations* stop short before this moment was reached, but among the mass of Malchair's drawings at the Ashmolean Museum and Corpus Christi College there are at least sixty which can safely be classified as having been done during lessons out of doors; a number are so inscribed. A study of these reveals a general pattern, but little in the nature of a routine. The pattern seems to have run this way In the first lessons, the pupil was simply made to feel at his ease; then he was shown how to use his alphabet; then to notice phrases; then to compose; then to particularise and to compose his particular phrases; and finally how to achieve an independent vision, to be able to look about for himself and respond to direct visual experience. The drawings illustrate these successive stages. There are slight sketches drawn in a disarmingly simple and casual fashion for a pupil daunted by the difficulties which confronted him for the first time. There are more elaborate sketches of the phrases which could be seen at every turn: Magdalen Tower and its reflection; willows beside an elm; a sapling through which the light was passing. Numerous examples survive from the stage which followed—the development of simple compositions—in which particular attention was paid to the unique character of every individual viewpoint. With the next series, he is to be found luring his scholars onwards. Wide-sweeping vistas were less frequently chosen; more attention was given to the particular, to foreground, to things near at hand, in which the abundance of material was less overwhelming and in which the unique character of every part could be more closely studied. Gradually the pupil was taken further and further afield in search of suitable motifs until he could at last be liberated from the restriction of conventional response. These were the final lessons. Here the training ended. Here the pupil attained his majority.

The progress so planned can, of course, seldom have worked out so. Many never completed the

course. Some, unable to shed their earlier training at school, were already too set in their ways to benefit from such tuition. Others only wished to ape their master's manner. But a few, such as Aylesford and Crotch, did achieve emancipation, and it was these that sowed the seeds for future harvests.

As an artist in his own right, Malchair has not received a great deal of attention. This is understandable. Until comparatively recently he was to be found in none of the standard works of reference (with the exception of the Grove's *Dictionary of Music and Musicians*); outside the Oxford collections, which comprise the bulk of his surviving output, his work is seldom to be met with; and before he can be judged as an artist it is necessary to separate the drawings he did for their own sake from those made for his pupils which, in varying degrees, are intentionally poor in quality. He merits some study, however, for in fact he was an artist of originality with a rare sensitivity and an intensely personal feeling for landscape.

Apart from his acknowledged debt to Robert Price—'from whom I received a deal of useful information respecting the art of drawing'[1]—nothing is known of any training that he may have received as an artist. In all probability he was largely self-taught. As it was almost invariably his practice to inscribe his drawings with place-names and dates, we are seldom in any doubt as to where and when he sketched. Before 1760, London, Sussex, the Bristol area, and Herefordshire, furnished him with his subjects. After that date it was only during the summer vacations that he was able to spend more than a night or two away from Oxford, and the majority of his drawings were either made within walking- or riding-distance of the University, or among the lanes and quiet corners of the city itself. Up to 1776, in September, he is often to be found in the neighbourhood of Gloucester, Worcester or Hereford where, at the time, he was playing in the Three Choirs' Festival. With the exception of the three tours of North Wales (1789, 1791 and 1795), after 1780 only visits to friends such as John Skippe, or to one of Lord Clive's estates—near Ludlow or Montgomery—took him away from the Thames Valley.

Something of Malchair's originality stems from the fact that he learnt his art in the open fields and remained relatively unaffected by current convention and practice. But it also derived in part from his economic independence as an artist which enabled him to work as he pleased without having to render his experiences in a manner necessarily intelligible or acceptable to others. Though demonstrably a water-colourist, his favourite medium was soft pencil and monochrome wash which he used in a manner peculiarly his own, the 'lead' pencil as though it were a brush, the wash to the limit of its capacity between the extremes of wet and dry. Working in monochrome was thus for him a kind of painting, and (as he has already been quoted as saying) in painting, objects can be represented without linear outline which, strictly speaking, does not exist. With this technical equipment his approach to landscape was essentially that of a tonalist, of one with an eye for colour reduced to its tonal values, as it is so reduced in a black and white photograph. This tonal regard for nature had a liberating effect upon his choice of subject-matter, as it enabled him to consider as suitable motifs scenes and natural phenomena for which the linear vocabulary was inadequate—the varying effects of sunlight at any angle to the line of sight and at any time of day, atmospheric modulations, patterns of texture, and momentary effects like the blanching of willow leaves in a breeze or sun-beams revealed by the dust of demolition (Pl. 252). Certain passages in the *Observations* reflect this enhancement.

[1] Written on a scrap of paper attached to the first page of Vol. II, Malchair drawings, Corpus Christi College, Oxford.

232

Although the morning and evening with the autumn are favourite times for the painter, yet he well knows that nature can paint at all seasons and hours, for she has an innumerable variety of extraordinary ways to produce effects for painting, many of which are full as sublime and awful as the rising or setting sun. Wonderful effects are observable when the objects are between the sun and spectator, but they are so little known that few would subscribe to the truth of them were they ever so well represented. Nothing is more enchanting than the shadows of clouds travelling on the surface of the earth. Their extremities occasion the most variegated prismatic effects on trees, mountains, buildings and all other objects, while the more opaque part of them renders all that is eclipsed by it most solemnly obscure. One half of the prospect dazzles the eye with splendour while the other is, in part, scarcely visible, then suddenly each side changes complexion and forty different pictures are produced from the same subject in an hour.

His growing interest in transient effects led him in 1769 to start noting the precise hour when he made a drawing (by means of a numeral and a stroke—e.g. 9/, signifying 9 a.m., and /9, denoting 9 p.m.). This soon became habitual. In the same year, after writing the date and the name of the place he had drawn, for the first time he added a comment—'approach of a thunder storm'. Thenceforth, observations on the weather or on some other matter appear frequently. The following are typical: 'The first drawing of this unpropitious summer'; 'a prodigious fine evening, a cessation of a dry cold north wind'; 'the approach of a thunder storm—very hot, wind south and west, a heavy shower at 4 o'clock, no lightning and but one faint and distant clap of thunder heard at the end of the shower'; and 'Heard the Nightingal and Cuku'.[1]

While fully conversant with the traditional modes of landscape composition—which he was happy to teach his pupils—hardly ever do they seem to have been in his mind when he was selecting a subject and deciding upon his viewpoint. Instead, he appears to have allowed the scene to compose itself, as indeed it did when he had found the exact position from which to work and had taken some care over framing the result on his paper. The view *At Longfort in Lord Rhadnor's Park near Salisbury* (Pl. 250) illustrates how critical the choice of viewpoint could be. One of a series that he made of Oxford views in 1776, the *Tower and Chapel of Oxford Castle* (Pl. 251), taken at 7 o'clock in the evening, is another drawing for which the artist carefully positioned himself. In this case it is the lightly sketched foreground which makes a significant contribution. Among both topographers and painters of landscape at this time it was customary to take as the foreground or bottom edge of the picture a line which lay some distance ahead, which, by keeping even the nearest objects at a distance, left the spectator uncommitted to any particular point in space and enabled him to wander, so to speak, at will before the scene, to enter it where he wished and leave it how he chose. In such works the landscape plays a passive part. It is there to be visited. A double-page in Vol. I of this work (Pls. 57–60) of drawings by Hoppner, Richard Cooper and the elder Barret exemplifies this type of composition. In the work of Cotman, on the other hand, we are given no such options. By drawings such as the *Shady Pool* (Vol. II, Pl. 72) and the *Ploughed Field* (Vol. II, Pl. 73) our eye is held at the apex of the cone of vision, as it is only at this point that the scene revealed the particular disposition that the artist required. Malchair's *Oxford Castle*, here reproduced life-size, is an early example of a landscape composed by means of the single point vision. His inscription on the back of the *Moel y Frydd* (Pl. 253), with its idiosyncratic spelling, reads: 'Moel y ffrydd Near Llanummowddy in Merioneth shire—met

[1] Among those of Malchair's pupils who adopted their teacher's habit and manner of so inscribing their drawings, none took to it with more enthusiasm than William Crotch. It is perhaps worth noting that Constable seems to have started inscribing his drawings in a similar fashion around 1806—the year in which he and Crotch first became acquainted.

with Mr. Richards the clargyman of the place.' The drawing has been cut down by about an inch all round and the date is consequently missing, but an autograph hand-list[1] enables it to be identified as one of three he did on the same day—August 4, 1795—while staying at Dinas Mawddwy. In general his work is lacking in strength, a reflection, perhaps, of his gentle and sensitive disposition. By contrast, the drawings of the '90s are vigorous and boldly expressive as though, before his sight finally left him, he had found some deep and hitherto unsuspected reserve of power within himself.

In the past, artists with teaching practices have all too freely been referred to as 'fashionable drawing-masters'. This designation has its proper uses and should be used with discretion to distinguish those whose practices were conducted for an exclusive clientele. The elder Cozens, Gresse, Paul Sandby, John Varley, Girtin and Glover may all rightly be described as fashionable teachers of their day. Francis Nicholson and William Payne, the next two artists with whom we are concerned, were also drawing-masters with flourishing practices who were patronised by the fashionable *élite*. The first of these, Francis Nicholson (1753-1844), was born at Pickering in Yorkshire. At the local secondary school which he attended, his master predicted that he would be another 'Cozens, who went to London and became a famous draughtsman', a remark which indicates the high repute enjoyed by Alexander Cozens at that time. After taking lessons for three years from a painter at Scarborough, Nicholson returned to Pickering, where he found sporting patrons who wanted portraits painted of their horses and dogs. He made two prolonged visits to London for the purpose of further study (partly under Conrad Martin Metz), and on returning to Yorkshire settled at Whitby in 1783. He was now painting portraits and water-colour landscapes, and at Scarborough 'during the spaw [Spa] season' his drawings had a ready sale. Even at this early period he was an experimenter. 'For Scarborough', he writes, 'I manufactured an incredible number of drawings. My process was by etching on a soft ground the different views of the place, from which were taken impressions with black lead. This produced outlines so perfectly like those done by the pencil, that it was impossible to discover any difference. This was nearly half of the work, and in the long days of summer I finished them at the rate of six daily.'

In 1789 he first exhibited at the Royal Academy, and began to furnish drawings for Walker's *Copper Plate Magazine*, in which fourteen engravings after his pictures appeared with dates ranging from 1792 to 1801. Leaving Whitby in 1792 he went to Knaresborough, finding his market now at Harrogate, where he attracted the notice of a distinguished patron, Lord Bute, and was taken by him to make drawings in the island of Bute. Moving after this from Knaresborough to Ripon, he won the patronage of Walter Fawkes of Farnley Hall, Turner's patron, who purchased several of Nicholson's drawings in 1798, when his top price was £2 2s. By 1803 Nicholson had settled in London. He was by now a successful painter, and soon became in great demand as a teacher. An amusing account of what it was like to have become a fashionable drawing-master is given in the notes for a biography of the artist written by a member of his family.

The opening of the Water Colour Exhibition in the year 1805 may be dated as the commencement of Mr. Nicholson's fame and success in London. In conjunction with Glover, Varley, Prout and others an advance in the art of water colour painting was made such as to astonish and call forth the admiration of the public. The next step, after admiring, was to imitate the work of these artists, and for some years after their doors were beset and the streets where they resided thronged with the carriages of the nobility

[1] Coll. Mr. Ian Fleming-Williams.

and gentry. It became an absolute craze among ladies of fashion to profess landscape painting. They eagerly paid their guinea an hour for the privilege of witnessing the progress of a picture by their favourite professor. To such a degree was this mania carried that every hour of the day was devoted to this easy and lucrative employment, and the more difficulty there was found in obtaining permission, the greater of course became the anxiety to gain it. No time was too early, no hour too late, for receiving what was called a lesson. It may be remembered by one lady—should she read this—that in applying to know the hours Mr. Nicholson had to spare she was told 'the only one vacant was at eight o'clock in the morning, twice a week'. 'Oh,' she exclaimed, 'that is quite impossible—I never get to bed before four or five in the morning.' Finding, however, there was no alternative, and resistless fashion ordaining that she should be a pupil of Nicholson, she actually used to be roused from her first slumbers and in an elegant *deshabille*, nightcap, and with hair *en papillotte*, repair to Charlotte Street at the early hour specified. It is true she yawned much during the period of the visit, but at nine o'clock her carriage fetched her home to resume her broken night's rest and to obtain the requisite energy for commencing the dissipations of the day, and with the comfortable reflection of being a Pupil of Mr. Nicholson.

In 1804 Nicholson joined in founding the Society of Painters in Water-Colours, and at its first exhibition sold a large proportion of his fourteen exhibits, the average price being £5 12s. and the highest £15 15s. In the following year he increased the number of his exhibits to twenty-six, and in 1809 to forty-one. Within a few years he had amassed sufficient means to keep himself in comfort, and though he continued to draw for his own pleasure and to make experiments with pigments and vehicles, he retired from active work long before his death. 'In 1844 we lost the aged Nicholson, whose last effort, when dying at the age of 91, was to have himself lifted up, to brighten a dark cloud in a picture of a shipwreck.'[1] So writes Harriett Martineau, that 'dim daguerrotype in the album of old renowns'.

Nicholson's work covers a very long period and varies considerably in style. His early drawings (he was well over thirty when he settled down to landscape work), such as the *Dropping-Well, Knaresborough*[2] (Pl. 254) are in the tinted manner, shaded with Indian ink and then coloured. Round about 1795 he was making drawings of *Blackfriars Bridge* and *London Bridge* exactly in the style of Malton. Soon after 1790 he was painting mountain and lake scenes such as the *Loch Lomond*[3] of 1794 with rather thin and metallic colouring. Here and in *Kirkstall Abbey*[4] of about the same date notes of emerald and pale blue appear among the foreground foliage, and a key of pale blue pervades the whole drawing. There is in his work at this period a lack of accent and contrast; though the lighting is that of sunshine, there is nowhere any warmth. The foliage at this date is characteristic and both of these drawings suggest that Nicholson knew and followed the methods of William Payne. His usual subjects were romantic rocks and shipwrecks, lake scenery and waterfalls. The *Cascade near Gayle, Wensleydale*[5] is a good example of his skill in rendering the mass and torrent of a waterfall, but here, as in his landscapes, his work is too soft, woolly and indecisive. He relied overmuch on what he called 'washing in and washing out', and on the use of sponge and stump. Though a man of ideas and probably an excellent teacher, he was on the whole a mediocre artist.

In 1820 Nicholson published an illustrated quarto volume, *The Practice of Drawing and Painting Landscapes from Nature, in Water Colours . . . with observations on the Study of Nature and various other matters relative to the Arts*. In this treatise he describes his stopping-out process for securing highlights, to which reference has already been made. It may be added, however, that it was in 1799, more than

[1] *History of England during the Thirty Years Peace*, 1849.
[2] B.M. 1876. 5.10.925(LB.3).
[3] V.A.M. E.344-1927.
[4] Coll. Herbert Acford, 1932.
[5] V.A.M. 367-1880.

twenty years before the publication of the *Practice of Drawing*, that the council of the Society of Arts passed the following resolution:

> Having received this session from Mr. Francis Nicholson of Rippon [*sic*] in Yorkshire, a Drawing intended as a specimen of the Process for producing the lights in stained Drawings, by removing, after the shadows are washed in, the Colour where the lights are required; giving by this means the effect of Body Colour with greater clearness and without any of its disadvantages: and it appearing that Mr. Nicholson's method of tinting drawings promises to be of use in the practice of Drawing in Water Colours, and produces a more spirited effect, the Society agreed to Mr. Nicholson's proposal, and purchased from him, at the price of Twenty Guineas, the complete process for performing the Work.

Nicholson's process, perhaps because it had an air of mystery, was overhauled in his lifetime and was given credit for many effects produced by much simpler means. This is illustrated by an amusing account written by W. H. Pyne[1] with reference to the Earl of Warwick (John 'Warwick' Smith's patron):

> His Lordship, who had travelled, saw nature with the eye of a painter; and possessing this feeling, he naturally became a collector of such works as might promote his improvement, in an art in which he took so much delight.
>
> 'On looking over his portfolios, containing the works of Sandby, Rooker, Cozens, Warwick Smith, and others of the water-colour school,' saith my informant, 'I was struck with some clever pieces, scenes in Ireland, executed in body colours by Walmsley, one of the scene painters at Covent-garden theatre. The subjects were highly picturesque, representing rocks and waterfalls, his Lordship's favourite studies.'
>
> 'What think you of these?' said my Lord Warwick—'I admire them much, Sir: the rocks are boldly designed;—but what I most admire is the water, rolling so turbulently over its rocky bed. There is the advantage of body colours, my Lord, you can *put on* the lights; now, in transparent water-colours you must *leave* the lights; hence, you never can represent such scenes with clearness, force, and spirit, united. There rests one of the insurmountable difficulties of that species of art, touching the means for the faithful imitation of nature.'
>
> 'Now Sir,' replied Lord Warwick, 'this is what I expected;—every connoisseur—nay, almost every artist—has made the same remarks; but, Sir, I will surprise you, and that, I trust, most agreeably.' His Lordship then drew from his portfolio two large drawings, scenes in North Wales, of subjects similar to those of Walmsley's. When my informant, who was no mean professor himself, exclaimed, 'Marvellous! Is it possible? Can these be done in transparent water-colours?' 'Yes Sir.' 'By whom, my Lord?' 'By Francis Nicholson, a provincial artist, living in the neighbourhood of York.' 'I never heard the name, My Lord, till now.' said the professor; 'but as Pope said of our great moralist' (then in obscurity), 'he will soon be *deterré*. Such a genius must be one of us: the metropolis is his sphere.'
>
> We have lived to behold such wonders in water-colour painting, that of late, nothing short of a miracle in this art could excite surprise.
>
> The discovery of Mr. Nicholson's process for preserving the heightenings pure and clean in touch, threw a new light upon this department of study; and, it is manifest, that from the time his drawings appeared upon the walls of the first exhibition of the Society of Painters in Water Colours, in Brook-street, that many of its members, professors of landscape, have wrought their elegant designs with a greater degree of force and effect. For although each continued to pursue *his own particular style*, yet the example of such works, exhibiting, as they did, powers and capacities in the materials with which they were wrought, that had been developed by him alone, acted as a stimulus to their exertions. Hence, we now behold in the paintings in water-colours, a boldness, richness, and daring splendour of effect, which, referring to the designs of our best professors, in some degree emulate the powers of paintings in oil, and incorporating with these properties, those peculiar to water-colours, the British school has, at length, achieved the honour of having created a new, and most captivating style of art.

Some technical points in Nicholson's book are of interest. Though he is said to have been specially interested in securing the permanence of colours, he advocates the making of all greys in under-

[1] *Somerset House Gazette*, I, 1824, p. 30.

painting with a mixture of indigo and Indian red, a fatal process because the indigo of his time always faded on exposure to light, leaving the underlying red as the dominant tone. What is more interesting is that, at this early period, he recommended the process of damping the paper, even for the tinted drawing; sometimes wetting the back of the paper, sometimes taking off superfluous moisture from the front surface with tissue or blotting paper. This marks a change, for it seems fairly certain that Sandby and the topographers worked on a dry surface, though James Roberts in 1800[1] said that it was 'absolutely necessary to wet the drawing *on the back*', especially while painting skies. Another part of his book deals with the direct laying in of local colour, which was the accepted practice by the time his book was published. Nicholson, who was brought up in the methods of the older school, saw that the direct laying of natural colours was likely to give more brilliancy, but, as he shared with his contemporaries a belief in perfection of tone relationship, was afraid that the absence of modelling in shades of grey throughout an under-painting might cause loss of breadth, harmony and repose. At the same time he had sufficient enlightenment and liberality to welcome changes of procedure.

Though a teacher with a wide circle of pupils like Nicholson, William Payne (*fl.* 1776–1830) was on the whole a better artist. Of Payne's early life little is known except that he came to London in 1790 from Plymouth, where he was employed as a civil engineer in the Dockyard. Basil Long[2] gives reasons for caution in accepting the statement that he was a native of Devonshire. He developed a style of his own, and exhibited first in 1776 (so we may put his birth-date at about 1755 to 1760), and from 1786, while still residing at Plymouth, exhibited local views at the Royal Academy. Sir Joshua Reynolds praised his work and was specially interested in drawings of the slate quarries near Plympton, his own birthplace. In 1809 Payne was elected an associate of the Society of Painters in Water-Colours, exhibiting there from 1809 to 1812. His prices (given in a manuscript list in the Library of the Victoria and Albert Museum) were high compared with those of Nicholson. In 1809 he sold *View near Lidford, Devon* and *Vicinity of Dartmoor* for forty guineas each, and *Chepstow Castle* for thirty-five guineas. In the next three years he disposed of several pictures at a price of thirty guineas apiece. He exhibited also, at the British Institution and elsewhere, at various dates from 1809 to 1830. There is no evidence that he was living after 1830.

Payne's great popularity as a drawing-master no doubt increased his sales and enhanced his prices. W. H. Pyne[3] wrote:

We must not neglect to name Mr. William Payne, as his style preceded that of Glover's. To this gentleman's commencement as a teacher, indeed, properly may be dated the fixed period for superseding the established precepts for teaching, for the more fascinating properties of washing, colouring, and effect. The method of instruction, in the art of drawing landscape compositions, had never been reduced so completely to the degenerate notions of this epoch of bad taste, as by this ingenious artist. Mr Payne's drawings were regarded as striking novelties in style. His subjects in small, were brilliant in effect, and executed with spirit—they were no sooner seen, than admired, and almost every family of fashion were anxious that their sons and daughters should have the benefit of his tuition. Hence, for a long period, in the noble mansions of St. James's Square and Grosvenor Square, and York Place, and Portland Place, might be seen elegant groups of youthful amateurs, manufacturing landscapes, *à la Payne*. The process certainly was captivating, as exhibited in his happiest works, though much of their merit was the result of dexterity and trick, as exemplified by the granulated texture obtained by *dragging*.

[1] James Roberts, *Painting in Water-Colours*, 1800.
[2] B. S. Long, 'William Payne', *Walker's Quarterly*, January 1922.
[3] *Somerset House Gazette*, 1824, I, p. 162.

His pupils, however, were not all amateurs, for in 1794 John Glover told Farington that he had received eight lessons in drawing from Payne. His method of 'dragging', mentioned in the above excerpt, is again described[1]:

> It should be observed, that the ingenious inventor of this style contrived to use the painting-brush for the foreground, in a way that he termed *dragging*, namely, on its side, which dexterously applied, left a number of accidental lights, very useful and characteristic of pebbles on the sea shore, or for a gravelled road, and particularly effective in producing the roughness on the surface of rocks, or the texture of the bark of trees. The whole being carefully tinted, by a judicious washing and blending, which must be done by passing lightly over the whole with a painting brush moderately saturated with pure water, the drawing is then ready for the finishing touches. This last operation is performed by taking advantage of those accidents and lights which the drag of the brush has left, and by undertouching and adding spirit to the shadows with Cologne-earth, or Vandyck-brown, separately, or mixed with the other tints as may be necessary; and by this simple process in proportion to the taste and judgment of the operator, will the drawing be valuable as a work of art. This may be justly said of the process;—that, applied by the amateur who is an adept at execution, and imbued with a taste for design, very delightful drawings may be wrought thereby. The style of Payne, indeed, is so eminently calculated for producing effect with facility, that it is peculiarly suited to the amateur who practises landscape drawing merely for amusement.

Basil Long points out that the dragging used so freely by Turner, Cotman and others was not invented by Payne but occurs in water-colours by Dutch artists of the seventeenth century. Payne, however, possibly discovered it for himself and influenced others by his use of a pleasant device.

Many colourmen still list a pigment named Payne's Grey, which he invented, containing a mixture of Prussian blue, lake and yellow ochre. It was the basis of all his work. The following article[2] may be quoted, first because it suggests that he had died before 1831, and secondly for its description of his method:

> His style was easy to comprehend; it was showy, and the coteries of fashion and the votaries of novelty patronized it with a furor that is scarcely to be matched in the annals of modern charlatanry. The process, nevertheless, in the hands of a skilful artist, was capable of producing works agreeable to the eye, and valuable in proportion to the taste with which they were designed and executed; although its ingenious inventor degenerated into a style of unsufferable mannerism.
>
> The chiar'-oscuro of this style was principally wrought by the use of a compound colour denominated 'Payne's gray'. With this and a mixture of indigo the sky was prepared, and the distant mountains laid-in; the middle-ground was effected with the gray alone;—and the foreground was prepared with lamp-black or Indian-ink. These materials working freely, and combining in a pleasing harmony of simple light and shadow, afforded a ready preparation for Mr. Payne's process of colouring;—and simple enough assuredly it was. The sky was warmed with a wash of gambouge and light red, or mineral red, precipitated in that yellow pigment. The rocks, banks, and fore-ground, were strongly tinted with burnt-sienna, and yellow-ochre; and the trees were coloured by the varieties of green compounded of burnt-sienna, indigo and gambouge.
>
> Thus prepared, the vigour of the finishing on the bark of trees, on the rocks, the irregularities of the fore-ground, and other near objects, was superseded by touches of Vandyck-brown, or Cologne-earth. How many waggon-loads of woven elephant and imperial, 'ye gods' were consumed by amateur artists in the reign of King George the Third, of blessed memory, in practising the elegant art of drawing-à-la-Payne!

In some of his earlier works, such as *View from Stonehouse Bridge*,[3] Payne comes close to Nicholson and the earlier topographers, but though he clung to their practice of underpainting in grey, he aban-

[1] *Magazine of the Fine Arts*, I, 1832.
[2] *Library of the Fine Arts*, II, 1831, p. 364.
[3] B. Long, *op. cit.*, pl. I.

doned the pen outline and worked freely with brush outlines, almost like a Chinese painter. The most typical works to illustrate his later style are his *Landscape Composition*[1], *Coast Scene with Figures*[2] and *Waterfall*,[3] all of them showing his liking for a dark foreground, with a heavy mass of rocks, trees or shadow on one or both sides, and light tints of grey under warm washes of yellow and orange in the middle distance. Basil Long refers more than once to reddish tones in Payne's drawings, but perhaps these are due to the fading of indigo. With his free, flowing touch Payne showed great manual dexterity. A particular trick of his brush-work appears in the striations, or quasi-parallel strokes, usually of lamp-black or Indian ink in the foreground and of Payne's Grey in the middle planes and distances, with which he breaks his surfaces. 'These striations', says Long, 'run in all directions and consequently sometimes form angles with each other; they are frequently horizontal or nearly so, notably in the foreground and on water; on trees of the middle distance, for instance, or on figures they are often diagonal; their length varies from small fractions of an inch to, say, an inch and a half.' Long, who always took the keenest interest in Payne's work, drew attention to another group of drawings, mostly compositions made on rough, brown, rather absorbent paper, and largely painted with opaque colour. Among them are the *Shipping at Swansea*[4] and *Coast Scene with Figures*. These, and indeed his other drawings as well, are distinguished by his skilful indication and grouping of his figures— peasants, fishermen, smugglers or wayfarers. In 1826 he was painting small subjects, e.g. his *Conway Castle*[5] in solid body-colour on white paper. An exhibition of Payne's work was held in 1937 at Plymouth, and the permanent collection in the Plymouth Art Gallery contains many examples of his art, which was very largely devoted to west-country subjects.

The French colony in Dublin during the eighteenth century harboured and produced not a few artists. Among those born of Huguenot parents were the two brothers John James Barralet (1747–1815) and John Melchior Barralet (*fl.* 1774–1787), both of them painters in water-colour and drawing-masters. For a short time John James ran a drawing school in James Street, Golden Square. John Melchior was probably the younger brother, and his birth may be dated as about 1750. In 1774 he was living in London; exhibited at the Free Society of Artists in that year, and at the Royal Academy till 1787; then fades from notice, and little more is known of his career. W. F. Wells is said to have received some lessons from him about 1774. J. M. Barralet's admirable work in the tinted manner is reminiscent of Sandby, and is well exemplified by *All Saints' Church and the Archbishop's Palace*,[6] *Maidstone* and *Courtyard with a Mansion, with Figures*.[7]

Probably also of French parentage, John Laporte (1761–1839) almost certainly received lessons from J. M. Barralet, for there is obvious affinity in their work, and in 1779 Laporte gives his address as 'At Mr. Barralet's, No. 3 Orange Street, Leicester Fields'. Basil Long, who was interested in Laporte as well as in Payne, embodied the results of his knowledge and research in an article on Laporte[8] and gives very full information about this artist and his work. He exhibited at the Royal Academy from 1779 to 1832, and at Suffolk Street, the British Institution, and the New Water-Colour Society. He had a considerable practice as a drawing-master, and Dr. Thomas Monro was among his pupils. He continued his relations with the Monros for many years, and Monro told Farington[9] that he had

[1] V.A.M. 1051–1884. [2] V.A.M. 48–1879. [3] V.A.M. 1053–1884.
[4] V.A.M. 49–1879. [5] Walker's Gallery, 1922.
[6] V.A.M. 507–1873. [7] V.A.M. P.20–1925.
[8] B. Long, 'John Laporte and P. La Cave', *Walker's Quarterly*, VIII, 1922.
[9] *Diary*, July 5, 1803.

239

purchased drawings from Laporte to the value of £500 or £600. For the use and instruction of his pupils Laporte issued several works, usually illustrated by soft-ground etchings, such as his *Sketches of Trees*, 1798–1801, which contains not merely tree studies but drawings of landscape and architecture; a *Drawing Book*, 1800; and *A New Drawing Book*, 1809. From 1801 and 1804, in conjunction with W. F. Wells, he issued a publication which is important for the modern collector, *A Collection of Prints illustrative of English Scenery, from the drawings and sketches of Thos. Gainsborough, R.A.*

In 1789 Laporte was in the Isle of Wight, where he met John Hassell. In 1792 he made probably his first visit to Wales, returning frequently thereafter, and in 1795 and later made excursions to Ireland. He was at his best, not a very exalted best, when he worked in body-colour, as in his large *View of Shalfleet, Isle of Wight*.[1] He had a liking for this kind of subject, in which he followed the Dutch tradition, for lake and river scenes with a boat and figures in the foreground, and for the rugosities of gnarled tree trunks. When he used pure water-colours, his colour was rather thin and metallic, like that of Nicholson. Now and then he shows an approximation to Girtin in the fabric of his work especially in his use of little sets of wet spots and blobs. They were clearly apparent in *On the River Wye*, an excellent example of his work on a fairly large scale, shown by Messrs. Agnew in 1936. Not that the drawing could be mistaken for a Girtin—it had not got the bones and solidity, and the actual drawing was flimsy—but the relationship was there. A good idea of his style and method in pure water-colour is given in the fourteen plates illustrating *The Progress of a Water-Coloured Drawing*, showing the various stages through which a drawing passes, from the outline to its finished state. The book was published about 1810, at the price of two guineas, by G. Testolini, an artist's colourman, of 73, Cornhill.

Mention may be made here of P. La Cave, landscape painter and drawing-master, whose life is even more obscure than that of Laporte. Such information as is known about him was assembled by Basil Long.[2] Of French descent, and possibly son or grandson of F. M. La Cave, the engraver, La Cave was in this country before 1799, and exhibited Devonshire views at the Royal Academy in 1801. The date 1806 occurs on his *Landscape with Horses at Plough*,[3] and after that he disappears from ken. His rather feeble rustic scenes, with cattle and sheep, show him a weak draughtsman and a poor colourist, with a certain resemblance to Payne. A large Pastoral, exhibited at Walker's Gallery in 1941, however artificial in composition, was imposing and perfectly preserved in colour. Evidently he worked from recipes, composing his drawings indoors from recollections of Berchem or Claude Vernet. His slickness, like that of Payne, was probably attractive to pupils who liked a swift and definite system. Some of his drawings are signed 'La Cave' and others 'Le Cave', the former being his correct family name. A memorable point in connection with La Cave is that he had a direct influence upon Cotman. Dawson Turner, Cotman's patron, had a large collection of La Cave's drawings, for at the sale of his library one of the items in the catalogue reads: 'LA CAVE. A collection of two hundred and eighty sketches of this improvident but very clever artist, consisting of Landscapes, Figures, Animals, etc., in which his touch was particularly flowing, rich and beautiful. Very little is known of this artist, who excelled in depicting the Cow, an animal which in this collection is figured in every possible way.' Cotman borrowed from Dawson Turner, and made tracings of, several of the drawings of cows, and Kitson[4] points out that the Cotman cow, a familiar object in his drawings, was derived from his

[1] V.A.M. 816–1877.
[2] B. Long, 'John Laporte and P. La Cave', *Walker's Quarterly*, VIII, 1922.
[3] V.A.M. 1271–1871.
[4] S. D. Kitson, *Life of John Sell Cotman*, 1927.

240

study of La Cave. In 1804 Cotman wrote to Dawson Turner: 'Oh, to be looking at some of your La Cave Sketches.'

Mention has been made of a meeting between Laporte and John Hassell (1767–1825) in the Isle of Wight. Hassell was an engraver and drawing-master, and the friend of George Morland, whose life he wrote in 1806. In 1808 Hassell published his *Speculum; or Art of Drawing in Water Colours*, which by 1818 had reached a third edition. On the front page is the advertisement: 'Drawing taught, and Schools attended by the Author. Letters addressed to J. Hassell, No. 5, Newgate Street, will be duly attended to.' Later, in 1823, he issued his *Camera: or Art of Drawing in Water Colours*. His largest and most interesting book, however, of this nature is his *Aqua Pictura*, published in monthly parts in 1813. The idea was, as the preface states, to take a drawing by one of the most celebrated draughtsmen of the age, and to publish four colour plates to illustrate progressive stages of his work. The drawings selected were by Payne, Wheatley, Varley, Girtin, Prout, Cox, De Wint and others. For the text the method was adopted of explaining in detail the progress of the drawing, analysing its methods, and illustrating by a dash of colour each tint mentioned as being employed in the picture. Each picture is illustrated by four plates—an etched outline to give the drawing, a monochrome aquatint to show the addition of washes in ink or sepia, the same washed over with a yellow colour to give it warmth, and an aquatint finished in colours to represent the completed drawing. The volume has great documentary value as illustrating the drawings of nineteen artists who were outstanding in 1818, but it is extremely rare, since many copies have been broken up for the sake of framing the coloured plates.

Hassell was not only the author of drawing-books, but he also produced several glorified guide-books illustrated mainly by colour aquatints from his own drawings. He began with a *Tour of the Isle of Wight* in 1790; it was in 1789 that he met Laporte on the island. In 1793 his *Picturesque Guide to Bath* takes us all the way to the West Country, starting from London by 'that beautiful and elegant outlet, Piccadilly.' In 1817 he published *Picturesque Rides and Walks ... round the British Metropolis*. The two dumpy volumes in small octavo contain a hundred and twenty views which, though limited in size, are charmingly composed and tinted, and make an interesting record of the topography of London and its surroundings at a time when Paddington and Kensington were still rural villages. The *Tour of the Grand Junction Canal* followed in 1819, with twenty-four plates from his drawings. Canals at this period were the great highways of commerce, and the shares of the Grand Junction, opened as far as Uxbridge in 1801, had risen in 1818 from their original price of £100 to £250. Shortly before the publication of Hassell's book it was the vogue to visit Uxbridge on barges drawn by horses gaily decked with ribbons. This was a favourite excursion with Nollekens, the miserly sculptor; and the pleasures of the trip induced Benjamin West, when President of the Royal Academy, to paint a picture of the barge by which he travelled, introducing his own portrait among the passengers on the crowded deck. Hassell's last engraved work appears in the illustrations to *Excursions of Pleasure and Sports on the Thames*, published in 1823.

A water-colour painter who made his income largely by private tuition was Richard Sasse (1774–1849). Born as Richard Sass, he was the elder half-brother of Henry Sass (1788–1844), who founded a drawing-class in Charlotte Street, Bloomsbury in 1818, which became well known. Henry continued to run this school until 1842 and, though an indifferent portrait-painter, was a capable teacher. Frith and C. W. Cope began their training there, as did Millais, who passed into the Royal Academy schools when only eleven years old. Richard Sasse exhibited first at the Royal Academy in 1791,

when he was only seventeen. His subjects were landscapes enlivened by figures and cattle, and he was in advance of his time as a direct colourist. In 1811 he became teacher of drawing to the Princess Charlotte and for a time was landscape painter to the Prince Regent. He worked in London, but on the conclusion of peace went to the Continent in 1815, and in 1825 settled in Paris, where he died. He added the 'e' to his name either to avoid confusion with his half-brother or, as suggested in the British Museum catalogue of drawings, because he found Sasse a more readily accepted name when he was living in Paris. Several aspects of his work are represented in the Victoria and Albert Museum.

Joseph Barber (1757 or 1758–1811) enjoyed high esteem in Birmingham both as a man and a teacher, and gave instruction to David Cox and several eminent local artists. He has a kinship with John Laporte in colour and with William Payne in his handling of trees and foreground. His unpretentious but accomplished work was little known till a group of twenty of his water-colours appeared at Sotheby's in February 1934. The Victoria and Albert Museum acquired three of these drawings which, in conjunction with a water-colour of 1802, *The North Arch of Llangollen Bridge*,[1] already in the collection, show him as a studious and versatile painter.

Another drawing-master who produced agreeable and interesting work in water-colour was James Baynes (1766–1837). Born at Kirkby Lonsdale, he was assisted by a patron who went with him to London, where he studied under Romney and entered the schools of the Royal Academy. His subjects were usually landscapes, sometimes with cattle and figures, in North Wales, Cumberland, Norfolk, Kent and elsewhere. Though one of the lesser water-colourists, his work is sufficiently distinguished by a pleasant feeling for colour and intelligent observation. He exhibited at the Royal Academy almost continuously from 1796 till his death. He was a successful teacher, and many young artists who came to the front in the earlier years of the nineteenth century owed to him a grounding of sound knowledge and workmanlike practice.

Landscape and little else was taught by all the drawing-masters so far mentioned in this chapter. Before concluding, some reference should be made to flower painting and to those who specialised in teaching this branch of the water-colour art. Undoubtedly the most important was Georg Dionysius Ehret (1708–1770), one of the greatest botanical artists of his century. Born in Heidelberg, he received his first lesson in drawing from his father. Apprenticed originally as a gardener, it was not long before his outstanding gifts as a flower painter attracted the attention of botanists outside his native land. After some years of travelling about Europe, in 1736 he finally chose to settle in England, where he remained for the rest of his life. To quote from Wilfrid Blunt's[2] comprehensive work on the botanical illustrators, from which much in this section has been taken:

> By the middle of the century he had become a popular figure in London society: the 'highest nobility in England' clamoured to receive instruction from him, and in his autobiography he proudly inscribes the names of the duchesses and countesses whom he numbered among his pupils. 'If I could have divided myself into twenty parts,' he adds, 'I could still have had my hands full.'

The success of Ehret's tuition immediately opened up a delightfully novel field for the amateur water-colourist and numerous teachers of both sexes were quick to take advantage of the new fashion. James Sowerby (1757–1822), perhaps the best and certainly the best-known English botanical draughtsman, who had been trained at the Royal Academy Schools, combined portraiture with the teaching of flower painting until he began work on his tremendous *English Botany*, the final and

[1] V.A.M. 129–1885.
[2] W. Blunt, *The Art of Botanical Illustration*, 1950, p. 146.

thirty-sixth volume of which came out in 1814. His first work was *An easy Introduction to drawing Flowers according to Nature*, 1788, which appeared in a second edition in 1791 with the title *A Botanical Drawing Book*.

Patrick Syme (1774–1845) was another teacher of flower painting. He was born in Edinburgh, where for a time he practised as a portrait painter. It was his paintings of flowers, however, which aroused most interest, and, after taking over his brother's practice as a drawing-master, in 1810 he published *Practical Directions for Learning Flower-Drawing*. In this he writes that he intends

to illustrate the art of Drawing and Painting Flowers, by progressive delineations consisting of Eighteen Drawings, accurately copied from Nature. Six of these are finished drawings, intended as examples of Yellow, Orange, Red, Purple, Blue, and White Flowers: six represent the successive stages of the colouring of these flowers; and the remaining six are simple outlines of the same plants.

Though Syme was a distinguished scientific botanist, he knew as an artist the necessity for selection and the value of restraint. These qualities are not so apparent in the books published by George Brookshaw, with illustrations from his own drawings. His *New Treatise on Flower Painting, or every Lady her own Drawing Master* was published in 1818, followed in 1819 by three volumes: *Six Birds*, *Groups of Fruit* and *Groups of Flowers*. An extract from the preface to the first of these will show how such books were produced to meet popular requirement:

The following Drawings are submitted to Young Ladies with the view of promoting the taste for drawing Birds, many of which, from their elegant forms and beautiful plumage, are interesting and appropriate subjects for the pencil. . . . They progressively unfold the delicate touches of the art, and tend to awaken a taste for the chastened and elegant beauties of nature. The next attempt will be on Fruit Painting, in the course of which will be introduced instructions and designs for Painting on Velvet.

The chastened and elegant beauties of nature brings us to a much neglected field of study—the drawing-mistresses. Though not as numerous as their masculine counterparts, according to Farington[1] they were no less importunate. On returning to his house from the Academy one April he found none other than the famous Miss Mary Lawrence (who, in 1799, had published a folio monograph on roses) waiting for him with an introductory note from Charles Greville, Lord Warwick's brother. She told him that she lived with her parents in Queen Anne Street and gave lessons in botanical drawing at half a guinea a lesson. She had called on him to ask whether he would see that her flower painting was given a place in the forthcoming exhibition. Farington explained that flower paintings were unfortunate subjects to hang with pictures. Her visit seems to have affected her chances of success somewhat adversely, for although altogether she had fifty-three flower pieces accepted by the Academy between 1794 and 1830, in this particular year, as Farington drily notes, her pictures were not placed. She was the second to have called on such an errand within the space of a few days. Farington's entry[2] records:

Mrs. Noel and Her Daughter called on me to request that a picture which she has sent to the Exhibition might be placed in some situation—She represented that it was of great consequence to Her to have a picture in the Exhibition as Her scholars judged her ability in the Art from that circumstance. The last year Her picture was rejected and damaged. She said she supported a family of 4 children by giving lessons in painting and drawing. That she went out to give lessons and Her daughter taught at home.

[1] *Diary*, April 9, 1804. [2] *Diary*, April 8, 1804.

She spoke of West and Cosway as Her friends—She said she had been advised by Mrs. Soane to apply personally to the members of the Committee—I told Her there was an inundation of pictures, but that [her] representation would have due weight with me. She said Her fortune had been taken by Her Husband who had left her with a family to be provided for.

This lady fared better than Miss Lawrence. In that year one of her works, an allegorical subject, was accepted.

246 'A Pollard Oak near West Hampnett Place, Chichester'

B.M. 1943.4.10.1 5¼ × 6¼: 134 × 160 *Water-colour on vellum*

John DUNSTALL (d. 1693)

An East View of the Quarter Guard on Hampton Court Green 1733

247 'The Quarter Guard on Hampton Court Green, 1733'

Coll. Mr & Mrs Paul Mellon 8⅛ × 12¾: 207 × 324 *Pen and grey wash*

Bernard LENS (1682–1740)

248 'Portrait of a Chinese Soldier'
Coll. Mr & Mrs Paul Mellon $9\frac{7}{8} \times 6\frac{1}{2}$: 250 × 165 *Water-colour*
William ALEXANDER (1767–1816)

249 'Bamborough Castle, Northumberland'

V.A.M. P.13–1928 9 × 19: 228 × 483 *Water-colour, signed and dated 1871*

John CALLOW (1822–1878)

250 'At Longfort in Lord Rhadnor's Park near Salisbury, 29 Sept. 1768'

Oxford, Corpus Christi 7¼ × 11¼: 184 × 286 *Pen and wash*

John Baptist MALCHAIR (1729–1812)

251 'The Tower and Chapel of the Castle, Oxford, August 24, 1776'
Oxford, Bodleian Library. Ms. Top. Oxon. b.222, fol 18 10 × 7¾ : 254 × 197 *Pencil and wash*
John Baptist MALCHAIR (1729–1812)

252 'Canterbury Building, Christ Church, Oxford, February 26, 1783'
Oxford, Ashmolean Museum $11\frac{3}{4} \times 18\frac{3}{4}$: 298 × 476 *Pencil and wash*
John Baptist MALCHAIR (1729–1812)

253 'Moel y Frydd'
Coll. Mr Ian Fleming-Williams $16\frac{1}{8} \times 21\frac{3}{4}$: 409 × 552 *Black chalk and wash*
John Baptist MALCHAIR (1729–1812)

254 'The Dropping-Well, Knaresborough'
B.M. 1876.5.10.925 (LB 3) $11\frac{3}{4} \times 16\frac{3}{8}$: 298 × 415 *Water-colour*
Francis NICHOLSON (1753–1844)

255 'Near Okehampton'
B.M. 1859.8.6.90 (LB 1) $12\frac{1}{8} \times 16\frac{1}{8}$: 307 × 412 *Water-colour*
William PAYNE (c. 1760–d. after 1830)

256 'Winter Landscape'
Coll. Mr Leonard G. Duke 12 × 16½: 304 × 419 *Water-colour*
William PAYNE (c. 1760–d. after 1830)

257 'View on a river'
B.M. 1886.6.24.2 (LB 2) $11\frac{3}{8} \times 16\frac{1}{4}$: 290 × 413 *Water-colour*
John James BARRALET (1747–1815)

258 'The Road to East Grinstead'

Coll. Mr & Mrs Paul Mellon $13\frac{3}{4} \times 22\frac{1}{2}$: 349×572 *Water-colour, signed and dated 1784*

John Melchior BARRALET (fl. 1774–1789)

259 "Morning' (one of a set of four)
Coll. Mr & Mrs Paul Mellon $10\frac{3}{8} \times 15\frac{1}{8}$: 264×384 *Body-colour*
John LAPORTE (1761–1839)

260 'Carisbrooke Castle Chapel, Isle of Wight'
B.M. 1886.9.3.6 (LB 1a) $3\frac{3}{8} \times 4\frac{7}{8}$: 86 × 124 *Water-colour*
John HASSELL (1767–1825)

261 'Lakeside scene'
Coll. General Sir John and Lady Anderson 14 × 20: 356 × 508 *Water-colour*
Peter LA CAVE (fl. 1794–1810)

262 'River and Trees'

Ipswich Museum $9\frac{3}{8} \times 13$: 238×330 *Black chalk*

George FROST (1734–1821)

263 'Landscape with castle high above a river'

Coll. Mr & Mrs Paul Mellon $8\frac{5}{8} \times 11\frac{1}{8}$: 217×282 *Water-colour*

Joseph BARBER (c. 1757–1811)

APPENDIX II

The Amateur

The amateur deserves to be included in any history of the English water-colour school both because of the intrinsic merit of some of his work and because of the part he played as pupil, friend, patron, teacher and general make-weight. As artists in their own right, a number have already been noted in these volumes—Francis Place, William Taverner, Sir George Beaumont and John White Abbott, for example—and at least two of those shortly to be mentioned—Lord Aylesford and William Crotch—were of equal importance. Here, however, it is the intention to deal with the subject of the amateur in general and with the subsidiary rôles he assumed, rather than with the outstanding representatives of his class.

The main period of amateur water-colour drawing and painting lasted for about a hundred years, from 1750 to 1850. Both before and after this period there were a number of talented men and women who drew and painted without thought of remuneration, but for our purpose, without much fear of loss, we shall be able to work quite comfortably within that span of time. The same span would only have to be extended a little to include the working lives of most of the greatest of the professional landscape water-colourists.

To understand why it was during these years that the amateur flourished, it is necessary to consider him a little closely and to review the conditions which prevailed to favour such prosperity. Firstly, as to his character and circumstances. It was of prime importance that he should be a man of means, or one with a mind sufficiently disengaged from professional matters to permit free and unrestricted enquiry. He had to be sufficiently educated to enjoy a wide range of intellectual and cultural interests. He had to feel that society was well enough disposed towards him to possess a degree of confidence in all that he did, without having to give much thought as to how he was regarded by others, and without having to feel that he should excel. He could not be too engrossed in politics and administration. Without any need for estrangement from society at large, he had to be content to work within a small social unit, his family or a local group, that preserved its individual character while remaining in touch and sharing its interests with others. While maintaining a degree of detachment he had to be capable of sustained endeavour. He should also possess some talent for drawing.

The conditions favouring the amateur artist are those in which certain classes enjoy a considerable amount of leisure; in which the practice and appreciation of painting is wide-spread; in which the work of the artist is reckoned to be a subject upon which all are entitled to have and to offer their opinions; and in which drawing and painting are regarded as normal recreational occupations for members of either sex. These conditions will only obtain when there exists a style based on a simple and readily understood visual vocabulary and grammar relating to painting as common speech relates to literature; when this style is suitable for the representation of a subject with a wide appeal; when the style is readily adaptable to associated interests and professional requirements other than

those of the artist; when adequate tuition is easily obtainable; and when the necessary materials are undemanding and simple to use as well as easy to come by.

Only during the period 1750–1850 were all these conditions fulfilled. Before that time, with a few notable exceptions, the artist occupied a comparatively isolated position in society, he seldom practised his craft outside the studio, and only the lesser talents remained to work in the provinces. The public at large had little knowledge of painting as there were no exhibitions and, except at auctions, pictures and drawings were to be seen only in their owner's houses and cabinets. Apart from the portrait, subject-matter and style both had a limited appeal as artists tended to cater for a taste formed during the Grand Tour, and critical appreciation was chiefly confined to those who had completed their education by making that journey. Though drawing was taught in certain schools as a skill of some service to children from the artisan classes, and though a fortunate few in better circumstances had been tutored in the art, it had not as yet become part of a schoolboy's education. At the universities, there was no such instruction to be found. Only in the two main resorts of fashion, London and Bath, had copying and sketching become a recognised and laudable diversion. Manner, preferably one with easy-flowing and imitable characteristics, is of the greatest importance to the amateur, and so far there was little evidence of the existence of an indigenous native style, let alone one possessing these qualities. Before the 1750s, if an amateur wished to cultivate a taste for drawing, he had to learn a continental manner from books in translation, as he would learn Latin or French, or from engravings by continental masters if, as would probably be the case, he was unable to find someone to instruct him.[1] The antiquarians and local historians excepted, before this period few among the educated classes had felt the need for a knowledge of drawing in the pursuance of their professions or of their other interests. Until this time, if a professional artist such as Richardson or Jervas[2] could not be persuaded to give instruction as to a friend, it was not easy to obtain tuition, for there were very few drawing-masters about. Before the recognition of water-colour as a medium that has the advantages of simplicity, cleanliness and portability, and before the artists' colourmen began to manufacture their boxes, cakes of colour, drawing-books, sketching-stools and the other impedimenta with which the tyro delights to burden himself, if the amateur was not prepared to learn the complex and arduous business of painting in oils, he had only the pen or the port-crayon for his use, neither of which, in the hands of the beginner, produces the sort of effects that reward the uninitiated.

After 1850, people changed and conditions altered. Women had just as much leisure, and water-colour painting before marriage and between confinements became recognised as one of their especial occupations. Men, however, turned aside from such trivialities. More manly pursuits were encouraged at the public schools. Grown men found dabbling with colours on a piece of paper incompatible with a sense of their own dignity. Leisure could be better spent on sport or courtship, on the reading of newspapers and scientific journals, on experimental science itself, on travel, billiards, literary compositions and, most important of all, in serious converse away from the ladies. Many in the upper classes took to money-making and found it a full-time occupation. Banking, business and commerce were talked about openly in the salons. Land was no longer the main source of inherited wealth. The artists themselves were also to blame, if blame is to be awarded, for the

[1] In this context it is worth noting that many of the most popular drawing-masters of the '50s, Chatelaine, Vivares, Bonneau, Goupy, taught a continental style.
[2] From whom, it is said, Alexander Pope took lessons.

decline of the amateur painter. They now formed a professional body from which the amateur was rigidly excluded. They now painted pictures plain enough for all to understand and pronounce upon, executed in a manner that all could admire, but which, with the emphasis on finish and fine detail, few amateurs could ever hope to emulate. Those water-colourists who adopted a different style exhibited works that amazed by their technical brilliance, but which could only intimidate a beginner or non-professional. The amateur is prepared to accept the fact that his work is inferior to that of the professional in degree, but he does not enjoy the humiliation of knowing that it differs in kind. Now, good enough was no longer good enough. Now there was only good art and bad art, the best and the rest, and it is not in the nature of the amateur to aspire to the best. He thus learned to be ashamed of his status. His best was now amateurish.

There were other contributory causes towards the decline. It was a well-to-do amateur landscape artist with some experience of optical aids, William Henry Fox Talbot, who discovered how photographic images could be permanently affixed on to paper without the aid of the human hand. Henceforth, many who before would have sat happily on a hillside with a sketch-book and water-colour box now carried around with them the delightfully mysterious if cumbersome pieces of apparatus with which, under a black cloth, they could view and record scenery as no artist had been able to do before—and all in the twinkling of an eye. The country began to take art education seriously and the subject acquired an institutional character. Recognising the need for properly conducted and approved centres for instruction where only acceptable and beneficial systems of training were adopted, in 1840 the Government made grants to encourage the founding of such establishments. By 1852 there were twenty-one nationally subsidised Schools of Design. These of course were for the children of factory workers, but as immense pains were taken to devise fool-proof methods of both teaching and learning, the infection, if it may be so called, soon spread and it was not very long before the sons and daughters of wealthier homes were being taught by system. The aim, to quote the words of that remarkable man Henry Cole, was 'to teach the public to know what good art is'. Ruskin had strong ideas about how and what the young should be taught. Here is a set of exercises for a child from his book *The Elements of Drawing*:

Exercise 1. A square which is filled in with an even tone by cross-hatching.
Exercise 2. Copy a line drawing of flowers, fruit, etc., first with pencil, then pen.
Exercise 3. Tone gradation of a long rectangle by cross-hatching.
Exercise 4. As '3' in pencil and pen.
Exercise 5. Draw a capital letter, using a ruler for the straight lines, and drawing the curves freehand. Tint it with a flat tone in pencil.
Exercise 6. Draw tree branches.
Exercise 7. Practise flat washes, and graduated tints. A simple colour chart of tones to help tone matching.
Exercise 8. Copy a stone in pencil.

Art became a subject for examination. Ruskin believed in examinations. Here are his views on the matter:

I think art examination should have three objects:
1. To put the happiness and knowledge which the study of art conveys within the conception of the youth, so that he may in after-life pursue them, if he has the gift.
2. To *enforce* (the present writer's italics), as far as possible, such knowledge of art amongst those who are likely to become its patrons or the guardians of its works, as may enable them usefully to fulfil those duties.

3. To distinguish pre-eminent gift for the production of works of art, so as to get hold of all the good artistical faculty born in the country, and leave no Giotto lost among the hill-shepherds.

In fact Giotto might not have done too badly when faced with the following syllabus for the 1st and 2nd Grade Examinations of the Science and Art Department:

1st Grade:

(a) Copy from an easy outline, in lead pencil on paper. (Prize: Small drawing board and T-square.)
(b) Outline drawing of objects—cube, chair, table, etc. (Prize: Grant's *Geometry*, Redgrave's *Colour Manual*, Burchett's *Definitions of Geometry*.)
(c) Outline drawing from memory of common objects. (Prize: Pair of compasses with pen and pencil joints.)
(d) Easy patterns in practical geometry. (Prize: Colour box suitable for colouring mechanical drawings.)

2nd Grade:

(a) Freehand outline from a copy.
(b) Freehand outline from a solid form.
(c) Freehand outline from memory of common objects.
(d) Exercises in practical geometry.
(e) Exercises in perspective.
(f) Exercise in mechanical drawing.

(Prizes: Burchett's *Geometry and Perspective*, large drawing board and T-square, box of maths. instruments, box of 10 colours with slabs, etc.) Only one sub-division can be taken at one examination.

The amateur is defined as one who loves, is fond of, or has a taste for, anything; also as one who cultivates anything as a pastime. Ruskin and the other enthusiastic systematisers failed to distinguish between vocational and recreational training. Instead of learning to love, to become fond of, or to acquire a taste for, drawing, how many, one wonders, came to loathe it under their well-meaning ministrations?

Having reviewed the periods before and after the age in which the amateur flourished, there remains to be considered the age itself, and the men and women who enjoyed the facilities it so bounteously provided. In granting leisure to the upper classes and at the professional level, it was not exceptional, but in the extent to which it supplied all the other requirements already mentioned it was unique. Original paintings and drawings produced in greater quantities by a growing population of artists became increasingly accessible. Following the initial success of the first London annual exhibitions in the '60s (which inspired artists in other cities, Liverpool in 1768, for example, to form themselves into bodies for a similar purpose) there were for a time only half-hearted attempts to increase the number. After 1800, however, there was a sudden proliferation of new exhibiting societies and institutions in London and also in the provinces, where the Norwich Society, 1803, provides an outstanding example. Additional opportunities for seeing pictures were provided by the artists themselves, who began to open their own private galleries or to hire rooms so that their work could be shown. It became a social necessity to view and to be seen viewing some of these exhibitions. In the seventeenth century—when the first cabinets were formed—both artists and amateurs (as connoisseurs) had collected drawings by Old and Modern continental Masters, but it was not until the eighteenth century that the acquisition of drawings was generally recognised as an indulgence proper to a nobleman or gentleman with a well-stocked library, and it was not until our period that native artists were capable of producing work of a quality which warranted inclusion in such collections. Among collectors, engravings had been as sought after and almost as highly prized as original drawings, but hitherto native craftsmen had been no match for the great continental masters of the craft.

248

During the '60s, however, there arose in this country a school of engravers which was soon equal to any to be found abroad. The leaders of this school swiftly created a new public and it was they and their followers, as much as the artists themselves (amongst whom must be included artist-engravers such as Paul Sandby), who popularised painting and, in particular, the landscape *genre*. It was not only with the artists' work that people became familiar. For some time the painters themselves had been striving for an acknowledgement which would place them to greater advantage—the proper recognition of their status as members of a profession. This was achieved in 1768 by the founding of the Royal Academy. Society raised not the slightest objection to the creation in its midst of such an imposing body, especially when the presiding Academician was a man of Reynolds' intellect and cast. On the contrary, the Academy's leading personalities, its affairs and its seasonal occasions soon became topics of general interest. Invited, but unable in turn to invite, hitherto the subject of hospitality had been the cause of some embarrassment to the profession. Now, a return could be made. Now, at banquets and soirées, its members could play the part of host without fear of equivocation. Now, all those upon whose interest the artists' livelihood depended—Princes of the Blood, Ministers of the Crown, the nobility and all others of recognised importance—could be received in a gratifyingly subordinate rôle as guests. The seating plans of the Academy dinners to be found in Farington's journal, with peers and commoners placed with due regard for precedence between senior and junior Academicians and associates, reflect the satisfaction the painter-politicians gained from designing and conducting such festivities. Reciprocal entertaining followed. As officials in their own right, painters were now to be seen at state occasions, and before long the names of leading artists, along with those of the other professions, were to be found on the invitation lists of the most prominent hostesses. By their licence to appear thus, the few gained ground for the many. Meetings with artists on an equal footing as guests in town led to invitations into the country where the social order was somewhat relaxed and there prevailed a pleasant air of informality. As accepted guests, artists were introduced around the neighbourhood and, on occasion, proudly displayed as novelties. As guests, as professionals in a non-professional capacity, they were expected to advise on artistic matters in general, and if their host or members of his family had a practical bent, very naturally, they would be encouraged to offer criticism and to instruct. Some, not unwillingly, became sketching companions. Although some hosts took undue advantage of the relationship, others cultivated the friendship of the artists. All in all there was a degree of mutual benefit. Painters became known both as men with a recognised position in society and as individuals and through their own network quickly circulated news of the most fruitful associations. The amateurs were refreshed by contact with professional standards and values, and gained immeasurably from working side by side with able draughtsmen.

The new position of the artist *vis-à-vis* society was largely responsible for fulfilling another of the conditions required by the amateur, that he should not be looked at askance. But this and the remaining conditions were finally provided for by the professional water-colourist and by the nature of the medium he used. Water-colour materials, being simple, compact, easy to use, and easy to put away, were ideal for the amateur's needs and no sooner were they in general demand than the artists' colourmen saw to it that they were to be found in adequate supply. The demand for tuition, as the previous chapter will show, was also more than sufficiently well cared for. We are left with the last two requirements to consider, the consistent and adaptable style and, perhaps the most important of all, a subject for representation which all could appreciate.

In the latter half of the eighteenth century there existed a consistent and coherent style of water-

249

colour drawing that permitted artists to work freely within its limits and that also suited the amateur, who could appreciate its aims (as well as the moments when these were achieved), and understand the technical means as, in a rudimentary form, it was not beyond his powers to master them. For a few whose interest in art had started at the top, the fact that it was a style derived from universally approved models was an attraction, but it was on a different level, through its adaptability, that it gained the majority of its adherents.

For a long time drawing had been looked upon as a useful skill in certain occupations. Among artisans and craftsmen, military and civil engineers, among mariners, surgeons and physicians, ever since the sixteenth century there had been draughtsmen. Drawing had also long been part of the curriculum in many schools. But it was not until well into the eighteenth century, that is until there existed a mature and uniform style of draughtsmanship, that drawing began to be widely practised in these trades and professions, and that the need for it was fully recognised in others. Hitherto, both the Services had been slow to appreciate its value, but by the middle of the century the authorities had begun to change their views on the subject. The teaching of drawing at the newly formed Military and Naval Academies at Woolwich and Portsmouth undoubtedly had something to do with this, for by the middle of the century young officers who had benefited from this training were already serving on land and at sea. It is more likely, however, that the change was wrought by the recommendations of senior commanders with experience of a better-trained and more mobile enemy. Effective mobility depends on information, on reconnaissance, on knowledge of the ground or waters over which forces can operate, and in recent wars England had suffered from a lack of such knowledge. One of those who spoke most strongly of the need for draughtsmen was Anson in the introduction to the published account (1748) of his *Voyage round the World*. After stressing the vital importance of recorded observations and 'every species of mechanical and commercial information', he goes on to suggest that the Navy should issue regulations to ensure that persons 'with the character of an engineer and the skills and talents necessary to that profession' should be embarked in men-of-war as they might 'serve to secure our Fleets from those disgraces with which the attempts against places on shore have often been attended'. The skills required were those of a draughtsman 'who acquires the habit of observing much more at one view, and retains what he sees with more correctness than he could ever have done, without his practice and proficiency in drawing'. Anson's views were eventually well enough received for a directive to be issued by the Admiralty to all commanders afloat, that officers qualified in draughtsmanship should be employed wherever and whenever possible to provide plans and sketches of ports, watering-places, anchorages, coasts and wherever troops could land, 'taking particular care, when in *Foreign Parts*, not to do anything to give Umbrage or offence to the Governors, or Inhabitants, of Places in Friendship with the King'. Presumably this was carried out, as the directive was reinforced with threats of non-payment of wages if the instructions were not complied with.

The sappers and gunners were no distance behind in adapting the art of drawing to their own purposes. Wherever possible, illustrations were included with the reports submitted by their serving officers too, and after Paul Sandby's appointment at Woolwich, these perceptibly improve in quality. In 1779 a young gunner, Capt. William Congreve, was sent to Prussia to report on forming a corps of artillery for the service of cavalry. On his return he submitted a detailed memorandum and each manœuvre described was illustrated with a drawing. Many of these are mere plans and diagrams, but sometimes the sketches show dramatic incidents with small delicately drawn rear-guard figures on prancing horses discharging their pistols at close range while the teams limber up. Whether Congreve

250

was chosen for the mission because of his abilities as a draughtsman or whether his drawings merely reflect current practice it is not possible to say, but he was obviously a man possessed of real artistic talent. Brigadier-General Robert Lawson was another who made effective use of drawings in his reports. Sometime before 1790 he submitted one on *Garrison Gun-Carriages for Sea-Lines and Barbet Batteries with Platforms and Stands for Firing over the Parapets of Fortifications*, and after the Egyptian campaign he sent in another entitled: *Memorandums of Artillery arrangements and Alterations to be made in Carriages, Harness, Ammunition, etc., on the Expedition to Egypt, 1801*. The first presented his proposals for the raising of large pieces to a parapet and their subsequent aiming, and suggested methods for the absorption of the recoil on firing. The mechanism is explained largely by means of a number of exquisite little water-colour drawings with clear blue skies and figures in full colour, the blues and reds making just those accents which would have pleased his old master Sandby. The same delight in execution informs the illustrations for the 1801 memoranda, which are mainly devoted to describing extemporised techniques to meet the unusual character of the terrain—a primitive type of caterpillar track, for example, made from cask-staves lashed to the rims of the wheels to prevent them from sinking into the sand. A fine drawing illustrates what Lawson called a rock mortar, which consisted only of a large hole drilled into solid rock into which the charge and shot were placed, the hole itself acting as the barrel.

Drawing, it was discovered, could also play a part in military tactics. In 1794, another of Sandby's pupils, George Frederic Koehler, accompanied Lieut.-Col. (afterwards Sir John) Moore alone on a number of reconnaissances of enemy positions in Corsica. These are described in Moore's Diary, and the drawings Koehler made while observing the enemy come in for a deal of favourable comment. On February 17, for instance, after Moore had been ordered to move against the opposing forces at Martello Bay: 'Upon leaving the general I found the regiment under Major Pringle at the place directed. Major Koehler walked with me, and from a drawing he had taken gave me a perfect idea of the work I was to attack.'[1] Afterwards, Koehler's sketches were sent in with Moore's full report, with the explanatory note: 'The drawings which accompany this were taken up on the spot by Major Koehler, to whom I have been greatly indebted both for his assistance and advice.'

Until the Napoleonic Wars, there was no compulsion for a young infantry or cavalry officer to learn to draw, for the advantages which a commander could gain from adequate maps, plans and panoramas were not as yet widely appreciated. It was, however, conceded to be a useful attainment. In *Cautions and Advices to Officers of the Army, particularly Subalterns* (1760), the author, 'an Old Officer',[2] suggested to his readers that 'drawing will be of great use to you in ornamenting your plans, etc., if you incline to study Fortifications; if not it is an Amusement in itself and highly entertaining'. This advice was echoed by the Earl of Pembroke when urging his son to continue with his drawing lessons during a prolonged tour of the Continent, in 1779: 'Drawing, especially from Nature, will not only be an entertainment, but of great use to you, particularly in your military profession. Especially from Nature', he reiterates, 'you do not draw ground on reconnaissance in the grand style.' This last was a dig at his son's tutor, who had boasted in a letter home that he had arranged for a drawing-master at Strasbourg to teach his charge 'in the Grand Style, and not in the trifling taste of the small finished landscapes'.[3]

It was John Gaspard Le Marchant (1766–1812) (see also pp. 217–18 and 265), as enterprising and energetic a cavalry officer as he was an enthusiastic amateur artist, co-founder of the Staff and Junior

[1] *The Diary of Sir John Moore*, 1904, Vol. I, p. 55.
[2] Capt. Francis Grose, antiquary.　　　　　[3] *The Pembroke Papers*, 1942.

Military Colleges (later at Sandhurst), who finally established drawing as an essential part of an infantry or cavalry officer's training. Le Marchant fully realised both the strategic and the tactical benefits that a commander could derive from having a properly trained and organised team of officer-draughtsmen on his staff, especially in entirely un-mapped and unfamiliar country like that to be found in the Peninsula. The idea was that these young (and therefore expendable) officers could be sent out to reconnoitre upon whatever terrain the commander desired particulars of, for the planning of the movements of his forces. From such assignments an officer trained to sketch and to observe the nature of 'ground', i.e. terrain, could return with information of a degree of reliability far superior to that to be obtained from a verbal description. In courses of two dozen or so, such young men were trained at the Staff College which Le Marchant and General Jarry (a renegade put to good use) founded at High Wycombe in 1801. Having been so trained, they were immediately put to work in the field, and with their sketch-books and pencils, they made a significant contribution to the ultimate success of Wellington's long but carefully planned campaign of marching and counter-marching.

The military and naval draughtsmen were trained to draw ground and coast-lines. They were instructed by such men as Paul Sandby, William Alexander, Sawrey Gilpin, John Callow and Thales Fielding because these were best qualified to teach topographical configuration, the depiction of locality being part of their special and greater department—landscape. The last of the stipulations listed was the need for a subject or theme which had a wide appeal and which was suitable for representation. For the recognition and adoption of such a subject it was necessary that it should be one of which all had had some experience and of which all possessed some general or specialised knowledge. Man himself, of course, provides the obvious theme, but in attempting this the amateur is at a disadvantage, for on this subject his knowledge is too specialised for him readily to gain the satisfaction he seeks, the pleasure of delineation. It is too 'difficult'. In the seventeenth and the early part of the eighteenth centuries, the human face had found favour among amateurs, and some of these, working in the miniature tradition—Thomas Flatman, Sir James Palmer and Anne Killigrew, for instance— had attained a near-professional standard of competence. But this required a prohibitive degree of exertion for the average man or woman of leisure, and it was not until a less demanding alternative presented itself that drawing and painting became recognised as a recreation for all.

Landscape, of course, was that alternative. To us this may seem an obvious choice, but in fact before certain changes in attitude occurred in the eighteenth century and land came to be viewed as landscape (for a time, a different matter altogether from the appreciation of landscape painting, which has a longer history) this choice was by no means an obvious one to make. While it is true that landscape painting itself made a significant contribution towards this change, its influence was revelatory rather than causal in character. It served to direct attention rather than to arouse it. The change was initiated primarily by a new attitude towards land as land, by what is generally termed the agricultural revolution. Though land had always been the main source of wealth, it was not until the eighteenth century that full attention was given to its exploitation, and that principles of a scientific nature were applied to its development and management. It has been called the age of the improving landlords. It was certainly the first in which the idea of improvement became wide-spread, as it was the first to enjoy the rich fruits that resulted. The newly enlarged estates became concerns with the owners participating far more than their forbears had done in a managerial capacity, while both recognising and accepting responsibility for the housing and welfare of their tenants and employees. Looking down from a point of vantage upon his land with its fields, woods, hedgerows, streams and

252

habitations, it had to be an unfeeling owner indeed who could not experience pride at least, if not a new and positive pleasure at such a prospect. And if he was not an unfeeling man, among the sentiments he felt at such a viewpoint there would have been one that others could share, a sentiment for that which men have called landscape. This sentiment was not new. It had long been a subject for both poets and painters. It was not even new for the Englishman, for many had felt its powers in the environs of Rome and among the surrounding hills. But in England, as an idea commonly held, and in particular as one capable of finding common expression, it was new.

Though it is suggested that this new wide-spread recognition of landscape rose out of a day-to-day working acquaintance with the land, it was in literature, in painting and in landscape architecture that it found conscious expression. In painting, at first it is often most plainly to be seen catering unashamedly for the pride of possession in the numerous portraits of country houses by such artists as George Lambert and Richard Wilson, and in the many lavishly produced volumes devoted to gentlemen's country seats containing engraved illustrations after the work of water-colourists such as Sandby, Hearne and Rooker. A portrait of a house or of its demesnes remained a subject to suit amateur taste long after it had ceased to interest the professional. But the idea of landscape was not only associated with present prosperity. It also became closely linked with a feeling for the past. Family history and the history of a locality in which a family resided had been a subject of general interest for many generations. Many of the earliest county histories and many subsequent accounts of localities were written by country gentlemen. The eighteenth century, indeed, almost looked upon a sense of history as a prerogative of breeding. For a time topographical representation was all the amateur antiquarian attempted or asked of those artists whom he employed but, inspired perhaps by those who in Italy had found in landscape an evocative experience, as antiquities became invested with the new poetic sentiment that emerged from the union of painting and history, plain factual description yielded to a new *genre*—views of places of acknowledged interest imbued with an ineffable nostalgia. This the amateur seems to have regarded almost as an intrusion into a province that was his by right, and though the professionals led the way, he soon almost succeeded in making it his own. Fewer subjects than the ruins of Tintern, Kirkstall, Fountains and Netley abbeys more frequently received his, or her, repeated attentions, and few subjects are to be found more monotonously depicted in his, or her, surviving sketch-books and albums.

The subsequent development of landscape among water-colourists has been the central theme of this book and there is therefore no need here to follow it further. Only this point perhaps requires emphasis. As the artist moved further afield in search of new subjects for his pencil, to the Derbyshire dales and the lonely wastes of Yorkshire, to the Lakes, and to the Highlands of Scotland, the amateur was ever close upon his heels, and even on occasion, as in the case of Robert Price's tour of North Wales, ahead of him.

Before concluding with notices of a handful of amateurs, some attention should be given to the part the amateur played in a capacity subsidiary to that of the professional. It was pointed out at the beginning of this chapter that the greatest age for water-colour painting was almost identical with what might be called the age of the amateur. This is no coincidence and, after all, is not very surprising. One would expect to find high achievement on the one hand balanced by a corresponding rise in the level of attainment on the other. But this relationship was one founded upon the principle of *quid pro quo* and in certain other respects the benefactor was indebted to the beneficiary. Thus, with reason, it could be said that without the amateur such heights of professional achievement might

253

never have been reached. While there is no need to argue this case, there is something to be gained from a brief examination of the evidence which might be brought forward to support it. As very few of the water-colourists were able to subsist entirely on the sale of their paintings, the majority elected to teach, and as most of their pupils were amateurs, the sum of the proceeds from their fees must have represented a substantial portion of the profession's gross earned income. But besides the considerable economic gain from teaching there were incidental but commensurate benefits of a less material character. In the rôle of domestic drawing-master, through his pupils the painter could often establish social connexions greatly to his advantage as a practising artist. Instances come to mind. Was Girtin's enviable position at Harewood (where, it is said, a room was always kept for his use) entirely due to his reputation as a rising painter, or was he not equally favoured as the young heir Edward Lascelles' teacher? Of how much advantage was it also to Girtin that his reputedly favourite pupil Amelia Long was the daughter of Sir Abraham Hume,[1] and the wife of Charles Long, later Lord Farnborough, a virtuoso renowned if not positively notorious for his meddling in art politics? Cotman, it will be recalled, painted his famous Greta series while staying with the Morritts at Rokeby, to whom he had been introduced by his new friends the Cholmeleys of Brandsby, as one capable of relieving Mrs. Morritts' ennui by engaging her in drawing lessons. And for examples of assistance of another kind received from one-time pupils at the end of a painter's career, there should be remembered Sir George Beaumont's contributions to J. R. Cozens' upkeep after the artist's mental breakdown, when he was least able to appreciate what was being done for him; as well as the touching story of poor old Joseph Goupy, who was granted a pension in the nick of time after one of his pupils, in this case King George III, had spied him standing disconsolately at a coffee-house door and had discovered after subsequent inquiry that he was not merely down on his luck but awaiting imminent arrest for debt.

Then, there must be taken into account the amateur's support of the water-colourists as patrons and talent-spotters. Having had practical experience themselves, they were in a particularly favourable position to appreciate the finer points of the art, and to recognise promise in immature work. They could often sense the necessity for a rejection of conventional practice and understand the painter's need for advance. In addition, they spoke his language. Beaumont and Dr. Monro are remembered chiefly as patrons who collected the work of contemporary artists, and who made it their business to help the struggling young painter, but there were numerous other amateurs who bought handsomely and gave encouragement and advice when it was most needed. One example must suffice. As a young man, John Keyse Sherwin (1751?–1790), painter, engraver and water-colourist, worked as a wood-cutter on the Mitford estate near Petworth in Sussex. One day he was admitted to the house when some of the family were amusing themselves with drawing. His failure to conceal his interest in what was going on was noted by Mr. Mitford, who asked him 'if he could do anything in that way'. Sherwin said he could not, but would like to try. Though his hand was so stiff and callous that he could only grasp the pencil with difficulty, the youth produced a drawing on the spot that 'astonished not only all present, but the Society of Arts, to whom it was presented by Mr. Mitford, and the Society's silver medal was voted to him on the occasion'.[2] This, presumably with further encouragement from the Mitfords, started him on his career. Mitford's immediate dispatch of his

[1] Sir Abraham Hume was one of the most prominent collectors of his time to whom Reynolds left a choice of his Claudes and who owned, among many works by Italian and other masters, Watteau's *Bal Champêtre*.
[2] *The Gentleman's Magazine*, LXI, p. 277.

254

young protégé's first efforts to the Society of Arts, the award of the Silver Palette, and the fact that Sherwin subsequently gained further awards, illustrate the effectiveness of the system of patronage that operated at this time. Information of every kind travelled quickly through this system—a country-wide network of family and political connexions—and, as by rank the amateur was entitled to use it for his own purposes, it was not just tidings of newly-discovered talent that thus received rapid circulation. Intelligence of anything that might be of interest—new ideas, new trends and new techniques—was disseminated with equal rapidity, and at the same time over a greater area than that covered by the profession.

The amateur also served as an agent in other capacities. Throughout the seventeenth and eighteenth centuries, and until a distinction was established between the two parties during the early nineteenth century, the amateur had always been welcomed into professional circles. This placed him in a particularly advantageous position from which to act as a general go-between. As one of its recognised members, society would listen to him; as a fellow practitioner, the profession would pay some heed to what he had to say. He could thus perform useful service as a negotiator and conciliator. On occasion he also served quite unintentionally as interpreter between the painter working ahead of his time and the non-comprehending public, as it was in a diluted form in his own work, which could be readily understood, that the ideas and intentions of such painters sometimes first began to find general acceptance. Free of the restrictions imposed by professional etiquette, in addition the amateur often acted as a link between painter and painter, carrying information from studio to studio, effecting introductions, acting as a disinterested mediator, and passing on the experience of one generation to another. This last brings us to mention a situation frequently to be met with in a study of the period, in which the normal rôle of master and pupil is reversed, the young painter-to-be receiving his initial instruction at the hands of an amateur, a reversal which professional pride later forbade and state education rendered unnecessary.

Finally, friendship itself must be taken into account as the amateur was peculiarly suited as a companion for the professional artist. His art was a natural expression of his sociability. He liked to draw and paint in company. On art matters he was prepared to learn and to follow another's lead. Unhampered by an excessive desire to excel, he was as ready to appreciate the work of others as he was pleased to show his own. Working only for the pleasure it afforded, he needed little encouragement to pick up his pencil, and being of a sociable disposition he could easily be diverted from his labours. While comparatively untrammelled by artistic doubts and anxieties he nevertheless could be sufficiently aware of the main issues to understand the manifold problems which they raised. Examples of such friendships abound. Constable once wrote to his wife that he was sick of amateurs as they were the greatest enemies the art had, but he was always capable of speaking out perversely in a moment of irritation, and in fact few painters gifted with the capacity for friendship owed more to the interest and companionship of amateurs. While still himself an amateur, his first painting companion, John Dunthorne, a local plumber and glazier, was likewise a spare-time landscape artist who spent all his available leisure hours at the easel. Constable's first connections of importance for his future career were with two amateurs, Sir George Beaumont, who became a lifelong friend, and Dr. John Fisher, Rector of nearby Langham and later Bishop of Salisbury, who was one-time tutor to H.R.H. Prince Edward. It was through Dr. Fisher that Constable first made the acquaintance of his nephew John Fisher, another amateur, who became the artist's closest and most faithful friend. During his formative years, the work of three amateurs strongly influenced Constable's development

as a draughtsman. Beaumont introduced him to the traditional modes of handling pencil, pen and wash (as well as to Girtin's more revolutionary manipulation of water-colour); through George Frost (Pl. 262) he learned to use black chalk and the stump in a manner based on that of Gainsborough; and, seemingly, it was through his friendship with William Crotch that he discovered the new Oxford tonality which, subsequently, he was himself to exploit so successfully. During his stay in the Lakes, in 1806, he was the guest of a family of amateurs, the Hardens. Amateurs are to be numbered amongst those few who were first capable of understanding the painter's intentions, and of recognising what he was achieving. When writing to another amateur friend, George Constable of Arundel, about the *Hampstead Heath with a Rainbow* (now in the National Gallery), Constable revealed how much this enlightened appreciation meant to him: 'I have lately turned out one of my best bits of Heath, so fresh, so bright, dewy and sunshiny, that I preferred to any former effort, at about 2 feet 6, painted for a very old friend—an amateur who well knows how to appreciate it, for I now see that I shall never be able to paint down to ignorance Almost all the world is ignorant & vulgar.'[1]

Paul Sandby was another artist who enjoyed the society of amateurs, and many of his friends were one-time pupils. Two of these, Col. Gravatt and Charles Greville (from whom Sandby received the secrets of the aquatint process) have already been mentioned in a previous volume[2]. Another close friend was George Simon, Viscount Newnham, afterwards 2nd Earl of Harcourt, who etched several of the drawings Sandby made at Stanton Harcour, one of the family properties near Oxford. The following extracts from a letter he wrote to Sandby in 1794 or 1795 are sufficient to reveal the affectionate regard he had for the painter.

> I am sorry and glad that you do not come here. I am sorry, because I am always happy in your company; and am glad, because it would not be agreeable to you, and, beside, the reason of your being in London is a very pleasing one to me. I own I am astonished at hearing you have any business, for you have genius in your art, and good sense—two obstacles that I thought you would never overcome, and which, I am sorry to tell you, will never be half the use to you that a little fan-painting, with a due portion of vanity, folly, pertness, and impudence, would have been to you. . . . Fools honour title and fortune, and everyone else is obliged to have some outward respect for them; but real genius never courts them without there is other merit to embellish them. . . . But let me recommend you to cultivate, though not in a mean manner, the acquaintance of as many as you can, for there is wonderful virtue in the words 'my Lord!' It sounds well to say, 'I dined on such a day with the Duke', or, 'I have passed so many months with my Lord'. The rich citizen, who pays well, will like your pictures the better.[3]

If the number of titles to be counted in Sandby's circle of friends is anything to go by, Newnham was preaching to the converted in the last part of his letter, but nevertheless it is salutary to see how little genuine friendship was affected by differences of rank, even in that age. When in pursuit of his main interest the amateur allowed neither differences of rank nor of age to count for much. The Norfolk collector and amateur Thomas Harvey encouraged the young apprentice John Crome to come to Catton and see his pictures as often as he wished, and seems to have given him the free run of the house. When staying with the Beaumonts at Coleorton in 1808, each day after breakfast William Alexander found himself following his host to the painting-room where the two donned aprons and painted away together until well into the afternoon. And Richard Wilson's pupil Thomas Jones, persuaded by that equally enthusiastic amateur Oldfield Bowles of North Aston to come down into the country for a month or two and teach him to paint, found friendship stretched almost too far when,

[1] *John Constable's Correspondence*, V, 1967, p. 35. [2] Vol. I, p. 106,
[3] W. Sandby, *Thomas and Paul Sandby*, 1892, p. 137.

as he almost plaintively recorded in his Diary, they 'both applyd to painting with very little intermission for 5 months'.

In presenting the role of the amateur, so far our arguments have been designed to stress the positive side of his association with the profession. Historical credence demands some recognition of the other, the negative side of this relationship.

Soon after the word amateur was first generally adopted in the 1780s it deteriorated in meaning. To dabble had originally meant to splash, to bespatter or besprinkle, but after the turn of the century, with the increasing popularity of water-colour, a dabbler became one who worked in the style of an amateur—as it were carelessly, somewhat disdainfully, in a well-bred and off-hand fashion. Having been branded thus the amateurs accepted the synonym and began not only to refer to themselves in mock disparaging tones as dabblers, but to perform in a manner markedly less whole-hearted than that which had characterised the work of earlier generations. Though by their steadily increasing number the amateurs had added considerably to the momentum of the water-colour movement in its earlier phases, *en masse* they were unable to keep pace with the later acceleration of professional advance and in consequence became a dead rather than a living weight, from which, for its very survival, the movement was eventually forced to free itself. This emancipation was not achieved without attrition and loss. The first signs of a rift followed closely upon the distinction of the amateur as belonging essentially to a class of artist apart from that of the main body. The younger professional artists began to keep more to themselves and to form groups and associations from which the amateur was carefully excluded. In order to maintain a hold on affairs, the older type of patron-amateurs in turn formed themselves into powerful bodies, such as the 'Committee of Taste' and the British Institution, with self-ordained powers of dictation and discrimination on matters pertaining to art. Divorced from friendly understanding, and subjected to ostensibly beneficent but interpretatively repressive measures, in defiance the younger painters rebelliously agreed upon aims that were in opposition to those held by the older generation, and sought for a new class of patron that would be less inclined to refer their achievements to precedent. Having thus lost touch, the amateur fell back to take up station, as it were, aside from the revolutionary process, as a regretful but helpless reactionary.

If, through an unwillingness to change their view-point, the amateurs as a body suffered defeat in the manner just described, it was not before they had unmanned or reduced to a condition of sterility almost as many artists as they had made. The biographers of the water-colour painters who, after all, sit down to write of their subjects because of the work they produced, seldom fail to record their disapproval of any activity such as teaching, which diverted the artists from their main purpose, the painting of pictures. But when due allowance has been made for such understandable prejudice, there remains a substantial body of evidence to support the view that the attentions of amateurs, whether as patrons or pupils, in a great many cases had a deleterious effect on the productivity of artists as well as upon the quality of the work they produced, and, as a corollary, that had not certain painters held courageously to their ideals and principles, despite such attentions, it is likely that the number of casualties would have been greater. For though the painter at the commencement of his career may find stimulus and even encouragement from a circle of admiring young faces, upon the spirits of an older man the experience of a few hundred hours of repetitious drawing lessons can have an entirely contrary and crushing effect, especially if he still cherishes ambitions and hopes that teaching can never fulfil.

There are also many examples which could be quoted here to illustrate both the deficiencies of

amateur patronage and the tiresome importunities of the amateur pupil. Two not dissimilar stories suggest that the professional artist had ever to be on the watch for amateur presumptuousness. The first concerns Richard Wilson and was told to Farington[1] by the banker Sir William Elford:

> Wilson had been invited to a gentleman's house but when he approached it he turned to an acquaintance and said, 'Are there any young ladies?' He was answered to the affirmative, 'Do they draw?' continued Wilson. The reply was 'Yes'; 'Good morning to you, then' sd. Wilson & turned away.

The second is narrated by the journalist William Jerdan and tells of Turner and their mutual host, de Tabley.

> Turner, our prince of landscape-painters, of whom Lord de Tabley had been a most liberal patron, spent a day or two at Tabley when I was there. In the drawing-room stood a landscape on an easel on which his Lordship was at work as the fancy mood took him. Of course, when assembled for the tedious half hour before dinner, we all gave our opinions on its progress, its beauties and its defects. I stuck a blue wafer on to show where I thought a bit of bright colour or a light would be advantageous; and Turner took the brush and gave a touch here and there, to mark some improvements. He returned to town, and—can it be credited!—the next morning at breakfast a letter from him was delivered to his Lordship containing a regular bill of charges for 'Instruction in Painting'. His Lordship tossed it across the table indignantly to me and asked if I could have imagined such a thing; and as indignantly, and against my remonstrances, immediately sent a cheque for the sum demanded by 'the drawing-master'.[2]

From Cotman there comes many a piteous cry at the cruel fate which had made him a mere drawing-master, 'the very thing I dreaded most on setting out in life', but it is a casually frank entry in the diary of one of the uncomplaining Crome's pupils, Richenda Gurney, which, because of its hideous triviality, speaks most eloquently of the artist captive in a drawing-room. The entry is brief (and quoted in a different context, Vol. II, p. 60):

> Jan. 17 (1798). I had a good drawing morning, but in the course of it gave way to passion with both Crome and Betsy—Crome because he would attend to Betsy and not to me, and Betsy because she was so provoking.

Having said something about amateurs in general, the conditions which favoured them, and their part in water-colour history, there remains to be reviewed the work they produced. Though it is beyond the capacity of the historian to compute the number of amateurs that at one time or another was engaged in drawing and painting, the total must run into many thousands in each of the generations that belonged to our period alone, and the mind boggles at the thought of attempting to multiply even this indeterminate figure by another equally uncertain number to arrive at a sum which might represent their total output of drawings. Fortunately, there is no need to pursue such a statistical will-o'-the-wisp, as it is only necessary to register an acknowledgement that the field is enormous and that we have but a poor idea of its extent. It is to be hoped that in time we may know more, for though the greater part is monotonous in character, yet much has already been discovered that warrants critical appreciation and it is likely there is as much again awaiting attention.

In his book on *Early English Water-colours*, Iolo Williams (one of the first to pay much attention to amateur work) observed that the amateur tended to be old-fashioned, that he was inclined to produce drawings 'which seem stylistically one generation earlier than the work of professionals of the same age'. While in general this is undoubtedly true—for, conservative by nature, the amateur was taught by men who found it easier to impart what they had been taught than that which they themselves had learned—yet there were many who worked very much in the mode, a few whose work even

[1] *Diary*, October 8, 1809. [2] Whitley, 1821–1837, p. 135.

anticipated stylistic changes, and a number working independently in isolation away from the main stream whose productions seem curiously out of period altogether—neither behind nor ahead of the general advance. As the acquisition of manner was the amateur's chief concern and as he achieved this by imitation, though difficult to identify as being by an individual hand, it is often comparatively easy to associate his productions with a region—Norwich, Exeter, Bath, Oxford or Birmingham—where a dominant personality presided or a group of artists was established, or with one of the better-known teachers and their following. When making such general classifications, the only confusion which may arise is that caused by an amateur's transference from one teacher to another when, for a time, his work may reflect the characteristics of both artists together, or when, after he has mastered the new style, his new manner seems so very unlike his old. Though when viewed singly the general air of accomplishment and good taste which informs the productions of such a follower has undoubted charm, one has only to see a number of his drawings together to experience a sensation of tedium, and there is hardly anything more likely to raise doubts as to the viability of such an individual than the sight of his life's work in albums or portfolios, with its conscientious but deadly evenness of performance and inflexible mediocrity. Happily, not all teachers imprinted their personality and manner so ruthlessly upon those they taught and by no means all of the amateurs were content to be thus stereotyped, as those to whom we now can turn will readily show.

First a group of landowners: Robert Price of Foxley, Herefordshire (1717–1761); Oldfield Bowles of North Aston, Oxfordshire (1739–1810); The Earl of Aylesford (1751–1812); and Sir Richard Colt Hoare of Stourhead, Wiltshire (1758–1838). All four were men with estates that flourished under their direction; all were men of independent spirit with wide-ranging interests. Three of them, Price, Aylesford and Colt Hoare, came of families in which the arts had long been cultivated.

Robert Price's grandfather made his Grand Tour in the 1670s. His father, Uvedale Tomkyns Price (1685–1764), had included Spain in his Tour and had been a member of the famous artists' club, the Rose and Crown (of which Thornhill, Watteau, Hogarth and Rysbrack were also members), and in later life became a frequent riding companion of Gainsborough's, who painted his portrait in which he is depicted holding a port-crayon in one hand and a landscape drawing in the other.[1] In the late 1730s, after an education at Winchester, Robert Price made his continental tour. While in Rome he studied music under Andrea Basili, took lessons in drawing with Giovanni Battista Busiri, and met William Windham of Felbrigg, Norfolk, with his tutor Benjamin Stillingfleet, with whom he became fast friends. Both Price and Windham bought a number of Busiri's landscape drawings.[2] They parted, to meet again in Geneva where they were joined by others of their kind, and for a year or so the party remained together, writing entertainments (for which they painted the scenery, and composed and performed the music), mounting expeditions, and both delighting and scandalising the Swiss by their high spirits. In due course the party broke up, but with a plan in view which seems to have been none other than to return and rejuvenate the arts in London. Price called in at Paris to try to persuade some of the engravers there to join the scheme. His father was delighted at his safe return, commended him for spending his money wisely on drawings and prints, and was full of praise for his drawing. 'He looks upon me as a great connoisseur in painting', Price wrote back to his friends in Geneva, 'and as such has introduced me to all his acquaintance among painters, which is pretty numerous . . . he looks upon me as a great dab at it [drawing] and tells me I draw much better than

[1] E. Waterhouse, *Gainsborough*, 1958, pl. 60.
[2] Those that Windham purchased are to be seen still at Felbrigg, exactly where he hung them.

259

he does.' London proved a disappointment, and after his marriage to Sarah Barrington in 1746, Price moved down to Foxley, where he could read, compose, paint and develop his ideas in complete freedom. As his father now resided in Bath, he took over the care and management of the estate with enthusiasm, throwing uplands into pasture, removing useless hedgerows, and experimenting with crops and stock to improve the yield. As a surveyor of the roads in the surrounding parishes he impressed all by his impartiality in first making passable those furthest from his own land. Foxley lay in a valley formed by wooded hills and it was here that he made the most striking and original improvements, cutting and planting, and laying winding paths to create something quite new—prospects designed to arouse an admiration for natural beauty. Requiring a daily companion with parallel interest, he installed Windham's tutor Stillingfleet in a nearby cottage. Soon Price infected his friend with his own enthusiasm for agriculture, and Stillingfleet began to publish the results of their researches into the art of husbandry. To illustrate these publications, Price provided drawings. Besides busying himself with land management, with painting, and with the care of a rapidly increasing family, Price found time himself to publish an abridgement of a treatise by Rameau on musical harmony. Stillingfleet followed suit with *Principles and Power of Harmony*, founded on Tartini's newly published *Trattato di Musica*. Nature, the fount and well-spring of all, was a living being in Foxley philosophy. Stillingfleet wrote thus of her in the last-mentioned work: 'Music is the voice of industry, of content, of serenity, of innocence; in short, it is the voice of Nature, uncorrupted, unoppressed and as such is heard, and once was more frequently heard, in our fields and villages.'

Having already ridden down the Wye to Tintern (a reconnaissance that anticipates William Gilpin's tour by more than a decade), Price ventured further into wilder and still more primitive regions, to the fastnesses of North Wales, which, hitherto, few men of his tastes had attempted to penetrate. Two drawings dated 1758 record him at Llanberis, and sixteen others record a tour that he made of the area the following year with his brother-in-law Daines Barrington and Stillingfleet, during which, while the other two collected rare plants, he made more than fifty sketches. Described by Stillingfleet as the most perfect character he ever knew, Price died a widower at the early age of forty-four leaving behind his fourteen-year-old son Uvedale as heir.

With his practical experience of land-management and husbandry and his deep love of the arts, Price epitomises the kind of landowner who, by just such a combination of interests, contributed so much towards the general change of attitude that brought about a wide-spread recognition of land as landscape. His surviving drawings show him to have been amongst the few who, at this time, were consciously attempting to reconcile the Italian generalised notions of landscape with a first-hand experience of the English scene. The undated *View from the Parsonage Garden at Ross* (Pl. 264), a work entirely native in feeling, suggests that a knowledge of the one did not necessarily diminish a response to the other. Though cut off thus in his prime Price did not carry all with him to the grave. From him his son Uvedale received more than a material inheritance, and in later life gave proof of this by developing many of the ideas his father had held on natural beauty in his own writings on the Picturesque. And in the work of the young German John Malchair (whom Price had taken under his wing in 1757), there is clear evidence that at least one artist made good use of both the older man's ideas and his methods of practice.[1]

Oldfield Bowles (1739–1810), recorded as 'a most accomplished country Squire . . . an adept at

[1] It has been suggested that Gainsborough also was infected with the ideas currently held at Foxley about natural beauty. See E. Waterhouse, *Gainsborough*, 1958, p. 23.

all those rural and athletic exercises appropriate to men of wealth and leisure',[1] was also a typical amateur of the landowning classes. Inheriting his property, North Aston, from his father (a one-time Verdurer of Windsor Forest), though of a less original turn of mind than Price, he too divided his time between the management of his estates and the pursuit of the arts, and, like Price's Foxley, North Aston became a meeting-place for musicians and painters—professional and amateur alike. A crony of Sir George Beaumont's, Bowles belonged to the loosely-knit group of professional and amateur artists who brought about the revival of interest in Richard Wilson round about the turn of the century. Bowles' interest in that artist undoubtedly stemmed from the long hours that he spent in his painting-room with Wilson's pupil Thomas Jones, who was a guest at North Aston from March 1773 to March 1774. Possessing both pictures and sketch-books by Wilson, Bowles' own painting and drawing (Pl. 265) are closely modelled on the manner of the older man. Though equally devoted to his country property, where he built a small theatre, Bowles was much more closely associated with artistic circles in London. He exhibited fairly regularly, and for many years was a member of a small select club which used to meet and dine in the winter and summer seasons. Named the Society of St. Peter Martyr, the membership of the club was confined to eight: four amateurs, Sir George Beaumont, the Hon. Augustus Phipps, Bowles and his son Charles; and four professionals, Benjamin West, Farington, George Dance and Thomas Hearne. In addition, Bowles was also closely associated with Malchair and his Oxford School.

In Heneage Finch, the 4th Earl of Aylesford (1751–1812), we have an amateur who, together with Place, Taverner and White Abbot, deserves notice as an artist in his own right. Born at Packington, the family home in Warwickshire, he was the eldest son of the 3rd Earl.[2] All the Finches proliferated. Our Earl was the eldest of eleven and in turn became the father of thirteen. Most of them seem to have taken to art in some form or another. His mother was renowned for her needle-work pictures. Two of his brothers, Edward and Daniel, were accomplished landscape draughtsmen. Both his sisters and his wife Louisa painted exquisite studies of flowers, moths and butterflies. Two of his daughters, Elizabeth, who died in 1879, and Frances, who lived to be 95 and died in 1886, drew and painted competent landscapes in their father's manner.

After his education at Westminster, Aylesford spent the years 1767–71 at Oxford, where he became a member of Malchair's flourishing little school for amateurs. Some time between coming down from the university and his election to the Dilettanti Society in 1776, he travelled in Italy and Sicily, though it is not easy to see exactly when the trip was made as he became a Member of Parliament in 1772, a Fellow of the Royal Society in 1773, and is down as having spoken in the House in 1774. He succeeded to the title in 1777 and soon after obtained the first of a series of Appointments which required regular attendance at Court. In 1782 he married Louisa Thynne, eldest daughter of the Marquis of Bath. An occasional exhibitor at the Royal Academy in the '80s, after a row in 1790 involving his protégé the architect Joseph Bonomi and his friend Joshua Reynolds (which culminated in the President's resignation) he did not exhibit again. A man of abounding energy whose interest in a new subject could be quickly aroused, by his contemporaries Aylesford was considered remarkable

[1] William Wing, *The Annals of North Acton*, 1867.
[2] To whom Handel's friend Charles Jennen left his collection of pictures, his library of music containing many of Handel's autograph scores, besides the organ on which Handel was accustomed to play when staying with Jennen, and which is still in use in the church at Packington.

for his 'perseverence in endeavouring to accomplish whatever he undertook'.[1] His favourite outdoor sport was archery, at which he excelled. He was a skilled ivory-carver and turner. Under Bonomi's guidance he studied architecture and perspective and, though it is not yet certain how many, if any, of his designs were realised, built a church in the grounds at Packington of quite astonishing originality. Having learnt etching while at Oxford, and having later practised it in the manner of Piranesi,[2] in the 1790s he turned to it with renewed zest and, working almost entirely by himself, became the finest artist-etcher of his day. This renewal of interest led him to Rembrandt and to the formation of what is said to have been an unequalled collection of the Dutch master's etchings.

Most of Aylesford's drawings, of which the greater number are still at Packington, were done when he was on one of his holiday tours. Though probably the outstanding product of the Oxford School, he seldom dated or inscribed a drawing at the time it was drawn, and never initialled or signed one. The names of the places he depicted are only to be found on the mounts, written in brown ink. His mature style is strongly characteristic. Almost always he employs pen and grey and brown wash, beneath which there can occasionally be seen a faint initial pencilling. The pen-work, generally in brown, plays an important part, but in a manner peculiarly his own, to indicate textures and to particularise, rather than to contain with outline. His washes are numerous, but when he avoids excessive overworking there is to be seen a very distinctive quality, a kind of bloom, especially in his greys, which can lend great charm to his drawings. Some are palely tinted in colour, in others he uses a touch of red chalk here and there to suggest accents of local colour. When a passage has become overloaded with successive washes he will occasionally employ a little white body-colour. Though the subjects which attracted him were most often humble in character—dilapidated barns, tumble-down cottages and crumbling ruins—occasionally, as when on tour in Scotland, he is capable of attempting something on a grander scale and of successfully handling broad sweeps of moorland and mountain. It is often extremely difficult, if not entirely impossible, to distinguish between his drawings and those of his brothers and daughters. Tantamount almost to a signature, however, there is often to be seen in his work a zig-zag flourish, with which, after delineating some vegetation or other foreground material, he will often casually dismiss the remainder. This mannerism is even to be seen in some of his wash drawings, dashed in with a brush like a final exclamation of satisfaction. Besides this 'signature', it is Aylesford's understanding of light which most surely distinguishes his work from that of his family, for none of the other Finches shared his acuteness of feeling for the slant and depth of shadow and for subtle gradations of atmospheric recession.

At the inaugural meeting in 1785 of the Woodmen of Arden, the archery club at Meriden of which Aylesford was made perpetual Warden, one of the first members to be elected was the Rev. William Bree (1754–1822), Rector of nearby Allesley, an almost exact contemporary of the Earl's and likewise a keen water-colourist. Though his manner plainly derived from Aylesford's, Bree's drawings with their soft, gentle washes, delicate pen-work, and rounded forms are quite distinctively his own (Pl. 268). As his work is so widely scattered it is at present not easy to obtain a clear idea of its scope. So far none has been seen of a subject outside the Allesley, Packington, Maxstoke region. Quite often his drawings are signed or initialled and dated—the earliest-known is inscribed 1783.

Though best known as the historian of his native Wiltshire, Sir Richard Colt Hoare (1758–1838)

[1] Farington, *Diary*, October 24, 1812.
[2] So successfully that his book plate for the library at Packington has recently, though mistakenly, been attributed to Piranesi himself.

262

was also an amateur and patron of some distinction. An interesting passage from his *History of Modern Wiltshire*, already quoted (Vol. I, p. 138) for its reference to the Swiss artist Ducros, acknowledges his debt to Warwick Smith 'to whom, as an instructor, I owe the little I do know of drawing'. A member of the banking family, it was grief after the sudden death of his young wife in 1785, two years after their marriage, that started him on the first of his extensive tours of the Continent. On the second of these, in 1789, he set out to journey the length of the ancient Via Appia from Rome to Brindisi in company with the landscape painter Carlo Labruzzi, with the splendid intention of afterwards publishing a work illustrated by engravings from the many drawings Labruzzi was to make *en route*. Unfortunately, the project was never fully realised. Things started well, with Labruzzi sketching and Hoare noting every antiquity that they came upon, but then rain and flooding drove them off the Via and when, after struggling on, Labruzzi became seriously ill, all hope of completing the journey had to be abandoned. Work on the publication itself only proceeded as far as the engraving of twenty-four of Labruzzi's drawings, of which twelve were finally issued.[1] Watching Labruzzi's manipulations of his bright and fluent washes of water-colour seems to have had little effect upon Hoare's own style, which is seldom anything but monochromatic and rather heavy-handed in manner (Pl. 269), but this experience, coupled with his friendship with the equally facile Ducros, must nevertheless have rendered him particularly sensitive, on his return to this country, to work by native artists that exhibited brilliance in any comparable degree. It therefore comes as no surprise to find Hoare's name down as having ordered four drawings in 1795 from the twenty-year-old Turner, and to find him quickly following up this first commission with others from the same artist—including twenty of Wiltshire's county town, Salisbury. In addition to his *History of Wiltshire*, Hoare published many accounts of his travels: *Journal of a Tour in Ireland*, 1807; *A Tour through the Island of Elba*, 1814; *Hints to Travellers in Italy*, 1815; *Recollections of Abroad*; *Journals of Tours on the Continent between 1785 and 1791*, 1817; and *A Classical Tour through Italy and Sicily*, 1819; besides numerous other works on antiquities, family pedigrees, architecture and the collections at Stourhead. Many of these were illustrated with engravings from his own drawings. The Stourhead catalogue, privately and post-humously printed, refers to the nine hundred or so drawings that he made during his continental tours alone, only part of his remarkable output as a draughtsman.

Before moving on to three representatives of the professional classes, perhaps this is the place to mention one who, though temperamentally unsuited to a solitary existence in the country, could not bring himself to live anywhere else. John Skippe (1741–1812), the only son of a Herefordshire squire, went up to Oxford in 1760. There he was one of the first to take lessons with Malchair, who at this time, with little experience of teaching, was making overmuch use of engravings after the Bolognese masters as models for his pupils to copy. In 1766 Skippe left England for the first of three prolonged sojourns in Italy, from the last of which he did not return until 1777. While it is by no means clear exactly what it was that kept him abroad for so long, self-pitying references to feeling ill-used and to being debarred from happiness suggest that if there were any real grounds at all it was paternal disapproval of an intended marriage that kept him away from home. On his return he took a house to be near his married sister Penelope Martin at Overbury, at the foot of Bredon Hill in Worcestershire. Here he remained for the rest of an uneventful life. The best of his drawings were made while he was

[1] Entitled *Via Appia illustrata ab urbe Roma ad Capuam*, they appeared without text in 1794. See F. J. B. Watson, 'A Forgotten Artist of the 18th Century', *The Antique Collector*, June 1960.

abroad, such as the *View of Mount Grimsel* (Pl. 270)[1] and those he brought back with him from a tour of the Near East in 1775–6. Though he occupied himself with an original project, the cutting, printing and issuing of chiaroscuro wood-cuts from Old Master drawings in his collection (with which he attempted, and failed, to gain public notice), the several hundreds of drawings he made after his return are unvaryingly uniform and dull performances in the manner of the Bolognese he had copied while at Oxford many years before, the work of a man seemingly incapable of rousing himself to attempt anything more ambitious. An inscription on the mount of one of these pathetically records the fearful lassitude which their manufacture apparently did nothing to dispel: 'Designs by John Skippe, in the composing of hundreds of which he amused himself in his winter nights.'

General Sir George Bulteel Fisher, K.C.H. (1764–1834), was the youngest of nine sons born to John Fisher and his wife, Elizabeth Laurens, a Huguenot heiress. Born at Peterborough, where at the time his father was incumbent, Fisher was a member of the family which played such an important part in the life of John Constable. His eldest brother John, Bishop of Salisbury, was one of the painter's first patrons, and his nephew John, Archdeacon of Salisbury (the son of another brother Philip, Master of the Charterhouse), became Constable's closest and most valued friend. Some confusion tends to arise from the fact that in the family the third brother Benjamin, who served in the army as a Royal Engineer, was known as 'the General', to distinguish him from George, who was referred to as 'the Colonel'. Sir George, 'the Colonel', the subject of this note, entered the Royal Artillery, and therefore presumably must have studied under Paul Sandby at the Woolwich Military Academy, of which he was eventually to become Commandant. A number of the drawings which he made during his service in North America during the 1790s were afterwards engraved, as he was one of the first of the water-colourists to work in Canada. During the campaign in the Peninsula he commanded the forts on the Tagus until 1810 when, owing to some misunderstanding with Wellington, he left that seat of war. Constable met him for the first time at the Bishop's in Seymour Street when 'the Colonel' described his having assisted the panorama painter, Robert Barker, to make drawings of the scenery in Portugal around Cintra for one of that artist's panoramas at Leicester Fields. In 1814 they met again at Seymour Street, an encounter that Constable wrote of thus to his wife: 'Last Thursday I had a very pleasant day at the Bishop of Salisbury's. I was invited to meet a brother of the Bishop's, Colonel Fisher, who is an excellent artist. Many years ago he made some beautiful drawings in America, which are engraved. The Colonel is just returned from Spain, and was very interesting in his accounts of it—which part of his conversation I preferred to his telling me how Rubens made his pictures, for that I thought loss of time'. Like so many amateurs, Fisher considered that his practice in the art entitled him to speak with authority on all matters relating to painting. As R. B. Beckett observes: 'It would seem that he had a way of giving Constable advice about his work in the manner of a commanding officer talking to a subaltern.'[2] Two further extracts from Constable's correspondence complete the picture. In June 1824 he wrote to his wife: 'He (the Bishop) says I must visit the Colonel at Charleton, this or next month for a day or two. I do not wish it, as I begin to tire of going to school.' And two years later to his friend, Sir George's nephew, who quite understood Constable's feelings, he wrote: 'The Colonel has some of his heartless atrocious landscapes in Seymour Street & has sent to consult me on them. How shall I get out of such an infernal scrape. Truth is out of the question. Then what part can I play—praise is safe—& the whole of no consequence—?'

[1] Coll. Mr. E. Holland-Martin.
[2] R. B. Beckett, *John Constable's Correspondence*, II, 1964, p. 344.

264 'View from the Parsonage Garden at Ross'
Coll. Mr Ian Fleming-Williams 7×11: 178×279 *Pencil and wash*
Robert PRICE (1717–1761)

265 'Ashburne in the Peak, May 13, 1789'
Coll. Sir Arthur Elton, Bt. 6¼×8: 159×203 *Chalk*
Oldfield BOWLES (1739–1810)

266 'Blackistone Edge, near Littleborough'
Coll. The Earl of Aylesford $7\frac{7}{8} \times 10\frac{3}{4}$: 200×273 *Water-colour*
Heneage Finch, 4th Earl of AYLESFORD (1751–1812)

267 'Waterfall at Gwrchles Mill in Denbighshire'
Coll. The Earl of Aylesford $10\frac{5}{8} \times 15\frac{5}{16}$: 270×389 *Water-colour*
Heneage Finch, 4th Earl of AYLESFORD (1751–1812)

268 'Derelict Mill Machinery'
Coll. Mr & Mrs Cyril Fry $10\frac{3}{8} \times 14\frac{1}{2}$: 264 × 368 *Water-colour*
Rev. William BREE (1754–1822)

269 'East View of Roch Castle, Pembrokeshire 1793'
Coll. Mrs Elinor Williams $7\frac{1}{2} \times 11\frac{1}{2}$: 191 × 292 *Sepia*
Sir Richard Colt HOARE (1758–1838)

270 'A View upon Mount Grimsel'
Coll. Mr Edward Holland-Martin 8½ × 13½: 215 × 345
Pencil, pen and grey wash
John SKIPPE (1741–1812)

271 'View from Candie, Guernsey'
Coll. Le Marchant family 5⅛ × 3¾: 130 × 86 *Water-colour*
John Gaspard LE MARCHANT (1766–1812)

272 'The Thames from Charlton'

V.A.M. P.8–1914 $17\frac{1}{2} \times 25\frac{1}{16} : 428 \times 635$ *Water-colour*

Sir George Bulteel FISHER (1764–1834)

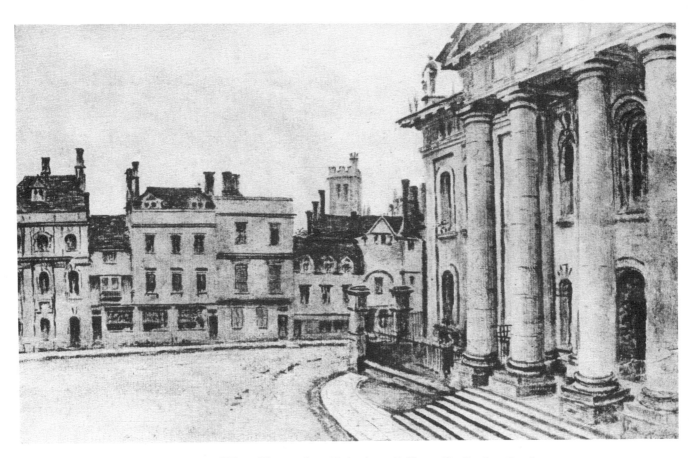

273 'The Clarendon Printing Office, Oxford, 1801'
Coll. Mr Ian Fleming-Williams $9\frac{3}{4} \times 14\frac{1}{2}$: 247×368 *Water-colour*
William CROTCH (1775–1847)

274 'Hampstead, from behind Wetherall Place, 1807'
Coll. Mrs Elinor Williams $4\frac{1}{2} \times 7$: 114×178 *Water-colour, some body colour*
William CROTCH (1775–1847)

275 'View of Reading, Berkshire'
Coll. Mrs Elinor Williams 5 × 6¾: 127 × 171 *Water-colour*
George HERIOT (1766–1844)

276 'Kirkstall Abbey' (Copy after Thomas Girtin)
Coll. Mr & Mrs Paul Mellon 13 × 20½: 320 × 520 *Water-colour*
Amelia Long, Lady FARNBOROUGH (1762–1837)

277 'Mam Tor & Odin Lead Mine near Castleton, Derbyshire'
Coll. Mr Ian Fleming-Williams 13⅝ × 18⅞: 346 × 480 *Water-colour, signed and dated 1789*
William DAY (1764–1807)

278 'Family scene; two women and a child'

Coll. Mr & Mrs Cyril Fry $10\frac{1}{8} \times 13$: 257 × 330 *Pen and ink, signed and dated 1784 on reverse*

William LOCKE (1767–1847)

279 'Holyhead, high water'

Coll. Mr & Mrs Paul Mellon $5\frac{1}{4} \times 10\frac{3}{4}$: 133 × 273 *Water-colour*

Rev. James BULWER (1794–1879)

280 'Reapers'
Coll. Mr & Mrs Paul Mellon $7\frac{5}{8} \times 18\frac{3}{8}$: 194×466 *Water-colour*
Louisa, Marchioness of WATERFORD (1818–1891)

281 'Aldeburgh, 1812'
Coll. Mr Ian Fleming-Williams $9\frac{1}{8} \times 14\frac{3}{4}$: 232×375 *Water-colour*
"WORTHING DRAUGHTSMAN"

282 'From the door of the villa Medici April 2 83-Wednesday'

Coll. Sir George Beaumont Bt. $10\frac{7}{16} \times 14\frac{3}{8}$: 265 × 365 *Pencil and water-colour*

Sir George Howland BEAUMONT Bart. (1753–1827)

283 'Dunmow June 16 1803'

Coll. Sir George Beaumont Bt. $5\frac{3}{8} \times 7\frac{3}{4}$: 137 × 197 *Pencil and grey wash*

Sir George Howland BEAUMONT Bart. (1753–1827)

284 'Entrance to the Grotto of Possilipo, Naples'
Coll. Mr D. F. Snelgrove $9\frac{3}{8} \times 15\frac{5}{8}: 238 \times 397$ *Water-colour*
Thomas JONES (1742–1803)

285 'The Hot Wells, Bristol'
Coll. Mr D. F. Snelgrove $10 \times 13\frac{5}{8}: 254 \times 345$ *Black stub and grey wash*
Dr. Thomas MONRO (1759–1833)

SIR G. BULTEEL FISHER MAJOR-GEN. J. G. LE MARCHANT W. CROTCH

Perhaps Constable was a little harsh in his judgment. Individually Fisher's water-colours, with their almost incongruously pale washes of delicate tinting and carefully arranged screens of outlining, have a certain poetic charm, but when seen, as they recently appeared on the art market, in bulk, one does find oneself sympathising with a professional like Constable who was called upon to make encouraging comments upon drawings of such uniform character. When working more like his brother the Bishop on a small scale, Fisher achieved a pleasant enough quality. In later life, however, he seems to have found only the largest available sheets of paper to his taste, and for this size his pale fairy tints, as he managed them, are hardly adequate.

Major-General John Gaspard Le Marchant (1766–1812) has already been mentioned in this chapter. Had he not been killed at the age of forty-six when leading a charge at the Battle of Salamanca, it is likely that he would have been better known as an artist, for some of the water-colours he made in the Peninsula shortly before his death are of a quality greatly superior to that of which the average amateur was capable. Oddly enough it was his talent for drawing which first brought him into notice. While stationed at Gibraltar as a very young officer, having forsworn cards (owing to heavy debts incurred in Dublin), he found that he had to live a life apart from the garrison mess. For solace, he turned to music and sketching. A little later, as a cornet in the Inniskilling Dragoons, he was placed in command of the escort detailed to accompany George III from Dorchester to Weymouth. His youth aroused comment, and when Sir George Yonge, the Secretary at War, showed his drawings of Gibraltar and the Barbary Coast to the King, the Royal interest was further intensified. Thereafter his career was assured, as his subsequent promotions by preferment testify. Until the sudden maturing of his style around 1810, Le Marchant's progress as an artist had followed a normal course. The drawings he made during the dismal campaign of '93 in Flanders were line-and-wash sketches in the manner of Farington, who, in 1791, had taken on his brother-in-law, Peter Carey, as a pupil. Then Le Marchant had lessons with William Payne and learnt to paint more freely with the brush. After this, William Alexander (whose appointment as drawing-master he had secured at his newly-formed Military Academy at Marlow) taught him to use lighter and more delicate hues, to apply his washes in a less demonstrative fashion, and to pay more attention to drawing. From this combination of influences and techniques Le Marchant evolved his own style. As is shown by the drawing made in his native Channel Islands (Pl. 271), inscribed *View from Candie of the opposite Islands in a September night*, this was very little different from that of the more advanced among the professionals working at this time. During the morning of July 22, 1812, Le Marchant made a pencil sketch of the environs of Salamanca; that afternoon, his son saw his body being carried off the battlefield by a group of his own troopers.

Dr. William Crotch (1775–1847) had a very different history. The son of a Norwich carpenter with musical interests, at the age of two years and two months the child William began to pick out the tunes he had heard on an organ made by his father. Within a few weeks he could play *God Save the King*, and four months later the Easter Hymn, concluding with chords in each hand. News of the astonishing child quickly got around and he made his first appearance before an invited gathering, a prodigy of two years and seven months. He was barely three when his mother took him round Norfolk on the first of a long series of tours, and only three and a half when he was summoned to appear before the Royal family at Buckingham House. It was not until he was ten that friends finally prevailed upon his mother to release him from a gruelling life of concert appearances as the Musical Child. In 1787 he was settled at Oxford with a family which kept a music shop. Here his education

265

began. At the age of fifteen he became organist of Christ Church and at twenty-two Professor of Music. In the year of the latter appointment he married a local girl, Martha Bliss, the grand-daughter of a one time Astronomer Royal. In 1805 with his family, he moved to London, where he maintained a successful practice as a music teacher, lecturer and conductor. He came to know Constable, who made a delightful drawing of him at the piano playing Mozart. On the foundation of the Royal Academy of Music in 1823 he was made its first Principal—an appointment which he held for nine years, and which was only terminated after he had been reported by the female supervisor for, in a moment of musical exuberance, kissing one of his women students. Owing to a steady decline in health, his remaining years were spent in retirement. He died at his son's house in Taunton.

'My love of drawing', Crotch wrote in his *Memoirs*,[1] 'seems to have made its appearance in less than a twelve-month after that I showed for the sister art. I have ever found it a source of amusement after the fatigue of professional duties, so that I cannot tell which I love best of these two sisters.' Though he made his first untutored drawing from nature in 1789, it was not until he came to know Malchair in the late '90s that Crotch made a regular practice of sketching, and, strangely enough, it was not until after Malchair had lost his sight and was therefore unable to watch his young disciple's progress that Crotch's work begins to show signs of his influence. By 1800 the old man was totally blind. In that year Crotch made the first of his drawings that show a real understanding of tonality. As a privileged disciple, rather than as a pupil in the strictest sense, Crotch had access to Malchair's portfolios, and it was from the drawings he found there, which had been made for their own sake (and not from the remainder, the stock-in-trade of a drawing-master), that he learnt 'the use of the pencil uncontaminated by conventional signs for things visible'.[2] He thus became first and foremost a tonalist, and in consequence one who selected his subjects less for the sake of their pictorially associative qualities than for the direct impression they made at the moment of choice. The two examples of his work illustrated (Pl. 273 and Pl. 274) show how unrestricted was his vision. The view of the *Clarendon Printing Office at Oxford* was taken from his dressing-room window in Broad Street in July 1801. As the inscription on the back of the drawing records, he started and completed it between 3.45 a.m. and 9.15 a.m. The water-colour of *Wetherall Place, Hampstead*, so similar in both choice of subject and treatment to Constable's Hampstead sketches of a later date, suggests, as do others, that it was not always the amateur who was influenced by the professional.

As was said earlier on, the amateur corpus is immense and from the many scores of interesting draughtsmen (and women) whose work is to be found in public and private collections as well as in the possession of their descendants, others besides the few with which this chapter concludes might equally well have been selected. Although rather better than average, George Heriot's (1766–1844) pleasing little water-colours are no better than those produced by a dozen or more amateurs of his class. Said to have been Girtin's favourite pupil, Amelia Long, Lady Farnborough (1762–1837), was by no means the only young woman to have charmed her drawing-master (Pl. 276, a direct copy of Girtin's *Kirkstall Abbey*). William Day (*fl.* 1764–1807), who accompanied John Webber on two tours in 1788 and 1789, was only one of those who worked alongside a professional artist as a sketching companion and learned a great deal in the process. And the Rev. James Bulwer (1794–1879) was among the many clergymen who found time from their parish duties to work with pencil and paint-brush (Pl. 279).

[1] Norwich Central Library, Norwich MS. 11244.
[2] From a letter written to Crotch by A. W. Callcott, June 6, 1843, Norwich Central Library, Norwich MS. 11088.

It is for contrary reasons, however, because they were relatively atypical, that the remaining three—William Locke[1], the anonymous 'Worthing draughtsman', and Lady Waterford—have been selected for inclusion. Nearly all the amateurs we have mentioned were landscape painters. William Locke (1767–1847) is known chiefly for his figure-work. The son of the connoisseur and collector William Lock (whose name is always associated with his estate Norbury in Surrey), William the younger, when hardly more than a child, showed remarkable promise as a figure-draughtsman. He was petted and over-praised by his family and the many who visited Norbury. Via Mrs. Delany and Fanny Burney news of his precosity even reached the Queen, who expressed herself as charmed with the work of the eighteen-year-old. Henry Fuseli, who knew which side his bread was buttered, called one of his drawings 'divine' and dedicated to him his lectures on painting. Dissatisfied both with himself and with those who so readily applauded his every effort, in 1789 William left the sheltered family circle for Rome. This cured him of ambition, for the work he saw there told him the truth about his own talent. On his return he gave up painting and with it all thoughts of becoming an artist. Executed in a vigorous and expressive manner, as examples of youthful promise his drawings possess a certain piquancy. As a measure of his skill and sensibility, it is perhaps significant that his work in pen and wash on more than one occasion has been mistaken for that of George Romney.

It is hardly possible to pursue the study of English drawings for any length of time without encountering unsigned and unattributed work by amateur hands. In most cases it is not difficult to associate such work with one or another of the professional water-colourists who practised as drawing-masters, as the individuals responsible had little of themselves to add to that which they had learned from their teachers. Occasionally, however, the student comes upon an isolated drawing, or group of drawings, that strikes a different note, that bears the impress of a recognisable though anonymous personality. The artist here called 'the Worthing draughtsman' is just such a one. So far only forty or so of his drawings have been identified. The earliest is dated 1809, the latest 1832. He has been named after the South Coast resort as he seems to have worked there, and in the surrounding region, most often; but he is also to be found sketching in Suffolk, Gloucestershire, Worcestershire, Kent, Oxfordshire, the Midland counties, North Wales and elsewhere. His views of country houses such as Wroxton Abbey, Mote Park, Compton Verney, Packington and Hampton Lucy suggest that he was on terms of some familiarity with their owners. His unorthodox style is strongly characteristic. The attractiveness of his work is founded upon his unusually direct and simple vision, the almost naïve originality of his design sense, his velvety soft monochrome washes, and the sharp brilliance of his colour (Pl. 281). Some of his drawings are squared up in pencil for enlarging. So far he has defied identification.

Louisa, Marchioness of Waterford (1818–1891), the friend of Ruskin, G. F. Watts and Burne-Jones, is here mentioned to represent those few who worked in the period that followed the age of the amateur. The charming example illustrated (Pl. 280), provides us with a fitting conclusion to this chapter.

[1] William Lock added an 'e' to his name soon after the death of his father, but reverted later to the original spelling. As his work is referred to generally as by 'William Locke', this spelling is used when his name occurs in this work (Eds.).

APPENDIX III

Two Patrons and an Historian

After the many references to him in the preceding pages, Sir George Beaumont hardly requires an introduction. He has been mentioned both as a collector and as a patron; his name has been linked with the two Cozens and Richard Wilson, as well as with Hearne, Girtin and Constable; he has appeared also as a leader of the opposition against Turner; and, once again, as the advocate of the 'brown tree' and of pictures the colour of an old fiddle. But hitherto he has been seen only as a subsidiary figure. He was more than this. At one time it was suggested that he should be nominated to succeed his friend Benjamin West as President of the Royal Academy, and, so effectively did he pursue his interests, on another occasion the opinion was expressed that he was aspiring towards supreme dictatorship in the art world. The aim here is to review the position that he held as the leading patron and connoisseur, to dwell briefly on him as an artist, and to place him where he rightfully belongs among the many painters who were his friends.

Born at Great Dunmow, Essex, the only surviving child of George Beaumont, sixth baronet, and his wife Rachel Howland, George Howland Beaumont (1753–1827) succeeded to the title at the age of eight on the death of his father. Little is known of his schooldays, apart from what Henry Angelo, a fellow Etonian, tells us in his *Reminiscences*; but Angelo's all too pleasing accounts are notoriously unreliable and his sentimental anecdotes of Beaumont—'wandering alone in sequestred spots' amid 'ancient towers and turrets, woodlands, glades and water', of placing him, Angelo, a younger boy, ever by his side at the drawing table or protecting him from the more exuberant bread-pelting members of the art classes—are of as little value to the modern biographer as are the pages he devotes to Alexander Cozens, their drawing-master. While we can safely ignore Angelo's characteristically ingratiating jibe at Cozens' expense, that in the Drawing School only Beaumont understood what was being taught, it is nevertheless true that Beaumont's abiding love of painting began while he was at school, and what is more likely than this was nurtured if not inspired by Cozens, one of the most original teachers of his generation?

The sketching holiday in Norfolk with Woollett the engraver, Thomas Hearne (who became a life-long friend), and the amiable tutor Davy already mentioned[1] confirmed Beaumont in his love of painting, and soon after going up to Oxford the following year, 1772, he joined the flourishing school of fellow-enthusiasts that had gathered round another original teacher, John Malchair. While at Oxford he made the acquaintance of Viscount Guernsey (later the 4th Earl of Aylesford), who became a distinguished amateur, and of Oldfield Bowles, squire of nearby North Aston, both Malchair's pupils. In later years Beaumont's visits to North Aston, where he played a leading part in the elaborate amateur theatricals, became an annual event. It was there that he met Thomas Jones, whom

[1] Vol. I, p. 175.

268

Bowles had brought down from London to instruct him in painting; and it was there that he first met his future wife, Margaret Willes, who, with the neighbourhood, had come in from Astrop to enjoy one of the theatrical entertainments. They were married in 1778. Though childless, the marriage provided only happiness and content, for his wife shared in many of his interests and won many hearts by her sensitive understanding and selfless generosity. After their honeymoon in the Lakes, where they were joined by Farington and Hearne, the Beaumonts took up residence at Dunmow.

For two years the Beaumonts returned to the Lakes during the summer months, then in May 1782 they set off for Italy on a tour which was to be of the greatest importance for Beaumont's artistic development as it brought him in contact with J. R. Cozens, the son of his old drawing-master at Eton. For the historian, one of the most satisfactory habits cultivated by Malchair and his pupils was that of inscribing their drawings with the date and place. It is thus always possible to follow Beaumont on his travels and sometimes even to know of his whereabouts for days on end. On this, their first trip abroad, the Beaumonts arrived in Rome, via Schaffhausen and Turin, in the first week of October. Cozens was in Naples at this time. As a member of William Beckford's entourage he also had left England in May, but had arrived in Italy sooner. After his patron's departure in September, he himself had stayed on in Naples for a few weeks before returning to Rome, which he reached early in December. His influence upon Beaumont's work is to be seen for the first time in the drawings which the latter made around the end of the month, so that they must have met soon after Cozens' arrival there.

Like so many of his fellow-countrymen at this time, Beaumont seems to have regarded Rome and the Campagna primarily as a limitless store of subjects for his pencil. Though he went the rounds of churches and galleries, there is little evidence of this to be found among his many scores of drawings, in which the ancient city is seen almost entirely in terms of landscape, a landscape of ruins mellowed by golden light. Furthermore, like Cozens and the other water-colourists of the day, he seems to have spent the greater part of his time outside the city walls—beside the Tiber, or among the villas, lakes and cataracts of the surrounding hills. It must have been in company with 'Little Cousins', as Thomas Jones called him, that Beaumont spent nearly two weeks at Tivoli the following May (1783), for the pencil-and-wash drawings he made then are so like Cozens' own that, as Paul Oppé[1] wrote, 'were it not that his inscriptions are unmistakable and his preparatory washes simpler than, and different from, Cozens' own, some of his drawings might pass for the master's beginnings in an uninspired moment'. Whatever the relationship between Cozens and Beaumont, whether it was that of painter and patron, master and pupil, or merely that which can spring up naturally between compatriots on foreign soil, they were clearly on terms of reasonable familiarity.

Jones, who had been in Italy since 1776, recorded Beaumont's arrival on March 9:

> I waited upon the above gentleman, whom I had the honour of knowing in England, and during his short stay at Naples, had many interviews. The day before he set off on his return, we made an excursion by sea, to Mare Chiaro, Gaiola, etc., on the coast of Posillipo, to take views and make studies.[2] I happened to have by me an unfinished view of Velletri painted at Rome some years ago, which Sir George

[1] A. P. Oppé, *Alexander and John Robert Cozens*, 1952, p. 113. It was of one of these sketches of Tivoli that Oppé once remarked to the present writer that in his view the sky must have been washed in by Cozens, and, bearing in mind the readiness of the professional in the eighteenth century to come to the aid of an amateur sketching companion (especially a wealthy and influential one), this is not at all difficult to credit.

[2] Drawings made on this trip by both artists have survived.

took a particular fancy to, and wished me to paint a companion. I made him a esent of the unfinished picture, but desired to be excused painting the companion till I arrived in England.[1]

If Beaumont accepted Jones' picture, it is the only work of art he is known to have acquired on this tour. It was on a later visit to Italy that he bought the Michelangelo marble Tondo, now in the Royal Academy.

When Beaumont returned from Italy in July 1783 he was thirty years of age. Within ten years he was to become a figure of some consequence in the London art world, recognised as a discerning critic and patron, respected as a friend of the leading painters, and consulted by those seeking preferment, These were the years of his friendship with Sir Joshua Reynolds (who painted his portrait in 1788), and with Gainsborough, the years when he sat in Parliament, when he was elected to the Dilettanti Society, when he began to collect pictures (Claude's *Narcissus* being his first purchase of an important old Master) and when he opened his gallery at Grosvenor Square to visitors.

It was in the summer of 1793 that the Beaumonts went for the first of their holidays in North Wales. Finding the hills and valleys so much to his taste, and so full of subjects for his pencil, six of the following eight summers were spent there. Many friends were invited to join them on these holidays, the Oldfield Bowles and Uvedale Price families, as well as artists such as Farington and Girtin.[2] By this time Farington (scenting possibly a source of power), had become an intimate member of the Beaumont circle and it was probably his approval of one of Beaumont's recent landscapes—a view of Dedham—that encouraged the baronet in 1794 to send a picture again to the exhibition at the Royal Academy.[3] This was more favourably received than the first had been and for the next thirty years Beaumont was a regular and enthusiastic exhibitor. In all, thirty-six examples of his work were hung on the walls of Somerset House.

This period witnessed a barely concealed struggle for power between the Academy, representing the profession, and the main body of connoisseurs and patrons. Beaumont, as being both a practising, if amateur, painter and a member of the feudal order, came to be regarded with suspicion by the extremists in both camps. To begin with his work was praised by the painters, who seem to have been gratified to find such a talented amateur in their ranks. J. S. Copley, the history painter, thought highly of the landscape Beaumont showed in the exhibition of 1794 which, he announced to a group of his colleagues, would have done credit to any artist in any country. But this enthusiasm diminished as the struggle deepened and as Beaumont was regarded increasingly as a leader of the opposing forces. A fellow-exhibitor considered a moonlight picture which he sent into the exhibition of 1804 to be trash and his other two submissions of that year very well for an amateur, but rubbish when compared with what pictures should be. In 1806 his paintings were thought to be too low in tone. By 1808 professional opinion had so hardened that even his sketches, which he had no intention of exhibiting, were found wanting. Farington[4] asked George Dance what he thought of these, and afterwards noted the reply:

He said they were very well to amuse an amateur, and exhibited considerable dexterity in practice, but it was that sort of thing that ten thousand persons might do if disposed to adopt the practice; that it was something like what is called striking in penmanship, a matter of execution more than of the mind.

[1] *Memoirs of Thomas Jones*, Walpole Soc., XXXII, 1951, p. 121.
[2] And in 1800, perhaps, the young Cotman (Vol. II, p. 74).
[3] He first exhibited in 1779—a view of Keswick.
[4] *Diary*, January 6, 1808.

270

That in such sketches there is no attention to nature or to the peculiar character of the object, but all is made subservient to a particular practice.

Until 1804, when not on holiday or staying with friends, the Beaumonts divided their time between Dunmow and London, but in that year the receipt of a handsome legacy enabled them to start building a new Hall at Coleorton, the old Beaumont property in Leicestershire. As architect they employed their friend George Dance. By 1808 the house was completed, and in the summer of that year they moved in, bringing with them their finest pictures from Grosvenor Square. Their friends helped with the grounds: Uvedale Price bombarded them with advice about planting and sent a man to see that it was properly done; the Wordsworths, whom they had met on a Lakeland holiday in 1803, designed the winter garden. Soon their lives were centred upon Coleorton. It was here that they invited their closest friends and their favourites from the literary and artistic circles—Walter Scott, Southey, Samuel Rogers, Hearne, Farington, William Alexander, Wilkie, Benjamin Haydon (who failed to remain unimpressed) and, in 1823, Constable. All accounts of Coleorton agree with Constable's in his letters to his wife. All were struck by the regular hours kept and by the happiness of the household and the surrounding tenantry, by the beauty of the pictures, and by the long hours their host spent in his painting-room at the top of the house. Here it was that Constable copied his host's Claudes while Beaumont worked unharassed at his easel.

'He is very entertaining.' the painter wrote, 'so full of delightful stories about painting—and he laughs, sings, whistles and plays with his dog who is a very surly fellow, but quite friends with me. This is the most punctual house that ever was—at 9 breakfast—no lunch—dinner four—tea seven—prayers 10— bell always rings as the clock is striking those hours.
'Sir G. rides out about 2, fine or foul—rises at 7—walks in the garden—the horses come under the window—he feeds the birds at breakfast—after dinner the paper is read out, and at 7 tea and then some book or play read by Sir G.
'You would laugh to see my bedroom, I have dragged so many things into it, books, portfolios, paints, canvases, pictures, etc., and I have slept with one of the Claudes every night.'[1]

Of his stay at Coleorton with Wilkie, Benjamin Haydon afterwards wrote: 'We dined with the Claude and Rembrandt before us and breakfasted with the Rubens landscape, and did nothing morning, noon, or night, but think of painting, talk of painting, dream of painting, and wake up to paint again.'[2] Painting was even discussed as they mounted the stairs on their way to bed, when they noted the effects of light from their candles and took turns to stand back and observe the shadows while arguing as to how they could best be represented.

The first decade of the new century also saw Beaumont at the very heart of affairs in the world of art. Like many of their class, he and his wife were constantly on the look-out for new talent and in their correspondence with friends such as Uvedale Price there were regular exchanges about new discoveries. For example, the following from Price to Lady Beaumont written in 1801:

I have just seen a young artist of the name of Varley, who promises very well. Lord Essex brought him into Herefordshire with him, and to the music-meeting [probably the Three Choirs Festival], where I saw him and his drawings. He chiefly studies landscape, but draws everything that comes in his way; I never saw so eager a creature or one so devoted to his profession. Lord Essex tells me that Edridge and Hoppner have a high opinion of him as a very rising artist; and Knight [Richard Payne Knight], who saw his drawings at Hereford, was so pleased with them, that he has invited him to Downton to meet

[1] R. B. Beckett, *John Constable's Correspondence*, II, 1964, p. 296.
[2] *The Autobiography and Memoirs of Benjamin Robert Haydon*, A. P. D. Penrose ed., 1927, p. 84.

you and Sir George; and if after *tasting* him there, we like him sufficiently, I will ask him to come on with us to Foxley. He is a great talker, and his ideas are sometimes a little wild, but that is better than being too tame.[1]

In 1802 Beaumont was called upon to serve on a committee (later to be known derisively as the Committee of Taste) appointed by Parliament to administer public funds which had been set aside for the commissioning of monumental sculpture for St. Paul's, the establishment of which, in some circles, was considered to be a resounding victory for the connoisseurs over the profession. Three years later, in 1805, he was numbered among those responsible for the launching of the British Institution, a body which further challenged the Academy's supremacy. The aims of this organisation were to encourage the arts by holding annual exhibitions of work by living artists and to provide copying facilities for the students. The success of the first exhibition encouraged the Directors to plan more ambitiously. They negotiated for a Government grant; they worked towards the foundation of a National Collection (ever a dream of Beaumont's), and they initiated a series of exhibitions of paintings by the Old and more recent Masters.

1805, of course, was also the year in which the Society of Painters in Water-Colours held its first exhibition. Though Farington recorded Beaumont as having spoken contemptuously of the Society's exhibition in 1807 and as having deplored the current 'rage for water-colours,' there is little reliable evidence to support the notion that he was in any way actively opposed to the Society as such. He complained of the lack of harmony and breadth in the exhibits, it is true, but this is understandable from an admirer of J. R. Cozens and of Girtin, masters respectively of harmony and of breadth. Among the very few lines that record Beaumont's opinions on the subject, there is only one passage which suggests that the effects of his expressed views were considered damaging. This is to be found in Farington's notes[2] of a conversation he had with the artist A. W. Callcott:

> He spoke of the great change in the disposition of the public to purchase Water Colour drawings at the Exhibitions of these Societies; said it shewed how temporary public opinion is; how much of fashion there is in liking any particular kind of art; and added that he believed Sir George Beaumont had done much harm to the Water Colour painters by his cry against that kind of art.

Earlier in the same conversation, Callcott had also spoken of Sir George's 'continued cry against Turner's pictures', and this brings us to the more important issue, the campaign which Beaumont is alleged to have conducted against Turner.

If one examines the material upon which such a supposition is based, it will be found that Farington's *Diary* is the sole source of supply, and if references in this are checked, they point with one exception to a single informant, Callcott. The pattern is interesting. It begins in April 1807, shortly after Callcott had been elected an associate, with an entry recording his complaint that Beaumont undervalued the work of Turner. The next entry is the one just quoted. After a further two years' silence on the subject, in the entry for April 8, 1813, we come upon Callcott's strongest and most outspoken accusation:

> Callcott called, and told me that he declined exhibiting this year thinking it prudent so to do. He said he had not sold a picture in the Exhibition in the last three years, or received a commission arising from it. He said Sir George Beaumont's persevering abuse of his pictures had done him harm; that he had reason to expect that Lord Brownlow would have purchased his large upright landscape exhibited

[1] Permission to include this extract from the Beaumont Correspondence has been kindly given by The Pierpont Morgan Library.
[2] *Diary*, June 8, 1811.

272

two years ago, but was prevented by Sir George's remarks upon it. The picture was, however, twelve months afterwards bought by Sir Richard Hoare.

He said Turner has also suffered from the same cause, and had not sold a picture in the Exhibition for some time past. Turner called upon Callcott at Kensington a while since and then said that he did not mean to exhibit from the same cause that prevented Callcott, but he has since altered his mind and determined not to give way before Sir George's remarks. Callcott said he had no objection to its being mentioned that he forebore from exhibiting from the cause here assigned. He said that at the last year's private view of the Exhibition Sir George manifestly declined any intercourse with him, and turned from him when addressed by him.

A week later, on April 15, Farington told Beaumont that Callcott had not exhibited 'on account of the persevering run of criticism against him, and that Turner intended the same, but afterwards determined to exhibit'. To which Beaumont replied that 'he, personally liked Callcott, but did not approve his manner of colouring his pictures, nor his imitating Turner; indeed, there was no knowing the pictures of one from those of the other'. The next day, Farington saw Callcott again, who, mollified by Farington's report of his talk with Sir George, this time complained in more general terms of the Directors of the British Institution, maintaining that they were not patrons of artists, but breeders of artists, the Institution being 'a nursery for such a purpose'. All, it seems, stems from Callcott, with the single exception of an entry in the *Diary* for June 3, 1815, which notes a conversation the diarist had with the portrait painter Thomas Phillips, the lackey of Turner's patron Lord Egremont. During this conversation Phillips spoke of the 'great injury done to Turner by the reports of Sir George Beaumont and his circle. . . . By such speeches Phillips thought Turner was greatly injured.' It is this not disinterested evidence supplied by Callcott and Phillips, and only this, which, when added to Beaumont's own undoubtedly outspoken comments, has led to the assumption that there had been a persistent and highly organised attempt to boycott Turner, a 'holy war', as Finberg calls it,[1] led by Beaumont. There was undoubtedly a vocal and influential body of opinion, of which the Directors of the British Institution formed the hard core, that disliked both Turner and his paintings, and it is probable that the artist and his followers suffered more than a little inconvenience from the presence of such a body. But it is as surely a misreading of the evidence to conclude that this resistance constituted a deliberately organised campaign, as it is an injustice to Beaumont and his fellow-Directors. Beaumont certainly had his faults and limitations, but the notion that he was capable of leading such a crusade falls entirely outside our knowledge of both his character and the rules of conduct to which he so strictly and consistently adhered.

At the same time it must be admitted that this warm-hearted and sensitive man, probably the most remarkable patron of his generation, was not without his weaknesses. On questions of principle he would stick fast, and the streak of obduracy he exhibited when standing out for what he believed to be right contrasts oddly with his general demeanour which otherwise was gentle in the extreme. Less easy to condone in a character of such steadfast probity are his occasional pettinesses—the eagerness he sometimes displayed to associate himself with the great names of the preceding generation, or his inability at times to conceal an innate sense of the rectitude of his judgment in matters pertaining to art. Finally, there should be included in our reckoning a failure that some might find more easily acceptable—his readiness to brush aside common practice, to bulldoze his way through in order to gain his ends (which were often admirable in themselves) without much consideration for what others might be thinking or feeling. This, however, was a characteristic of the class to which

[1] A. J. Finberg, *The Life of J. M. W. Turner, R.A.*, 1961, p. 220.

he belonged and one which, in the wake of indignation, merely aroused grudging admiration and respect. One example will suffice. In 1807, Beaumont's protégé Wilkie sent in his picture *The Blind Fiddler* to the exhibition at the Royal Academy. As the picture was then Beaumont's property he was as anxious as Wilkie himself that it should be well noticed. At that time it was customary for exhibitors, especially those with a pull, to enquire of members of the hanging committee as to the placing of their works in the forthcoming exhibition, to insure, of course, that their productions were not skied or otherwise unsatisfactorily hung. A few days before the opening of the exhibition in that year, Beaumont called on Paul Sandby to enquire about the siting of *The Blind Fiddler* and of his own submission, a view of *Keswick Lake*.[1] This, Sandby seems to have found in no way surprising; it was the tenor of the conversation that followed which the old painter felt he had to report to his fellow-Academicians, for Sir George went on to say that in his view the Academy ought to set aside their laws upon this occasion and elect Wilkie an Academician at once, without requiring that he should first be an associate! Northcote's recorded comment on the reception of Sandby's report is illuminating. He was less indignant at the proposal itself than at the thought of a painter of the lowest (i.e. rustic) and not the highest (i.e. Historical) department of art being considered for such extraordinary promotion. Anecdotes of Beaumont the patrician, however, are greatly outnumbered by those which tell of the delicacy and tact he normally displayed when implementing his generous designs.

While the list of those he helped in one way or another reads almost like an index—Alexander, Arnald, Beechey, Coleridge, Collins, Constable, Cozens, Dance, Daniell, Edridge, etc., it was his gift of understanding and, in an age of fine social distinctions, the pains he took to alleviate fears of condescension and discount obligation, which singles him out from amongst those of his class who shared his interests. Furthermore, though capable of imaginatively generous gestures such as the famous one of the purchase and gift of a property, Applethwaite, to Wordsworth (whom he had not then met) so that the poet and Coleridge could live near to each other to their mutual and the world's advantage, Beaumont would concern himself equally willingly with more tedious and unrewarding business—a pension for the widow of some obscure painter, for instance.

In both conversation and writing he could seldom resist an opportunity to offer advice, and his correspondence with painters abounds in injunctions. By quoting at first hand the maxims and opinions of men such as Reynolds and Gainsborough, whom he had known intimately, he was often able to add considerable weight to his arguments, but it is his own voice that speaks most plainly, if at times pontifically, in the letters, and the counsel he offered contains a great deal of good sense, much of which derived from his own observations and his own painting experience.

His most generally quoted—and all too often mis-quoted—sayings are those to be found in a paragraph in Leslie's *Life of Constable* in which the author was seeking to emphasise certain differences of opinion, or of taste, that enlivened the two artists' conversations on art, and by establishing these differences, to present Beaumont as a reactionary critic, who preferred the mellow tones of old pictures (whether induced by time, or, artificially, by unscrupuous dealers) to those of the modern school—i.e., Constable's. To make his point, Leslie gives three examples of Beaumont's intransigence: his attempts to match the tints of a Gaspard Poussin landscape in one of his own; his recommendation of the colour of an old Cremona violin for the prevailing tone of everything; and the famous question he is credited with having put to Constable, 'Do you not find it very difficult to

[1] Farington, *Diary*, April 13, 1807.

274

determine where to place your *brown tree*?' (Leslie's italics). Each example, of course, was given to enable Leslie to quote Constable's, his hero's, pointed replies. The Baronet comes out poorly from the exchanges, as it was intended that he should. But if the picture thus lightly sketched in of Beaumont as a critic is a true one (and for this we have to rely upon Leslie's recollections of what Constable told him), it is certainly only partly true and by no means the whole picture. In Beaumont's correspondence very different views are to be found, some of which are in almost direct opposition to those expressed in Leslie's report. To one he urges vigilance lest a single colour should dominate a work and, long before Constable evolved his method of broken handling, warns a young friend against smoothness and insipidity, pointing out that in nature only polished objects are smooth and all else is varied by 'innumerable lights, reflections and broken tints'.[1] 'Perhaps no man', he continues, 'ever understood this fact better than Rembrandt; and it is this which renders his drag, his scratch with the pencil-stick, and his touch with the palette-knife, so true to nature, and so delicious to an eye capable of being charmed with the treasures of the palette.' He is also to be discovered issuing a warning that 'you can never improve upon the simplicity of your first intentions', and that 'the notion of endeavouring to improve on them by an introduction of more taste or refinement is extremely dangerous'.[2] He detested what he called 'manner' and adjured those young painters who came to see his collection not to deviate from the line nature had marked out for them. One of Constable's most frequently quoted letters, that to his friend Dunthorne in which he cried that 'there was room enough for a natural painture',[3] was written one May morning on returning from a visit to Grosvenor Square, and evidently with Beaumont's dicta still ringing in his ears, for many of the sentiments in it are those which it was his patron's custom to profess—that there was no easy way of becoming a good painter; that it required long contemplation and incessant labour; and that nature was the fountain's head, the source from which all must originally spring. Beaumont's reflexions arc also echoed in Constable's avowals in the same letter to forswear idle visits and the company of common people, to make laborious studies from nature and to attempt pure and unaffected representations of the scenery that might employ him when he returned to the country. All this, which the twenty-six-year-old painter took to heart, was well given. Where, at this time, was the pedant of the brown tree? During that summer (1802) Constable made a number of 'laborious studies from nature' as he had resolved, but it is significant that towards the end of his sojourn in the country he painted one—the *Dedham Vale* now in the Victoria and Albert Museum—based on his recollection of his patron's favourite painting, Claude's *Hagar and the Angel*.

The Beaumonts were not great travellers. Wales, the Lake District, visits to friends, and their own Coleorton provided them with all the pleasure and relaxation they needed. After the Italian trip of 1782/3, they only ventured abroad together once—to the Low Countries in 1786—before their last years, when they went to Switzerland, in 1819, and again to Italy in 1822. Dated drawings record all three tours.

After a rich and varied three-score years and ten, a kindly fate permitted Beaumont to make one last splendid gesture before the end. During the early '20s he had been urging upon the authorities the necessity of forming a national collection of paintings which would be 'under the guardianship of a body which "never dies"'. Every year, he said, he saw 'such proofs of the carelessness with which

[1] A. Cunningham, *The Life of Sir David Wilkie*, 1843, p. 135.
[2] *Ibid.*, p. 344. [3] Beckett, *op. cit.*, p. 22.

people suffer these inestimable relics to be scrubbed, scraped and polished, as if they were their family plate, that I verily believe if they do not find some safe asylum, in another half century little more will be left than the bare canvas'. His dearest wish was realised when the great Angerstein Collection was purchased for the nation in 1824 and the house where it hung was opened to the public. In 1826, as he had promised when lobbying for a national gallery, Beaumont gave his own small but, in quality, superlative collection to the nation; thus, among others, Rubens' *Chateau Steen*, the Canaletto *Stonemason's Yard*, three Claudes, two pictures by his old friend Richard Wilson, and a Rembrandt went to join the Angersteins.

The following year, 1827, he died.

Like many other amateurs who developed an accomplished and graceful manner, Beaumont was a prolific draughtsman. He had been well schooled. Few could have enjoyed a more distinguished succession of instructors: Alexander Cozens, Hearne, Malchair, J. R. Cozens, Farington, Girtin, and finally Constable, with Reynolds, Gainsborough and Wilson as advisers thrown in for good measure. Possibly this was the trouble, for on looking through his considerable output, one is conscious that the influence of first one and then another of his teacher-companions is all too apparent. Stylistically he seems to have been pulled now this way and now that, so that the style he eventually achieved, while exhibiting all the proprieties, is curiously impersonal and lacking in character.

Although from time to time he amused himself with rapidly-taken likenesses bordering on caricature, he was of course chiefly a landscape draughtsman. His earliest datable landscapes, painstaking pencil studies of Castle Acre, were made on the holiday already referred to with Hearne and Woollett in 1771. None of his Oxford drawings has so far been identified. In the next group, those he did on his honeymoon in the Lakes, both Hearne's and Farington's influence is plainly to be seen, with the latter's calligraphy in the ascendant.

Unquestionably his finest drawings are those which he made during the latter part of his first Italian tour in 1783, when J. R. Cozens was working by his side or at least near at hand. It was then, under Cozens' tutelage, that he began to use colour for the first time. A number of the Italian water-colours he is known to have made are so far untraced—conceivably because they have been given greater names—but the remainder form an impressive group.[1] From Italy, and Cozens, he acquired an entirely new feeling for light, and, whether a slight sketch or a carefully worked-up water-colour, all the later Italian views are illumined by a gentle ambience. It was during the hours in company with Cozens that he also learned something from the other's mastery of subtle modulation and from his genius for selective phrasing. While all his life retaining a little of what he had recently learned, it is nevertheless remarkable, as well as a trifle disappointing, to see how quickly he reverted to the manner of Hearne and of Farington after his return to this country.

The next influence to be discerned in the sequence is that of Thomas Girtin, but this too was short-lived. It is to be found only in a few water-colours and in a series of rapid atmospheric notations, of rain and sunlight, around the end of the century. At the same time Beaumont was beginning to evolve his own manner in a medium traditional enough, but apparently of his choice—black and white chalk on grey paper. By the next decade his manner was established, and thenceforward, though still a stylistic compound, for better or worse and in whatever medium, his drawings are recognisably his.

There is no need to end thus, on a note of faint praise. Unlike the majority of amateurs Beaumont

[1] Coll. Sir George Beaumont, Bart.

276

regarded himself as primarily an oil-painter. In his time he was considered the finest amateur painter of his day. This still seems a just estimation.

* * *

Dr. Thomas Monro (1759–1833) occupies an outstanding position in the history of British water-colour art, not because of his own work, good of its kind though it was, but because of his formative influence upon Girtin, Turner and many other young artists at the close of the eighteenth century and the beginning of the nineteenth. A pleasing and sympathetic record of Monro has been written by his great-grandson, the late Dr. W. Foxley Norris, Dean of Westminster.[1] After going through his medical schools, Thomas Monro inherited from his father a good position as a mental physician in London, and in this capacity was one of those who attended King George III. As was the case with Sir Francis Seymour Haden later, art, and not science, was the true mistress of his life. From his father, who died in 1791, Dr. Monro also inherited considerable means, good taste and a large collection of books and prints and in turn became a collector and patron of art. It was in keeping with his character that he had a netting fixed under the roof of his brougham in which he placed drawings for study during his journeys, just as Sir George Beaumont carried Claude's little picture of *Hagar and the Angel* with him in his coach. He was never without paper, charcoal and Indian ink, and would drive about the lanes and farms near his country home at Fetcham in Surrey, making hundreds of the compositions and sketches which are in existence today.

His work of this nature was much influenced by Gainsborough, whom he is said to have known. Like young Constable he 'saw Gainsborough in every hedge and hollow tree'. His drawings are so much akin to the master's in subject, method and material that in the past they have frequently been confused with Gainsborough's work. Dr. Foxley Norris, writing about Monro's sketches, says that they 'were made out of doors on a pad [or block as we should now call it] in Payne's grey or Indian-ink wash, sometimes on grey, sometimes on blue, sometimes on white paper; then they were taken home to be worked over with charcoal, crayon or Indian ink. In some of the sketches the figures— single or in groups—and animals were cut out in white paper, stuck on to the sketch in the appropriate place with gum, and then treated with brush or crayon to bring them into tone with the rest. I have one or two examples of this method of composition in my possession, and many years ago I was told by one who had watched Dr. Monro at work that he would take a great deal of trouble about the placing of these groups and figures, pinning them on the drawing first in one place, then in another until he satisfied himself as to their proper place in the composition. The same person also told me that in some of the sketches the outline was added with a stick of dry Indian ink while the paper was still wet.' It is possible that more line work was done out-of-doors than Dr. Foxley Norris realised, as experiments have shown that many sketches were made on dry paper with a stick of Indian ink dipped in water. When he introduced colour, Monro followed the practice of his time in making a complete drawing in Payne's grey and then adding a slight wash of local colour. His colour work is not often seen, but examples can be found in the Ashmolean Museum, Oxford, and in the Victoria and Albert Museum, together with many specimens of his monochrome art.

Monro had an enthusiastic love for graphic art of all kinds although his own work was derivative and limited in scope. At the time when he took Girtin and Turner under his protection 'he had been

[1] O.W.S. Club, II, 1924–5.

intimately acquainted with Wilson, Marlow, Gainsborough, Paul Sandby, Rooker, Hearne, Cozens, and all who were eminent in the study of landscape; and at his select winter evening Conversaziones these and other distinguished artists and amateurs enjoyed much intellectual and friendly intercourse'.[1] Hoppner was another close friend, and Monro was constantly in touch with Sir George Beaumont, William Locke and other wealthy collectors. The catalogue of the sale of his possessions, after his death, shows that he owned a considerable number of sketches by Gainsborough as well as that artist's Camera Obscura, with ten subjects of landscapes, sea-pieces and moonlight.[2] He owned a large number of drawings by J. R. Cozens, to whom he had given long and special care when that painter became insane. There were numbers of other chosen drawings by Hearne, Laporte, Dayes, Wilson and Sandby, besides work by Claude, Canaletto and others. Farington notes that Monro had occasion to reckon up what his collection of drawings had cost and found that it amounted to about £3000. For drawings by Hearne he had paid about £800, and about £500 for Laporte's work. All of these drawings he loved intensely, but he was happiest when they were placed at the disposal of his friends, especially when they were budding painters.

In 1794, when Turner and Girtin were still in their 'teens, Monro moved from Bedford Square to No. 4 or 6, Adelphi Terrace, built about twenty years before by the brothers Adam. Here he was always ready to welcome young artists, giving them access to his pictures and portfolios, letting them sketch from his windows overlooking the Thames, and assisting them with judicious advice. On winter afternoons and evenings he made his house a combination of studio and drawing-school. Double desks were provided, so that candles, and perhaps ink and water, might serve to sketchers sitting opposite each other. Here in their early days sat Turner and Girtin, and they were followed, as the years went on, by John and Cornelius Varley, Joshua Cristall, John Sell Cotman, William Hunt, Henry Edridge, John Linnell, Copley Fielding, Peter De Wint and many others. The youthful artists were introduced to masterpieces of drawing and set to copy them. Cozens was the model for Turner and Girtin, and their work was produced as the model for the next generation. For Dr. Monro's family it was exasperating at times to find the place filled with nondescript youths of scanty manners and no position; Turner, for instance, being notably a rough diamond. Dr. Foxley Norris relates that his great-grandmother, on their appearance, was inclined to 'have her dinner upstairs', and that his Aunt Sally used to make complaints about the Bohemian invasion. The good doctor himself was much more hospitable. True, he kept their drawings, not of much seeming value in those days, but he gave the younger ones half-a-crown and their supper. When his collection was sold in 1833, Dr. Burney was standing beside Turner in the sale-room. 'I understand', said Turner, pointing to some lots bearing his own name, 'that you have the bad taste to admire those things more than I do now.' 'It will be sufficient for me to say', answered the polite connoisseur, 'that I admire everything you do, Mr. Turner.' 'Well', returned the other, a little flattered, 'perhaps they are not so bad; for half-a-crown—and one's oysters.'[3] Turner, in his later life also, when talking to David Roberts, said: 'Girtin and I have often walked to Bushey and back to make drawings for good Doctor Monro at half a crown apiece and a supper.'[4] Farington, giving further evidence, says that 'Dr. Monro's house is like an Academy in an evening. He has young men employed in tracing outlines made by his

[1] *Library of the Fine Arts*, 1832, III, p. 310.
[2] These are on permanent exhibition at V.A.M.
[3] Roget, I, p. 82.
[4] Turner spoke thus in error. Monro did not move to Bushey until about 1805.

278

friends.'[1] Four years later, Farington met Turner and Girtin at dinner who told him 'that they had been employed by Dr. Monro 3 years to draw at his house in the evening. They went at 6 and stayed till ten. Girtin drew in outlines and Turner washed the effects. They were chiefly employed in copying the outlines or unfinished drawings of Cozens, etc., etc., of which copies they made finished drawings. Dr. Monro allowed Turner 3s. 6d. each night—Girtin did not say what he had.'[2] Monro not only gave his young protégés the run of his house in Adelphi Terrace and of his wonderful collection, but attended them free of charge when they were ill, and took them down to stay with him in his country cottage at Fetcham or at Bushey. In the British Museum is a drawing by Girtin entitled *Dr. Monro's House, Fetcham, Surrey*, but this is wrong, and the drawing by William Alexander, also in the Museum, shows the house as it stands today. We have seen with what result the Doctor took John Varley to sketch at Polesden.[3] Cotman was at Fetcham and made drawings at Ashtead and other places in the neighbourhood in 1799, and it is recorded that William Hunt was a guest on more than one occasion at Bushey, doing sketches. In the Victoria and Albert Museum is a portrait drawing by Edridge of Hearne dated 1800,[4] with a background of cottages in Ashtead churchyard and Hearne seated on the plinth of Ashstead Church. They were almost certainly staying with Monro at the time.

To the end of his life Dr. Monro continued to encourage young artists. In 1828, on the recommendation of Varley, he invited Welby Sherman to stay with him at Bushey. In a letter to George Richmond, September–October 1828, Samuel Palmer (both he and Sherman were then under the immediate influence of Blake) wrote with some characteristic touches of sarcasm:

> I suppose you know that Mr. Sherman is or has been with Dr. Monro at Bushy. He likes an artist to live with him, and work for him from the cottages, etc., thereabout. He has had some of the first-rate housepainters and sky sloppers and bush blotters there. I fear Welby won't do for him not having the requisite facility. . . . Mr. Sherman went recommended by Varley to Dr. Monro: he got there at night. Next morning he made a sketch of the Dr.'s house before breakfast. After breakfast two steeds were caparison'd on one of which mounted the Dr. and on the other Discipulus, & set forward to depict from Nature. The Doctor led the way to that selected scene which he intended to commend first of all to his visitor's attention. It did not consist wholly of nature or wholly of art. Had *we* had the happiness of beholding it, how must it have rais'd our esteem and admiration of his taste who first discover'd and explored it. . . . The picturesque tourists arrived at the Arcadia of their destination:—and Behold!—It was a *Brick Field*!!!!! The Doctor's outline was soon done & he went home to tint it; Mr. S. remained several hours, & made three sketches: one of which, when he came home in the evening, the Doctor (who by this time had quite finish'd his own) kept; & politely informed Mr. Sherman that his carriage was going to town the next morning and that he might if he pleas'd avail himself of that convenience; which he accordingly did. He is more miserable than ever. Mr. Varley has been very kind: teaching him something of that process in water & oil which is likely to please. . . . Mr. Varley told him he remember'd spending three days upon a drawing; walking all over London to get rid of it, & being rejoiced at last to sell it for a shilling!

Monro's influence never crystallised into technical instruction. He never seems to have made any attempt to force upon his protégés his own manner of drawing, and in the case of Turner and Girtin he bade them absorb and copy J. R. Cozens. Dr. Foxley Norris[5] says: 'His life and work, without doubt, vitally affected the course of the early history of the art of water-colour painting. The standards and ideals which he insisted upon had much to do with the building up of the unrivalled position

[1] *Diary*, December 30, 1794.
[2] *Diary*, November 11, 1798.
[3] See Vol. II, p. 99.
[4] V.A.M. D.542–1906. [5] *Op. cit.*

279

which the English water-colours school attained, and in the history of that branch of art the name of Thomas Monro, "the good doctor", will always have an honoured place.'

It is not inappropriate to quote an opinion written in the more stilted language of 1832, when Monro was still alive: 'Girtin and Turner—indeed all the disciples of the Monro school—occasionally copied and studied from the same prototypes. From the elaborate and tasteful delineations of Hearne and Rooker, they acquired the rudiments of a just and accurate insight into the properties of topographical design; and from the drawings of Cozens, a practical knowledge of breadth and simplicity, united with the charm of aerial perspective. Girtin and Turner combining these qualities (for we must speak of them *par éminence*, they being moreover the elder disciples of the school,) and superadding their own enlightened perceptions to the knowledge thus acquired, laid the foundation of that superstructure which they raised to the glory of the British school of water-colour painting.'[1]

* * *

The historian included in the heading of this chapter is W. H. Pyne, whose main importance lies in the fact that he was the first to make systematic records of the early movement in water-colour painting and to inform us with some detail about his contemporaries and their method of work. A very full account of his life and work is given by Roget.[2] William Henry Pyne (1769–1845) was the son of a leather-seller in Holborn. Pyne is said to have had a clever drawing-master, possibly Henry Pars. He practised in water-colour, exhibited at the Royal Academy from 1780 to 1811, and was one of the foundation members of the Old Water-Colour Society, from which he resigned in 1809. Most of his works were landscapes, but he had great skill in introducing figures and animals; and so we find him in 1790 and 1791 showing drawings with such titles as *Travelling Comedians, A Puppet-Show, Village with figures merry-making*, etc. Like Robert Hills, who was born in the same year, Pyne made full use of the etching needle for the publication of his drawings. His *Microcosm* contained over a thousand small groups of rustic figures 'for the embellishment of landscapes' etched by Pyne and aquatinted by J. Hill from 1802 to 1806. In 1808 he drew, and presumably himself etched, the sixty plates of *The Costume of Great Britain*, illustrating many quaint English customs and occupations. To judge the scope of the work one has only to glance at such titles as *Leather Dressing, Woman selling Salop, Halfpenny Showman, Lord Mayor, Lamplighter, Lottery Wheel*, and so on in indiscriminate sequence.

As a practical artist Pyne did little further work, apart from an occasional landscape, but he continued to labour in the cause of art, till the end of a long and harried career, as a writer and editor of works for the press. He supplied the text for important volumes with illustrations in colour aquatint, such as the *History of the Royal Residences*, 1819. Later, he used his pen as a critical writer on art, and adopting the *nom de plume* Ephraim Hardcastle wrote a series of papers in the *Literary Gazette*, which were afterwards collected in two octavo volumes and published by Longman in 1823 under the title *Wine and Walnuts*. Then came the *Somerset House Gazette*; *Weekly Miscellany of Fine Arts, Antiquities and Literary Chit-Chat*, issued in 1823–4. Pyne, who describes himself in the first number as one of the 'virtuosi greybeards', edited and probably wrote the whole of the *Gazette* himself. He was then fifty-four and lived for twenty years longer—in his latter days insolvent and in a debtors' prison—contributing a re-hash of his old material, together with new matter, to the *Library of the Fine Arts, Magazine of the Fine Arts*, and *Fraser's Magazine*. For G. Robins the auctioneer, he compiled the

[1] *Library of the Fine Arts*, III, p. 311. [2] Roget, I, pp. 138–141.

catalogues of the Benjamin West Collection in 1829 and the Watson Taylor Collection in 1832. 'Gossip', says an obituary notice, 'was at once his *forte* and his foible. No one could tell a story better or more graphically.' Much of what he published is sheer journalism, and fanciful at that, yet at the same time he includes plenty of serious and reliable matter about the current practice of painting in water-colour. From before 1790, when he first exhibited his own work, Pyne was keeping an observant eye upon the methods in use. He watched the early practice and development of Girtin and Turner, and was in a position to study the whole advance of the water-colour movement from the tinted drawing to the bolder methods which were introduced at the beginning of the nineteenth century. In this chapter, and in several other chapters of this book, there has been frequent occasion to quote from Pyne's contemporary records.

BIBLIOGRAPHY AND BIOGRAPHICAL SOURCES

I General Works

Baker, C. H. C. and Constable, W. G. *English painting, 1500–1700.* 1930
Baldry, A. L. *British marine painting.* 1919
Barnard, G. V. *Paintings of the Norwich school.* 1950
Bell, C. F. *Fresh light on some water-colour painters of the old British school [etc.].* Walpole Soc., vol. v, 1917
Binyon, R. L. *The followers of William Blake.* 1925
 Landscape in English art and poetry. 1931
 English water-colours. 1933; 1944
 English water-colours from the work of Turner, Girtin, Cotman [etc.]. 1939
Boase, T. S. R. *English art, 1800–1870.* 1959
Bury, A. *Water-colour painting of today.* 1937
 Two centuries of British water-colour painting. 1950
 Some marine water-colours. ows, xxiv, 1946
 Aspects of the middle phase of water-colour painting. ows, xxix
Callow, W. *Notes on the 'Old Water Colour Society'.* ows, xxii, 1944
Chesneau, E. *English school of painting.* 1885
Clifford, D. *Water-colours of the Norwich school.* 1965
Cundall, H. M. *The Norwich school.* Ed. by G. Holme. 1920
 Masters of water-colour painting. 1922
 History of British water-colour painting. 2 ed. 1929
Cunningham, A. *The lives of the most eminent British painters [etc.].* 6 vols. 1929–32
Davies, R. *Chats on old drawings.* 1923
Dickes, W. F. *The Norwich school of painting.* 1905
Digeon, A. *The English school of painting.* 1956
Edwards, E. *Anecdotes of painters [etc.].* 1806
Farington, J. [Manuscript diary, 1793–1821, in the Royal Library, Windsor Castle.]
 The Farington diary, edited by J. Greig. 7 vols. 1923–27
Fedden, R. *Modern water-colours.* 1917
Finberg, A. J. *The English water-colour painters.* 1905
 Early English water-colour drawings by the great masters. Ed. by G. Holme. 1919
Finberg, A. J. and Taylor, E. A. *Development of British landscape painting in water colours.* 1917
Foster, Sir W. *British artists in India, 1760–1820.* Walpole Soc., xix, 1931
'Fraser's Magazine', 1830–58
Fry, R. *Reflections on British painting.* 1934
Goodwin, M. *Artist and colourman.* Published . . . for Reeves [etc.]. 1966

Guillemard, F. H. H. *Girtin's sketching club.* 'Connoisseur', lxiii, 1922
Hendy, Sir P. *English water-colours.* 'Britain Today', February 1949
 British water-colours. 'Britain Today', December 1951
Hodgson, J. E. and Eaton, F. A. *The Royal Academy and its members, 1768–1830.* 1905
Holme, C. *English water-colour.* 1902
 Masters of English water-colour painting. 1903
 The Old Water-Colour Society, 1804–1904. 1905
 The Royal Institute of Painters in Water-Colours. 1906
Hughes, C. E. *Early English water-colour.* 1913. Rev. ed. by J. Mayne, 1950
Huish, M. B. *British water-colour.* 1904
Johnson, C. *English painting from the seventh century to the present day.* 1932
Laidlay, W. J. *The origin and first two years of the New English Art Club.* 1907
Lamb, Sir W. R. M. *The Royal Academy.* 1951
Lemaitre, H. *Aquarellistes anglais.* 'Etudes anglaises', vii, ii, 1953
 Le paysage anglais à l'aquarelle, 1760–1851. 1955
Library of Fine Arts. 1831
Littlejohns, J. *British water-colour painting.* 1931
London: *Old Water-Colour Society's Club.* Annual volumes, 1923–24–
 Royal Society of Painters in Water-Colour. 'The Old Society, 1822–1922'. 1922
 Society of Painters in Water-Colour. See Manuscripts (English) in V. & A. Library
 Victoria and Albert Museum. Press cuttings from English newspapers, 1685–1835
 Walker's Gallery. 'Walker's Monthly', 1928–39
 Walker's Gallery. 'Walker's Quarterly', 1921–32
 Walpole Society. Annual volumes, 1912–
Lucas, E. V. *The British School.* 1913
Lytton, Hon. N. S. *Water-colour.* 1911
MacColl, D. S. *The New English Art Club.* Studio, 1945
Maas, J. *Victorian painters.* 1968
Maurois, A. *Chefs-d'œuvre des aquarellistes anglais [etc.].* 1939
May, W. W. *Marine Painting.* 1888
Mayne, J. *English romantic water-colors.* Metropolitan Mus. of Art, Bulletin. New ser., xx, 1962
 Taste in water-colour. 'Apollo', April 1963

Monkhouse, W. C. *The earlier English water-colour painters.* 1890

Oppé, A. P. *The water-colours of Turner, Cox, De Wint.* 1925

Paris, H. J. *English water-colour painters.* 1945

Proctor, I. *Masters of British painting.* 1955

Pyne, W. H. *Wine and walnuts.* 2 vols. 1823
 The rise and progress of water-colour painting in England. 'Somerset House Gazette', 1822–23

Redgrave, G. R. *A history of water-colour painting in England.* 1892

Redgrave, R. and Redgrave, S. *A century of painters of the English school.* 1866

Redgrave, S. *Catalogue of the water-colours in the South Kensington Museum.* 1876

Reynolds, A. G. *An introduction to English water-colour painting.* 1950

Rich, A. W. *Water-colour painting.* 1918

Ritchie, M. T. *English drawings: an anthology.* 1935

Roget, J. L. *History of the Old Water-Colour Society, now the Royal Society of Painters in Water-Colour.* 1891

Rothenstein, Sir J. *An introduction to English painting.* 4 ed. 1951

Ruskin, J. *The works of John Ruskin.* 39 vols. 1903–12

Russell, J. *From Sickert to 1948: the achievement of the Contemporary Art Society.* 1948

Sandby, W. *The history of the Royal Academy of Arts from . . . 1768 to the present time.* 1862

Selection of facsimiles of water-colour drawings from the most distinguished British artists. 1825

Shepherd, G. *A short history of the British school of painting.* 1881

'Studio' special numbers: 1903, 1905, 1906, 1917–18, 1919, 1920, 1921, 1922–23

Vertue, G. *Vertue note books.* Walpole Soc., vols. XVIII, XX, XXII, XXIV, XXVI, XXIX, XXX

Walpole, H. *Anecdotes of painting in England.* 1762–63

Warner, O. *An introduction to British marine painting.* 1948
 Marine water-colours at South Kensington. 'Apollo', XLV, 1947

Wedmore, Sir F. *English water-colour.* 1902

Wheeler, C. *A sketch of the original foundation of the Old Water Colour Society.* 1871. Reprinted OWS, II, 1934

Whitley, W. T. *Artists and their friends in England, 1700–1799.* 1928
 Art in England, 1800–1837. 1928–37

Wilenski, R. H. *English painting.* 4 ed. 1964

Williams, I. A. *Early English water-colours and some cognate drawings by artists born not later than 1785.* 1952

Wodderspoon, J. J. *Crome and his work. . . . Some account of the Norwich school of artists.* 1858; 1876

Young, G. M. *Early Victorian England, 1830–1865.* 1934

II Drawing-Books, Technique and Instruction

Ackermann, R. *Lessons for Beginners in the Fine Art.* 1796
 13 Plates Illustrating Rustic Figures. 1798
 A Treatise on Ackermann's Superfine Water-Colours, etc. 1800
 Ackermann's New Drawing Book of Light and Shadow. 1809
 Ackermann's New Drawing Book of Light and Shadow. 1812
 Ackermann's Drawing-Book of Trees. 1841

Alder, W. *A Child's Instruction Book . . . of Colouring Prints.* 1864

Alken, H. *Illustrations for Landscape Scenery.* 1821

Alken, S. *Book of Aquatint Landscapes.* 1794

Allen, G. B. *Water-Colour Paintings, etc.* 1898

Alston, J. W. *Hints to Young Practitioners, in the Study of Landscape Painting.* 1806

Andrews, J. *Lessons in Flower Painting.* ?mid-19th C.

Angelo, M. *The Drawing School. . . . New Discoveries . . . in the preparation of Water-Colours.* 1777

The Art of Drawing in Perspective. 1777

The Art of Drawing and Painting in Water-Colours. 1755

The Artist's Assistant. 1786

The Artist's Repository and Drawing Magazine. 1784–1786

The Artist's Repository, or, Encyclopedia of the Fine Arts. 1813

The Art of Painting in Water-Colours. 1832

Atkinson, J. S. *Groups of Figures from Nature.* 1817

Bacon, J. *The Theory of Colouring.* 1866

Bardwell, T. *The Practice of Painting and Perspective Made Easy.* 1756

Barnard, G. *The Continental Drawing Book.* 1837
 Drawing from Nature. 1877
 The Theory and Practice of Landscape Painting in Water-Colours. 1855

Barret, G. *Theory and Practice of Water-Colour Painting.* 1840

Bartolozzi, F. *Cipriani's Rudiments of Drawing.* 1796

Boot, W. H. J. *Trees, and how to Paint them in Water-Colours.* 1883

Bowles, C. *Bowles's Artist's Assistant.* 1790
Bowles's Art of Painting in Water-Colour. 1786

Bowles, J. *A Curious Collection of Beasts, Horses, and Birds.* 1750

Bright, H. *Ackermann's Rudimental Drawing-Book for Beginners in Landscape.* 1843
Bright's Advanced Landscape Drawing Book for 1845. 1845

Brookshaw, G. *A New Treatise on Flower Painting.* 1818
Groups of Flowers Drawn and Accurately Coloured after Nature; Groups of Fruit . . . Six Birds etc. 1819
Six Birds, Accurately Drawn and Coloured after Nature. 1817
Groups of Fruit. 1817
Supplement to the Treatise on Flower Painting. 1817

Browne, A. *Ars Pictoria.* 1669, 1675
Appendix to the Art of Painting. 1675
Book of Drawing, Washing, Limning, etc. 1652

Bryant, J. *Progressive Lessons in Landscape.* 1807

Buchanan, R. *Buchanan's Initiatory Drawing Lessons.* 1828–1830

Bulkley, J. *A Treatise on Landscape Painting.* 1821

Burford, T. *Six Landscapes from Original Paintings.* 1762–1763

Burgis and Barfoot. *Four Engravings of Landscape.* 1815

Burn, Rob. S. *The Illustrated London Drawing-Book.* 1853

Burnett, J. *An Essay on the Education of the Eye.* 1880
A Practical Treatise on Painting. 1827
An Essay on the Education of the Eye. 1839
Practical Hints, on Light and Shade in Painting. 1829
Practical Hints on Portrait Painting. 1860

Burton, F. *The Artist's Arcanum.* 1799

Burton, J. *Cottages from Nature.* 1792

Calvert, F. *The Young Artist's Instructor.* 1823
Rural Scenery. ?1825
The Amateur Draughtsman. 1825

Carmichael, R. P. *Marine Painting in Water-Colour.* 1859

Cawse, J. *The Art of Painting Portraits, Landscapes, Animals, Draperies, Satins &c.* 1840

Chase, J. *A Practical Treatise on Landscape Painting.* 1861

Chevreul, M. E. *The Laws of Contrast of Colour.* 1859

Clark, J. *Practical Perspective Exemplified in Landscapes.* 1809
A Series of Practical Instructions in Landscape Painting. 1827

Clark, J. H. *A Practical Essay on the Art of Colouring and Painting Landscapes in Water-Colours.* 1807
A Practical Illustration of Gilpin's Day. 1824
The Amateur's Assistant. 1826
Elements of Drawing and Painting in Water-Colours. 1848

The Compleat Drawing Master. 1763

Cooper, T. S. *Thirty-Four Subjects of Cattle, etc. Designs for Pictures.* 1837
Groups of Cattle, Drawn from Nature. 1839

Cox, D. *A Treatise on Landscape Painting.* 1813–1814
A Series of Progressive Lessons Intended to Elucidate the Art of Landscape Painting. 1823
The Young Artist's Companion. 1825
Progressive Lessons on Landscape for Young Beginners. 1816

Cozens. A. *Principles of Beauty Relative to the Human Head.* 1778

Craig, W. M. *An Essay on the Study of Nature in Drawing Landscape.* 1793
The Complete Instructor in Drawing Figures. 1806
A Course of Lectures on Drawing, Painting, and Engraving. 1821

Cumberland, G. *Thoughts on Outline, Sculpture, and the System that Guided the Ancient Artists in Composing their Figures and Groupes.* 1796

Dagley, R. *A Compendium of the Theory and Practice of Drawing and Painting.* 1819

Darling, Thompson and T. Simpson. *Six Landscapes.* 1799

Darton, W. and T. *A New Drawing Book of Views.*

Day, C. W. *Art of Miniature Painting.* 1852

Delamotte, P. H. *The Art of Sketching from Nature.* 1871

Dibdin, T. C. *Progressive Lessons in Water-Colour Painting.* 1848
Guide to Water-Colour Painting. 1859

Dighton, D. *Sketches.* 1821

The Draughtsman's Assistant; or, Drawing Made Easy. ?1795

Edwards, W. H. *Flower Drawing and Painting in Water-Colour.* 1820

Ellis, T. J. *Sketching from Nature.* 1887

Enfield, W. *Young Artist's Assistant.* 1822

Everard, A. *Flowers from Nature.* 1835

Excellency of the pen and pencil. 1668

Ferguson, J. *The Art of Drawing in Perspective.* 1775

Field, G. *Chromatography: A Treatise on Colours and Pigments.* 1835, 1885
Chromatic or, an Essay on the Analogy and Harmony of Colours. 1817

Fielding, E. *Bernard's Water-Colour Book.* u.d.
Mixed Tints: Composition and Use. 1856

Fielding, N. *Subjects after Nature.* 1836
Copies after Nature. 1836
What to Sketch: Hints on Use of Water-Colour. 1859

Fielding, T. H. *A Synopsis of Practical Perspective, Lineal and Aerial.* 1836
On the Theory of Painting. 1836
On Painting in Oil and Water Colours, for Landscape and Portraits. 1839

The Florist. 1760

Flower Painting. *A Series of Progressive Lessons Intended to Elucidate the Art of Flower Painting in Water-Colours.* 1815

Foster, Vere. *Sketches in Water-Colours,* and similar works. 1873–1900

Francia, L. *Progressive Lessons.* 1813

Gandee, B. F. *The Artist, or Young Ladies' Instructor in Ornamental Painting, Drawing, etc.* 1835

Gartside, M. *An Essay on Light and Shade, on Colours, and on Composition in General.* 1805

Ornamental Groups, Descriptive of Flowers, Birds, Shells, Fruit, Insects, etc., and Illustrative of a New Theory of Colouring. 1808

Gibbs, W. *The Universal Decorator; a Complete Guide to Ornamental Design. . . . The Illustrations by William Gibbs.* 1858–1860

Gilpin, W. *Three Essays: On Picturesque Beauty; on Picturesque Travel; and on Sketching Landscape.* 1792
Three Essays. 1808
The Last Work Published of the Rev. William Gilpin. 1810
Six Landscapes. 1794
Original Drawings.
Hints to Form the Taste and Regulate of Judgement in Sketching Landscape. 1790

Gore (?Goeree), W. *The Art of Limning, etc.* 1674

Green, B. *A Drawing Book of Landscapes.* 1786
Seventy-Eight Studies from Nature. 1809

Hamilton, G. *The Elements of Drawing, for the Use of Students.* 1812

Hanbury, A. *Advanced Studies of Flower Painting in Water-Colours.* 1885

Harding, J. D. *Elementary Art.* 1838
Harding's Drawing Book. 1837–1838
Lessons on Art. 1854
Lessons on Trees. 1855
The Principles and Practice of Art. 1845

Harley, G. *First Principles of Landscape-Drawing.* 1829
Lessons on Drawing Trees. 1829

Harris, M. *Natural System of Colours.* 1811

Harrison, H. *Instructions for the Mixture of Water-Colour.* 1830

Hassell, J. *The Speculum; or, Art of Drawing in Water-Colours.* 1816
Aqua Pictura, etc. 1813
The Camera. 1823

Hatton, T. *Water-Colour without a Master.* 1855
The Art of Painting in Water-Colour. 1855
Hints for Sketching in Water-Colour. 1863

Haydocke, R. *A Tracte Containing the Arts of . . . Painting, etc.* 1598

Hayter, C. *An Introduction to Perspective, Drawing and Painting.* 1825

Heath, W. *Rustic Sketches.* 1824
Marine Studies. 1824

Henderson, P. *The Seasons.* 1806

Hilliard, N. *A Treatise concerning the Art of Limning.* 1598

Hodson, Thomas and Dougall, J. *Cabinet of the Arts.* 1805

Howard, F. *Colour as a Means of Art.* 1838
The Sketcher's Manual. 1846

Hullmandel, C. J. *Hullmandel's Lithographic Drawing Book for 1827.* 1827

Hulme, F. Edward. *Flower Painting in Water-Colour.* 1883
A Series of Sketches from Nature of Plant Form. 1868

Ibbetson, J. C. *Process of Tinted Drawing.* 1794
An Accident; or, Gamut of Painting, etc. 1803

Jones. I. *Facsimile of Inigo Jones' Roman Sketchbook of 1614.* ?1832

Jones, W. E. *The Royal Road to Water-Colour Drawing.* 1884

Kennion, E. *An Essay on Trees in Landscape.* 1815
Students' Sketchbook of Studies in Landscape Drawing. early 19th C

Landscape Painting. A Series of Progressive Lessons, Intended to Elucidate the Art of Landscape Painting in Water Colours. 1812

Laporte, J. *Views.* 1799
The Progress of a Water-Coloured Drawing. ?1807
Laporte's Sketch Book. 1829

Leitch, R. P. *A Course of Water-Colour Painting.* 1880
Lessons in Water-Colour Painting. 1865
A Course of Painting in Neutral Tint. 1875

Leitch, R. P. and Callow, J. *Easy Studies in Water-Colour Painting.* 1881

Lens, Bernard and Lairesse, G. de. *For the Curious Young Gentlemen and Ladies. . . . A New and Compleat Drawing Book.* 1751

MacArthur, B. and Moore, J. *Lessons in Figure Painting in Water-Colour.* 1882

M'Kewan, D. H. *Lessons on Trees in Water-Colours.* 1859

MacWhirter, J. *Landscape Painting in Water-Colour.* 1900

Malcolm, J. P. *An Historical Sketch of the Art of Caricaturing, with Graphic Illustrations.* 1813

Mallet, A. M. *La Géométrie Pratique.* 1702

Malton, J. *A Select Collection of Landscapes for Practice in Drawing.* 1808
The Young Painter's Maulstick. 1800
A Complete Treatise on Perspective, in Theory and Practice. 1776

Manskirch, F. J. *Ackermann's New Drawing Book.* 1808
Romantic Views Representing the 4 Hours of the Day. 1797

Merigot, J. *The Amateur's Portfolio; or, The New Drawing Magazine.* 1815–1816
A Treatise on Practical Perspective. 1819

Merrifield, M. P. *Portrait Painting in Water-Colour.* 1852

Metz, C. M. *Imitations of Ancient and Modern Drawings.* 1789

Milbourne, H. *Studies of Cows from Life.* 1805

Miles, L. C. *Water-Colour Painting.* 1872

Miller, A. *Treatise on Water-Colour Painting.* 1848

Mitchell, T. *The Principles of Drawing and Painting.* 1811

Morland, G. *Sketches.* 1791
Sketches by G. Morland. 1792–1793 and subsequent eds.
A Collection of Eight Selected Sketches of Villagers, Favourite Animals, etc. 1793–1807
Eight Views. 1801
Four Sketches. 1815

Murray, Mrs. E. *The Modern System of Painting in Water-Colour.* 1869

Nattes, J. C. *Nattes's Practical Geometry.* 1819

Needham, J. *Studies of Trees.* 1880

A New Drawing-Book of Out-lines, etc. 1722

New Hints . . . on the Art of Miniature Painting. 1837

Nicholson, F. *Six Lithographic Impressions of Sketches from Nature.* 1820

The Practice of Drawing and Painting Landscape from Nature. 1820

Nisbet, E. *Flower Painting for Beginners.* 1889

 On Painting in Water-Colours. 1897

Noble, R. P. *A Guide to Water-Colour Painting.* 1850

Norgate, E. *Miniatura; Art of Limning.* ed. Martin Hardie. 1919

O'Neill, H. *A Guide to Pictorial Art.* 1849

Orme, W. *William Orme's Rudiments of Landscape Drawing.* 1801

 Orme's Process of Tinting, etc. 1810

 Studies from Nature. 1810

Page, T. *The Art of Painting.* 1720

Painting. *A Series of Progressive Lessons Intended to Elucidate the Art of Painting in Water Colours.* 1811

Parkinson, T. *Flower Painting Made Easy.* ? date

Payne, J. *The Art of Painting in Water-Colour.* 1797

 The Artist's Assistant. 1799

Peachum, H. *The Art of Limning . . . in Water-Colour.* 1606

Peele, J. *The Art of Painting in Water-Colour.* 1732

Penley, A. *A System of Water-Colour Painting.* 1850

 Sketching from Nature in Water-Colour. 1869

Perkins, E. E. *Elements of . . . Flower Painting in Water-Colour.* 1834

Phillips, G. F. *The Theory and Practice of Painting in Water-Colours.* 1838

 A Practical Treatise on Drawing, and on Water-Colour Painting. 1839

 Principles of Effect and Colour as Applicable to Landscape Painting. 1833

Pickett, W. *Twenty-Four Plates Divided into Ninety-Six Specimens of Cottages.* 1812

Portrait Painting. *Progressive Lessons Intended to Elucidate the Art of Portrait Painting.* 1824

Poynter, E. J. *Poynter's South Kensington Drawing-Book.* 1870

Pretty. *A Practical Essay on Flower Painting in Water-Colours.* 1812

Pricke, R. *Perspective Practical.* 1698

Priestley, J. *A Familiar Introduction to the Theory and Practice of Perspective.* 1780

Prout, S. *Bits for Beginners.* 1817

 Rudiments of Landscape in Progressive Studies. 1813 and subsequent eds.

 Progressive Fragments. 1817

 A New Drawing Book, in the Manner of Chalk. 1819

 Prout's Drawing Book. 1820

 Prout's Drawing Book of Cottages, etc. 1819

 Easy Lessons in Landscape Drawing. 1819

 A Series of Easy Lessons in Landscape-Drawing: Contained in Forty Plates. 1820

 A Series of Views in the North of England. 1821

 A Series of Views of Rural Cottages in the West of England. 1819

 Marine Sketches. 1820

 Marine Studies. 1814

 Hints on Light and Shadow, Composition, etc., as Applicable to Landscape Painting. 1838 and subsequent eds.

 Prout's Microcosm. 1841

 A Collection of Twenty-Three Original Water-Colour Drawings. No date

Pyne, G. *A Rudimentary and Practical Treatise on Perspective for Beginners.* 1857 (5 ed.)

Pyne, W. H. *Artistic and Picturesque Groups for the Embellishment of Landscape.* 1817

 Microcosm; or, A Picturesque Delineation of the Arts, Agriculture, Manufactures, etc., of Great Britain. 1806 and subsequent eds.

 W. H. Pyne on Rustic Figures in Imitation of Chalk. 1817

 Etchings of Rustic Figures. 1815

 Copperplates for Etchings of Rustic Figures. 1814

 Rudiments of Landscape Drawing. 1812

Rehberg, F. *Drawings Faithfully Copied from Nature at Naples.* 1794

 Outlines of Figures and Drapery. ?1794

Roberts, J. *Introductory Lessons, with Familiar Examples in Landscape.* 1800

Robson, W. *Grammigraphia; or the Grammar of Drawing.* 1799

Ronald, F. *Mechanical Perspective.* 1828

Rowlandson, T. *The World in Miniature.* 1817

Russell, G. *The Art of Miniature Painting.* 1855

Sanderson, W. *Graphice, etc.* 1658

Sayer, R. *Introduction to Drawing Ships.* 1788

 The Artist's Vade Mecum. 1762

 The Florist. 1760

Serres, D. and J. *Liber Nauticus. . . . Marine Drawing.* 1805

Shepheard, G. *Vignette Designs.* 1814–1815

Simpson, G. *The Anatomy of the Bones and Muscles.* 1825

Smith, —. *Studies of Flowers from Nature.* ?1820

Smith, J. *The Art of Painting in Oyl.* 1723

 A Short . . . Method of Painting in Water-Colour. 1730

Smith, T. *The Art of Drawing.* 1825

 Young Artist's Assistant in the Art of Drawing in Water-Colours. ?1825

Sowerby, J. *A New Elucidation of Colours.* 1809

Stubbs, G. *An Illustrated Lecture on Sketching from Nature in Pencil and Water Colour.* ?1850

Syme, P. *Practical Directions for Learning Flower Drawing.* 1810

 Werner's Nomenclature of Colours. 1814

Taylor, J. S. *A . . . Book of Modern Water-Colour Pigments.* 1887

Townsend, W. H. *A System of Foliage, with Hints on the Acquirement of a Touch.* 1844

287

Varley, J. *Precepts of Landscape Drawing.* 1818
 The Painting and Composition of Water-Colour. 180?
 A Treatise on the Principles of Landscape.
 Practical Treatise on Perspective. 1815–1820
 Design. 1823
 Observations on Colouring . . . from Nature. 1830
Vivares, F. *Eight Engravings of Ruins.* 1750
Warren, H. *Hints upon Tints.* 1833
 Painting in Water Colours, Part I. 1856
Wells, W. F. *Passions of the Soul.* ?1800
Whittock, N. *The Art of Drawing and Colouring from Nature, Birds, Beast, Fishes and Insects.* 1830
 The Art of Drawing and Colouring from Nature, Flowers, Fruit, and Shells. 1829
 The Oxford Drawing Book, or the Art of Drawing. 1825

The Youth's New London Self-Instructing Drawing Book. 1834
 The Miniature Painter's Manual. 1844
Wier, H. *Animals.* 1870
Willson, H. *The Use of a Box of Colours.* 1842
 A Practical Treatise on Composition, Light and Shade, and Colour. 1851
Winsor, W. and Newton, H. C. *The Handbook of Water-Colour.* 1842
Wood, J. G. *Footsteps to Drawing, According to the Rules of Perspective.* 1816
 The Principles and Practice of Sketching Landscape Scenery from Nature. 1816
The Young Artist's Complete Magazine, for the Instruction of the Youth of Both Sexes. ?1850
The Young Ladies' Drawing Book; or Complete Instructor in Drawing and Colouring Flowers, Fruit and Shells. ?1830

III Conservation and Restoration

Armstrong, Sir W. *The permanency of water-colour.* 'Art Journal', 1886
Beaufort, T. R. *Pictures and how to clean them [etc.].* 1926
Bellows, A. F. *Watercolour painting: some facts and authorities in relation to its durability.* 1868
'Burlington Magazine', LVII, 1930 (on the fading of water-colour pictures)
Church, Sir A. H. *The chemistry of paints and painting.* 1890
Dillon, F. *Light and watercolour: a reply.* 'The Nineteenth Century', August 1886
Fielding, T. H. *On painting in oil and water colour . . . and on the best method of repairing old paintings.* 1839; 1846
 The knowledge and restoration of old paintings [etc.]. 1847
Hall, H. C. *Restoration of water colour drawings.* 'Apollo', April 1950
London. Imperial Arts League. Journal, 1915: *The permanence of water-colour pigments.* By T. H. Russell. [*The durability of water-colour.* By J. S. Taylor]

Merritt, H. *Dirt and pictures separated [etc.].* 1854
Plenderleith, H. L. *The conservation of prints, drawings and manuscripts.* 1937
Report to the Science and Art Department of the Committee of the Council on Education of the action of light on water-colour 1888
Robinson, Sir J. C. *Light and water-colour.* 'The Nineteenth Century', June 1886
 Light and water-colour: a series of letters addressed to the Editor of *The Times* (principally by Sir J. C. R. and Sir J. D. Linton). 1887
The Times, September 19, 1936: *The Cotman water-colours—a work of conservation*
Varley, J. *A treatise on optical drawing instruments. . . . Also a method of preserving pictures in oil and water-colour.* 1845
Ward, O. F. M. *Notes on the preservation and restoration of water-colour drawing.* ows, V 1927–28
Watson, E. F. *A few observations on picture cleaning and restoring.* 1863

IV Private Collections

Bacon, Sir H. and Sir E.
 Agnew. *Water-colours in the coll. of Sir H. B.* 1946
 Arts Council. *English water-colours from the H.B. coll.* 1948
 ows, XXXVII, 1962

Behrens, W. H.
 The W.H.B. coll. [of water-colour drawings]. 'Connoisseur', IX, X, 1904

Colman Collection
 The Colman coll. of the Norwich school of painters. 'Country
 Life', LXXX, 1936
 The Colman coll. (A. P. Oppé.) 'Burlington Mag.',
 August 1945
Davis, Gilbert
 Arts Council. *Water-colours from the Gilbert Davis coll.* 1949
 Second series, 1955
Girtin, Thomas, jun.
 Sheffield: Graves Art Gallery. *Early water-colours from
 the coll. of T. Girtin.* 1953
 OWS, XXXVII, 1962
 R.A. Exhib. 1962
Harewood House
 Catalogue of pictures and drawings at Harewood House. By
 T. Borenius. 1936
Ingram, Sir Bruce and Lady
 OWS, XXXII, 1957
Keith, Mrs. Cecil
 OWS, XLII, 1967
London. University College
 Select list of the prints and drawings in University Coll. By
 A. M. Hind. 1930
London. Walker's Gallery
 See (in V. & A.), handlist of exhibition cats.
Mackintosh of Halifax, Viscount
 The Norwich school at Thickthorn Hall, Norfolk. 'Con-
 noisseur', May 1963
Mellon, Mr. and Mrs. Paul
 Colnaghi, *English drawings and water-colours from the coll.
 of Mr. and Mrs. P. Mellon.* 1964–65
Nettlefold, Frederick John
 A catalogue of the pictures and drawings in the collection of

F. J. Nettlefold. By C. R. Grundy and F. G. Roe.
 1933–38
Oppé, A. Paul
 Royal Academy 1958
 Sheffield: Graves Art Gall. 1952
 Ottawa: Nat. Gall. of Canada. [With a bibl. of A.P.O.'s
 writings.] 1961
Pilkington, A. D.
 Colnaghi. 1958
Powell, H. A.
 Cat. of water-colours and drawings of the early British school.
 1931; 2nd ed. 1947
Smythe, Canon F. H. D.
 South London Art Gall. *English water-colours 1750–1875.*
 1954
Westwood, Percy J.
 Exhibition of old water-colours at the Architectural Association.
 'Architect. Ass. Jour.', LIII
Williams, I. A.
 Aberystwyth: Nat. Lib. of Wales. *Early English water-
 colours and other drawings.* 1953
 Sheffield: Graves Art Gall. 1952
Windsor Castle
 Victorian water-colours at Windsor Castle. OWS, XV, 1937
 Drawings at Windsor Castle. 'Connoisseur', XCII, 1933
 A. P. Oppé, *English Drawings at Windsor Castle.* 1950
Witt, Sir John
 The John Witt Coll. Part II: English School, Courtauld
 Inst. of Art. Exhib. 1963
Wright, J. Leslie
 Royal Academy. *Masters of British water-colours, 17th–19th
 century.* 1949

V Public Collections

Barnsley: Cooper Art Museum
 Notes on a collection of English drawings. 1937
Bedford: Cecil Higgins Museum
 Bury, A. *Water-colours and drawings in the . . . collection.*
 OWS, XXXVI, 1959
Birmingham: Museum and Art Gallery
 Cat. of drawings. 1939
 Illus. of one hundred water-colours. 1953
 Cat. of paintings. 1960
 Davies, R. *Water-colours in the . . . Gallery.* OWS, XVI, 1938

Bristol: Museum and Art Gallery
 Bristol scenery. 1962
Cambridge: Fitzwilliam Museum
 Bury, A. *The Fitzwilliam Museum.* OWS, XXXI
Cardiff: National Museum of Wales
 *The British water-colour school: handbook to the Pyke Thompson
 Gallery.* 1939
Dublin: Museum of Science and Art
 'General guide to the art collections', XII. *Catalogue of
 water-colours and oil-paintings [etc.].* 2 ed. 1920

Edinburgh: National Gallery Scotland
 Cat. of water-colours and drawings. 1957
Florence: Fondazione Horne
 Ragghianti, L. *Disegni inglesi della Fondazione Horne: catalogo critico.* 1966
Glasgow: Art Gallery
 ows, XLI, 1966
Hereford: Art Gallery
 Bury, A. ows, XXIV
Leeds: Art Gallery
 Water-colours and drawings. [1962]
 Bury, A. ows, XXXV
Leicester: Museum and Art Gallery
 Water-colours and drawings. 1963
Liverpool: Walker Art Gallery
 Water-colours and drawings at the . . . Gallery. 1960
 Early English drawings and water-colours. 1968
London: British Museum [Prints and Drawings]
 Handbook to the drawings and water-colours in the Department [etc.]. By A. E. Popham. 1939
 Catalogue of British drawings. I, XVI & XVII centuries. By E. Croft-Murray and P. Hulton. 1960
London R.I.B.A.
 Architectural drawings. 1961
London: Courtauld Institute of Art
 Handlist of drawings in the Witt Coll. 1956
London: Victoria and Albert Museum
 Catalogue of the first circulating collection of water-colour paintings of the British school. 1904; 2nd 1907; 3rd 1921
 National Gallery of British Art [etc.], II. *Catalogue of water-colour paintings by British artists and foreigners working in Great Britain.* 1908; Rev. ed. 1927; Supp. 1951
 Water-colours in the Dixon bequest [etc.]. 1934
 Marine water-colours at South Kensington. 'Apollo', April 1947

South Kensington Museum (afterwards V. & A.)
 Descriptive catalogue of the historical collection of water-colour painting in the . . . Museum. By S. Redgrave. 1877
Manchester: Whitworth Art Gallery
 Historical catalogue of the collection of water-colour drawings. . . . By C. Monkhouse. 1894
 Davies, R. *Water-colours at the . . . Gallery,* ows XVII, 1939
 Twenty early English water-colour drawings in the . . . Gallery. [?1951]
Melbourne: National Gallery of Victoria
 Oil paintings, water-colours, [etc.]. 1948
Newcastle: Laing Art Gallery
 Illustrated catalogue of water-colour drawings [etc.]. 1938; 2 ed. 1939
Norwich: Castle Museum
 Catalogue of pictures. 1937
 Short guide to the Norwich School pictures. 1951
 Illustrated guide to the collection of Norwich School pictures. 1951
 ows, XXXIX, 1964
Nottingham: Art Museum
 Catalogue of the Samuel William Oscroft bequest of paintings and drawings of the English school. 1924
 ows, XXXVII, 1962
Oxford: Ashmolean Museum
 Bury, A. *Water-colours at the Ashmolean.* ows, XXXIII
Paris: Musée du Louvre
 La peinture anglaise. 1938
Philadelphia: Pennsylvania Academy of Fine Arts
 Illustrated catalogue of the English water-colours. 1886
Preston: Harris Museum and Art Gallery
 The Haslam bequest. 1949
Sheffield: City Art Galleries
 Early English water-colours. 1966
 ows, XXXVIII, 1963
Worcester: Victoria Institute
 Catalogue of the Sale bequest of water-colours. 1918

VI Individual Artists

This section is composed of

 (a) books referred to by the author
 (b) monographs on artists *mentioned* in the work
 (c) references to biographical sources on artists *not mentioned* but thought necessary to a survey of the subject.

The majority of the material included has been taken from the indices in the National Art Library, Victoria and Albert Museum. For further articles, reviews etc., students are recommended to consult the *Art Index*. Entries in Thieme-Becker, *Allgemeines Lexikon der Bildenden Künstler* have not been noted, as this source is generally known.

The abbreviated references in the following section relate to the works listed under artists' names.

Binyon L. Binyon: *Catalogue of Drawings by British Artists in the British Museum*. 1898–1907

Bryan M. Bryan: *Dictionary of Painters and Engravers*. 1903

BM I British Museum; *Catalogue of British Drawings*. I, XVI & XVII centuries, 1960

Caw Sir J. L. Caw: *Scottish Painting, 1620–1908*. 1908

Clayton E. C. Clayton: *English Female Artists*. 1876

Clement and Hutton Clement and Hutton: *Artists of the 19th Century*. 1879

Clifford D. Clifford: *Water-Colours of the Norwich School*. 1965

Cundall H. M. Cundall: *History of British Water-Colour Painting*. 1908; 1929

Cunningham A. Cunningham: *The Lives of the Most Eminent British Painters*. 1828, etc.

DNB *Dictionary of National Biography*. 1908, etc.

Dayes E. Dayes: *The Works of the late E. Dayes*. 1805

Dickes W. F. Dickes: *The Norwich School of Painting*. 1905

Edwards E. Edwards: *Anecdotes of Painters*. 1808

FAS Fine Art Society

Graves DICT A. Graves: *A Dictionary of Artists 1760–1893*. 1901

Graves RA A. Graves: *The Royal Academy . . . contributors*. 1905

Graves SOC. of A A. Graves: *The Society of Artists of Great Britain 1760–1791 and The Free Society of Artists 1761–1783*. 1907

Graves BI A. Graves: *The British Institution 1806–1867*. 1908

Graves LOAN A. Graves: *A Century of Loan Exhibitions 1813–1912*. 1913–15

Hughes C. E. Hughes: *Early English Water-colour*. 1913; 1950 (rev.)

Huish M. B. Huish: *British Water-colour Art*. 1904

Lemaitre H. Lemaitre: *Le Paysage Anglais à l'Aquarelle 1760–1851*. 1954

Nettlefold F. J. Nettlefold Collection. Catalogues by C. R. Grundy and F. G. Roe, 4 vol. 1933–38

Ottley H. Ottley: *A Biographical and Critical Dictionary*. 1866

ows *The Old Water-Colour Society*. Annual vols. 1924 etc.

Prideaux S. T. Prideaux: *Aquatint Engraving*. 1909

RA 1934 Royal Academy: *Exhibition of British Art*. 1934 Commemorative Cat.

Redgrave DICT S. Redgrave: *A Dictionary of Artists of the English School*. 1878

Redgrave CENT S. and R. Redgrave: *A Century of British Painters*. 1866; 1947 (rev.)

Rees T. M. Rees: *Welsh Painters, Engravers, etc. 1527–1911*. 1912

Roget J. L. Roget: *History of the Old Water-Colour Society*. 1891

Sandby W. Sandby: *The History of the Royal Academy*. 1862

Strickland W. G. Strickland: *A Dictionary of Irish Artists*. 1913

VAM Victoria and Albert Museum: *Catalogue of Water-colour paintings*. 1927; Suppl. 1951

Williams Iolo A. Williams: *Early English Water-colours*. 1952

Williamson G. C. Williamson: *History of Portrait Miniatures*. 1904

Windsor A. P. Oppé: *English Drawings . . . at Windsor Castle*. 1950

ABBOTT, John White (1763–1851)
A. P. Oppé: *J.W.A. of Exeter*. Walpole Soc. XIII, 1925
'Apollo' March 1933
Oxford Arts Club 1931
Walker's Gall. 1938
FAS 1952

Redgrave: Graves RA: Binyon: Williams: Hughes: VAM: Lemaitre

ABSOLON, John (1815–1895)
Clement and Hutton: Graves RA: VAM: Cundall

ADAM, Robert (1728–1792)
P. Fitzgerald: *R.A.* 1904
R.A.'s picturesque compositions 'Burlington Mag.' LXXX, 56, 1942
John Fleming, *R.A. and his circle in Edinburgh and Rome*. 1962
Kenwood: Drawings by Robert and James Adam 196?
Binyon: VAM: Cundall: Windsor: Williams: Redgrave: RA 1934: DNB

AGLIO, Agostino (1777–1857)
VAM: Williams: Binyon: Cundall: DNB: Redgrave

291

ALEXANDER, Edwin (1870–1926)
J. Patterson: *E.A.* ows, IV, 1926

Who's Who 1906: Cundall: Huish: Caw

ALEXANDER, Herbert (1874–1946)
L. Housman: *H.A.* 'Studio' XXXI, 1904

ALEXANDER, William (1767–1816)
A. G. Reynolds: *British artists abroad, II: Alexander and Chinnery in China.* 'Geog. Mag.' X, No. 5, 1947

Binyon: Graves RA: VAM: Cundall: Hughes: Williams: Redgrave DICT, CENT: DNB: Roget

ALKEN, Henry (1785–1851)
M. Hardie: *The coloured books of H.A.* 'Queen' CXVIII, 194, 1905
W. S. Sparrow: *H.A.* 1927
Lincoln, Usher Art Gall. 1948
Ellis and Smith Gall. 1949

Redgrave: Binyon: Graves RA: VAM: Cundall: Williams: DNB

ALKEN, Samuel (1784–*c.* 1825)
Redgrave: Binyon: Graves RA: Williams: DNB

ALLAN, David (1744–1796)
T. C. Gordon: *D.A. of Alloa.* 1951

Cunningham: Redgrave: Graves RA: DNB: Caw: Williams: Windsor: Binyon: RA 1934: Roget

ALLAN, Robert Weir (1851–1942)
FAS 1924

Graves RA: Caw: VAM

ALLEN, Joseph William (1803–1852)
Ottley: Redgrave: Graves RA: Binyon: Cundall: VAM: Nettlefold: DNB

ALLINGHAM, Helen (1848–1926)
H. B. Huish: *Happy England as painted by H.A. With memoir.* 1903
FAS 1886, 87, 91, 94, 98, 1901, 08, 13
Clement and Hutton: Clayton: 'Studio', Summer No. 1900: VAM: Cundall

ALLOM, Thomas (1804–1872)
Redgrave: Binyon: VAM: Hughes: DNB

ALLPORT, Henry C. (*fl.* 1808–1823)
Roget: Redgrave: Binyon: Graves RA: VAM: Cundall

ANDERSON, William (1757–1837)
Redgrave: Graves RA: Binyon: Williams: VAM: Cundall: Windsor: DNB

ANDREWS, George Henry (1816–1898)
Graves DICT, RA: Bryan: VAM: Cundall

ANGELL, Mrs. Helen Cordelia (1847–1884)
Clayton: Graves RA: VAM: Cundall

ANNESLEY, Charles (Working mid. XIX C)
Binyon: Williams

ARCHER, John Wykeham (1808–1864)
VAM: Binyon: Cundall: DNB: Redgrave

ARNALD, George (1763–1841)
Ottley: Redgrave DICT, CENT: Graves RA: Binyon: Williams: VAM: Roget: Hughes

ATKINS, Samuel (*fl.* 1787–1808)
Redgrave: Graves RA: Binyon: VAM: Williams: Cundall: DNB

ATKINSON, John Augustus (1775–1818)
Redgrave: Graves RA: Binyon: Roget: VAM: Cundall: Williams: Hughes: Windsor: DNB

AUSTIN, Samuel (1796–1834)
B. S. Long: *S.A.* 'Connoisseur' LXXXIV, 1929

Roget: Graves RA: Binyon: VAM: Cundall: Hughes: DNB: Redgrave

AYLESFORD, Heneage Finch, *4th Earl of* (1751–1812)
Redgrave: Graves RA: Binyon: VAM: Cundall: Williams: Windsor: Lemaitre

BADHAM, E. Leslie (1873–1944)
J. E. Rey: *Notes on old and modern Hastings.* 1935
Renaissance Gall. 1936

BALMER, George (*c.* 1806–1846)
Redgrave: Binyon: VAM: Cundall: Hughes: DNB

BARBER, Charles (1784–1854)
Redgrave: VAM: Cundall: DNB: Roget

BARBER, John Vincent (1788–1838)
Redgrave: Graves RA: DNB: Cundall: Hughes

BARKER, Benjamin (1776–1838)
Redgrave: Roget: Graves RA: VAM: Cundall: Williams: DNB

BARKER, Robert (1739–1806)
G. Bapst: *Essai sur l'histoire des panoramas et des dioramas.* 1891
DNB

BARKER, Thomas (1769–1847)
P. Bate: *T.B. of Bath.* 'Connoisseur' X and XI
Sir E. Harrington: *A schizzo on the genius of man.* 1793.
Bath, Victoria Art Gall.: *Barker of Bath.* 1962

Graves RA: Binyon: VAM: Cundall: Williams: DNB: Roget: Redgrave

BARLOW, Edward (1642– ?)
E. Lubbock: *Barlow's Journal of his life at sea.* 1934
I. A. Williams: *The manuscript of Barlow's Journal.* 'Bookman' LXXXVI, 1934

BARLOW, Francis (*c.* 1626–1702)
Redgrave: Binyon: BM I: Williams: VAM: Cundall:
Windsor: RA 1934: DNB

BARNARD, Rev. William Henry (1767–1818)
Williams: Windsor

BARRALET, John James (*d.* 1812)
Redgrave: Graves RA, SOC. of A: Binyon: Cundall:
Williams: DNB

BARRALET, John Melchior (*fl.* 1774–1787)
Redgrave: Graves RA, SOC. of A: Cundall: Williams:
VAM: Roget

BARRAUD, William (1810–1850)
VAM: Cundall: DNB: Redgrave

BARRET, George, I (1732–1784)
T. Bodkin: *Four Irish landscape painters.* 1920
Redgrave DICT, CENT: Roget: Binyon: Graves RA: VAM:
Cundall: Williams: DNB

BARRET, George, II (?1767–1842)
Some Letters of G.B. II. OWS, XXVI
A. Bury: *G.B. II.* 'Connoisseur' CV, 1940
Redgrave DICT, CENT: Roget: Binyon: VAM: Cundall:
Williams: Windsor: Hughes: DNB: Lemaitre

BARRET, James (*fl.* 1785–1819)
Redgrave: Graves RA: Binyon: Cundall: Williams:
Roget

BARRET, Miss M. (*fl.* 1797–*d.* 1836)
Redgrave: Graves RA: Cundall: Roget

BARROW, Joseph Charles (*fl.* 1789–1802)
Graves RA, SOC. of A: Binyon: Cundall: Williams:
Hughes: VAM Supp.: Roget

BARRY, James (1741–1806)
The works of J.B. 1809 2v
A description of a series of pictures by J.B. 1817
Redgrave DICT, CENT: Binyon: Graves RA: Williams:
DNB: Roget

BARTLETT, William Henry (1809–1854)
W. Beattie: *Brief memoir of W.H.B.* 1855
J. Britton: *A brief biography of W.H.B.* 1855
'Country Life' February 15, 1968
FAS 1892
VAM: DNB: Redgrave: Hughes: Binyon

BARTOLOZZI, Francesco (1727–1815)
A. W. Tuer: *F.B. and his works.* 1882
C. H. S. Johns: *B., Zoffany and Kauffmann.* 1924
A. B. de Vesme: *Cat. des estampes de F.B.* 1928
E. Soares: *F.B. e os seus dicipulos em Portugal.* 1930
Hodgkins Gall. 1906
Redgrave DICT, CENT: Graves RA: Binyon: VAM:
Cundall: Williams: Windsor: RA 1934: DNB: Roget

BAYNES, James (1766–1837)
Redgrave: Roget: Bryan: Graves RA: Binyon: VAM:
Cundall: Williams: DNB

BEAUCLERK, Lady Diana (1734–1808)
B. C. Erskine: *Lady D.B.* 1903
DNB: Binyon: VAM: Cundall: Williams: Windsor:
Redgrave

BEAUMONT, Sir George Howland, Bart. (1753–1827)
VAM MSS: Letters to Dr. T. Monro from Sir G. B. 1808–
1821
W. A. Knight: *Memorials of Coleorton.* 1887
M. Greaves: *Regency patron: Sir G.B.* 1966
Leicester Museum and Art Gall. 1938 (VAM copy with
notes by C. F. Bell)
Leicester Museum and Art Gall. 1953
Cunningham: Redgrave DICT, CENT: Graves RA: DNB:
Roget: Hughes: Binyon: Williams: Cundall

BEAUMONT, John Thomas Barber (1774–1851)
W. S. Beaumont: *The Beaumont Trust and its founder
J.T.B.B.* 1887
DNB: Redgrave: Graves RA: Williamson

BENTLEY, Charles (1806–1854)
F. G. Roe: *C.B.* 'Walker's Quart.' I, no. 3, 1920
Redgrave: Roget: DNB: Binyon: VAM: Cundall: Hughes

BENTLEY, Joseph Clayton (1809–1851)
Redgrave: Graves BI: VAM: Cundall: Hughes: DNB

BENWELL, John Hodges (1764–1785)
VAM: Williams: Cundall: DNB: Redgrave

BEVERLEY, William Roxby (?1811–1889)
F. L. Emanual: *W.R.B.* 'Walker's Quart.' I, no. 21
Clement and Hutton: Graves RA: Binyon: VAM:
Hughes: DNB

BEWICK, Thomas (1753–1828)
VAM MSS: Letters and documents
Memoir by T.B. himself, 1862, 1924, 1961
F. G. Stevens: *Notes on a coll. of drawings.* FAS 1881
D. C. Thomson: *The water-colours of T.B.* 1930
C. M. Weekley: *T.B.* 1953
Redgrave DICT, CENT: Binyon: VAM: Williams: RA 1934:
DNB

BIFFIN, Sarah (1784–1850)
Clayton: Graves RA: Williamson: Cundall: Redgrave

BLAKE, William (1757–1827)
*A descriptive catalogue of pictures . . . by W.B. in water-
colours . . . for sale. . . . 1809*
A. Gilchrist: *Life of W.B.* 1880
R. L. Binyon: *The art of W.B.* 1906
G. K. Chesterton: *W.B.* 1920
D. Figgis: *The painting of W.B.* 1925

Sir G. Keynes: *Illus. to Young's 'Night Thoughts' . . . water-colours by W.B.* 1927
Sir G. Keynes: *Pencil drawings by W.B.* 1927, 2nd ser., 1956
New York, Pierpont Morgan Lib.: *Illus. to the Book of Job . . . Facsimile.* 1935
San Marino; Henry E. Huntingdon Lib.; C. H. C. Baker: *Cat. of W.B.'s drawings . . . in the lib.* 1938
Sir G. Keynes: *Blake.* 1945
H. Lemaitre: *W.B. peintre ésotérique.* 1947
W. G. Robertson: *The Blake Coll. of W. Graham Robertson.* 1952
A. S. Roe: *B.'s illus. to the Divine Comedy.* 1953
W. Gaunt: *The arrows of desire: study of W.B.* 1956
Sir A. Blunt: *The art of W.B.* 1959
Sir G. Keynes: *W.B.* 1965
Tate Gall., M. Butlin: *W.B.* 1966

 Boston U.S.A., Museum of Fine Arts 1880, 1891
 Walsall, Art Gall. and Mus. 1893
 Royal Academy 1893
 Carfax Gall. 1904, 1906
 Nat. Gall. 1913
 Manchester, Whitworth Inst. 1914
 Nottingham, Mus. and Art Gall. 1914
 Cotswold Gall. 1923
 Burlington Fine Arts Club 1927
 Paris, Bib. Nat. 1937
 Philadelphia, Mus. of Art 1939
 New York, Knoedler Gall. 1941
 Zurich, Kunsthaus 1947
 Tate Gall. 1947
 Antwerp, Mus. 1947
 Bournemouth, Arts Club 1949
 Port Sunlight, Lever Art Gall. 1950

Binyon: VAM: Windsor: Williams: Redgrave: Cundall: Redgrave DICT, CENT: Lemaitre

BOITARD, Louis Philippe (*fl.* 1738–1760)
Binyon: Williams: Windsor: DNB: Redgrave

BONE, Henry Pierce (1779–1855)
VAM MSS: 2 letters from J. I. Richards to H.B. 1801
J. J. Rogers: *Notice of H.B.*
 Truro: Royal Institution of Cornwall 1951
Roget: Graves RA, BI: DNB: Cundall: Redgrave DICT, CENT

BONE, Robert Trewick (1790–1840)
Redgrave: Graves RA, BI: DNB

BONINGTON, Richard Parkes (1802–1828)
J. D. Harding: *Subjects from the works of R.P.B. drawn on stone by J.D.H.* 1829
P. Mantz: *Bonington.* 'Gaz. des Beaux Arts' 2 ser., XIV, 1876
H. Frantz: *The art of R.P.B.* 'Studio' XXXIII, 1904
H. Stokes: *Girtin and B.* 1922
A. Dubuisson and C. A. Hughes: *R.P.B. life and work.* 1924

A. Dubuisson: *Influence de B . . . sur la peinture de paysage en France.* Walpole Soc. II, 1913
C. E. Hughes: *Notes on B.'s parents.* Walpole Soc. III, 1914
R. Fry: *B. and French art.* 'Burlington Mag.' II, 1926
G. S. Sandilands: *R.P.B.* 1929
C. R. Grundy: *B. and Prout.* 'Connoisseur' May 1925
A. Dubuisson: *Bonington.* 1927
O. Benesch: *B. und Delacroix.* 'Münchner Jahrbuch', N.S. II, 1925
H. Marguery: *Notes sur R.P.B.* 1931
R. L. Binyon: *English water-colours . . . Turner, R.P.B., etc.* 1939
Hon. A. Shirley: *Bonington.* 1940
S. Race: *Notes on the Boningtons.* 1950
M. Gobin: *R.P.B.* 1955
M. L. Spencer: *R.P.B.: a re-assessment . . . of his art.* (Unpub. thesis for the University of Nottingham)

 Cosmoramic Gall. 1834
 Hogarth Gall. n.d.
 Patterson's Gall. 1913
 Squire Gall. 1922
 Paris, M. Gobin 1936
 Burlington F.A. Club 1937 (VAM copy, notes by C. F. Bell)
 Stafford Gall. 1939
 King's Lynn 1961
 Nottingham Mus. and Art Gall. 1965
 Agnews 1962

Redgrave DICT, CENT: Hughes: DNB: Nettlefold: Cunningham: Graves RA, BI: Binyon: VAM: Cundall: Lemaitre

BOUGH, Samuel (1822–1878)
S. Gilpin: *S.B.* 1905
R. Walker: *S.B. and G. P. Chalmers.* n.d.
DNB: Caw: Graves RA: Cundall: VAM: Binyon

BOURNE, James (1773–1854)
VAM: Binyon: Williams: Cundall: Redgrave

BOWLES, Oldfield (*ex.* 1772–1795)
Graves RA, SOC. of A

BOYCE, George Price (1826–97)
A. E. Street: *G.P.B.* 'Arch. Review' J, 1899 and OWS XIX, 1941
Bryan: Graves RA: VAM: Roget

BOYNE, John (1759–1810)
Binyon: VAM: Williams: Windsor: Cundall: DNB: Redgrave

BOYS, Thomas Shotter (1804–1874)
H. Stokes: *T.S.B.* 'Walker's Quart.' J no. 18. 1925–6
'Architectural Review' LX, 1926
E. B. Chancellor: *Original views of London.* 1926, 1954
Graves RA: Binyon: DNB: VAM: Hughes: Cundall: RA 1934: Nettlefold: Lemaitre

BRABAZON, Hercules Brabazon (1821–1906)
T. M. Wood: *The water-colour art of H.B.B.* 'Studio'
xxxv, 1905
Sir F. Wedmore: *H.B.B.* ?1910
Mrs. H. B. Combe: *Notes on the life of H.B.B.* ?1910
D. S. MacColl: *The study of B.* ?1910
C. L. Hind: *H.B.B.* 1912
Goupil Gall. 1892, 1906
Hastings Mus. and Art Gall. 1907
Brabazon House 1919, 1928
Eldar Gall. 1920
Cooling Gall. 1926
FAS 1926, 1935, 1942
Beaux Arts Gall. 1928, 1936
Cincinnati Mus. 1926
Hove Mus. and Art Gall. 1933
Adams Gall. 1947
Albany Gall. 1968
Cundall: VAM

BRANDARD, Robert (1805–1862)
Bryan: DNB: Binyon: VAM: Cundall: Hughes: Redgrave

BRANDOIN, Michel Vincent (1733–1807)
VAM: Binyon: Windsor

BRIERLY, Sir Oswald Walters (1817–1894)
Pall Mall Gall. 1887
Bryan: Graves RA: Cundall: DNB

BRIGHT, Henry (1814–1873)
F. G. Roe: *H.B. of the Norwich school.* 'Walker's Quart.'
I, no. 1 1920
Binyon: Bryan: Graves RA: Dickes: DNB: VAM: Cundall:
Clifford: Nettlefold: Redgrave

BRITTON, John (1776–1857)
Binyon: Cundall: DNB: Roget: Redgrave: Hughes

BROCKEDEN, William (1787–1854)
Redgrave: Bryan: Binyon: Graves RA: VAM: Cundall:
Hughes: DNB

BROOKE, William Henry (1772–1860)
Williams: DNB: Redgrave

BROOKING, Charles (1723–1759)
Aldeburgh Festival and Bristol Museum and Art Gall.
1966
Redgrave DICT, CENT: Bryan: Binyon: VAM: Cundall:
Williams: DNB

BROWN, Alexander Kellock (1849–1922)
Graves RA: Caw

BROWN, John (1752–1789)
Williams: Redgrave: Caw

BROWN, Ford Madox (1821–1893)
VAM MSS: Letter from A. Hughes to F.M.B. 1894
Birmingham Museum and Art Gall.: *Cat. of drawings*
1939 and supp.
Liverpool, Walker Art Gall. 1964
DNB: Graves RA, BI: Binyon: Cundall: VAM: RA 1934

BUCK, Adam (1759–1833)
Leicester Gall. 1925
Binyon: Graves RA: Cundall: Williams: Windsor:
DNB: Redgrave

BUCK, Samuel (1696–1779) Nathaniel BUCK (working
1727–1753)
Binyon: Williams: Windsor: Cundall: DNB: Redgrave

BUCKLER, John (1770–1851)
Binyon: VAM: Williams: Cundall: DNB: Redgrave

BUCKLER, John C. (1793–1894)
Oxford, Bodleian Library: *Drawings of Oxford by J.C.B.*
1951
Binyon: Williams: Roget

BULMAN, Job (*fl.* 1767)
Binyon: Williams: Windsor

BULWER, Rev. James (1794–1879)
C. F. Bell: *The Bulwer Coll.* 'Walker's Quart.'; J. S.
Cotman, nos. 19, 20, 1926; M. E. Cotman, no. 21,
1927
Clifford

BUNBURY, Henry William (1750–1811)
Redgrave: Graves RA: Williams: Binyon: Cundall:
VAM: RA 1934

BURGESS, John (?1814–1874)
R. Aspa: *J.B.* 'Walker's Quart.' IV, no. 16, 1925
Graves RA: Cundall: Roget: VAM: Hughes

BURGESS, William (*c.* 1749–1812)
Redgrave: Graves RA: Binyon: Williams: VAM Supp.:
DNB

BURNE-JONES, Sir Edward Coley, Bart. (1833–1898)
Cartwright (afterwards Ady): *Sir E.B.J.* 1894
Memorials of E.B.J. 1904
T. E. Welby: *The Victorian romantics—the early work of
E.B.J.* 1929
A. L. Baldry: *B.J.* 1909
C. B. Stevenson: *Sir E.B.J.* OWS, IX, 1932
R. Ironside and J. Gere: *Pre-Raphaelite painters.* 1948
VAM: Cundall: RA 1934: DNB

BURNEY, Edward Francis (1760–1848)
Redgrave: Binyon: Graves RA: VAM: Williams: Cundall:
Hughes: RA 1934: Roget

BURTON, Sir Frederick William (1816–1900)
VAM: Cundall: DNB

CADENHEAD, James (1858–1927)
Caw: Who's Who 1911: Cundall

CALDECOTT, Randolph (1846–1886)
R.C.'s Sketches. 1890
H. R. Blackburn: *R.C.* 1886
M. G. Davis: *R.C.* 1946
VAM MSS: R.C. letter to Edmund Evans. 1884
C. Phillips: *R.C.* 'Gaz. des B-Arts' XXXIII, 1886

Binyon: Bryan: Cundall: DNB: VAM: Redgrave CENT

CALLCOTT, Sir Augustus Wall (1779–1844)
S. Dafforne: *Sir A.W.C.* 1875
 RA 1875
Redgrave DICT, CENT: Roget: Bryan: DNB: VAM:
Cundall: Williams: Hughes: Nettlefold

CALLCOTT, Maria, Lady (1785–1842)
R. B. Gotch: *Maria Lady C.* 1937

Binyon: DNB: Williams

CALLOW, John (1822–1878)
H. M. Cundall: *William Callow.* 1908

Roget: Graves DICT: Cundall: Hughes: DNB

CALLOW, William (1812–1908)
Martin Hardie: *W.C.* ows, XXII
William Callow. 1908 (copy in VAM with notes by C. F.
Bell); 'Walker's Quart.' XXII, 1927
 Leicester Gall. 1907, 1913
 Walker's Gall. 1927, 1955, 1958
 Squire Gall. 1938

Roget: Graves DICT: VAM: Cundall: Hughes: Nettlefold:
RA 1934: Huish: Lemaitre

CALVERT, Edward (1799–1883)
S. Calvert: *Memoir of E.C.* 1893
E. Calvert: *Ten spiritual designs* (H. P. Horne, *Brief
notice of E.C.*). 1913
R. L. Binyon: *The followers of William Blake.* 1925
A Grigson: *A Cornish artist E.C.* 'West Country Mag.'
1946
R. Lister: *E.C.* 1962
 Royal Academy 1893
 Carfax Gall. 1904

Binyon: Bryan: Graves RA: RA 1934: DNB: Roget:
Redgrave CENT

CAMERON, Sir David Young (1865–1945)
Paintings of Sir D.Y.C. 'Studio' extra pub. 1919
D. Meldrum: *Water-colours of the Highlands by D.Y.C.*
'Apollo' 1929
Sir J. L. Caw: *Sir D.Y.C.* ows, XXVII
D. Martin: *The Glasgow school of painting.* 1908
 Grosvenor Gall. 1924
 Leicester Gall. 1905

FAS 1903
 Paterson's Gall. 1906
 Cotswold Gall. 1929
 Barbizon House 1934
Who's Who 1911: VAM: Caw

CAMPBELL, John Henry (1757–1828)
Williams

CANALETTO, Giovanni Antonio (1697–1768)
H. Finberg: *Canaletto in England.* Walpole Soc. IX, 1921–2
D. von Hadeln: *The drawings of C.* 1929
W. G. Constable: *Canaletto.* 1962 (2v)
K. T. Parker: *The drawings of C. at Windsor Castle.* 1948

CAPON, William (1757–1827)
Binyon: Williams: Windsor: DNB: Clifford: Redgrave

CARMICHAEL, James Wilson (1800–1868)
Redgrave: Graves DICT, RA, BI: Cundall: DNB: Hughes:
VAM

CARTER, H. B. (*fl.* 1824–*d.* 1867)
Binyon: VAM: Cundall: Redgrave

CARTER, Hugh (1837–1903)
Graves DICT, RA: Cundall: VAM: Nettlefold

CARTER, John (1748–1817)
Rev. W. A. Dampier: *Memoir of J.C.* 1850

Redgrave: Walpole *Anec*: DNB: Graves RA, SOC. of A:
Binyon: Williams: VAM: Cundall: Roget

CARTWRIGHT, Joseph (1789–1829)
Strand Panorama 1822

Redgrave DICT, CENT: Binyon: Graves RA, BI: VAM:
Cundall: DNB

CARWITHAM, Thomas (worked about 1720)
Williams

CATTERMOLE, George (1800–1868)
R. Davies: *G.C.* ows, IX 1932

Roget: Cundall: Graves DICT, RA, BI: Binyon: VAM:
Hughes: DNB: Redgrave DICT, CENT

CATTON, Charles II (1756–1819)
Clifford: DNB: Roget: Redgrave DICT, CENT

CHALON, Alfred Edward, R.A. (1780–1860)
VAM MSS: Letters to and from John Constable 1822–51
C. R. Leslie: *Autobiog. recollections.* 1865
 'Amateur Art' Exhib. 1897

Redgrave CENT, DICT: Roget: Graves DICT, RA, BI:
Bryan: Binyon: Cundall: Hughes: Windsor: VAM:
DNB

CHALON, John James (1778–1854)
Redgrave DICT, CENT: Roget: Graves DICT, RA, BI:
Binyon: VAM: Cundall: Hughes: DNB

CHAMBERS, George (1803–1840)
Memoir of G.C. 1837
J. Watkins: *Life and career of G.C.* 1841
J. Watkins: *G.C.* OWS, XVIII, 1940
Roget: Cundall: Graves DICT, RA, BI: VAM: Binyon:
Hughes: Nettlefold: DNB: Redgrave

CHATELAIN, John Baptist (1710–1771)
Redgrave: Binyon: Graves SOC. of A: VAM: Williams:
Cundall: Windsor: DNB: Roget

CHINNERY, George (1774–1865)
J. Orange: *Pictures by G.C. now in A. G. Stephens Coll.
Hong Kong.* 1923
J. J. Cotton: *G.C.* (reprints from *Bengal, Past and Present*).
1924
A. G. Reynolds: *British artists abroad, II. Alexander and
Chinnery in China.* 'Geo. Mag.' XX, V
H. and S. Berry-Hill: *G.C.* 1963
Tate Gall. 1932
Squire Gall. 1936
Arts Council Scottish Committee 1957
Maas Gall. 1961
Binyon: Graves RA, SOC. of A: Williamson: VAM:
Cundall: Hughes: Williams: DNB: Redgrave

CHURCHYARD, Thomas (1798–1865)
D. Thomas: *T.C. of Woodbridge.* 1966
Graves DICT, RA

CIPRIANI, G. G. (1727–1785)
Edwards: Redgrave DICT, CENT: Graves DICT, RA,
SOC. of A: Binyon: Cundall: VAM: Williams: Windsor:
DNB: Roget

CLAUSEN, Sir George (1852–1944)
George Clausen. 1923
F. G. Roe: *G.C.* OWS, XXIII
Goupil Gall. 1902
Leicester Gall. 1909, 1912
Grosvenor Gall. 1921
Paterson Gall. 1907
Durban Art Gall. 1931
Barbizon House 1933, 1934
Arts Council 1949
Graves DICT, RA: Who's Who 1912: VAM

CLENNELL, Luke (1781–1840)
A. Dobson: *Bewick and his pupils.* 1884
Redgrave CENT, DICT: Roget: Graves DICT, RA, BI:
DNB: Bryan: Cundall: Hughes: Williams

CLERISSEAU, C. (1721–1820)
Count A. Dudan: *Trois artistes français en Dalmatie* 'Paris
Congrès d'Histoire de l'Art' 1921, Actes II, 1924
Clerisseau drawing found. 'Times' February 11, 1963
Redgrave: Binyon: Cundall: VAM: Williams: DNB:
Roget

CLERK, J., of Eldin
VAM MSS: P. Sandby letter to J.C. 1775
Redgrave: Caw: Binyon: DNB

CLEVELEY, John II (1747–1786)
Edwards: Redgrave: Roget: Graves RA, SOC. of A: DNB:
Williams: Cundall: VAM: Binyon

CLEVELEY, Robert (1747–1809)
Redgrave: Graves DICT, RA, BI: DNB: VAM: Binyon

CLINT, George (1770–1854)
Redgrave DICT, CENT: Clement and Hutton: Graves
DICT, RA, BI: Williamson: DNB

COLE, Sir Henry (1808–1882)
VAM MSS: Sir H.C. *Diaries* 1822–82, 58 vols.
Holiday Journals 1832–5, 1870–2
Graves RA: DNB: VAM

COLEMAN, William Stephen (1829–1904)
Modern Gall. 1904
Graves DICT, RA: Cundall: VAM: Nettlefold

COLLET, John (c. 1725–1780)
Edwards: Redgrave: Bryan: DNB: Binyon: Cundall:
VAM: Williams: Windsor

COLLIER, Thomas (1840–1891)
A. Bury: *T.C.* 1944
Windsor Gall. 1904
FAS 1931
Collectors' Gall. 1920
Graves DICT, RA: Cundall: VAM: Nettlefold

COLLINGWOOD, William (1819–1903)
Graves DICT, RA, BI: Cundall: VAM

COLLINS, Chas. (1700–1744)
Binyon: Williams: Nettlefold: RA 1934: Redgrave

COLLINS, Samuel (*fl.* 1780–1790)
Binyon: Williams: DNB: Redgrave

COLLINS, William (1788–1847)
VAM MSS: *W.C.* List of pictures and patrons 1808–46
VAM MSS: Diary of Mrs. W.C. for 1835
VAM MSS: Journal of Mrs. W.C. 1836
W. Collins: *Memoirs of the life of W.C.* 1848
Redgrave DICT, CENT: DNB: VAM: Cundall: Binyon:
Roget

CONDER, Charles (1868–1909)
F. G. Gibson: *C.C.* 1914
J. Rothenstein: *The Life and Death of C.* 1938
Dutch Gall. 1903
Leicester Gall. 1904, 1905–6, 1913
Paris, Gall. Durrand-Ruel, 1906
Nat. Gall. 1927
Beaux-Arts Gall. 1930, 1932, 1939
Sheffield, Graves Art Gall. 1967
VAM: Cundall

CONSTABLE, John (1776–1837)
VAM MSS: Letters to and from J.C. 1822–51
VAM MSS (typewritten): Correspondence, etc. Compiled
by R. B. Beckett. 15 vol. 1953–6
C. R. Leslie: *Memoirs of J.C.* 1843 & other eds.
Sir C. J. Holmes: *Constable—influence on landscape painting.*
1902
Sir J. D. Linton: *C's sketches.* 1905
Sir J. D. Linton: *C's sketches.* 'Mag. of Fine Arts' II,
1906
M. Hardie: *C's water-colours.* OWS, XII, 1935
R. L. Binyon: *English water-colours . . . Turner, Constable,
etc.* 1939
Hon. A. Shirley: *J.C.* 1944
K. Badt: *J.C.'s clouds.* 1950
A. G. Reynolds: *Cat. of the Constable coll. at the* VAM. 1960
R. S. Ferguson: *An analysis of J.C. drawings selected from
the Henry E. Huntington Library.* 1961

Nettlefold: RA 1934: DNB: Roget: Redgrave DICT, CENT:
Hughes: Cundall: Williams: Binyon: Lemaitre

COOKE, Edward William (1811–1880)
Graves RA, BI: Bryan: Clement and Hutton: Cundall:
DNB: VAM: Hughes: Nettlefold: Redgrave CENT

COOKE, William Bernard (1778–1855)
London, Soho Square 1822 (Drawings)
Redgrave DICT, CENT: Graves DICT: DNB: Binyon:
Hughes: Roget

COOPER, Richard (1740–1814)
Redgrave: Graves RA, SOC. of A: DNB: Cundall: VAM:
Roget

COOPER, Thomas Sidney (1803–1902)
T. S. Cooper: *My Life.* 1890
E. K. Chatterton: *T.S.C.* 1902
Graves DICT, RA, BI: Binyon: DNB: VAM: Cundall:
Hughes: Nettlefold

CORBOULD, Henry (1787–1844)
Redgrave: Graves RA, BI: DNB: Binyon: Hughes

CORBOULD, Richard (1757–1831)
Redgrave: Graves DICT, RA, BI: DNB: Binyon: VAM:
Cundall: Hughes: Williams: Windsor: Roget

COSWAY, Richard (1740–1821)
G. C. Williamson: *R.C.* 1897, 1905
Amateur Art Exhib. 1895
FAS 1898
Cundall: DNB: Cunningham: Redgrave CENT, DICT:
Binyon: Cundall: Williams: Windsor: RA 1934

COTES, Francis (1726–1770)
Walpole *Anec:* Edwards: Redgrave DICT, CENT: DNB:
Williams: VAM: Binyon: Windsor: RA 1934

COTMAN, John Sell (1782–1842)
Masters of English landscape painting. 'Studio' sp. no. 1903
F. Wedmore: *The Norwich School, Cotman and Crome.*
'Mag. of Fine Arts' I, 1906
The water-colours of J.S.C. 'Studio' sp. no. 1923
A. P. Oppé: *Cotman and the Sketching Soc.* 'Connoisseur'
1923
A Batchelor: *Cotman's diary.* 1924
S. C. K. Smith: *Cotman.* 1926
C. F. Bell: *J.S.C.* (the Bulwer coll.) 'Walker's Quart. V'
1926 (VAM copy notes by C. F. Bell)
S. D. Kitson: *J.S.C. letters from Normandy.* Walpole Soc.
XIV, XV, 1926, 1927
S. D. Kitson: *J.S.C.* OWS, VII, 1929–30
F. Rutter: *C. sketches pasted on the back of C. watercolours.*
'Illus. London News' CLXXXIX, 1936
S. D. Kitson: *Life of J.S.C.* 1937
London, RIBA: *Architectural drawings by J.S.C.* 1939 (VAM
copy notes by C. F. Bell)
R. L. Binyon: *English watercolours from the works of
Turner, Cotman, etc.* 1939
A. P. Oppé: *Struggles of a painter, J.S.C.* 'London
Mercury' 1937
R. J. Colman: *The Colman coll.* 1942
Norwich, Castle Museum: *Illus. guide to coll. of Norwich
School pictures.* 1951
V. G. R. Reinacker: *J.S.C. 1782–1842.* 1953
A. P. Oppé: *Cotman and his public.* 'Burlington Mag.'
1942
Burlington Fine Arts Club 1888
Norwich, Norwich Art Circle 1888
Walker's Gall. 1906, 1927
Patterson's Gall. 1913
Nat. Gall. 1922
Cotswold Gall. 1928
Norwich, Castle Mus. 1927
Squire Gall. 1932
Manchester, Whitworth Inst. 1937
Agnews 1958

Binyon: Dickes: Graves DICT, RA, BI: Redgrave DICT,
CENT: Hughes: Roget: Clifford: DNB: RA 1934:
Nettlefold: Lemaitre

COTMAN, Joseph John (1814–1878)
'Sprite', pseud.: *Norwich artist reminiscences.* J.J.C. 1925
A. Batchelor: *Cotman in Normandy.* 1926
VAM: Cundall: Dickes: Clifford: Williams: DNB: Roget

COTMAN, Miles Edmund (1810–1858)
C. F. Bell: *M.E.C.* 'Walker's Quart.' 1927 (VAM copy
has notes by C. F. Bell)

Binyon: Williams: Cundall: VAM: Dickes: Clifford:
DNB: Roget: Redgrave

COVENTRY, Robert M. G. (1855–1914)
Graves RA: Caw: Who's Who 1912: Cundall

COX, David (1783–1859)
Sir T. Cox: *D.C.* Birmingham City Art Gall. n.d.
N. N. Solly: *A memoir of life of D.C.* 1873
F. Wedmore: *D.C.* 'Gent. Mag.' March 1878
W. Hall: *Biog. of D.C.* 1881
G. R. Redgrave: *D.C. and P. De Wint.* 1891
A. J. Finberg: *The drawings of D.C.* 1909
F. G. Roe: *D.C.* 1924
A. P. Oppé: *Water-colours of Turner, Cox, etc.* 1925
B. S. Long: *D.C.* ows, x, 1933
C. A. E. Bunt: *D.C.* 1949
F. G. Roe: *Cox the Master.* 1946
Sir T. Cox: *D.C.* 1947, 1954
　120 Pall Mall 1859
　Burlington Fine Arts Club 1873
　Birmingham Mus. and Art Gall. 1890
　Walker's Gall. 1904, 1905, 1906, 1960
　Swansea, Art. Gall. 1953
Redgrave CENT: DNB: Roget: Hughes: Binyon: Windsor: RA 1934: Nettlefold: Williams: Cundall: VAM: Lemaitre

COX, David, II (1809–1885)
Graves DICT, RA: DNB: Roget: Binyon: VAM: Cundall: Williams

COZENS, Alexander (*c.* 1710–d. 1786)
A Roman sketchbook by A. Cozens. Walpole Soc. XVI, 1928
H. Hardie: *A.C.* 'Collector' November, December 1930
A. P. Oppé: *A. and J. R. Cozens.* 1952 (VAM copy has notes by C. F. Bell)
Fresh light on A.C. 'Print Collectors' Quart.' 1921
A. P. Oppé: *The parentage of A.C.* 'Burlington Mag.' 1919
　Burlington Fine Arts Club 1916
　FAS 1930
　Tate Gall. 1946
　Sheffield, Graves Art Gall. 1946
　Manchester, Whitworth Art Gall. 1956
Edwards: Redgrave DICT, CENT: DNB: Roget: Cundall: Hughes: Williams: VAM: Windsor: RA 1934: Lemaitre

COZENS, John Robert (1752–1797)
F. Gibson: *Alexander and J. R. Cozens.* 'Studio' 1917
C. F. Bell: *J.R.C.* Walpole Soc. XXIII, 1935
VAM MSS (typewritten): *Sketch-books of J.R.C.*, intro. notes and list of contents by C. F. Bell. 1923
A. P. Oppé: *Alexander and J. R. Cozens.* 1952 (VAM copy has add. material by C. F. Bell)
　Burlington Fine Arts Club 1923 (VAM copy has add. material inserted)
　Manchester, Whitworth Art Gall. 1937, 1956
Edwards: Redgrave DICT, CENT: DNB: Roget: Cundall: Graves RA, SOC. of A: Windsor: Hughes: RA 1934: Nettlefold: Lemaitre

CRAIG, William Marshall (*fl* 1788–d. 1828)
R. Edwards: *Queen Charlotte's painter in water-colours.* 'Collector' XI, 1930
Redgrave: Graves DICT, RA, BI: DNB: Binyon: VAM: Cundall: Williams: Windsor: Roget

CRANE, Walter (1845–1915)
VAM: Press cuttings and ms. notes relating to W.C. 1903
P. G. Konody: *The art of W.C.* 1902
W. Crane: *An artist's reminiscences.* 1907
　Whitechapel Fine Art Exhib. 1889–91
　FAS 1891
　Doré Gall. 1902
　Dickinson's Gall. 1903
　Carfax Gall. 1905
　Dowdeswell Gall. 1907
　Leicester Gall. 1912
　Bromhead Cutts Gall. 1920
VAM: Cundall: Huish

CRAWHALL, Joseph (*c.* 1860–1913)
M. Hardie: *J.C.* ows, XXIII, 1945
A. Bury: *J.C.* 1958
　Paterson's Gall. 1912, 1906
　Spink and Son 1948
　Reid Gall. 1961
Caw: Graves RA: VAM: Cundall

CRESWICK, Thomas (1811–1869)
Graves DICT, RA, BI: DNB: VAM: Cundall: Hughes: Nettlefold: Redgrave DICT, CENT

CRISTALL, Joshua (*c.* 1767–1847)
R. Davies: *J.C.* ows, IV, 1926–7
W. G. S. Dyer: *J.C.: Cornish painter.* 1958
W. G. S. Dyer: *J.C.: Pres. of OWS.* Camborne Pub. Lib. 1962
Redgrave DICT, CENT: DNB: Roget: Graves DICT, RA, BI: Binyon: Cundall: Hughes: Williams: RA 1934

CROME, John (1768–1821)
J. Wodderspoon: *J.C.* 1858–76
L. Binyon: *J.C.* 1897 ('Portfolio' no. 32)
L. Binyon: *J.C. and J. S. Cotman.* 1906
C. H. C. Baker: *Crome.* 1921
S. C. K. Smith: *Crome.* 1923
R. H. Mottram: *J.C. of Norwich.* 1931
R. J. Coleman: *The Coleman coll.* 1942
Norwich, Castle Mus.: *Ill. guide to the coll.* 1951
　Prosser's Gall. n.d.
　Ryder Gall. n.d.
　Norwich, Castle Mus. 1921, 1927
　Agnews 1958
Binyon: VAM: Cundall: Williams: Dickes: Clifford: Redgrave DICT, CENT: Roget: DNB: RA 1934: Nettlefold: Lemaitre

CROTCH, William (1775–1847)
Charterhouse School, Surrey: 1964
Binyon: Williams: DNB: Lemaitre

CRUIKSHANK, George (1792–1878)
Hamilton: *Memoir of G.C.* 1878
W. Bates: *G.C.* 1878
W. B. Jerrold: *G.C.* 2 vol. 1882, 1883
Douglas: *Works of G.C.* 1897
Stephens: *G.C.* 1897
J. Grego: *C's Water-colours.* 1904
W. H. Chesson: *G.C.* 1908
A. M. Cohn: *G.C., cat. raisonné of the work . . . 1806–77.*
1924
Binyon: VAM: Cundall: DNB: Roget: Redgrave DICT,
CENT

CRUIKSHANK, Isaac (*c.* 1756–1810)
Hamilton: *Memoir of G. Cruikshank.* 1878
Douglas: *Works of G. Cruikshank.* 1878
Marchmont: *The three Cruikshanks.* 1897
G. Stephens: *G. Cruikshank.* 1897
R. Edwards: *I.C.* 'Burlington Mag.' LII, 1928
E. B. Krumbhar: *I.C., cat. raisonné.* 1966
Binyon: Williams: Cundall: VAM: DNB: Redgrave

CRUIKSHANK, Robert (1789–1856)
Hamilton: *Memoir of G. Cruikshank.* 1878
Douglas: *Works of G. Cruikshank.* 1903
Marchmont: *The three Cruikshanks.* 1897
G. Stephens: *G. Cruikshank.* 1897
Binyon: Williams: Cundall: VAM: DNB: Redgrave

CUITT, George, I
Redgrave: DNB: Bryan: Graves RA: Binyon

CUITT, George, II
Redgrave: DNB: Graves RA

DADD, Richard (1817–1887)
VAM MSS: Walpurgis Night, etc., 19 pen drawings by
R.D. (*c.* 1840)
Graves DICT, RA, BI: Bryan: Binyon: VAM: Cundall

DALL, Nicholas Thomas (*fl.* 1760–*d.* 1777)
Redgrave: DNB: Graves DICT, RA, SOC. of A: Binyon:
Williams

DANBY, Francis (1793–1861)
A. Stokes: *Life of G. Petrie.* 1868
G. Grigson: *Some notes on F.D.* 'The Harp of Aeolus'
1948, and 'Cornhill Mag.' 1946
Arts Council 1961
Redgrave DICT, CENT: Roget: Graves DICT, RA, BI:
Binyon: VAM: Cundall: DNB: Lemaitre

DANBY, Thomas (1818–1886)
Roget: Graves DICT, RA, BI: Bryan: DNB: Binyon: VAM:
Cundall: Nettlefold

DANCE, George (1741–1825)
Redgrave: Graves RA, SOC. of A: DNB: Binyon: Windsor:
RA 1934

DANCE-HOLLAND, Sir Nathaniel (1735–1811)
Binyon: Windsor: Williams: DNB: RA 1934: Redgrave
DICT, CENT

DANIELL, Rev. Edward Thomas (1804–1843)
R. A. I. Palgrave: *12 etchings by E.T.D. and short life.* 1882
F. R. Beecheno: *E.T.D. memoir.* 1889
Norwich Art Circle July 1891
Binyon: Dickes: Graves RA, BI: Clifford: DNB

DANIELL, Samuel (1775–1811)
Binyon: VAM: Williams: Cundall: DNB: Roget: Redgrave

DANIELL, Thomas (1749–1840), and William (1769–
1837)
VAM MSS: 2 letters to T. Pennant. 1796
Sir E. Cotton: *The Daniells in India.* Indian Hist. Rec.
Com. Proceedings XI, 1929
M. Hardie: *T.D.* 'Walker's Quart.' 35 and 36, 1932
A. G. Reynolds: *British artists abroad III: T. and W. D.
in India.* 'Geog. Mag.' XX, 1947
T. Sutton: *The Daniells.* 1954
M. Andrew: *Picturesque India with the Daniells.* 'Con-
noisseur' March 1963
Walker's Gall. 1933, 1961
Commonwealth Institute 1960
Redgrave: DNB: Graves RA, BI, SOC. of A: Roget:
Binyon: VAM: Cundall: Williams: Windsor

DANIELL, William (1769–1837)
Sir E. Cotton: *The Daniells in India.* Indian Hist. Records
Com. Proceedings XI, 1929
M. Hardie and M. Clayton: *T. and W. D.* 'Walker's
Quart.' XXXV, XXXVI, 1932
A. G. Reynolds: *British Artists Abroad III: T. and W. D.
in India.* 'Geog. Mag.' XX, 1947
T. Sutton: *The Daniells.* 1954
Walker's Gall. 1933, 1961
Commonwealth Institute 1960
Redgrave: DNB: Graves RA, SOC. of A, BI: Roget: Nettle-
fold: Lemaitre

DAVIDSON, Charles (1824–1902)
Graves DICT, RA, BI: VAM: Cundall: Hughes

DAVIS, John Scarlett (1804–1844)
Library of the Fine Arts I. 1831
Hereford, Art Gall. and Museum 1937
Hereford, Art Gall and Museum 1950 (typewritten)
Redgrave: Graves DICT, RA, BI: DNB: Binyon: Cundall:
VAM: RA 1934: Hughes

DAVIS, Samuel (*c.* 1757–*fl.* 1809)
VAM: Williams

DAWSON, Nelson (1859–1941)
'Studio' Sp. nos. 1898, 1901
 Royal Arcade Gall. 1890
 Leicester Gall. 1911
Graves DICT, RA

DAY, William (1763–1804)
Williams

DAYES, Edward (1763–1804)
VAM MSS: 4 documents including a work diary, 1798–
 1811
 J. Dayes: *E.D.* OWS, XXXIX
 Cotswold Gall. 1926
Edwards: Redgrave DICT, CENT: DNB: Graves DICT, RA,
 SOC. of A: Williamson: Roget: Cundall: Binyon:
 VAM: Hughes: Windsor: Nettlefold: RA 1934:
 Lemaitre

DEANE, William Wood (1825–1873)
Redgrave: Graves DICT, RA, BI: Roget: Cundall:
 Binyon: Williams: Hughes: VAM: Nettlefold: DNB

de CORT, Hendrik (1742–1810)
Binyon: Williams: Windsor: DNB: Redgrave DICT, CENT

DELAMOTTE, William (1775–1863)
Binyon: VAM: Williams: Windsor: Cundall: DNB:
 Roget: Redgrave: Hughes

DENHAM, John Charles (*fl.* 1800–1840)
Roget: Graves RA: Roget

DENNING, Stephen Poyntz (1795–1864)
Redgrave: Bryan: Graves DICT, RA, BI: Binyon:
 Cundall: Roget

DEVIS, Anthony (1729–1817)
S. H. Pavière: *The Devis family of painters.* 1950
Preston, Harris Mus. and Art Gall: *Drawings by A.D.*
 1956
 Preston, Harris Mus. and Art. Gall. 1937
Edwards: Redgrave: Bryan: Graves SOC. of A, RA:
 Binyon: Williams

DEVIS, Arthur (*c.* 1711–1787)
S. H. Pavière: *The Devis family of painters.* 1950
Preston, Harris Mus. and Art Gall. 1937
Edwards: Redgrave: Graves SOC. of A: Bryan

DEVIS, Arthur William (1763–1832)
S. H. Pavière: *The Devis family of painters.* 1950
Preston, Harris Mus. and Art Gall. 1937
Redgrave: DNB: Windsor: Graves RA, BI, SOC. of A:
 Cundall: Binyon

DE WILDE, Samuel (1748–1832)
Binyon: VAM: Williams: Cundall: DNB: Windsor:
 Redgrave

DE WINT, Peter (1784–1849)
W. Armstrong: *Memoir of P. De W.* 1888
G. R. Redgrave: *David Cox and P. De W.* 1891
A. De Wint: *A short memoir of P. De W.* 1900
'Studio' Sp. no.: *P. De W.* 1903 (VAM copy with notes
 by C. F. Bell) 1917, 1919, 1922
M. Hardie: *A woody landscape by P. De W.* 1908
A. P. Oppé: *The water-colours of Turner, Cox and De W.*
 1925
M. Hardie: *P. De W.* 1929
VAM: *Picture book of P. De W.* 1929
R. Davies: *P. De W.* OWS, I, 1923–4
A. G. Fell: *P. De W.* 'Connoisseur' XCIII, 1934
Lincoln, Usher Art Gall.: *Cat. of P. De W. coll.* 1942,
 1947
C. G. E. Bunt: *P. De W. and the peaceful scene.* 1948
 Burlington F. A. Club 1873
 Vokins Gall. 1884
 Cotswold Gall. 1928
 Squire Gall. 1932
 Lincoln, Usher Art Gall. 1937
 Palser Gall. 1937
 Agnews 1966
DNB: Roget: Redgrave DICT, CENT: Hughes: RA 1934:
 Nettlefold: Bryan: Graves RA, BI: Cundall: Williams:
 Binyon: Lemaitre

DIBDIN, Thomas Colman (1810–1893)
 Portland Gall. 1850
Graves RA, BI: Hughes: Cundall: VAM: Binyon

DIGHTON, Robert (1752–1814)
L. Fagan: *Collectors' Marks*
Redgrave: DNB: Graves RA, SOC. of A: Williamson:
 Williams: VAM: Binyon: Cundall: Windsor: RA 1934

DITCHFIELD, Arthur (1842–1888)
Binyon: Cundall

DIXON, Robert (1780–1815)
VAM: Williams: Cundall: Clifford: Dickes: Redgrave

DODGSON, George Haydock (1811–1880)
Roget: Graves DICT, RA, BI: Bryan: Cundall: DNB:
 VAM: Nettlefold

DONOWELL, John (*fl.* 1755–1786)
Redgrave: Graves RA, SOC. of A: Williams

DORRELL, Edmund (1778–1857)
VAM: Williams: Cundall: Roget: Redgrave

DOUGLAS, Sir William Fettes (1822–1891)
J. M. Gray: *8 photogravures. Works of W.F.D.* 1885
Graves DICT, RA, BI: Cundall: Caw: Clement and Hutton:
 VAM: DNB

DOWNMAN, John (1750–1824)
VAM MSS (typewritten): *Cat. of miniatures and D. drawings at Chequers.* 1921
J.D.: *48 original first sketches of portraits.* 1894
G. Pyecroft: *Art in Devonshire.* 1883
G. C. Williamson: *J.D.* 'Connoisseur' 1907
FAS 1895, 1898
Bryan: DNB9 Sandby: Graves RA, SOC. of A, BI: Redgrave: Binyon: VAM: Cundall: Williams: Windsor: RA 1934: Lemaitre

DOYLE, Richard (1824–1883)
Binyon: Cundall: DNB: Redgrave CENT

DUNCAN, Edward (1803–1882)
R. Davies: OWS, VI, 1928
F. L. Emanuel: 'Walker's Quart.' XIII, 1923
Bryan: Roget: Prideaux: Graves RA, BI: Binyon: VAM: Cundall: Nettlefold: DNB: Redgrave CENT

DUNSTALL, John (*c.* 1693)
Williams: BM I

DUNTHORNE, John (1770–1844)
Leslie: *Life of Constable.* 1843
DNB: Graves RA, BI: Williams

DUPONT, Gainsborough
Edwards: Redgrave: Bryan: DNB

EARLE, Augustus (Worked about 1806–1838)
Binyon: Windsor: Redgrave

EAST, Sir Alfred, RA (1849–1913)
Sir A.E.: *Brush and pencil notes in landscape.* 1914
Leicester Gall. 1912, 1914
FAS 1888, 1890
Dowdeswell Gall. 1905
Newcastle-upon-Tyne, Laing Art Gall. 1914
Who's Who 1913: Cundall: VAM

EDRIDGE, Henry, RA (1769–1821)
VAM MSS (typewritten): Letters to Dr. T. Monro from H.E. 1808–21
Squire Gall. 1932
Redgrave DICT, CENT: Roget: DNB: Williams: Cundall: Windsor: RA 1934: Hughes: Lemaitre

EDWARDS, Edward, ARA (1738–1806)
Redgrave DICT, CENT: DNB: Rees: Bryan: Graves DICT, RA, SOC. of A, BI: Williams: Binyon: VAM: Cundall

EDWARDS, George (1694–1773)
Redgrave: DNB: Rees: Cundall: Williams

EDWARDS, Sydenham Teak (1768–1819)
Binyon: VAM: Cundall: Williams: DNB: Redgrave

EHRET, Georg Dionysius (1708–1770)
Williams: DNB: Redgrave

ELGOOD, George S. (1851–1943)
FAS 1891, 1904, 1893

ELMORE, Alfred (1815–1881)
Bryan: Graves DICT: Strickland: Sandby: Redgrave CENT

EMES, John (Worked about 1785–1805)
Binyon: Williams: VAM: DNB: Redgrave

ENGLEHEART, George (1752–1839)
DNB: Cundall: Redgrave

ETTY, William (1787–1849)
W. C. Monkhouse: *Pictures by W.E.* 1874
A. Gilchrist: *Life of W.E.* 1855
W. Gaunt: *E. and the nude.* 1943
D. Farr: *W.E.* 1958
DNB: Graves DICT, RA, BI, CENT: RA 1934: Redgrave CENT

EVANS, William (of Bristol) (1809–1858)
Ottley: Redgrave: Roget: Graves DICT: Rees: Cundall: Binyon: DNB

EVANS, William (of Eton) (?1797–1877)
A. Bury: *W.E. of Eton.* 'Connoisseur' CXII, 1943
Redgrave: Roget: Graves DICT: Rees: Cundall: DNB: Hughes

FARINGTON, Joseph (1747–1821)
Dictator of the R.A. 'Walker's Quart.' V, 1921
The F. diary ed. J. Greig. 8 vol. 1922–8
F. Rutter: *Wilson and F.* 1923
Walker's Gall. 1922
DNB: Sandby: Redgrave DICT, CENT: Cundall: Williams: Windsor: Roget

FARNBOROUGH, Amelia Long, Lady (1762–1837)
Roget: Graves RA: DNB: Binyon: VAM Supp.: Williams

FEARNSIDE, W. (*fl.* 1791–1801)
Graves RA: VAM

FIELDING, Copley (1787–1855)
S. C. K. Smith: *C.F.* OWS, III, 1925
Vokins Gall. 1886
Prosser's Gall. n.d.
Redgrave DICT, CENT: Roget: Graves DICT, LOAN: Cundall: Binyon: Williams: DNB: Nettlefold: RA 1934: Hughes

FINCH, Francis Oliver (1802–1862)
Mrs. E. Finch: *Memorials of the late F.O.F.* 1865
R. Lister: *Edward Calvert.* Append. III, 1962
Roget: DNB: Graves DICT: Redgrave: Cundall: Binyon: VAM: Williams: Redgrave CENT: Hughes

FISHER, John (Bishop) (1748–1825)
Williams: Windsor: DNB

FISHER, John George Paul (1786–1875)
Binyon: Cundall: DNB

FISHER, Sir George Bulteel (1764–1834)
Graves RA: VAM: Williams

FISHER, William Mark (1841–1923)
VAM MSS: Letters to H. M. Cundall from M.F. with
biog. inform. 1878
V. Lines: *M.F. and Margaret Fisher Prout.* 1966
Beaux-Arts Gall. 1938
Royal Soc. Ptrs. in Water-colours. 1966
VAM: Nettlefold

FLAXMAN, John (1755–1826)
Twenty-five drawings by J.F. 1863
The drawings of J.F. in Univ. Coll. Gall. 1876
The classical compositions of J.F. 1879
RA 1881
Cotswold Gall. 1923
Cunningham: DNB: Binyon: Williams: VAM: RA 1934:
Redgrave DICT, CENT

FORREST, Thomas Theodosius (1728–1784)
Gentleman's Mag. 1784
Redgrave: DNB: Graves RA, SOC. of A: VAM Supp.:
Williams

FOSTER, Myles Birket (1825–1899)
H. M. Cundall: *B.F.* 1906
L. Glasson: *B.F.* OWS, XI, 1933
Vokins Gall. 1882, 1888
Dowdeswell Gall. 1889
Tooth Gall. 1898
Leicester Gall. 1909
Newcastle-on-Tyne, Laing Art Gall. 1925
Graves DICT: DNB: Bryan: Cundall: VAM: Nettlefold:
Hughes

FRANCIA, François Louis Thomas (1772–1839)
E. Le Beau: *Notice sur F.* 'Mem. de la Soc. d'Agriculture
Calais' n.d.
Roget: DNB: Cundall: Gaz. des Beaux Arts 1912:
Williams: Binyon: VAM: Nettlefold: RA 1934: Red-
grave DICT, CENT: Hughes: Lemaitre

FRIPP, Alfred Downing (1822–1895)
H. S. Thompson: *G.A. and A.D.F.* 'Walker's Quart.'
XXV, XXVI, 1928
Roget: Graves DICT, RA: Cundall: VAM

FRIPP, George Arthur (1813–1896)
H. S. Thompson: *G.A. and A.D.F.* 'Walker's Quart'
XXV, XXVI, 1928
Roget: Graves DICT, RA: Cundall: DNB: Hughes

FROST, George (1754–1821)
Binyon: Williams: DNB: Redgrave

FUGE, James (d. 1838)
Cundall: Graves DICT, BI

FUSELI, Henry (1741–1825)
H.F.: *Lectures on painting.* 1801 and other editions
J. Knowles: *Life and writings of H.F.* 1831
J. Timbs: *Anecdote biography.* 1862
P. Ganz: *The drawings of H.F.* 1949
N. Powell: *The drawings of H.F.* 1951
F. Antal: *F. studies.* 1956
Auckland City Art Gall.: *A coll. of drawings by H.F.* 1967
Zurich, Kunsthaus 1926
Arts Council 1950
Washington, Smithsonian Inst. 1954
DNB: Cundall: Binyon: Williams: VAM: RA 1934:
Redgrave DICT, CENT: Lemaitre

GAINSBOROUGH, Thomas (1727–1788)
P. Thicknesse: *A sketch of the life and paintings of T.G.* 1788
A catalogue of the pictures and drawings of the late Mr. G. 1789
Lord Leveson Gower: *The drawings of T.G.* 1907
W. T. Whitley: *T.G.* 1915
Sir C. J. Holmes: *Constable, G., and Lucas.* 1921
M. Woodall: *G.'s landscape drawings.* 1939
M. Woodall: *T.G.* 1949
O. Millar: *T.G.* 1949
B. Taylor: *Gainsborough.* 1951
E. K. Waterhouse: *Gainsborough.* 1958
Prosser's Gall. n.d.
Grosvenor Gall. 1885
Ipswich Mus. 1927
Bath, Victoria Art Gall. 1951
Arts Council 1953, 1960
DNB: Edwards: Sandby: Redgrave DICT, CENT: Roget:
Hughes: Windsor: Binyon: Nettlefold: RA 1934:
Lemaitre

GASTINEAU, Henry (c. 1791–1876)
Redgrave: DNB: Roget: Graves DICT, RA, BI: Cundall:
VAM: Nettlefold: Hughes

GAYWOOD, Richard (Worked 1650–1680)
Binyon: DNB: Redgrave

GENDALL, John (1790–1865)
G. Pyecroft: *Art in Devonshire.* 1883
Graves RA, BI, LOAN: Redgrave: Binyon: Prideaux:
Cundall: VAM: DNB

GESSNER, Johann Conrad (1764–1826)
Graves RA: VAM: Cundall: Redgrave

GIBSON, Patrick (b. about 1782, d. 1829)
Binyon: Williams: DNB: Redgrave

303

GILBERT, Sir John, RA (1817–1897)
VAM copy of C. R. Leslie's *Constable* 1845 has notes by Sir J.G.
R. Davies: *Sir J.G.* ows, x
R. Soc. Ptrs. in Water-colour 1898
Binyon: DNB: Graves RA, BI, LOAN: Roget: Cundall: VAM: Nettlefold

GILLIES, Margaret (1803–1887)
Graves DICT, RA, BI, LOAN: Clayton: Roget: Cundall: Binyon: VAM: DNB

GILLRAY, J. (1757–1818)
T. Wright: *The caricatures of J.G.* 1851
T. Wright: *The works of J.G.* 1873
D. Hill: *Mr. Gillray, a biog.* 1965
D. Hill: *Fashionable contrasts: Caric. by J.G.* 1966
DNB: Everitt, Eng. caricaturists 1886: Binyon: VAM: Cundall: Williams: Redgrave

GILPIN, Sawrey (1733–1807)
Redgrave DICT, CENT: Graves RA: DNB: Roget: Binyon: Cundall: VAM: Williams: Windsor

GILPIN, Rev. William (1724–1804)
VAM MSS: A fragment, containing a description of the Thames . . . 37 sketches by S.G. 1764
W.G.: *Two essays . . . on the author's mode of executing rough sketches.* 1804
W. H. Grove.: *Memoir of W.G.* 1851
I. A. Williams: *The artists of the G. Family.* ows, xxix
Kenwood 1959
Walpole: Redgrave DICT, CENT: DNB: Roget: Prideaux: Cundall: VAM: Binyon

GILPIN, William Sawrey (1762–1843)
Redgrave DICT, CENT: DNB: Graves RA: Roget: Cundall: VAM: Hughes

GIRTIN, Thomas (1775–1802)
R. L. Binyon: *T.G.* 1900
M. Hardie: *The technical aspect.* ows, xi, 1933
A sketch book of T.G. Walpole Soc. xxxvii, 1938
R. L. Binyon: *English water-colours from the work of Turner, Girtin, etc.* 1939
R. Davies: *T.G.'s water-colours.* 1924 (VAM copy has notes by C. F. Bell)
J. Mayne: *T.G.* 1949
T. Girtin and D. Loshak: *The art of T.G.* 1954
FAS 1875
Leicester Gall. 1912
Cotswold Gall. 1926, 1928
Squire Gall. 1932
Agnews 1953
Dayes: Edwards: Redgrave DICT, CENT: Roget: Graves RA, LOAN: Cundall: Prideaux: VAM: Binyon: Williams: Windsor: DNB: Nettlefold: RA 1934: Hughes: Lemaitre

GLOVER, John (1767–1849)
VAM MSS: Drawings by J.G. belonging to A. Winfield, n.d.
B. S. Long: *J.G.* 'Walker's Quart.' xv, 1924
Roget: DNB: Redgrave CENT. DICT: Graves DICT, RA, BI, LOAN: Binyon: Cundall: VAM: Williams: Nettlefold: RA 1934: Hughes

GOODALL, Edward Angelo (1819–1908)
Graves DICT, RA, BI: Clement and Hutton: Cundall: VAM: Roget: Huish

GOODALL, Frederick, RA (1822–1904)
Reminiscences of F.G. 1902
FAS 1894
Graves DICT, RA, BI, LOAN: DNB: Sandby: Binyon: Cundall: VAM: Roget

GOODALL, Walter (1830–1889)
Rustic figures from drawings exhib. ows, 1855–7
Graves DICT, RA, LOAN: DNB: Roget: Cundall

GOODEN, James Chisholm (d. after 1875)
Graves RA, BI: Roget: VAM

GOODWIN, Albert (1845–1932)
The Diary of A.G. 1934
FAS 1886
Rembrandt Gall. 1902, 1904
Leggat Gall. 1919, 1922
Collectors' Gall. 1920
Vicars' Gall. 1925
Birmingham, Museum and Art Gall. 1926
Walker's Gall. 1961
Albany Gall. 1967
DNB: Bryan: Redgrave: Graves RA, BI, LOAN: Caw: VAM: Nettlefold

GORDON, Sir John Watson (1788–1864)
Redgrave DICT, CENT: DNB: Bryan: Graves RA, BI, LOAN: Caw: RA 1934

GORE, Charles (1729–1807)
Walpole Soc. xxii., 1934
Redgrave: Binyon: Graves LOAN: Williams: Roget

GOUPY, Joseph (d. 1763)
Documents relating to an action . . . against J.G. Walpole Soc. ix, 1921
Walpole *Anec.*: DNB: Graves SOC. of A: Cundall: Binyon: Redgrave DICT, CENT

GRAVATT, Col. W. (Worked about 1790)
Binyon: Williams

GRAVELOT, Hubert F. B. (1699–1773)
Binyon: Williams: Windsor: DNB: Redgrave DICT, CENT

GREEN, Amos (1735–1807)
Binyon: Cundall: VAM: Williams: DNB: Redgrave

GREEN, Benjamin (*c.* 1736–*c.* 1800)
Binyon: DNB: Redgrave

GREEN, Charles (1840–1898)
FAS 1898
Bryan: Graves RA, DICT: Cundall

GREEN, Harriet (born Lister) (Working 1784)
Williams: VAM Supp. (Lister)

GREEN, H. Townely (1836–1899)
Graves DICT, RA: Cundall: VAM

GREEN, James (1771–1834)
Strickland: Cundall: Williams: Graves RA, BI: DNB:
Redgrave

GREEN, William (1760–1823)
Binyon: Cundall: Williams: DNB: Redgrave

GREENAWAY, Kate (1846–1901)
M. H. Spielmann: *K.G.* 1905
A. C. Moore: *A century of K.G.* 1946
FAS 1891, 1894, 1898, 1902
Bryan: Graves RA: Cundall: VAM

GRESSE, John Alexander (1741–1794)
Edwards: Redgrave DICT, CENT: Roget: Graves SOC. of A:
Binyon: Cundall: VAM: Williams: Windsor: DNB

GRIFFITH, Moses (1747–1819)
'Country Life' July 2, 1938
'Walker's Monthly' August, September 1938
T. Pennant: *The life of Thomas Pennant.* 1793
Walker's Gall. 1939 (VAM copy has notes by C. F. Bell)
Redgrave: DNB: Rees: Binyon: Cundall: VAM:
Williams

GRIMM, Samuel Hieronymous (1733–1794)
H. Wellesley: *Cat. of drawings by S.H.G.* 1850
Rotha M. Clay: *S.H.G.* 1941
Squire Gall. 1932
Redgrave: Graves SOC. of A, RA: Binyon: Cundall:
VAM: Williams: Windsor: DNB: Nettlefold

GROSE, Francis (*c.* 1731–1791)
DNB: Binyon: Williams: Windsor: Redgrave

HADLEY, J. (*fl.* 1729–1758)
'Mag. of Art.' II, 1904

HAGHE, Louis (1806–1885)
DNB: Cundall: Binyon: Graves DICT, BI: VAM: RA 1934:
Redgrave CENT: Hughes

HALE, William Matthew (1837–1929)
W. M. Hale: *The family of Hale.* 1936
Graves RA, DICT: VAM Supp.: Huish

HAMILTON, William (1751–1801)
DNB: Edwards: Redgrave DICT, CENT: Sandby: Graves
RA, LOAN: Binyon: VAM: Williams: Nettlefold: Roget

HARDEN, John (1772–1847)
Binyon: Williams: Windsor

HARDIE, Charles Martin (1858–1917)
Caw: Graves RA

HARDING, James Duffield (1797–1863)
C. Skilton: *J.D.H.* OWS, XXXVIII, 1963
Roget: Graves DICT, RA, BI, LOAN: DNB: Redgrave
DICT, CENT: Ottley: Cundall: Binyon: VAM: Nettle-
fold: Hughes: Lemaitre

HARDWICK, John Jessop (1832–1917)
Graves DICT, RA, BI: Nettlefold

HARDY, Thomas Bush (1842–1897)
Richardson Gall. 1901
Bryan: Graves DICT, RA: Binyon: VAM: Cundall:
Nettlefold

HARGITT, Edward (1835–1895)
Graves DICT, RA, BI, LOAN: Ottley: Cundall: VAM

HARLOW, George Henry (1787–1819)
Binyon: VAM: DNB: Redgrave DICT, CENT

HARVEY, Thomas (1748–1820)
Dickes: Binyon: Williams: Clifford

HARVEY, William (1796–1866)
Binyon: DNB: Redgrave

HASSEL, John (1767–1825)
Redgrave: DNB: Prideaux: Graves DICT, RA: Binyon

HAVELL, William (1782–1857)
A. Bury: *W.H.* OWS, XXVI
'Connoisseur' December 1949
Walker's Gall. 1906
Redgrave DICT, CENT: Roget: Prideaux: Graves DICT,
RA, BI, LOAN: Cundall: Binyon: VAM: Williams:
Windsor: DNB: Nettlefold: RA 1934: Hughes

HAY, T. Marjoribanks (1862–1921)
Caw: Graves DICT, RA

HAYES, Claude (1852–1922)
'Studio' XXXIII
E. P. Reynolds: *C.H.* 'Walker's Quart.' 7
Dowdeswell Gall. n.d.
FAS 1896
Woodbury Gall. 1901
Stafford Gall. 1912
Walker's Gall. various dates
Graves DICT, RA: VAM

HAYES, Edwin (1820–1904)
VAM MSS: 47 letters to H. M. Cundall, 1850–1912
Dowdeswell Gall. 1894
Graves DICT, RA, BI, LOAN: Strickland: VAM: Nettlefold

HAYES, Frederick William (1848–1918)
C. R. Grundy: *F.W.H.* 1922
Sutherland Public Art Gall. 1922
Graves DICT, RA: VAM

HAYMAN, Francis (1708–1776)
Kenwood 1960
Binyon: Williams: DNB: RA 1934: Redgrave DICT, CENT

HAYTER, Sir George (1792–1871)
Binyon: Cundall: DNB: Redgrave

HAYWARD, John Samuel (*fl.* 1805–1812)
VAM MSS: P. S. Munn letter to J.S.H. 1803
VAM MSS: Notes on J.S.H.'s connection with Drawing
Soc. *c.* 1855
VAM MSS: Extracts from H.'s journal of a journey to
Italy *c.* 1855
VAM. MSS. J. H. Barnes: *The artistic life of J.S.H.* 1922
Redgrave: Graves DICT, RA: Roget: Williams

HEAPHY, Thomas (1775–1835)
Roget: VAM: Redgrave DICT, CENT

HEAPHY, Thomas Frank (1813–1873)
H. Hubbard: *T.H.* ows, xxvi, 1948

DNB: Redgrave: Graves DICT, RA, LOAN, BI: Binyon:
Roget

HEARNE, Thomas (1744–1817)
'Art Journal' 1907
Redgrave DICT, CENT: DNB: Roget: Hughes: Finberg's
Turner: Graves RA, SOC. of A, LOAN: Binyon:
Cundall: VAM: Williams: Windsor: Nettlefold: RA
1934: Lemaitre

HEATH, William (1795–1840)
Binyon: VAM: Cundall: Redgrave

HENDERSON, Charles Cooper (1803–1877)
VAM

HENDERSON, John (1764–1843)
Binyon: VAM: Roget: Hughes

HERIOT, George (1766–1844)
J. C. A. Heriot: *G.H.* 'Americana' v, 1910

DNB: Binyon: Prideaux: Graves RA: VAM: Williams

HILLS, Robert (1769–1844)
'Walker's Quart.' III, 1923
'Burlington Mag.' February 1945
ows, xxv, 1947
'Connoisseur' CL, 1962

Redgrave CENT, DICT: Roget: DNB: Cundall: Graves
DICT, RA, BI: Binyon: Cundall: VAM: Williams:
Windsor: Hughes

HINE, Henry George (1811–1895)
Leicester Gall. 1905
FAS 1930
DNB: Bryan: Cundall: Graves DICT, RA, LOAN: Binyon:
VAM: Nettlefold

HOARE, Sir Richard Colt (1758–1838)
Journal of a tour in Ireland. 1807
Recollections abroad during 1785–1791. 1815–18

Redgrave: Binyon: DNB: Roget

HODGES, William, RA (1744–1797)
Sir W. Foster: *William Hodges in India.* 1925
A. G. Reynolds: *British artists abroad, I: Capt. Cook's
draughtsmen.* 'Geog. Mag.' XIX, 1947

Edwards: Sandby: Redgrave DICT, CENT: DNB:
Williamson: Prideaux: Graves RA, SOC. of A, LOAN:
Cundall: Binyon: Williams

HOGARTH, William (1697–1764)
J. Nichols: *The genuine works of W.H.* 1808–10
A. Dobson: *W.H.* 1891 and subsequent eds.
J. Burke: *H. and Reynolds.* 1943
M. Ayrton: *H.'s drawings.* 1948
A. P. Oppé: *The drawings of W.H.* 1948
R. B. Beckett: *W.H.* 1949

Walpole: Redgrave DICT, CENT: Graves SOC. of A, LOAN:
Binyon: Williams: Cundall: Windsor: DNB: RA 1934:
Hughes

HOLLAND, James (1800–1870)
H. Stokes: *J.H.* 'Walker's Quart.' XXIII, 1927
R. Davies: *J.H.* ows, VII, 1930
M. Tonkin: *The life of J.H.* ows, XLII, 1967
'Studio' Sp. no. 1915
Warren Gall. 1928

Redgrave DICT, CENT: DNB: Roget: Graves DICT, RA, BI,
LOAN: Binyon: VAM: Cundall: RA 1934: Hughes:
Nettlefold: Lemaitre

HOLLAR, Wenceslaus (1607–1677)
F. Sprinzels: *Hollar: Handzeichnungen.* 1938
J. Urzidil: *Hollar.* 1942
Prague Narodní Gall. 1959
Manchester City Art Gall. 1963

Binyon: Cundall: Williams: Windsor: DNB: BM I:
Redgrave: Lemaitre

HOLLOWAY, Charles Edward (1838–1897)
Goupil Gall. 1897

Bryan: Graves DICT, RA, LOAN: Cundall: VAM

HOLMES, James (1777–1860)
A. T. Storey: *J. H. and John Varley.* 1894

Redgrave DICT, CENT: Roget: Williamson: Graves DICT,
RA, BI, LOAN: Cundall: DNB: Hughes

HOLWORTHY, James (1781–1841)
VAM MSS: Soc. of Painters in Water-colours. Coll. of papers including items addressed to J.H. 1808–21

Redgrave DICT, CENT: Roget: Graves DICT, RA: VAM: Cundall: Williams: DNB: Hughes

HOPPNER, John (1759–1810)
DNB: Binyon: VAM: Williams: Windsor: Redgrave DICT, CENT: Hughes

HOUGH, William (*fl.* 1857–1894)
Graves DICT, RA, BI: Cundall: VAM

HOUGHTON, Arthur Boyd (1836–1875)
L. Housman: *A.B.H.: selec. of work.* 1896

Roget: Graves DICT, RA, BI, LOAN: Binyon: Cundall: VAM: DNB: Redgrave

HOWITT, Samuel (*c.* 1765–1822)
Hewitt family: *The pedigree of Hewitt or Howitt of London.* 1959

DNB: Redgrave: Prideaux: Graves DICT, RA, SOC. OF A, LOAN: Cundall: Binyon: VAM: Windsor

HUNT, Alfred William (1830–1896)
V. Hunt: *A.W.H.* OWS, 11, 1925

FAS 1884
Burlington Fine Arts Club 1897

Graves DICT, RA, LOAN: Cundall: VAM: Nettlefold

HUNT, Cecil A. (1873–1965)
A. Bury: *C.A.H.* OWS, XXXVIII, 1963

FAS 1919, 1934
Ryder Gall. 1907
Agnews 1938
Colnaghi 1945

Who's Who: VAM

HUNT, William Henry (1790–1864)
'Fraser's Mag.' October 1865
J. Ruskin: *Notes on S. Prout and W.H.H.* 1879
F. G. Stephens: *W.H.H.* OWS, XII, 1936

Cotswold Gall. 1927
Norwich Castle Museum (Cyril Fry coll. of W.H.H.'s water-colours) 1967

Redgrave DICT, CENT: DNB: Roget: Cundall: Graves DICT, RA, BI, LOAN: Binyon: VAM: Hughes: Nettlefold

HUNT, William Holman, OM (1827–1910)
A memoir of W.H.H.'s life. 1860
F. W. Farrar: *W.H.H.* 1893
H. W. Shrewsbury: *Brothers in art: Studies in W.H.H. and J. E. Millais.* 1920
A. C. Gissing: *W.H.H.* 1936
W.H.H.: Some contemporary notices. OWS, XIII, 1936

FAS 1886
Leicester Gall. 1906
Manchester, City Art Gall. 1906
Glasgow, Corporation Gall. 1907

Graves RA, BI, LOAN: DNB: VAM: Roget: Hughes

HUNTER, Colin, ARA (1841–1904)
DNB: Caw: Graves DICT, RA, LOAN: Cundall: Nettlefold

HUTCHISON, R. Gemmel (1855–1936)
Caw: Graves DICT, RA, LOAN: Who's Who 1924

IBBETSON, Julius Caesar (1759–1817)
B. L. K. Henderson: *Morland and Ibbetson.* 1923
Rotha M. Clay: *J.C.I.* 1948
'Gentleman's Mag.' 1817

Tooth Gall. 1939
Kenwood 1957

Graves RA, BI, LOAN: Binyon: VAM: Cundall: Williams: DNB: RA 1934: Roget: Redgrave DICT, CENT: Nettlefold

INCE, Joseph Murray (1806–1859)
Redgrave: Bryan: Graves DICT: DNB: VAM: Cundall: Binyon: Williams

INGRAM, William Ayerst (1855–1913)
Dowdeswell Gall. 1911, 1914
Goupil Gall. 1886
FAS 1888, 1902

Graves DICT: Who's Who 1914: VAM

JACKSON, Samuel (1794–1869)
DNB: Redgrave: Roget: Graves DICT: Cundall: VAM: Hughes

JACKSON, Samuel Phillips (1830–1904)
DNB: Graves: VAM: Cundall: Roget: Nettlefold

JOHNSON, Charles Edward (1832–1913)
VAM: Sale Cat. 1927, December 12–13 at Sheen, of water-colours by C.E.J. (with prices)
Graves DICT: Who's Who 1913

JOHNSON, Harry John (1826–1884)
Graves DICT: Cundall: Binyon: VAM: DNB: Roget: Nettlefold

JONES, Inigo (1573–1652)
J. P. Collier: *I.J. remarks on his sketches for masques, etc.* 1848
S. C. Ramsey: *I.J.* 1924
J. A. Gotch: *I.J.* 1928
C. F. Bell and P. Simpson: *Designs by I.J. for masques, etc.* Walpole Soc. XII, 1924
P. Fraser and J. A. Harris: *Cat. of drawings by I.J.* RIBA (typescript in VAM)
Washington, Nat. Gall. of Art 1967

Walpole *Anec.*: Binyon: Williams: Windsor: DNB: BM I: RA 1934: Redgrave: Lemaitre

JOY, John Cantiloe (1806–1866); William (1803–1867)
DNB: Graves DICT: Norwich Castle Mus. Cat. 1909:
VAM: Binyon: Cundall: Clifford: Redgrave: Hughes

JUKES, Francis (1745–1812)
Redgrave: DNB

KAUFFMANN, Angelica (1741–1807)
Lady V. Manners: *A.K.* 1924
A. Hartcup: *Angelica: portrait of an 18th c. artist.* 1954
Budapest, Hungarian Mus. of Fine Arts 1909
Kenwood 1955
Clayton: Graves RA, SOC. of A, LOAN: Binyon: Cundall:
Williams: VAM: Windsor: DNB: Redgrave DICT, CENT:
Nettlefold

KAY, John (1742–1826)
DNB: Redgrave: Caw: Cundall

KEATE, George (1729–1797)
DNB: Graves DICT, SOC. of A: Binyon: Cundall: VAM:
Redgrave

KEENE, Charles Samuel (1823–1891)
G. S. Layard: *The life and letters of C.S.K.* 1892, 1893
The work of C.K. 1897
Sir L. Lindsay: *C.K.* 1934
F. L. Emanuel: *C.K.* 1935
D. Hudson: *C.K.* 1947
Burlington F. A. Club n.d.
FAS 1891
Dutch Gall. 1903
Museums Gall. 1923
Arts Council 1952
Leicester Gall. 1966
DNB: Cundall: Graves DICT: Binyon: RA 1934

KENT, William (1684–1748)
J. Hardy: *Some designs of Mr. Inigo Jones and Mr. W.K.*
1744
B. S. Long: *Some drawings by W.K.* 'Connoisseur'
LXXVIII, 1927
M. Jourdain: *The work of W.K.* 1948
Redgrave: DNB: Cunningham: Binyon: Williams

KIRBY, John Joshua (1716–1774)
Binyon: Cundall: Williams: DNB: Roget: Redgrave

KNELLER, Sir Godfrey (1646–1723)
H. G. Collins Baker: *Lely and Kneller.* 1922
Lord Killanin: *Sir G.K. and his time, 1646–1723.* 1948
Binyon: Windsor: DNB: RA 1934: Redgrave DICT, CENT

KNIGHT, John Baverstock (1785–1859)
Rev. F. Knight: *Biog. of J.B.K.* 1908
Rev. F. Knight: *J.B.K.* 1925 (Dorset Year Book XXI)
D. S. MacColl: *J.B.K.* 'Burlington Mag.' May 1919
Graves DICT, RA: DNB: VAM: Binyon: Williams

LACAVE, Peter (*fl.* 1794–1810)
B. S. Long: *John Laporte and P. LaC.* 'Walker's Quart.'
VIII, 1922
Redgrave DICT, CENT: Graves RA: Cundall: VAM:
Williams

LADBROOKE, John Berney (1803–1879)
Graves DICT, RA, BI: DNB: Dickes: Clifford

LADBROOKE, Robert (1768–1842)
Graves DICT, RA, BI: Dickes: Cundall: Williams: DNB:
Clifford: Redgrave

LAING, James G. (1852–1915)
FAS 1910
Caw: Graves DICT, RA: RA Cat. 1909, 1914

LAMBERT, George (1710–1765)
DNB: Redgrave DICT, CENT: Walpole: Graves LOAN:
Cundall: Williams

LANDSEER, Sir Edwin H. (1802–1873)
VAM MSS: Various correspondence, *c.* 1820–1919, and C.
S. Maun, *The works of Sir E. Landseer.* 1843
'Fraser's Mag.' July 1856
A. Graves: *Cat. of the works of Sir E.L.* 1874
A. Chester: *The art of Sir E.L.* 1920
French Gall. 1855
RA 1874 and 1961
Redgrave DICT, CENT: DNB: Graves RA, BI, LOAN:
Cundall: Binyon: VAM: Roget: Hughes: Nettlefold

LAPORTE, John (1761–1839)
VAM MSS: J.L. letter to Mr. Dayman. 1801
B. S. Long: *J.L. and Peter Lacave.* 'Walker's Quart.' VIII,
1922
Redgrave: Graves DICT, RA, BI: Cundall: Prideaux:
Binyon: DNB: VAM: Roget: Nettlefold

LAROON, Marcellus, II (1679–1772)
R. Raines: *M.L.* 1967
Aldeburgh and Tate Gall. 1967
Binyon: Williams: Windsor: DNB: BM I: Redgrave

LAWRENCE, Sir Thomas, PRA (1769–1830)
VAM MSS: Various correspondence etc.
D. Goldring: *Regency portrait painter.* 1951
D. E. Williams: *Life and correspondence of Sir T.L.* 1831
Sir T.L.'s letter-bag. 1906
T. S. Mulvaney: *Letters and correspond. with Sir T.L.* 1907
Sir W. Armstrong: *Lawrence.* 1913
K. Garlick: *Sir T.L.* 1954
K. Garlick: *A cat. of the paintings, drawings and pastels of
Sir T.L.* Walpole Soc. XXXIX, 1964
RA 1904
Edward Gall. 1913
Prosser's Gall. n.d.
Bristol Mus. and Art Gall. 1951

308

DNB: Sandby: Graves RA, SOC. of A, BI, LOAN: Binyon: Williams: Windsor: RA 1934: Roget: Redgrave DICT, CENT: Hughes

LAWSON, Cecil Gordon (1851–1882)
Sir E. W. Gosse: *C.L. Memoir.* 1883

FAS 1883
Grosvenor Gall. 1882

Graves RA: Caw: VAM: Binyon: Cundall: DNB: Redgrave CENT: Nettlefold

LEAR, Edward (1812–1888)
E. Lear: *Journals of a landscape painter in Southern Calabria.* 1852
VAM MSS: Letter to L. Coomb from E.L. 1882
The letters of E.L. 1907. *Later letters.* 1911
A. Davidson: *E.L.* 1938
E.L.'s Indian Journal. 1953
E.L.'s Corfu. 1965

Alpine Club 1931
Tunbridge Wells, Craddock and Barnard Gall. 1937
FAS 1938
Redfern Gall. 1942
Adams Gall. 1946, 1947
Walker's Gall. 1950
Arts Council 1958

Bryan: DNB: Prideaux: Graves RA, BI: Binyon: VAM

LEIGHTON, Lord Frederic, PRA (1830–1896)
Mrs. A. Lang: *Sir F.L., life and works.* 1884
G. C. Williamson: *Frederic Lord L.* 1902
E. Staley: *Lord L.* 1906
Mrs. R. Barrington: *The life, letters and work of F.L.* 1906
W. Gaunt: *Victorian Olympus.* 1952

Japanese Gall. 1891
FAS 1896, 1897
RA 1897
Leighton House 1955

DNB: Bryan: Graves DICT, RA, LOAN: VAM: Binyon: Cundall: Roget

LEITCH, William Leighton (1804–1883)
A. MacGeorge: *Memoir of W.L.* 1884

Graves DICT, RA, BI: DNB: Caw: Cundall: Binyon: VAM: Hughes: Nettlefold

LEMOYNE de Morgues, Jacques (*fl.* 1564–1588)
S. Lorant: *The New World.* 1946

Walpole: BM 1: Williams: VAM

LENS, Bernard, III (1682–1740)
Strickland: Williamson: DNB: Graves SOC. of A, LOAN: Binyon: Williams: Cundall: VAM: Windsor: Redgrave DICT, CENT

LESLIE, Charles Robert (1794–1859)
Autobiographical recollections. 1800
J. Dafforne: *Pictures by C.R.L. and biog. sketch.* 1875
VAM MSS (typewritten): Correspondence and other memorials of John Constable, VII (1953)
J. Constable: *The letters of J.C. and C.R.L.* 1931
Suffolk, Record Soc. Vol. IV, iii, *C.R.L.* 1965

DNB: Bryan: Graves RA, BI, LOAN: Binyon: VAM: Cundall: Redgrave DICT, CENT

LEWIS, Frederick Christian (1779–1856)
'Walker's Monthly' May 1929

Redgrave: Roget: DNB: Rees: Prideaux: Graves DICT, RA, BI: Binyon: VAM: Hughes

LEWIS, George Robert (1782–1871)
Redgrave: Roget: DNB: Prideaux: Rees: Graves DICT, RA, BI: Binyon: Cundall: Hughes

LEWIS, John Frederick (1805–1876)
R. Davies: *J.F.L.* OWS, III, 1926
H. Stokes: *J.F.L.* 'Walker's Quart.' XXVIII, 1929

Redgrave DICT, CENT: Roget: DNB: Graves DICT, RA, BI, LOAN: Binyon: Cundall: VAM: RA 1934: Hughes

LINES, Samuel R. (1804–1833)
Birmingham Museum and Art Gall. 1894
DNB: Graves DICT: Redgrave: Cundall

LINNELL, John (1792–1882)
VAM MSS: *S. Palmer: letter to J.L.* 1828
A. T. Story: *The life of J.L.* 1892
RA 1883
Tooth Gall. 1882
U.S.A. Salt Lake Art Center 1964

DNB: Bryan: Graves RA, LOAN: Binyon: Cundall: VAM: RA 1934: Roget: Redgrave CENT: Hughes: Nettlefold: Lemaitre

LINTON, Sir James Dromgole (1840–1916)
FAS 1884, 1893
Dowdeswell Gall. 1887
RI 1886

Graves RA, LOAN: VAM: Roget: Nettlefold

LINTON, William (1791–1876)
Cundall: Binyon: VAM: DNB: Redgrave

LITTLE, Robert (1854–1944)
FAS 1907
Leicester Gall. 1911

Caw: Huish: Graves RA

LIVERSEEGE, Henry (1803–1832)
C. Swain: *Memoir and engravings from the works of H.L.* 1835
G. Richardson: *The works of H.L.* 1875

Redgrave: Graves RA, BI: Cundall: Cunningham: Binyon: VAM: DNB

LOCKE, William (1767–1832)
Redgrave: VAM: Williams: DNB

LOCKER, Edward Hawke (1777–1849)
Binyon: Cundall: VAM: Williams: DNB: Roget

LOCKHART, William Ewart (1767–1832)
Bryan: DNB: Caw: Graves RA, LOAN: Cundall

LODGE, William (1649–1689)
Binyon: Williams: Walpole *Anec.*: DNB: Redgrave

LONGCROFT, Thomas (Worked 1786–1793)
Binyon: VAM

LOUND, Thomas (1802–1861)
Redgrave: DNB: Graves RA, BI: Cundall: Dickes: VAM:
Clifford

LOUTHERBOURG, P. J. de (1740–1812)
'Archives alsaciennes d'histoire de l'art' Nouv. Sér.
I, 1948
DNB: Sandby: Graves RA, SOC. of A: Binyon: VAM:
Cundall: Williams: Windsor: RA 1934: Roget:
Redgrave DICT, CENT: Hughes

LOVE, Horace Beevor (1780–1838)
Graves DICT: VAM

MACBETH, Robert Walker (1848–1910)
VAM MSS: Coll. of letters to H. M. Cundall. 1880
RA 1911
VAM Supp.: Caw

McCULLOCH, Horatio (1805–1867)
A. Fraser: *H.McC.* 1872
Caw: Cundall: DNB: Redgrave

MACGREGOR, W. Y. (1855–1923)
Who's Who: Caw

MACKENZIE, Frederick (1787–1854)
Graves RA, LOAN: DNB: Roget: Prideaux: Cundall:
Binyon: VAM: Windsor: Redgrave DICT, CENT: Hughes

MACKINTOSH, C. Rennie (1868–1928)
T. Howarth: *C.R.M.* 1952
C.R.M. and the Glasgow School of Art. 1961
Glasgow, McLellan Gall. 1923

MACLISE, Daniell (1806–1870)
Binyon: Cundall: VAM: DNB: Redgrave DICT, CENT:
Hughes: Caw

McTAGGART, William (1835–1910)
J. L. Caw: *W.McT.* 1917
D. Fincham: *W.McT.* 1935
Tate Gall. 1935
Edinburgh, Nat. Gall. Scot. 1935
Manchester, City Art Gall. 1937
FAS 1967
Caw: Graves RA, LOAN

MACWHIRTER, John (1839–1911)
M. H. Spielmann: *The art of J.McW.* 1904
The McW. sketchbook. 1906
Sinclair: *Life and work of J.McW.* 'Art Journal' 1903
Bristol, Frost and Reid Gall. n.d.
Leicester Gall. 1910, 1911
FAS 1901
DNB: Who's Who: Caw: Graves RA, LOAN: VAM

MAHONY, James (1810–1879)
Graves RA: Strickland: Graves RA: Cundall: VAM

MAISEY, Thomas (1787–1840)
Graves RA: Cundall: VAM

MALCHAIR, John Baptist (c. 1731–1812)
'Oxoniensia' VIII, X, 1943, 1944
'Burlington Mag.' August 1943
J. H. Mee: *Old Holy Well Music Room, Oxford.* 1910
Binyon: Williams: VAM: Lemaitre

MALTON, James (c. 1766–1803)
DNB: Graves RA, SOC. of A: Binyon: Strickland: VAM:
Cundall: Roget: Redgrave: Hughes

MALTON, Thomas, I (1726–1801)
DNB: Graves RA, SOC. of A: Strickland: Binyon: Cundall:
VAM: Roget: Redgrave: Hughes

MALTON, Thomas, II (1748–1804)
Binyon: Cundall: Williams: VAM: Windsor: DNB:
Roget: Redgrave DICT, CENT: Hughes: Nettlefold

MANBY, Thomas (d. 1695)
DNB: Williams: BM I: Redgrave

MANSKIRSCH, Franz Joseph (1770–1827)
Binyon: Williams: Windsor

MARLOW, William (1740–1813)
Guildhall Art Gall. 1956
Redgrave DICT, CENT: DNB: Graves RA, SOC. of A, LOAN:
Cundall: Binyon: Williams: VAM: Roget

MARSHAL, Alexander (fl. 1660–1690)
Binyon: Cundall: Williams: Windsor: Redgrave DICT,
CENT

MARSHALL, Herbert Menzies (1841–1913)
Abbey Gall. 1935
FAS 1886
Graves RA: Who's Who 1913: VAM

MARTIN, Elias (1739–1818)
H. Frohlich: *Broderner E. and J. F. Martins.* 1939
Stockholm Nat. Mus.: *Akvareller och teckningar ar E.M.*
1943
Arts Council 1963
Graves RA, SOC. of A: DNB: Williams: VAM: Binyon:
Redgrave

310

MARTIN, John (1789–1854)
Binyon: Cundall: VAM: DNB: Redgrave DICT, CENT

MASON, George Hemming (1818–1872)
Birmingham Roy. Soc. of Artists 1895
Burlington F. A. Club 1873
DNB: Clement and Hutton: Graves RA: Cundall:
Redgrave: Lemaitre

MAURER, John (fl. 1713–1761)
Windsor: Redgrave

MAY, Philip William (1864–1903)
J. Thorpe: P.M. 1932
Leicester Gall, 1903, 1908, 1912
FAS 1895, 1899
DNB: Bryan: Cundall: VAM

MAYOR, William Frederick (1866–1916)
Graves RA: VAM

MELVILLE, Arthur (1855–1904)
R. Feddon: A.M. ows, I, 1923
A. E. Mackay: A.M. 1951
RI 1906
Newcastle-upon-Tyne, Laing Art Gall. 1906
Caw: Graves RA: Cundall: VAM

MIDDLETON, John (1827–1856)
Redgrave: Dickes: Cundall: Graves RA, BI: VAM: DNB:
Clifford

MILLAIS, Sir John E. (1829–1896)
A. L. Baldry: Sir J.E.M. 1899
J. G. Millais: Life and letters of J.E.M. 1899
J. E. Reid: Sir J.E.M. 1909
M. Lutyens: M. and the Ruskins. 1967
RA 1898, 1967
FAS 1901
Grosvenor Gall. 1886
DNB: Binyon: Bryan: Cundall: VAM: RA 1934

MILLER, James (fl. 1773–1791)
Redgrave: Graves RA, SOC. of A: Binyon: Williams:
VAM: Cundall

MITCHELL, Thomas (fl. 1763–1789)
Binyon: Williams: DNB: Redgrave

MOGFORD, John (1821–1885)
Dowdeswell Gall. 1883
Bryan: Graves BI: VAM: Cundall: DNB

MONAMY, Peter (c. 1670–1749)
'Walker's Monthly' February 1936
DNB: Bryan: Graves LOAN: VAM: Binyon: Cundall:
Redgrave DICT, CENT: Nettlefold

MONRO, Dr. Thomas (1759–1833)
Foxley Norris: Dr. T.M. ows, II, 1924
'Connoisseur' XLIX, 1917
VAM MSS (typewritten): Letters to Dr. T.M. 1808–21,
1918
VAM 1917
Palser Gall. 1939
DNB: Graves RA, BI: Williams: VAM: RA 1934: Roget:
Redgrave CENT: Hughes

MOORE, Henry (1831–1895)
F. Maclean: H.M. 1905
FAS 1887
Woodbury Gall. 1904
Bryan: Graves RA, BI, LOAN: DNB: VAM: Cundall:
Nettlefold

MOORE, James, FSA (1762–1799)
C. F. Bell: Fresh light on some water-colour painters from the
coll. and papers of J.M. Walpole Soc. V, 1917
Graves SOC. of A: Williams: Roget: Hughes

MORE, Jacob (1740–1793)
Binyon (as Moore): Williams: DNB: RA 1934: Redgrave:
Caw

MORLAND, George (1763–1804)
G. Dawe: The life of G.M. 1807, 1904
G. C. Williamson: G.M. 1904, 1907
'Connoisseur' IX, 1904
J. Grundy: G.M. 'Connoisseur' Extra no. 1906
Sir W. Gilbey: G.M. 1907
F. Buckley: G.M.'s sketch-books. 1931
Morland Gall. 1806
Vokins Gall. 1884
VAM 1904
Tooth Gall. 1939
Arts Council 1954
Bryan: DNB: Graves LOAN: VAM: Cundall: Windsor:
Binyon: Roget: Redgrave DICT, CENT: Hughes:
Nettlefold

MORTIMER, John Hamilton (1741–1779)
VAM MSS (typewritten): G. Benthall, much material
1955–61
DNB: Cunningham: Binyon: Graves RA, BI, LOAN:
Williams: Cundall: VAM: Windsor: RA 1934: Roget:
Redgrave DICT, CENT

MOSER, Mary (1744–1819)
Binyon: Cundall: Williams: VAM: DNB: RA 1934:
Redgrave DICT, CENT

MUIRHEAD, David (1867–1930)
Gosvenor Gall. 1923
Colnaghi 1928
Rembrandt Gall. 1933
Caw: VAM

MULLER, William James (1812–1845)
N. N. Solly: *Memoir of W.J.M.* 1875
A letter from W.J.M. ows, xxv, 1947
 Birmingham Mus. and Art Gall. 1896
 Bristol Mus. and Art Gall. 1962
 Redgrave DICT, CENT: DNB: Bryan: Graves RA: Cundall:
 Binyon: VAM: RA 1934: Roget: Hughes: Nettlefold:
 Lemaitre

MULREADY, William (1786–1863)
VAM MSS: Various material 1804–63
F. G. Stephens: *Memorials of W.M.* 1867
J. Dafforne: *Pictures and biog. sketch of W.M.* 1872
 Soc. of Arts 1848
 Bristol Mus. and Art Gall. 1964
 DNB: Redgrave DICT, CENT: Strickland: Binyon:
 Cundall: VAM: Roget: Hughes

MUNN, Paul Sandby (1773–1845)
 Graves RA, SOC. of A: DNB: Binyon: Williams: VAM:
 Cundall: Roget: Redgrave DICT, CENT

MURRAY, Sir David (1849–1933)
 FAS 1887
 1 Langham Chambers 1934
 Clement and Hutton: Caw: Graves RA

NASH, Frederick (1782–1856)
 Squire Gall. 1932
 Redgrave: DNB: Binyon: VAM: Cundall: Windsor:
 Roget: Hughes: Nettlefold

NASH, Joseph (1808–1878)
 DNB: Binyon: VAM: Cundall: Roget: Hughes

NASMYTH, Alexander (1758–1840)
 Caw: Binyon: Williams: DNB: Redgrave DICT, CENT:
 Nettlefold

NASMYTH, Patrick (1787–1831)
 O. and P. Johnson Ltd.: *The Nasmyth family.* 1964
 Binyon: VAM: DNB: Redgrave DICT, CENT: Nettlefold:
 Caw

NATTES, John Claude (*c.* 1765–1822)
 Binyon: VAM: Williams: Cundall: Windsor: DNB:
 Roget: Redgrave: Hughes

NEALE, John Preston (1780–1847)
 Redgrave: DNB: Bryan: Binyon: VAM: Williams:
 Cundall: Windsor: Roget

NESFIELD, William Andrews (1793–1881)
A. Bury: *W.A.N.* ows, xxvII
 DNB: Binyon: VAM: Cundall: Roget: Hughes

NICHOLL, Andrew (1804–1886)
 Binyon: VAM: Cundall

NICHOLSON, Francis (1753–1844)
B. S. Long: *F.N.* 'Walker's Quart.' xIV, 1924
R. Davies: *F.N.* ows, vIII, 1931
 Roget: DNB: Binyon: Williams: VAM: Cundall: Windsor:
 Redgrave DICT, CENT: Hughes: Nettlefold

NIEMANN, Edmund John (1813–1876)
 Binyon: VAM: Cundall: Nettlefold

NINHAM, Henry (1793–1874)
 Dickes: VAM: Williams: Cundall: Clifford

NISBET, Robert Buchan (1857–1942)
VAM MSS: Eleven letters to F. C. Torrey. 1899–1909
 St. George's Gall. *c.* 1897
 FAS 1911
 Caw: VAM

NIXON, John (*d.* 1818)
 DNB: Cundall: Strickland: Williams: Binyon: VAM:
 Redgrave

NORTH, John William, ARA (1842–1924)
H. Alexander: *J.W.N.* ows, v, 1927
 Birmingham Roy. Soc. of Artists 1895
 FAS 1895
 VAM: Nettlefold

NORTHCOTE, James (1746–1831)
VAM MSS: Letters to J.N. 1773–1830
W. Hazlitt: *Conversations with J.N.* 1830 and sub. eds.
E. Fletcher: *Conversations of J.N. with James Ward.* 1901
 Redgrave DICT, CENT: DNB: VAM: Cundall: Roget:
 Nettlefold

OAKLEY, Octavius (1800–1867)
 DNB: Bryan: Cundall: VAM: Roget: Redgrave

O'CONNOR, James Arthur (1791–1841)
T. Bodkin: *Four Irish landscape painters.* 1920
 DNB: Strickland: Binyon: Redgrave: Nettlefold

OLIVER, Isaac (*c.* 1556–1617), and Peter (1594–1648)
A. G. Reynolds: *Niclaus Hilliard and I.O.* 1947
 DNB: Williamson: Binyon: Williams: Cundall: Windsor:
 BM I: Redgrave DICT, CENT

O'NIELL, Hugh (1784–1824)
 DNB: Graves RA: Binyon: VAM: Cundall: Redgrave
 DICT, CENT: Hughes

ORME, William (*fl.* 1791–1819)
 Graves RA: VAM

ORROCK, James (1829–1913)
Light and water-colours. Series of letters by J.O. to 'The Times'. 1887
J. Webber: *J.O.* 1904
 Dowdeswell Gall. 1886, 1887
 FAS 1893
Caw: VAM: Nettlefold

OTTLEY, William Young (1771–1836)
Binyon: Williams: DNB: Redgrave

OWEN, Samuel (*c.* 1768–1857)
Roget: DNB: Cundall: VAM: Binyon: Williams: Redgrave DICT, CENT: Hughes

OWEN, William (1769–1825)
Binyon: VAM: DNB: Redgrave DICT, CENT

PALMER, H. Sutton (1854–1933)
 Vicars' Gall. 1934
 FAS 1934
Graves RA, LOAN: VAM

PALMER, Samuel (1805–1881)
VAM MSS: Letters, etc., 1830 etc.; Letters from A. H. Palmer to Martin Hardie 1910–32
A. H. Palmer: *S.P.: a memoir.* 1882
A. H. Palmer: *Life and letters of S.P.* 1892
R. L. Binyon: *The followers of William Blake.* 1925
M. Hardie: *S.P.* ows, IV, 1927
G. Grigson: *The visionary years.* 1947
Oxford, Ashmolean Mus.: *Paintings and drawings by S.P.* 1960
 RA 1893
 Cotswold Gall. 1923
 VAM 1926
 Arts Council 1956, 1957
 Sheffield, Graves Art Gall. 1961
DNB: Roget: Graves RA, BI, LOAN: VAM: Williams: Cundall: RA 1934: Redgrave CENT: Hughes: Nettlefold: Lemaitre

PARIS, Matthew
M. R. James: *Drawings of M.P.* and *More drawings.* Walpole Soc. XIV, 1926, and XXXI, 1946
Manchester, John Rylands Library. Bull. XXVIII, II, 1944
R. Vaughan: *M.P.* 1958
Bradley: *Dictionary of miniatures.* 1889
DNB: Graves RA

PARS, William (1742–1782)
Edwards: DNB: Bryan: Graves RA, SOC. of A: Binyon: VAM: Williams: Cundall: RA 1934: Roget: Redgrave: Hughes: Lemaitre

PARSONS, Alfred (1847–1920)
 Leicester Gall. 1915
DNB: Graves RA, LOAN: Nettlefold

PARTRIDGE, John (1790–1872)
Redgrave: DNB: Binyon: Graves RA, BI, LOAN

PATERSON, Emily Murray (1855–1934)
'Walker's Monthly' November 1930
 McLean's Gall. 1909
 Walker's Gall. 1930, 1935
 Barbizon House 1932
Caw: Who's Who

PATERSON, James (1854–1932)
Sir J. Caw: *J.P.* ows, X, 1933
 Paterson's Gall. 1902
 FAS 1908
Graves RA, LOAN: Caw: Huish

PAYNE, William (*fl.* 1776–1803)
B. S. Long: *W.P.* 'Walker's Quart.' VI, 1921
'Apollo' XXXIX, 1939
DNB: Graves RA, SOC. of A, BI: Bryan: Binyon: VAM: Williams: Cundall: RA 1934: Roget: Redgrave

PEARSON, William (*fl.* 1798–1813)
Graves RA: Binyon: Williams: VAM: Hughes

PENLEY, Aaron Edwin (1807–1870)
Binyon: VAM: Cundall: DNB: Redgrave: Hughes

PETHER, William (1738–?1821)
Redgrave: DNB: Bryan: VAM Supp.

PICKERING, George (*c.* 1794–1857)
Graves DICT: Cundall: VAM: DNB

PINWELL, George John (1842–1875)
G. J. Williamson: *G.J.P.* 1900
 Birmingham, Roy. Soc. of Artists, 1895
Bryan: DNB: Graves LOAN: Binyon: VAM: Cundall: Roget: Redgrave DICT, CENT

PLACE, Francis (1647–1728)
A. M. Hake: *Documents relating to F.P.* Walpole Soc. X, 1922
DNB: Bryan: Binyon: Williams: Windsor: BM I: RA 1934: Redgrave: Lemaitre

POCOCK, Nicholas (1740–1821)
R. Davies: *N.P.* ows, V, 1927
DNB: Graves RA, BI, LOAN: VAM: Cundall: Binyon: Williams: Windsor: Roget: Redgrave: Hughes: Nettlefold

PORTER, Sir Robert Ker (1777–1842)
DNB: Graves RA, LOAN: Binyon: Williams: VAM: Cundall: Roget: Redgrave: Hughes

BIBLIOGRAPHY

POTTER, Beatrix (1866–1943)
M. Lane: *The Tale of B.P.* 1947
A. C. Moore: *The Art of B.P.* 1955
Nat. Book League 1966

POUNCY, Benjamin Thomas (*d.* 1799)
VAM: Williams: Cundall: DNB: Redgrave

POWELL, Sir Francis (1833–1914)
Caw: VAM

POWELL, Joseph (*fl.* 1796–*d.* 1834)
J. Mayne: *J.P.* 'Burlington Mag.' September 1948
Modern Gall. 1915
Graves DICT, RA, BI: Williams: VAM: Binyon: Cundall:
DNB: Redgrave

POYNTER, Ambrose (1796–1886)
H. M. Poynter: *The drawings of Ambrose Poynter, 1836.*
1931
FAS 1903
BM 1966
Graves RA: Cundall: VAM: DNB

POYNTER, Sir Edward James (1836–1919)
A. Margaux: *The art of E.J.P.* 1905
M. Bell: *Drawings of E.J.P.* 1906
BM 1966
Graves RA, BI, LOAN: VAM: Roget

PRICE, Edward (*fl.* 1820–1856)
Roget: Graves RA, BI

PRICE, William Lake (1810–after 1891)
VAM: Cundall: Roget

PRITCHETT, E. (*fl.* 1828–1864)
Graves DICT, RA, BI: Hughes

PRITCHETT, Robert Taylor (1828–1907)
DNB: Graves RA: VAM

PROUT, John Skinner (1806–1876)
Redgrave: DNB: Cundall: Binyon: VAM: Roget: Hughes

PROUT, Samuel (1783–1852)
J. Ruskin: *Notes on S.P. and Hunt.* 1879
'Studio' Sp. no. 1914
J. Quigley: *Prout and Roberts.* 1926
A. Neumeyer: *An unknown coll. of English water-colours at
Mills College.* 1941
C. E. Hughes: *S.P.* ows, VI
J. G. Roe: *Some letters of S.P.* ows, XXIV
Squire Gall. 1932
Redgrave DICT, CENT: Roget: DNB: Graves RA, BI:
Cundall: Binyon: VAM: Williams: RA 1934: Hughes:
Nettlefold: Lemaitre

PROUT, Samuel Gillespie (1822–1911)
VAM

PUGIN, Augustus Charles (1762–1832)
B. Ferrey: *Recolls. of A. N. Welby Pugin and his father
A.C.P.* 1861
F. G. Roe: *Pugin the elder.* ows, XXXI
DNB: Roget: Binyon: Graves RA, BI, LOAN: VAM:
Williams: Cundall: Windsor: Redgrave DICT, CENT:
Hughes

PUGIN, Augustus Welby Northmore (1812–1852)
B. Ferrey: *Recolls. of A.N.W. and his father Augustus
Charles Pugin.* 1861
P. Waterhouse: *Life and works of A.W.P.* 1898
VAM MSS (typewritten): J. H. Powell 'Pugin in his home'.
1963
DNB: Graves RA: Binyon: VAM: Cundall: Roget: Red-
grave DICT, CENT: Hughes

PYE, John (1782–1874)
VAM MSS: A coll. of J.P.'s corresp. and papers. 1813–84
DNB: Graves SOC. of A: Roget: Redgrave: Hughes

PYNE, James Baker (1800–1870)
VAM MSS: J.B.P. picture memoranda. 1840–69
DNB: Graves RA, BI, LOAN: Binyon: Cundall: Roget:
VAM: Redgrave DICT, CENT: Hughes: Nettlefold

PYNE, William Henry Ephraim Hardcastle (1769–1843)
A Bury: *W.H.P.* ows, XXVIII, 1950
Binyon: VAM: Williams: Cundall: DNB: Roget: Redgrave
DICT, CENT: Hughes

RACKHAM, Arthur (1867–1939)
A. S. Hartrick: *A.R.* ows, XVIII, 1940
D. Hudson: *A.R. life and work.* 1960
Patterson's Gall. 1906
Leicester Gall. 1905, 1919, 1935
Museums Gall. 1932
Maggs Bros. 1938
Graves RA, LOAN: VAM

RAMBERG, John Henry (1763–1840)
Binyon: DNB: Redgrave

RATHBONE, John (*c.* 1750–1807)
Binyon: VAM: Cundall: DNB: Redgrave

READ, Samuel (1815 or 1816–1883)
Bryan: Roget: Cundall: Binyon: VAM: DNB

REDGRAVE, Richard (1804–1888)
Binyon: VAM: Cundall: DNB: Redgrave CENT

REID, John Robertson
FAS 1899
Leicester Gall. 1907
Graves DICT, RA: Caw: Nettlefold

314

REINAGLE, Ramsay Richard (1775–1862)
'Collector' x, 1930
Panorama, Strand 1802–31
Sandby: Redgrave DICT, CENT: Roget: DNB: Bryan: Graves RA, BI, LOAN: VAM: Williams: Cundall: Hughes

REVELEY, Willey (*fl.* 1781–*d.* 1799)
DNB: Binyon: Graves RA: VAM: Cundall: Redgrave

REYNOLDS, Sir Joshua (1723–1792)
J. Northcote: *Memoirs of J.R.* 1813, 1818
J. Farrington: *Memoir of Sir J.R.* 1819
A. Graves: *History of the works of J.R.* 1899–1901 (VAM copy grangerised by W. Roberts)
E. K. Waterhouse: *Reynolds.* 1941 (VAM copy has notes by C. F. Bell)
D. Hudson: *Sir J.R.* 1958
Prosser's Gall. n.d.
Grosvenor Gall. 1883–4
Arts Council 1949
Graves RA, LOAN: Binyon: Redgrave: Hughes

REYNOLDS, Samuel William (1773–1835)
Binyon: VAM: Cundall: DNB: Redgrave

RICH, Alfred William (1856–1921)
VAM: Nettlefold

RICHARDS, John Inigo (*c.* 1720–*d.* 1810)
DNB: Graves RA, SOC. OF A: Binyon: Rees: VAM: Williams: Cundall: Windsor: Redgrave: Nettlefold

RICHARDSON, Jonathan, I (1665–1745), II (1694–1771)
DNB: Bryan: Graves LOAN: Binyon: Windsor: RA 1934: Redgrave DICT, CENT

RICHARDSON, Thomas Miles, I (1784–1848)
Memorials of old Newcastle-upon-Tyne . . . with a sketch of the artist's life. 1880
R. Welford: *Art and Archeology: The three Richardsons.* 1906
Newcastle-upon-Tyne, Laing Art Gall. 1906
DNB: Roget: Graves RA, BI, LOAN: Cundall: VAM: Nettlefold

RICHARDSON, Thomas Miles, II (1813–1890)
Newcastle-upon-Tyne, Laing Art Gall. 1906
Roget: Graves RA, B.: Cundall: VAM: Nettlefold

RICHMOND, George (1809–1896)
R. L. Binyon: *The followers of William Blake.* 1925
A. M. W. Stirling: *The Richmond Papers.* 1926
Bryan: Graves RA, BI, LOAN: VAM: Cundall: DNB: Roget: Redgrave CENT

RIGAUD, Stephen Francis (1777–1861)
DNB: Redgrave: Roget: Graves RA, BI: Cundall: VAM: Williams: Hughes

ROBERTS, David (1796–1864)
VAM MSS: Letter to W. H. Dixon, etc. 1864
J. Ballantine: *The life of D.R.* 1866
J. Quigley: *D.R.* 'Walker's Quart.' x, 1922
J. Quigley: *Prout and Roberts.* 1926
M. Hardie: *D.R.* OWS, 1947
A. G. Reynolds: *British artists abroad, V: Roberts in Spain, etc.* 'Geo. Mag.' XXI, 1949
Leicester Gall. 1847
Guildhall Art Gall. 1967
Bryan: Caw: Cundall: Graves DICT, RA, BI, LOAN: Binyon: VAM: DNB: RA 1934: Redgrave DICT, CENT: Hughes: Nettlefold: Lemaitre

ROBERTSON, Andrew
Letters and papers of A.R. 1895
Redgrave DICT, CENT: DNB: Bryan: Graves RA, BI, LOAN: Cundall: Roget: Caw

ROBERTSON, George (*c.* 1748–*d.* 1788)
C. F. Bell: Walpole Soc. V, 1915–17, p. 54
DNB: Bryan: Graves RA, SOC. OF A: Binyon: VAM: Williams: Cundall: Redgrave

ROBINS, Thomas Sewell (1814–1880)
Bryan: Graves RA, BI: VAM: Cundall

ROBSON, George Fennell (1788–1833)
T. Uwins: *G.F.R.* OWS, XVI (re-print)
Redgrave DICT, CENT: DNB: Bryan: Graves RA: Binyon: VAM: Cundall: Roget: Hughes: Nettlefold: Lemaitre

ROGET, John Lewis (1828–1908)
A. Bury: *J.L.R.* OWS, XXVI

ROOKE, Thomas Matthew
P. H. Bate: *English Pre-Raphaelite Painters.* 1901
Extracts from letters to Sir S. Cockerell, OWS, XXI
Graves RA, LOAN: Huish

ROOKER, Michael Angelo (1743–1801)
DNB: Binyon: Cundall: Graves RA, SOC. OF A: Williams: VAM: Windsor: RA 1934: Roget: Redgrave DICT, CENT: Hughes: Nettlefold: Lemaitre

ROSSETTI, Dante Gabriel (1828–1882)
VAM MSS: Many letters to and from D.G.R.
W. M. Rossetti: *D.G.R., his family letters.* 1895
F. M. Hueffer: *R., a critical essay.* 1902
H. C. Marillier: *Rossetti.* 1904
P. J. Toynbee: *Chronological list . . . of paintings and drawings from Dante by D.G.R.* 1912
Sir M. Beerbohm: *R. and his circle.* 1922
E. Waugh: *Rossetti, his life and work.* 1928
H. M. R. Angelli: *D.G.R.* 1949

G. H. Fleming: *R. and the Pre-Raphaelite Brotherhood*. 1967
RA 1883
Burlington F. A. Club 1883
New Gall. 1897
Lawrence, Kansas Univ. 1958
Graves RA, LOAN: Binyon: VAM: Cundall: DNB: RA 1934

ROWBOTHAM, Thomas Leeson, I (1783–1853)
DNB: Strickland: VAM: Cundall: Roget: Hughes

ROWBOTHAM, T. L., II (1823–1875)
DNB: Redgrave: Strickland: Binyon: VAM: Cundall: Hughes

ROWLANDSON, Thomas (1756–1827)
J. Grego: *R. the caricaturist*. 1880
A. P. Oppé: *T.R. drawings and water-colours*. 1923
O. Sitwell: *T.R.* 1929
V. P. Sabin: *Cat. of water-colours by T.R.* 1933, 1948
F. G. Roe: *Rowlandson*. 1947
A. W. Heintzelman: *Water-colour drawings of T.R.* 1947
A. Bury: *R. drawings*. 1949
B. Falk: *T.R. life and art*. 1949
J. Hayes: *Cat. of water-colours in London Mus*. 1960
Burlington F. A. 1882
Leicester Gall. 1903
Gutekunst Gall. 1907
Colnaghi 1912
Walker's Gall. 1923
Cotswold Gall. 1929
Squire Gall. 1932, 1938
F. T. Sabin Gall. 1938, 1939
Birmingham, Mus. and Art Gall. 1949
Arts Council 1950
Whitechapel Art Gall. 1953
Reading Mus. and Art Gall. 1962
Graves RA, SOC. of A, LOAN: Binyon: Hughes: VAM: Williams: Cundall: Windsor: RA 1934: Roget: Redgrave: Nettlefold

RUSKIN, John (1819–1900)
W. G. Collingwood: *The art teaching of J.R.* 1891
C. E. Goodspeed and Co.: *Cat. of paintings, drawings, etc., of J.R.* 1931
R. A. Wilenski: *J.R.* 1933
J. H. Whitehouse: *R. the painter and his works at Bembridge*. 1938
P. Quennell: *J.R.* 1949
J. Evans: *J.R.* 1954
M. Lutyens: *Millais and the Ruskins*. 1967
A. Severn: *The Professor. A.S.'s memoir of J.R.* 1967
Royal Institute 1886
Roy. Soc. Painters in Water-colour 1901
Manchester, City Art Gall. 1904
FAS 1907

RA 1919
Arts Council 1954, 1960, 1964
Verona, Museo di Castelvecchio 1966
Roget: Binyon: VAM: Cundall: RA 1934: Hughes: Lemaitre

RYLAND, William Wynne (1732–1783)
'Connoisseur' XXVIII, 1910
Authentic memoirs of W.W.R. 1784
DNB: Binyon: Windsor: Redgrave

SALT, Henry (1780–1827)
Binyon: Williams: DNB: Redgrave

SAMUEL, George (Work, 1784–c. 1823)
VAM: Williams: Cundall: DNB: Roget: Redgrave: Hughes

SANDBY, Paul (1725–1809)
W. Sandby: *P. and Thomas Sandby*. 1892
A. P. Oppé: *The drawings of P. and T.S. at Windsor*. 1947
Nottingham, Mus. and Art Gall. 1884
Royal Amateur Art Soc. 1909
FAS 1931, 1932
Guildhall Art Gall. 1960
Redgrave: Roget: DNB: Graves RA, SOC. of A, BI: Cundall: Hughes: Binyon: VAM: Williams: Windsor: RA 1934: Nettlefold: Lemaitre

SANDBY, Thomas (1721–1798)
W. Sandby: *P. and T. Sandby*. 1892
A. P. Oppé: *The drawings of P. and T.S. at Windsor*. 1947
Nottingham Mus. and Art Gall. 1884
Redgrave: Roget: DNB: Graves RA, SOC. of A, BI: Cundall: Windsor: Williams: VAM: Hughes: Lemaitre

SANDERS, John (1750–1825)
Redgrave: DNB: Bryan: Graves RA: Cundall

SARGENT, John Singer (1856–1925)
Mrs. Meynall: *The work of J.S.S.* (intro. by Mrs. M 1903
VAM MSS: Coll. letters to H. M. Cundall. 1911
W. H. Downes: *J.S.S.* 1925
A. Stokes: *J.S.S.* OWS, III, 1925
E. Charteris: *J.S.S.* 1925
M. Hardie: *J.S.S.* (intro. by M.H.). 1930
C. M. Mount: *J.S.S.* 1957
Carfax Gall. 1903, 1905, 1908
Pittsburg, Carnegie Inst. 1917
Burlington House 1926
New York, Metropolitan Mus. 1926
Barbizon House 1927
Chicago, Art Inst. 1954
Birmingham, Mus. and Art Gall. 1964
Hughes: VAM: Caw: Cundall

SARJENT, Francis John (*fl.* 1800–1811)
Graves RA: VAM

SASSE, Richard (1774–1849)
DNB: Graves RA, BI: Strickland: Binyon: VAM: Williams:
Cundall: Redgrave

SCANDRETT, Thomas (1797–1870)
Redgrave: Graves RA, BI: Hughes

SCHARF, George (1788–1860)
DNB: Bryan: Graves RA: Binyon: VAM: Cundall:
Redgrave

SCHARF, Sir George (1820–1895)
DNB: Bryan: Graves RA: Binyon

SCHETKY, John Christian (1778–1874)
S. F. L. Schetky: *Ninety years of work and play.* 1877
Redgrave: DNB: Graves RA, BI: Caw: Binyon: Cundall:
Windsor: Roget

SCHNEBBELIE, Jacob C. (1760–1792)
Windsor: DNB: Redgrave

SCHNEBBELIE, Robert Blemmel (*fl.* 1803–1849)
DNB: Graves RA: Cundall: Binyon: VAM: Windsor:
Redgrave

SCOTT, Samuel (?1702–1772)
A. Dobson: *Eighteenth century vignettes,* 3rd series. 1896
Redgrave DICT, CENT: Bryan: Binyon: Williams:
Cundall: RA 1934: Roget: Hughes

SCOTT, Tom (1854–1927)
Caw

SCOTT, William Bell (1811–1890)
VAM: Cundall: DNB: Caw

SERRES, Dominic (1722–1793)
Edwards: Redgrave DICT, CENT: DNB: Graves RA:
Binyon: VAM: Williams: Cundall: Hughes: Nettlefold

SERRES, Dominic M. (Worked about 1778–1804)
Binyon: VAM: Williams: Cundall: Redgrave DICT, CENT

SERRES, John Thomas (1759–1825)
Memoirs of J.T.S. 1826
Edwards: Redgrave DICT, CENT: DNB: Graves RA:
Williams: Binyon: VAM: Cundall

SEVERN, Arthur (1843–1931)
FAS 1892, 1899, 1901
Leicester Gall. 1906, 1911
Graves RA: VAM Supp.

SEVERN, Joseph (1793–1879)
VAM MSS: J. Constable, letters, etc. 1822–51
W. Sharp: *Life and letters of J.S.* 1892
Lady Birkenhead: *Against oblivion: the life of J.S.* 1943
H. E. Rollins: *The Keats Circle.* 1948
DNB: Bryan: Graves RA, BI: VAM: Cundall: Roget

SEYMOUR, James (1702–1752)
Binyon: Williams: Windsor: DNB: Redgrave DICT, CENT

SHARP, Michael William (d. 1840)
Redgrave DICT, CENT: DNB: Graves RA, BI, LOAN: Roget

SHEE, Sir Martin Archer, PRA (1769–1850)
M. A. Shee: *The life of Sir M.A.S.* 1860
Sandby: Redgrave CENT, DICT: Graves RA, BI, LOAN:
DNB: Strickland: Binyon

SHELLEY, Samuel (c. 1750–1808)
R. Davies: *S.S.* OWS, XI, 1934
Redgrave CENT, DICT: Roget: Graves DICT, RA, SOC. of A,
BI: DNB: Cundall: Williams: Binyon: VAM: Windsor:
Hughes

SHEPHEARD, George (c. 1770–1842)
Binyon: Williams: Cundall: DNB: Redgrave

SHEPHERD, George (*fl.* 1800–1830)
DNB: Graves RA: Binyon: VAM: Cundall: Windsor:
Redgrave: Nettlefold

SHEPHERD, George Sidney (*fl.* 1821–*d.* 1861)
Redgrave: DNB: Graves DICT, RA: Cundall: Binyon:
VAM: Nettlefold

SHEPHERD, Thomas Hosmer (*fl.* 1817–1840)
DNB: Cundall: Graves LOAN: Binyon: VAM

SHERLOCK, William P. (Worked 1800–1820)
Binyon: VAM: Cundall: DNB: Redgrave

SHIELDS, Frederick James (1833–1911)
E. Mills: *Life and letters of F.J.S.* 1912
The Chapel of the Ascension by F.J.S. (with biog. note). 1912
BATE: *The English Pre-Raphaelite painters.* 1901
Manchester, Brasenose Club 1889
Manchester, Royal Institution 1875
Alpine Club 1911
Manchester, City Art Gall. 1907
Dowdeswell Gall. n.d.
DNB: Graves LOAN

SHIPLEY, William (1714–1803)
Redgrave DICT, CENT: DNB: Bryan: Williams: Roget

SILLETT, James (1764–1840)
Clifford: Dickes: Binyon: VAM: Cundall: DNB: Redgrave

SIMPSON, William (1823–1899)
W. Simpson: *Autobiography.* 1903
Pall Mall Gall. 1864, 1869
German Gall. 1862
Colnaghi 1878
Clement and Hutton: Caw: Cundall: Graves LOAN:
Binyon: VAM: DNB

SINGLETON, Henry (1766–1839)
Binyon: VAM: Williams: Cundall: DNB: Redgrave

317

SKELTON, Jonathan (*fl.* 1754–1758)
S. Rowland Pierce: *J.S. and his water-colours.* Walpole Soc. XXXVI, 1960

Manchester Univ. Whitworth Art Gall. 1960

VAM: Williams: Lemaitre

SKIPPE, John (*c.* 1742–1796)
Binyon: VAM: Williams: DNB: Redgrave

SMALLWOOD, William Frome (1806–1834)
Redgrave: Graves RA: Bryan: VAM

SMIRKE, Robert (1752–1845)
Binyon: DNB: Roget: Redgrave DICT, CENT

SMITH, John Raphael (1752–1812)
J. Frankau: *J.R.S.* 1902

Bryan: DNB: Graves RA, SOC. of A, LOAN: Binyon: VAM: Redgrave: Hughes

SMITH, John 'Warwick' (1749–1831)
B. S. Long: *J.'W.'S.* 'Walker's Quart.' XXIV, 1927
I. A. Williams: *J.'W.'S.* OWS, XXIV, 1946

Roy. Soc. Painters in Water-colours 1928

FAS 1937

Preston, Harris Mus. and Art Gall. 1949

Redgrave DICT, CENT: Roget: DNB: Williams: VAM: Binyon: Cundall: RA 1934: Hughes: Nettlefold: Lemaitre

SMITH, Joseph Clarendon (1778–1810)
Redgrave: Bryan: Graves RA, BI: Binyon: VAM: Williams: Cundall: Roget

SMITH, W. Collingwood (1815–1887)
Graves RA, BI: Bryan: Binyon: VAM: Cundall: Roget: Nettlefold

SMYTHE, Lionel Percy (1839–1918)
R. M. Whitelaw: *L.P.S.* OWS, I, 1923

Graves RA, BI, LOAN: VAM

SOLOMON, Simeon (1840–1905)
S. Solomon: *A vision of love revealed in sleep.* 1871 (VAM copy has biog. press cuttings)
A. Swinburne: *S.S.* 'The Bibelot' XIV, 1908
B. Falk: *Five years dead.* 1937
J. E. Ford: *S.S.* 1964 (photocopy in VAM)
Baillie Gall. 1905
U.S.A. Durlacher Gall. 1966

DNB: Graves RA: Binyon: VAM: Cundall

STANFIELD, William Clarkson (1793–1867)
'Gentleman's Mag.' IV, July 1867
J. Dafforne: *C.S.: short biog. sketch.* 1873
C. Dickens (letters): The story of a great friendship. 1918

RA 1870

Guildhall Art Gall. 1967

DNB: Bryan: Graves RA, BI, LOAN: Cundall: Hughes: Binyon: VAM: Redgrave DICT, CENT: Nettlefold: Lemaitre

STANNARD, Joseph (1797–1830)
DNB: Graves BI, LOAN: Clifford: Dickes: VAM: Redgrave

STARK, James (1794–1859)
Norwich, Art Gall. 1887
Dudley Gall. 1911

Dickes: DNB: Bryan: Graves RA, BI, LOAN: Clifford: Binyon: VAM: Cundall: Roget: Redgrave DICT, CENT: Nettlefold

STEER, Philip Wilson (1860–1942)
R. Ironside: *P.W.S.* 1943
D. S. MacColl: *Life, work, etc., P.W.S.* 1945
Goupil 1894, 1909, 1924
Eldar Gall. 1920
Barbizon House, 1927, 1934, 1935, 1937, 1939
Tate Gall. 1929, 1943
Nat. Gall. 1929
Palser Gall. 1937
FAS 1942
Birkenhead, Williamson Art Gall. 1951
Arts Council 1960

Graves RA, LOAN: VAM

STEPHANOFF, Francis Philip (1788–1860), and James (*c.* 1787–1874)
DNB: Graves RA, BI, LOAN: Cundall: Binyon: VAM: Roget: Redgrave

STEVENS, Alfred (1817–1875)
VAM MSS: D. S. MacColl correspondence. 1847–1934; *A.S.* letters, etc. 1852
H. H. Stannus: *The drawings of A.S.* 1908
R. Southern: *A.S.* 1925
K. R. Tondrow: *A.S.* 1939
Tate Gall.: *The works of A.S.* 1950
K. R. Tondrow: *A.S.* 1951
Tate Gall. 1911, 1915
Sheffield, Mappin Art Gall. 1912
Manchester, City Art Gall. 1929
Leicester Gall. 1946

DNB: Bryan: Binyon: Graves RA, LOAN: VAM: RA 1934: Redgrave

STEVENS, Francis (1781–1823)
Redgrave DICT, CENT: Roget: Graves RA, BI: VAM: Cundall

STOTHARD, Thomas (1755–1834)
VAM MSS: Letter. 1801
Cat. choice coll. pictures and drawings. 1845
A. E. Bray: *Life of T.S.* 1851
Memorial to T.S. 1867–68 (Material in VAM)

A. Dobson: *Eighteenth-century vignettes*, 1st series. 1897
A. C. Coxhead: *T.S.* 1906
Redgrave DICT, CENT: DNB: Bryan: Binyon: Graves RA, BI, LOAN: VAM: Williams: Cundall: Windsor: Roget: Hughes

STUART, James 'Athenian' (1713–1788)
DNB: Graves SOC. of A, LOAN: Cundall: Williams: Redgrave

STUBBS, George (1724–1806)
Arts Council: *Rediscovered Anatomical Drawings*. 1958
Binyon: Windsor: DNB: RA 1934: Redgrave DICT, CENT

SULLIVAN, Luke (*d.* 1771)
Binyon: Cundall: DNB: Redgrave

SUNDERLAND, Thomas (1744–1823)
R. Davies: *T.S. some family notes*. OWS, XX, 1942
Walker's Gall. 1961
VAM: Williams

SWAINE, Francis (*d.* 1782)
Binyon: Williams: Cundall: DNB

TALMAN, John (*d.* 1726)
'Wren Soc.' XVII
S. R. Pierce: "*Turris Fortissima*". 'The Antiquaries Journal' XLIV, 1, 1964
Redgrave: Walpole *Anec.*: DNB: Williams

TALMAN, William (*fl.* 1670–1700)
Binyon: Williams: Wilkie: DNB: Redgrave

TATHAM, Frederick (1805–1878)
R. L. Binyon: *Followers of William Blake*. 1926
DNB: Binyon: Roget

TAVERNER, William (1703–1772)
Walpole *Anec.*: Redgrave DICT, CENT: DNB: Bryan: Cundall: Binyon: VAM: Williams: RA 1934: Lemaitre

TAYLER, Frederick (1802–1889)
Roget: Clement and Hutton: DNB: Bryan: Cundall: Williams: Binyon: VAM: Roget: Redgrave CENT: Hughes: Nettlefold

TAYLOR, William Benjamin Scarsfield (1781–1850)
Redgrave: DNB: Cundall: Strickland

THACKERAY, William Makepeace (1811–1863)
M. H. Spielmann: *W.M.T.* 1899
New York, Grolier Club 1912
DNB: Redgrave: Clement and Hutton: Binyon: VAM: Cundall: Roget: Hughes

THIRTLE, John (1777–1839)
Norwich, Art Circle 1886
Dickes: Clifford: VAM: Williams: Cundall: RA 1934: Redgrave: Nettlefold

THOMSON, John (of Duddingston) (1778–1840)
W. Baird: *J.T.* 1895, 1907
R. W. Napier: *J.T.* 1919
DNB: Graves DICT, RA, BI: Caw: Cundall

THORNHILL, Sir James (1675–1734)
W. R. Osman: *Study of the work of Sir J.T.* 1950 (Photocopy of the typescript is in VAM)
Guildhall Art Gall. 1958
DNB: Graves LOAN: Redgrave: Sandby: Binyon: Williams: VAM: Cundall: Windsor: RA 1934: Roget

TILLEMANS, Peter (1684–1734)
Sir R. Cotton: *Cat. coll. paintings . . . P.T.* (etc.). 1733
DNB: Redgrave: Cundall: Binyon: VAM: Williams: Windsor

TOMKINS, Charles (*b.* 1757–after 1804)
Binyon: Windsor: DNB: Redgrave

TOMKINS, Charles F. (1798–1844)
Graves RA, BI: VAM: Binyon

TOMKINS, Peltro William (1759–1840)
Binyon: VAM Supp.: DNB: Redgrave

TOPHAM, Francis William (1808–1877)
F. G. Kitton: *Dickens and his illustrators*. 1899
Clement and Hutton: Graves RA: Binyon: VAM: Cundall: DNB: Roget: Redgrave

TOWNE, Francis (1740–1816)
A. P. Oppé: *F.T.* Walpole Soc. VIII, 1920
Burlington F. A. Club: Cat. of coll. of paintings and drawings by F.T. 1929–30 (Typewritten ms. in VAM)
M. Hardie: *F.T.* 'Collector' XI, 1930
A. Bury: *F.T.* OWS, XXXVI, 1961
A. Bury: *F.T.* 1962
　20, Lower Brook Street 1805
　Burlington F. A. Club 1929
　Agnews 1949
　York, Corp. Art Gall. 1950
Graves RA, SOC. of A, BI: Williams: Binyon: VAM: Cundall: DNB: RA 1934: Redgrave: Hughes: Nettlefold: Lemaitre

TRESHAM, Henry (1750–1814)
C. Robert: *Römisches Skizzenbuch aus den 18ten Jahrh.* 1897
Redgrave DICT, CENT: Roget: DNB: Strickland: Graves RA: Binyon: Sandby: VAM: Williams: Cundall

TURNER, Joseph Mallord William (1775–1851)
VAM MSS: John Rye: Coll. of his correspondence, etc., relating to Turner. 1813–84
VAM MSS: A cat. of works in the possession of F. H. Fawkes of Farnley Hall. 1850
T. Miller: *T. and Girtin's picturesque views, 60 years since.* 1854

J. Ruskin: *Cat. drawings . . . exhib. Marlbro' House.*
 1857–8
P. G. Hamerton: *Life of J.M.W.T.* 1879
J. Ruskin: *Cat. of drawings and sketches by T. . . . at the
 Nat. Gall.* 1881
G. W. Thornbury: *Life of J.M.W.T.* 1862
Turner: *J.M.W.T.'s vignette drawings.* 1884–5
C. F. Bell: *List of works contributed to public exhibitions.* 1901
 (VAM copy has notes by C.F.Bell)
Sir W. Armstrong: *Turner.* 1902
'Studio' Special nos. 1903 (VAM copy has notes by C. F.
 Bell) 1909
T. A. Cooke: *Water-colour drawings of T. in the Nat. Gall.*
 1904
London, Nat. Gall.: *A complete inventory of the drawings of
 the Turner bequest.* 1909
A. J. Finberg: *T.'s sketches and drawings.* 1910
A. J. Finberg: *T.'s water-colours at Farnley Hall.* 1912
E. G. Cundall: *Fonthill Abbey: five water-colours.* 1915
Walpole Soc. I, 1911–12; II, 1912–13; III, 1913–14; VI,
 1917–18 (All articles by A. J. Finberg)
H. W. Underdown: *Five T. water-colours.* 1923
London, Nat. Gall., Millbank: *Cat. Turner coll.* 1920
A. P. Oppé: *Water-colours of T.* 1925
G. S. Sandilands: *J.M.W.T.* Intro. by G.S.S. 1928
A. J. Finberg: *In Venice with T.* 1930 (VAM copy has
 notes by C. F. Bell)
'Manx Museum Journal' September 1936
B. Falk: *T., the painter.* 1938
A. J. Finberg: *Life of J.M.W.T.* 1939 (VAM copy has
 notes by C. F. Bell)
R. L. Binyon: *English water-colours from the work of T.
 (etc.).* 1939
C. Clare: *J.M.W.T.: His life and work.* 1951
Sir J. Rothenstein: *Turner.* 1962
M. R. F. Butlin: *Turner: Water-colours.* 1962
L. Herrmann: *J.M.W.T.* 1963
Sir J. Rothenstein and M. Butlin: *Turner.* 1964
London, Tate Gallery: M. Chamot: *Early works of
 J.M.W.T.* 1965
London, Tate Gallery: M. Butlin: *Later works of
 J.M.W.T.* 1965
J. Lindsey: *J.M.W.T.*
 RA 1886, 1887, 1889
 FAS 1900
 Prosser's Gall. Cat. no. 16 n.d.
 Manchester, Sch. of Art 1906
 Wolverhampton, Munic. Art Gall. 1908
 Newcastle-upon-Tyne, Laing Art Gall. 1912
 Agnews, 1913, 1951, 1967
 Cardiff, Nat. Mus. of Wales 1914
 Paris, Bibliothèque Nat. 1937
 Boston, Mus. of Fine Arts 1946
 Brussels, Palais des B.-Arts 1948
 Leeds, City Art Gall. 1948
 Chelsea Soc. 1949

 Great Britain: Brit. Council 1950
 Manchester, City Art Gall. 1952–3
 New York, Otto Gerson Gall. 1960
 Melbourne, Nat. Gall. of Victoria 1961
 Washington, U.S.A.: Smithsonian Inst. 1963–4
 Manchester, Univ. (Whitworth Art Gall.) 1966
 Cotswold Gall. 1923, 1924, 1926, 1927, 1929
 DNB: Redgrave DICT, CENT: Binyon: VAM: Williams:
 Cundall: Windsor: RA 1934: Roget: Nettlefold:
 Lemaitre

TURNER, William (of Oxford) (1789–1862)
A. L. Baldry: *W.T. of Oxford.* 'Walker's Quart.' XI, 1923
M. Hardie: *W.T. of Oxford.* OWS, IX, 1932
L. Herrmann: *W.T. of Oxford.* 'Oxoniensia' XXVI, XXVII,
 1961–2
 Soc. Ptrs. in Water-colours 1832
 Oxford Univ. Gall. 1895
 DNB: Bryan: Graves DICT: Cundall: Binyon: VAM:
 Redgrave: Nettlefold

UNDERWOOD, Thomas Richard (1765–1836)
 Cundall: Williams: VAM: Roget: Redgrave: Hughes

UWINS, Thomas (1782–1857)
VAM MSS: Correspondence between John Constable and
 T.U. 1822–51
Memoir. 1858, 2 vol.
 Redgrave DICT, CENT: Clement and Hutton: DNB:
 Cundall: Binyon: VAM: Williams: Roget

VAN DE VELDE Family
London Nat. Maritime Mus.: *V. de V. drawings.* 1958
 Colnaghi 1937
 BM Cat. of Dutch and Flemish Drawings 1931: BM I:
 Williams: Redgrave

VAN DYCK, Sir Anthony (1599–1641)
Description of the Duke of Devonshire's sketch book. 1902
M. Jaffe: *V.D.'s Antwerp sketch book.* 1966
 Grosvenor Gall. 1887
 Woodburn's Gall. 1835
 RA 1900
 BM Cat. Dutch and Flemish Drawings 1931: Binyon:
 Williams: Redgrave DICT, CENT

VAN HUYSUM, Jacob (c. 1687–1746)
 Binyon: Williams: DNB

VARLEY, Cornelius (1781–1873)
B. S. Long: *C.V.* OWS, XIV, 1937
 Redgrave DICT, CENT: DNB: Binyon: VAM: Williams:
 Cundall: Windsor: Roget: Hughes: Lemaitre

VARLEY, John (1778–1842)
A. T. Story: *James Holmes and J.V.* 1894
B. S. Long: *List of works exhibited by J.V.* OWS, II, 1925

A. Bury: *J.V. of the 'Old Society'*. 1946
 Ryder Gall. 1906
 McLean's Gall. n.d.
 Prosser's Gall. n.d.
 Japanese Gall. 1891
 Hanover Gall. 1904
 Walker's Gall. 1906
 Goupil Gall. 1913
 Cotswold Gall. 1926
 Redgrave DICT, CENT: DNB: Graves DICT: Cundall:
 Binyon: VAM: Williams: Windsor: RA 1934: Hughes:
 Nettlefold: Lemaitre

VARLEY, William Fleetwood (*c.* 1785–1856)
 VAM: Williams: Cundall: DNB: Redgrave: Hughes

VICKERS, Alfred Gomersal (1810–1837)
 Redgrave DICT: Bryan: Binyon: VAM: Cundall: DNB:
 Hughes: Nettlefold

VINCENT, George (1796–?1836)
 Dickes: Cundall: DNB: Roget: Redgrave DICT, CENT:
 Nettlefold

WAGEMAN, Thomas Charles (1737–1863)
 Redgrave: Graves RA, BI: Cundall: Binyon: VAM

WAITE, Robert Thorne (1842–1935)
 Vokins Gall. 1886, 1888
 Dowdeswell Gall. 1891, 1898
 FAS 1897
 Leicester Gall. 1907
 Bristol, Frost and Reid Gall. 1900
 Graves DICT, RA: VAM: Nettlefold

WALE, Samuel (*d.* 1786)
 Binyon: Williams: DNB: Redgrave DICT, CENT

WALKER, Frederick (1840–1875)
 J. C. Carr: *F.W.: an essay.* 1885
 Sir C. Phillips: *F.W.* 1894
 J. G. Marks: *Life and letters of F.W.* 1896
 C. Black: *F.W.* ?1902
 J. L. Roget: *F.W.* OWS, XIV, 1937
 Deschamp Gall. 1876
 FAS 1895
 Cundall: DNB: Binyon: VAM: Roget: Redgrave DICT,
 CENT: Nettlefold

WALKER, William (E.) (1780–1863)
 Redgrave: Roget: Cundall: Graves DICT, RA: VAM:
 Nettlefold

WALLS, William (exh. 1887–1893)
 Caw: Graves RA, LOAN: VAM

WALMESLEY, Thomas (1763–1805 or 1806)
 DNB: Strickland: Cundall: Graves RA, SOC. of A:
 Binyon: VAM: Williams: Redgrave

WALTER, Henry (1799–1849)
 Graves RA, BI, LOAN: Binyon

WALTON, Elijah A. (1833–1880)
 Pall Mall Gall. 1868, 1869
 4 Westminster Chambers 1872
 DNB: Clement and Hutton: Graves DICT, RA, BI, LOAN:
 Cundall: VAM

WARD, James (1769–1859)
 VAM MSS: J.W. letters 1844–59
 J. Frankau: *William W. and J.W.* 1904
 'Connoisseur' Extra no. 1909
 A. Bury: *J.W.* 'British Racehorse' X, IV, 1958
 'Arte Figurativa' VIII, ii, 1960
 6 Newman Street 1822
 Mount Street Gall. 1907, 1908
 Tooth Gall. 1939
 Arts Council 1960
 Graves DICT: DNB: Binyon: VAM: Williams: Cundall:
 RA 1934: Roget: Redgrave DICT, CENT: Nettlefold

WARREN, Henry (1794–1879)
 VAM: Cundall

WATERFORD, Louise, Marchioness of (1818–1891)
 C. Stuart: *Short sketch of the life of L.W.* 1892
 A. J. C. Hare: *The story of two noble lives.* 1892
 H. M. Neville: *Under a border tower.* 1896
 RA 1893
 Cundall: VAM

WATERLOW, Sir Ernest (1850–1919)
 'Art Journal' Christmas no. 1906
 FAS 1920
 Graves DICT, RA: DNB: VAM

WEBBER, John (?1750–1793)
 D. J. Bushnell: *Drawings by J.W.* 1928
 A. G. Reynolds: *British artists abroad, I. Capt. Cook's
 draughtsman.* 'Geog. Mag.' XIX, X, 1947
 Redgrave DICT, CENT: DNB: Edwards: Graves: Prideaux:
 Binyon: VAM: Williams: Cundall: Roget

WEBSTER, Thomas (1800–1886)
 Redgrave DICT, CENT: Roget: VAM: DNB

WELLS, William Frederick (1762–1836)
 B. S. Long: *W.F.W.* OWS, XIII, 1936
 Redgrave DICT, CENT: DNB: Cundall: VAM: Williams:
 Hughes

WEST, Benjamin (1738–1820)
 J. Galt: *Life, studies and works of B.W.* 1820
 G. Evans: *B.W. and the taste of his time.* 1959
 West's Gall. 1822, 1826
 Brooklyn, Inst. of Arts and Science 1922
 DNB: Roget: Binyon: VAM: Williams: Cundall: Windsor:
 Redgrave DICT, CENT

WESTALL, Richard (1765–1836)
DNB: Graves DICT, RA, BI, LOAN: Binyon: VAM: Williams: Cundall: Windsor: Roget: Redgrave DICT, CENT: Nettlefold

WESTALL, William (1781–1850)
Binyon: VAM: Williams: Cundall: DNB: Roget: Redgrave DICT, CENT: Hughes

WHAITE, Henry Clarence (1828–1912)
Manchester, City Art Gall. 1908
Graves DICT, RA, BI, LOAN

WHEATLEY, Francis (1747–1801)
'Connoisseur' Extra no. 1910
W. Roberts: *The cries of London.* 1924
F. G. Roe: *Sketch portrait of F.W.* 1938
Graves Gall. 1906
Aldeburgh Festival Ex. and Leeds City Art Gall. 1965
DNB: Cundall: Edwards: Strickland: Binyon: VAM: Williams: RA 1934: Roget: Redgrave DICT, CENT: Nettlefold

WHICHELO, C. John M. (*d.* 1865)
Binyon: VAM: Williams: Cundall: Windsor: DNB: Roget: Redgrave

WHISTLER, J. A. McNeill (1834–1903)
H. W. Singer: *J.A.McN.W.* 1904
E. R. and J. Pennell: *The life of J. A. McN. W.* 1908, 1911, 1920
B. Sickert: *Whistler.* 1908
A. E. Gallatin: *W.'s pastels.* 1913
E. R. and J. Pennell: *The Whistler Journal.* 1921
J. Laver: *Whistler.* 1930, 1951
J. Laver: *Paintings by W.* 1938
J. Laver: *Whistler.* 1942
H. Gregory: *The world of J. McN. W.* 1961
D. Sutton: *Nocturne.* 1963
D. Sutton: *J. McN. W.* 1966
Goupil Gall. 1892, 1904
New York, Met. Mus. 1910
Nat. Gall. 1912
Colnaghi 1915
Glasgow Univ. 1935
New York, Carroll Carstairs Gall. 1938
Arts Council 1960
Graves RA, LOAN: VAM: Cundall

WHITE, John (*fl.* 1585–1593)
R. L. Binyon: *The drawings of J.W.* Walpole Soc. XIII, 19
S. Lorant: *The new world.* 1946
P. Hulton: *J.W.* 'History Today' May 13, 1963
DNB: Binyon: BM I: Williams: RA 1934

WHYMPER, Josiah Wood (1813–1903)
DNB: Roget: Cundall: VAM

WIGSTEAD, Henry (*fl.* 1774–1785)
Redgrave: Graves RA, BI, LOAN: Williams

WILD, Charles (1781–1835)
Redgrave: Roget: DNB: Cundall: Graves RA, BI, LOAN: Binyon: VAM: Williams: Windsor: Hughes

WILKIE, Sir David (1785–1841)
VAM MSS: Material concerning life and works of Sir D.W. 1804–41 and Cat. raisonné, *c.* 1842
A. Cunningham: *Life of D.W.* 1843
A. Rainbach: *Memoirs and recollections.* 1843
J. W. Mollett: *Sir D.W.* 1881
Lord Gower: *Sir D.W.* 1902
Arts Council 1951, 1958
Caw: Graves RA, BI, LOAN: Binyon: VAM: Cundall: Windsor: DNB: Redgrave DICT, CENT

WILKINSON, Rev. Joseph (*fl.* 1810)
Redgrave: Binyon: VAM: Williams

WILLIAMS, Hugh William ('Grecian') (1773–1829)
Redgrave: DNB: Caw: Rees: Williams: Binyon: VAM: Cundall: Roget

WILSON, Andrew (1780–1848)
Binyon: VAM: Williams: Cundall: DNB: Redgrave

WILSON, Richard (1714–1782)
A. Bury: *R.W.* 1947
A. G. Reynolds: *British artists abroad, IV. Wilson and Turner in Italy.* 'Geog. Mag.' XXI, 1948
B. Ford: *The drawings of R.W.* 1951
W. G. Constable: *R.W.* 1953
Cardiff, Nat. Mus. Wales: *R.W. in the Museum.* 1961
Manchester, City Art Gall. 1925
Tate Gall. 1925, 1949
Birmingham, Mus. and Art Gall. 1948, 1949
Sandby: Graves RA, SOC. OF A, LOAN: Binyon: VAM: Williams: DNB: RA 1934: Roget: Redgrave DICT, CENT: Hughes: Nettlefold: Lemaitre

WIMPERIS, Edmund Morison (1835–1900)
E. Wimperis: *E.M.W.* 'Walker's Quart.' IV, 1921
Dowdeswell Gall. 1887
Richardson Gall. 1901
Frost and Reed Gall. 1901
Walker's Gall. 1928, 1931
FAS 1932
DNB: Graves RA, LOAN: Cundall: VAM: Nettlefold

WINTOUR, John Crawford (1825–1892)
Caw: Graves LOAN: Cundall

WITHERINGTON, William Frederick (1785–1865)
Sandby: Redgrave: Clement and Hutton: Graves RA, BI, LOAN: Cundall: VAM: DNB: Nettlefold

WOLF, Joseph (1820–1899)
A. H. Palmer: *Life of J.W.* 1895
A. B. R. Trevor-Battye: *J.W. 1899* 'Artist' xxv, i, 1899
DNB: Graves RA, BI, LOAN: Cundall: VAM: Nettlefold

WOODWARD, George Moutard (?1760–1809)
DNB: Binyon: Williams: VAM: Windsor: Redgrave

WOOLLETT, WILLIAM (1735–1785)
FAS 1885
Redgrave DICT, CENT: Roget: DNB: Graves SOC. of A:
Binyon: Williams: Windsor: Hughes

WOOTTON, John (1686–1765)
Binyon: Williams: Windsor: DNB: Redgrave DICT, CENT

WORTHINGTON, T. (*fl.* 1800)
Graves RA: Roget

WRIGHT, John Masey (1777–1866)
DNB: Roget: Graves RA, BI: Binyon: VAM: Williams:
Cundall: Redgrave: Hughes

WRIGHT, Joseph (of Derby) (1734–1797)
W. Bemrose: *Life and works of J.W.* 1885
S. C. K. Smith: *W. of D.* 1922
B. Nicolson: *J.W. of Derby.* 1968

Mr. Robins Rooms, Covent Garden 1785
Derby, Art Gall. 1883
RA 1886
Graves Gall. 1910
Derby, Pub. Lib. Mus. and Art Gall. 1934
Derby, Art Gall. 1947
Arts Council 1958
Sandby: Graves RA, SOC. of A, LOAN: Williams: DNB:
RA 1934: Roget: Redgrave DICT, CENT

WYCK, Jan (1652–1700)
Binyon: Williams: Windsor: DNB: Redgrave

WYLD, William (1806–1889)
Binyon: VAM: Cundall: Nettlefold

YATES, G. (Worked about 1827–1837)
Binyon: Williams

YOUNG, Tobias (*fl.* 1821–*d.* 1824)
Redgrave: Cundall: VAM: Williams

ZUCCARELLI, Francesco (1702–1788)
A. Rosa: *F.Z.* 1952 (2 ed.)
Binyon: VAM: Williams: Cundall: Windsor: DNB:
Roget: Redgrave DICT, CENT

1901 *Golf (The Man and the Book)*, 'Macmillan's Magazine', November.

1902 *A Sketching Club, 1855–1880*, 'The Artist', January.
The Pictorial History of Golf, 'Connoisseur', III, 144–7.

1903 *Modern Etchings of the Foreign Schools in the National Art Library*. Victoria and Albert Museum. Catalogue. H.M.S.O.

1904 *A Great Painter-Etcher: Old Crome*, 'Connoisseur', VII, 3–8.
George Morland. I: The Man and the Painter (with bibliography). 'Connoisseur', IX, 156–63.
George Morland. II: The Engravings, 'Connoisseur', IX, 199–207.
Sittings at Sir Thomas Lawrence's: Curious History of a Picture, 'Magazine of Art', April.

1905 *Catalogue of Works by James A. McN. Whistler*. Victoria and Albert Museum. (Revised and enlarged, with bibliography, 1908, 1912, 1921.)
The Illustrators of Don Quixote, 'Connoisseur', XIII, 69–75

1906 *Modern Etchings and Aquatints of the British and American Schools in the National Art Library, Victoria and Albert Museum*. Catalogue. H.M.S.O.
F. Lippmann, *Engraving and Etching: A Handbook*. 312 pp. Translated from the German by M.H.
English Coloured Books. London, 340 pp. 28 coloured plates.
The 'Auld Lang Syne' Sketching Club, 1865–1867, 'Chambers Journal', January.
The Pictorial History of Skating, 'Connoisseur', XIV, 151–7.

1907 *The Tours of Dr. Syntax: Rowlandson's Unpublished Illustrations*, 'Connoisseur', XVIII, 215–19.
The Moxon Tennyson, 1857, 'Book-Lover's Magazine'.
Heraldry and Autographs: The Stammbuch or Album Amicorum, 'Connoisseur', XIX, 231–4.

1908 *John Pettie, R.A.*, 'Art Journal', April.
John Pettie, R.A., H.R.S.A. London, 278 pp. 50 coloured plates.

1910 *John Pettie: Sixteen Examples of the Artist's Work*. Introduction by M. H. London, 12 pp.
Frederick Goulding, Master Printer of Copper Plates. Stirling, 167 pp. 10 plates.

1912 *Herman A. Webster*, 'Print Collectors' Quarterly', II, No. 1, 56–73.
Herman A. Webster in 'Prints and their Makers', ed. F. Carrington. New York, 1912; London, 1913. (M.H.'s contribution on pp. 239–58 is in part a republication of his article for the 'Print Collectors' Quarterly'.)

1913 *The Etched Work of Samuel Palmer* (with catalogue), 'Print Collectors' Quarterly', III, No. 2, 207–40.

1917 In J. S. Engall, *A Subaltern's Letters, 1915–1916*. Introduction by M.H.

1918 *Boulogne, A Base in France, being 32 Drawings from the Sketchbook of Capt. Martin Hardie*. London, 8 coloured plates and 24 collotypes.

1919 Edward Norgate, *Miniatura, or the Art of Limning*, edited from the MS. in the Bodleian Library and collated with other MSS. by M. H. Oxford, III pp.

1920 With H. Warner Allen, *Our Italian Front*. London, 203 pp. 50 water-colours by M.H. reproduced in colour.
With Arthur K. Sabin, *War Posters issued by Belligerent and Neutral Nations, 1914–1918*. London, 46 pp. 80 plates.
Modern Wood Engravers. Catalogue. Victoria and Albert Museum.
Catalogue of Paintings, Drawings and Prints in the Collection of Arthur F. Stewart. Privately printed. 89 pp. 35 collotypes.

1921 In L. D. Luard, *Horses and Movement*. Foreword by M.H.
The British School of Etching. (Foreword by Sir Frank Short.) Print Collectors' Club publication No. 1. 33 pp. 12 plates.
The Etched Work of W. Lee-Hankey, R.E., from 1904 to 1920. Catalogue. London, 97 pp. 188 plates.

1922 In W. P. Robins, *Etching Craft*. Foreword by M.H.
Our Duty to Art. Address at the Annual Prize-Giving of the Wolverhampton School of Art. London, 12 pp.

1923 *Etchings and Lithographs of Claude Shepperson, A.R.A., A.R.E.* (with catalogue), 'Print Collectors' Quarterly', X, No. 4, 444–71.

1924 *Engraved Ornament, Rosenheim Collection*. Catalogue. Sotheby's.
The Pageant of Empire. Souvenir Volume (British Empire Exhibition, Wembley). Edited by M.H. London, 55 pp.

324

1925 *Etchings and Dry Points from 1902 to 1924 by James McBey*. Catalogue. London, 224 plates.
The British Empire Lithographs, 'Apollo', October.

1926 *Picture Book of the Work of John Constable*. Victoria and Albert Museum. Introduction by M.H.

1927 *Samuel Palmer*. (With list of works exhibited, and extracts from letters.) 'Old Water-Colour Society's Club', IV, 25–50.

1928 *Samuel Palmer*. Print Collectors' Club publication No. 7. 67 pp. 22 plates.
Picture Book of Victorian Paintings in Victoria and Albert Museum. Introduction by M.H.

1929 *Peter De Wint*. Introduction by M.H. Famous Water-Colour Painters series, No. 5. London, 6 pp. 8 coloured plates.

1930 *J. S. Sargent*. Introduction by M.H. Famous Water-Colour Painters series, No. 7, 6 pp. 8 coloured plates.
Edward Lear, 'Art-Work', Summer.
Early drawings of the British Water-Colour School: An Identification, 'Collector', June.
Early Artists of the British Water-Colour School: Francis Towne, 'Collector', September and October.
Alexander Cozens, 'Collector', November and December.

1931 *Charles Meryon and his 'Eaux-Fortes sur Paris'*. Print Collectors' Club publication No. 10. 30 pp. 22 plates.
Exhibition of British and Foreign Posters. Catalogue. Victoria and Albert Museum. Introduction by M.H.
The Technique of Water-Colour, I. 'Studio', October.

1932 *W. Turner of Oxford* (with catalogues, and list of works exhibited). 'Old Water-Colour Society's Club', IX, 1–23.
With Muriel Clayton, *Thomas Daniell, R.A., 1749–1840; William Daniell, R.A., 1769–1837* (with 2 portraits and 10 reproductions). 'Walker's Quarterly', Nos. 35 and 36. 106 pp.
The Technique of Water-Colour, II. 'Studio', April.

1933 *The Etchings and Engravings of Stanley Anderson* (with catalogue). 'Print Collectors' Quarterly', XX, 221–46.

1934 *Thomas Girtin, the Technical Aspect of his Work*. 'Old Water-Colour Society's Club', XI, 1–20.

1935 *Constable's Water-Colours*. 'Old Water-Colour Society's Club', XII, 1–16.
The Wood-Engravings of Clare Leighton (with catalogue), 'Print Collectors' Quarterly', XXII, No. 2, 139–65.

1938 *The Etched Work of James McBey (1925–37)*, 'Print Collectors' Quarterly', XXV, No. 4, 421–45.

The Liber Studiorum Mezzotints of Sir Frank Short, R.A., P.R.E. (catalogue and introduction). Print Collectors' Club publication No. 17. 129 pp. 25 plates.

1939 *The Mezzotints and Aquatints of Sir Frank Short, R.A., P.R.E., other than those for the Liber Studiorum* (catalogue and introduction). Print Collectors' Club publication No. 18. 75 pp. 16 plates.
A Sketch Book of Thomas Girtin, 'Walpole Society', XXVII, 89–95. Plates.
Scottish Art. Catalogue. Royal Academy.

1940 *Etchings, Dry-Points, and Lithographs by Sir Frank Short, R.A., P.R.E.* (catalogue and introduction.) Print Collectors' Club publication No. 19. 89 pp. 16 plates.

1942 *Cotman's Water-Colours; The Technical Aspect* and *Cotman as Etcher*, 'Burlington Magazine', LXXXI, 171–6.

1944 *The Royal Society of Painters-Etchers and Engravers: A Brief History*, 'Studio', September.
William Callow, 'Old Water-Colour Society's Club', XXII, 12–23.

1945 *Joseph Crawhall*. 'Old Water-Colour Society's Club', XXIII, 28–35.

1947 *Flower-Paintings*. Leigh-on-Sea. 13 pp. 25 plates.
David Roberts, R.A., 'Old Water-Colour Society's Club', XXV, 10–20.
Robert Hills 'Extollager', 'Old Water-Colour Society's Club', XXV, 38–40.

1949 *English Water-Colours of the XVIIIth Century*. London, 42 pp. 41 illustrations.
Dictionary of National Biography—Articles
Walter Greaves (1846–1930)
Arthur Ambrose McEvoy (1878–1927)
Sir Francis (Frank) Short (1857–1945)
Introductions to catalogues of exhibitions.
Amelia M. Bowerley (Glasgow, 1909)
C. E. Johnson, R.I., 1832–1913 (Leicester Galleries, 1913)
E. M. Synge, A.R.E. (Connell, 47 Old Bond Street, 1913)
Auguste Lepère, 1849–1918 (Colnaghi, 1920)
T. Austen Brown, 1857–1924 (Leicester Galleries, 1924)
Fred. C. Richards, R.E., 1878–1932 (Colnaghi, 1932)
Peter De Wint and P. Wilson Steer (Palser Gallery, 1937)
James Holland, R.W.S., 1800–1870 (Leger Galleries, 1949)
Anna Airy, R.I., R.O.I., R.E. (R.B.A. Galleries, published posthumously, 1952)

325

INDEX

of Artists Mentioned this in Volume

The numerals in *Italics* refer to the principal entries relating to each artist and those in **Bold** type refer to the Figure Numbers of the Illustrations.

328

335

GENERAL INDEX

TO VOLUMES I TO III

GENERAL INDEX

to Volumes I to III

The figures on the SAME LINE as an artist's name indicate the pages in which the MAIN INFORMATION about the artist will be found. The sub-headings on subsequent lines are of three kinds: if the main information about an artist covers several pages, sub-headings have been given to facilitate reference to a particular item in those pages; other sub-headings bring together smaller items of relevant information from other parts of the book; and the sub-headings in *italic* give the titles of all works by the artist which are reproduced in the book as *Plates*.

Drawings, whether they are reproduced as Plates or are mentioned in the text, are entered individually under their *titles* in the main alphabetical sequence; but in many cases the titles have been inverted, to make a subject-word the first word. This has been done in order to abstract the maximum subject-value from the Plates, and to obviate long lists under such words as *Study* . . . and *Landscape*. . . . Frequently used titles such as *Landscape with Trees* have been omitted altogether from the title-entries in the main alphabet; but *all* titles of actual Plates appear in the lists given under each artist's name.

Plate numbers are indicated by **Bold** type. The letter n after a page-number indicates that the information will be found in a footnote on that page.

ADDENDA AND CORRIGENDA

The following relates to Volumes I and II of this work, previously published, and has been partly compiled from recommendations kindly offered in correspondence.

Vol. I p. 12 line 13 *The Art of Drawing* . . . full details can be found in J. F. Fulton's *Bibliography of the Hon. Robert Boyle*, Oxford 1961
(Dr. Johannes Dobai)

I p. 38 line 1 'William Williams of Norwich', one of these drawings is in the VAM, P. 136-1931 (Mr. J. Naimaster)

I p. 57 line 9 up After 'A. P. Oppé' read 'on the other hand, thinks that some of the landscape drawings, mainly those at Chatsworth, may belong to his English period, but that the group in the British Museum are either of Flemish subjects or were made on visits to the Netherlands'. (1st ed.)

I p. 57 note 3 For 'LXVIII, 1936' read 'LXXIX, 1941' (1st ed.)

I p. 64 line 8 up For 'pouring' read 'poring'

I p. 68 line 20 (Pl. 29) applies to *Clermont at a distance* . . . on the following line

I pls. 18 II 19 Transpose titles (1st ed.)

I p. 94 line 3 up Edward Edwards, for '1736' read '1738'

I p. 65 For 'Emmaeus' read 'Emmaus'

I p. 67 de Loutherbourg, now ascribed to James Gillray (Mr. Draper Hill)

I p. 111 line 3 Clérisseau, for '1722' read '1721' (1st ed.) (Mr. T. J. McCormick)

I p. 111 line 5 Transpose the dates 1757 and 1770 (1st ed.) (Mr. T. J. McCormick)

I p. 133 line 4 up For 'Servon' read 'Servoz'

I pl. 128 For 'Waterloo' read 'Westminster' (1st ed.)

I pl. 130 For 'pencil' read 'pen' (1st ed.)

I p. 167 line 18 For 'Griffiths' read 'Griffith'

I p. 167 & pls. 168 & 169 Griffith for 'after 1809' read '1819' (Mr. J. Naimaster)

I p. 179 line 4 For 'Charles' read 'H. M.' Cundall

I p. 203 line 2, etc. Fuseli was elected Professor of Painting in 1799, Keeper in 1804, resigned as Professor of Painting in 1805 but held both offices from 1810 until he died.

The Night Hag has closer affinities to William Young Ottley than Fuseli.

Spirit in the form of a Beautiful Maiden . . . is now ascribed to T. M. Von Holst
(Dr. Gert Schiff)

I p. 211 last line For 'Juke's' read 'Jukes''

I p. 213 note For 'Robert E.' read 'Robert R.' Wark

I p. 219 line 9 After Wigstead insert (d. 1800)

I pl. 204 Title should read 'Œdipus cursing his son Polynices' (1st ed.)

I p. 220 line 21 After . . . *sketch*, read 'This last drawing is now in the Royal Collection at Windsor Castle; Dighton also recorded the *Westminster Election of 1788* and *Westminster Election of 1796*. Both of these drawings are in the London Museum'
(1st ed.) (Dr. John Hayes)

I p. 223 last line and pls. 228 and 229 Alter 'Henry' to read 'Henry Thomas' Alken (1785-1851)

I p. 229 line 11 For 'c. 1670' read '1684 or 6'

I p. 229 note 1 'Matthew Walker Knott', pseudonym for Gregory Robinson, D.S.C.
(Mr. J. Naimaster)

I p. 230 line 5 up After '. . . in England' delete following sentence and insert 'A Shipbuilder's Yard, the only known drawing of detailed ship building by Scott, is a good example of his somewhat timid handling.'

I p. 235 line 18 After 'father' insert '(d. 1777)' (Mr. Andrew Wilson)

I p. 235 note 3 Add, 'Illus. in *Walker's Monthly* pre-1939'

I pls. 236 and 237 Transpose captions

I pl. 239 For 'Ponte' read 'Pont y'

I p. 238 DANCE N. after '101' add '148'

I p. 239 GRIFFITH M. for '332, 333' read '166, *167*'

I p. 240 HOWITT S. after 230 add 231

I p. 242 SCOTT S. delete 231

I p. 243 For 'Yoeman' read 'Yeoman'

II p. 24 line 2 up For 'Munro' read 'Monro'

p. 24 note 6 For 'grandson' read 'great grandson'

p. 25 top line For 'Aunt Isabel' read 'Great grandmother (Hannah Woodcock, Mrs. Thomas Monro)' (Dr. J. Jefferiss)

II p. 39 note 8 For 'Coleman' read 'Colman'

p. 96 line 6 up For '1926' read '1927'

II p. 110 add note The grandson of John Varley, John Varley, Jr. (Exhib. 1870, d. 1899), painted subjects in the East and causes confusion by using the same signature
(Mr. J. Naimaster)

II p. 146 line 20 For 'by Bonington' read 'to Bonington'

II p. 146 line 17 up For '1894' read '1804'

II p. 149 line 18 After '. . . ballerinas' add note: lithograph by T. H. Maguire entitled *Pas de Quatre*, Beaumont and Sitwell, *The Romantic Ballet*, 1938, p. 106 (Mr. J. Naimaster)

II pl. 127 For 'Mendon' read 'Meudon'

II p. 167 line 4 up Delete '(both were in the Fine Art Society in 1941)'

II p. 187 line 6 up for 'David' read 'Davis'

II p. 188 line 12 'Mrs. Nares, Beverly's daughter, spelt the name with a final e'
(Mr. J. Naimaster)

II pls. 163–170 For '1837' read '1828'

II pl. 172 For 'L'Institute' read 'L'Institut'

II. p. 189 line 5 and p. 244 For 'D. F. Tomkins' read 'C. F. Tomkins'

II pl. 187 For 'Tour d'Horloge' read 'Tour de l'Horloge'

II pls. 195, 196 For 'Henry' read 'Harry'

II p. 218 line 21 For 'burst' read 'bursts'

II p. 227 note 2 For 'Seyforth' read 'Seyffarth'

II p. 228 *and* Index FENNEL not FENNELL

II p. 233 line 3 up and pl. 266 For '*c.* 1933' read '1935' (Mr. J. Naimaster)

II pl. 217 For 'Peverill' read 'Peveril' and for 'VAM 111' read 'VAM 411'

p. 235, note 1 Add 'probably the drawing now in the Henry Huntingdon Library, San Marino, California'

Index, Wimperis, Edmund Morison not Morrison